Disputers of the
TAO

Philosophical Argument in Ancient China

A.C.Graham

OPEN COURT
Chicago and La Salle, Illinois

Map on p. ii reproduced by permission from Yu-lan Fung's *A History of Chinese Philosophy*, translated by Derk Bodde and published by Princeton University Press.

Open Court Publishing Company is a division of Carus Publishing Company.

© 1989 by Open Court Publishing Company

First printing 1989
Second printing 1991
Third printing 1993
Fourth printing 1995
Fifth printing 1997

Printed and bound in the United States of America.

Library of Congress Cataloging-in-Publication Data

Graham, A.C. (Angus Charles)
 Disputers of the Tao: philosophical argument in ancient China/A.C. Graham.
 p. cm.
 Bibliography: p.
 Includes index.
 ISBN 0-8126-9087-7—ISBN 0-8126-9088-5 (pbk.)
 1. Tao 2. Philosophy, Chinese. I. Title.
B127.T3G69 1989 89-32227
181'.11–dc20 CIP

Disputers of the
TAO

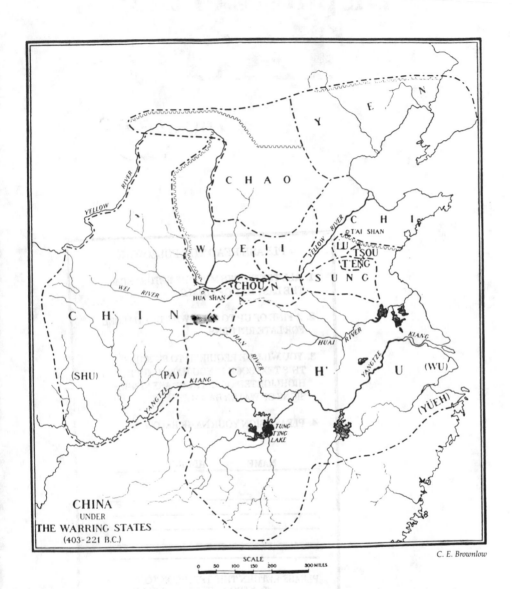

CHINA
UNDER
THE WARRING STATES
(403-221 B.C.)

SCALE

0 50 100 150 200 300 MILES

C. E. Brownlow

Contents

PREFACE

This is a general history of Chinese philosophy in the classical age (500–200 B.C.) which takes advantage of the progress of textual, grammatical and exegetical studies over the last few decades. Its theme is as much *how* the sages thought as what they thought, with the focus on debate between rival schools. We now know that there is much more rational discourse in the literature than used to be supposed, especially since scholars ceased to be deterred by textual problems from taking full account of the Later Mohist corpus. But just as much attention will be given to the analysis of modes of thinking at the opposite extreme from Western rationality, to the aphorisms of *Lao-tzu*, the correlations of Yin-Yang cosmology and the divinatory system of the *Yi*. Direct quotation will sometimes exceed exposition, to avoid that dangerous detachment of 'thoughts' from thinking and saying which leaves little behind but labels and slogans, 'universal love' (Mo-tzu), 'Human nature is good' (Mencius), 'Human nature is bad' (Hsün-tzu).

The major histories of Chinese philosophy available in English earlier in this century came from Chinese stimulated to re-examine their tradition by influences from the West, by Pragmatism (Hu Shih) and Neo-Realism (Fung Yu-lan). In recent years the most original proposals have come from the borders between Western sinology and professional philosophy, for example from the philosopher Herbert Fingarette in *Confucius: The Secular as Sacred*, and the sinologist Roger Ames and philosopher David Hall in *Thinking Through Confucius*. We, like the Chinese, fully engage with the thought only when we relate it to our own problems. I shall not scruple to ride a couple of hobby-horses of my own: the impossibility of fully disengaging analytic from correlative thinking, and a 'quasi-syllogism' useful for interpreting Chinese thought which has also altered my perspective on Western moral philosophy—not because I suppose that the understanding of Chinese philosophy depends on swallowing my own, but because it does depend on philosophising for oneself. Taking Chinese thought seriously is not simply a matter of acknowledging the rationality of some of it (and perhaps denying the name 'philosophy' to the rest), nor of discovering something valuable to oneself in the poetry of

Lao-tzu or the diagrams of the *Yi.* Its study constantly involves one in important contemporary issues in moral philosophy, the philosophy and history of science, the deconstruction of established conceptual schemes, the problems of relating thought to linguistic structure, and correlative thinking to logic.

References are supplied to existing versions of the texts, but all quoted passages are newly translated. This is necessary to ensure consistent equivalents to the key words. In any case available translations inevitably represent all stages in the progress of sinology over the last century; the reader searching for a quoted passage in an older version may sometimes find it hard to recognise. Romanisation follows the Wade-Giles system. I have occasionally supplied tone marks to distinguish words pronounced in different tones which would otherwise be confusable (for example the Emperor Chòu overthrown by the Chou).

Since the book is designed for the general reader interested in philosophy, works of scholarship available only in Chinese or Japanese are mentioned only when depending on evidence unpublished in Western languages. I apologise if this does less than justice to the importance of Far-Eastern scholarship. For full acknowledgement of aid from others I would have to mention everyone with whom I have discussed the issues fruitfully over the 30 years or more that I have worked in this field. Many will find their names in the body of the work; I select for explicit thanks only some who have read and criticised substantial parts of the manuscript, Christoph Harbsmeier, Roger Ames, Henry Rosemont, Hal Roth, Robert Henricks.

I wish to thank also the institutions in which I have worked on this book; the Institute of East Asian Philosophies, Singapore; the Department of Linguistics, Tsing Hua University, Taiwan; the Department of Religious Studies, Brown University; the Department of Philosophy, University of Hawaii; and also the School of Oriental and African Studies, London, where I did my earlier researches into Chinese language and philosophy.

ABBREVIATIONS

Texts

An	*Analects*
Cz	*Chuang-tzu*
HF	*Han Fei-tzu*
HN	*Huai-nan-tzu*
Hs	*Hsün-tzu*
Kz	*Kuan-tzu*
LSCC	*Lü-shih ch'ün-ch'iu ('Lü Spring and Autumn')*
Lz	*Lao-tzu*
Me	*Meng-tzu ('Mencius')*
Mo	*Mo-tzu*

Editions and Journals

BSOAS	*Bulletin of the School of Oriental and African Studies* (London)
BSS	*Basic Sinological Series (Kuo-hsüeh chi-pen ts'ung-shu)* 國學基本叢書
ed.	edited
HJAS	*Harvard Journal of Asiatic Studies*
HY	*Harvard-Yenching Institute Sinological Index Series*
JAOS	*Journal of the American Oriental Society*
JCP	*Journal of Chinese Philosophy*
PEW	*Philosophy East and West*
SPPY	*Ssu-pu pei-yao* 四部備要
SPTK	*Ssu-pu ts'ung-k'an* 四部叢刊
tr.	translated

Translators

D	Duyvendak
G	Graham
L	Legge
RG	(*Kuan-tzu*) Rickett, '*Guanzi*'
RK	(*Kuan-tzu*) Rickett, '*Kuan-tzu*'
W	Watson
WB	Wilhelm-Baynes

Introduction

China, like the other civilizations of the Old World, draws its basic ideas from that time of awakening between 800 and 200 B.C. which Karl Jaspers[1] has called the Axial Period, the age of the Greek and Indian philosophers, the Hebrew prophets and Zarathustra. The creative thinking of that era seems everywhere to have sprung up amid the variety and instability of small competing states; in China it begins towards 500 B.C. in a time of political disunion, and may be judged to lose its impetus with the reunification of the empire in 221 B.C.

Our present knowledge of Chinese history begins with the oracle inscriptions of the Shang, traditionally remembered as the second dynasty, preceded by the Hsia; this was overthrown by the Chou in the neighbourhood of 1040 B.C.* The Chou identified their supreme authority *T'ien* ('Heaven'), a sky-god hardly distinguished from the sky itself, with Ti, the high god of the Shang; and they claimed that the dispossessed Shang had forfeited the *T'ien-ming* ('mandate of Heaven') by their misrule, a concept which was to be used to justify later changes of dynasty for the rest of Imperial history. The early Chou dynasty was remembered as a Golden Age when the Empire (*T'ien-hsia* 'all below Heaven') was united under the Emperor (*T'ien-tzu* 'Son of Heaven'), and all the descendants of those enfiefed by the founder remained faithful to their lord. This unity was no less than the political unity of the world, for to the Chou, and to every succeeding dynasty until the final confrontation with the West, there was nothing outside China except barbarians bringing or rebelliously refusing tribute. In 770 B.C., however, barbarian invasion drove the Chou eastward and the Empire disintegrated. The fiefs emerged as independent states, and the semi-barbarian rulers of Ch'u and Yüeh in the south soon threw off allegiance to Chou, if they had ever recognised it, by taking the title of *wang* ('King') formerly reserved for the Chou Emperor. For a while peace was intermittently preserved by the hegemony of the most powerful lords, Duke Huan of Ch'i (685–643 B.C.) and later Duke

* The traditional date of 1122 B.C. for the Chou conquest is now widely abandoned. Recent proposals are 1045 B.C. (Nivison, 'Dates of Western Chou'), 1046 (Pankenier) and 1040 (Nivison, '1040 as the Date').

Wen of Chin (636–628 B.C.). The final struggle, in which one lord after another took the title of King, ended with the victory of another semi-barbarian border state, Ch'in in the north-west, which in 256 B.C. annexed what remained of the domain of Chou itself, and in 221 B.C. reunified the world under the 'First Emperor' (Shih-huang-ti).

Behind the well-documented political surface we can catch sight of deep social and economic changes. In early Chou all land belonged in theory to the Son of Heaven, who allotted it to hereditary fiefholders required periodically to pay homage at his court, especially favouring his own kin. These lords, with titles translatable as Duke, Marquis, Earl, Viscount, Baron, had their own hereditary ministers and officials, in lines generally branching from their own families. Below was a much larger class of retainers, 'knights' *(shih)*, from whom minor offices were filled. All were assigned lands, which the poorer of the knights farmed themselves but the higher ranks organised as manors, with serfs cultivating part of the land for themselves and part for their lord. Goods circulated through tribute and gift rather than trade, cities were noble fortresses, artisans were a hereditary caste of serfs attached to estates or courts. Battle was waged between aristocratic archers in chariots, with auxiliary infantry from the common people; wars were comparatively short and, for the nobles, restrained by a code of chivalry. Even after the dissolution into competing states the kinship ties of rulers for a long time remained important, at least in political rhetoric. The weapons and ornaments of the aristocracy were of bronze, the rest of the people remained in the Neolithic Age.

During the 300 years which concern us the already dislocated system of the Chou was in course of transformation at every level. Towards the 6th century B.C. China entered the Iron Age, later than in cultures further west and beginning not with wrought but with cast iron, suitable for hoes and ploughshares but not weapons, which were predominantly of bronze down to the 3rd century B.C. As the great fiefs emerged as independent states, the conflicts of noble families resulted in centralisation under the victor who, whether of the old ducal line or a usurper from another family, increasingly chose his ministers for talent rather than birth. As the great states swallowed the small the knightly class of the defeated became masterless, seeking office in any state which would employ them; at the same time newly conquered lands came to be entrusted to appointed administrators rather than divided out into new fiefs. Trade expanded, money circulated, land itself became saleable, there were rich merchants who sometimes won high office. The manors broke up into peasant

holdings, subject to tax and forced labour by the state, from which emerged commoner landlords drawing rent and hiring wage labour. Wars were now fought between mass armies of conscripted peasants, with success in war as a further channel of social mobility.

By the end of the period there were four recognised classes: knights, peasants, craftsmen, merchants, ranked in that order by their presumed value to the state. The great change after reunification by the Ch'in dynasty and its successor the Han (206 B.C.–A.D. 220) is that, in spite of a brief and partial return at the beginning of the Han to the Chou policy of distributing fiefs, China becomes from now onwards a centralised empire administered by an appointed bureaucracy of literati, not by a hereditary aristocracy educated in the chariot and the bow. *Shih*, still the name of the office-holding class, has come to be more conveniently translatable as 'scholars' or 'literati' than as 'knights'. During the last centuries of disunion, with the bureaucratisation of the competing states, the at least partially literate knightly class had become increasingly open to the talents and freer to serve whichever ruler offered the best terms. The thinkers of the Axial Age are all in or on the edge of this now fluid class, not excluding those who show signs of being on the way in from the crafts (the Mohists) or who, refusing office to plough their own fields, are becoming indistinguishable from peasants (the Shen-nung communities). Although one could get rich by trade, it remains the common assumption that the road to wealth and power is through high office; consequently nearly all of them are preoccupied with such questions as when it is morally right to accept office in these degenerate times (the Confucians), who deserves appointment (the Mohists), whether it is better to avoid employment for the benefits of private life (Chuang-tzu). Their whole thinking is a response to the breakdown of the moral and political order which had claimed the authority of Heaven; and the crucial question for all of them is not the Western philosopher's 'What is the truth?' but 'Where is the Way?', the way to order the state and conduct personal life. From the viewpoint of the rulers who listen at least to the more practical of them, they are men with new answers to the problem of how to run a state in these changing times; and this problem is indeed central to all of them, whether they have practical answers (the Legalists), or ponder the moral basis of social order and its relation to the ruling power of Heaven (Confucians, Mohists), or as defenders of private life think the proper business of the state is to leave everyone alone (Chuang-tzu). No one questions that government is by nature authoritarian; if an alternative is seen to rule by legitimate force it is the abolition or minimalisation of

government, leaving people to organise their affairs by custom. There are theoretical anarchists in ancient China, but no democrats.

Among the Axial Age civilizations, as Benjamin Schwartz observes, China alone has the sense of looking back from present disruption towards an empire and culture which flourished in the immediate past. In the others, belief in lost Golden Ages, "to the extent that it exists at all, is marginal and often different in kind".[2] None of the divergent Chinese schools accepts the states into which the world has divided as the natural units of political organisation. Except for Yangists and Taoists who refuse the responsibilities of office, all have at the back of their thinking, however theoretical, the purpose of attracting rulers to a project for recovering the lost and longed-for political and social cohesion. By about 300 B.C. there was a nearly general recognition that times had changed, that there could be no return to the institutions of Chou, that the practice of offering one's programme as the regime of sage kings even earlier than the Chou was no more than a convention; hopes now centred on so reforming one state that it could conquer or win the peaceful allegiance of the rest. With the final victory of Ch'in in 221 B.C. there was a brief renunciation of the past unparalleled until the Cultural Revolution in the 1960s; the conqueror burned the classics and the annals of the states and proclaimed himself 'First Emperor'. However, this radicalism was inadequate to the lasting needs of a civilization in which a unique capacity for political and cultural integration has been inseparable from the sense of continuing tradition. Without pursuing inquiry into the causes, we may mention the one which has always been obvious to Western observers, an exceptionally tight yet widely extended family structure which subordinates youth to age, which centres social duty on filial piety and relations with the other world on the cult of ancestors. As early as the Shang, as we know from the oracle bone inscriptions, ancestor worship had been a crucial obligation for the ruling family at least.

The fixing of attention on the origins of tradition, which makes China unique in the Axial Age, has a perhaps unexpected parallel later in history, Western Europe up to about A.D. 1700. Our own tradition refused for a thousand years to believe that the Roman Empire had gone forever, then saw its own accelerating development as a 'renaissance' of the Classical Age, its break with the Mediaeval church as a return to primitive Christianity, its emerging science as the recovery of ancient Egyptian and Jewish wisdom ciphered in the Hermetic corpus and the Kabbalah. (Newton himself supposed that he was rediscovering truths which would be known to Moses, Pythagoras and Moschus the Phoenician).[3] It is

arguable that even now, in spite of the decline of Bible-reading and classical education, most of us are on a direct line to Greece and Israel in the Axial Age which bypasses most other thought before Descartes and Galileo; the layman introducing himself to Mediaeval or Renaissance thinking has strayed into an alien climate of the mind demanding the same intellectual and imaginative effort as the philosophy of another civilization. Although there is undeniably a 'Western tradition'—the route traced backwards through the diverging and converging currents which lead from the Axial Age to ourselves—I am inclined to think that the idea of a 'Western civilization', pushed back beyond A.D. 1600 to incorporate at each fork the culture more directly ancestral to ours, is no more than a retrospective fiction by which we claim for ourselves most of the genius we have heard of since Homer.[4] The parallel with the West, limited as it is, may suggest why Chinese thinkers, while appealing to the authority of the ancient sage kings, display such variety and originality: there is no greater stimulus to discovery than the belief that the truth was once known and so can be known again. There is the difference of course that the West never did overcome its centrifugal forces. It wanted to do so, and, at the beginning of close acquaintance with China in the 17th and 18th centuries, was inclined to look up to it with awe and envy; but it can be seen in retrospect that it was our unconquerable diversity and instability which in the 18th century roused us to the Faustian daring of committing ourselves fully to the forces driving towards an unknown future.

One generalisation which seems to hold everywhere in the Axial Age is that the basic thoughts, on which the Old-World civilizations have subsisted ever since, originated in small competing states, and that creativity weakened with their absorption into great empires (Alexander's, the First Emperor's, the Mauryan in India, the Achaemenid in Iran). Here again China is peculiar in that, although as elsewhere empire in due course disintegrates, there is always a return to unity. Down to the present century it presented the unique spectacle of an empire surviving from the age of Egypt and Babylon, and preserving a pre-alphabetic script like theirs as an instrument of continuity and unity, legible through the millenia for speakers of mutually unintelligible dialects. About the time when the First Emperor was looking for the elixir of life China discovered the secret of the immortal empire, the unkillable social organism. If ideas have any effect at all on social forces, Chinese philosophy of the Axial Age must be judged a tremendous practical success. (The disadvantages of that success when China finally collided with a less stable and more dynamic civilization are another matter.) The outcome was the syncretism

first tried out in the *Lü Spring and Autumn* (c. 240 B.C.), with Confucianism emerging as the dominant ingredient from about 100 B.C. One cannot explore it without being impressed by its success in integrating diverse tendencies so that they become socially cohesive. Let us try to write down in a condensed prescription the Chinese secret of the immortal empire embracing nearly a quarter of the human race, defeating the destiny by which all things come and go.

1. (From Confucianism). An ethic rooted, below the level of critical reflection, in the most enduring social bonds, kinship and custom, which models the community on the family, relates ruler/subject to father/son and past/present to ancestor/descendant.

2. (From Legalism). A rational statecraft with the techniques to organise an empire of unprecedented size and largely homogenise custom throughout it.

3. (From Yin-Yang). A proto-science which places man in a cosmos modelled on community.

4. (From Taoism, reinforced from the Later Han by Buddhism). Personal philosophies relating individual directly to cosmos, allowing room within the social order for the unassimilable who might disrupt community.

5. (From Mo-tzu through the argumentation of the competing schools). A rationality confined to the useful, which leaves fundamental questions outside its range.

Both in China and the West the Axial Age has a range of interests which narrows as the culture crystallises, a contraction which is both cause and effect of the loss of texts, sometimes forever, sometimes to be rediscovered with fertile consequences a thousand years later, revealing the heliocentric theory of Aristarchus or Hero of Alexandria's steam engine. Here the most striking difference between the traditions at the two ends of the civilized world is in the destiny of logic. For the West, logic has been central and the thread of transmission has never snapped; there was always, even when there was very little else, the part of Aristotle's *Organon* translated, just before it was too late, from Greek into Latin by Boethius. In China the proto-logic of the Sophists and Later Mohists was still a live influence on the first major philosophical revival, the Neo-Taoism of the 3rd and 4th centuries A.D., but its documents had already dwindled to the mutilated remains available today, and without the textual scholarship to work out their problems. In the 7th century the book *Mo-tzu* itself disappeared, except for a fragment which did not include the dialectical chapters; the full text was not recovered until the 16th century. The

Chinese cultural organism, which assimilated Confucian morality, Legalist administrative techniques, Yin-Yang cosmology, Taoist and in due course Buddhist mysticism, simply ejected the Sophists and Mohists, as well as the Buddhist logic imported from India which briefly flourished in the 7th century. In spite of sporadic revivals of interest, China did not digest them until it encountered Western rationalism. They had not however quite lost their nutritional value; the renewed study of the Mohist and Buddhist logic inside its own tradition has helped China to absorb the foreign substance being forced down its throat at gunpoint by the West.

It is a commonplace that even in the Axial Age rational demonstration had a much smaller place in Chinese than in Greek thought; indeed there is none at all in the famous books from which the general reader gets his idea of Chinese 'philosophy', the *Analects* of Confucius, *Lao-tzu*, the *Yi*. Work in recent decades on the analysis of Chinese concepts, identification of technical terms, uncovering of the presuppositions behind apparent gaps in argument, textual criticism of the corrupt and mutilated writings on dialectics, not to mention the grammar of the language itself, has revealed that most of the ancient Chinese thinkers are very much more rational than they used to look. There was indeed, besides the Sophists primarily interested in logical puzzles, a school which fully shared the Greek ideal of bringing all knowledge within the scope of reason, the Later Mohists. What may strike us as remarkable is that the immediate reaction to the birth of a Chinese rationalism was the explicit anti-rationalism of Chuang-tzu, which left a much more lasting mark on Chinese civilization. We might sum up the Chinese attitude to reason in these terms: reason is for questions of means; for your ends in life listen to aphorism, example, parable, and poetry. The Sophists did practice argument for its own sake, if only in the spirit of fun, which is perhaps near the origin of a pure delight in disinterested reason in Greece too; but the lasting effect in China was to convince everyone except the Mohists that problem-solving without useful purpose is a pointless frivolity. The Mohists themselves were moralists judging all issues by the principle of utility, and what they took from the Sophists was the tools for building a logically sophisticated utilitarianism. The other example of a developed system, at the level however not of philosophy but of social science, is the Legalist theory of the state; and this too sprang directly from practical considerations, from the problems of statecraft.

Since means are dependent on ends, it is inevitable that on the Chinese scale of value the wise dicta of Confucius and Lao-tzu are primary, the practical rationality of Mo-tzu and Han Fei is secondary, the

games with logical puzzles of Hui Shih and Kung-sun Lung are at best tertiary. As it happens, the Western tradition seems by now to be abandoning its long quest to find rational grounds for its ends. Many would now agree that on the one hand our disinterested truths never do free themselves from their roots in concepts shaped by questions of means, on the other that philosophers who have anything to say to us about ends are those like Kierkegaard and Nietzsche who think in the style of Chuang-tzu rather than Kant. Might one say that Chinese civilization, the strength of which was always in its sense of balance, has seen reason in its right proportions from the very beginning? That would not be incompatible with recognising that our unlimited, perhaps unreasonable, commitment to reason, has achieved on the plane of means results unattainable by any other path, including the whole of modern science and technology.

In this history of early Chinese thought we shall centre attention on *how* the thinkers think, over the whole spectrum from Later Mohist rationalism to Chuang-tzu's anti-rationalism.

THE BREAKDOWN OF THE WORLD ORDER DECREED BY HEAVEN

1. A CONSERVATIVE REACTION: CONFUCIUS

Among the states into which the Chou Empire dissolved there was a small dukedom in the Shantung peninsula, Lu, which had originated as the fief of the Duke of Chou, younger brother of King Wu the founder of the dynasty. It can be seen from the *Tso Commentary* (*Tso chuan*, 4th century B.C.), a history from 722 to 466 B.C. attached to the *Annals* of Lu, that this state prided itself on preserving the culture of Chou. Thus in 542 B.C. a visitor from the state of Wu asked to hear the music of Chou, and witnessed with critical comments the *Songs* performed by skilled singers, and the Wu, Shao, and other ancient dances. In 540 B.C. an emissary from the great state of Chin "examined the books at the office of the Grand Historiographer, saw the symbols of the *Yi* and the annals of Lu, and said 'The ceremony of Chou is all in Lu. Only now do I understand the potency of the Duke of Chou and why Chou reigned.' "[1]

Early Chinese history is a record of rulers, ministers and generals, and has little to say of philosophers unless they hold office. At first sight we seem unusually well-informed about K'ung Ch'iu of Lu, commonly known as Confucius (a Latinisation by the first missionaries of K'ung *fu-tzu* 'Master K'ung'), who is even provided by tradition with exact dates (551–479 B.C.). Unfortunately, as the earliest who in later centuries came to be seen as the greatest, he was inevitably the centre of progressively accumulating legend; we shall not attempt to extract a nucleus of historical truth.* The oldest source for his teaching is the *Lun-yü* ('Assorted Sayings'), commonly known as the *Analects*, a selection of sayings and brief anecdotes of the Master and of some of his disciples. Other collections

* For a biographical sketch of Confucius based strictly on the three earliest sources (*Analects, Mencius, Tso*), see Lau, *Analects* (Penguin version 161–94).

probably circulated in different branches of his school, for of quotations from the Master by the two most important of the early Confucians, Mencius and Hsün-tzu, most of the former's and all of the latter's are missing from the *Analects*. The *Analects* itself shows signs of accretion; in particular the last five chapters (chs. 16–20) differ considerably from the rest. However, given a book homogeneous in thought, marked by a strong and individual mind, and with inadequate criteria at our disposal for distinguishing the voice of the original teacher (very much as with the Gospel sayings of Jesus), it is convenient to accept it as the record of the earliest stage of Confucianism without asking how much of it is in the actual words of the founder.

The Confucius of the *Analects* is a teacher, surrounded by a circle of disciples, who vainly aspires to the high office which would enable him to reform government; he sets a precedent which will be followed by philosophers for the next three centuries by travelling with his disciples from state to state seeking a ruler who will listen to him. He wins audiences from Duke Ling of Wei (534–493 B.C.), Duke Ching of Ch'i (547–490 B.C.), and in his own state of Lu Dukes Ting (509–495 B.C.) and Ai (494–468 B.C.). It may be a mistake to think of him as finding his message first and attracting disciples afterwards. His thought and his sense of mission are of a kind which might develop naturally from the experience of an ordinary teacher of the *Songs*, *Documents*, ceremony, and music of Chou, distinguished at first only in that his disciples learn from him, as from an inspiring schoolmaster, much more than is on the curriculum. The *Tso Commentary* records that in 518 B.C. Meng Hsi-tzu of Lu, humiliated by his own ignorance of ritual, sent his two sons to Confucius, purely to study ceremony.

Ceremony and music

Let us start with Confucius as he sees himself, the preserver and restorer of a declining culture, who would not presume to invent anything.

"In transmitting but not originating, trusting in and loving the ancient, I would venture to compare myself to our old P'eng." (*Analects* 7/1)

In studying the *Documents* and *Songs* of early Chou, and the ceremonies and music, Confucius recognises the importance of thinking, but is inclined to put the stress rather on learning.

"To learn without thinking is stultifying, to think without learning is dangerous." (2/15)

"I used to go without food all day, without sleep all night, to think. No use, better to learn." (15/31)

"My disciples, why does none of you learn the *Songs*? The *Songs* may be used to stir imagination, to become observant, to get people together, to complain, at home in serving your father and abroad in serving your lord; and you will remember many names of birds, animals, plants and trees." (17/9)

This may seem an unpromising beginning to a philosophical tradition, but let us continue. The institutions which for Confucius are central to Chou culture are its ceremony and its music. The word *li* 禮 'ceremony' embraces all rites, custom, manners, conventions, from the sacrifices to ancestors down to the detail of social etiquette. *Li* in social intercourse corresponds to a considerable extent with Western conceptions of good manners; the Confucian gentleman moves with an effortless grace within the framework of fixed convention, informing every action with consideration and respect for the other person. *Yüeh* 樂 ('music'), which embraces dance, is primarily the music and dance of sacred rites; correspondingly, ceremony is continuous with music in being conducted with style like an artistic performance. What above all distinguishes *li* from Western conceptions of good manners is that for Confucius it has everywhere the efficacy of sacred rite, an efficacy in transforming human relations which is independent of the powers to which explicitly religious rituals are addressed.

The enormous importance which Confucius ascribes to ceremony by no means implies that he identifies the ritual with the moral. He has a different word, *yi* 義 (related to another *yi* 宜 'fitting'), for the right, which is conceived as the conduct fitting to one's role or status, for example as father or son, ruler or minister.

"It is the right which the gentleman deems the substance, it is through ceremony that he performs it, through humility that he expresses it, through being trustworthy that he perfects it, the gentleman!" (15/18)

"If those above love ceremony, none of the people will presume to be irreverent; if they love the right, none will presume to disobey; if they love trustworthiness, none will presume to be insincere." (13/4)

The effect of ceremonial forms in the social hierarchy is, as this last passage implies, that instead of actions merely being fitted to each other as right (the people *obeying* the ruler) attitudes become harmonious (the people *revering* the ruler).

"The disciple Yu-tzu said 'In the employment of ceremony it is harmony which is most to be valued. In the Way of the former kings it is

this which is most beautiful, follow it in small things and great. Where things are not on course, if you harmonise by the knowledge of harmony without regulating it by ceremony, they still cannot be put on course." (1/12)

Music no doubt also inspires this harmony, although Confucius never theorises about its overwhelming effect on himself.

"The Master while in Ch'i heard the Shao, and for three months did not notice the taste of meat. He said 'I did not conceive that making music had reached such heights.'" (7/14)

Chapter 10 of the *Analects* records detailed observations of the Master's own ceremonial performance.

"When summoned by his lord to serve as usher, his expression was serious, his step brisk. When with clasped hands he bowed to his colleagues on left and right, his robes moved evenly in front and behind. His hurrying advance was a glide. When the guest withdrew he would invariably announce 'The guest no longer looks back.'" (10/2)

Although there are later ritualist texts which prescribe such details, Confucius himself never lays down rules about them. It may be presumed that his disciples noted points in the performance of the supreme artist in ceremony of which he would perhaps not himself be conscious, as refinements of a personal style from which one could learn without necessarily imitating him. There are items in the series in which his good manners plainly have nothing to do with prescribed forms.

"The stable caught fire. On returning from court the Master said 'Is anyone hurt?'. He did not ask about the horses." (10/11)

The past to which Confucius looks back is not the beginning of things; there is no cosmogonic myth in pre-Han literature, merely a blank of pre-history before the first Emperors, who for Confucius are the pre-dynastic sages Yao and Shun. Although interested in the institutions of all the Three Dynasties which followed he draws primarily on the last, the Chou, the one of which the tradition is not yet extinct. Indeed he sees history down to the Chou not as regress but as progress.

"Chou had the two earlier dynasties as examples to it. How glorious is its culture! I follow Chou." (3/14)

In spite of this fidelity to Chou he sees the rebuilding of contemporary culture as a process of selecting and evaluating past and present models.

"The Master called the Shao music both perfectly beautiful and perfectly good. He called the Wu music perfectly beautiful but not perfectly good." (3/25)

"Lin Fang asked about the basic in ceremony. The Master said 'An

excellent question! In ceremony prefer the thrifty to the extravagant, in mourning put grief before meticulousness.' " (3/4)

Elsewhere we see him applying the former of these critical principles to a traditional observance.

"To wear a hempen cap is the ceremony, but the black silk cap of today is thriftier, so I follow the majority. To prostrate oneself before ascending the steps is the ceremony, but today people prostrate themselves at the top, which is lax; even at the cost of diverging from the majority I do it before ascending." (9/3)

Government as ceremony

A pair of concepts first prominent in the *Analects* is *Tao* 道 'the Way' and *te* 德 'Potency'. In this text *Tao* is used only of the proper course of human conduct and of the organisation of government, which is the Way of 'antiquity', of 'the former kings', of 'the gentleman', of 'the good man' and of 'Wen and Wu' the founders of Chou, or else of what someone teaches as the Way ('my Way', and 'our master's Way'). Confucius does not use it, as Confucians as well as Taoists soon came to do, of the course of the natural world outside man. *Te*, which has often been translated as 'virtue' (to be understood as in 'The virtue of cyanide is to poison' rather than in 'Virtue is its own reward'), had been traditionally used of the power, whether benign or baleful, to move others without exerting physical force. Confucius uses it in this sense of the charisma of Chou which won it universal allegiance, but moralises and widens the concept, so that it becomes the capacity to act according to and bring others to the Way.

The two concepts are interdependent, as later in *Lao-tzu* (also entitled *Tao te ching* 'Classic of the Way and of Potency'); a person's *te* is his potentiality to act according to the *Tao*.

"One not persistent in maintaining Potency, not sincere in his trust in the Way, how can you tell whether he is there or he isn't?" (19/2)

"Be intent on the Way, be grounded in Potency, rely on nobility, take recreation in the arts." (7/6)

An extremely remarkable feature of Confucius' thought is his conviction that all government can be reduced to ceremony. In a state which has the Way the ruler wins the reverent submission of all by ceremony alone without the need of force, through the Potency which emanates from his person. In an age when government was detaching itself more and more from the ritual functions of kings this indeed looks like a reversion to an obsolete past of primitive magic (although we shall

later be re-examining this point in the light of Fingarette's observations); as Schwartz notices, the early Chou *Documents* already give great weight to penal law.[2]

"Are you capable of ruling the state by ceremony and deference? Then what difficulties will you have? If you are incapable of ruling the state by ceremony and deference, what have you to do with ceremony?" (4/13)

"If you guide them by government, hold them even by punishment, the people will elude you and have no shame. If you guide them by Potency, hold them even by ceremony, the people will both have shame and draw near you." (2/3)

Confucius accepts law as belonging to the apparatus of government,[3] but measures success in ruling by how little it is necessary to apply it.

"In hearing litigation I am no different from others, but the point is surely to bring it about that there is no litigation!" (12/13)

"Chi-k'ang-tzu asked Confucius about government: 'What if we were to execute those without the Way to get nearer to those who have it?'

'When you engage in government,' Confucius answered, 'what need have you for executions? If you desire to be good the people will be good. The gentleman's Potency is the wind, the small man's Potency is the grass. The grass in the wind from above is sure to bend.'" (12/19)

Although Confucius protests at excessive taxation and recognises the need to enrich the people before expecting them to respond to teaching,[4] he sees the radical cure of social ills, not indeed in simply returning to Chou institutions, but in arranging the ideal court ceremonial by a critical selection from the rituals of the Three Dynasties, Hsia, Yin or Shang, and Chou.

"Yen Yüan asked about ruling a state. The Master said 'Put into effect the calendar of Hsia, ride the carriage of Yin, wear the cap of Chou. For music, the Shao and Wu. Banish the airs of Cheng and keep glib people at a distance. The airs of Cheng are wanton, glib people are dangerous.'" (15/11)

Ideally the ruler should not have to do anything at all, simply trust to the Potency which radiates from him. Confucius once even uses the term *wu wei* 無為 'doing nothing' later to become characteristic of Taoism.

"One who put in order by doing nothing, would not that be Shun? What is there that he did? Just assumed a respectful posture and faced south." (15/5)

"One who engages in government by Potency may be compared to the North Star; it occupies its place and all the stars pay homage to it." (2/1)

This can hardly be intended as practical politics, but there is no question of his confidence in Potency as a universal civilizing influence.

"The Master wished to live among the barbarian Nine Tribes. Someone said 'They're uncouth, what about that?' He said 'If a gentleman lived among them what uncouthness would there be?'" (9/14)

This is not quite the faith in the universal influence of the good man which Mencius was later to support by his doctrine of the goodness of human nature. It is rather a faith in the power of trained manners, customs, and rituals to harmonise attitudes and open the inferior to the influence of the superior. His single reference to human nature emphasises not man's goodness but his malleability.

"The Master said 'By nature we are near to each other, by habituation we diverge.' The Master said 'Only the highest wisdom and lowest folly do not shift.'" (17/2)

Heaven and the spirits

When in the 17th and 18th centuries Confucius first attracted attention in the West many saw him as a rationalist sceptical of the existence of supernatural beings. To Westerners preoccupied with the emerging conflict between reason and religion this seemed the obvious interpretation. It took some time to appreciate that, except for the Mohists, no one in ancient China much cared whether consciousness survives death or whether Heaven is a personal God or impersonal principle, issues of overwhelming importance to Jesuits and *philosophes*. The attitude of Confucius is that we should not be diverted from human affairs by matters which do not concern us. There is no reason to question that he recognises the sacrifices to Heaven, mountain and river gods, and ghosts of ancestors, as the greatest of ceremonies, harmonising not only man with man but man with cosmos. But for him the value of ceremony is in the harmony itself and does not depend on anything outside. He is not interested in how the sacrifices relate us to cosmos; our business is with man, and to speculate about the realm of the numinous is idle curiosity. It is not so much that he is a sceptic as that he does not care whether you are a sceptic or not.

"The Master did not talk about marvels, feats of strength, irregularities, gods." (7/21)

"Chi-lu asked about serving the ghosts and gods. The Master said, 'Until you can serve men how can you serve the ghosts?'

'Permit me to ask about death.'

'Until you know about life how can you know about death?'" (11/12)

"Fan Ch'ih asked about wisdom. The Master said 'To work at doing right for the people, and to be reverent to the ghosts and gods but keep them at a distance, may be called wisdom." (6/22)

"He sacrificed as though they were present, sacrificed to gods as though the gods were present. The Master said 'Unless I involve myself in the sacrifice it is as though I did not sacrifice.'" (3/12)

A story in a Han anthology of largely pre-Han material, unlikely to be genuine but very typically Confucian, has the Master judging the propriety of questions about the spirits entirely by the consequences for human behaviour.

"Tzu-kung asked Confucius whether the dead have knowledge or not. Confucius said: 'If I preferred to say that they do have knowledge, I am afraid that filial sons and obedient grandsons would hinder life to send off the dead. If I preferred to say that they do not, I am afraid that unfilial offspring would abandon the dead without burial. If you wish to know whether the dead have knowledge or not, delaying until death to know it for yourself you still won't be too late.'"[5]

The shift of attention to the human realm, and refusal to speculate outside its range, became general throughout the age of the philosophers. The question whether "the dead have knowledge" is raised occasionally, but in terms of whether ghosts can harm the living, not of personal survival; the only kind of immortality welcomed, when the prospect of it was conceived in the 3rd century B.C., is the prolongation of life by elixirs, not survival as a ghost. Some, including the Confucian Hsün-tzu, take it for granted that consciousness ends at death. Otherwise, except by the Mohists, who do argue at length that the dead are conscious, the issue is left open and treated as a theme for wit rather than serious argument. Thus in a story which turns up in the 3rd century B.C. a king of Ch'u is about to sacrifice two prisoners of war in order to smear his battle drums with their blood; they escape this fate by arguing

"If the dead lack knowledge, it will be pointless to use us to smear the drums; if they do have knowledge, when you are about to go into battle we shall stop the drums sounding."[6]

In 265 B.C., according to another story, Queen Hsüan of Ch'in on her deathbed commanded that her lover be buried alive with her, but was similarly dissuaded.

"'Do you think that the dead have knowledge?'

'They do not,' said the Queen.

'If Your Majesty's divine intelligence plainly knows that the dead lack knowledge, why uselessly bury the man you loved in life beside an unknowing corpse? But if the dead do have knowledge, his late Majesty's wrath has been mounting for a long time.' "[7]

Only the Mohists take the issue wholly seriously. Besides arguing in detail that ghosts and gods exist and are conscious they point out as contradicting himself a Confucian who maintains both that "Ghosts and gods do not exist" and that "The gentleman must learn the sacrificial ceremonies."[8]

Whether Heaven is a personal or impersonal power is another issue on which no one argues except the Mohists, who accuse the Confucians of holding that "Heaven is unseeing and the ghosts are not daimonic"[9], that is, they lack the daimonic insight which uncovers secret wrongdoing. It is in any case a question of degree, for even such as Hsün-tzu, for whom Heaven is highly impersonal, have no other paradigm than a human ruler and fall into personifying imagery. In the case of Confucius, his reticence allows us to see only that he tends to personify when pondering with awe and humility whether Heaven is on the side of his mission. It is a question he asks himself especially when in danger on his travels.

"Heaven generated the Potency in me, what can Huan T'ui do to me?" (7/23)

"When imprisoned in K'uang the Master said 'Since King Wen died has not the culture come to reside in me? If Heaven is about to abandon this culture, those who die afterwards will not get to share in it; if Heaven has not yet abandoned this culture, what can the men of K'uang do to me?' " (9/5)

"The Master said 'There's no one, is there, who recognises me.' Tzu-kung said 'Why is it that no one recognises you?' The Master said 'I neither resent Heaven nor blame man; in learning about the lower I have fathomed the higher. The one who recognises me, wouldn't it be Heaven?' " (14/35)

Of the death of his favourite disciple, in whom he put his greatest hopes, we read

"When Yen Yüan died the Master said 'Alas, Heaven has abandoned me, Heaven has abandoned me." (11/9)

Confucius may be seen to fluctuate between a faith that Heaven will protect his mission and despair that Heaven has abandoned him. He struggles to understand 'destiny' (*ming*, literally 'decree', what Heaven has decreed). The reconciliation which he calls "knowing destiny" and claims to have attained[10] at the age of 50 is a calm recognition that personal fortune and the rise and fall of good government are ultimately

beyond man's control, and that to be at peace it is enough to have done one's best. When a disciple is endangered by a certain Kung-po Liao Confucius says

"The Way being about to prevail is destiny, the Way being about to fall to ruin is destiny. What can Kung-po Liao do about destiny?" (14/36)

"Ssu-ma Niu was worried that 'All other men have brothers, I have none.' Tzu-hsia said 'I have heard that death and life are destined, and riches and honours depend on Heaven. If the gentleman is reverent and without failings, and deals with others respectfully and with ceremony, everyone within the four seas will be a brother to him. What misfortune is it to the gentleman to have no brothers?' " (12/5)

It appears from the *Tso Commentary* that court historiographers, diviners, physicians and musicmasters already had a cosmology in which the course of the heavenly bodies was called the 'Way of Heaven'. To co-ordinate the Way of human custom and its seasonal festivals with the cycles of Heaven in a universal Way seems in retrospect an obvious step, and it was later to be made. But there is only one reference to the Way of Heaven in the *Analects*:

"What the Master has to say about human nature and the Way of Heaven we cannot get to hear." (5/13)

There is however one passage which implies a fundamental unity of Heaven and man. It suggests that with the perfect ritualisation of life we would understand our place in community and cosmos without the need of words, a thought which seems to anticipate Taoism.

"The Master said 'I should like to do without speech'. Tzu-kung said 'If you do not speak what message will your disciples have from you?'. 'Does Heaven speak?', he said. 'The four seasons proceed by it, the hundred things are generated by it. Does Heaven speak?" (17/19)

But the Way is mentioned explicitly only as the proper course of human conduct and government. Indeed he thinks of it as itself widened by the broadening of human culture.

"Man is able to enlarge the Way, it is not that the Way enlarges man." (15/29)

The thread which unifies morality

Until very recently most Western readers of Confucius tried to detach his moral thinking from its bedding in ceremony, which they discarded if not as dross then at any rate as significant only within Chinese society. The

major Confucian virtue *jen* 仁, commonly translated 'benevolence', an unselfish concern for the welfare of others, can indeed from Mencius onwards be understood in detachment from ceremony. But the translation 'benevolence' is not appropriate to the *Analects* itself, where Confucius is forming a new concept by adapting an old word to his own insights. *Jen* had been the stative verb corresponding to the noun *jen* 人 which the aristocratic clans of Chou used to distinguish themselves from the common people. Thus in two of the *Songs* a lady admires a man riding out to hunt as "handsome and martial", "handsome and strong", "handsome and *jen* (noble, lordly)". By the time of Confucius the noun *jen* was widening to the ordinary word for a human being. But throughout the history of Imperial China there was some hesitation in applying the noun to include barbarians, although it was always understood (as already by Confucius) that they are civilizable by the adoption of Chinese customs; genetically they are *jen*, but until civilized they tend to be classed rather with the beasts and birds. The noble, civilized, fully human, pride themselves on their manners and conventions, but above all on the virtues which give these meaning and which distinguish themselves from the boors and savages who do not know how to behave. The stative verb *jen*, as it was inherited by Confucius, covers like English 'noble' the whole range of superior qualities distinctive of the man of breeding. Granted that it is coming to mean 'human, humane' rather than 'noble', it may be convenient to stay with 'noble' as the *ad hoc* equivalent in the present chapter; being nearer to the older meaning, it suggests the sort of concept which Confucius is narrowing in the direction of benevolence. In any case he finds human qualities at their full flower only in the *chün-tzu* 君子 ('lord's son'), a word with very much the same social and moral range as English 'gentleman'. Its opposite is *hsiao-jen* 小人 'small man', 'vulgar man'.

Confucius more than once joins the stative verb with the noun, for example

"A noble who is ignoble (= a human who is inhuman), what has he to do with ceremony? A noble who is ignoble, what has he to do with music?" (3/3)

At the source of the varied qualities which distinguish the noble is a disinterested concern for the other person.

"Chung-kung asked about being noble (= human). The Master said 'Behave abroad as though welcoming an important guest, employ the people as though conducting an important sacrifice. What you do not

yourself desire do not do to others. No one in the state will resent you, no one in the family will resent you." (12/2)

Here, in the middle of the usual ceremonial references, we come on the grand generalisation, "What you do not yourself desire do not do to others", the negative form of the Golden Rule at the heart of ethics, which in the West too sprang from a mind not much inclined to analysis, that of Jesus. Confucius, who generally gives the impression of synthesising a view of life from the contemplation of rites, texts, pieces of music, persons in legend or history rather than of abstracting ideas, does have a universal pattern running through his teaching.

"The Master said 'Tzu-kung, do you think of me as someone who has learned a lot and retained it?'

'Yes,' he answered, 'Is that wrong?'

'Wrong, I have one thread running through it.' " (15/3)

"Tzu-kung asked 'Is there a single word which one could act on all one's life?' The Master said 'Wouldn't it be likening-to-oneself (shu)? What you do not yourself desire do not do to others.' " (15/24)

Shu 恕 is one of the phonetic cognates of ju 如 'be like' which are basic to analogical thinking in Chinese, and is written with the same graph distinguished by the 'heart' radical which tends to mark verbs of thinking and feeling ('thinking of [self and other] as alike'). The art of definition developed only gradually throughout the classical period, but towards the end of it we find it neatly defined in the syncretistic Shih-tzu.

"Likening-to-oneself is using one's own person to measure. What you do not yourself desire do not do to others, what you dislike in others reject in yourself, what you desire in others seek in yourself, this is likening-to-oneself"[11]

Also illuminating are Hsün-tzu's three rhymed slogans for shu.

"For the gentleman there are three sorts of likening-to-oneself.

Being unable to serve your lord

Yet expecting obedience from a servant

is failure to liken-to-oneself.

Being unable to give parents their due

Yet expecting sons to be filial

is failure to liken-to-oneself.

Being unable to be respectful to an elder brother

Yet expecting a younger to take orders from you

is failure to liken-to-oneself.

If a knight is clear about these three sorts of likening-to-oneself it will be possible for him to correct his person."[12]

Although only the negative side of the Golden Rule is included in the formulation the positive is also affirmed.

"The Master said: 'Tseng-tzu, I have one thread running through my Way.' Tseng-tzu assented. When the Master went out the disciples asked 'What did he mean?'.

'The Master's Way', said Tseng-tzu, 'is nothing but doing-one's-best-for-others *(chung)* and likening-to-oneself *(shu)*.' " (4/15)

Chung 忠 is used especially of devoted loyalty to a ruler, but also of wholeheartedness on behalf of inferiors. It is a phonetic cognate of *chung* 中 'centre', the graph as with *shu* being distinguished by the 'heart' radical. The fullest collection of early Confucian definitions, by Chia Yi in the 2nd century B.C., has

"Concern for and benefiting issuing right from the centre of you is called *chung*."[13]

While *shu* is not a virtue but a form of analogical thinking, *chung* is one of the Confucian virtues, displayed on behalf of others in general and of one's prince in particular. For the disciple Tseng-tzu at least, the one thread cannot be quite reduced to a single concept; there has to be both the wholeheartedness on behalf of others and the act of putting oneself in their places by which one learns what to do for them.

It is this single thread which unifies courage, reverence, and the other dispositions which are distinctively noble or human.

"Fan Ch'ih asked about being noble. The Master said 'One is concerned for others.' He asked about being wise. The Master said 'One knows others'. (12/22)

Jen as such does not imply knowledge; indeed, in observing that all virtues go astray without learning, Confucius gives as one illustration

"To love nobility more than learning deludes one into foolishness." (17/8)

Jen is not sufficient for sagehood, which requires knowledge and ability as well.

"Tzu-kung said 'What of someone who by his bounty to all the people is capable of helping everyone? May he be called noble?'

'Is that to do with being noble?', said the Master. 'With sagehood surely. Even Yao and Shun would have trouble with that. As for the noble, himself desiring to stand up he stands others up, himself desiring to get through he gets others through. The ability to find the analogy in the nearest may be called the secret of nobility.' " (6/30)

Here the attitude to others which springs from likening them to oneself is presented not in negative but in positive terms.

A striking feature of Confucius' treatment of *jen* is that he does not see it as a matter of degree. Either you have it or you don't; and even in most of the best of us it is only intermittent. He says of his own disciples:

"In the case of Yen Yüan, his heart for three months at a time does not go off course from being noble. As for the rest of them, they attain it only for a day or a month." (6/7)

One should perhaps see *jen* as the orientation which makes right action effortless, following attainment of just the right balance between self and others, a precarious balance which hardly anyone is able to sustain. The perfectly and permanently disinterested person being a very rare creature, Confucius is cautious in recognising even the greatest men as *jen*, and disclaims it of himself.[14] It seems however that since it is a matter of attuning the desires on behalf of self and others, when you do have *jen* it comes effortlessly and instantaneously:

"Is nobility so far away? As soon as I desire to be noble, nobility arrives." (7/30)

To identify the one thread unifying the ceremonial raises the possibility of treating it as a principle wholly detached from ceremony, which becomes mere social convention. This was what Mo-tzu was soon to do, subjecting all conventions to the principle of concern for everyone and the test of practical utility. But such a detachment from tradition and custom always remained foreign to Confucianism. For Confucius the instant in which you conquer self to see self and others in perfect proportion is an instant in which accord with conventions becomes effortless and the exercise of style within fixed forms is an uninterrupted flow. The achievement of *jen* results immediately from 'return to ceremony' (*fu li* 復禮), which may be understood as the recovery of the meaning of ceremony by which it ceases to be mere formality.

"Yen Yüan asked about the noble. The Master said 'By conquest of self returning to ceremony one becomes noble. If by conquest of self you return to ceremony for a single day, the whole world will acknowledge you as noble. Becoming noble derives from oneself, not from others!'

'I would ask you to itemise it'.

'What isn't according to ceremony don't look at, don't listen to, don't say, don't do.'" (12/1)

Confucius and 20th-century Western philosophy

Although Confucius was important to 18th-century *philosophes* as the example of an enlightened moralist independent of revealed religion, his

thought was until very recently seen as irrelevant to serious philosophy. It was assumed that a sage expressing himself in brief and scattered dicta has nothing to teach a true philosopher, whose interest in China, if any, will be in the rational argument which begins with Mo-tzu. However, in the present century Western philosophy has turned back on itself to question its own conceptual schemes, and searches ancient or alien thinkers, on the lookout for revealing alternatives. The help one can get from pre-Socratics or Chinese in unlearning one's own conceptual habits has little to do with their degree of logical sophistication. That Confucius can be relevant to contemporary philosophising was first appreciated by the professional philosopher Herbert Fingarette, whose *Confucius: the Secular as Sacred* (1972) revitalised all our thinking about the sage.

Fingarette, who originally dismissed Confucius as a "prosaic and parochial moralizer",[15] came to see him as a guide to a moral philosophy which recognises the performative function of language and its interdependence with social convention. He starts from J. L. Austin's concept of the "performative utterance", which undermined the assumption that language either describes what objectively is or evokes emotion or action. Such formulas as 'I promise to . . . ' or 'I choose . . . ', the judge's 'Guilty' or the 'I do' of the marriage ceremony, do not describe an action, nor do they evoke it; the utterance of the words is itself the act. Performative speech or gesture assumes a context of accepted convention, whether unformulated (as when one reads the significance of a minute variation in a handshake or a smile) or overtly developed as the ritual within which 'Guilty!' or 'I do!' acquires the force of an irrevocable deed. The web of convention within which we live is in the first place inherited from tradition, but refines itself or deteriorates with the creative fluidity or sterile rigidity of performance. As more and more in language which had seemed descriptive turns out to be performative (Fingarette leaves open the question whether "ultimately *all* utterances are in some essential way performative"[16]), it becomes less and less plausible to dismiss Confucius' call for the 'correction of names' as a survival of the magical thinking which precedes the discovery of objective truth. There seems after all to be nothing wrong with primitive word-magic except its tendency to intrude into the natural order from the social order where it actually works.

In Chinese *ming* 名 'name' is cognate with *ming* 命 'command, decree', and it is often the latter which is used for the act of naming. For Confucius, naming is primarily the act which, in calling somebody 'ruler' or 'subject', 'father' or 'son', ordains his social function. When asked by a disciple about government (*cheng* 政 'enforcement of the correct', distin-

guished from *cheng* 正 'correct' by the 'beating' radical associated with force), Confucius, who prefers an unforced order, surprises him by saying that the first thing he would correct is names.

"Tzu-lu said 'If the Lord of Wei entrusts the government (= enforcement of the correct) to you, what will you do first?'

'Correct names, surely!', the Master said.

'How far you can stray from the point! What would that correct?'

'Tzu-lu, you are a boor. On matters of which he is ignorant a gentleman expresses no opinion. If names are incorrect, saying is out of accord. If saying is out of accord tasks are not fulfilled. If tasks are not fulfilled ceremony and music remain inert. If ceremony and music remain inert punishment is misapplied. If punishment is misapplied the people have nowhere to put hand or foot. Therefore what the gentleman names is sure to be sayable, and what he says is sure to be performable. It is simply that the gentleman is never haphazard in what he says." (13/3)*

On one occasion Confucius is disgusted that the name of a ritual vessel is being used loosely; even these little things have their repercussions on the social order.

"The *ku* is un-*ku*. What sort of a *ku* is that?" (6/25)

The crucial thing however is the naming of social roles.

"Duke Ching of Ch'i asked Confucius about government. Confucius

* Waley (*Analects* p. 21f) and Creel (*Shen* pp. 117–19) treat the 'correction of names' saying as the one item in the *Analects* which cannot be older than Mencius and Hsün-tzu. It is undeniably one of the *Analects* passages most literary in appearance, with the only example in the book of the sorites form later so common (If A then B, if B then C); it does not impress as likely to be a saying of Confucius jotted down in his own words. However reports of spoken discourse may vary widely in the extent to which they are reworked in literary language; and in any case what matters is whether we can assume, as with the rest of the *Analects,* that the saying belongs to the earlier phase of Confucianism, before Mencius. The first Confucian to mention the 'Correction of Names' is Hsün-tzu, who has a whole chapter on it with the phrase as title. He does not mention Confucius, but this accords with his general practice; there are only half-a-dozen direct quotations from Confucius in his essay chapters (*Hsün-tzu* chs. 1–24), none of them from the *Analects.* A decision depends on where one wishes to fit the passage in the history of Chinese thought. Waley and Creel read it as assuming the logical interest in names and objects which began with the Sophists. I am more impressed by Fung Yu-lan's placing of it, as reflecting a concern for the ritually correct name likely to be much older than logical inquiries into language. Nor am I persuaded that the reference to punishment implies a later Confucianism coming to terms with Legalism. The *Analects* accept punishment as a practical necessity, and to declare that it will be misapplied if ceremony and music are inert seems to me fully consistent with its thought.

replied: 'The ruler rules, the minister ministers, fathers are fatherly, sons sonly.'

'Excellent!' said the Duke. 'Indeed, if the ruler does not rule and the minister does not minister, if fathers are unfatherly and sons unsonly, even if there is grain would I get to eat it?' " (12/11)

Re-reading the 'Correction of Names' passage in the light of this one, we see that the succession of tasks which transfers grain from the fields to the dining table depends on each person doing what rightly used names instruct him to do; and only when the process is running smoothly will ceremony and music come to life to harmonise relations, and enforcement of order by punishments be morally informed.

Returning to Fingarette, Confucius is relevant to the present as a precursor who can teach us to think ourselves inside the unnoticed context of ritualised behaviour with which performative speech and gesture are in interaction, which analytic philosophy has rediscovered but tries to objectivise in value-free terms, as "the intelligent practice of learned conventions and language."[17] Thus the element of the magical and the sacred in the *Analects,* which has seemed to be the detritus of primitive assumptions in a mind freeing itself from the supernatural, on the contrary reflects a profound insight into the workings of social convention. The ritual act, influencing through interrelations which the agents do not analyse, does have an efficacy different in kind from the act calculated as means to an end. The man of Potency who has, not an abstract knowledge of conventions, but an effortless skill and grace in operating with them, although 'doing nothing', does enhance the order around him. In the this-worldly orientation of Confucius there is a recognition that the sacred, understood as a power for good independent of the wills of individuals, does not issue from an external realm of spirits but is inherent in the spontaneity of ritualised relations between persons.

Fingarette thinks that Confucius can help us to escape other dichotomies with which analytic philosophy is unsatisfied, such as mind/body and inner/outer. Of these the former never emerged in pre-Han philosophy; the word *hsin* 心 'heart' is sometimes translated 'mind', reasonably enough in later philosophy influenced by Indian Buddhism, but in the classical period it refers only to the heart as the organ with which one thinks, approves and disapproves. (Thinking is not in traditional China located in the brain.) The dichotomisation of inner (*nei* 內) and outer (*wai* 外) does emerge in the 4th century B.C.; thus Mencius, in a manner quite familiar in the West, classes all moral virtues as not outer but inner.[18]

Readers who take this dichotomy for granted assume that Confucius, who is plainly much more than a stickler for the formalities, must have located his *jen* 'nobility, humanity' in the inner rather than the outer man. But according to Fingarette "*jen* and its associated 'virtues', and *li* too, are not connected in the original text with the language of 'will', 'emotion', and 'inner states'. The move from *jen* as referring us to a person on to *jen* as 'therefore' referring us to his inner mental or psychic condition or processes finds no parallel in the *Analects*."[19] *Jen* is conceived rather as "a directed force operating in actions in public space and time, and having a person as initial point-source and a person as the terminal point on which the force impinges."[20] Fingarette reads this as a warning to us today not to psychologise moral philosophy. Confucius is not a victim of the post-Cartesian superstition of mind as 'ghost in the machine'; he does not conceive the difference between ritual as dignified and reverent perform-ance and as empty formality in terms of the presence or absence of dignity and formality in the performer's mind.

This claim has excited much criticism, but mainly from sinologists who have not come to question the dichotomy and suppose that if Fingarette does not recognise *jen* as inward he must be treating it as outward.[21] But his approach to the mind/body problem, although of the kind sometimes called 'logical behaviourism', does not deny that Con-fucius and ourselves can have secret thoughts. The position is that silent verbal thinking and speaking aloud are a single process, in which the uttered does not draw its meaning or value from the unuttered. The disciple Yen Yüan, whose "heart for three months at a time does not go off course from *jen*"),[22] is evidently thinking nobly in his heart even when not doing anything. Confucius does more than once refer to examining oneself 'within' *(nei)*.

"When you see your better, think about becoming his equal; when you see a worse, examine yourself within." (4/17)

"I have yet to see anyone who is capable of seeing his own errors and accusing himself within." (5/27)

"If examining within he finds nothing unwholesome, what else has he worry about or to fear?" (12/4)

These imply private self-examination, perhaps of unspoken thoughts as well as of past actions. But the reference is to looking back at one's own actions, in implicit contrast with looking out at other people's. The contrast is not between mind and body as inner and outer compartments of oneself. Confucius can help us escape being "blinded by a mind-matter

dualism, or by the behaviourist *acceptance* of the dualist way of dividing the world, along with the denial of the reality of the 'mental' half."[23]

A further advantage of studying Confucius, according to Fingarette, is that he gives us the opportunity to rethink moral philosophy without certain concepts which have seemed crucial to the West, such as choice and responsibility. "Confucius does not elaborate the language of choice and responsibility as these are intimately intertwined with the idea of the ontologically ultimate power of the individual to select from genuine alternatives to create his own spiritual destiny, and with the related ideas of spiritual guilt, and repentance or retribution for such guilt."[24] The claim that the concept of moral choice is foreign to Confucius has offended many readers. Confucius is of course very much concerned with choice in the most general sense of the word, as settling after due consideration on a particular course of action.

"If you don't say 'What shall I do about it, what shall I do about it?' there's nothing I can do about you." (15/16)

But choice in this general sense does not necessarily imply even the posing of alternatives. It might be the contemplation of one's situation, and the examples of sages in similar situations, until inclination spontaneously settles in a certain direction. As for the narrower sense which Fingarette finds specifically Western, Schwartz objects with some justice that he seems to be thinking of "choosing between 'value systems' or creating one's own values", although the Judaeo-Christian tradition at least conceives free choice as "freedom to choose between the known good and the known evil", which is "in no way different from Confucius's choice between following the way and straying from it."[25] However, it does seem to be the case that Confucius is not in the habit of posing alternatives at all. For him, you follow the Way if clear-sighted enough to see it and strong enough to persist in it, otherwise you simply fall away from it out of blindness or weakness. It is only later, with the rise of schools with competing principles, that we meet with such metaphors as the crossroads[26] (conspicuously absent in the *Analects*, in spite of many references to the Way, walking, paths, tracks), or the weighing of alternatives as though on a balance.

In particular, Confucius does not think in terms of choices between *ends*. He is very much concerned with 'desires' (*yü* 欲) and especially with 'intent' (*chih* 志 , a cognate of *chih* 之 'go to' written with the 'heart' radical), with whether one is intent on learning, on nobility, on the Way, but has no separate word for the goal of desire or intent. In place of choice

between ends he has likes and dislikes spontaneously altering as learning progresses: you leave behind ignorant preferences as the Way becomes clearer and see them retrospectively as deviations from the Way. Confucius once speaks of a man who by listening to bad advice from someone has "had his intent confused (*huo* 惑) by him."[27] Fingarette notes that when Confucius uses this word *huo* the thought is not "of a mind in doubt as to which course to choose but of a person being inconsistent in his desires or acts."[28] Confucius twice answered requests to explain the word.

"You desire life for one you love and death for one you hate. To desire that someone lives yet also that he dies is confusion." (12/10)

"Forgetting in a moment of rage not only your own safety but your parents', isn't that confusion?" (12/21)

The overriding imperative is to learn and arrive at knowledge; once you know, orientation towards action may be left to take care of itself as confused inclinations sort themselves out. To apply the metaphor of weighing which Confucius does not use, the agent is not the weigher but the arm of the balance itself.

"The wise are not confused, the noble do not worry, the brave do not fear." (9/29)

"From 15 I was intent on learning, from 30 had found my feet, from 40 was not confused, from 50 knew the decree of Heaven, from 60 had an attuned ear, from 70 followed what the heart desires without transgressing rule." (2/4)

Fingarette notices one case in the *Analects* which a Westerner would discuss in terms of choice between conflicting duties to family and state.

"The Governor of She told Confucius: 'Here we have an Upright Kung, who testified against his own father for stealing a sheep.' Confucius said: 'Where I come from upright men are different from this. The father covers up for the son, the son covers up for the father, and therein is the uprightness.' " (13/18)

Confucius does not argue, simply offers his own preference for consideration. Argument would be pointless, since the issue is which course you find yourself preferring in the light of your whole knowledge of the world and of yourself. That the crux of the matter is which way you spontaneously tend in full knowledge may be seen in a discussion of the Confucian doctrine that parents must be mourned for three years, later a target of Mohist criticism. The disciple Tsai Wo had objected that one year is long enough. Confucius answers:

" 'Would you be comfortable eating rice and wearing brocade?'
'I would.'

'If you would, then do it. When the gentleman is in mourning, he does not relish eating tasty food, does not enjoy listening to music, is not comfortable living at home, which is why he will not do that. If as it seems you would be comfortable, then do it.'

"After Tsai Wo went out the Master said 'How ignoble is Tsai Wo! A child has lived three years before it leaves its parents' bosom. Mourning for three years is the mourning current throughout the world. Did Tsai Wo have three years of love from his parents?' " (17/21)

The issue is a matter of taste, but tastes change with knowledge and experience. The proper duration of mourning is how long you want to mourn if you fully appreciate how much your parents have done for you; the Way is what you would want to do if you had the wisdom of the sage. Confucius himself, according to his little autobiographical sketch, set out in pursuit of knowledge at 15, by 40 found that all confusions of inclination had sorted themselves out, and by 70 desired for others what they desired for themselves and so wanted to do precisely what he ought to do. A point of interest here, not discussed by Fingarette, is that Confucius has evaded another Western dichotomy, fact/value, in a way which seems common to the Chinese tradition in general; we shall be returning to it in discussing later thinkers. Confucius and his successors seem to assume that the value of conduct derives from the value of wisdom. One might be disposed to reject this as an obvious fallacy. If wisdom is confined to knowledge of fact, value cannot be derived from it; if wisdom includes knowledge of value the derivation is circular. But the Chinese assumption is that action starts from spontaneous motives and that before asking 'What shall I do?' I am already being drawn in one direction or another. We may test the consequences by laying down a quasi-syllogistic formula to be applied by particular agents in particular situations.[29]

> In awareness of everything relevant to the issue I find myself moved towards X; overlooking something relevant I find myself moved towards Y.
>
> *In which direction shall I let myself be moved?*
> Be aware of everything relevant to the issue.
> Therefore let yourself be moved towards X.

'Everything relevant to the issue' would be every fact, sensation, emotion, which moves me spontaneously in one direction or another. 'I am aware of everything relevant' would be judged as one judges 'All men are mortal' in the classical syllogism, for example by Popper's principle that a strictly universal statement is unverifiable but demands assent if one persistently

fails to refute it. To be aware of everything relevant I would have to try out imaginatively all spatial and temporal viewpoints from which I might find myself moved. Similarly, the *shu* 'likening to oneself' which is the basis of morals for Confucius is a trying-out of how I find myself moved from other personal viewpoints. Whether for purposes of the argument personal viewpoints correspond strictly with spatial and temporal might be questioned, but I have argued in detail elsewhere that they do.[30]

We conclude this section with David Hall the philosopher and Roger Ames the sinologist, who in *Thinking Through Confucius* (1987) have proposed Confucius as a model for the post-modernist who has left behind the West's long dependence on the transcendent. Western thought has hitherto been dominated by pairs such as God/world, mind/body, reality/appearance, good/evil, in which A is transcendent in the sense that "the meaning or import of B cannot be fully analysed and explained without recourse to A, but the reverse is not true."[31] Chinese thought on the other hand tends rather to conceptual polarities with A and B each "requiring the other for adequate articulation". This feature of Chinese thought has long been noticed in the Yin-Yang correlations,[32] but we have continued to take it for granted that Heaven and the Way must share the transcendence of our own principles. However, while in the West a scientific law of nature, just as much as a divine command or a Platonic form, loses its authority if not declared transcendent, unchanged by changes in the phenomena to which it applies, Confucius knows no obstacle to recognising that principles "have their source in the human, social contacts which they serve". We have overlooked that Confucius sees Heaven as interacting with man, who in responding reacts on Heaven, affects his destiny, reconstitutes the Way. Here we may recall that remarkable dictum of his, "Man is able to enlarge the Way, it is not that the Way enlarges man."[33] This capacity to order life without appeal to the transcendent, whether as pre-existing and universally applicable moral principle, legal enactment or law of nature, is possible because he has a different conception of cosmic and social order. Hall and Ames distinguish 'logical' or 'rational' order imposed by transcendent principles or laws from 'aesthetic' order, of harmonious interrelations in which Heaven and the Way are themselves involved. Confucius prefers the aesthetic order sustained by ritual, music, and performative naming to the order sustained by laws and punishments, which is 'rational', and will in due course be explicitly rationalised by the Legalists.

One is impressed by the range of issues to which Confucius is coming to be seen as relevant. Not that he can take all the credit for it; the relevance

in most cases is of Chinese thought in general, the basic assumptions of which are first visible in Confucius.

The centrality of Confucianism in Chinese civilization

Confucianism is the earliest of the competing tendencies in the thought of ancient China, and also the one which about 100 B.C. emerges as final and permanent victor. To see this fact in perspective it is necessary to consider whether it may be misleading to think of Confucius as founder of a philosophical school in direct competition with others. At the end of the age of the philosophers Ssu-ma T'an (died 110 B.C.) classified them as the 'Six Schools', Yin-Yang, *Ju* (Confucian), Mohist, Legalist, 'School of Names' (Sophist) and Taoist.[34] Although most of these were no more than tendencies distinguished retrospectively, the *Ju* and the Mohists were undoubtedly true schools maintained through generations of teacher and disciple. There is however an important difference between the two; the Mohists are the upholders of ten specific doctrines, while the *Ju* are professional teachers, not primarily of ideas, but of the subjects classified by the time of the Han as the Six Arts, ceremony, music, archery, charioteering, writing and mathematics. Their literary curriculum, which by the Han had grown into the Six Classics, consists of the basic texts of the Chou civilization preserved in Lu, the *Documents* (proclamations of Chou and pre-Chou rulers), the *Songs* (anthology of early Chou verses), and the *Spring and Autumn* (chronicle of Lu down to the time of Confucius), to which came to be added the *Yi* (Chou manual of divination with Han appendices), the *Record of Ceremony* (largely Han codifications of and discourses on traditional rituals which as long as they remained alive were probably unwritten), and the soon lost *Record of Music*. It is likely that the term *Ju*, a word meaning 'soft' first applied perhaps by men who rule and fight to the softies who merely teach, was already used of professional teachers before Confucius, who once tells a disciple "Be a gentleman *Ju*, not a vulgar *Ju*".[35] It is not clear how far the pre-Han Confucians were conceived as a school of thought to be ranked beside the Mohists and the rest. Thus the earliest history of the philosophers, in the 'Below in the Empire' chapter at the end of *Chuang-tzu*, probably from early in the 2nd century B.C., starts from Mo-tzu and puts the *Ju* right outside, as teachers with an acknowledged social function preserving part of the ancient tradition of the Way; "As for what resides in the *Songs* and *Documents*, in ceremony and music, there are many among the gentry of Tsou and Lu,

the teachers with memorandum tablets in their sashes, who are able to clarify it."[36]

Hardly any information survives about a teaching profession before Confucius, but we have noticed how natural it is to see his thought as springing from the preoccupations of such a profession.[37] The rise of Confucianism might then be seen as pervasion of the class of teachers, who discover through Confucius the 'one thread' uniting the diverse disciplines which they teach. This pervasion may have been quite gradual. When in early texts one meets with the moral terminology one associates with Confucianism, it is by no means to be taken for granted that it implies an allegiance to Confucius; such terms are likely to have been common to the whole class of teachers of manners and morals. Thus there is a collection of moralising discourses ascribed to Yen Ying, chief minister of Duke Ching of Ch'i (547–489 B.C.), the *Spring and Autumn of Yen-tzu*, which appears in the bibliography of the *Han History* as Confucian, but has long puzzled scholars as to where to place it. The discourses are often followed by praises of Yen Ying's perspicacity ascribed to Confucius (or in a few cases to Mo-tzu); but when Yen Ying speaks of Confucius it is to make severe criticisms, which were taken over by the Mohists in their anti-Confucian polemics.[38] Ch'i was the great state in the Shantung peninsula, and we can understand that its teachers might well resent the authority of the sage from the tiny neighbouring state of Lu, and elevate their own Yen-tzu at his expense. But this resistance had broken down by the Ch'in and early Han, when the historian Ssu-ma Ch'ien speaks of Ch'i and Lu as the centres of Confucianism.[39]

The peculiar lasting power which enabled the Confucians to overcome their apparently stronger rivals may be traced then to their monopoly of traditional education. The difficulty in dispensing with them may be seen even in the one great persecution they suffered, by the First Emperor. After reuniting the world in 221 B.C. he decided to set up inscribed stones proclaiming his glory. These could not of course publicise the ruthlessly amoral doctrines of the Legalists which had brought him to power; he "set up the stone, consulted with the *Ju* from Lu, and inscribed it with praises of the Potency in Ch'in."[40] In 219 B.C. he demanded the help of 70 *Ju* from Ch'i and Lu in preparing for the Imperial sacrifice to Heaven on Mount T'ai, but after hearing them squabble over the details of ritual dismissed them. In 213 B.C. he burned all records of the past except of his own state of Ch'in, forbade private ownership of "the *Songs*, the *Documents*, and the words of the hundred schools," and ordained severe punishments for all who "appeal to the past to condemn the present."[41] In 212 B.C. according to

Ssu-ma Ch'ien's history, he buried alive some 460 scholars on suspicion of sedition.* However, he never dispensed with a team of 70 erudites exempted from the ban on possession of the classics, apparently Confucian, certainly including the notorious Confucian turncoat Shu-sun T'ung, who continued serving different masters down to the Han. It may be suspected that if you wanted your son to have a more than practical education you always had to send him to the *Ju*, however much you might grumble that they were stuffing the lad's head with a lot of nonsense.

The strength of the Confucians was that as preservers of the Chou tradition they were the guardians of Chinese civilization as such. It was never quite possible to treat them as just another of the competing schools unless, like the First Emperor beginning history with himself, or Mao Tse-tung during the Cultural Revolution, you could contemplate razing it to the foundations to make a wholly new start. One may add that since Confucianism roots all its general ideas in the minute study of existing custom, arts and historical precedent, it alone held the promise of the full integration of the individual into his culture, community, and cosmos which must be part of the secret of China's social immortality.

2. A RADICAL REACTION: MO-TZU

Rational debate in China starts with the first rival of Confucius, Mo Ti (Mo-tzu), and develops in sophistication with the clash of competing schools. The book *Mo-tzu*, the corpus of the Mohist school, provides remarkably little information about its founder, not even the name of his native state. The dialogues of Mo-tzu and disciples or opponents, curiously impersonal compared with those of Confucius, throw us an occasional biographical scrap; in one King Hui of Ch'u (488–432 B.C.) refuses to grant an interview to a man of such low status,[1] and there are others which at any rate place him in the late 5th century B.C. But whether in *Mo-tzu* or elsewhere the only stories told of him present him in the role, not of teacher challenging Confucius, but of master craftsman competing with a certain Kung-shu Pan. In the most famous, which fills a whole chapter of *Mo-tzu*,[2] he hears in Lu that Kung-shu Pan has invented a scaling ladder which the great state of Ch'u will use to conquer the little state of Sung. He hurries to Ch'u, demonstrates that he can counter all

* Ssu-ma Ch'ien (c. 90 B.C.) *Shih chi* (ch. 6) 257f, tr. Chavannes, v.2, 176f. But it is likely that the persecution of the scholars was exaggerated in Confucian legend (Bodde in Twitchett and Fairbank 95f).

Kung-shu Pan's nine possibilities of attack, and when threatened with death replies that it will be useless to kill him because 300 of his followers are already operating his engines of defence on the walls of Sung. Passing through Sung on his return journey he is refused shelter from the rain by the warden of one of the city gates. Later legend, for which these two are the master craftsmen of their age, presents Mo-tzu as inventor of a marvellous kite[3] which however the Mohist version of the tale credits to Kung-shu Pan.

"Kung-shu Pan shaved bamboo to make a kite. When the kite was finished he flew it, and it did not come down for three days. Kung-shu Pan thought himself supremely skilful. Mo-tzu said to him 'The kite you made is not worth the linchpin of a wheel made by me. A piece of wood 3 inches long, which it takes only a moment to cut out, will support a load of 50 piculs. Therefore if one's achievement is beneficial to man, call it 'skilful'; if it is not call it 'maladroit'." (*Mo* 49392–94 tr. Mei 256)

It would seem then that Mo-tzu was a man of low status, an artisan, judging by the last story a carpenter, and that this has something to do with his most distinctive innovation, that he judges institutions not by the tradition of Chou but by their practical utility, by whether like the linchpin of a wheel they are beneficial to the people. The last quarter of the book is devoted entirely to the defence of cities, and is full of highly technical information about military engineering. Even the Later Mohist *Canons*, a manual of disputation, repeatedly takes its examples from money, prices, carpentering, rich merchants, and has a section defending the determination of prices by supply and demand.[4] In passing from the *Analects* to *Mo-tzu* one has the impression of descending to a lower stratum of society, without access to the high culture of Chou. The notoriously graceless style of early Mohist writing, ponderous, humourless, repetitive, suggests the solemn self-educated man who writes only for practical purposes and has no opportunity to polish his style as an adviser to princes. Although the moral terminology of Mohism has much in common with Confucianism one pair of Confucian terms is notable for its absence, the 'gentleman' and his opposite the 'vulgar man'.

That the Mohist school flourished side by side with the Confucian right down to the beginning of the Han and then vanished once and for all may have something to do with the fact that in little states centred on cities the lower strata exerted a political force which they lost with the reunification of the Empire. Thus we read in the *Tso Commentary* that in 519 B.C. Prince Ch'ao of Chou "started a rebellion with the support of those among the former officials and the Hundred Crafts who had lost their

jobs, together with the descendants of Kings Ling and Ching."[5] In 477 B.C. in Wei "the Duke made the artisans work too long. The Duke wished to expel Shih P'u, but before he could do so trouble broke out, and on the Hsin-ssu day Shih P'u attacked the Duke with the support of the artisans."[6] The evidence does not however entitle us to treat Mohism as the ideology of artisans as a self-conscious class. As far as our information goes, the great agency of political change in ancient China was not class war but the centralisation and bureaucratisation of states. The Mohists seem to be among the men from below for whom offices are now open. Such attention as they get from rulers is won by craftsmen who have made themselves indispensable as military engineers, but not presumably (as Schwartz notices)[7] by the court artisans who make the luxury goods which they so vigorously denounce. It seems clear that by this period you were already of the knightly class if you had the education and skills to attract a ruler to employ you. The essay 'Elevation of Worth' in the first of its three versions both assumes that office-holders are knights and advocates promotion to the highest offices even from the peasantry and the crafts, as also does the Confucian Hsün-tzu's 'Kingly System'.[8] We may see the Mohists as *arrivistes* on the verge of or in the knightly class, introducing fresh approaches foreign to the old hereditary knighthood to which most Confucians belonged.

Throughout the 4th and 3rd centuries B.C. we meet the Mohists as a highly organised community under a Grand Master, which by the end of the period had split into three sects which denounced each other as 'heretical Mohists'. It appears from the dialogue chapters of *Mo-tzu* that members who took office in a state were expected to contribute to the funds of the organisation, and that if they betrayed Mohist principles the Grand Master could order their retirement,[9] also that the school taught ten specific doctrines, which are those expounded in the ten essays which are the core of the book *Mo-tzu*.[10] Each essay is preserved in three versions, which probably come from the three sects into which the school divided. The three versions, although they often run parallel from sentence to sentence, are never identical in phrasing, which suggests that they were written down from a common oral tradition which may or may not go back to the discourses of Mo-tzu himself. Of the total of 30 core chapters seven are lost and three of the shortest are not ascribed to Mo-tzu. There is a great deal of textual and stylistic evidence that the three unattributed chapters are replacements for chapters already lost when *Mo-tzu* assumed its present form, and that their insertion in the wrong series has pushed the arrangement of the three versions askew.[11] When corrected, the series

show different tendencies which may be labelled 'Purist', 'Compromising', and 'Reactionary'; we begin to understand what the Mohist sects must have been fighting over.

	Not ascribed to Mo-tzu	Purist	Compromising	Reactionary
Elevation of Worth		ch. 8	9	10
Conforming Upwards		11	12	13
Concern for Everyone	14	15	16	
Rejection of Aggression	17	18	19	
Thrift in Utilisation	20	21	(22)	
Thrift in Funerals	(23)	(24)	25	
Heaven's Intent		26	27	28
Elucidating Ghosts	(29)	(30)	31	
Rejection of Music	?	?	32	?
Rejection of Destiny		35–37	(dislocated by transpositions)*	

Of the unattributed chapters, chapter 17 can be identified from parallels with the 'Heaven's Intent' triad as a fragment of the missing conclusion of the Purist chapter 26. Until we come to consider the divisions between the sects we shall follow the Purist versions when they are available.

The three tests of argument

As may be seen from their names, the ten doctrines cover a varied assortment of political and cultural issues on which Mohism rejects the Chou tradition represented by Confucius; that some of them do touch on what we should call philosophical issues is quite incidental. Since their doctrines are new the Mohists have to give reasons for them, which they lay out in consecutive essays; this is the beginning of systematic debate in China. It is in *Mo-tzu* that we first meet the word *pien* 辯 'argue out alternatives', cognate with *pien* 辨 'distinguish', which was to become the established term for rational discourse. It is the distinguishing of the right alternative, the one which 'is this' (*shih* 是) from the wrong alternative, the one which 'is not' (*fei* 非). We find also in *Mo-tzu* a recognition that the soundness of a thought has nothing to do with who thinks it.

* The 'Rejection of Destiny' chapters are ch. 35 Purist, ch. 36 Reactionary, ch. 37 Compromising. But ch. 35 applies the tests as presented in ch. 36 and vice versa, which may be explained by the transposition of 35/10–18 with 36/5–13; also 35/18–33 is full of special features of the Compromising chapters, so should belong to ch. 37 (G. *Divisions in Early Mohism* 12–16).

"Master Mo-tzu in argument *(pien)* with Ch'eng-tzu cited Confucius. 'You are no Ju,' said Ch'eng-tzu, 'why do you cite Confucius?' Mo-tzu said 'This is something exact for which there is no substitute.' " (48/58f, tr. Mei 238)

Except when casting an argument in dialogue form the Mohists do not name the author of a thesis; they discuss it on its own merits. This is not at all in the style of the Confucians, who expect a thinker to exemplify as well as talk about the Way. The Confucius so vividly presented in the *Analects* teaches above all by being the man he is; Mo-tzu on the other hand, like most Western philosophers, is a nonentity, whose name even for his own school is no more than a label for his thoughts.

The last of the ten essays, 'Rejection of Destiny', lays down three tests by which a doctrine is to be judged. The Purist version calls them 'gnomons', after the astronomer's post of standard height for measuring the length and direction of the sun's shadow throughout the day. After lamenting the harm done by fatalists to orderly government, it proceeds:

"How then are we to judge plainly whether the thesis of these people is the right alternative? Master Mo-tzu pronounces: to assert one must establish norms. To assert without norms is comparable with establishing the directions of sunrise and sunset from on top of a rotating potter's wheel: which alternative is to be judged right or wrong, beneficial or harmful, cannot become plainly known. Therefore to assert one must have the Three Gnomons. What do we mean by the Three Gnomons? Master Mo-tzu pronounces: there is finding the assertion's root, the evidence for it, and the use of it. In what does one find the root of it? One finds it far back in the practice of the sage kings of old. In what does one find the evidence for it? One finds it down below by scrutinising what is real for the ears and eyes of the Hundred Clans. On what does one use it? One applies it in punishment and administration, and observes whether it coincides with the benefit of the Hundred Clans and people of the state. This is what is meant by assertion having the Three Gnomons." (35/6–10, tr. W 117f)

The Three Gnomons correspond to categories into which much Western thinking falls, as in unsophisticated argument for the existence of God—God exists because the Bible says so, because many have encountered him in personal experience, and because without belief in him ordered society would collapse. At this level it is not yet thinkable that even the wisest men of the past may not have known, or that the belief beneficial to society might not be the one confirmed by experience. The doctrines of the ten essays are in fact established by the Three Gnomons, although for most of them only the first and third are applied. The second,

the test of common observation, is used only for questions of existence, and so for only two of the doctrines, the existence of ghosts and other spirits and the non-existence of Destiny. Although there is some doubt as to how widely the term Hundred Clans (*pai hsing* 百姓) extends at this period, in *Mo-tzu* it already covers the whole people.

As for the existence of ghosts of the dead and the gods of mountains and rivers, those who deny their existence are easily refuted by appeal to the many indubitable records of people who have seen and heard them. The stories, no doubt transcribed verbatim from livelier writers, make a welcome interlude in the heavy-handed Mohist expositions.

"If you want something which the multitude all saw or heard about, such a case as the Earl of Tu is a past example. King Hsüan of Chou killed his minister the Earl of Tu who was guiltless. The Earl of Tu said 'My lord kills me though guiltless. If you think the dead have no knowledge, so much for that; if the dead do have knowledge, within three years be sure that I shall make my lord know it'. Three years later King Hsüan gathered the lords of the states to hunt in Fu. Hundreds of hunting chariots, thousands of attendants, filled the moors. At noon the Earl of Tu in an unpainted chariot drawn by a white horse, in a red coat and cap, with a red bow in his hand, with red arrows under his arm, chased King Hsüan and shot at him up in the chariot. Hit right in the heart and sagging at the spine he collapsed inside the chariot, sprawled over his bowcase and died. At this time there was none of the attendants of Chou who did not see it, no one farther away who did not hear of it, and it is on record in the annals of Chou." (31/14–19, tr. W 95f)

But we find no such confirmation of the existence of Destiny.

"When it comes to how we know whether Destiny exists or not, we know it by what is fact for the ears and eyes of the multitude. If someone has heard it, has seen it, one says that it exists; if no one has heard it, has seen it, one says that it does not. But why not try investigating it by what is fact to the Hundred Clans? From of old up to now, since the people first originated, has there ever been anyone who saw the thing Destiny, heard the voice of Destiny? There never has been." (36/5–7 tr. Mei 189)

On the eight issues for which questions of existence do not arise the Mohist arguments divide between the first and third tests, between proofs that the doctrines descend from, are 'rooted' in, the practice of the wisest kings of old, and that the results are beneficial to all. As critics of the Chou tradition the Mohists take their sage kings indifferently from the founders of all the Three Dynasties (Hsia, Shang, Chou) and the pre-dynastic Yao and Shun. The appeal (but only in the Purist versions) is to the authority

not of antiquity but of wisdom, not to 'the former kings' but to 'the sage kings of old'. Three Purist essays in fact start by saying that the government of the "kings, dukes and great men of old" led to poverty, underpopulation and disorder until the principles of 'Elevation of Worth', 'Rejection of Aggression' and 'Rejection of Destiny' came to be recognised.[12]* The assumption, unquestioned throughout the core chapters, is that the problems of government are unchanging, and therefore that solutions if correct will already have been known to the wisest men of the past. Elsewhere in *Mo-tzu* however innovation is explicitly upheld.

"They (the Ju) say too: 'The gentleman follows and does not originate.' We answer: in ancient times Yi originated the bow, Chu armour, Hsi Chung the carriage, Ch'iao Ch'ui the boat. Does it follow that the armourers and wheelwrights of today are all gentlemen, and the four originators all vulgar men? Moreover whatever they now follow someone must have originated, so everything they follow is the Way of the vulgar man." (39/19f, tr. W 128)

The criticism of traditional practice by the utilitarian test

The first and third tests, agreement with the practice of the sage kings and practical results, interact in Mohist thought. You distinguish the sage kings from the tyrants by whether their policies proved beneficial or harmful in practice; you adopt a new course for its practical effects and then search history for confirmation that the sage kings did the same; and you put your own thoughts in the mouths of those you identify as sages, knowing that since the thought is right the sage would have shared it. This implies that the third, the utilitarian test, outweighs any ancient authority which can be cited on the other side. For the Mohists, it provides a principle by which to judge all traditional morality. Thus Confucian filial piety imposed an extraordinarily long and severe period of mourning, for a father three years (in practice 25 months). It is seen by Confucians as a duty which the filial son will perform without counting the cost; to raise utilitarian objections simply shows you are not a gentleman.[13] The Mohist 'Thrift in Funerals' concedes that supporters and critics of extravagant funerals and prolonged mourning "Both say 'We are the ones who are

*Commentators and translators (including both Watson and Mei, W 18, 117: Mei 30, 101, 182) have found this so surprising that they emend *ku* 古 'ancient times' to *chin* 今 'now' without textual authority.

handing down from our ancestors the Way of Yao, Shun, Yü, T'ang, Wen and Wu", proposes to "observe what happens if you try them out in turn in governing the myriad people of the state", and proceeds to show that mourning practices which interrupt work and injure health contribute to impoverishing the people and weakening the defences of the state. The utilitarian principle is presented as nothing less than the final criterion of whether action is moral or immoral.

"If elaborate funerals and prolonged mourning can really enrich the poor, increase population, secure the endangered and order the disordered, they are benevolence, the right, the service of a filial son" (25/12–15 tr. W 66).

If however they do not, "they are not benevolence, not the right, not the service of a filial son." The utilitarian principle is seen as 'transcendent' as defined by Hall and Ames,[14] detached from all custom, which loses its authority when seen to vary from one society to another.

"The upholders today of elaborate funerals and prolonged mourning pronounce: 'If really these are not the Way of the sage kings, how to explain why the gentlemen of the central states perform them without fail, cling to them instead of doing away with them?' Master Mo-tzu says: this is what one calls getting used to the familiar and taking the customary for the right. Formerly east of Yüeh there was the country of Shai-shu; at the birth of the first son they dismembered and ate him, calling it an obligation to his younger brothers. When a grandfather died they carried away the grandmother and abandoned her, saying 'It is impermissible to live with the wife of a ghost'. This was recognised policy above and recognised custom below, performed without fail, clung to instead of done away with; but is it really the Way of the benevolent and the right?" (25/74–78, tr. W 75)

This piece of social anthropology continues with two more tribes which think it filial for the son to expose his father's body to rot and then bury the bones, or to burn the body on a pyre and say his father is ascending with the smoke.

Valuation by utility is taken to the extreme of refusal to recognise anything as valuable in itself; this is a utilitarianism which never raises the question 'Useful for what?'. This attracts attention especially in criticisms of the Confucian elevation of music. The Mohists have little to say about the other great civilizing influence, ceremony, except to reproach Confucians for "multiplying and elaborating ceremonies and music"[15] but 'Rejection of Music' is one of their ten doctrines. The essay under this title is a prolonged assault on the great state orchestras, as a reckless waste of resources which should be used for the benefit of the people. The word

yüeh 樂 'music' is written with the same graph as *lo* 'joy' and in spite of the divergence of pronunciation was originally the same word; Confucians had the habit of saying 'Music is joy'.[16] The Mohist essay acknowledges that music is enjoyable, but dismisses this as an irrelevance; what matters is that it fails the first and third tests, "does not coincide with the practice of the sage kings long ago", nor with "the benefit of the myriads of the people below."[17] The assumption that there can be no good *reason* (*ku* 故) for an activity except its usefulness shows up startlingly in one of the Mo-tzu dialogues, in which a Confucian appeals to the kinship of the two words written with the same graph.

"Mo-tzu asked a *Ju* 'For what reason does one make music?'

'Music is deemed a joy.'

'You have not answered me. Suppose I ask "For what reason does one make houses?" and you say "To shelter in them from cold in winter and heat in summer; and it is in the house that one keeps men and women separate," then you have told me the reason for making houses. Now I ask "For what reason does one make music?", and you said "Music is deemed a joy (= entertainment is deemed an entertaining)"; this is as though I said "For what reason does one make houses?" and you said "A house is deemed a house".' " (48/46–49, tr. Mei 237)

The attack on the extravagance of courts is generalised in 'Thrift in Expenditure', which demands a life reduced to the bare necessities even for rulers. Here, as in 'Thrift in Funerals' and 'Rejection of Music', one seems to recognise the outlook of men who have risen from below by thrifty habits, and see in the high culture of the courts only waste and extravagance. One can understand why for the Confucian Mencius the very word *li* 利 'benefit' has been so soiled by Mohist and later by Yangist calculations of benefit and harm that one can hardly translate him coherently without switching the English equivalent to 'profit'.

The unifying principle of morality

The Mohist calculations of benefit and harm are on behalf of all, guided by the principle of 'Concern for Everyone' (*chien ai* 兼愛). The most popular English equivalent is 'universal love', which is convenient but rather misleading; it is both too vague (*chien* implies 'for each' rather than 'for all')[18] and too warm (the Mohist *ai* is an unemotional will to benefit people and dislike of harming them). The Mohists were dour people whose ears were open to the demands of justice rather than to the appeal of love. When King Hui of Ch'in (324–311 B.C.) refused to execute

for murder the son of the Grand Master Fu Tun, he replied, "By the law of the Mohists whoever kills a man suffers death, whoever wounds a man suffers mutilation. This is how one deters killing and wounding."[19] He executed his son himself.

The case for 'Concern for Everyone' is a good example of the heavy, repetitious development of the very earliest organised arguments in Chinese literature. It proceeds by a series of questions.

(1) "What is beneficial to the world, what is harmful?", answered by listing six harms: "states attacking each other, families dispossessing each other, people robbing each other, ruler or minister not gracious or loyal, father or son not compassionate or filial, discord between elder and younger brother."

(2) "Then on examination from what do these harms spring?", answered by "They spring from lack of mutual concern." States attack each other because "today the lord of a state knows concern for his own state but not for another's state," and correspondingly for the rest of the first three harms. Then it proceeds through the full list of six, running from "Therefore if lords of states lack mutual concern they are sure to go to war" to "If elder and younger brother lack mutual concern there will be discord between them," and concludes "In all cases the reason why the world's calamities, dispossessions, resentments and hates arise is lack of mutual concern. This is why the benevolent reject it."

(3) "Having rejected it, with what do we replace it?" answered by "Replace it by the standard of concern of each for everyone and mutual benefit."

(4) "How then do we act on the standard?" The answer is that on all levels (state, family, person) each is to have as much concern for another as for himself.

"Regard another's state as you regard your own, another's family as you regard your own, another's person as you regard your own. So if the lords of states are concerned for each other they will not go to war . . . " (15/11–15, tr. Mei 82)

It continues of course with the rest of the eight harms, and concludes: "In all cases, that the world's calamities, dispossessions, resentments and hates can be prevented from arising springs from mutual concern."

Mo-tzu's 'Concern for Everyone' evidently derives from the 'one thread' of Confucius. But Confucius conceived it as a guideline through the variegated web of ritual obligations, while Mo-tzu abstracts it as a transcendent principle by which the obligations themselves are to be judged. 'Concern for Everyone' is a concern for each person irrespective of

relations of kinship with oneself. It is this relentless driving of a principle to its logical conclusion which gives Mohism its appearance of being foreign, not merely to Confucian thinking, but to the whole of Chinese civilization as in these few centuries it assumes its lasting shape. No one else finds it tolerable to insist that you should be as concerned for the other man's family as for your own. The doctrine in any case involved a complication, not clarified until the refinement of the ethical system by the Later Mohists; although concern for others should be equal, irrespective of kinship, it is to the benefit of all that each should include among his duties the care of his own kin. 'Concern for Everyone' is a principle of moral but not social equality. This issue comes up in an exchange between the Confucian Mencius and the Mohist Yi-tzu. Mencius, as evidence that impulses to good belong to human nature, had taken the case of a child about to fall into a well; anyone whether kin or not will be shocked and run to help.[20] Yi-tzu takes this to imply that concern for a child is independent of kinship although each child is in the care of its own family; moreover the same will apply to the ruler's concern for the people, which in the words of one of the Chou *Documents* is "as though protecting a baby."[21]

"Yi-tzu said: 'According to the Way of the *Ju*, the men of old were "as though protecting a baby". What does this saying mean? As for us, we think that there are no degrees of concern, but the application starts from the nearer.' "

Hsü-tzu told Mencius about it. "Does Yi-tzu truly think," said Mencius, "that a man sees his elder brother's son as near to him in the same way as a neighbour's baby is near to him? He is taking advantage of a special instance: when the baby is crawling towards the well it is not its own fault. Moreover when Heaven generates a thing it causes it to be from a single root, but Yi-tzu's case has two roots."[22]

Yi-tzu's two 'roots' are the principles which Mencius sees as incompatible, equal concern for all and special care of one's own kin.

The most direct application of 'Concern for Everyone' is in the doctrine of 'Rejection of Aggression'. It will be remembered that "states attacking each other" was the first of the six harms which are eliminated by mutual concern. The case against aggressive war is built up by a meticulous weighing of benefit and harm, in the first place to the aggressor, in the second place to all. War interferes with sowing and harvesting, kills countless numbers in battle or famine, wastes quantities of weapons and horses, leaves the ghosts of ancestors with no one to sacrifice to them. Why then go to war? Kings say, "We covet the glory of conquest and the benefit we get from it."[23] The Mohist, for whom glory has no practical use,

replies: "If you consider the motive for conquest, it can be put to no use; if you consider his gains, they are less than his losses." The capture of a small city may cost tens of thousands of men, a serious matter in an age when generally underpopulated states competed to attract migrants to their undeveloped lands. "Of lands there is a surplus, of the king's subjects a shortage. Now if you expend the lives of the king's subjects, and aggravate misery both above and below, to fight over an empty city, this is to throw away something you are short of for something you have more than enough of."

But what of the great states, Ch'u and Yüeh in the south, Chin and Ch'i in the north, which have most certainly gained by swallowing the smaller? The objection to that is that the benefit to a few is at the expense of harm to the many. "Even if in four or five cases states have gained benefit from it one still calls it failure to practice the Way." It is as though a physician had a medicine which cured four or five men in 10,000: "one would still call it failure to practice medicine." Examples follow of states ruined by war, "former ones of which we have heard with our ears and recent ones we have seen with our own eyes." In an age when authorship and date are so often in doubt one is grateful to notice that all the instances lie between 473 and 431 B.C., coming down to the time of Mo-tzu himself.

The Purist series is remarkable, in this essay and elsewhere, in never mentioning defensive war, or the wars by which the sage kings overthrew the tyrants whom they replaced. One is tempted to suspect that Mo-tzu himself was a pure pacifist, and that he supposed that the sage kings came peacefully to power when the people went over to them from the tyrants. However, if that is so the Mohist school must have changed course very early in its history. The Mohists of the next century still oppose aggression, but not only advocate but specialise in defensive war. The story of Mo-tzu coming to the relief of Sung is, as we noticed at the beginning of this chapter, the only substantial fact or legend told about him. One of the Mohist Grand Masters, Meng Sheng, contracted with the Lord of Yang-ch'eng in Ch'u to defend his city. In 381 B.C. the Lord of Yang-ch'eng was condemned to death, presenting the Grand Master with the choice of betraying him or sacrificing all the Mohists in Ch'u in a hopeless fight. When reproached for being ready to "let Mohism die out from the world" he replied "I am not only the Lord of Yang-ch'eng's teacher but his friend, not only his friend but his vassal. If I do not die for him, certainly no one will ever again look for a reverend teacher, worthy friend or loyal vassal among the Mohists. It is by dying for him that I shall do the duty of a Mohist and pass on our tradition." After sending two

emissaries to convey the succession to a Mohist of Sung he fought to the death with his 83 disciples. The two emissaries, against the orders of the new Grand Master, returned from Sung to die with them.[24]

The centralisation and bureaucratisation of the state

The political ideal of Mohism appears in the doctrines of 'Elevation of Worth' and 'Conforming Upward'. While the Confucians at first resisted the tendency of the times towards centralised and bureaucratised states with increasing social mobility, the Mohists welcomed it. Mencius still favours hereditary offices, with promotion from below as an exceptional measure; it is not until the 3rd century that we find a Confucian, Hsün-tzu, using without reservations the Mohist slogan 'Elevate worth and employ ability'. The egalitarian implications of 'Concern for Everyone' did not lead the Mohist in the direction of democracy; like the rest of the philosophers he assumes that government, if one has to have it at all, must be from above. If we think of Mohism as springing from a class to some extent comparable with the merchant class of Renaissance Europe (and there is indeed a strong flavour of 'the Protestant ethic and the spirit of capitalism' about the whole movement), the comparison is with the stage in the 15th and 16th centuries when the middle classes of Spain, France and England welcomed absolute monarchy as defending them against local magnates and affording new opportunities to rise in the world. The Mohist, like the Confucian, seeks audience with princes and hopes to be appointed to high office. His egalitarianism is expressed, in the Purist version, in the demand for a pure meritocracy exemplified by the sage kings.

"Even among peasants, or among craftsmen and traders, if someone had ability they appointed him, and gave him a high title, ample salary, full responsibility for the work and full power to command." (8/17f tr. W 20)

"Therefore no one in office was irreversibly noble, no one among the people was irrevocably base; if someone had ability they appointed him, if not, degraded him." (8/20 tr. W 20f)

In 'Conforming Upward' the purpose of government is seen as "the unifying of morality (yi 義) throughout the world". Yi is the word cognate with yi 宜 'fitting' which we have elsewhere translated 'the right'. It is the fitting thing to do in relation to parents, rulers, and also to self; thus it is yi to fight to the death when insulted.[25] The primitive war of all against all before the origin of the state is seen by the Mohist not (as for example by

the Confucian Hsün-tzu) in terms of conflicting desires but of conflicting moralities. Individuals compete, but whether for themselves or for family or lord seems not to enter the argument.

"In ancient times when the people originated, in the period before there was punishment and administration, the saying went: 'Everyone in the world has a different morality'. Hence for one man there was one morality, for two men two, for ten men ten; with the multiplication of men what they called morality multiplied too. Consequently a man judged his own morality to be morality and other men's not, so they all judged each other immoral. Hence within the family father and son, elder brother and younger, fell into resentment and hatred, became alienated and incapable of co-operating harmoniously. The Hundred Clans throughout the world all by water, fire and poison deprived and injured each other, even having excess of strength were incapable of working for each other, left excess resources to rot and refused to share them with each other, concealed the proper Way and refused to teach it to each other. Throughout the world they were as disordered as the beasts and birds.

"It was clear that the reason why everywhere under Heaven there was disorder derived from having no head of government. Therefore they chose the worthiest and most acceptable man under Heaven and established him as Son of Heaven." (11/1–6, tr. W 34f)

This reminds one of Western theories of the primal Social Contract; there is however no contractual exchange of liberty for the benefits of government, and no emphasis on the people as a whole choosing the ruler. The Emperor, finding the world too big to govern, proceeds to appoint Councillors. Emperor and Councillors then appoint the lords of the 10,000 fiefs or states, who in turn appoint heads at lower levels. Assuming then that everyone 'conforms upward' instead of 'allying with others below', and the Emperor himself practices the concern for and benefiting of all which is conforming to his only superior, Heaven itself, morality will be both unified and perfected throughout the world.

But what if the superiors to whom one conforms are themselves immoral? The hierarchy consists, in the Purist version, of Emperor, lords of states, district heads, and village heads, by-passing all kinship groups. The Emperor by rewards and punishments enforces on all the injunction, "If there are errors above, criticise them; if there are good men below, recommend them." To start at the bottom, the village head announces to the Hundred Clans:

"If you hear of something good or bad, be sure to report it to the *district* head. What the district head judges right or wrong, be sure you all judge

right or wrong. If you discard your bad tenets and practices and learn the district head's good tenets and practices, how would the district be disorderly? Consider why the district is orderly; it is the district head who is able to unify the morality of the district, that is why it is orderly." (11/13–16, tr. W 36)

Similarly the Hundred Clans of a district are required to report on its administration to the lord of the state, and of a state to the Emperor himself. An administrator demands conformity not to himself but to the level above him. There remains the problem of what to do if the rottenness is at the very top. The Chou themselves, by justifying their overthrow of the Shang on the grounds that Heaven abandons the tyrant, had established a precedent to which new dynasties continued to appeal throughout Imperial history.

The Purist version concludes:

"If the Hundred Clans everywhere under Heaven conform upward to the Son of Heaven but not to Heaven, calamity will still not be escaped. Now if whirlwinds and rainstorms come over and over again, this is how Heaven punishes the Hundred Clans for not conforming upward to Heaven." (11/22–24, tr. W 37).

The implication, although not spelled out, must be that the people should shift their allegiance to a claimant to the throne who does display concern for everyone. The people of the village conform not to the village but to the district head, and so on upwards stage by stage; the people of the Empire should therefore conform not to the Emperor but to Heaven.

Heaven, spirits and Destiny

That the Mohists came from a lower social stratum than other schools is again suggested by their uniqueness in maintaining, side by side with incisive criticism of traditional values, a belief in rewarding and punishing divinities which belongs rather to folk religion. The tendency throughout the classical age is to ignore the spirits of the dead and of the mountains and rivers after paying them their customary respects, and to regard Heaven as an impersonal power responsible for everything outside human control, including the undeserved misfortune to which you resign yourself as your destiny. This trend of the times is intolerable to the otherwise forward-looking Mohists.

"The Ju think that Heaven is unseeing and the ghosts are not daimonic. Heaven and the ghosts are displeased; this is enough to bring ruin to the world." (48/50f tr. Mei 237)

"Kung-meng-tzu said: 'Gods and ghosts do not exist,' and also said 'The gentleman must learn the sacrificial ceremonies.' 'To maintain that ghosts do not exist yet learn the sacrificial ceremonies,' said Master Mo-tzu, 'is like learning the ceremonies for guests though there are no guests, making a fishnet though there are no fish.'" (48/40–42 tr. Mei 236)

It is not however that in matters of religion the Mohist reveals an unexpected vein of conservatism. Confucians could pay Heaven and the spirits their respects, without much caring whether Heaven is a personal being and the spirits exist, because theirs is an aristocratic code backed by shame rather than guilt. The conduct which the noble owes to his self-respect, whether in China or in Europe, does not have to be backed by promises or threats from above, may even defy them (Catholic nobilities in Europe observed their codes of duelling and courtly love at the risk of their souls). But the Mohist's ethic, precisely because it is new, requires another sanction than self-respect and the respect of peers; he is driven in the same direction as the great Middle-Eastern religions, with their universal moralities ordained by a personal God who will judge the mighty as they deserve. The function of Heaven and the spirits in the Mohist scheme is to enforce the true morality by reward and punishment, and correct or compensate for the world's injustices. But there is little evidence of a spiritual dimension deeper than a guilty fear of ghosts. The Mohists are in a sense *less* religious than some they would denounce as sceptics. The awe and resignation with which thinkers as far apart as Confucius and Chuang-tzu accept the decree of Heaven has much more of the sense of the holy than anything in *Mo-tzu*.

The essay 'Heaven's Intent' fully personifies Heaven, crediting it with seeing everything below, with desire and dislike, intent and thought. It starts by accusing gentlemen throughout the world of the inconsistency of fearing blame from the head of family or state, from whom one could flee to another family or state, yet ignoring Heaven, who sees and rules everywhere. The argument once again proceeds by questions.

(1) "What then does Heaven desire and dislike? Heaven desires us to do the right and dislikes us doing wrong." So if we behave morally we do what Heaven desires; and "if we do what Heaven desires, Heaven will likewise do what we desire."

(2) "What then do we desire and dislike? We desire fortune and prosperity, dislike misfortune and ruin."

(3) "How then do we know that Heaven desires us to do the right and dislikes us doing wrong? When there is rightdoing in the world we live, without it we die; with it we are rich, without it poor; with it we are

orderly, without it disorderly." It follows that "Those who accord with Heaven's thought are concerned for each one of each other, reciprocate by benefiting each other and are sure to be rewarded; those who go counter to Heaven's thought hate each other separately, reciprocate by plundering each other, and are sure to be punished."

(4) "Who then has been rewarded for according with Heaven's thought?" Answer, the sage founders of the Three Dynasties. "Who was punished for going counter to Heaven's thought?" Answer, the tyrants Chieh and Chòu, Yu and Li.

"Master Mo-tzu pronounces: by way of illustration, we have Heaven's Intent as the wheelwright has the compasses and the carpenter the L-square. Wheelwrights and carpenters take up compasses and L-square to measure the round and the square throughout the world, and say 'What coincides is this, what does not coincide is not.'" (26/41f tr. Mei 140)

Although they believe in the survival of consciousness after death the Mohists do not speak of being compensated for injustice in this world by reward in the next. The dead are themselves one of the agencies which reward and punish on earth. It may occur to one to ask why the Mohist takes it as a simple fact that good and bad do get requited in this world, a fact so obvious that after the crucial third question in 'Heaven's Intent' it is used as the proof that what Heaven desires is that men should do the right. The answer is perhaps that he is thinking primarily of the collective effect of moral behaviour leading to a healthy, wealthy, and orderly society. Since he thinks in terms of the community and its ruler rather than of individuals, the justice of the universal order would not require an absolute justice for each person.

"Master Mo-tzu fell ill. Tieh Pi came forward and inquired

'You claim, sir, that the gods and ghosts are clear-seeing and able to bring blessings or disaster; the good they reward, the bad they punish. Now you, sir, being a sage, why have you fallen ill? Would it be that something in your doctrine is bad or that the gods and ghosts do not clearly know?'

'Even if I do fall ill,' said Master Mo-tzu, 'why conclude that the gods and ghosts are not clear-seeing? There are many directions from which illness can come to a man. It can happen from heat and cold, it can happen from overwork. It is as though of a hundred doors one has shut a single one; why be surprised if thieves find a way in?'" (48/76–79, tr. Mei 240)

In the immediately preceding dialogue however a disciple who objects that in spite of following the Master he is as poor as ever is told that he cannot be as righteous as he supposes. Even on the individual level, the

Mohists certainly think it morally more stimulating to ascribe misfortune to one's own wrongdoing than to lament one's fate.

To the extent that the Mohists acknowledge imperfection in Heaven's justice to individuals, they differ from Confucians only in degree. On the widest scale, in the rise and fall of dynasties, Confucians too assume that Heaven takes the side of the good. The difference between them derives from the Mohist's utilitarianism. The Confucian thinks of the right as done for its own sake, and frees himself from the temptation to do wrong for the sake of gain by saying that wealth and poverty, long life and early death, are decreed for him by Heaven and outside his control. He can therefore act rightly with an untroubled mind, leaving the consequences to Heaven. For the Mohist on the other hand, judging all conduct in terms of benefit and harm, there can be no meaning in a morality detached from consequences. He is in a position to discard the fiction that material welfare is unaffected by how one acts, and he sees a fatalism which clings to it as not encouraging but undermining morality. At the same time he is driven in the direction of another moralising fiction, that if you behave rightly you can be sure of your reward.

In ordinary discourse the *ming* 'decree' of *T'ien-ming* 'Decree of Heaven' (which as Heaven's mandate to a dynasty is commonly translated 'Mandate of Heaven') had come to be used alone in the sense of 'Destiny'. The Mohist, as we have noticed,[26] actually argues for the non-existence of a thing called Destiny, on the grounds that no one has ever seen or heard it. His crucial objection however is to the practical effects of fatalism. Fatalism is one of the reasons why in ancient times before the sage kings the 'kings, dukes and great men' failed to make the people rich, numerous, and orderly.

"The fatalists pronounced: 'If destined to be rich we shall be rich, to be poor poor; if destined to be numerous we shall be numerous, to be few few; if destined to be orderly we shall be orderly, to be disorderly disorderly; if destined to live long we shall live long, to die young die young. What advantage is there in making efforts?" (35/3f, tr. W 117)

"How then do we know that fatalism is the Way of the tyrants? Formerly the poor people of past ages were greedy for food and drink and idle in doing their work, so that resources of food and clothing were insufficient and worries about cold and hunger came to them. They didn't know how to say 'I haven't tried hard enough, have lagged at work', they were sure to say 'It is my inevitable destiny that I shall be poor'. Formerly the tyrant kings of past ages did not restrain the indulgences of eye and ear and the vicious intents of their hearts, would not take advice from near or

far kin, and so lost the throne and overturned the altars of the state; they did not say 'I haven't tried hard enough, I have governed badly', they were sure to say 'It was my inevitable destiny to lose it.' " (35/36–39 tr. W 122)

Divisions in the Mohist school

The account of Mo-tzu in the 'Below in the Empire' chapter of *Chuang-tzu* mentions fierce arguments between factions which called each other 'heretical Mohists'. Han Fei late in the 3rd century B.C. also mentions that the school had split into three sects, from which the three versions of the core chapters may be presumed to have come.[27] When these are disentangled[28] it can be seen that the 'Purist' series is designed to defend Mohist doctrine against rival thinkers who reject 'Concern for Everyone', support fatalism, or fail to recognise the Son of Heaven as himself a subject of Heaven, while the 'compromising' is aimed at 'kings, dukes, great men, knights and gentlemen' who might adopt Mohism as the ideology of the state.[29] Evidently the issue over which the sects fought was the perennial one of doctrinal purity or accommodation to political realities. 'Below in the Empire' mentions one of the competing factions as the 'Mohists of the South', among whom is counted a certain Teng-ling-tzu named by Han Fei as leader of one of the three sects. It would be especially difficult to maintain the purity of ideals in moving from the advanced North to the relatively backward South, where the great state of Ch'u was the last to cling to the principle of hereditary office.* Once in the 'Reactionary' series there is a comparison of Heaven to the ruler of a state which takes as example the kings of the biggest Southern states, Ch'u and Yüeh,[30] suggesting that this series does come from the South.

Accommodation, as might be expected, is greatest on the politically sensitive doctrines. On 'Elevation of Worth' the Compromiser does not mention promotion of peasants, craftsmen, and traders, and is not explicit that appointment is to depend solely on merit; the Reactionary dilutes the doctrine to the demand that those appointed be "not *necessarily* blood relations of kings, dukes and great men, enriched and ennobled without reason, or handsome of face."[31] On 'Conforming Upward', the Compromiser does have the chief at each level calling on the people to conform to

* Hsü 98 cf. 45–47. The generalisation that the political development of the South was backward is subject to the qualification that Ch'u was ahead of other states in putting conquered territories under appointed administrators instead of dividing them up into hereditary fiefs. But even these posts "were generally filled by sons of rulers or other nobles." (Hsü 93).

the level above himself, but omits the crucial point that they also send up reports over his head; the Reactionary reverts from a bureaucratic to a completely feudal hierarchy of Emperor, rulers of states, and 'lords of families', with each demanding conformity not to his own superior but to himself. As for the difficult question of what to do if the Emperor himself is failing to conform to Heaven, the Compromiser simply says that he should reform his government, the Reactionary does not envisage his possible corruption at all. The Reactionary version of 'Rejection of Aggression' is lost, but the Compromiser not only differs from the Purist in acclaiming defensive war and the wars of the sage kings against the tyrants, he unobtrusively allows the just aggression, repeatedly describing the well-governed state as strong enough to "defend itself at home" and "go punishing abroad".[32]

Of especial interest is a change of attitude towards antiquity. The Purist certified his doctrines as those of the sage kings by proving them, on utilitarian grounds, to be the wisest, not by historical evidence that they held them. He is not far from the practice which by 300 B.C. had become normal, of putting one's words in the mouths of traditional or frankly imaginary sages as a pure convention with which rival thinkers do not quarrel. But in the other two series the appeal to antiquity is wholly serious and requires heavy documentation. The Compromiser says of Concern for Everyone:

"How do we know that the former sage Six Kings personally practiced it? Master Mo-tzu says: It is not that I was alive in their time and personally heard their voices, saw their faces; I know it by what they wrote on bamboo and silk, inscribed on metal and stone, carved on vessels, to pass down to their descendants of future generations." (16/49f tr. W 44)

He proceeds to quote three of the *Documents*, one for each of the Three Dynasties, and one of the Chou *Songs*. He and the Reactionary constantly insist that the 'former kings' (a phrase stressing antiquity rather than wisdom, not used by the Purist) judged their principles so important that they wrote them on bamboo and silk, inscribed them on metal and stone, and they back the claim with ample quotations very much in the manner of Protestant sectaries citing Scripture. There are scarcely any of these quotations in the Purist series, and no emphasis on their authority. For the Compromiser this text-hunting was perhaps no more than a tactical measure, to have an answer ready for literal-minded kings, dukes and great men, for he leaves untouched the 'Three Standards' (the Purist's Three Gnomons). The Reactionary however actually replaces the second of them ("the ears and eyes of the Hundred Clans") by "the writings of the

former kings". He also expands the first test ("the practice of the sage kings") to "the intent of Heaven and the ghosts and the practice of the sage kings". To elevate the will of Heaven and the spirits from the tested to one of the tests seems to imply independent access to it, possibly through the shamans so influential in the culture of Ch'u.[33]

We can well understand why the Mohist sects disputed so fiercely. It would seem to the Purist that out of eagerness for political power the true teaching of Mo-tzu had been shamefully diluted by the Compromiser and utterly betrayed by the Reactionary.

3. RETREAT TO PRIVATE LIFE: THE YANGISTS

The *Analects* has several stories of Confucius meeting hermits who refuse to contribute to good government by taking office. These may be later dramatisations of an issue which had not yet arisen in Confucius' time, but a shirking of what for Confucians, Mohists, and later for Legalists is the responsibility of all who are of the knightly class is increasingly common from at latest the 4th century B.C. Two tendencies to withdrawal from politics to private life are discernible throughout the age of the philosophers. On the one hand we have the moralistic hermit who retires to plough his own fields in protest against the corruption of the times, and clings to his principles even if the price is starvation or suicide. On the other we have the man who simply prefers the comforts of private life to the burdens and perils of the increasingly murderous struggle for power and possessions. A syncretistic writer in *Chuang-tzu* classifying five ways of life damaging to good government sharply distinguishes the two types, as his second and fourth categories.

"To have finicky ideas and superior conduct, to be estranged from the age and different from the vulgar, to discourse loftily and criticise vindictively, interested only in being high-minded—such are the tastes of the hermits of mountain and valley, the condemners of the age, who wither away or drown themselves. . . .

"To head for the woods and moors, settle in an untroubled wilderness, angle for fish and live untroubled, interested only in doing nothing—such are the tastes of the recluses of the riverside and seaside, the shunners of the age, the untroubled idlers."[1]

The image of an untroubled idler fishing in the river rather suggests Chuang-tzu himself. But before the rise of Taoism, and to some extent right down to 200 B.C., the name associated with the second tendency is

Yang Chu (Yang-tzu). Like so many of the philosophers, the main evidence of his date is a story of an audience with a datable ruler, in his case King Hui of Liang (370–319 B.C.).[2] It may however be better to think of a movement it is convenient to call Yangism than of a single thinker called Yang Chu. Since tendencies in pre-Han thought came to be classified retrospectively as schools with founders like Confucianism and Mohism, there is always a danger that the name of one prominent representative has been picked out as a label. Yang Chu has no book recorded under his name even in the oldest bibliography, that of the *Han History*, the surviving documents which expound the doctrines ascribed to him do not mention his name, and he is identified with the doctrines only in contexts contrasting him with other philosophers, by the Confucian Mencius and the syncretistic *Lü Spring and Autumn* (c. 240 B.C.) and *Huai-nan-tzu* (c. 140 B.C.). Mencius contrasts him with Mo-tzu, as representatives of opposite extremes.

"Yang-tzu chose selfishness; if by plucking out one hair he could benefit the world he would not do it. Mo-tzu was concerned for everyone; if by shaving from his crown right down to his heels he could benefit the world he would do it."*

The *Lü Spring and Autumn* has him in a list of 10 philosophers:

"Confucius valued benevolence, Mo Ti valued being for everyone, . . . Yang Chu valued self. . . . "[3]

But the most informative is *Huai-nan-tzu.*

"Singing to the strings and dancing to the drum to make music, deferential bows and turns to train one in ceremony, elaborate funerals and prolonged mourning to send off the dead—these Confucius advocated but Mo-tzu condemned. Concern for everyone, elevation of worth, service to the ghosts, rejection of Destiny—these Mo-tzu advocated but Yang-tzu condemned. Keeping one's nature intact, protecting one's genuineness, and not letting the body be tied by other things—these Yang-tzu advocated but Mencius condemned."[4]

Since the victory of Confucianism Yang Chu has been remembered as a pure egoist, on the authority of Mencius' polemic. But 20th-century scholarship, both Chinese and Western, prefers the testimony of *Huai-nan-tzu*, which has no axe to grind, and is excellently informed about Confucianism, Mohism, and no doubt Yangism as well.[5] Evidently egoism was not what Yang Chu taught, but something that Confucians justly

* *Me* 7A/26. Cf. also 3B/9 "Yang is for selfishness, which is to have no lord; Mo is concerned for everyone, which is to have no father. To have neither father nor lord is to be a bird or a beast."

or unjustly read into his teaching. It has been noticed too that the three doctrines there ascribed to him are the themes of certain chapters of the *Lü Spring and Autumn*, which is a philosophical encyclopedia:[6]

Ch. 1/2 'Life as Basic'

Ch. 1/3 'Giving Weight to Self'

Ch. 2/2 'Valuing Life'

Ch. 2/3 'The Essential Desires'

Ch. 21/4 'Be Aware of What It Is For'.

More recently it has been noticed that a block of four chapters in *Chuang-tzu* is not Taoist but displays the same constellation of ideas:

Ch. 28 'Yielding the Throne'

Ch. 29 'Robber Chih'

Ch. 30 'Discourse on Swords'

Ch. 31 'The Old Fisherman'

These chapters probably come from a little after the fall of Ch'in in 209 B.C.* Thus we now have at our disposal a substantial Yangist literature, from a late stage of the movement, but unaffected by Taoism.

The *Chuang-tzu* 'Primitivist' chapters mention "the argumentation 辯 (*pien*) of Yang and Mo".[7] From the Yangist chapters of the same book we can see how the Yangist style of argument differed from the Mohist. Except for 'Yielding the Throne' they consist entirely of dialogues, of which two in 'Robber Chih' (between a Confucian and a worldly man, and between a worldly man and a Yangist) are genuine debates in which both speakers have their say. There are no appeals to the sage kings, and Robber Chih denounces all of them after a Golden Age long before the Yao and Shun with whom Confucian and Mohist historiography starts. There is, however, much citation of instances from history and legend, and this is the debating technique of which the Yangist seems most conscious. 'Yielding the Throne' consists of two series of examples collected from older sources, evidently for use in debate; the first of them is of men admired by the Yangists, the second is of the moralistic hermits whom they despise. In 'Robber Chih' we find the debaters appealing to these and similar examples, which are meticulously classified and enumerated. The dialogues, unlike those in *Mo-tzu*, are highly literary, and the narrative style of their settings is the most advanced in pre-Han literature ('The Old Fisherman' in particular is not the usual summary anecdote framing

* Three chapters (excluding 'Discourse on Swords') were identified as Yangist by Kuan Feng in 1962. I would also take 'Discourse on Swords' as a Yangist warning against injury of life by pointless bloodshed. For the dating, cf. G. *Studies* 307–313.

dialogue but scene presented to the eye and ear). The Yangist *pien* in *Chuang-tzu* is an art of persuasion with as much rhetoric in it as logic, and reminds one forcefully how honestly rational the Mohists are, in their plodding early phase as well as in the logically sophisticated *Canons* of the Later Mohists. The word *pien* itself is used only in a secondary sense, as the stative verb, 'eloquent, persuasive'.[8] The literary sophistication may belong only to the last phase of the movement. It is lacking in the *Lü Spring and Autumn* chapters, less reliable as a guide to style however, being essays conforming to the plan of the whole book.

The Yangist teachings

A philosophy entitling members of the ruling class to resist the overwhelming moral pressures to take office remained a permanent necessity in Imperial China. Yangism is the earliest, to be superseded in due course by Taoism and, from the early centuries A.D., by Buddhism. But Yangism differs from its successors in having nothing mystical about it. It starts from the same calculations of benefit and harm as does Mohism, but its question is not 'How shall we benefit the world?' but 'What is truly beneficial to man?', more specifically 'What is truly beneficial to myself?' Is it wealth and power, as the vulgar suppose? Or the life and health of the body and the satisfaction of the senses? The Mohists cared only for the useful, the Yangists ask 'Useful for what?'.

Of the three doctrines ascribed to Yang Chu in *Huai-nan-tzu*, 'Keeping one's nature intact' introduces the concept of human nature into Chinese philosophy. (Confucius' "By nature we are near to each other, by habituation we diverge"[9] is a sociological rather than a philosophical observation). *Hsing* 性 'nature' is a noun derived from the verb *sheng* 生 'be born, live' (used causatively, 'generate'). It is graphically distinguished from it by the addition of the 'heart' radical, which in pre-Han texts may however have been supplied by later graphic standardisation. Even in the graphically standardised texts available to us the radical is indifferently included or omitted in such phrases as 'keep life/nature intact', 'nourish life/nature', 'harm life/nature', which belong to the ordinary terminology in which questions of health had been discussed since far back in the Chou.[10] For the Yangist, *hsing* is primarily the capacity, which may be injured by excess or by damage from outside, to live out the term of life which Heaven has destined for man.

"It is the nature of water to be clear; mud dirties it, so it fails to be clear. It is man's nature to live out his term; other things disturb him, so he fails

to live out his term. A 'thing' is a means to nourish one's nature, not something one uses one's nature to nourish. Of the confused among the people of this age, most are using their natures to nourish other things, which is failing to know the weighty from the light. If you don't know the weighty from the light, the weighty is deemed light and the light weighty." ('Life as Basic')

"Therefore the sage's attitude to sounds, sights and tastes is that when beneficial to his nature he chooses them, when harmful to his nature he refuses them. This is the Way of 'keeping one's nature intact'." ('Life as Basic')

"Therefore the sage controls the myriad things in order to keep intact what he has from Heaven. If what is from Heaven remains intact the spirit is harmonious, the eye and ear clear, the nose and mouth sensitive, the 360 joints all supple." ('Life as Basic')[11]

To injure health by excess or risk life to multiply possessions is to forget that things are only means to the life generated in us by Heaven; one's possessions are replaceable, one's life is not. As for the second doctrine ascribed to Yang Chu, 'protecting one's genuineness' (chen 真), Confucius is presented as asking the old fisherman about it.

" 'Let me ask what you mean by "genuine".'

'The genuine is the most quintessential, the most sincere. What fails to be quintessential and sincere cannot move others. Thus forced tears however sorrowful fail to sadden, forced rages however formidable do not strike awe, forced affection however much you smile will not be returned. Genuine sorrow saddens without uttering a sound, genuine rage strikes awe before it bursts out, genuine affection is returned before you smile." ('The Old Fisherman')

Confucius is denounced for preferring the ceremonial to the genuine.

"Ceremony is what worldly custom has manufactured. The genuine is what we use to draw on Heaven, it is spontaneous and irreplaceable. Therefore the sage, taking his standard from Heaven, values the genuine and is untrammelled by custom. The fool does the opposite; incapable of taking his standard from Heaven he frets about man, ignorant of how to value the genuine he timidly lets himself be altered by custom, and so remains unsatisfied." ('The Old Fisherman')[12]

As for the third doctrine, 'not letting the body be tied by other things', the extreme example of endangering oneself by involvement with another thing is possession of a state or the Empire itself. The Yangist may judge it safe to accept a throne (in practice of course it would be an office), but may also prefer to renounce it rather than endanger his own life or the lives of

other people. His principle that life is more important than any possession leads him to put the lives of the people before the advantages to himself of possessing the state. An example is Tan-fu, an ancestor of the Chou, who renounced Pin rather than endanger his people by fighting the invading Ti.

" 'To send to their deaths the sons and younger brothers of those with whom I dwell is more than I could bear. Get on as best you can here, all of you. What difference does it make whether you are subjects to myself or to the Ti? Besides, I have heard that one does not let the means of nourishing do harm to what they nourish.'

"He departed staff in hand, and the people followed in procession behind him. Then he founded a state under Mount Ch'i. The Great King Tan-fu may be pronounced capable of honouring life. One capable of honouring life, though rich and noble, does not let what nourishes do harm to his person, though poor and lowly does not let a benefit be a tie to the body." ('Be Aware of What It Is For', also in 'Yielding the Throne')[13]

The more characteristic case is the refusal of a throne for the sake of one's own health. But even here the preference for life over possessions is assumed to extend to the lives of others, with the paradoxical consequence that the man least likely to want the state is the best man to rule it.

"Yao resigned the Empire to Tzu-chou Chih-fu, who replied:

'It might not be a bad idea to make me Emperor. However, just now I have an ailment which is worrying me. I am going to have it treated, and have no time now to bother about the Empire.'

"The Empire is the weightiest thing of all, but he would not harm his life for the sake of it, and how much less for any other thing! Only the man who cares nothing for the Empire deserves to be entrusted with the Empire." ('Valuing Life', also in 'Yielding the Throne').[14]

Fidelity to one's nature, genuineness, not being tied by possessions, are all themes which pass into Taoism; even the thought that the man who puts his own life before the Empire is the best man to rule it reappears as a typical Taoist paradox in *Lao-tzu*.[15] But in philosophical Taoism health and life are nourished by *not* interfering with spontaneity by calculations of benefit and harm, while Yangist thinking is a meticulous weighing of means and ends. Ends, which in Mohism as we saw tend to disappear from sight,[16] are discussed with the verb *wèi* 為 'do for, do for the sake of'. Thus the selfishness of which Mencius accuses Yang Chu is *wèi wo* 為我 'doing for my own sake'. 'Robber Chih' has a debate between a Confucian who claims to "do for the sake of behaving well" and a worldly man who accuses him of "doing for the sake of reputation" and describes

himself as "doing for the sake of benefit"; a Yangist then criticises both for "neglecting what doing is for and making a human sacrifice of oneself for what it is not for".[17] The *Lü Spring and Autumn* has an essay on the same theme.

"One's person is what doing is for the sake of, the Empire is a means to doing for the sake of it. Be fully aware of what something is for, and what is weightier and what lighter will be grasped. Suppose we have a man who cuts off his own head in exchange for a cap, or executes his own person in exchange for a coat; the world will certainly think him deluded. Why? A cap is a means to adorn the head, a coat is a means to adorn the person. If you execute the adorned to get the means of adornment you do not know what it is for." ('Be Aware of What It Is For'.)[18]

We have noticed that Confucius seems not to think in terms of choice between alternatives.[19] But with the appearance of rival doctrines choice moves to the conceptual foreground. The word *ch'ü* 取 'take', when used in explicit or implicit contrast with words for 'refuse', is regularly translatable by 'choose'. The estimating of 'heavier' and 'lighter' alternatives implies the image of balancing on scales also familiar in the West. The metaphor of the crossroads, the absence of which Fingarette notices in the *Analects*,[20] turns up in an anecdote told variously of Mo-tzu and of Yang Chu. Hsün-tzu cites it in connexion with respect or neglect for merit in appointing ministers.

"Yang Chu wailed at the forked road saying: 'Isn't this where you take a half step wrong and wake up a thousand miles astray?'. Grievously he bewailed it. This too is a fork to glory and disgrace, safety and danger, survival and ruin, far more grievous than the fork in the road."[21]

The supposed egoism of Yang Chu

It is by now plain that the Yangist does not think of himself as Mencius sees him, as a selfish man who prefers his own comfort to taking office and benefiting the people. He can justly claim to be concerned for life in general, not just his own; the 'Discourse on Swords', for example, is a protest against the useless bloodshed of the swordfighting enjoyed by rulers as a spectator sport. There is however something a little shifty about that dictum "Only the man who cares nothing for the Empire deserves to be entrusted with the Empire". If not a principled egoist, the Yangist is at any rate an individualist concerned to benefit his own person and leave others to do the same.

"The most genuine in the Way is for maintaining one's person, its

leftovers for ruling a state, its dirt and weeds for ruling the Empire." ('Valuing Life')[22]

"If one estimates the trouble something will cost, anticipates reverses, judges it harmful to one's nature, and therefore refuses to accept it, that is not out of a need for praise and repute. When Yao and Shun abdicated the throne it was not out of benevolence to the world, they wouldn't for the sake of vainglory injure life. When Shan Chüan and Hsü Yu would not accept the offer of the throne, it was no empty gesture of humility, they would not by taking on its tasks injure themselves. All these men took the beneficial course and refused the harmful, and if the world cites them as examples of men of excellence, by all means let us give them the credit, but it was not to win praise and repute that they did it." ('Robber Chih').[23]

That Confucians and Mohists would be bound to see Yangists as preachers of selfishness shows up clearly in a dialogue put in the mouths of Yang Chu and a disciple Meng Sun-yang and Mo-tzu's chief disciple Ch'in Ku-li, which survives in the 'Yang Chu' chapter of *Lieh-tzu* (c. A.D. 300). In this late book Yang Chu is used as spokesman of a hedonism which prefers the full enjoyment of the moment to length of life, but the present dialogue is one of several episodes borrowed from earlier sources and seems to be Mohist in origin.[24] As in Mencius' denunciation of Yang Chu, the conventional posing of the issue as between a part of the body and an external possession is sharpened to the extreme case, whether to exchange a single hair for the whole world.

"Ch'in Ku-li asked Yang Chu:

'If you could help the whole world by the loss of a hair off your body, would you do it?'

'The world would surely not be helped by a single hair.'

'Supposing it did help, would you do it?'

Yang Chu did not answer him. Meng Sun-yang said:

'You have not fathomed what is in the Master's heart. Let me say it. Supposing for a bit of your skin you could get a thousand in gold, would you give it?'

'I would.'

'Supposing that by cutting off a limb at the joint you could win a state, would you do it?'

Ch'in Ku-li was silent for a while.

'That one hair matters less than skin', said Meng Sun-yang, 'and skin less than a limb, is plain enough. However, go on adding to the one hair and it amounts to as much as skin, go on adding more skin and it amounts

to as much as one limb. A single hair is certainly one thing among the myriad parts of the body, how can one treat it lightly?' "25

Here the Mohist speaks of "helping the whole world", the Yangist of "winning a state", but neither quibbles over the difference. Both mean the same thing, the achievement of political power which is on the one hand the only means of benefiting the people in general, on the other hand the supreme goal of personal ambition. Yang Chu's principle that one's body is more important than the greatest of the external things which are used to nourish it forbids him, when the Mohist has pushed him into a corner, to say that he would give a hair to benefit the world by good government. Yang Chu is embarrassed, but his disciple recovers the initiative by forcing the Mohist to admit his reluctance to sacrifice a limb for the opportunity to benefit a state.

But what Mencius and Ch'in Ku-li see as Yangist selfishness is very far from being a principled egoism. One may indeed raise the question whether Chinese thought ever poses the problem of philosophical egoism as it is understood in the West. Some translators, including myself in the past, have translated the phrase *wèi wo* applied by Mencius to Yang Chu by 'egoism' instead of 'selfishness'. But one has the impression that Chinese thinkers perceive persons as inherently social beings who are more or less selfish rather than as isolated individuals who will be pure egoists unless taught morality. This is suggested, for example, by one of the five dialogues of Mo-tzu and a certain Wu-ma-tzŭ who declares that "To ignore the men of today and praise the former kings is to praise rotten bones"26 and explicitly defends selfishness.

"Wu-ma-tzu said to Mo-tzu:

'I am different from you, I am incapable of concern for everyone. I am more concerned for men of Tsou than of Yüeh, of Lu than of Tsou, of my district than of Lu, of my family than of my district, for my parents than for the rest of the family, for my own person than for my parents, because I judge by nearness to myself. If you hit me it hurts, if you hit someone else it doesn't. Why should it be what doesn't hurt that I ward off rather than what does? Therefore, by existence of myself, there are occasions for killing someone else on account of myself, none for killing myself on account of a benefit.'

'Are you going to hide your morality?', said Master Mo-tzu, 'or tell others about it?'.

'Why should I hide my morality? I shall tell others about it.'

'In that case, if one man, ten men, the whole world, are persuaded by

you, then one man, ten men, the whole world, will wish to kill you to benefit themselves. If one man, ten men, the whole world, are not persuaded by you, then one man, ten men, the whole world, will wish to kill you as a practitioner of dangerous tenets. If whether persuaded or not they wish to kill you, it's a case of "What gets you hanged is your own mouth"; you are the one who by establishing it as a norm gets yourself killed.'

'To whom is your tenet beneficial?', Master Mo-tzu added. 'If as beneficial to no one you refuse to say it, you might as well not have a mouth.' "*

Mo-tzu, anticipating the paradoxes of self-reference which interested the Later Mohists,[27] sees a contradiction in preaching selfishness: to affirm the principle publicly is to disobey it. Wu-ma-tzu's arguments draw a clear line between my own pains which hurt me and other people's which do not, and could be used in favour of a true egoism. The striking thing however is that he is using them to defend a relative selfishness; he has a 'morality' (yi) which prescribes doing more or less to people according to their distance from himself. It would be Confucianism if it were not for that final step of preferring himself to his parents.

Mo-tzu is credited with another argument against selfishness, set in the characteristic Yangist form, balancing parts of the body against external possessions. If this and the Wu-ma-tzu dialogue are genuine, doctrines associated with Yang Chu go back to 400 B.C. or earlier. It is likely however that the Mo-tzu dialogue chapters contain dramatisations of issues facing the school after their founder's death.

"In the myriad affairs nothing is to be valued above the right. Suppose you tell a man 'I'll give you a cap and shoes if you let me cut off your hands and feet', will he do it? Certainly he will not. Why? Because cap and shoes are less valuable than hands and feet. If you continue 'I'll give you the Empire if you let me execute your person', will he do it? Certainly he will not. Why? Because the Empire is less valuable than one's person."

One is startled to see Mo-tzu apparently conceding the whole Yangist case. But there is one more step to go.

"One will fight to the death over a single word, which is the right being more valuable than one's own person. Therefore I say: 'In the myriad affairs nothing is to be valued above the right'."[28]

This answer may be unexpected, but the assumption behind it deserves pondering. One might be inclined to object that the man who

* Mo 46/52–60, tr. Mei 219f. Reading 常之殺身 for 殺常之身.

risks his life to avenge an insult is motivated by pride, which is egoistic, not by a moral principle. But his pride is stirred because he accepts that he would be justly despised as a coward if he refuses to do the socially prescribed thing for a man in his position. On what egoistic calculation can he prefer death to shame as merely an unpleasant emotion? The example is well chosen, as a moral reaction likely to be more rather than less common in a state of moral anarchy. It seems that in one way or another we cannot escape valuing life below *yi*, 'the right', the word which when used of a conception of the right we have been translating 'morality'. This connects with a problem we noted earlier,[29] why the Mohist conceives the primaeval war of all against all as a clash, not between interests, but between moralities. We may conclude that he sees individuals, even at the extreme of competition, as always recognising some code applicable both to themselves and to others, although they cannot arrive at harmony until united in an organised society with a single code. If so, he has no conception of an absolute egoism, only of varying degrees of selfishness and unselfishness. Perhaps philosophical egoism is conceivable only in a highly atomised society such as our own, perhaps it is not conceptually coherent at all. Is it plain that an egoist can reject humility, gratitude, kindness and love as interfering with his own interests, without being committed to rejecting pride, revenge, cruelty and hate, which can clash with the same interests? But if one continues discarding passions by this logic, how much of the man is left? Without pursuing this thought,* we may doubt whether a theoretically pure egoism would be conceived by individuals so closely cemented by kin relations as the ancient Chinese.

Valuation of the right above life is not incompatible with valuation of life above possessions, and one Yangist essay successfully integrates them. The passage starts with a quotation from a certain Tzu-hua-tzu, said elsewhere[30] to have dissuaded Marquis Chao of Hán (358–333 B.C.) from war by arguing that if he would not give one hand in exchange for the Empire it is illogical to risk his life fighting over a small territory.

"Tzu-hua-tzu said: 'The complete life is highest, the depleted life next, death next, the oppressed life lowest.' Hence when one says 'Honour life' it is the complete life which is meant. In 'complete' life the six desires all get what suits them, in 'depleted life' they get part of what suits them; and with depletion of life the honouring of it decreases, the more the depletion the less we honour it. In 'death' we have no means of knowing and revert to the unborn. In 'oppressed life' none of the six desires gets what suits it,

*I have developed this argument in *Reason and Spontaneity* 14–29.

all get what we utterly hate. Examples are subjection and disgrace. No disgrace is greater than for wrongdoing (= the not *yi*), so wrongdoing is of the oppressed life, but is not the only oppressed life. Hence it is said: 'The oppressed life is worse than death.'" ('Valuing Life').[31]

We conclude with the most eloquent of Yangist discourses, the conclusion of Robber Chih's diatribe against Confucius.

"Now let me tell you what man essentially is. The eyes desire to look on beauty, the ears to listen to music, the mouth to discern flavours, intent and energy to find fulfilment. Long life for man is at most a hundred years, at the mean eighty, at the least sixty; excluding sickness and hardship, bereavement and mourning, worries and troubles, the days left to us to open our mouths in a smile will in the course of a month be four or five at most. Heaven and earth are boundless, man's death has its time; when he takes up that life provided for a time to lodge in the midst of the boundless, his passing is as sudden as a thoroughbred steed galloping past a chink in the wall. Whoever cannot gratify his intents and fancies and find nurture for the years destined for him, is not the man who has fathomed the Way.

"Everything you say I reject. Away with you, quick, run back home, not a word more about it. Your Way is a crazy obsession, a thing of deception, trickery, vanity, falsehood. It will not serve to keep the genuine in us intact, what is there to discuss?" ('Robber Chih').[32]

4. IDEALISATION OF THE SMALL COMMUNITY: THE UTOPIA OF SHEN-NUNG

The Yangist chapters of *Chuang-tzu* show a special aversion to the moralistic hermits and the self-sacrificing ancients whom they revered, in particular the brothers Po Yi and Shu Ch'i, who at the rise of Chou refused to accept the new dynasty, and starved to death under Mount Shou-yang. 'Yielding the Throne' reproduces in chronological order as examples for debate a series of stories about the moralists' heroes, stripped of approving comments in the sources;[1] the text as we have it breaks off with the two brothers. Robber Chih uses the same example with some more recent ones, and concludes:

"These six are worth no more than a dead dog in the street, a stray pig, a beggar with his bowl. They were all men who to get themselves a name made light of death, and did not remember to nurture life from the roots to their destined old age."[2]

Later tradition assumed that the moralistic hermits judged the

corruption of the age by more or less Confucian standards. Thus Ssu-ma Ch'ien, writing the biography of Po Yi and Shu Ch'i, takes it for granted that they refused allegiance to Chou out of loyalty to the defeated Shang. But in the corners of the literature we catch tantalising glimpses of quite different ideas—that every man should work for his living, that rulership should depend on merit and not be hereditary,[3] that the sage ruler teaches but does not enforce by punishment. Confucian and Mohist teachers, often reproached for eating at others' expense, sometimes found themselves at a moral disadvantage against these hermits industriously working their own fields. One of the Mo-tzu dialogues has him debating with a certain Wu Lü who thinks it his duty to support himself by ploughing and making pots; Mo-tzu answers this implicit reproach to himself as a teacher by arguing in detail that the inventor of agriculture did more good by teaching people to plough than he would by ploughing himself.[4] Nor were the things which touched the hermits' consciences always the traditionally recognised sorts of misgovernment. Ch'en Chung, of one of the greatest families of Ch'i, living with his mother and an elder brother on the latter's stipend from the state, left the house because he judged the income unrighteous, and supported himself by weaving sandals, nearly dying of starvation; he once vomited up the meat of a goose on hearing it was a gift from his brother.[5]

One idea which flourished in these circles was the Utopia of Shen-nung, which at least one hermit community tried to put into practice.* Shen-nung ('Divine Farmer') is the legendary inventor of agriculture, and appears in royal calendars as a farmer's god.[6] He marks one stage in a process which can be traced right through the classical age, the invention or adoption of prehistoric Emperors representing new philosophical or political ideals. Confucius had introduced the pre-dynastic Yao and Shun, unmentioned in the early Chou literature, as the immediate predecessors of Yü, founder of the Hsia dynasty. Their names always remain the symbols of the two main moralistic schools, the Confucians and Mohists. The Mohists, however, late in their history settled on Yü as their patron sage, because of his self-sacrificing labours draining the Flood. The name of Shen-nung appears in the 4th century B.C. as representative of a

* The argument on which this chapter is based is developed at length in 'The Nung-chia "School of the Tillers" and the Origins of Peasant Utopianism in China', G. Studies 67–110. In that paper I assumed that the idealisers of Shen-nung were known as Nung-chia in their own time. But it now seems to me more probable that Nung-chia is no more than the Han bibliographer's heading for farming manuals, and I have switched to a more conservative translation, 'Farmers' School'.

coherent and quite distinctive political ideal. Throughout the literature down to the 2nd century B.C. he is the head of a decentralised empire of tiny fiefs, who ploughs with his own hands and reigns in universal peace without ministers, laws or punishments. His function as ruler is limited to teaching agriculture, inspecting the fields, and maintaining a constant grain supply by storing in good years and issuing in bad. The Way of Shennung has the look of a peasant ideal; as with the Mohists, we seem to glimpse something from outside the ruling class. There is the difference, however, that the Mohists seem to be rising into the knightly class, while the recluse ploughing his own fields is rather sinking down from it. Shennung finally slipped into Confucian historiography in the 'Great Appendix' of the *Yi*, but as inventor of agriculture and of markets, without reference to his questionable methods of government. The Legalist *Kuan-tzu* has a note: "Therefore the Emperors in the *Documents* amount to eight but Shen-nung is not included among them, because in his time there were no stations and one man could not employ another."[7]

The Golden Age of Shen-nung

The Han bibliography, which retrospectively classified the philosophers in ten schools, each with its strengths and weaknesses, listed farming manuals under the heading 'Farmers' School'. Its strength was in providing useful agricultural information, its weakness that some "thought there was no point in serving the sage kings, wished to make the ruler plough side by side with his subjects, and upset the degrees of superior and inferior."[8] The first book on the list, entered as pre-Han, carries the title *Shen-nung*. The book is long lost, but syncretistic writings such as *Huai-nan-tzu* (c. 140 B.C.) preserve a great deal of information about the legendary Emperor, backed by quotations from what may have been chapters of the book, the 'Law', the 'Teaching', the 'Numbers', and the 'Prohibition' of Shen-nung.

"Therefore the 'Law of Shen-nung' says: 'If in the prime of life a man does not plough, someone in the world will go hungry because of it; if in the prime of life a woman does not weave, someone in the world will be cold because of it.' Therefore he himself ploughed with his own hands, and his wife herself wove, to give a lead to the world.

"In guiding the people, he did not value commodities difficult to obtain, did not treasure things without use. Consequently, any who did not work hard at ploughing had no means to support life; any who did not work hard at weaving had nothing with which to clothe the body. Whether

one had ample or less than enough was each person's own responsibility. Food and clothing were abundant, crimes and vices did not breed; they lived untroubled in security and happiness, and the world ran on an even level. So there was no scope for Confucius and Tseng Shen [his disciple] to exercise their goodness, or for Meng Pen and Ch'eng Ching [men of valour] to put people in awe of them."*

The Chinese Emperor's three ceremonial pushes on the plough on New Year's Day, once imitated in the 18th century by the King of France, may well have originated in the Shen-nung ideal. But Shen-nung and the rulers of his line really worked for their living like everybody else.

"The rulers of the House of Shen-nung carried loads on their backs, their wives carried loads on their heads, to govern the Empire. Yao said: 'Compared with Shen-nung I am like the twilight to the dawn.' "[9]

That the Way of Shen-nung is a contemporary ideal read back into the past is once mentioned in *Huai-nan-tzu*:

"Vulgar people mostly honour the past above the present; therefore those who cultivate a Way have to credit it to Shen-nung or the Yellow Emperor before it can be taken seriously".[10]

Elsewhere, however, it is accepted that under the first farmer, Shen-nung, and his predecessor the first hunter, Fu-hsi, order was maintained without rewards or punishments, commands or restrictions, but denied that the same Way is realisable today.

"What in ancient times was a means to order would nowadays be a means to disorder. Shen-nung and Fu-hsi applied neither rewards nor punishments, yet the people did no wrong. However, one who establishes an administration cannot if he dispenses with laws bring the people to order."

"In former times, under Shen-nung there were no restrictions or commands but the people followed him; under Yao and Shun there were restrictions and commands but no punishments. The House of the Hsia Emperors kept their word, the men of Yin [Shang] swore oaths, the men of Chou made covenants.

"Coming down to the present age, men are shameless and careless of disgrace, greedy for gain and seldom embarrassed. If you wish to put them in order by means of the Way of Shen-nung, their disorder will be inevitable."[11]

This historical scheme is not the one already orthodox by the time of

* HN (ch. 11) Liu 11/22B. Cf. also LSCC (ch. 21/4) Hsü 21/11A, where the quotation is ascribed to the 'Teaching of Shen-nung'.

Huai-nan-tzu, which has the Yellow Emperor intervening between Shen-nung and Yao. It is peculiar also in that historical decline is on the one hand an increase of restrictions, on the other a deterioration of the mutual trust on which the old order depended, culminating in the proliferation of covenants under the Chou. That this scheme belongs to the Shen-nung doctrine is confirmed by the earliest full account of the legend of Po Yi and Shu Ch'i, in the *Lü Spring and Autumn*.† In this the brothers denounce the Chou, not for usurping the throne, but for ruling by force instead of by the peaceful policies of Shen-nung. The immediate occasion for the protest is the sight of the Chou making alliances with nobles against the Shang, in covenants with three copies smeared with the blood of sacrificial victims, one for each party and a third to be buried. They are witnessing the final breakdown of mutual trust. We find the same historical scheme without the Yellow Emperor in a poem ascribed elsewhere to the two brothers.

> "Climb that Western mountain,
> Pick its herbs.
> They exchange tyranny for tyranny
> And don't know that they do wrong.
> Shen-nung, Shun, the Hsia are as though they had never been.
> Who deserves our allegiance?
> Alas! Away we go.
> The mandate has dwindled away."[12]

On the issue of whether power is most secure when centralised or when delegated to fiefholders, which became crucial under the Ch'in, the regime of Shen-nung is cited as the one with the most fiefs.[13] Small fiefs appear also in a chapter of *Lao-tzu* which two early sources[14] take to be a description of the Utopia which ended in the age of Shen-nung:

"Make fiefs small and their people few, ensure that though there are arms for a troop or battalion they are not used, ensure that the people take death too seriously to move far away [that is, are sufficiently content with life to stay], and even if they have boats and carriages there is no occasion to ride them, even if they have armour and weapons there is no occasion to display them. Ensure that men return to the use of knotted cords [the aids to memory before writing], want no sweeter food or finer dress, are content to be where they are, delight in their customs. Neighbouring fiefs

† LSCC (ch. 12/4) Hsü 12/8B–10A. Also Cz 28/74–86, tr. G. 232f, which however abbreviates the covenants.

will see each other in the distance, hear the sound of each other's cocks and dogs, but the people will grow old and die without ever coming or going."[15]

The Utopia of Shen-nung appears to be an anarchistic order based on mutual trust in small communities, and one may well ask what function is left for an Emperor and nobles who work with their own hands for a living, and do not command, make laws, reward or punish, go to war. The answer is that they have their uses for agriculture.

> "Formerly, when Shen-nung ruled the Empire . . .
> The mild rain fell when it was due,
> The five grains flourished.
> In spring they sprouted, in summer grew up,
> In autumn were harvested, in winter stored.
> There were monthly inspections, there were seasonal trials,
> At the year's end they reported how much had been done.
> In due season the grains were tasted
> And offered as a sacrifice in the Hall of Light."[16]

"The 'Prohibition of Shen-nung': 'What grows up through spring and autumn is not to be injured or obstructed; carefully tend what is beneficial in the land, so that the myriad things complete their growth; do not snatch away what benefits the people, and the farmers will work in accord with the seasons."[17]

Another passage anticipates the 'Constantly balanced granary', the storing of grain in good years and issuing of it in bad, which became one of the foundations of economic policy in Imperial China, and the main precedent cited by Henry Wallace in introducing a similar policy in the United States in 1938.[18]

"The 'Numbers of Shen-nung' says: 'If one grain fails, take less of the one grain, and let the issue of the grain be tenfold; if two grains fail, take less of the two grains, and again let the issue of the grain be tenfold.' Maintain a full supply: give the old grain to those without food, lend new seed to those without seed. Hence there will be no tenfold prices and no profiteering people."[19]

This combination of the practical with the naive does rather suggest the viewpoint of peasants who see no reason why the ruler should not be working for his living as they do, and reflect that if he did he would not be grabbing a share of their crops and would be too busy to fight wars. The Shen-nung ideal is of a world of village communities where a man's word

can be trusted by his neighbours without the need of oaths and covenants, where only idle hands make mischief and disputes are better settled by local custom than by calling in the law, under leaders who work their own fields and are obeyed because everyone can see the point of their decisions.

Hsü Hsing

The Shen-nung idealists, lost to sight in an underworld of mostly nameless recluses, just once come into full view. About 315 B.C. Mencius tried to win back a Confucian who had joined them, Ch'en Hsiang. This accident has saved from oblivion the community of a certain Hsü Hsing, who came from the great state of Ch'u in the south to the little north-eastern state of T'eng. Mencius' account puts at our disposal the only principled challenge to economic privilege, and the only reasoned defence of it, to be found in the extant literature.

"There was a man who professed the tenets of Shen-nung, Hsü Hsing, who travelled from Ch'u to T'eng, approached the gate and announced to Duke Wen: 'A man from far away, I have heard that your lordship is conducting benevolent government, and wish to be granted a place to live and to become your subject.' The Duke gave him a place. He had several dozen disciples, who all wore coarse cloth and wove sandals and mats for a living.

"Ch'en Hsiang and his younger brother Hsin, disciples of Ch'en Liang [a Confucian], travelled from Sung to T'eng with ploughshares on their backs. 'We have heard,' they said, 'that your lordship conducts sagely government, which is to be a sage yourself. We wish to be subjects of a sage.'

"Ch'en Hsiang saw Hsü Hsing and was delighted, abjured all his own learning and learned from him. When Ch'en Hsiang saw Mencius he expounded Hsü Hsing's tenets, saying

'As for the lord of T'eng, he is a worthy ruler indeed, but he has not yet heard the Way. The worthiest feed themselves by ploughing side by side with the people, rule while cooking their own meals. Now however T'eng has granaries and treasuries, which amounts to supporting oneself by oppressing the people. Is he then so worthy?' "[20]

Mencius replies by calling attention to the division of labour.

" 'Does Hsü Hsing eat only grain he has planted himself?', said Mencius.

'He does.'

'Does Hsü Hsing wear only cloth he has woven himself?'

'No. He wears coarse hemp.'

'Does he wear a cap?'

'He does.'

'What sort does he wear?'

'He wears coarse silk.'

'Does he weave it himself?'

'No, he gets it in exchange for grain.'

'Why not weave it himself?'

'It would interfere with ploughing.'

'Does he cook with metal and earthenware pots, does he plough with iron?'

'Yes.'

'Does he make them himself?'

'No, gets them for grain.'

'Getting tools and vessels for grain is not reckoned to be oppressing the potter and smith; and the potter and smith getting grain for the tools and vessels, is that reckoned to be oppressing the farmer? In any case, why doesn't Hsü Hsing become potter and smith himself, so that he can use only things from inside his own house? Why all this complicated trading with the various crafts? Why does Hsü Hsing put up with all the bother?'

'Obviously you can't do the work of the various crafts and plough as well.'

'Then is ruling the Empire the one thing you can do and plough as well? There is the great man's work, there is the small man's work. In any case the things made by the various crafts are at the disposal of each one of us; if we are to use only what we make ourselves, that's to bring everyone in the world to distress. Hence the saying "Some exert their wits, some exert their strength. Exerters of their wits rule, exerters of their strength are ruled. The ruled feed others, the rulers are fed by others." It is the general scheme throughout the world.'"

After being denounced at length for betraying Confucianism to join "the shrike-tongued man from the Southern barbarians who denies the Way of the former kings", Ch'en Hsiang raises another point.

"If we follow the Way of Hsü Hsing there will not be two prices in the market and there will be no dishonesty in the capital. Even if you send a mere boy to market no one will cheat him. Cloth or silk of the same length

will be equal in price; hemp or flax or raw silk of the same weight will be equal in price; the five grains in the same quantities will be equal in price; shoes of the same size will be equal in price.'

'The inequality of things', said Mencius, 'is an essential of the things. Some are worth twice or five times, ten or one hundred times, a thousand or ten thousand times as much as others. In reducing them to the same, you will be disordering the Empire. If fine shoes are the same in price as rough ones, who will make them? To follow the Way of Hsü Hsing is to draw everyone into committing dishonesties. How would one be able to govern the state?'"

Here Mencius has missed the point. By the Way of Shen-nung you store grain in good years and issue it in bad, which keeps prices steady. Consequently "there will be no tenfold prices and no profiteering people." Ch'en Hsiang would be referring to this when he says that "there will not be two prices in the market and there will be no dishonesty in the capital." He is concerned with keeping prices steady rather than equal, although unlike Mencius (who is thinking of the varied goods available in a city) he advocates a simple life in which variety is a minor consideration and there is consequently not much variation in price. He has the right to take quantity as the representative factor in price just as he takes ploughing as representative of manual labour.

The influence of the Shen-nung ideal

The Shen-nung ideal influenced the other eremeticist movement of the period, which leads from Yangism to Taoism; through them it is ancestral to all Chinese Utopianism. As a practical manual of agriculture the lost *Shen-nung* even made a mark on the ruthlessly authoritarian Legalists, for whom the main concerns of state were agriculture and war. Agricultural manuals are among the categories exempted from the 'Burning of the Books' in 213 B.C.[21] The Legalists' use of *Shen-nung* is attested by a note on the book by the bibliographer Liu Hsiang (79–08 B.C.): "I suspect it is what Li K'uei and Lord Shang talk about."[22] Li K'uei and Lord Shang are the first two authors listed in the Legalist section of the Han bibliography. Li K'uei, chief minister of Marquis Wen of Wei (424–397 B.C.), whose lost book however, to judge by our general experience of early Chinese texts, would have contained later material,* is remembered as the

─────────────

* Legalist texts ascribed to chief ministers are suspect in any case; it seems to have been a convention to write in the name of a great minister, presumably of one's own state *(Kuan-tzu, Book of Lord Shang)*. Cf. p. 267f below.

first to propose the policy of storing and issuing grain, also recommended in the 'Numbers of Shen-nung'. If the Legalists did get this idea from *Shennung*, we can understand why the other work mentioned by Liu Hsiang, the still extant *Book of Lord Shang* (c. 240 B.C.), is so respectful of the Golden Age of Shen-nung.

"In the age of Shen-nung, they were fed by the ploughing of the men, clothed by the weaving of the women; he ruled without the use of punishments and administration, he reigned without resorting to weapons and armour. When Shen-nung died, they took advantage of strength to conquer the weak, of numbers to oppress the few. Therefore the Yellow Emperor instituted the formalities of ruler and minister and of superior and inferior, the ceremonies for father and son and for elder and younger, the union of couples as husband and wife. At home he put to work the executioner's axe, abroad he employed weapons and armour. So it was a change in the times. Seen from this viewpoint, it is not that Shen-nung was loftier than the Yellow Emperor; that his name is none the less honoured was because he was suited to his times."[23]

In accepting the reality of Shen-nung, Lord Shang has to deny that his example is relevant today. He requires a founder of the state and of war to mark the start of the present order. The role is filled by the legendary warrior Huang-ti ('Yellow Emperor'), whose defeated enemy Yen-ti was later to be identified with Shen-nung.[24] One might ask why Lord Shang chose to treat the Way of Shen-nung as superseded by historical change, as does *Huai-nan-tzu*; why not simply reject it as inherently impracticable? But the development and expansion of the Chinese states was a constant process of conquering and absorbing smaller and more loosely organised communities. That in such communities there can be order not imposed from above was a fact fully appreciated by Legalists such as Han Fei;[25] it attracted attention especially in the case of the dangerous barbarians of the Western frontier. Thus in one story a Duke of Chin asks an emissary of the Jung why they fight so well, and is told that government in China has been deteriorating ever since "that supreme sage the Yellow Emperor invented ceremony and music, laws and measures"; the Jung need no institutions to make their king just and his subjects loyal, "the government of the whole state is like one person ruling his own life, we do not know how we are ruled."[26]

Legalism triumphed temporarily with the reunification of the Empire by the Ch'in. But during the interlude of civil war between the fall of Ch'in in 209 B.C. and victory of Han in 202 B.C. the Shen-nung ideal revived among Yangists and Taoists weary of a state ordered solely by laws and punishments. The 'Primitivist' and Yangist chapters of *Chuang-tzu*,

datable to this period,† accept the interposition of the Yellow Emperor as inventor of the state and of war, but take his reign as the start of decline.[27] The 'Primitivist' has Shen-nung as last ruler in a Utopia of immemorial age.[28] The Yangist 'Robber Chih' however sees Shen-nung as the culmination of a preceding progress.

"Moreover I have heard that in ancient times the birds and beasts outnumbered men, so men all lived in nests to escape danger. In the daytime they gathered acorns and chestnuts, at nightfall perched in the treetops, and so were named the people of the House of Yu-ch'ao ('Nester'). In ancient times men did not know how to clothe themselves; in summer they piled up quantities of firewood, and when winter came burned it, and so were named the people of Chih-sheng ('Know how to live'). In the age of Shen-nung

> They slept sound,
> They woke fresh.
> The people knew their mothers,
> But did not know their fathers,
> And lived together with the deer.

They fed themselves by ploughing, clothed themselves by weaving, and there was no mischief in their hearts. This was the culmination of utmost Potency.

"However, the Yellow Emperor was unable to maintain Potency at its utmost, he battled with Ch'ih-yu in the field of Cho-lu, and made the blood stream for a hundred miles. Yao and Shun arose, and instituted ministers: T'ang expelled his lord, King Wu killed Chòu. From this time on men took advantage of strength to bully the weak, of numbers to oppress the few. Since T'ang and Wu [founders of Shang and Chou] they have all been the troublemaking sort."[29]

With the rise of the Han the Yellow Emperor revives and joins Shen-nung, Yao, Shun and Yü among the sage emperors adopted as patrons of rival schools. The school was Huang-Lao, which appealed to the authority of Lao-tzu as teacher and of the Yellow Emperor as founder of the state. A fragmentary book from this period, *Yü-tzu*, advises us to "follow only the rulers as far back as the Yellow Emperor and down to Shun and Yü", and a further stray fragment explains why:

"The Yellow Emperor knew from the age of ten that Shen-nung was wrong and reformed his goverment."[30]

† For the Primitivist, whom I date about 205 B.C., cf. p. 306–11 below.

5. THE SHARPENING OF RATIONAL DEBATE: THE SOPHISTS

In China rationality develops with the controversies of the schools, and dwindles as they fade after 200 B.C. With the debates of Mohists and Yangists fully launched, and the Confucians pulled into them, attention begins to shift from the practice to the theory of *pien* 'arguing out alternatives',[1] the distinguishing of the right alternative from the wrong. During the 4th century B.C. we meet for the first time thinkers who are fascinated by the mechanics of argumentation, delight in paradoxes, astonish their audiences by 'making the inadmissible admissible'. When during the Han the philosophers were classed in the Six Schools these, and others with more practical interests in naming, came to be known retrospectively as the School of Names. Earlier they were known simply as *pien che* 辯者 'those who argue out', sometimes translated 'Dialecticians'. Confucians, Taoists and Legalists alike scorn them for wasting their time on abstractions such as 'the similar and the different', 'the hard and white', 'the limitless' and 'the dimensionless'. Only the Mohists do not join in this general derision; some of the same themes appear in the Later Mohist *Canons,* from which we learn that the hard and white represent mutually pervasive properties in general, and that the limitless and the dimensionless have the full technical sense of the infinite and the point (the latter however understood by the Mohists as the starting point of a measurement).[2]

It is customary to call these thinkers 'sophists' and compare them to the Greek propounders of paradoxes, to the Eleatics however rather than to the Sophists proper. Although they have little in common with the latter,* the label 'Sophist' does call attention to a configuration of tendencies at the birth of rational discourse which is common to Greece and China. In both traditions we meet thinkers who delight in propositions which defy common sense, and consequently are derided as frivolous and irresponsible. In both, these thinkers belong to the early period when reason is a newly discovered tool not yet under control, seeming to give one the power to prove or disprove anything. In both, the exuberance with which they play with this astonishing new toy leads not only to 'sophistries' but to paradoxes of lasting philosophical significance. In both, the pride and pleasure in logical acrobatics calls attention to the relation between words and things. In both, to exult in one's skill in proving both sides of a case pushes in the direction of relativism. Nothing

* Cf. Reding, *Fondements* 455–500. Reding 280–346 translates all early stories about Hui Shih.

could be more disorientating, more disruptive, than reason first awakening to and revelling in its powers. One may well wonder how philosophy ever gets past this stage, with the most ancient paradoxes forever returning to plague it. The first discovery of uninhibited reason is that it leads inevitably to absurd conclusions. So why go farther? The Greeks did get past this initial disorientation, the Chinese never did.

The most famous of the Sophists were Hui Shih, a chief minister of King Hui of Wei (or Liang, 370–319 B.C.) and friend of the Taoist Chuang-tzu, and Kung-sun Lung, who entertained his patron the Lord of P'ing-yüan in Chao (died 252 B.C.) with his notorious argument that a white horse is not a horse. Since it was the Mohists who started and remained at the forefront in philosophical argumentation, one notices without surprise that as advisers of princes both show the influence of the Mohist doctrines of non-aggression and concern for everyone. There are stories of both of them advising princes against war, in one of which Kung-sun Lung in reproaching King Hui of Chao (298–266 B.C.) directly appeals to the principle of concern for everyone;[3] and the Ten Theses of Hui Shih, which we shall consider shortly, culminate in an appeal to "let concern spread to all the myriad things."

Hui Shih

The sparseness of the remains of Hui Shih is perhaps the most regrettable of all the losses in ancient Chinese literature, for everything recorded of him suggests that he was unique among the early thinkers for his breadth of talents and interests, a true Renaissance man.* The leaders of most schools aspired at least in theory to guide some ruler on the path they identified as the Way; but if we except the great statesmen to whom some Legalist works are dubiously ascribed, they were lucky to get even minor offices or sinecures. How did a sophist become chief minister in the state of Wei? And how is it that we keep meeting this most successful man of the world in the company of that disreputable layabout Chuang-tzu, who mocks his rigid logic but laments him after his death as his only truly stimulating opponent?[4] Not that his various roles are incompatible, for from a direction different from Chuang-tzu's his fellow statesmen, too, see him as having too theoretical a mind.

"Hui Shih composed a law code for King Hui of Wei. When it was finished he showed it to the people, who all thought it good. He presented it to King Hui, who thought it good and showed it to Ti Chien.

* I owe this observation to conversation with Christoph Harbsmeier.

'It's good', said Ti Chien.

'Will it work?'

'No.'

'If it's good why won't it work?'

'Suppose we have men lifting a heavy log. Those in front chant "Heave ho!", those behind join in. For lifting a heavy log that's good enough. Not that there aren't the airs of Cheng and Wei to sing, but they wouldn't be so suitable. The state is the heaviest log there is to lift.' "[5]

There is a story of Hui Shih being worried that Chuang-tzu wants to supersede him as chief minister. He gets the lofty reply:

"In the South there is a bird, its name is the phoenix, do you know of it? The phoenix came up from the South Sea to fly to the North Sea; it would rest on no tree but the sterculia, would eat nothing but the seeds of the bamboo, would drink only from the sweetest springs. Just then an owl had found a rotting mouse. As the phoenix flew over, it looked up and glared at it, 'Shoo!'. Now am I to take it that for the sake of that state of Wei of yours you want to shoo at me?"[6]

No doubt it was in his humbler days that Hui Shih was close to Chuang-tzu, and they saw less of each other when he rose high in the world. Hui Shih's mind, to judge from another story, had a further dimension missing from almost all thinkers of the classical period, a genuine curiosity about the explanation of natural phenomena. Down to about 250 B.C. proto-scientific theorising belongs to the world of astronomers, diviners, and physicians; no one in the philosophical schools shows any interest in cosmology, or, except for the Later Mohists who studied optics and mechanics, in any science. Yet we read of Hui Shih:

"There was a strange man of the South called Huang Liao, who asked why heaven did not collapse or earth subside, and the reasons (ku 故) for wind, rain, and thunder. Hui Shih answered without hesitation, replied without thinking, had explanations for all the myriad things, never stopped explaining, said more and more and still thought he hadn't said enough, had some marvel to add."[7]

In the Later Mohist sciences ku is used strictly of causes;[8] did Hui Shih offer genuinely causal explanations as we find them in the Mohist optics and mechanics, or was he satisfied with the correlative system-building they avoided but which was always to be the mainstream of cosmological speculation? Unless archaeology turns up new documents we shall never know.

Hui Shih owes his place as one of the major thinkers of China entirely to a single passage in the earliest history of the schools, the 'Below in the Empire' chapter of *Chuang-tzu*.[9]

"Hui Shih had many formulas, his books filled five carts, but his Way was eccentric, his words were off centre. He tabulated the ideas of things, saying:

(1) The ultimately great has nothing outside it, call it the 'Greatest One'. The ultimately small has nothing inside it, call it the 'Smallest One'.

(2) The dimensionless cannot be accumulated, yet its girth is a thousand miles.

(3) Heaven is as low as earth, the mountains are level with the marshes.

(4) Simultaneously with being at noon the sun declines, simultaneously with being alive a thing dies.

(5) Being similar on the large scale yet different from the similar on a small scale, it is this we call 'similar and different on a small scale'. The myriad things to the last one being similar, to the last one being different, it is this we call 'similar and different on a large scale'.

(6) The south has no limit yet does have a limit.

(7) I go to Yüeh today yet arrived yesterday.

(8) Linked rings can be disconnected.

(9) I know the centre of the world: north of Yen up in the north, south of Yüeh down in the south, you are there.

(10) Let concern spread to all the myriad things; heaven and earth count as one unit."

We number the theses purely for convenience, and there can be no certainty that Hui Shih presented them as a united sequence. But they do make an impression of homogeneity, exposing paradoxes which result from dividing and counting, and guiding towards the conclusion that all things are one, like Zeno's paradoxes.* With the loss of Hui Shih's explanations there is little point in attempting a close analysis, but one can offer a tentative account on the following lines:

(1) Counting is relative to division; either the infinite whole or the indivisible point which is its smallest division may be counted as one.

(2) The indivisible division presents a paradox; any quantity is the sum of its smallest divisions, yet the sum of points remains a point.

(3) The infinite whole presents another paradox; since from any

* The standard interpretation of Hui Shih's theses as spatio-temporal paradoxes has recently been challenged by Reding, who tries the different approach of relating them to political issues from which they might be plucked out of context and presented as sophistical absurdities by hostile thinkers. (Reding, *Fondements* 350–377).

position the distance upwards and downwards is infinite, mountains should be level with marshes.

(4) The indivisible division of time, the moment, likewise presents a paradox; the last moment of life is the first of death, so a thing is simultaneously alive and dead.

(5) In dividing and naming, we assume that we can give, for example, the name 'horse' to objects similar to each other and different from other objects;† but if we push similarity and difference further horses turn out to be both different from each other and similar to everything else.

(6) Space presents the further paradox that it both must and cannot have a limit.

(7) Combining the indivisible divisions of space and time, it appears that if I cross the line between one state and another at the moment between one day and the next, I both left one state today and reached the other yesterday.

(8) If indivisible divisions truly exist, it follows that connected rings can be fined down to pure circles and passed through each other without resistance.

(9) Space if infinite has its centre everywhere.

(10) Since division leads to contradiction don't divide at all, and therefore be as concerned for all other things as for yourself.

At what level of sophistication did Hui Shih defend his theses? That, for example, space both must and cannot have a limit is for many of us the first philosophical thought we pick up in childhood; one would like to know how rigorously Hui Shih succeeded in formulating the paradox. There is a discussion of it in *Lieh-tzu* (c. A.D. 300) which seems on both internal and external evidence[10] to have been borrowed from a lost chapter of *Chuang-tzu*.

"T'ang of Yin asked Chi of Hsia

'Have there been things from the very first?'

'Unless there were things from the very first, how would there be things now? Would it be admissible for the men after us to say there are no things now?'

'Does no thing then precede or succeed another?'

'The ends and starts of things

Have no limit from which they began

The start of one is the end of another,

† This assumption is explicit in the *Canons* and Hsün-tzu, cf. p. 140f, 265 below.

The end of one is the start of another,

How would we know which comes first?

But of what is outside things, of what preceded events, I do not know.'

'Are there then limit and exhaustibility above and below and in the eight directions?'

'I do not know.'

"T'ang persisted in asking. Chi said:

'Since on the one hand what is nothing is limitless and on the other what is something is inexhaustible, how would I know of them? But outside the limitless there is nothing else which is limitless, inside the inexhaustible there is nothing else which is inexhaustible. Beside the limitless nothing else is limitless, beside the inexhaustible nothing else is inexhaustible. This is why I know that they are limitless and inexhaustible, without knowing that they are limited and exhaustible.'"*

If Nothing is infinite there is a second infinite (since the infinite has *nothing* outside it?), and if Something is infinitely divisible a second infinitely-divisible (there being *something*, the point, inside its finest divisions?)—a contradiction, so they are finite. This may well be Chuang-tzu's version of his friend's lost proof that space is infinite yet also finite, but translated into the poetic language of Taoism. Hui Shih himself no doubt preferred the drily analytic style which we find in Kung-sun Lung and the Later Mohists.

Stories of Chuang-tzu making fun of him for being too logical give some impression of his style.

"Chuang-tzu and Hui Shih were strolling on the bridge above the River Hao.

'Out swim the minnows so free and easy', said Chuang-tzu. 'That's how the fish are happy.'

'You are not a fish. Whence do you know the fish are happy?'

'You aren't me, whence do you know I don't know the fish are happy?'

'We'll grant that not being you I don't know about you. Then granted you are not a fish, the case is complete that you don't know the fish are happy.'

'Let's go back to where we started. When you said "*Whence* do you know the fish are happy?", you asked me the question already knowing that I knew. I knew it from up above the Hao.'"[11]

Here Chuang-tzu's final stroke of wit is not necessarily mere exploitation of the accident that of the ways of asking 'How do you know?'

* *Lieh-tzu* (ch. 5) 5/1A, tr. G 94–96. The postulation of a lacuna in the text now seems to me unnecessary.

in Chinese Hui Shih happened to ask with *an* 安 'whence?' rather than for example with *ho-yi* 何以 'by what means?'. For Chuang-tzu all knowing is relative to viewpoint. There is no answer to 'How do you know?' except a clarification of the viewpoint from which you know, which relates to the whole of your concrete situation.

There is another dialogue which suggests that Hui Shih shares the Later Mohist view that the function of names is to communicate that an object is like the objects one knows by the name.[12] It is interesting to see that his example of a definition is not by genus and differentia but by analogue and differentia. The King criticises his chief minister for using too many analogical illustrations in his discourse.

"'When you speak of affairs, sir, I wish you would simply speak directly, with no analogies.'

'Let's suppose we have a man who does not know about *tan*', said Hui Shih. 'If he says "What are the characteristics of a *tan* like?", and you answer "Like a *tan*", will it be communicated?'

'It will not.'

'If then you answer instead "A *tan* in its characteristics is like a bow, but with a string made of bamboo", will he know?'

'It could be known.'

'It is inherent in explanation,' continued Hui Shih, 'that by using what he does know to communicate what he does not you cause the other man to know it. For Your Majesty now to say "No analogies" is inadmissible.'"[13]

'Below in the Empire' has a further list of 21 sophisms, heterogeneous, and ascribed to the Sophists in general. They include some more spatio-temporal paradoxes:

"A stick one foot long, if you take away half every day, will not be exhausted in ten thousand ages."

"A wheel does not touch the ground" (it touches it nowhere because the point of contact is dimensionless?).

"The L-square is not square, the compasses cannot make circles" (because they can only approximate to the geometrically perfect figures?).

"When the arrow is at its fastest there is a time when it neither travels nor is at rest" (between the first moment of flight and last of rest on the string?).

There are two more of which we do have clear pre-Han evidence in the Mohist *Canons*.

(1) "The eye does not see."

The eye is a means to seeing, does not itself see. Cf. *Canon* B 46 "The knower sees by means of the eye and the eye by means of fire but the fire

does not see. . . . Seeing by means of the eye is like seeing by means of the fire."

(2) "The shadow of a flying bird has never stirred."

The shadow does not move, it appears or disappears with the arrival or obstruction of the light, as explained in *Canon* B 17 at the head of a series on the shadow as an interference phenomenon.

Canon: "The shadow does not shift. Explained by: being re-made.

Explanation: Where the light reaches the shadow disappears."

Kung-sun Lung

Kung-sun Lung deserves fuller treatment than Hui Shih for a reason which overrides all others, that we are not in the frustrating position of having to guess what his arguments would be. We have not only his theses but his demonstrations, which for logical sophistication have no equal in the literature except for those in the last part of the Mohist *Canons,* which are very much shorter. There are however two great obstacles to the understanding of Kung-sun Lung. The first is textual; it has only lately been recognised that the book called *Kung-sun Lung tzu* was forged between A.D. 300 and 600, and that the second half of it is a mixture of banality and nonsense contrived with the aid of misunderstood scraps of the *Canons.*[14] But it preserves three pre-Han essays, the 'White Horse', 'Pointings and Things' and 'Left and Right', all examples of *pien* as the arguing out of alternatives, in the form either of dialogue or of a case followed by its refutation. Among these the 'White Horse' shows evidence of dislocation among the questions and answers of the dialogue; we shall follow a rearrangement adopted on purely textual grounds some time before the proposal of the present interpretation.[15]

The second obstacle is conceptual, the difficulty of finding an angle of approach from which the arguments will make sense. The difficulty shows up very plainly in the 'White Horse'; the arguments are clear, yet the first seems an obvious *non sequitur* (" 'Horse' is that by which we name the shape, 'white' is that by which we name the colour. To name the colour is not to name the shape. Therefore I say 'A white horse is not a horse'") and the rest seem to assume an elementary confusion of identity and class membership. As the understanding of Chinese argumentation progresses error on this scale becomes less and less credible. Fung Yu-lan tried to make the 'White Horse' thesis more interesting by taking it to deny the identity of the universals 'white horse' and 'horse'.[16] But there is no evidence of a Realist doctrine of universals in ancient China. Discussions

of the common name, in the *Canons* and *Hsün-tzu*, take what we would call Nominalism for granted;[17] and to credit them with conceiving universals without asking whether they recognised common names as problematic is as though one were to identify some piece of porcelain as a milk bottle, because of its shape, without asking whether the Chinese drink milk. More recent attempts to prove the arguments valid by translating them into symbolic logic I find equally unconvincing.[18]

Recently Chad Hansen has proposed a radical shift of viewpoint, as following from his questionable but important hypothesis that Chinese nouns resemble the mass nouns rather than the count nouns of Indo-European languages.[19] This would mean that *ma* 馬 'horse' functions like the English mass noun 'sand', and different *ma'* will be conceived as like scattered grains of sand; the class/member relation becomes one kind of whole/part relation, distinguished from others by the similarity of parts. It is notable that the *Canons* use the same terms, *chien* 兼 'collection' and *t'i* 體 'unit', to cover both relations, with the latter defined as "a part in a *chien*."[20] Although I disagree with the detail of Hansen's interpretation, his shift of angle opens up a new perspective from which the previously unrelated fall into place. Without being committed to the mass-noun hypothesis, one is awakened to the recognition that Kung-sun Lung does present the white horse as a whole of which white and horse are parts. Of the other two essays of Kung-sun Lung, the 'Left and Right' is explicitly about whole and part. There are many rival interpretations of 'Pointings and Things', but the only one which takes account of its apparent organisation as argument followed by refutation already before Hansen's breakthrough took the theme to be the pointing out of part from whole.[21] This raises the possibility of a reading of the three essays with a common thread running through all. It has the further advantage that the question of whether one can make divisions without contradiction is a known preoccupation of the age, central to both Hui Shih and Chuang-tzu.*

In Chinese as in English it is common sense that 'horse' being more general than 'white horse' one is entitled to say 'A white horse is a horse'; to put it in a Western terminology, the relation affirmed is of class membership, not of identity. This obvious point is already made in a story of Kung-sun Lung being refuted by the simple common sense of a descendant of Confucius, K'ung Ch'uan. The Sophist had cited an instance of Confucius himself appearing to differentiate a 'man of Ch'u' from a 'man', to which K'ung Ch'uan answers:

* The present intepretation of the essays is developed at length in G *Studies* 193–215.

"Whenever we say 'man' we refer to men in general, just as whenever we say 'horse' we refer to horses in general. 'Ch'u' by itself is the state, 'white' by itself is the colour. If you wish to widen the 'man' in it you have to leave out the 'Ch'u', if you wish to specify the name of the colour you must not leave out the 'white'."†

But Kung-sun Lung's tactic is to by-pass class and member by imposing a different whole/part division. His style of argument was commonly described as 'separation of the *chien-pai* 堅白 .** The phrase *chien-pai* 'hard and white' was long misunderstood in the deceptive light of a forged chapter entitled 'Hard and White', which distinguishes in a stone the hardness known by touch from the whiteness known by sight. This implies an awareness of sense perception as problematic for which there is no firm evidence in China before the arrival of Buddhism. But it is plain from the *Canons* that *chien pai* was a technical term for mutual pervasives, a metaphorical extension from hardness and whiteness to cover such pairs as space and duration, length and breadth.[22] The *Canons* define it among the geometrical terms:

Canon A66: "*Chien-pai* is not excluding each other.

Explanation: Different positions do not fill each other. Not being each other is excluding each other."

The mutually pervasive shape and colour of the white horse is itself an example of the *chien-pai* which the Sophist separated. Thus Hsü Shen (fl. A.D. 100), commenting on a reference to 'separating the *chien-pai*', says

"Kung-sun Lung was a man of Chao who enjoyed hair-splitting and paradoxical talk. On the grounds that 'white' and 'horse' cannot be joined as one thing he separated them and deemed them two."[23]

Now if we separate the mutually pervasive white and horse in the white horse, then we have only to apply the principle that the whole is not one of its parts to infer that the white horse is not the horse which is one of its components. This principle appears in the *Canons* in the form 'Ox and horse are not horse'. It is criticised on the grounds that we have no more right to say '*x* and *y* are not *y*' than '*x* and *y* are *y*'; if *y* being non-*x* makes the pair non-*x* then *x* being *x* would make the pair *x*; what should be said is '*x* and *y* are non-*x* and non-*y*'.

Canon B 67: "There are the same grounds for denying that ox and horse

† *K'ung-ts'ung-tzu* v. 1, 75B–76A. For evidence that this compilation of the 3rd century A.D. is here reproducing an older source, cf. G *Studies* 179 n18.

** For *chien-pai*, cf. G *Logic* 170–176.

are not horse as for admitting it. Explained by: the combination [*chien*, the collection interpretable either as whole or as class]

Explanation: If it is admissible that one not being ox they are not ox, then one being ox although the other is not, it is admissible that they *are* ox. Therefore, if it is inadmissible to say either 'Ox and horse are not ox' or 'Ox and horse are ox', then, it being admissible of one but not the other, it is likewise inadmissible to say ' "Ox and horse are ox" is inadmissible.'

Moreover, if neither ox nor horse is two, but ox and horse are two, then, without ox being non-ox or horse being non-horse, there is no difficulty about 'Ox and horse are non-ox and non-horse'."

This meticulous criticism of '*x* and *y* are not *y*' would be pointless unless the principle was being used in analysing controversial issues. It can be seen that it would make an ideal weapon for Kung-sun Lung. If he perceives that it has nothing to do with the physical separability of oxen and horses he can astonish his audience by extending it to the mutually pervasive, 'separating the *chien-pai*' by proving that since hardness and whiteness are not hardness, and shape and colour are not shape, the shape horse combined with the colour white are not a horse.

Since the genuine remains of Kung-sun Lung are so sparse, we shall do him the honour of translating them complete.

The 'White Horse'

We mark the order of the questions and answers (Q,A) in the extant text by numbers, in the present rearrangement by letters.

(A-D/1–4) Q. "Is it admissible that a white horse is not a horse?

A. It is admissible.

Q. Why?

A. 'Horse' is that by which we name the shape, 'white' is that by which we name the colour. To name the colour is not to name the shape. Therefore I say, 'A white horse is not a horse'."

If we are thinking of the white horse as a member of the class of horses this is a *non-sequitur*; all that is proved is that the colour white is not a horse. But it is valid for Kung-sun Lung because he is confining the name 'horse' to one of the two parts of the whole 'white horse'. The grounds for claiming that ox and horse are not ox was, as we learn from the *Canon*, that "one not being ox they are not ox". On the same lines he has only to show that one member of the combination 'white horse' is not a horse, and his case is proved. If we allow him to make his rather dubious analysis of the

white horse into two mutually pervasive parts, and confine the name 'horse' to one of them, what could be plainer than that the white horse is not the part of it so named?

He is playing a trick on us of course. In ordinary Chinese discourse a thing is described as 'having shape and colour' (both conceived as inside it), not as being the shape, with the colour outside it. But there is an asymmetry which disguises this sleight-of-hand. The 'Five colours' are fully enumerable, green, red, yellow, white, black; but shapes are innumerable, with square and round commonly taken as representative. How does one describe the shape of a horse except as like a horse? One can imagine an alert objector stopping Kung-sun Lung in his tracks right at the start: 'Inadmissible. What names the shape is not 'horse' but 'like a horse'.' He misses the opportunity, and from now on the Sophist is in full command.

On Kung-sun Lung's analysis to say 'A white horse is a horse' is like taking literally the English synechdoche 'my trusty blade' for 'sword' and saying 'A sword is a blade'. To test our interpretation let us from now on compare the argument stage by stage with a parallel demonstration that 'A sword is not a blade', in which the word 'sword' is everywhere substitutable by 'hilt and blade'. The objector is obstinately clinging to the misunderstanding that one is denying that sword-blades are blades, taking the proposition as analogous to 'A sword is not a weapon'.

Analogue A-D. Q. Is it admissible that a sword is not a blade? A. Yes. Q. Why? A. The blade is the steel, the hilt is the handle. The handle is not the steel. So the sword is not the blade.

From the second exchange onwards it is plain that the objector, like K'ung Ch'uan and like ourselves, does understand the sophism as excluding white horses from horses; the common sense interpretation is the same in Chinese as in English, Kung-sun Lung is attacking from an angle as unfamiliar to his contemporaries as to us. The difficulty is to find anything wrong with his logic once one has let his initial definitions pass. The objector's first reaction is that if no coloured horses were horses there would be no horses in the world, overlooking the point that if the horse is the shape every combination of horse and colour includes a horse.

(EF/7,8) Q. "You deem a horse which has colour not a horse. It is not the case that the world has colourless horses; is it admissible that the world has no horses?

A. Certainly horses have colour, which is why one has white horses; supposing that horses were colourless, and one had only simple horses, how would one select a white horse? Therefore the white is not the horse.

A white horse is horse and white combined; horse and white horse. (Commentator's paraphrase of the mutilated passage: "*White and horse* are two things. When we bring together the two things as a common body, one may not one-sidedly call them '*horse*' "). Therefore I say, 'A white horse is not a horse'."

The Sophist has turned the objection neatly round. That the uncompounded horses which do not exist would be colourless proves that the colour is added to the horse, and puts us back where we started; the whole which is horse and colour is not the part which is horse. If we are right in identifying a lacuna fillable from the anonymous old commentary (probably from the 7th century A.D.*), the Sophist concludes by saying explicitly that you cannot call the combination after one of its parts.

Analogue EF. Q. Then you deem a blade with handle not a blade. There are no blades without handles in use; are there then no blades in use? A. Of course blades have handles, otherwise there would be no swords. Supposing blades had no handles and were simply blades, where would you find a sword? You have only confirmed that the hilt is not the blade. The sword is the hilt and the blade. (?You cannot one-sidedly use 'blade' for both hilt and blade?). So a sword is not a blade.

In dividing shape from colour Kung-sun Lung invites the accusation that he is abolishing the link between them; 'white horse' does not add to all horses all the white of horses, snow and jade as 'ox and horse' adds all oxen to all horses, it is a *chien pai* combination referring only to what is both white and a horse. This is the objector's next point.

(GH/9,14) Q. "If horse not yet combined with white is deemed horse, and white not yet combined with horse is deemed white, and you put horse and white together under the compound name 'white horse', this is applying the same name to them combined as uncombined, which is inadmissible. Therefore I say, 'It is inadmissible that a white horse is not a horse.'

A. 'White' does not fix anything as white; that may be left out of account. 'White horse' mentions the white fixing something as white; what fixes something as white is not the white. 'Horse' selects or excludes none of the colours, therefore one may answer it with either a yellow or a black. 'White horse' selects some colour and excludes others, and the yellow and the black are both excluded on grounds of colour; therefore one may answer to it only with a white horse. To exclude none is not to exclude some. Therefore I say 'A white horse is not a horse'."

* Cf. G *Studies* 152–155 for the date of the commentary.

The Sophist is as well aware as the objector that a white horse, unlike ox and horse, is a combination of mutually pervasive parts. The weapon which has armed him for his startling 'separation of the *chien-pai*' is the perception that the principle 'x and y are not y' applies just as well to the mutually pervasive as to ox and horse. A white horse differs from a patch of white and a horse in that on the one hand it fixes what is white, on the other excludes horses of any other colour. Yet it remains the case that what excludes no colour ('horse') is not what excludes some colours ('white horse'). This is the first of the places where, if we assume the issue to be membership of the class of horses, he seems to be proving only that not all horses are white horses, confusing identity and class membership. But if he is thinking in terms of whole and part the reversal makes no difference, since the part is no more the whole than the whole is the part. One sees also that he is not, as K'ung Ch'uan supposed, missing the point that 'horse' is more general than 'white horse'; he has re-interpreted it as the liberty of horse to combine with other colours besides white.

Analogue GH. Q. If blades not yet joined to hilts are deemed blades, and hilts not yet joined to blades are deemed hilts, and you use the name 'swords' for all hilts and all blades together, this is applying the same name to them combined or uncombined, which is inadmissible. A. 'Hilt' does not specify what is hilted, 'sword' does; 'blade' does not exclude any handle, 'sword' excludes all but hilts. So the blade which does not exclude is not the sword which does. So the sword is not the blade.

The objector now points out that it is not simply, as the Sophist implies, that wherever there is a white horse there is a horse inside it; having a white horse is 'called' or 'deemed' having a horse. It is above all in this sequence that on a class/member analysis Kung-sun Lung seems to be confusing class membership with identity.

(I J/5,6) Q. "Having a white horse cannot be called 'lacking a horse'. What cannot be called 'lacking a horse' is having a horse. If having a white horse is deemed having a horse, why if judged to be white is it not a horse?

A. Someone who seeks a horse will be just as satisfied with a yellow or a black horse; someone who seeks a white horse will not be satisfied with a yellow or a black horse. Supposing that a white horse were after all a horse, what they seek would be one and the same; that what they seek would be one and the same is because the white would not be different from the horse. If what they seek is not different, why is it that such horses as the yellow and the black are admissible in the former case but not in the latter? Admissible and inadmissible are plainly contradictory. Therefore that a yellow and a black horse are one and the same in that they may

answer to 'having a horse' but not to 'having a white horse' is conclusive proof that a white horse is not a horse."

Here the Sophist arrives at his clinching proof, and instead of repeating his formulaic "Therefore I say 'A white horse is not a horse'," declares his case finally proved. Plain as it is that white horses are not the horses which are parts of themselves, it is plainer still that they are not the horses which combine with other colours. If we misread him in terms of class and member, it will seem on the contrary that he is sinking ever deeper into his confusion of identity and class membership. This misunderstanding results from treating the thesis he attacks as analogous, not with 'A sword is a blade' but with 'A sword is a weapon', which puts the sword inside the class of weapons, so that to object to it that spears are also weapons would be an elementary mistake. 'A sword is a blade' on the other hand puts the sword inside its own blade, excluding the hilt but filling the blade, therefore identical with it. To object to it that sword and blade cannot be identical because blades with other handles than hilts are not swords would be fully valid. If someone insists that a sword is a blade one could only suppose that he makes no distinction between hilt and blade; similarly on the Sophist's analysis if a white horse were a horse "the white would not be different from the horse."

Analogue I J. Q. Having a sword is not describable as lacking a blade, therefore is having a blade. Why then if it is hilted isn't it a blade? A. If you ask for a blade any kind of handle will do, but not if you ask for a sword. Supposing that the sword were the blade you would be asking for the same thing in both cases, because there would be no difference between hilt and blade.

The objector now protests that he is not claiming that there is no difference between the colour white and a horse. 'Having a white horse' is reduced to 'having a horse' by deleting the 'white' while continuing to refer to the same horse.

(K-N/13, 10–12) Q. "In 'having a white horse cannot be called "lacking a horse"', the point is that one separates off the white. Without separating off the white, having a white horse could not be called 'having a horse'. Therefore the reason why it is deemed having a horse is the horse alone, it is not having a white horse which is deemed having a horse. Therefore its being deemed having a horse (? ?); it cannot refer to any horse.

A. If you deem having a white horse having a horse, is it admissible to say that having a horse is to be deemed having a yellow horse?

Q. Inadmissible.

A. To deem having a horse different from having a yellow horse is to

differentiate a yellow horse from a horse. To differentiate a yellow horse from a horse is to deem a yellow horse not a horse. To deem a yellow horse not a horse, yet in the case of a white horse deem it having a horse, this is 'Flying things go underwater, inner and outer coffins are in different places', it is the world's worst fallacy and inconsistency."

The objector's deletion of 'white', like K'ung Ch'uan's, would be to the point if the issue were the generality of names. But Kung-sun Lung attacks from a direction to which the objector never orientates himself. As he has posed the issue, if omitting the colours of white horse and yellow horse is enough to show the identity of each with the horse which is part of it, then since the part is common to both they are identical with each other.

Analogue K-N. Q. In 'having a sword is having a blade' one separates off the hilt from the sword. The reason why it is deemed having a blade is the blade only, not the whole sword, but also not any blade. A. Is having a blade to be deemed having a scythe? Q. No. A. To deem having a blade different from having a scythe is to differentiate a scythe from a blade, so a scythe is not a blade. To admit of a scythe what you deny of a sword is the worst kind of inconsistency."

On this analysis the 'White Horse' is a relentlessly logical working out of the implications of its suspect premises. Once tricked by the initial analysis into accepting 'horse' as the name of the shape, with the colour outside it, the objector is trapped in an aberrant description of the white horse which fits it consistently but implies that it is not a horse. We may see the argument as an intellectual game to astonish and amuse the court of the Lord of P'ing-yüan. But it is a potentially instructive game; it shows, to those who notice that he has shifted the name 'horse' to the shape excluding the colour, that the move changes the logical implications yet allows an equally consistent description of the object. There could be a coherent description of the world in which only the shape of what we now call 'horse' is meant by 'horse', even one in which horses are called 'oxen' and oxen 'horses', and it would require no logical acrobatics to prove that what is commonly called a horse is not a horse. Chuang-tzu, who in spite of his mockery of logic had a subtler mind than the sensible K'ung Ch'uan, saw deeper than he did into the 'White Horse' argument, to judge by a fleeting reference to it: "Rather than use the horse to show a horse is not a horse, use what is not a horse."[24]

'Pointings and Things'

This brief essay has long fascinated logically minded readers, who have never reached agreement even on its theme. Most have started from

identifications of its crucial term *chih* 指 (noun, 'finger,' or verb 'point out') with some concept of Western philosophy (universal, quality, class, meaning) but failed to arrive at a logically consecutive or even a syntactically consistent reading. But any firm solution must start from the opposite direction, from its background in the literature of the time, which provides more evidence than has commonly been recognised.

(1) The verb *chih* 'point out' (nominalised, 'what is pointed out') is used of gesture, of discourse in general, but also specifically of the meaning of names, for example Hsün-tzu's "They instituted names to point out objects" and a Taoist's "These three, 'comprehensive', 'through-out', 'all', are different names for the same object, what they point out is one."[25]

(2) Several of the *Explanations* of the *Canons* (the nearest relatives of 'Pointings and Things' in the literature) fall into two parts, argument and refutation, with nothing to mark the changeover.[26] This essay, which falls into two parts, of which the first says "*chih* is not *chih*" and the second "it is not that *chih* is not *chih*", is surely of the same form. Recognition of this form forbids us to read the essay as a mere string of disconnected observations, and imposes the constraints necessary for testable interpretation.

(3) A few tantalising references in Taoist literature to a paradox of pointing suggest that it had something to do with pointing out part from whole. Chuang-tzu, mentioning it besides Kung-sun Lung's horse, concludes "Heaven and earth are the one *chih*, the myriad things are the one horse".[27] 'Below in the Empire' in *Chuang-tzu* mentions among the paradoxes of the Sophists "Pointing out one does not reach, reaching one does not detach,"[28] which reappears in Taoist phraseology among three ascribed to Kung-sun Lung in *Lieh-tzu* (c. A.D. 300), admittedly a late and unreliable authority:

"Having ideas, you don't fix it: having pointings-out, you don't reach it: having things you don't exhaust it."

A friend of Kung-sun Lung then gives brief explanations. "Without ideas, you fix the same in them: without pointings-out, you reach them all: what exhausts things there constantly is."*

Since the whole essay revolves round three concepts, world, things (of which "each has its own name") and *chih*, we shall take *chih* simply as 'point out, the pointed-out', and assume that the pointing out is always either of things or of world. The pointing out of world would have to be meaning it by the name 'world'. This involves a very suitable paradox;

* *Lieh-tzu* (ch. 4) 4/7A, reading 止 for 心 , a common corruption in the *Canons* (G Logic 460)

since one uses names to point out things from each other, how can 'world' function as a name? To say of 'comprehensive', 'throughout' and 'all' that "what they point out is one" already raises this poblem, and on the tongue of a Taoist may well be intentionally paradoxical.

The supreme test of this as of any other interpretation is whether it succeeds or fails in giving a logically consecutive reading of the essay.

> (*Thesis*) "When no thing is not the pointed-out, to point out is not to point it out.
>
> (*Argument*) Without pointing out of things from world, there is nothing by which to call things *not* the pointed-out. If the world itself is treated as the things, may they be called the pointed-out?
>
> That 'pointed-out' is something the world does not have in it, those 'things' the world does have in it.† It is inadmissible that what the world does have in it be deemed what it does not."

When the scope of meaning is extended to everything a paradox arises. The name 'world' does not point anything out, yet no thing is not what it points out. May one point out world by identifying it with the things one points out inside it? But that would violate the principle we observed behind the 'White Horse', that whole is not part nor part whole: "It is inadmissible that what the world does have in it [that is, its parts] be deemed what it does not." One might object that although the world is not any of its parts it is the sum of them all, and this will in due course turn out to be the answer in the refutation.

> (*Argument continued*) "There being no pointing out of world, the things may not be called the pointed-out,
> which is 'it not being to point it out,'
> which is 'no thing not being the pointed-out'.
> That there being no pointing out of world the things may not be called the pointed-out is there *not* being anything not the pointed-out,
> which is 'no *thing* not being the pointed-out',
> which is 'to point out not being to point it out'."

Here we mark the phrases referring back to the original thesis by inverted commas. The paradox throws one back and forth between three untenable

† The particle combination *yeh che* 也者 is a quotation device (G *Logic* 140f, 465), marking that '*chih*' and 'thing' refer as before, presumably as in the thesis itself. For other syntactic questions raised by the translation, cf. G *Logic* 457–468, G *Studies* 210–215.

positions: (1) the name 'world' does not point out anything: (2) it points out something which things are not: (3) it points *out* everything.

In the refutation Kung-sun Lung sorts out the problem by introducing the term *chien* 'collection' (used by the Later Mohists of whole or class in contrast with part or member) and a distinction between *pu wei* 不為 'is not deemed' and *fei* 非 'is not'. These enable him to clarify the point that although a thing is not deemed the world ('world' is not its name), it does not follow that things are not the world as parts of a whole.

> (*Refutation*) "There being no pointing out of world derives from each thing having its own name and not being deemed the pointed-out. When though not deemed the pointed-out we call them the pointed-out, we collect together the not deemed the pointed-out. It is inadmissible to take your step from having in it the not deemed the pointed-out to having nothing in it not deemed the pointed-out."

A thing is deemed an ox or horse, not the world; we apply the name 'world' to all of them added together. The proponent's error was to make the jump from no part being deemed the world (his "It is inadmissible that what world does have in it be deemed what it does not") to "No thing is not the pointed-out" understood as every part being deemed the world.

> (*Refutation continued*) "Moreover pointings-out are what world itself collects together. There being no pointing out of world is there undeniably being pointings-out of things, which is your
> 'there not being anything not the pointed-out, which is no *thing* not being the pointed-out'.
> It is not that to point out is not to point it out, it is pointing out combined with a thing which is not pointing it out."

By 'ox' and 'horse' we point things out from each other, by 'world' we aggregate all the pointings-out. This allows us to say of 'world' that "No thing is not the pointed-out," which is not equivalent to saying that each thing is deemed to be the world. It is the act of pointing combined with a specific thing which is not the pointing which extends over the whole world.

> (*Refutation concluded*) "Supposing that within world there were no pointing out of things, what would we have the opportunity to call *not* the pointed-out? If within the world there were no things, what would we have the opportunity to call the pointed-out? If there were pointing out of world but no pointing out of things, what would we have the opportunity to call *not* the pointed-out, call having in it no

thing not the pointed-out? Moreover if pointing out inherently and in itself is deemed not pointing it out, how is it that it depends on things in combination with which it is deemed pointing them out?"

Here Kung-sun Lung concludes by showing that to speak either of being or not being what is pointed out by 'world' always depends on pointing out things. His refutation shows that he was interested in resolving paradoxes as well as in startling people with them.

Left and Right

This dialogue, which is explicitly about part and whole, tries to pin down the difference between '1+1' and '2'. In the Chinese numerical system the figure 2 doubles the figure 1, horizontally as strokes in the graphs (——, 二), vertically as rods on the counting board.** Since the ones are said in the dialogue to be on left and right, Kung-sun Lung is evidently demonstrating his point visually, by placing counting rods apart and then combining them to make the figure 2. †† We can achieve the same effect by using the Roman numerals:

$$\text{I} \qquad\qquad \text{I}$$
$$\text{II}$$

(Thesis) "Is there I in II?
 —There is no I in II.
(Objection) Is the I over on the right in II?
 —No.
 Is the I over on the left in II?
 —No.
 If neither the I over on the left nor the I over on the right is in II, how is it that II is the one over on the left combined with the I over on the right?*
(Answer) Is it admissible that the I over on the right be called II?
 —Inadmissible.
 Is it admissible that the I over on the left be called II?
 —Inadmissible.

** For the counting rods used for calculation before the introduction of the abacus, cf. Needham v. 3, 5–9, 70–72.

†† I owe the observation about the relevance of counting rods for the 'Left and Right' to D. C. Lau.

* For the grounds for transposing this sentence from its isolated position at the end of the dialogue, cf. G *Studies* 195 n5.

Is it admissible that the I over on the right combined with the I over on the left be called II?

—Admissible.

—When the I over on the right has the other combined with it, may it be called altered?

—Admissible.

Altered from what?

—From being the I over on the right.

If it has altered from being the I over on the right, how can it be called the I over on the right? If it has not altered, how can it be called altered?"

The difference between the combined and the uncombined is the issue which Kung-sun Lung examined in the third exchange of the 'White Horse' in terms of 'white' and 'horse'.

6. THE DISCOVERY OF SUBJECTIVITY: SUNG HSING

Late in the 4th century B.C. we find in Mencius and Chuang-tzu a shift of attention inwards, to the heart, for ancient China the organ of thought and of approval and disapproval, and an explicit division of the inner and the outer man. We shall here consider two other early representatives of this tendency, Sung Hsing and the anonymous author of the *Nei yeh* 'Inward Training' in *Kuan-tzu*.

Sung Hsing and a colleague or disciple, Yin Wen, were members of the Chi-hsia Academy of scholars patronised by King Hsüan (319–301 B.C.) of Ch'i. They have left no writings,* but the 'Below in the Empire' chapter of *Chuang-tzu* presents them as the leaders of one of the five great trends in pre-Han thought. It mentions among their doctrines the Mohist-sounding 'Forbid aggression and disband troops', and describes their followers, distinguished by a cap called the 'Mount Hua', as travelling to preach throughout the Empire in the same devoted and self-sacrificing spirit as the Mohists. Hsün-tzu in his 'Rejecting the Twelve Philosophers' pairs Sung Hsing with Mo-tzu as "elevating the effective and useful, making much of thrift and blurring degrees and ranks".[1] Mencius met Sung Hsing travelling to dissuade the rulers of Ch'u and Ch'in from going to war, on the characteristically Mohist grounds that neither will benefit from it.[2]

* The extant book entitled *Yin Wen tzu* is from about A.D. 200, to judge by its affinity to the *Lao-tzu wei-chih li-lüeh* of Wang Pi (A.D. 226–249). Cf. Daor 1–39.

Mencius, who detested utilitarian calculations, complimented him on his good intentions but objected that he would only be encouraging rulers to think of advantage rather than of the benevolent and the right.

Where Sung Hsing differs from the Mohists is in a new prescription for achieving their reforms, the changing of the inner man by becoming aware of restricted viewpoints (*pie yu* 別宥 ： 囿 'separating pens'), the freeing of self-respect from the judgment of others, and recognition that man artificially inflates his few essential needs. Confucius and Mo-tzu understand 'conduct' (*hsing* 行) as social behaviour, Sung Hsing calls attention to 'the conduct which is the heart's' (*hsin chih hsing* 心之行). No doubt it was the failure of philosophers to convince rulers which led him to ask what it is inside a man which blinds him to the self-evidently right. 'Below in the Empire' names several doctrines specific to Sung Hsing and Yin Wen and tells us that they regarded them as the 'inside', the doctrines shared with the Mohists as the 'outside'.

"In dealing with the myriad things they took 'separating pens' as the start, they spoke of the heart's making room and called it 'the conduct which is the heart's', in order that we should be harmonious and happy together and that all within the four seas should be in tune. As for the 'essential desires' it was provision for these that they judged the most important. By 'To be insulted is not disgraceful' they helped the people not to quarrel, by 'Forbid aggression and disband troops' they helped the age to avoid war. . . . They regarded 'Forbid aggression and disband troops' as the outside, 'The essential desires are few and shallow' as the inside."[3]

Chuang-tzu, although no friend of moralists, respected Sung Hsing for his independence from social judgments and valuation of the inner over the outer.

"He refused to be encouraged though the whole world praised him, or deterred though the whole world blamed him, he was unwavering about the division between inner and outer, was discriminating in drawing the boundary between honour and disgrace—but then he soared no higher."[4]

That Sung Hsing should be criticised but respected by thinkers as far apart as Mencius and Chuang-tzu suggests that he played a major part in turning attention inward; it is a pity we have nothing in his own words to clarify his doctrines. We do have a story of Yin Wen defending 'To be insulted is not disgraceful' before King Min (300–284 B.C.) of Ch'i, but he limits himself to showing that refusing to fight when insulted is compatible with all the four points of conduct by which one is deemed to be a knight.[5] More informative are the criticisms of Sung Hsing by Hsün-tzu. He objects to 'To be insulted is not disgraceful' that to be insulted is

not morally disgraceful ('disgraceful in terms of *yi* 義 'right') but is socially disgraceful ('disgraceful in terms of *shih* 執 'social position'). Sung Hsing overlooks the two senses of both 'glory' and 'disgrace' in the usage established by the sage kings.

"These have two starting-points: there is moral glory and social glory, moral disgrace and social disgrace. Having well trained intentions and being ample in potency and act, clear in knowledge and thought, these are glories which emerge from within, it is these one calls 'moral glory'. Having honourable title and rank, with ample revenue or salary, as Emperor or lord of a state above or minister or noble below, these are glories which arrive from without, it is these one calls 'social glory'."[6]

Extending the same analysis to disgrace, Hsün-tzu decides that "the gentleman may have social but not moral disgrace, the small man social but not moral glory". Sung Hsing has no right to deny that even purely social disgrace is none the less a disgrace. Hsün-tzu also denies that the doctrine can put an end to private quarrels.

"Sung Hsing says: 'Being clear that to be insulted is not disgraceful will stop people fighting. Everyone thinks that being insulted is disgraceful, that is why they fight; if they know that it isn't, they will fight no longer.' To the answer 'Don't you think then it is essential to man to hate being insulted?', he says 'One hates it but is not disgraced by it.' In that case, I say to him, you will certainly not get the results you expect from this. Whenever men fight, the explanation is sure to be that they hate something, it is not basically that they find it disgraceful. If an actor or dwarf or favourite doesn't fight when sworn at, do you suppose it is because he knows that being insulted isn't disgraceful? He doesn't fight because he doesn't hate it. But if someone gets in through the drain and steals his pig, he'll chase him with drawn sword or spear at the risk of being killed or wounded. Do you suppose that's because he thinks the loss of a pig disgraceful? He doesn't shrink from a fight because he does hate it. Even if you think being insulted disgraceful, you don't fight unless you hate it; even if you do know it isn't, you are sure to fight if you do hate it."[7]

The interest of 'To be insulted is not disgraceful' is that it raises the issue of whether an individual's valuation of himself can be wholly independent of others' approval and disapproval; Sung Hsing and Chuang-tzu hold that it can and should be. The doctrine called 'Separating pens' is another sign of a shift of attention inwards, in this case to the motives behind a person's judgments. Each of us shuts himself off from a full view of things by his personal desires and dislikes, and can see everything in proportion only if he escapes from his enclosure. Later this

thought was to become commonplace; by the time of Hsün-tzu and the syncretist author of 'Below in the Empire' it was an established tactic to view rival thinkers as each confined to his little corner, blind to one's own comprehensive vision. The *Lü Spring and Autumn* has two chapters with the title 'Getting Rid of Pens', one of which uses Sung Hsing's term.

"Most listeners of the age are penned in somewhere, so when they listen they are sure to get things the wrong way round. There are many reasons for being penned in, but the crucial ones are sure to result from what a man is pleased with and what he dislikes. One gazing at the east wall does not see the west wall, one gazing southward does not notice the north, because attention has settled on something. There was a man who lost an axe, and suspected his neighbour's son. He watched the way he walked—he's stolen the axe. The way he looked—he's stolen the axe. The way he talked—he's stolen the axe. His gesture, posture, everything he did—he's stolen the axe. When digging in his own yard he found the axe. Afterwards when he saw his neighbour's son again, there was nothing in gesture or posture to suggest a man who steals axes. It was not that his neighbour's son had altered, it was himself that had altered. The alteration was from no other reason than being penned in somewhere."[8]

The examples in both chapters are all of prejudice distorting judgment. One of a father who, "penned in by love," thinks his ugly son handsome, has the comment: "Therefore only after you know when handsome is being seen as ugly and ugly as handsome are you able to know handsome from ugly."[9] This discrimination between the prejudices involved in different cases is presumably what is meant by 'separating pens'. Another story is of a man who runs off with gold in broad daylight.

"He was asked 'Why did you snatch somebody's gold in front of all these people?' He answered the magistrate 'I didn't see the people at all, I only saw the gold.' This is truly a fine example of being penned in by something. It is inherent in being penned in somewhere that you take daylight for dark, white for black, sage Yao for tyrant Chieh; the damage from being penned in is great indeed. Are not the rulers of ruined states all extreme cases of being penned in by something? Therefore whoever you may be it is necessary to separate pens before you will know."[10]

The *Lü Spring and Autumn* adds, perhaps reflecting the Yangist tendency of some of its chapters rather than the thought of Sung Hsing:

"If you separate pens you will be able to keep intact what you have from Heaven."

It is in the thought of Sung Hsing that we first meet a technical use of the noun *ch'ing* 情, with which we cope as best we can by phrasing with

the adjective 'essential'. In general usage the *ch'ing* of a situation or a thing is what confronts us as fact, irrespective of how we name, describe, or try to alter or disguise it.* In the technical sense as it first emerges in Sung Hsing, Chuang-tzu, Mencius and the Later Mohists, the *ch'ing* of *x* is that without which the name '*x*' would not fit it; the concept is close to the Aristotelian 'essence' except in being tied to naming, not to being. Since the copulative relationship in Classical Chinese is not marked by a verb like 'to be' used also of existence, indeed is not marked by a verb at all,[11] it is important to keep Chinese concepts as far as possible free from contamination by the Being of Western philosophy; I therefore prefer to use constructions with 'essential' rather than translate *ch'ing* directly by 'essence'.

By the 'essential desires' Sung Hsing understands those without which we would not be human. The term appears as title of one of the Yangist chapters in the *Lü Spring and Autumn*, which begins:

"When Heaven generated man it caused him to have hankerings and desires. Among desires there are the essential, for the essential there is measure. The sage cultivates measure in order to check the desires, and therefore acts only on the essential.

"Now the ear's desire for the five notes, the eye's for the five colours, the mouth's for the five flavours, are essential. These three noble and mean, worthy and unworthy, are as one in desiring, and even the sages Shen-nung and the Yellow Emperor are the same in this as tyrants Chieh and Chòu."[12]

Sung Hsing's 'The essential desires are few' assumes the same judgment that only the desires of the senses are essential to man, as may be seen from its refutation by Hsün-tzu.

"Sung Hsing says: 'The desires essential to man are few, yet everyone thinks the desires essential to himself are many, an error'. So he leads out his disciples, and makes his explanations subtler and illustrations clearer, with the intention of making people know the fewness of the essential desires. When you answer 'Do you suppose then that, of the essential to man, the eye does not desire all it can get of beauty, the ear of sounds, mouth of flavours, nose of scents, body of ease—do you suppose it is not essential to man to desire all he can get of these five?', he says 'Just these are man's essential desires.' I say: in that case your argument certainly does not hold. To suppose that the essential in man desires all it can get of these, yet it does not desire much, is comparable to thinking that it desires

* For the philosophical sense of *ch'ing*, cf. G Logic 179–182.

wealth and rank but not commodities, loves beauty but hates Hsi Shih [stock example of a beautiful woman]."[13]

The Kuan-tzu chapter, 'Inward Training'

Kuan-tzu is a miscellany of writings, most of them about statecraft and generally classified as Legalist, from between the 4th and the 2nd centuries B.C. It is named after Kuan Chung (died 645 B.C.), revered in Ch'i as its greatest chief minister. Its nucleus at least was probably written in Ch'i, where a variety of scholars were patronised and paid stipends in the 'Chi-hsia Academy'.[14] Four of the chapters describe meditative practice, 'The Lore of the Heart', in two parts (chs. 36,37), 'Exposing the Heart' (ch. 38) and 'Inward Training' (ch. 49). The last of these seems to be the oldest, from the 4th century B.C., and we shall ignore the rest. They have been claimed as the work of Sung Hsing and Yin Wen, but on very flimsy evidence*; we have no positive evidence that these thinkers were interested in meditation. But 'Inward Training', which is mostly in rhymed verse, is important as possibly the oldest 'mystical' text in China. Its practices may be seen as belonging, with the nurture of the 'flood-like *ch'i'* by Mencius, to an early phase before the breach between Confucianism and Taoism opened. There is no defiance of moral conventions as in *Chuang-tzu*, on the contrary it is assumed that the effect of contemplation is to make one a 'gentleman', in spontaneous accord with the benevolent, the right, and the ceremonial. It is interesting also in providing clear evidence that the meditation practiced privately and recommended to rulers as an arcanum of government descends directly from the trance of the professional shaman.

In the state and family cults of ancient China one sacrificed to a variety of spirits, of the dead and of the mountains and rivers, of which the higher were called *shen* 神 and the lower *kuei,* 鬼 , the words we have so far been translating 'gods' and 'ghosts'. The *Sayings of the States,* a collection of statesmen's speeches cognate with the *Tso Commentary,* has a description of the people who in ancient times were responsible for sacrifices to the *shen.*

"Their wisdom could compare what was due to those above and those below, their sagehood could illuminate them in the distance and expose them to full view, their eyesight could see them brightly lit, their hearing

* The proposal was made by Kuo Mo-jo, *Ch'ing-t'ung* 245–271. Cf. criticisms in G *Studies* 317, Rickett RK 157.

could discern their voices distinctly. Consequently the luminous *shen* descended on them, on men called shamans and women called sha-manesses."[15]

This has two points in common with the 'Inward Training', the brightening of the senses and the descent of the *shen*. But by this period the gods and ghosts, like Heaven itself, are in the direction of becoming depersonalised though still vaguely numinous forces of nature. One scarcely meets a named spirit in the philosophical literature. The word *shen* tends to be used as stative verb rather than noun, of mysterious power and intelligence radiating from a person or thing; as English equivalent we choose 'daimonic'. Man himself can aspire, not indeed to omniscience (since Chinese thinking does not deal in absolutes), but to that supremely lucid awareness which excites a shudder of numinous awe. Thus the sage in *Chuang-tzu* is the 'daimonic man', the divining stalks of the *Yi* are the 'daimonic things'.

In the 'Inward Training' the descent of the daimonic is understood in terms of *ch'i*, 氣 a word we shall leave untranslated. It was soon to be adapted to cosmology as the universal fluid, active as Yang and passive as Yin, out of which all things condense and into which they dissolve. But in its older sense, which remains the primary one, it is like such words in other cultures as Greek *pneuma* 'wind, air, breath'. It is the energetic fluid which vitalises the body, in particular as the breath, and which circulates outside us as the air. At its purest and most vital it is *ching* 精 , the 'quintessential', which above is perfectly luminous as the heavenly bodies, circulates in the atmosphere as the *kuei shen* (which at this depersonalising stage we translate 'the ghostly and daimonic'), and descends into man as his *shen* 'daimon', rendering him *shen ming* 神明 'daimonic and clear-seeing', so that he perceives the myriad things with perfect clarity.

> "In all things the quintessential
> Transforming becomes the living.
> Below it generates the Five Grains,
> Above becomes the constellated stars.
> Flowing between heaven and earth,
> Call it the ghostly and daimonic.
> Who stores it in the breast
> Call the sage." (*Kuan-tzu* 2/99 tr. RK 158, A)

The problem is to use the heart, the organ of thought, to guide the *ch'i* so that one is filled with the most quintessential, the body flourishes in good health to a ripe old age, and by the inward maturing of Potency one

spontaneously accords with the Way. The technique is moderation in diet, adjustment of posture and presumably controlled breathing. The purpose is to fix the heart by checking all disturbance by the passions.

> "In the anxious or sad, pleased or angry,
> The Way has nowhere to settle.
> Love and desire—still them.
> Folly and disorder—correct them.
> Don't pull it, don't push it,
> And good fortune of itself will come to stay.
> The Way of itself will come,
> To depend on and take counsel with.
> If you are still you grasp it,
> If you are restless lose it.
> The magical *ch'i* in the heart
> Now comes, now passes away,
> So small there's no smaller inside it,
> So great there's no greater outside it.
> The reason why we lose it
> Is injuring by restlessness.
> If the heart is capable of maintaining stillness,
> The Way of itself will be fixed." (2/104 tr. RK 168, N)

With the fixing of the heart the quintessential *ch'i*, which energises in the direction of the Way, pours in from the realm of the ghostly and daimonic outside.

> "With the heart fixed within,
> Sight is clear, hearing distinct,
> The four limbs are hard and firm,
> And can become an abode for the quintessential.
> The 'quintessential' is the quintessence of the *ch'i*.
> When the *ch'i* is on the Way it vitalises,
> When vitalised one imagines,
> When one imagines one knows,
> When one knows, one halts.
> The hearts of all are so shaped
> That if knowledge goes farther there is loss to life."
> (2/100 tr. RK 160, CD)

Contemplating with the heart perfectly fixed and the senses perfectly clear one grasps everything in its unity, in a knowing which in the poetic language of this text or in Taoism sometimes sounds like omniscience, but which in Western terms we may think of as an instantaneous synthesising

of all information as it comes. To push for further knowledge merely disturbs the synthesising flow.

> "Grasping the One, not letting it slip,
> He is able to lord it over the myriad things.
> The gentleman employs other things,
> Is not employed by other things.
> If you grasp the pattern of the One,
> An ordered heart resides within,
> Ordered words issue from the mouth,
> Ordered tasks are imposed on others.
> That done, the world will be in order." (2/101 tr. RK 161, D)

Although pre-Han philosophy knows nothing of a mind/body dichotomy, we find here the related thought that one orders and stabilises the heart as though by another heart inside it, which must not be allowed to die.

"When my heart is ordered the senses are ordered, when my heart is stabilised my senses are stabilised. What orders it is the heart, what stabilises it is the heart; it is the heart itself which is used to store the heart, inside the heart is another heart. That heart in the heart intends ahead of saying. Only after intending does it take shape, only after taking shape does it say, only after saying does it employ, only after employing is it ordered. Unordered it is necessarily disordered, and if disordered dies." (2/101, tr. RK 162f, G)

The quintessential *ch'i* if present ensures health and clears the passages through the nine orifices of the body, opening the senses for clear perception.

> "When the quintessential is present and of itself vitalises,
> The outside of you flourishes.
> Stored within as the fount and source,
> Flood-like it harmonises and calms.
> It constitutes the depths of the *ch'i*.
> If the depths do not dry up,
> The four limbs are firm.
> If the fount is not drained,
> The nine orifices allow clear passage.
> Then one is able to exhaust heaven and earth,
> And spread over the four seas." (2/102, tr. RK 163, H)

Mencius, as we shall see,[16] speaks similarly of the "flood-like *ch'i*," and his announcement that "The myriad things are all here at my disposal in myself" has a parallel here a few lines later.

"Concentrate the *ch'i*, be equal to the daimonic,
And all the myriad things will be present at your disposal."
(2/102, tr. RK 164, K)

This may well be the earliest Chinese interpretation of the experience of mystical oneness. In opening myself to the inflow from outside I become the quintessential which as the purest and most freely circulating *ch'i* pervades and unifies everything in the universe, and my insight into things meets no obstruction anywhere. We are repeatedly told that the quintessential and daimonic, and consequently the Way and one's Potency as well, come and go 'of themselves', and settle permanently only if the passions are stilled and the heart fixed. It is a spontaneous process to which we have to remove the obstacles.

"Hence this *ch'i*
Cannot be stayed by force,
But can be stabilised by Potency;
Cannot be called by the voice,
But one may go to meet it by intending as it comes.
By reverence hold it fast, don't let it go:
This call maturing of the Potency.
Potency being matured, knowledge issues,
And to the last one the myriad things are grasped."
(2/99, tr. RK 158, A)

At one point the quintessential as it settles is directly identified as a daimon (*shen* used nominally).

"There's a daimon of itself within one's person.
Now it goes, now it comes.
None is able to imagine it.
Lose it, there is sure to be disorder.
Grasp it, there is sure to be order.
If reverently you clean its abode,
The quintessential of itself will come."
(2/101 tr. RK 161f, F)

The shamanic origin of the exercise is plain. The point of it however is not to become a medium for the gods or for deceased ancestors. This is a programme for self-perfection, as usual addressed primarily to the ruler ("That done, the world will be in order"). Its purpose is to clarify senses and heart to a luminous awareness, on the assumption which we are noticing everywhere in pre-Han thought that in the perfect awareness of the sage spontaneous motivation will coincide with the Way. The exercise

by stilling personal desires opens the heart to be overwhelmed by spontaneous forces from outside the self. Does the sage now cease to be himself, become the daimon now settled in its abode? That perhaps would imply a too personal conception of the daimonic.

However, this is not yet Taoism, for the Way is still the practice of the familiar moral virtues.

> "The body not adjusted,
> The Potency will not come.
> The inward not stilled,
> The heart will not be ordered.
> Adjust the body, take care of the Potency,
> And the Benevolent from heaven, the Right from earth,
> Prodigally, of themselves will arrive.
> At the height of the daimonic and clear-seeing,
> In illumination! one knows the myriad things."
> (2/101, tr. RK 161, E)

Consequently, for 'Inward Training' as for Mencius, moral development is the recovery of the course proper to man's nature.

"Therefore to check anger nothing equals the *Songs*, to rid of cares nothing equals music, to regulate joy nothing equals ceremony, to maintain ceremony nothing equals reverence, to maintain reverence nothing equals stillness.

> If inwardly stilled and outwardly reverent
> You are able to recover your own nature,
> Nature will be fixed once for all."
> (2/103, tr. RK 166, M)

—From social to metaphysical crisis:

HEAVEN PARTS FROM MAN

The trends which we have so far considered may be seen as responses not to philosophical but to social crisis, Confucians from the old knightly class trying to renovate the old order, Mohists entering it from the crafts formulating a programme for the new, hermits disillusioned with politics experimenting with a social Utopia or developing a rationale for withdrawal to private life. Already however the sharpening of controversy has generated Sophists fascinated by logical puzzles, and Sung Hsing has been moved by the problems of converting rulers to attend to the inside of man.

Towards the end of the 4th century B.C. we begin to find ourselves in a quite different intellectual climate. The Confucians, who had seemed incapable of debating any issue more momentous than "Did Kuan Chung understand ceremony?", are now obsessed by the question whether human nature is morally good, or a mixture of good and bad, or neutral, or good in some but bad in others. The Mohists, who had been content to judge a heterogeneous mixture of moral and political issues by a utilitarian rule-of-thumb, are using the tools of the Sophists to build a utilitarian ethical system which will be logically impregnable. Chuang-tzu, who seems to have begun as a Yangist with the simple aim of protecting his own life, is seeking a view of man's place in the cosmos which will reconcile him to death. At the back of all three is a profound metaphysical doubt, as to whether Heaven is after all on the side of human morality. Mencius as a Confucian tries to dissolve it by confirming that the nature with which we have been generated by Heaven is indeed morally good; the Later Mohists escape it by shifting the justification of morality from appeal to Heaven's Intent to *a priori* demonstration; Chuang-tzu welcomes it, and throws away all conventional conceptions of the good for an ecstatic surrender to the spontaneity which irradiates us from Heaven.

· The dichotomy of Heaven and man is one of the constants of Chinese thought. Whatever is within the control of deliberate action derives from man, whatever comes from outside it derives from Heaven.

" 'What is it you call "Heaven", what is it you call "man"?'

'Oxen and horses having four feet one says is from Heaven, haltering horses' heads and piercing oxen's noses one says is from man.' "[1]

Except for the Mohists, who never introduce human nature into their discussions, and positively deny the existence of Destiny, the nature with which we are born and the uncontrollable events we encounter are by definition decreed for us by Heaven. The opening sentences of the *Doctrine of the Mean*, a Confucian treatise in the tradition of Mencius, spell out the implications for those who remain satisfied that Heaven is on the side of human morality.

"It is the decreed by Heaven which is called one's 'nature', it is the course in accord with one's nature which is called the 'Way', it is training in the Way which is called 'teaching'."[2]

What is it that precipitated the 4th-century B.C. split betwen Heaven and man, and by its consequences delayed the general acceptance of this formula so attractive to Confucians for a millenium-and-a-half, until the final victory of the Mencian theory of the goodness of human nature in the 12th century A.D.? We have so far met with human nature only as a Yangist concept. The Yangist doctrine of 'keeping one's nature intact', of nourishing life and avoiding all social responsibilities which could harm it, in order to last out one's natural term, was for Confucians the preaching of simple selfishness. Yet unquestionably Heaven has laid down a natural term for man, shorter than the tortoise's and longer than the mayfly's, and we accord with Heaven by taking care to complete it. The challenge is most provocative in the introductory sentences of the first Yangist chapter in the *Lü Spring and Autumn*, which lays down that the purpose of occupying the throne of the Empire is to use it for nourishing the life generated by Heaven, and pronounces that it is as the one best placed to nourish life that the Emperor is Son of Heaven.

"What first generates is Heaven, what by nourishing brings to wholeness is man. One able to nourish what Heaven generates and not interfere with it is called 'Son of Heaven'. Whatever the Son of Heaven does has for reason to keep what is from Heaven intact. This is why officials are established; the establishment of officials is to keep life intact. The deluded rulers of the present age multiply officials yet let them injure life, and so lose what one establishes them *for*."[3]

There is nothing selfish about using a throne to nourish the lives of all, but the more usual Yangist emphasis is on refusing to accept a throne at the least cost to one's own life. This too is no more than trying to fulfil the term decreed for you by Heaven. But if Heaven is on the side of the selfish Yang Chu, to what authority is a moralist to appeal?

That it was the Yangist challenge which raised the question of the goodness of human nature will be confirmed when we consider the first thinkers who discuss it, Shih Shih, Kao-tzu, Mencius; even Mencius conceives man's nature as the tendency, if he pays the same attention to the nurture of moral as of physical energies, to grow to moral goodness as to health and longevity. The Mohists took quite a different direction, but that they too were responding to the Yangists may be seen from the earliest of the Later Mohist treatises, the fragmentary *Expounding the Canons*. The fragment obscured by mutilation which immediately follows the title has two direct references to the issue:

"If on behalf of the criminal I declare that Heaven's Intent is the right alternative but it is his nature to be a criminal, I make it my song that Heaven's Intent is the wrong alternative. . . . The criminal will take selfishness as Heaven's Intent and what man judges wrong as right, and his nature will be incorrigible."[4]

After this introduction the Later Mohist corpus never again mentions either human nature or Heaven's Intent. Although the latter must have remained Mohist doctrine, it is implicitly recognised that it could no longer be appealed to in debate; the Mohist ethic has to be rebuilt on new foundations. *Expounding the Canons*, the *Canons* and their *Explanations* proceed to relate moral terms by a system of interlocking definitions starting from the undefined 'desire' and 'dislike', to show what, prior to all observation, "the sage desires and dislikes *beforehand* on behalf of men."[5]

Unlike Mencius and the Later Mohists, Chuang-tzu is not in the least worried by the discovery that accord with Heaven conflicts with man's morality. But that his thought too had its source in Yangism is strongly suggested by the story of Chuang-tzu and the strange magpie, which may well record his crisis of conversion.[6] In this story Chuang-tzu talks like a Yangist until he has the disillusioning insight that "it is inherent in things that they are ties to each other." But behind Chuang-tzu is another influence dividing Heaven from man, the practice of meditation. In the 'Inward Training' the stilling of passions and clarification of senses and heart leading to the coming and going of the daimon is assumed to orient one in the direction of the benevolent and the right. Mencius shares this assumption, which is in full accord with his own doctrine of natural goodness. It is supported by the experience that spontaneity in meditation leads rather to loss of self (Chuang-tzu's "The utmost man has no self") than to selfishness. There is some reason to think that Mencius identifies this with the *shu* 'likening-to-oneself' of Confucius, the putting of oneself in other people's places.[7] However, this spontaneity is also a liberation

from fixed standards. It is surrender to daimonic power from outside, which being independent of man is by definition from Heaven, and may collide with instead of confirming accepted morality. In such a conflict the spontaneous preference in heightened awareness carries with it a self-evident authority which is not merely a matter of subjective conviction. Given the underlying Chinese assumption that the good is what is spontaneously preferred by the wisest men, the implicit logic behind it may be tested by our quasi-syllogism.[8] For Chuang-tzu therefore it is not a matter of trying to justify moral conventions with or without the aid of Heaven; you take the side of Heaven against human selfishness and conventionality alike.

The metaphysical crisis marks a parting of the ways between rationalism, at its purest in Later Mohism, and anti-rationalism, first articulate in Chuang-tzu. It is only to be expected that the Mohists, committed to argumentation from the beginning, should refine their utilitarianism by the logical tools of the Sophists. The Later Mohist corpus is unique in the surviving literature in plainly recognising the *a priori*, using *hsien* 'beforehand' as a technical term and the image of an object behind a wall of which one knows only what is implied by its name; that it uses them without explaining them suggests however that they were already current in the usage of the Sophists. Chuang-tzu, in spite of a delight in playing at logic with his friend Hui Shih, is driven in the opposite direction by his identification of the influences from Heaven with the spontaneous in man, to be evoked by aphorism, poetry and parable. These however are the two extremes. The general development, from the controversy over human nature onwards, is towards unsystematised but tighter argument and increasing attention to definition. We can best illustrate this tendency from the definitions. The series of 75, followed by analyses of 12 ambiguous terms, which occupies most of the first half of the Mohist *Canons*, remains an unequalled achievement. But the Confucian Hsün-tzu begins his 'Correcting of Names' with a set of 14 interconnected definitions, and early in the Han, unfortunately too late to make the impact he deserved, Chia Yi (200–168 B.C.) defined in succession 56 Confucian moral terms, arranged in pairs and each provided with its opposite.[9] One notices that he uses the Mohist 'concern for everyone' to define *jen* 'benevolence', and that he locates it in the heart. The *yi* 'right' with which it contrasts is as usual defined in terms of the cognate *yi* 'fitting'.[10]

"The heart being concerned for every person is called 'benevolence'; the opposite is 'cruelty'.

"The conduct which is wholly fitting is called the 'right'; the opposite is the 'wanton'."

Remarkably, the fullest definitions of this central Confucian pair are by the Legalist Han Fei:

" 'Benevolence' refers to a man's wholehearted and joyful concern for other men, his delight in their good fortune and dislike of their misfortune. It is something which the living heart cannot check, it is not because he expects reward for it."

" 'Right' belongs to the service of minister to lord and inferior to superior, the degrees of father and son or noble and base, the dealings of friends and acquaintances, the portions of kin and stranger as insider and outsider. When minister serves lord and inferior cherishes superior, son serves father and base respects noble, friends and acquaintances help each other, and kinsman and stranger are treated as insider and outsider, each of these in the manner *fitting* to him, 'right' is said of the fittingness."[11]

Another unexpected sign of sophistication in definition crossing the boundaries between schools is that the Later Mohist interlocking of definitions affected even Taoists, whom one might have expected to dismiss it with "The name which can be named is not the constant name" from the opening sentence of *Lao-tzu*. A writer in *Chuang-tzu* offers a set of nine, deriving the basic Taoist terms 'Way' and 'Potency' from the undefined term 'the inevitable', what is outside man's control.[12]

1. FROM CONFUCIUS TO MENCIUS: MORALITY GROUNDED IN MAN'S NATURE AS GENERATED BY HEAVEN

Mencius like Confucius is known to us through a collection of sayings and dialogues mostly in no particular order, which have to be co-ordinated to reconstruct his thought. But *Mencius* differs from the *Analects* in that many discourses and dialogues pursue a thought at considerable length. The book is unusual among the early philosophical texts in raising no problems of authenticity; it is commonly accepted that the whole of it was put together by Mencius himself or his immediate disciples.

According to the biography in Ssu-ma Ch'ien's history,[1] Meng K'o (Meng-tzu, of which 'Mencius' is a Latinisation) was a man of Tsou, a tiny state adjoining Lu in the Shantung peninsula, close therefore to the centre of Confucianism. He studied in the school of Tzu-ssu, the grandson of

Confucius. In the book itself the datable events are his travels seeking interviews with the rulers of states, evidently towards the end of his life.[2] He visits King Hui (370–319 B.C.) of Liang, the state also called Wei, who mentions defeats of the state datable down to 323 B.C. The King, although advanced in years himself, addresses him as 'old man'. He meets also King Hui's successor King Hsiang (318–296 B.C.), then visits King Hsüan (319–301 B.C.) of Ch'i. It is this visit to Ch'i, ending soon after the state invaded Yen in 314 B.C., which especially deserves attention.

Since the time of Duke Huan (685–643 B.C.), the first ruler of a state to win recognition from the rest as overlord, Ch'i had been among the foremost in political and economic innovation as well as in patronising scholars. A large body of scholars honoured with titles, salaries, mansions, and freedom from official duties, met to debate under the Chi Gate of the capital. This institution, commonly called the 'Chi-hsia Academy' in English, was founded by King Wei (357–320 B.C.) and revived by the King Hsüan visited by Mencius. Mencius himself was actually made a titular minister in Ch'i,[3] an elevation which no other pre-Han Confucian is known to have equalled, but apparently no more than a sinecure.[4] The next great Confucian, Hsün-tzu, was a member of the academy under King Hsiang (284–265 B.C.). Ssu-ma Ch'ien lists a number of Chi-hsia thinkers of the time of King Hsüan who left writings; the only one of whom we have substantial fragments is Shen Tao, representative of one of the tendencies which came together in Han Fei as Legalism. He mentions Shen Tao and others as having studied 'Huang-Lao', the doctrine of the Yellow Emperor and Lao-tzu; this would be a retrospective judgment that their teaching resembled the early Han synthesis of Legalism and the Taoism of *Lao-tzu* which passed under that name in his own time. We have noticed[5] that the doctrine of the 'Inward Training', which would have come to look like Huang-Lao, both has affinities with Mencius and is likely to have come from the Chi-hsia circle.

In reading Mencius one is conscious of a climate of thought very different from that of Confucius nearly 200 years earlier. That absence of distinction between the inner and outer man which Fingarette admires in Confucius belongs to a stage already long past; the value of a man now derives from virtues definitely located within the heart. The greatest is still *jen*, but the word has narrowed and clarified in meaning. Confucius had inherited it as a word like English 'noble' covering everything distinctive of the man of breeding; seeking the unifying principle behind it he found pure benevolence, the disinterested concern for others, but for him this

was not yet the whole sense of the word. By the time of Mencius however *jen* is directly translatable by 'benevolence'. Another difference is that we no longer have the impression with Mencius that all moral concepts depend for their meaning on the context of ceremony. *Li* 'ceremony' is now the inward sense of good manners, and stands beside *jen* in a set of four cardinal virtues inside the heart, the benevolent and the right, ceremony and wisdom (*jen yi li chih* 仁義禮智). Ceremony was later to be pushed to the forefront again by Hsün-tzu, but no longer in the spirit of Confucius, now desacralised as a code of conventions imposed on resisting human nature as the only alternative to holding society together by force.

Government

The rulers whom Mencius visited on the grand tour towards the end of his life had, by assuming the title of 'king' (*wang* 王), formerly reserved for the Chou Emperor, implicitly staked their claim to establish by the conquest of their rivals the new dynasty which would reunify the world. The message by which Mencius hopes to convert them to Confucianism is that, although 'overlords' (*pa* 霸) such as Duke Huan of Ch'i (685–643 B.C.) and Duke Wen of Chin (636–628 B.C.) had won primacy among the states by force alone, kingship over all can be won only by winning the hearts of the people by benevolent government. Unlike Confucius, who sees the reform of government in terms of a judicious selection between the rituals of the Hsia, Shang, and Chou, Mencius wants political and economic measures. He tells King Hui of Liang:

"With territory no more than one hundred miles square it is possible to reign. If Your Majesty practises benevolent government towards the people, is sparing with punishments, reduces taxation, and makes ploughing deep and weeding prompt, and if the able-bodied use their leisure days training themselves to be filial, fraternal, loyal and trustworthy, in the service inside the family of their fathers and elder brothers and outside it of their elders and superiors, you could make them beat back with trimmed staves the hard armour and sharp weapons of Ch'in and Ch'u.

"Those others take away the people in the busy seasons, so that they cannot plough and weed to support their parents. Their parents freeze and starve; elder brother and younger, wife and child, are parted and scattered. Those others drive their own people to despair. If Your Majesty

goes forth to punish them, who will be a match for you? As the saying goes, 'No one is a match for the benevolent'. I beg Your Majesty not to doubt it." (*Mencius* 1A/5)

No doubt the practicality of his competitors, the Mohists, has something to do with his concern for planting every five-acre homestead with mulberry trees and not interfering with the breeding seasons of chickens, pigs, and dogs,[6] but he has an extreme aversion to their utilitarianism. It is essential that you do a thing because it is benevolent, because it is right, not like Mohists and Yangists on a calculation of benefit and harm. In the very first dialogue in the book Mencius, asked by King Hui "Would you have something with which to benefit my state?", answers:

"Why must Your Majesty say 'benefit'? I have only the benevolent and the right. If Your Majesty says 'How shall I benefit my state?' grandees will say 'How shall I benefit my family?', knights and commoners will say 'How shall I benefit myself?'. Superior and inferior will compete for benefit and the state will be in danger." (1A/1)

A reason for the military superiority of even a small state practising benevolent government is that the oppressed people of other states will go over to it. Mencius says, reporting his audience with King Hsiang:

"He asked abruptly 'How shall the world be settled?'

'It will be settled by unification' I answered. [Not, that is, by mere subordination to an overlord.]

'Who will be able to unify it?'

'Someone without a taste for killing people will be able to unify it.'

'Who will be able to give it to him?'

'No one in the world will not give it to him. Has Your Majesty noticed the rice shoots? If there is drought during the seventh and eighth months the shoots wither, if dense clouds gather in the sky and a torrent of rain falls the shoots suddenly revive. When that happens, who could stop it? There is as yet no shepherd of men in the world today who is without a taste for killing. Should there be one without a taste for killing, the people will crane their necks looking out for him. If that does happen, the people will go over to him as water tends downwards, in a torrent, who could stop it?' " (1A/6)

This expectation derives some substance from the mobility of populations at this period; rulers were in fact competing to attract knights with new ideas and skills to their courts—it is why some of them will even listen to a moralist like Mencius—and peasants to their still unopened lands. Mencius tells King Hsüan:

"If Your Majesty should now apply benevolence in the exercise of government, it will make the office-seekers throughout the world all wish to stand in your court, the farmers all wish to plough your virgin lands, the merchants all wish to store in your markets, the travellers all wish to go by your roads, and those throughout the world with a grievance against their rulers all wish to come and complain to Your Majesty. If that happens who could stop it?" (1A/7)

There is an implication of this policy of attracting popular support which Mencius develops with a boldness unparalleled in the literature. Although no democrat (he has no more conception than other Chinese thinkers of institutions to control the ruler, and is reactionary in defending the old manorial economy and the hereditary offices threatened by promotion from below),[7] he sees the support of the people as the source of legitimacy, and their defection as proof of unworthiness to rule. In principle of course the source of legitimate authority is the mandate of Heaven. But how do you know who it is that Heaven has appointed? He discusses the question in connexion with the story of Yao passing the throne to Shun instead of to his own son.

"'Is it the case that Yao gave the Empire to Shun?', said Wan Chang.

'No. The Emperor cannot give the Empire to another.'

'In that case when Shun possessed the Empire who had given it to him?'

'Heaven gave it to him.'

'When Heaven gave it to him, did it decree it in so many words?'

'No. Heaven does not speak, it simply reveals through deeds and affairs.'" (5A/5)

Mencius proceeds to split Heaven's acceptance of Shun into two acts, one specifically by Heaven, the other by the people.

"When he was put in charge of sacrifices the hundred gods delighted in them, which is Heaven accepting him. When he was put in charge of affairs the affairs were in order and the people satisfied with him, which is the people accepting him. Heaven gave it him, man gave it him; hence I say 'The Emperor cannot give the Empire to another.'" From this point Mencius drops all mention of the sacrifices and refers only to popular acceptance as proof of Heaven's mandate.

"The lords of fiefs throughout the Empire coming to pay homage went not to Yao's son but to Shun, litigants went not to Yao's son but to Shun, ballad singers eulogised not Yao's son but Shun. So they said 'It's Heaven'."

The discourse ends with a citation from one of the now lost *Documents*:

"Heaven looks through the eyes of our people, Heaven listens through the ears of our people." It is in the light of this dialogue that one sees the point of that claim of Mencius[8] that if a ruler ambitious to win the Empire distinguishes himself as merciful "no one in the world will not *give* it to him."

Another passage describes the ruler as receiving his throne from the people in the same way that a fief is received from himself.

"The people are to be valued most, the altars of the grain and the land next, the ruler least. Hence winning the favour of the common people you become Emperor, winning the favour of the Emperor you become lord of a fief, winning the favour of the lord of a fief you become a grandee. If the lord of a fief endangers the altars, replace him. If the victims being unblemished and the millet vessels clean you sacrifice at due times yet there is drought or flood, replace the altars." (7B/14. The altars of the grain and the land were the symbols of independence, the sacrifices ending only with the conquest of the state.)

As for replacing the Emperor himself, there were the precedents of the first two dynasties, overthrown by the sage kings T'ang and Wu, on the grounds that by misgovernment they had lost the mandate of Heaven. The Mohists had been cautious of touching this dangerous theme; even the Purist version of 'Conforming Upwards' leaves unsaid what the people are supposed to do if Heaven punishes them with natural calamities for conforming to the Emperor instead of to itself.[9] Mencius however is quite forthright when King Hsüan raises the issue, answering with a fine exercise in 'the correcting of names' (although he does not himself use this term).

" 'Is it the case that T'ang banished Chieh and King Wu smote Chòu?'
'According to the records, it is.'
'Is it admissible for a vassal to murder his lord?'
'One who robs benevolence you call a "robber", one who robs the right you call a "wrecker", and a man who robs and wrecks you call an "outlaw". I have heard that he punished the outlaw Chòu, I have not heard that he murdered his lord." (1B/8)

Mencius is not a defender of popular revolution; his position, which established itself permanently as Confucian orthodoxy, is that ministers should criticise boldly and resign on issues of principle while the people should make themselves felt only by the shifts of support towards or away from an occupant or contender for the throne which are the test of who has the mandate of Heaven. Ideally he thinks the tyrant should be removed by his own ministers, and among ministers by those of the old-fashioned

kind, those of his own blood. When asked by King Hsüan about ministers he insists on the distinction between ministers of the same and different surnames.

" 'I beg to ask', said the King, 'about ministers of royal blood.'

'When the ruler makes a serious mistake they admonish. If after repeated admonishments he still will not listen, they depose him.'

The King's face fell.

'Do not think it strange, Your Majesty. Your Majesty asked his servant a question, his servant dare not fail to answer directly.'

The king waited to recover his composure before asking about ministers with different surnames.

'When the ruler makes a mistake they admonish. If after repeated admonishments he still will not listen they retire.' " (5B/9)

The controversy with Kao-tzu over human nature

By the time of Mencius the problem of human nature had already assumed great importance in the Confucian school. Mencius himself is the first to claim that our nature is good, and no one yet dared the dangerous thought that it is bad, first proposed by Hsün-tzu in the next century; but three intermediate doctrines were already current. They are mentioned in a question to Mencius by a disciple.

"Kao-tzu says 'There is neither good nor bad in our nature.' Some say 'It is possible for our nature to become good, possible for it to become bad; this is why when Kings Wen and Wu arose the people inclined to good, when Kings Yu and Li arose the people inclined to crime.' Others say 'Our nature is good in some, bad in others; this is why even with sage Yao as ruler there was Hsiang, even with Ku-sou as father there was sage Shun, even with tyrant Chòu as elder brother's son, and ruler as well, there were Ch'i Viscount of Wei and Prince Pi-kan.' Now you say 'Our nature is good'; are all of them then wrong?" (6A/6)

This controversy belongs exclusively to the Confucian school, or at any rate to the professional teachers of traditional manners and morals, not all of whom necessarily recognised the authority of Confucius;[10] in the case of Kao-tzu, known to us only from *Mencius*, we have no clear information on this point. A historical sketch of the controversy by Wang Ch'ung (A.D. 27–c.100) provides information on several predecessors of Mencius whose works were still extant, all classed in the Han bibliography under the Confucian school. He credits them all with the third position, his own ('Our nature is good in some, bad in others'), but seems not to

distinguish it from the second ('It is possible for our nature to become good, possible for it to become bad.').

"Shih Shih, a man of Chou, thought that there is both good and bad in man's nature. If we pick out the good in man's nature and develop it by nurture the good grows, if we do the same to the bad in it the bad grows."[11]

Wang Ch'ung continues using the terminology of a later age (Yin and Yang, nature contrasted with passions).

"If we take this position, in what each of us nourishes in his nature there is both Yin and Yang, good and bad. On this theme Shih Shih wrote a piece 'Essay on Nourishing' (variant: 'Essay on Nourishing One's Nature'). Men such as Fu Tzu-chien, Ch'i-tiao K'ai and Kung-sun Ni also discussed the nature and passions, more or less in agreement with Shih Shih; all said there is both good and bad in our nature."

Here the descent from the Yangist principle of 'nourishing one's nature' is fully exposed. In order to reconcile it with morality the Confucian affirms that there are morally good tendencies in man to be nourished in the same way; but he fails to resolve the difficulty that bad tendencies have an equal claim to be inherent in our nature.

As for Kao-tzu's position that human nature is morally neutral, we find it, together with two others ascribed to him (that benevolence is internal but right external, and the cultivation of an 'unmoved heart'), in the first part of an essay in the *Kuan-tzu* miscellany entitled 'Admonitions'.* The *Kuan-tzu* collection is associated with Ch'i, and whether or not Kao-tzu himself came from Ch'i, his ideas were certainly well known there. This is attested by one of Mencius' discussions in Ch'i, in which both he and his interlocutors mention Kao-tzu.[12] It is in the same discussion that Mencius speaks of nourishing the *ch'i* in the manner of the 'Inward Training', which is also in *Kuan-tzu*.

We noticed[13] that the word *sheng* 'be born, live' and its derivative *hsing* 'nature' are distinguished graphically only by the 'heart' radical added to the latter. *Sheng* and *hsing* are used indifferently in such phrases as 'nourish life/nature' and 'injure life/nature', in which 'nature' refers to the natural term of life, so that which word is used makes no substantial difference. The practice of writing in the radical in any case developed only gradually. Later, Hsün-tzu was to distinguish by definitions two senses of *hsing*, as living process and its natural direction.[14] But neither the 'Admonitions' nor Kao-tzu as reported by Mencius show a clear awareness

* For the relation of the 'Admonitions' (*Kuan-tzu* ch. 26) to Kao-tzu, cf. G *Studies* 22–26, RG 376f

of the distinction, and the 'Admonitions' even leave us in doubt as to whether the word used is *sheng* or is *hsing* written without the radical.

"That which has no fixed direction but is rich in resources is life/nature."

"Appetising flavours, motion and rest, are the nourishment of life/nature. Liking and disliking, being pleased with and being angry, sadness and joy, are fluctuations of life/nature. Eyesight and hearing being plumb with the thing are powers of life/nature. Therefore the sage is moderate with appetising tastes and timely in motion and rest, guides and corrects the fluctuations of the Six *Ch'i*,[15] and forbids himself excesses with music and women. Crooked behaviour is absent from his members, erring words are not present in his mouth. Tranquilly to stabilise life/nature is sagehood. Benevolence issues from within, the right arises outside. He is benevolent, so refuses to employ the Empire for his own benefit, does the right so refuses to employ the Empire to make a name for himself."[16]

As with Shih Shih, the nourishing of life or nature is still conceived in Yangist terms, as care for health. One's nature "has no fixed direction but is rich in resources," and has to be guided by the benevolence within and the right which one acknowledges although it is external. Man's nature is conceived, not in contrast with the natures of other things, but as the life or nature he shares with them, in contrast with the morality peculiar to man. This is Mencius' target in one of his dialogues with Kao-tzu.

"Kao-tzu said: 'It is life *(sheng)* which is meant by "nature" *(hsing)*'.

'Is life meant by "nature"', said Mencius, 'as white is meant by "white"?'

'It is.'

'Is the white of white feathers like the white of white snow, the white of white snow like the white of white jade?'

'It is.'

'Then is the dog's nature like the ox's nature, the ox's nature like man's nature?' " (6A/3)

The dialogues with Kao-tzu proceed by a meticulous examination of analogies. Arthur Waley, writing in 1939, declared of Mencius: "As a controversialist he is nugatory. The whole discussion (Book VI) about whether Goodness and Duty are internal or external is a mass of irrelevant analogies, most of which could equally well be used to disprove what they are intended to prove."[17] That few scholars today would share Waley's scorn is a good illustration of our changed understanding of Chinese philosophy over the past half-century. D. C. Lau's paper in 1963 'On

Mencius' Use of the Method of Analogy in Argument' was a landmark as one of the first close analyses of ancient Chinese argumentation.[18] Times have changed also in that a philosophically-minded reader is no longer so likely to dismiss Mencius' reasoning simply as inference by analogy, understood as a loose and primitive way of thinking outside deductive logic. We are losing the faith, except in logic and mathematics, that a concept can be established by precise definitions which free the word from the analogies which guide its ordinary usage. Mencius uses analogy very much as we used the example of a sword to test whether Kung-sun Lung's 'White Horse' demonstration is coherent;[19] he refuses to accept as coherent Kao-tzu's claim that human nature has no tendency either to good or to bad unless it can be shown to be parallel with some fully comprehensible model.

In order to show that human nature can be conceived as morally neutral Kao-tzu first chooses the model of carved wood.

"Kao-tzu said 'Our nature is like the willow, the right is like cups and bowls. Making the benevolent and the right out of man's nature is like making cups and bowls out of the willow.'

'Are you able', said Mencius, by 'following the willow's nature to make cups and bowls out of it? Isn't it rather that to make cups and bowls out of it you have to violate the willow? If you violate the willow to make cups and bowls out of it, do you also violate man to make the benevolent and the right out of him? I suggest that if anything can lead the people of the world to think of the benevolent and the right as misfortunes it is this saying of yours.'" (6A/1)

The nature of a willow is to grow into a flourishing tree, and is violated when we chop and carve the wood into the shape which suits our purposes. Kao-tzu's analogy implies that human nature does have a direction of growth, and morality is against nature. But then Kao-tzu's own example tells against him; nature would be not neutral but bad. Neither for Kao-tzu nor for Mencius is this a thinkable possibility—what incentive would there be to moral behaviour?—although it was to become one with Hsün-tzu in the next century.

A static model, such as moulding clay, would not suit Kao-tzu's case any better; he needs a dynamic model which, in the words of the 'Admonitions', is "without fixed direction". He chooses the whirlpool.

"Kao-tzu said 'Our nature is like the whirlpool; if you open a channel for it in the east it flows eastward, if you open a channel for it in the west it flows westward. Man's nature has neither good nor bad allotted to it, just as water has neither east nor west allotted to it.'

'Granted water has neither east nor west allotted to it', said Mencius, 'does it have neither up nor down? Man's nature is good as water tends downwards. Nothing in man is not good, nothing in water does not tend downwards. Now water, if you make it jump by slapping it, can be made to rise above your forehead, or if you force it off course it can be made to settle on a mountain, but how would that be the nature of water? It is so from the situation in which it is placed. Although man can be made to become bad, his nature remains as it was." (6A/2)

Thus the dynamic model like the last implies that human nature tends in a direction which, if not good, will conflict with any good one tries to impose on it. Kao-tzu has failed to produce a model for a conception of human nature as morally neutral. Mencius does not in these exchanges let himself be put on the defensive by trying to prove that the direction is good rather than bad. After the exchange on "It is life which is meant by 'nature'," which we found it convenient to discuss first, he proceeds to attack another claim of Kao-tzu and the 'Admonitions', that the right is external although benevolence is internal. That benevolence, as a positive goodwill to others independent of rules, comes from inside a man, would be recognised as soon as the inside/outside distinction came to be drawn. Kao-tzu would not have to derive it from human nature; he might well ascribe it to the moral agent's control over the fluctuations of his natural likings and dislikes. On the other hand *yi* 'the right', which is what fits one's position as ruler or subject, father or son, elder or younger, would more easily be seen as external, inherent in the socially prescribed relations between persons. For Mencius, however, the right as much as the benevolent springs from within.

"Kao-tzu said 'Eating and sexuality are from our nature. Benevolence is internal not external, right is external not internal.'

'Why do you call benevolence internal but right external?', said Mencius.

'If someone is elderly and I treat him as elderly, it's not that I have the elderliness in myself. It is just as when something is white and I treat it as white; it's that I go by its whiteness there outside. That's why I call it external.'

'It is different from the case of whiteness. The whiteness of a white horse is no different from the whiteness of a white man. Would you say that the elderliness of an elderly horse is no different from the elderliness of an elderly man? Besides, are you saying that being elderly is right or that treating him as elderly is right?' " (6A/4)

For Kao-tzu the duty to defer to an elderly man is inseparable from his

elderliness, as external as the whiteness of a man or a horse. Mencius replies that since there is no such duty in the case of a horse, it cannot inhere in the elderliness common to man and horse. It goes not with being elderly but with treating as elderly. The exchange continues with a new example by Kao-tzu.

" 'My younger brother I love, a man of Ch'in's younger brother I do not love. This is explanation by relation to myself, therefore I call it internal. I treat as elder an elder who is a man of Ch'u, I also treat as elder an elder of my own family. This is explanation by relation to which is elder, therefore I call it external.'

'Relishing a man of Ch'in's roast is no different from relishing a roast of my own. There are such cases with all kinds of things. Is there then something external in relishing a roast?'. "

Kao-tzu's position here is that the test of whether something is internal or external is whether it varies with the relation of its object to oneself (for example, love depending on kinship) or with external differences. Mencius refutes this test by observing that many internal attitudes (for example, enjoyment of food) do not vary with the relation of their objects to oneself. The apparently irrelevant "Eating and sexuality are from our nature" at the start of this exchange was perhaps introduced to confirm that Kao-tzu recognised enjoyment of food as internal.

How the distinction is understood by both sides is slightly clearer in the next exchange, where the contrast is between "resides outside" and "derives from within". The inward attitude which for Mencius distinguishes right treatment of the elder from mere recognition of age is also specified; it is respect.

"Meng Chi-tzu asked Kung-tu-tzu, 'Why do you call right internal?'

'I put into effect my own respect, therefore call it internal.'

'If a neighbour is elder than your elder brother by a year, which do you respect more?'

'I respect my elder brother.'

'In serving wine which do you serve first?'

'I serve the neighbour first.'

'The one you respect more is the former, the one you treat as elder is the latter. It indeed resides outside, does not derive from within.'

Kung-tu-tzu couldn't answer, and told Mencius about it.

'Does he respect his uncle or his younger brother more?', said Mencius. 'He'll say "I respect my uncle." Say "If your younger brother is impersonator of an ancestor at a sacrifice, which will you respect more?" He'll say "I'll respect my younger brother". You say "What about the

respect for your uncle?" He'll say "It is because of the position my younger brother occupies." You say likewise "It is because of the position the neighbour occupies." Normal respect is for the elder brother, the temporary respect is for the neighbour.'

When Meng Chi-tzu heard this he said,

'Whether respecting uncle or younger brother I do respect. It indeed resides outside, does not derive from within.'

'On winter days', said Kung-tu-tzu, 'we drink hot water, on summer days cold. Then do eating and drinking too reside outside?' " (6A/5)

Mencius holds that the moral value of the fitting action towards a superior derives from the respect within the agent. The objection is raised that right treatment of an elder at a banquet depends on the age of the person and is independent of respect. Mencius replies that you do temporarily shift respect to the elder; it is parallel with cases in which respect even shifts from uncle to younger brother, so that it is not the age but the respect which matters. The objector answers that whether one respects uncle or younger brother itself depends on the external difference of whether or not the latter is in the position of honour. Mencius' disciple has the last word; whether one drinks hot water or cold likewise depends on the external difference between winter and summer, yet drinking plainly derives from the thirst within.

The question may be raised whether 'internal' in this debate means more than 'not outside the body'. The examples of the internal are benevolence, love, respect, enjoying roast meat, eating and drinking; all can be understood in behavioural terms. But however Kao-tzu may have thought about the matter, the theory of human nature which we shall now consider definitely locates the moral virtues in the heart.

The goodness of human nature

The problem of human nature well illustrates the point that however closely Western and Chinese philosophical concepts converge they are never quite the same. Here we may cite another interesting mistake of the truly great Arthur Waley, looking back at him with our superior wisdom half a century later.

"Again, Mencius insisted upon using common words in a way that was at variance with their ordinary and accepted meanings, or, in the case of words that had several accepted meanings, upon arbitrarily accepting one meaning and rejecting another. For example, *hsing* (nature) meant in ordinary parlance the qualities that a thing had to start with. Mencius

insisted on using the word *hsing* in a special sense that was quite at variance with its ordinary and accepted meaning. He meant by it the feelings of right and wrong, which according to him were inborn."[20]

If for Mencius *hsing* actually *means* "the feelings of right and wrong" we hardly need to look very closely at his case for its moral goodness. But he says explicitly that besides moral inclinations the desires of eye, ear, nose, mouth and body also belong to our nature.[21] As for *hsing* meaning in ordinary parlance "the qualities that a thing had to start with", that is no doubt what the English word 'nature' suggests, Latin *natura* deriving from *nascor* 'I am born'; and since *hsing* derives from *sheng* 'be born, live', it is easily accepted as an exact equivalent. It has been usual—I did it myself in early publications—to translate Kao-tzu's "It is *sheng* that is meant by '*hsing*'" as "It is inborn that is meant by 'nature'." And indeed Hsün-tzu in the next century does identify *hsing* with what we have from birth. But we have seen that in the ordinary parlance of the 4th century B.C., the *hsing* of an animate thing, in so far as it was distinguished from *sheng*, meant the course on which life completes its development if sufficiently nourished and not obstructed or injured from outside. Far from making the word mean whatever he likes, Mencius uses it precisely in the then-current sense, which is not quite that of English 'nature'. Not that one must abandon 'nature' and look for the *exact* equivalent. There are no exact equivalents; if we have translated many important Chinese words without discussion, it is only because the differences cannot be profitably explored within the limits of the present book.

That Mencius, like the Yangists, Shih Shih and the 'Admonitions', conceives *hsing* in terms of development requiring nurture and avoidance of interference may be seen from his frequent comparisons with plant growth, for example of the vegetation on Ox Mountain.[22] The most elegant and economical of his models of human nature is in a discourse apparently directed against the second of the rival theories, 'Our nature is good in some, bad in others.'

"Now barley, when we sow the seed and cover it over, if the soil is the same and the time of planting also the same, grows up with a rush and by harvest time is all ripe. Even if there are dissimilarities, these are because of the varying fertility of the soil, the nourishment by rain and dew, or inequalities in the work done by man. Therefore things of the same kind all resemble each other, why doubt it only in the case of man? The sage is of the same kind as ourselves." (6A/7)

There was even another word for 'the qualities that a thing had to start with', *ku* 故 , the 'original'. We find it contrasted with *hsing* in a *Chuang-tzu* story of Confucius questioning a skilful swimmer.

"Confucius said 'What do you mean by "I started from the original, grew up by nature, was matured by destiny"?'

'My ease on land, having been born on land, is original. My ease in water, having grown up in water, is nature. It being so of me without my knowing why is destiny.'"*

But Chinese *hsing* and Western nature do have an important similarity, reinforced on the Chinese side by the assumption that *hsing* is generated by Heaven; they seem to function both as descriptive and prescriptive concepts. Let us recall a Yangist formulation: "It is the nature of water to be clear; mud sullies it, therefore it fails to be clear. It is the nature of man to live long; other things disturb him, therefore he fails to live long."[23] *Hsing* is conceived as prescriptive, the course of *sheng* proper to a thing; even the clarity of water is evidently chosen as the *best* state of water. But the *hsing* of a thing is at the same time an observable fact about it, how it will be or become if there is no interference from outside. Yangists assumed we can establish man's *hsing* from observing how he develops when free from interference, and then appeal to it in defying current morality. We have the same apparent combination of factual and normative in the Western concept of nature, also a common weapon against traditional morality; we are usually ready to concede both that a man's nature is fact about him and that 'It is against my nature' is a strong reason not to perform an action. We need not consider the philosophical validity of the assumption.

Mencius' case for the goodness of human nature has to be assembled from separate discourses, some concentrated after the Kao-tzu dialogues, others scattered over the whole book. We may distinguish three steps in his argument.

Step 1: Moral inclinations belong to nature in the same way as the physical growth of the body. They germinate spontaneously without having to be learned or worked for, they can be nourished, injured, starved, they develop if properly tended but their growth cannot be forced. This is the most easily noticed part of Mencius' argument and perhaps the least original, since it is implicit in Shih Shih's thesis that there is good as well as bad in human nature, and we have no means of knowing how far he anticipated Mencius in his lost essay.

"The reason why I say that all men have a heart which feels for others is that supposing people see a child about to fall into a well they all have a heart which is shocked and sympathises. It is not for the sake of being on

* Cz. 19/53f tr. G 136. Mencius seems to make the same distinction in *Me* 4B/26 Cf. G *Studies* 49–53

good terms with the child's parents, it is not for the sake of winning praise from neighbours and friends, nor is it the case because they dislike the noise of it crying. Judging by this, without a heart which sympathises you are not a man, without a heart aware of shame you are not a man, without a heart which defers to others you are not a man, without a heart which approves and condemns you are not a man." (2A/6).

These four impulses are the 'emergent shoots' (*tuan* 端 , primarily shoots as they first appear above ground) of the four cardinal virtues recognised by Mencius. Mencius continues:

"A heart which sympathises is the emergent shoot of benevolence; which is aware of shame, of right; which defers to others, of ceremony; which approves and condemns, of wisdom. Men have these four shoots as they have four limbs; and since they have them, to claim to be unable is a crime against oneself, to say your ruler is unable is a crime against your ruler. If anyone having the four shoots in himself knows how to develop them to the full, it is like fire catching alight or a spring as it first bursts through. If able to develop them, he is adequate to protect all within the four seas; if unable, he is inadequate even to serve father and mother." (2A/6)

It is essential to Mencius' case that although moral education is indispensable it is, like the feeding of the body, the nourishing of spontaneous process. The process once launched accelerates, like fire catching, because we discover the pleasure of it. Just as the great cook Yi Ya identified the flavours which naturally appeal to our palates, so the sage's discovery of our moral nature was the discovery that "the patterned and the right please our hearts as fine meats please our mouths".[24] Mencius' definition of 'good' is "It is the desirable that is meant by the 'good'."[25] Of the enjoyment of the benevolent and the right he says

"If you enjoy they generate, if they generate how can they be stopped? At the question 'How can they be stopped?' without your noticing the feet are dancing to them, the hands are waving to them." (4A/27)

Mencius has another reason for regarding moral growth as spontaneous which takes us into deeper waters. He thinks of moral energy as belonging to the *ch'i*, the energetic fluids of the body and the atmosphere; man is morally as well as physically at his freshest after breathing the night and early morning air.[26] He speaks of the morally improving effects of nurturing his *ch'i* in a terminology shared with the 'Inward Training'. On a visit to Ch'i, after talking about the interaction of deliberate intent with the spontaneous energies of the *ch'i*, he is questioned about his own strong points.

"'I know how to speak, and I am good at nourishing my flood-like *ch'i'*.'

'May I ask what you mean by the "flood-like *ch'i*"?'

'A hard thing to speak of. It is the sort of *ch'i* which is utmost in vastness, utmost in firmness. If by uprightness you nourish it and do not interfere with it, it stuffs the space between heaven and earth. It is the sort of *ch'i* which matches the right with the Way; without these it starves. It is generated by accumulation of rightdoing, it is not that by sporadic rightdoing one makes a grab at it. If anything in conduct is dissatisfying to the heart it starves. That is why I say that Kao-tzu has never understood the right, because he thinks it external. There must be work for it, but do not adjust its course; do not let your heart forget it, but do not help it to grow.'" (2A/2)

Mencius continues with a story about a man of Sung who tugged at his riceshoots to help them to grow, instead of which they withered. The point immediately relevant to the goodness of human nature is the insight that moral growth can be hindered by trying to force it. But comparison with 'Inward Training' suggests that Mencius shares the experience of being drawn into the spontaneity of the most quintessential *ch'i*, finding all barriers to insight fall as it pervades all heaven and earth, and that he interprets the suspension of distinction between self and other as a moral selflessness. (We might compare also Hui Shih's last thesis, "Let concern spread over all the myriad things, heaven and earth count as one unit.") A Confucian would presumably understand the experience of universal oneness as in the first place oneness with other persons, the perfection of Confucius' *shu* 'likening to oneself'. It is interesting that Mencius' single reference to *shu* is in his most mystical-sounding saying, which unfortunately stands without context.

"The myriad things are all here at my disposal in myself. There is no greater joy than to look back into oneself and find integrity. There is nowhere nearer to seek benevolence than in action in which one persistently likens-to-oneself." (7A/4)

Step 2: So far nothing in Mencius' case is irreconcilable with Shih Shih's thesis that there is bad as well as good in human nature. It is up to Mencius to show that Shih Shih is wrong in finding bad inclinations in human nature, and we do find evidence that of all the earlier theories it is this one which Mencius takes as his main target. In the dialogue in which he is confronted with all three older theories[27] his reply is phrased in terms of the second, that 'it is possible for our nature to become good, possible

for it to become bad'. But at first sight it seems to weaken the claim that human nature is good to the point of making it indistinguishable from Shih Shih's doctrine.

"As far as the essential in him is concerned, it is possible to become good; this is what I mean by it being good. As for becoming bad, it is not the fault of the stuff he is made of. A heart which sympathises, all men have; a heart aware of shame, all men have; a heart which respects, all men have; a heart which approves and condemns, all men have. The heart sympathising is benevolence, the heart being aware of shame is the right, the heart respecting is ceremony, the heart approving and disapproving is wisdom. It is not that the benevolent and the right, ceremony and wisdom, are fused into us from outside; it is inherent in us to have them, it's simply that we no longer think about them." (6A/6)

The four virtues belong to man's *ch'ing* ('the essential'), that without which he would not be a man.[28] The affinity of *ch'ing* with Aristotelian essence may be seen by the reaffirmation in the case of each virtue that "all men have it," and still more clearly in a parallel we have already quoted, where the formula is "Without it you are not a man."[29] But granted that the four virtues are incipient in all, why does Mencius think that the mere possibility of becoming good implies that our nature is good and that the possibility of becoming bad is irrelevant? We have seen that for Yangists and others in the 4th century B.C. *hsing* is in the first place the natural term of life. Let us suppose that one is defending the Biblical estimate of threescore-and-ten against someone who refuses to go further than saying 'By nature men may live to 70, or die at 20, or be still-born.' One answers

'As far as the constitution of a normal man is concerned, he may live to 70; that is what I mean by 70 being his natural term. As for being still-born or dying at 20, it is not to be blamed on the capacities of the human constitution.'

There is a difference between the possibilities of living to 70 and of being still-born, and similarly between the possibilities of becoming good and becoming bad. The possibility of living to 70 and not very much longer is inherent in the human constitution, and is one of the characteristics which distinguish man from the tortoise and the mayfly. The possibility of dying early is common to all creatures, and is due not to their constitutions but to injury or undernourishment. Even if old men were as rare as saints and sages, we should still say that man's natural span is 70 if we believed that

(A) A man of normal constitution *may* live to 70 but not much longer;

without this possibility his constitution is not normal. (We should however disregard the possibility of further prolonging life by external means, by eating cinnabar or freezing in a block of ice).

(B) A man dies young, not from any cause in the human constitution, but from external causes or from his own neglect or over-indulgence.

Similarly, although men may become either good or bad, in terms of the current use of *hsing* Mencius has shown that man's nature is good if he has established the points we have seen him trying to establish:

(A) Anyone with the incipient moral impulses which belong to man's constitution *may* grow into a willingly and wholeheartedly benevolent man; without this possibility he would not be a man. (It would not be enough to claim only that he may learn to act rightly by submitting to standards imposed from outside).

(B) A man becomes bad, not because the incipient impulses are missing from his constitution, but because he neglects and starves them.

In order to find out the distinctive nature of a living thing one must discover the capacities which it realises if uninjured and sufficiently nourished. In the case of man these include his term of life and the moral perfection of the sage, and it is above all the latter which distinguishes him from other species. "The respect in which man differs from the beasts and birds is almost negligible; the common man loses it, the gentleman preserves it."[30] Here Mencius is representative of the whole Confucian tradition; even Hsün-tzu, who holds that our nature is bad, assumes that it is knowledge of *yi* 'the right' (not, as for Westerners, reason) which distinguishes the human species. Indeed the assumption is already implicit in the choice of *jen* 'human' as the major virtue.

Step 3: The second step does not quite dispose of the theory that there is bad as well as good in human nature. Granted that the moral inclinations belong to our nature and are what distinguishes us from animals, are not the appetites which conflict with them natural as well? It is sometimes held that Mencius eludes this difficulty by simply confining the scope of *hsing* to the exclusively human.[31] But he says explicitly that the physical appetites belong to our nature, although he thinks it morally healthy to reverse the habit of ascribing appetites to nature but representing morality as imposed on us by the decree of Heaven.

"The relation of mouth to tastes, eye to beauty, ear to sounds, four limbs to comfort, belongs to our nature; but some of the decreed for us is in them, and the gentleman does not choose to say 'nature'.

"The relation of benevolence to father and son, right to lord and

minister, ceremony to host and guest, wisdom to the man of worth, and of the sage to the Way of Heaven, belongs to the decreed; but some of our nature is in them, and the gentleman does not choose to say 'decree'" (7B/24)*

To understand Mencius' position we must again recall the underlying analogy with health and longevity. Free indulgence of the appetites endangers health, as the Yangist chapters of the *Lü Spring and Autumn* often remind us. Let us suppose that someone objects to saying that the natural term of human life is 70 on the grounds that the appetites are also natural, and therefore our nature has tendencies against as well as for longevity. We should answer that this does not imply a division in human nature; we simply have desires among which the desire for longevity conflicts with others only in the way that they conflict with each other. In order to live according to our nature it is therefore necessary to weigh desires against one another, judging between them according to whether they help or hinder us in realising our capacity for long life. Mencius gives an exactly parallel account of the conflict between appetite and morality. To say that goodness is natural is to say that we have moral inclinations which it pleases us to satisfy in the same way as the appetites, and which conflict with the appetites only as they conflict with one another. In making the stronger claim that human nature is good Mencius implies something more, that it is natural to prefer the moral to other inclinations.

He thinks this preference at least incipient in everyone. Implicitly he agrees with Mo-tzu[32] that for most people life is not quite the most important thing of all; there is some rock bottom of self-respect at which they prefer to sacrifice their lives for what they consider right. Mo-tzu's example was fighting to the death over an insult, Mencius' is starving rather than take food insultingly offered.

"Fish I desire, bear's paws too I desire; if I cannot get to have both, rather than fish I choose the bear's paws. Life I desire, the right too I desire; if I cannot get to have both, rather than life I choose the right. . . . Therefore there are things one desires more than life and things one hates more than death. Not only men of worth have a heart which thinks like this, all men have it; it is simply that the worthy are able to avoid losing it. One basket of food, one plate of soup, and if he gets it he will live, if he does not he will die, if you offer with a jibe even a tramp will not take, if you offer with a kick even a beggar will think it beneath him to accept." (6A/10)

In discussing choice Mencius uses the same model as the Yangists and

* Physical inclinations are also ascribed to man's nature in *Me* 6A/7.

Mohists, the sacrifice of possessions or parts of the body to preserve life. Our natural inclinations, physical and moral, belong to one whole, within which we prefer the major to the minor as we judge between members of the body. No appetite is bad in itself; gluttony, for example, is wrong only because it interferes with weightier concerns. Consequently it is not a matter of fighting the bad in our nature in order to promote the good; when we reject the minor for the major desire we accord with our nature as a whole, just as by defending the shoulder rather than a finger we protect the body as a whole. The Bad is Part of our nature

"A man's concern for his own body is for every part, and if concern is for every part nurture is of every part. If he is concerned for every foot and inch of his skin he nourishes every foot and inch of his skin. What better approach than this is there when we consider the question of the good or bad in it? [that is, in human nature]. Simply find an analogy for it in your own self. Among the members there are nobler and baser, major and minor; do not harm the major or nobler for the sake of the minor or baser. Whoever nourishes the minor in him becomes a small man, whoever nourishes the major in him becomes a great man. Take the case of a gardener; we should think him a poor gardener if he neglected his *wu* and *chia* trees to nourish his sour jujubes. It would take a madman to be ignorant enough to nurture one of his fingers at the cost of his shoulders and back. A man who likes to eat and drink is despised by other people because by nourishing the minor he loses the major; but if he isn't losing anything, isn't mouth or stomach something more than an inch or foot of the skin?" (6A/14)

"Kung-tu-tzu asked: 'Why is it that, although equally men, some become great men and some small?'

'Whoever goes by his major "members" becomes a great man,' said Mencius, 'whoever goes by his minor "members" becomes a small man.'

'Why is it that, although equally men, some go by their minor and some by their major?'

'Such an organ as ear or eye, since it does not think, is misled by other things. Being a thing in contact with a thing, it is simply pulled by it. As for that organ the heart, it does think; if we think we succeed, if we do not we fail. Among Heaven's gifts to us, if we first take our stand on the major, the minor will not be able to gain at their expense. This is all there is to becoming a great man.'" (6A/15)

Mencius holds that we can develop the full potentialities of the human constitution only if the heart is continually active, judging the relative importance of our various appetites and moral inclinations. To follow one's

nature is not a matter of surrendering to impulse, even to the most disinterested; unless we use the heart to think, the senses simply yield to the attraction of what excites them and withdraw attention from everything else. We notice again that general assumption of his tradition, that moral thinking starts when the senses are already responding to stimulation from outside, and that its function is to choose between reactions in the light of the fullest knowledge. The Yangists had likewise understood that a man can live out his natural term only if he consistently takes into account and judges between the beneficial and the harmful. For Mencius as for them, to know man's nature is to know the full potentialities of the human constitution, whether for length of life or for moral growth, and these potentialities can be realized only if the heart distinguishes between the nourishing and the harmful.

Two Confucian essays: the 'Great Learning' and the 'Doctrine of the Mean'

Among the many documents of the last centuries B.C. collected in the *Record of Ceremony* there are two, the 'Great Learning' and the 'Doctrine of the Mean', which assumed great importance in later Confucianism. Chu Hsi (A.D. 1130–1200) put them beside the *Analects* and *Mencius* as the 'Four Books' which contain the essence of Confucianism. Both are uncertainly dated in the 3rd or 2nd century B.C. Only the 'Doctrine of the Mean' plainly belongs to the Mencian branch of the school, but it is convenient to consider them together. We begin with the 'Great Learning' and its classic account of how the social order derives through the family from the self-cultivation of individuals.

"Those of old who wished to illumine luminous Potency to the world first ordered their own states, for which they first regulated their own families, for which they first cultivated their own persons, for which they first corrected their own hearts, for which they first integrated their own intentions, for which they first perfected their own knowledge. The perfecting of knowledge depends on arriving at the things.

"Only after the things have been arrived at is knowledge perfect, and only then is there integrity of intention, and only then are hearts correct, and only then are persons cultivated, and only then are families regulated, and only then are states in order, and only then is the Empire at peace."

The derivation of all social bonds from kinship which distinguishes Confucianism from Mohism is nowhere plainer than in the 'Great

Learning'. You extend to state and Empire the virtues learned inside the family.

"What is meant by 'to order the state you must first regulate your own family' is that no one whose own family remains unteachable is able to teach other men. Hence gentlemen even without going outside the family are making teaching complete throughout the state. Being filial as a son is the means to serve the ruler, being fraternal as a younger brother is the means to serve an elder, being compassionate as a father is the means to employ the multitude. The 'Proclamation to K'ang' says [of ruling] 'It is like protecting a baby'."

The secret of this outward extension from oneself is in Confucius' concept of *shu* 'likening to oneself'.

"Therefore the gentleman expects in others only what he has in himself, condemns in others only what he does not have in himself. There was never anyone who, without likening-to-oneself, could communicate to others what was stored in his own person."

"What you hate in the man above don't use in employing the man below, what you hate in the man below don't use in serving the man above. What you hate in the man in front don't use in going ahead of the man behind, what you hate in the man behind don't use in following after the man in front."

Cultivation of the person depends on correcting the heart, the organ of judgement, to prevent it being unbalanced in one direction or other by rage or fear, pleasure or anxiety. This in turn depends on 'integrating the intentions' (*ch'eng yi* 誠意), bringing them to integrity, a term which demands a closer look. *Yi* 'intention' is the word we shall be translating 'idea' in the Mohist *Canons*; it includes both the image or idea of a thing and the intention to act which is inseparable from it except in such abstract cases as the idea of the circle in Mohist geometry. *Ch'eng* 'integrity' derives from *ch'eng* 成 'become whole', used (in contrast with *sheng* 生 'be born') of the maturation of a specific thing. Graphically it is distinguished by the 'speech' radical, marking it as the wholeness or completeness of the person displayed in the authenticity of his words. We translate it 'integrity' (rather than the more popular equivalent 'sincerity') at the cost of some forcing of English; we use 'integrity, integral, integrate' to combine the two senses, wholeness and sincerity, which in English are drifting apart.

"What is meant by 'integrating one's intentions' is refusing to deceive oneself. To be as though hating a bad smell, as though loving a beautiful

sight, it is this that is meant by not being unfaithful to oneself. Therefore the gentleman is sure to be meticulous even in his solitude."

Integrity of intention depends in turn on perfection of knowledge, which itself depends on *ke wu* 格物 'arriving at the things' (often translated more loosely as 'investigation of things'). This phrase, not further elucidated in the essay, was to become a focus of controversy in Neo-Confucianism. What attracts attention is that the whole social order is conceived as depending on what seems to be an objective knowledge of things, 'arriving' at them as they are out there. This has often been understood as an anticipation of the scientific attitude which unfortunately failed to bear fruit. But the 'Great Learning' seems rather to be making explicit that derivation of all value from the value of knowledge itself which we have identified as one of the constants of Chinese thought. The right action which orders family and state is seen as following from integrity of intention, which depends on perfecting knowledge of oneself ('deceive oneself' is by the way the literal translation of *tzu ch'i* 自欺), knowledge of the things to which one is reacting, and knowledge of other people by *shu*, likening them to oneself and reacting from their standpoints.

'Doctrine of the mean' is the standard translation of the title *Chung yung* 中庸 , more literally 'The on centre and the usual', a term for moderation already used by Confucius.[33] Ssu-ma Ch'ien mentions the *Chung yung* as the work of Tzu-ssu, grandson of Confucius, in whose branch of the Confucian school Mencius studied.[34] This tradition is acceptable, if at all, only for the central part of the text, mostly in the form of sayings ascribed to Confucius. But the philosophical interest of the document is confined to a short introduction and long conclusion* which come from about 200 B.C.; they mention the standardisation of wheel gauges and of written characters which followed the Ch'in unification, and show affinities in thought with the appendices of the *Yi.†*

The introductory passage starts with three definitions.

"It is the decreed by Heaven which is meant by one's 'nature', it is the course in accord with one's nature which is meant by the 'Way', it is training in the Way which is meant by 'teaching'. That 'Way' is not to be parted from for a moment, what may be parted from is not the Way."

Although human nature is nowhere in the essay explicitly pro-

* The introduction and conclusion are the passages translated by Chan as p. 98 #1 and p. 106/-3 ("If those in inferior position. . . . ') to 113.

† For the composition and date of the 'Doctrine of the Mean', cf. Fung *History* v. 1, 369–371.

nounced good this is plainly the Mencian position. The Way, being in accord with one's nature, not simply with society, is required as much in private as in public; this essay, like the 'Great Learning', proceeds quickly to the point that "the gentleman is meticulous even in his solitude."

Since the Way is the following of man's nature it is the course, not only of sagely action, but of the spontaneous inclinations from which action starts.

"Pleasure in and anger against and sadness and joy not yet having issued is called being 'on centre'; all when they issue coinciding with measure is called 'harmony'. That 'centre' is the ultimate root of the world, that 'harmony' is the universal Way of the world. Make perfect the on centre and the harmonious, and heaven and earth will be seated in them and the myriad things nurtured by them."

Before the stirring of the passions one is on centre, not inclined in one direction or another, stationary at the root out of which the world grows; stirred to motion by the passions one is on the Way as long as they harmonise (ho 和, used primarily of the blending of different flavours to make a dish). To use a terminology first attested in Hsün-tzu,[35] man is 'roused by' (kan 感) and 'responds to' (ying 應) other things; the function of moral training is to ensure that the responses harmonise and coincide with the Way.

The long concluding passage of the 'Doctrine of the Mean' introduces the concept of integrity, even more important here than in the 'Great Learning'. It may be useful to place it in a scheme of corresponding terms.

sheng 生 'be born, generate'　　　hsing 性 'nature' (the tendency of generation)

ch'eng 成 'become whole, make whole'　　ch'eng 誠 'integrity' (wholeness as a person)

The pair on the left are verbs used as strictly parallel; a thing is first generated, then in course of maturation succeeds or fails in attaining the wholeness of the completed thing. The pair on the right departs from this symmetry; hsing is a noun, used of the natures of water or ox as well as man, while ch'eng is a nominalised verb used primarily of the human virtue of sincerity or integrity.

"Integrity is the Way of Heaven, integrating is the Way of man. The man who is integral is on centre without endeavour, succeeds without thinking, is effortlessly on the Way; he is the sage. The man who integrates is one who chooses the good and holds on to it firmly."

In the 'Doctrine of the Mean' the Mencian theory of the goodness of human nature is extended to a universal reconciliation of nature and morality on lines rather suggestive of Aristotelian teleology. Heaven generates the natures of things, by which, for example, each has its own natural term of life. Whether they exhaust their natures, attain to wholeness, live out their terms, remains open. Wholeness as a man is the integrity of the sage, who lives without effort according to the Way; the rest of us however have to make an effort to integrate ourselves. But man also helps other things to exhaust their natures. Heaven and earth require man as the third participant to complete their work.

"Only the world's most integral may be deemed capable of exhausting his own nature, in which case he is capable of exhausting other men's natures, in which case he is capable of exhausting other things' natures, in which case it is possible to assist the transforming and nurturing by heaven and earth, in which case it is possible to align as the third with Heaven and earth."

The 'Doctrine of the Mean' extends the use of integrity to cover the wholeness which distinguishes a thing from others, without which there would be no thing.

"Integrity is being spontaneously whole, the Way is the spontaneously on course. Integrity is the beginning and end of a thing; unless it is integral there is no thing. Therefore it is integrity that the gentleman most values. Integrity is not only spontaneously making oneself whole, it is the means of making other things whole. Making oneself whole is by humanity (jen), making other things whole is by knowledge. It is the Potency in our nature, it is the Way to join outer and inner."

Here it may be noticed that jen in narrowing to benevolence as the unifying principle of human goodness has not lost its relation to the word jen, 'human being'. Integrity is the Way by which inwardly I discover the benevolence which distinguishes me as human, and outwardly I know the distinctive wholeness of each thing and the nature which I can assist it in fulfilling.

When Mencius proclaimed the goodness of human nature he opened the way to the general solution of the problem of Heaven and Man as we find it in the 'Doctrine of the Mean' and also in the appendices of the Yi.

(1) Heaven decrees each thing's nature, what happens to it if it fulfils its nature, what happens to it if it does not.

(2) Heaven's Way consists of the courses proper to things, by which each can bring the capabilities of its nature to fruition.

(3) Man's sphere is to assist Heaven, by action which will nourish and

not injure the maturation of himself and other things according to their natures.

Thus the Way, without ceasing to be normative, becomes the single course along which a thing can in fact complete its development, as a tree can grow only if watered by the rain and the dew. One consequence of this scheme is an interaction between destiny and human action, my 'correct destiny' being what Heaven decrees for me if I do act rightly. To quote Mencius:

"Everything is destined; be reconciled to accepting your correct destiny. Therefore a man who understands destiny does not go on standing under a precarious wall. To die having exhausted the Way as it applies to him is the correct destiny, to die in fetters is not."[36]

2. FROM MO-TZU TO LATER MOHISM: MORALITY RE-GROUNDED IN RATIONAL UTILITY

The Later Mohist corpus stands out from the surviving literature not only for its logical sophistication, far in advance of the heavy-handed argumentation of early Mohism, but for its comprehensiveness, inquiring into not only problems of morals and government but logical puzzles, geometry, optics, mechanics, economics. It projects the vision of a universal knowledge organised in four disciplines, knowledge of names, of objects, of how to connect them, of how to act. The organisation of this corpus was long obscured by the state of the text, the problems of which scholars have been slowly disentangling over the past two centuries.* Its remains survive in six chapters of *Mo-tzu*:

Chs. 40, 41 *Canons* (*Ching* 經), A and B: the division into two chapters is arbitrary. The natural division is of definitions (A1–87) and propositions (A88–B82).

Chs. 42, 43 *Explanations of the Canons* (*Ching shuo* 經説). The *Canon* is regularly identified by quoting its first word as heading, a device unnoticed until the present century.†

Chs. 44, 45 The *Big Pick* (*Ta ch'ü* 大取) and the *Little Pick* (*Hsiao ch'ü*

* For the many problems of the corpus, and the evidence for the solutions assumed here, see my *Later Mohist Logic, Ethics and Science.*

† This discovery was made by Liang Ch'i-ch'ao (Liang 8ff) Cf. G *ut sup.* 95.

小取), longer and shorter collections of fragments of two documents including their titles, *Expounding the Canons* (*Yü ching* 語經) and *Names and Objects* (*Ming shih* 名實). The titles are taken from the opening words and are unrelated to the content (as in the *Analects* and much of *Chuang-tzu*).

The documents when sorted out turn out to have been written in three stages.

(1) *Expounding the Canons*, thirteen ethical propositions with accompanying explanations. The 'canons' of the title seems to be the original ten doctrines of Mo-tzu. There was also a lost document containing definitions of words in the essay titles formulating the ten doctrines; its existence is inferred from the conspicuous absence of these crucially important terms among the 75 definitions of the *Canons*.[1]

(2) The *Canons* and *Explanations*, which with the older *Expounding the Canons* compose a single manual of Mohist disputation, in the form of annotated definitions and propositions. The *Explanations*, which are notes or comments rather than detailed expositions, are sometimes missing and vary greatly in length and comprehensiveness; they were probably jotted down from teachers' oral explanations of *Canons*. The *Canons* themselves would be learned by heart.

(3) *Names and Objects*, a fragmentary but continuous treatise written after the completion of the manual.

The documents are datable only as from some time between the late 4th and late 3rd centuries B.C. The purpose of the manual is the clarification of the basic concepts of the four branches of knowledge, but a number of the *Explanations* include logical or scientific demonstrations of some length, and examination of the definitions and propositions shows that many of them are designed to interrelate logically. Both definitions and propositions fall into groups which run parallel throughout the two series, implying an organising principle which must be identified if the items are to be read in context. The key to it may be found in a *Canon* distinguishing three sources and four kinds of knowledge.

A80 *(Canon)* "*Knowledge.* By report, by explanation, by experience. Of the name, of the object, of how to connect them, of how to act.

(Explanation) Having received it at second hand, 'by report'. That if square it will not rotate, 'by explanation'. Having been a witness oneself, 'by experience'.

Of what it is called by, 'of the name'. Of what is so called, 'of the object'. Of the mating of name and object, 'of how to connect them'. Of intent and performance, 'of how to act'."

There is a related classification of four sources of doubt in *Canon* B10; we shall examine them in turn when dealing with the four branches of knowledge separately. Both sets correlate with the themes of the successive groups of *Canons*.

Theme	Definitions	Propositions	Knowing	Doubt due to
Discourse	A1–6	A88–B12	how to connect name to object	the accidental
Ethics	A7–39	(Expounding the Canons)	how to act	the undemanding
Knowledge and change	A40–51	B13–16	—	having passed
Geometry, optics, mechanics	A52–69	B17–31	objects	the coinciding
Argumentation	A70–75	B32–82	names	—

(A76–87 Appendix to definitions; 12 words with ambiguous usages).

Although it is sometimes convenient to impose our Western classifications and say that the Mohist discusses ethics, science, even logic, it is important not to lose sight of his own fourfold classification of knowledge. In particular, the *Canons* in which one may look for logic or proto-logic belong for him to two quite different arts, of discourse and argumentation. A central problem presented by the organisation of the *Canons* is why the four branches of knowledge are treated in groups falling into pairs separated by a group on the theme we have summed up as 'knowledge and change'. Why too is there no source of doubt corresponding to argumentation? We shall return to these questions later.[2]

Knowledge and naming

The *Canons* deal with knowledge by three forms of the word *chih* 知 'know', roughly corresponding to English 'wits', 'to wot (= know)' and 'wisdom'; the last two are graphically distinguished by the 'sun' (智)* and 'heart' (恕) radicals respectively. The definitions offered are contrastive.

* The 'sun' radical was eliminated in the graphic standardisation of the text except in the second half of the *Explanations*, where it survives throughout (G *ut sup.* 77).

A3 *(Canons)* "The 'wits' are the faculty.
 (Explanation) The 'wits': being the means by which one knows, one necessarily does know. (Like the eyesight)
A4 *(Canon)* 'Thinking' is the seeking.
 (Explanation) 'Thinking': by means of one's wits one seeks something, but does not necessarily find it. (Like peering)
A5 *(Canon)* 'Knowing' is the contact.
 (Explanation) 'Knowing': by means of one's wits, having passed the thing one is able to describe it. (Like seeing)
A6 *(Canon)* 'Understanding' is the clarity.
 (Explanation) 'Understanding': by means of one's wits, in discourse about the thing one's knowledge of it is apparent. (Like clear sight)"

Unlike other texts the *Canons* do not treat the heart as the organ of knowing, but speak always of the wits, that is of the intelligence or consciousness. Although thinking is fallible, the knowledge derived from it is conceived as certain.† As for knowing, it differs from perceiving in that it continues after perception is past; one is still able to describe the thing perceived. This point is developed in another *Canon*.

B46 *(Canon)* "When one knows, it is not by means of the five senses. Explained by: duration.
 (Explanation) The knower sees by means of the eye and the eye by means of fire but the fire does not see. If the only means were the five senses, knowing as it endures would not fit the fact. Seeing by means of the eye is like seeing by means of fire."

As for the four branches of knowledge, all but knowing how to act are classified in relation to names and objects. Objects, more literally solids (*shíh* 實 'solid, real', in contrast with *hsü* 虛 'tenuous, unreal'), are concrete and particular. The names which may or may not fit them are of three sorts.

A78 *(Canon)* "Names. Unrestricted, of the kind, private.
 (Explanation) 'Thing' is unrestricted; any object necessarily awaits this name. Naming something 'horse' is of the kind; for 'like the object' one necessarily has the use of this name.

† *Pi* 'necessarily' normally implies logical or causal necessity in the *Canons* (cf. p. 143 below); the point is presumably that what is known and not merely supposed (*yi wei* 以 為) is *a priori* certain (cf. A23, 24 " 'Sleep' is the wits not knowing anything. 'Dreaming' is supposing to be so while asleep." B10 "Is it knowing? Or is it supposing the already ended to be so?")

Naming someone 'Tsang' is private: this name stays in this object."

The theory of naming is purely nominalistic, as is the only other in pre-Han literature, that of Hsün-tzu's 'Correction of Names'. You name an object 'horse' and apply the name to everything which is like it, of its kind; 'horse' is simply a shorthand for 'like the object'. The assumption that common naming is by similarity is so deep-rooted that the Mohist excludes from common names not only the proper name which applies to only one object but the name 'thing' which applies to any object irrespective of similarity. Referring and saying merely tell us what an object is *like*.

A31 *(Canon)* "To 'refer' is to give an analogue for the object.

A32 *(Canon)* To 'say' is to emit references."

This is all that is needed for communication because to know what a thing is like is to know all about it.

B70 *(Canon)* "When you hear that something you do not know is like something you do know, you know them both. Explained by: informing.

(Explanation) A thing outside you do know, the thing in the room you do not know. Someone says: 'The colour of the thing in the room is like the colour of this.' Then the thing you do not know is like the thing you do know. It is as with 'White or black, with which does one win? [in argument over the colour of something]. This is like its colour, and what is like something white is necessarily white.' In the present case too you know that its colour is like something white, therefore you know that it is white.

"A name uses what you are clear about to correct what you do not know, it does not let what you do not know cast doubt on what you are clear about. (Like measuring an unknown length by means of a foot-rule). What is outside, you know by experience; what is in the room, you know by explanation."

Change and necessity

Let us return to the problem of the bridging section on knowledge and change which separates the two pairs of disciplines. For the Later Mohists, the deepest and most troubling of problems is the relation between knowledge and temporal change. They

are living in an age of rapid social and intellectual transformation, and want to establish the teaching of Mo-tzu on impregnable foundations. Alone among Chinese thinkers, they share with the Greeks the faith that all their questions can be settled by reason—in their own terms, by *pien*, the arguing out of alternatives. We saw that knowing is distinguished from perceiving by its continuance; after 'having passed' the thing one is still able to describe it.[3] We mentioned also[4] that of the four sources of doubt the one which corresponds to the bridging section is 'having passed'.

B10 *(Canon)* "One doubts. Explained by: the accidental, the undemanding, the coinciding, having passed.

(Explanation) (of the last item). Is it knowing? Or is it supposing the already ended to be so?—'having passed'."

The bridging definitions, which are of such words as 'commencement', 'transformation', 'motion', start with time and space, using for the former the verb *chiu* 久 'endure' nominalised, and understanding the noun *yü* 宇 'space' as extension.

A40 *(Canon)* "'Duration' is pervasion of different times.

A41 *(Canon)* 'Space' is pervasion of different places."

The bridging propositions explain that space and duration are not mutually pervasive *(chien-pai)*;[5] it is the 'durationless', the moment, which is mutually pervasive with space, and duration is the passage from one moment to the next. The purpose of this analysis is apparently to disconnect present from past and show that forms of government once good over the whole of space may lose their appropriateness with changing times, for the sequence concludes:

B16 *(Canon)* "Putting it in the time when it is so or in the not yet so. Explained by: in the time in question.

(Explanation) 'Yao is good at ruling' is from the present putting it in the past. If from the past it were put in the present, it would be 'Yao is incapable of ruling'."

So much for appeal to the examples of Yao and Shun in these changing times. The full significance of the bridging sections emerges when we come to the last two of the definitions, which contrast the temporarily 'staying' *(chih* 止 *)* and the unending, the 'necessary' *(pi* 必 *)*. This accounts for the placing of the bridging sections in the organisation of the *Canons*; the two preceding disciplines (how to connect name and object, and how to act) prove on examination to be concerned with the temporary, the two which follow (about objects and about names) with necessary relations, the causal between objects and the logical between names.

A40 *(Canon)* "To 'stay' is to endure as it was.

(*Explanation*) In the *not* staying which is durationless, something fits 'ox' and 'non-horse'. (Like an arrow passing a pillar). In the *not* staying which has duration, something fits 'horse' and 'non-horse'. (Like a man passing over a bridge)."

The *Canon* is about remaining x and non-y over a period of time. The *Explanation* points out that, since the definition forbids us to say x stays x for any one moment of the period, there is also *not* staying in which it is x and non-y. Otherwise, not staying extends over a period in which it begins as x and ends as non-x.*

A41 (*Canon*) "The 'necessary' is the unending.

(*Explanation*) It applies to cases where complements are perfect. Such cases as 'elder brother or younger' and 'something so in one respect or not in one respect' are the necessary and the unnecessary.† Being this or not this is necessary."

Staying x comes to an end, but being either x or non-x does not; it is necessary, for example, that one of brothers is either elder or younger. The word *pi*, which elsewhere in the literature implies no more than certainty, is used by the Later Mohists regularly of logical or causal necessity. It is used only of connexions (*ho* 合), causal between objects, logical between names; as for connexion between name and object, the opening sentence of the treatise called *Names and Objects* is "Names and objects do not connect necessarily."

A83 (*Canon*) "*Connexion*. Exact, appropriate, necessary.

(*Explanation*) (of the last item). When one is necessarily absent without the other, 'necessary'. What is of the sages, employ but do not treat as necessary. The 'necessary', admit and do not doubt. The converse apply on both sides, not on one without the other."

Here, "when one is necessarily absent without the other" allows one-way dependence, the "converse" requires two-way. The pronouncements of the sages, instructive as they are, are without the certainty of the logically necessary.

The 'a priori'

In one of the obscurer *Explanations* we find these mysterious sentences:

* The account of this *Canon* in G *ut sup.* 298f now seems to me forced and unconvincing.

† I formerly preferred to emend the text here (G *ut sup.* 299), but have since noticed that the apparently forced syntax has an exact parallel in *Expounding the Canons* 8 (quoted p. 157 below).

A93 "When we jump the city-wall the circle 'stays'. By the things which follow from or exclude each other we know *beforehand* what it is."

The corpus has other examples of *hsien* 先 'beforehand' used in a logical sense close to *a priori*, and of a wall shutting us off from observing a thing.[6] The meaning is presumably that when we go over the wall with the name 'circle' known beforehand we find objects in which it 'stays' throughout their duration. But how does the Mohist understand his claim that the circle is known without observation? When we examine his definition of the circle it turns out that it has been built up stage by stage from the undefined word 'like' without which, on his theory of naming, no common name could be understood. *Jo* 若 'like' has a phonetic cognate *jan* 然 'so' (= 'like it'). The quantifiers are defined by adding negatives in front of *jan*.

A43 "Of 'all' is of none not so."

Names and Objects 5 " 'Some' is not all".

To get from 'like' and 'so' through 'all' to the circle he requires one more preliminary definition, of 'straight'. He defines it in terms of visual alignment.

A57 " 'Rectilinear' is in alignment."

The rest follows on directly.

A53 " 'Of the same length' is each along all of the other when straight."

A54 "The 'centre' is that from which lengths are the same."

Here the *Explanation* refers back to the initial 'like': "Outward from this they are like each other "(measurements which are alike being equal).

A58 " 'Circular' is having the same lengths from a single centre."

We find another example of 'beforehand' and of the image of the wall in connexion with ethics.

Expounding the Canons 2. "Everything which the sage desires or dislikes *beforehand* on behalf of men, men learn from him as necessary through its essentials; but in the case of desires and dislikes born from the conditions they encounter, men do not learn them from him as necessary through their essentials. . . . Yesterday's thinking is not today's thinking, yesterday's concern for man is not today's concern for man. . . . Yesterday's wall to the wits is not today's wall to the wits."

What "the sage desires or dislikes beforehand on behalf of men" one learns by examining the *ch'ing* 'essentials', that without which the name

would not fit, presumably embodied in a definition. Examining the moral terms, we find that these too form a system, built up from the undefined 'desire' and 'dislike'. The *Canons* do not define but list senses of these two words, detaching an irrelevant use of *yü* 欲 'desire' in the sense of 'about to'.

> A84 "*Desire*. Immediate, having weighed the benefit: be about to.
> *Dislike*. Immediate, having weighed the harm."

'Benefit' and 'harm' are defined in terms of these, although in a way which requires replacing 'desire' by the retrospective 'be pleased'.

> A26 " 'Benefit' is what one is pleased to get.
> A27 'Harm' is what one dislikes getting."

As for the distinction between the immediately desired or disliked and the desired or disliked after weighing benefit and harm, the weighing is conducted in terms of *chien* 兼 'total' and *t'i* 體 'unit.' This pair, as we noticed in connexion with Kung-sun Lung,[7] covers both whole/part and collection/individual. The principle of weighing, as it emerges in the fragments on ethics in *Expounding the Canons,* is to prefer total to unit,— the arm to the finger, the whole person to the arm, everyone to one person. *Chien* is the first word of *chien ai* 'concern for everyone', so would have been defined among the lost definitions of terms in the formulations of the ten doctrines, as would *ai* 'concern', the most serious of all our losses among the Mohist definitions. We do have the definition of *t'i*.

> A2 *(Canon)* "A 'unit' is a division in the total.
> *(Explanation)* For example, one of two, the starting-point of a measured length."*

From weighing one can proceed to *wèi* 'on behalf of, for the sake of', a term as crucial for Later Mohists as for Yangists.[8]

> A75 "To be 'on behalf of' is to give most weight in relation to the desires, in the light of all that one knows."

One can make a good guess at the lost definition of concern from its place in the system; concern for a person would be something like 'desiring benefit and disliking harm to him, on his own behalf'. All Later Mohist references to concern for persons would fit this definition. The concern is at its purest as concern for oneself or for Tsang and Huo, the bondsman and bondswoman who are the stock examples of persons too humble for one to care about them except as human beings.

The definitions of the two major moral terms now follow directly.

* Cf. the definition of 'starting-point', cited below.

Benevolence, it may be noticed, is not defined as 'concern for everyone' (which is not a virtue but a moral principle), but as concern for individuals, with self-concern as the model.

A7 *(Canon)* " 'Benevolence' is concern for units.

(Explanation) Concern for oneself is not for the sake of making oneself useful. It is not like concern for a horse.

A8 *(Canon)* To do 'right' is to benefit.

(Explanation) In intent, one takes the whole world as portion; in ability, one is able to benefit it. One is not necessarily employed."

Virtues narrower in scope can be defined on the latter model.

A13 *(Canon)* "To be 'filial' is to benefit parents.

(Explanation) In intent, one takes one's own parents as portion; in ability one is able to benefit them. One does not necessarily succeed."

The point of the last two *Explanations* is to avoid a misunderstanding of the definitions. A man is to be judged morally, not by how much he does benefit in practice, but by the intent and the ability to benefit. The 'intent' of 'Heaven's intent', one of the ten doctrines, is one of the words with lost definitions, but its counterpart 'achievement' is a further member of the system.

A35 " 'Achievement' is benefiting the people."

Here then the old Mohist utilitarianism is developed as a highly refined system. By a series of interlocking definitions it is established *a priori* that the benevolent and the right are what will be desired on behalf of mankind by the sage, who consistently weighs benefits and harms on the principle of preferring the total to the unit. This system does not seem to be vulnerable, as I at one time assumed,[9] to a charge commonly made against Western Utilitarianism, that it confuses fact and value by starting from what men in fact desire. It elucidates what the *sage*, the man who knows most, desires on behalf of mankind; it has behind it what we have identified as a general assumption of Chinese philosophy, that desires change spontaneously with increasing knowledge and that 'Know!' is the supreme imperative. We leave the Mohist to the test of our quasi-syllogism.[10]

This *a priori* systematising is the most unexpected of the Later Mohist achievements, something one thinks of as Greek rather than Chinese. It is not however that the Mohists have somehow taken a leap outside the limits of Chinese thought. No one is surprised to meet this chain of six definitions in *Mencius*:

"It is the desirable that is meant by 'good'; having it in oneself, by

'trustworthy'; having it to the full, by 'admirable'; being radiant in its fullness, by 'great'; being transformed in greatness, by 'sage'; being unknowable in sagehood, by 'daimonic'."[11]

This chain does not surprise because it is loose, not strict, rhetorical rather than logical. However, it starts like the Mohist chain from the undefined 'desire', and by adding desirable characteristics builds up to the best stage of all. It would take only a little touch of logic from the Sophists to have Mencius thinking like a Later Mohist.

The first discipline: discourse (knowledge of how to connect names and objects)

We now consider the four disciplines in the order in which they are treated in the *Canons*. The first two, knowing how to connect name and object and knowing how to act, belong to the realm not of the necessary but of the temporarily staying. The first discipline, which we call the art of discourse, is concerned with the consistent naming of similar and different objects so that the names 'stay' in them throughout their duration. We have two accounts of the art of discourse, the second being the fragmentary treatise, *Names and Objects*, written after the completion of the *Canons* and *Explanations*. It differs from the first in shifting attention from the name to the sentence and to the classification of sentences as similar or different. Of the four sources of doubt, the one to which discourse is exposed is the accidental, of which only one of the examples given is intelligible:

B10 " . . . , the dweller in a booth being cold in summer—'the accidental'."

The reference is presumably to accidental circumstances interfering with the assumption that summer days are similar in being warm.

The propositions about discourse follow on immediately to a pair of *Canons* distinguishing four senses of 'same' and of 'different'. One of them is identified by the pair 'total/unit' which covers both 'collection/ individual' and 'whole/part'.

A86 *(Canon)*. "*Same*. Identical, as units in something, together, of a kind.

(Explanation). Being one object with two names is the sameness of identity. Not outside the total is sameness as units in it. Both occupying the room is sameness as together. The same in some respect is sameness in kind."

A87 *(Canon). "Different.* Two, not units in something, not together, not of a kind.

(Explanation). Being necessarily different if they [i.e., the names] are two is being two. Detached and independent is not units in something. Not in the same place is not together. Not the same in some respect is not of a kind."

By the Mohist theory of naming, you call an object 'horse' and extend the name to another which is like it, the same in kind (*lei* 類).[12] To decide whether a name fits you therefore require as standard (*fa* 法) something similar, and where the similarity is only of part, the relevant part as criterion (*yin* 因). The choice of standard is a matter of discretion.

A70 *(Canon)* "The 'standard' is that in being like which something is so.

(Explanation) The idea, the compasses, a circle, all three may serve as standard.

A71 *(Canon)* The 'criterion'* is where it is so.

(Explanation) Being 'so' is the characteristics being like the standard."

The idea would serve as standard in debate only as embodied in a definition, and the Mohist seems indeed to have no other word for definition than 'standard'. The propositions on discourse develop a procedure in successive *Canons.*

A94 *(Canon)* "When someone commits himself to a proposal, if the description takes a subtle turn, seek his reasons.

(Explanation) If he objects to the accepted claim, and makes it his business to establish this proposal, seek the standard for the proposal.

A95 *(Canon)* Where the standard is the same, examine what is the same in it.

(Explanation) Choose what is the same, and examine the subtle turn.

A96 *(Canon)* Where the standard differs, examine what is appropriate to it.

(Explanation) Choose this and pick out that, ask about reasons and examine appropriateness. Using the black or the not black in a man to make 'black man' stay, using his concern for some men or his lack of it for others to make 'concerned for man' stay—of these which is appropriate?"

* For this emendation (因 for 佴) cf. G *ut sup.* 214–216.

Such descriptions as 'black man' and 'concerned for mankind' do not fit perfectly, and allow such subtle turns as the proposal that since a man with blind eyes is a blind man a man with white skin and black eyes is a black man.† One has then to decide which part of the body or which members of mankind to take as the criterion.

> A97 *(Canon)* "Make the criterion stay, in order to distinguish courses.
> *(Explanation)* If the other man, referring to a respect in which it is so, deems it so in the instance here, refer to respects in which it is not so and inquire about them. (For example, the sage has respects in which he is not, yet he is)."

In discourse you choose the name of object or criterion or kind which stays for a period of time, you 'make it stay'. No complication arises however when the fit is exact, as with the circle.

> A98 *(Canon)* "The exact nowhere is not.
> *(Explanation)* The matching and the assent enter knowledge together. When after explanation you assent to more than that they match (for example, to a circle being nowhere rectilinear) or without explanation you assent on the basis of the matching, it is as though it were so of itself."

Returning to the inexact, having distinguished courses by the criterion, you have to fix the kind; you decide that the particular object is 'this' (*shih* 是), of the species in question. One can then proceed along the course chosen from the present instance to others.

> B1 *(Canon)* "Make the kind stay, in order to make the other man proceed. Explained by: the sameness.
> *(Explanation)* The other, on the grounds that it is so of the instance here, argues that it is so of this; I, on the grounds that it is not so of the instance here, doubt that it is so of this.
>
> B2 *(Canon)* If the fours differ, explain the difficulty of extending from kind to kind. Explained by: making 'the wide or the narrow' or 'all of the thing' stay.
> *(Explanation)* If said to have four feet, is it an animal? Or is it living thing or bird?—'all of the thing' and 'the wide or the narrow'. If what is so of the instance here were necessarily so of this, all would be milu deer."

The milu deer was said to have four eyes, because of deep cavities under the eyes. If I describe the instance here as four-eyed and four-

† The sophism "A white dog is black" in Cz 33/77 tr. G 284 is plausibly explained on these lines by the commentator Ssu-ma Piao (died A.D. 306). Cf. G *ut sup.* 344, 493.

footed, I commit myself to describing all milu deer but not all animals as four-eyed, all animals but not all living things as four-footed. It is to be noticed that the Mohist is *not* talking about inductive inference. His theme here is not inference from the known to the unknown but consistent description of the already known.

The last of these sections already bedevils with textual problems, which multiply as the series continues. Of the rest we shall note only that the next examines how names change their functions in combination. Thus when the name 'both' is added to the name 'two' and to the name 'fight' to make 'Both (are) two' and 'Both fight', we find that both do fight but they are not both two, although the objects remain two. For the authors of the *Canons* even a grammatical particle such as *chü* 俱 'all, both' is a name, and there is no evidence that they are aware of the sentence except as a combination of names.

The revised art of discourse in 'Names and Objects'

Like *Expounding the Canons*, the fragmentary treatise *Names and Objects* follows the widespread convention of taking the title from the first words ("Names and objects do not connect necessarily"). It is in fact concerned with sentences rather than names, and may be seen as an attempt to reconstitute the art of discourse in the light of the discovery of the sentence.

The fragments on names show advances in classifying types of naming and also in terminology. Instead of the traditional use of ox and horse as logical counters we once find the word *mou* 某 (commonly used as substitute for tabooed names) adapted as 'x'. In the following the opening sentences probably refer to the 'horse' and 'Ch'in horse' of another fragment:

> *Names and Objects* 2. "Of the named by shape and characteristics, you necessarily know that this is x if you know x. Of those one cannot name by shape and characteristics, even if you do not know that this is x, you may know x. The named by residence and migration, if they have entered the confines are all this; if they leave there, by this criterion they are not. Of the named by residence and migration, district and village names, 'Ch'i', 'Ching' and the like are all instances; of the named by shape and characteristics, 'mountain', 'hill', 'house', 'shrine' and the like are all instances."

The two following fragments probably go together, making 'big' an example of naming by number or measure. The first is the opening passage of the treatise:

"*Names and Objects.* Names and objects do not connect necessarily. If this stone is white, when you break up this stone all of it is the same as what is white; but even though this stone is big, it is not the same as what is big."

Then:

"In the case of anything named otherwise than by reference to number or measure, when you break it up all of it is this. Therefore one man's finger is not one man, but this one man's finger is this one man; one face of a cube is not a cube, but the face of a wooden cube is the wooden cube."

The last half of the treatise is fortunately intact. It argues at length that sentences which appear to be structurally alike may, because of idiomatic shifts in the combining of names, have different logical implications. Thus it may seem obvious that if we can say 'White horses are horses, riding white horses is riding horses', we can also say 'Robbers are people, killing robbers is killing people'. But *sha tao* 殺盜 'killing robbers' is the ordinary term for executing robbers, while *sha jen* 殺人 'killing people' has the pejorative sense of murder or massacre, so that the sentence appears to declare that it is wrong to execute robbers. In the Mohist terminology, it does not follow that if robbers are 'this' (people) it is 'so' that one is killing people. The Mohist does not however analyse these idioms, instead he declares that "a thing in some cases is this and it is so, in others is this but it is not so, in others is not this yet it is so", and classifies sentences accordingly. 'Robbers are people' belongs to the second of the classes, with other sentences which display the same kind of treacherous idiomatic shift.

Names and Objects 15. "Huo's parent is another, but Huo's serving her parent is not 'serving another' [*shih jen* 事人 'serving a husband'].

Her younger brother is a handsome man, but loving her younger brother is not loving a handsome man. [loving him for his looks].

A carriage is wood, but riding a carriage is not riding wood [idiom untraced].

A boat is wood, entering a boat is not entering wood [piercing or soaking into it].

Robbers are people; abounding in robbers is not abounding in people, being without robbers is not being without people.

How shall we make this clear? Disliking the abundance of robbers is not disliking the abundance of people, desiring to be without robbers is not desiring to be without people. The whole world agrees in accepting these; but if such is the case, there is no longer any difficulty in allowing that, although robbers are people, concern for robbers is not concern for people, unconcern for robbers is not unconcern for people, killing robbers is not killing people.

This claim is the same in kind as the others; the world does not condemn itself for upholding the others, yet condemns the Mohists for upholding this one. Is there any reason for it but being, as the saying goes, 'clogged within and closed without'?

These are cases of being this but it not being so."

The error the Mohist is criticising arises from putting 'Robbers are people' in the first of the three classes, for which he offers four examples:

Names and Objects 14. "White horses are horses, riding white horses is riding horses.

Black horses are horses, riding black horses is riding horses.

Tsang is a person, being concerned for Tsang is to be concerned for persons.

Huo is a person, to be concerned for Huo is to be concerned for persons.

These are cases of being this and it being so."

Number is irrelevant to these examples and is unmarked in the Chinese original; one could as well translate in the singular, but that would conceal the idiomatic shifts in the sentences. Since Tsang and Huo are slaves too humble for one to be concerned for anything about them except that they are persons, someone concerned for them is concerned for *anyone* as a person. Similarly, 'He rides a white horse' or 'He rides white horses' entitles us to infer that 'He rides horses' in the sense that he can ride any horse. In this class however the shifts do not affect the validity of the conclusion. It may be noticed that in both of the classes we have examined sentences are grouped without any regard for idiomatic or logical differences between them. The assumption is that differentiation is carried only far enough to settle one's particular problem. But after completing the three classes the Mohist goes back to his first class and points out a difference between the two pairs of generalised conclusions. Here quantification is for the first time relevant.

Names and Objects 17. "Concern for persons depends on concern for all persons, only then is one deemed to be concerned for

persons. Unconcern for persons does not depend on unconcern for all persons; one is not concerned for all persons, and by this criterion is deemed not to be concerned for persons.

Riding horses does not depend on riding all horses before being deemed to ride horses; one rides some horse, and by this criterion is deemed to ride horses. When it comes to not riding horses, it does depend on not riding any horse at all, only then does one not ride horses.

These are cases in which one applies to all and the other not."

It can be seen that the Mohist classifications of parallel sentences, whether they introduce quantification or not, have nothing to do with syllogistic demonstration. The reason why one cannot simply answer "Well, I prefer to put 'Robbers are people' in your first class and proceed to 'Killing robbers is killing people'" is that to do so would dissolve the idiom; the meaning would shift to the unproblematic 'A robber is a man, to kill a robber is to kill a man', with which the Mohist may be presumed to have no quarrel. Logical necessity belongs not to his art of discourse but to his quite different art of argumentation. The message of *Names and Objects* is more like Wittgenstein's than Aristotle's.

> *Names and Objects* 12. "Of things in general, if there are respects in which they are the same, it does not follow that they are altogether the same. The parallelism of sentences is exact only up to a certain point. If something is so of them there are reasons why it is so; but although its being so of them is the same, the reasons why it is so are not necessarily the same. If we accept a claim we have reasons to accept it; but although we are the same in accepting it, the reasons why we accept it are not necessarily the same. Therefore sentences which illustrate, parallelise, adduce and infer become different as they proceed, become dangerous when they change direction, fail when carried too far, become detached from their base when we let them drift, so that we must on no account be careless with them, and must not use them too rigidly. Hence saying has many methods, separate kinds, different reasons, which must not be looked at only from one side."

In shifting attention to the sentence (*tz'u* 辭), has the Mohist become aware of it as more than a string of names? This might be a difficult achievement in a language without morphological differences to distinguish the functions of words in the sentence. That he is aware of some kind of advance on the *Canons* is plain from a passage which repeats the four

types of sameness listed in *Canon* A86, followed by "Sameness with the same name"; it then lists four new ones followed by "Sameness with the same *root*."

> *Names and Objects* 6. "Sameness of the separated off, sameness of the accessory, sameness in being this, sameness in being so."

What does it intend by the 'root'? Comparison with the parallel sentences described as similar or different in being 'this' or 'so' fully elucidates the last two types. 'Sameness in being this' corresponds to the sharing of a noun complement ('. . . . are horses'), in being 'so' to the sharing of a nominalised verbal phrase ('riding horses'). In Classical Chinese syntax the former is the core of a nominal sentence and is substitutable by *shih* 'this', while a verb or verbal phrase ('. . . . rides horses') is the core of a verbal sentence and is substitutable by *jan* 'so'. The core can stand alone as the sentence or be expanded by the addition of the subject or other optional elements; it is not conveniently treated as predicated of a subject. With less confidence the 'sameness of the separated off' may be taken as corresponding to the sharing of a negative core ('. . . . are not horses'), of the 'accessory' as corresponding to a core ('. . . . is white') transferred to a dependent position ('white horse'). It seems then that *Names and Objects*, unlike the *Canons*, recognises the sentence as a structured whole, in which the 'root' is what we call the sentence core, the assertive element in it. This is confirmed by the description of the sentence:

> *Names and Objects* 10. "The 'sentence' is that which is born in accordance with the fact, grows to full length in accordance with a pattern, and proceeds according to its kind."

(That is, you do or do not proceed from 'Robbers are people' to 'Killing robbers is killing people' according to the class in which you place it.)

The distinguishing of the sentence from a string of names would follow from the recognition that the knowledge conveyed by sentences is different from the mere idea or image (*yi* 意) evoked by names. This point is made in a couple of the fragments:

> *Names and Objects* 3. "Knowing is different from having an image."
>
> "Having the image of a pillar is not having an image of wood, but having an image of the wood of this pillar. Having an image of the finger as being the man is not having an image of the man. Having an image of something as being a catch of game on the other hand is having an image of the birds."

In identifying the first of the Later Mohist disciplines as an art of discourse, we are not denying that the sentences in the form '*x* is *y*, to do something to *x* is to do it to *y*' are conceived as making valid or invalid inferences. The steps in the procedure for dealing with, for example, 'Robbers are people'—taking illustrations ('Her brother is a handsome man', 'A boat is wood'), running them parallel, checking them ('How shall we make this clear?'), and concluding with 'Killing robbers is not killing people'—are all given names, and the last is *t'ui* 推 'inference':

> *Names and Objects* 11. " 'Illustrating' is referring to another thing to make it clearer. 'Parallelising' is putting sentences side by side and letting all proceed. 'Adducing' is saying 'If it is so in your case, why may it not be so in mine too?'. 'Inferring' is using something in which the one he rejects is the same as those he accepts to make him accept the former."

But neither here nor in his art of argumentation (which does claim logical necessity) is the Mohist interested in establishing logical forms. He lays out his parallels, not in a fumbling search for the syllogism, but to show where the mutability of words in different combinations vitiates inferences, by false parallelism in the descriptions from which the inferences start. It is this which gives much of *Names and Objects* its curiously Wittgensteinian look. The resemblance to Wittgenstein is not altogether fanciful, if we think of Western and Chinese thought as moving in opposite directions past the same place. The West, after seeking necessary truths by logic for some 2,000 years, becomes aware of questionable assimilations and differentiations behind the formulation of the questions themselves, and discovers that instead of refuting a proposition you can undermine it by uncovering implicit paradigms and unnoticed distinctions. One might say that the West is now venturing out of logic into the Mohist art of discourse, which does not pretend to logical necessity. Chinese philosophising on the other hand, conducted in a language without the morphological distinctions which call attention to the logical relations in sentence structure, is very aware of discourse as a patterning of like and unlike in which the most visible danger to thought is from false parallels. The Mohist therefore develops procedures for testing description, but when he goes on to the argumentation which does have logical necessity he sees that as a quite separate discipline, in which the clarity and inevitability of every step makes it unnecessary to lay down procedures. We shall be returning to this theme when we examine correlative system-building.[13]

The second discipline: ethics (knowledge of how to act)

How to live and to act being the central concern of Mohism as of all Chinese philosophy, the ethical propositions were prepared first, in *Expounding the Canons*; the *Canons* have only the ethical definitions. Of the four sources of doubt, the one corresponding to knowledge of how to act is 'the undemanding'. One cannot judge how much credit to give a person if the right course is also the easy one.

> B10 *Explanation* "If the thing he lifts is light and the thing he puts down heavy, it is not a test of strength (for example, a stone and a feather); if he shaves the wood along the grain it is not a test of strength—'the undemanding'."

Given the central importance of ethics for the Mohist, and his success in producing a system of interlocking definitions, one might perhaps expect that this discipline would be credited with logical necessity. But he is well aware that his *a priori* system shows only that the benevolent and the right are what the wisest man would desire on behalf of mankind, and does not show what action is benevolent or right in a particular situation. This is the very first point made in the ethical propositions:

> *Expounding the Canons* 2. "Everything which the sage desires or dislikes beforehand on behalf of man, men learn from him as necessary through its essentials; but in the case of desires and dislikes born from the conditions they encounter, men do not learn from him as necessary through the essentials. The sage's fostering care is benevolent but without the concern which benefits. The concern which benefits is born of thinking. Yesterday's thinking is not today's thinking, yesterday's concern for man is not today's concern for man. The concern for man in concern for Huo is born from thinking about Huo's benefit, not about Tsang's benefit; but the concern for man in concern for Tsang is the concern for man in concern for Huo. Even if by getting rid of the concern for them the world would be benefited one cannot get rid of it. Yesterday's wall to the wits is not today's wall to the wits."

A fragment which seems to refer back to concern, thinking and benefit as the 'three things' continues:

* Cf. *Canons* B57, 58, which contrast the idea or mental picture of a pillar as 'known beforehand' with that of a hammer, which is 'not yet knowable', because identified not by shape but by function.

"Only when the three things are all complete are they sufficient to generate the enjoyment of benefit in the world. The sage has concern but does not have affirmations which benefit current situations, that is, affirmations about the transient. Even if there were no men at all in the world, what our master Mo-tzu affirmed would still be present."

The necessary, which by definition is the unending, would be invulnerable to change even if there were no human beings to know it. (Elsewhere, in recommending taking one's time over the answer to a profound question, the Mohist does not go quite as far as this: "Among Heaven's constants its presence is prolonged with man").[14] Practical decision on the other hand depends on weighing benefit and harm in variable circumstances. It deals with the 'not yet knowable' (opposite of 'known beforehand')* on the other side of the wall, and with desires which are not eternal but are made to stay over a period of time.

> A75 (Canon) "If the benefit or harm outside the wall is not yet knowable, but you will get money if you hurry for it, then to refuse to hurry for it is to take the doubt as grounds in making desire stay."

How then does one decide which course is beneficial to Tsang or Huo or oneself in the circumstances not of yesterday but of today? The Mohist, as we have seen,[15] distinguishes the immediately desired from the desired after 'weighing' (ch'üan 權). In the weighing of benefit and harm one prefers the total to the unit, humanity to individual, body to finger.

> Expounding the Canons 8. "Weighing light and heavy among those taken as the units is what is meant by 'weighing'. The wrong alternative when weighed becoming the right, and the wrong rejected as the wrong, are the 'weighed' and the 'immediate'. Cutting off a finger to save an arm is choosing the larger among benefits and the smaller among harms. Choosing the smaller among harms is choosing not the harmful but the beneficial; the choices open to you are under the control of others. When you encounter a robber, to save your life at the cost of an arm is beneficial, the encounter with the robber is harmful. Cutting off a finger or an arm is choosing the smaller among harms; one desires it because there is no alternative, it is not that one desires it immediately. Choosing the larger among benefits is not a matter of having no alternative, choosing the smaller among harms is. Choosing between things you do not yet have is

choosing the greater among benefits, renouncing one or other of things you already have is choosing the smaller among harms."

The weighing of benefit and harm, imagined in terms of harm to the parts of the body, is a procedure shared by Yangists and Mohists, and even on occasion by Mencius.† In the Yangist version, however, the weighing of the benefit to oneself is not reconciled with the care for the lives of all which makes a Yangist the best person to put on the throne,[16] should he find it safe to accept it. As we saw, the possibility of a pure philosophical egoism seems not to be conceived even by Yangists.[17] The Later Mohist ethic on the other hand achieves a perfect consistency; you prefer the world to yourself on the same grounds that you prefer an arm to a finger. The Mohist does however have the problem of reconciling an equal concern for everyone with greater care for parents and ruler than for others, the issue which led Mencius to accuse the Mohist Yi-tzu of having "two roots."[18] The Mohists do not question that each person has his portion in society, permanent in the case of the family, and requiring him to do more for some than for others.

> *Expounding the Canons* 9. "Doing more or less for those for whom it is right to do more or less is what is meant by 'grading'. Creditors, ruler, superiors, the aged, one's elders, near and far kin, are all among those for whom one does more. Doing more for the elder one is not doing less for the younger. One does more or less according to the degree of kinship, as far as the remotest degree where no issue of right arises."

But being obliged to do more for some people does not imply having any more love or concern for them. The Mohist declares with ruthless consistency that the righteous man has no more love for his parents than for others.

> *Expounding the Canons* 12. "Concern is as much for another's parents as for one's own."
> (*Ut sup.* 9) "By the standard laid down by the sage, you forget your parents when they die, for the sake of the world. Doing more for parents is your portion, and finishes with the ceremonies of death and farewell."

The model for the pure concern for a person, irrespective of praise or blame, usefulness or moral worth, is concern for oneself.

> *Expounding the Canons* 10. "Concern for man does not exclude

† Cf. *Me* 6A/14, quoted p. 131 above. Mencius too is contrasting *chien* 'total' and *t'i* 'unit', although it is there convenient to translate the *chien* as 'for every part' and *t'i* as 'member'.

oneself, one is oneself among those for whom one is concerned."
"Tsang's concern for himself is not for the sake of the others who
are concerned for himself. Those for whom one does more do not
exclude oneself, but the concern is neither more nor less; and
giving special attention to oneself is not on account of one's
worth."

A7 *(Canon)* "Concern for oneself is not for the sake of making oneself
useful. It is not like concern for a horse."

Concern being simply the desire to benefit and dislike of harming
either others or oneself it does not increase or decrease with numbers, and
being purely for the person's own sake is equal for all.

Expounding the Canons 4. (on the proposition "Even if a million
were born in one day concern would not be more") "Supposing
that the whole world would be harmed if of all men Tsang were to
die, I would make a point of caring for Tsang ten thousand times
more, but my concern for Tsang would not be more."

(Ut sup. 13) "Concern for everyone is equal, and equal to concern
for one."

The one exception to the perfect equality of concern (if one corrupt
fragment is to be trusted) is that the persons most beneficial to the world
deserve additional concern.

Expounding the Canons 5. "Being for the sake of the world more
concerned for Yü is being concerned for the sake of the man Yü
was."

The Later Mohist ethic provides a further example of Mohism seeming
to diverge from the Chinese in the direction of the Western norm. It is built
not on the social relationships of father and son, ruler and subject (these
enter only in the social organisation in which each has his portion), but on
individuals benefiting themselves, each other, and the world, which is the
totality of individuals. The *yi*, 'right', which by its etymology is the
appropriate to social position, is redefined as the beneficial.[19] We may see
here another aspect of the Mohist reaction to the challenge of Yang Chu.
Morality on the defensive against the Yangist 'valuing of self' becomes the
valuing of other selves as much as you value your own. One may hesitate
however to say that Mohism reached the Kantian concept of the individual
as an end in himself, since it has no objection to the killing of the innocent
if it is to the benefit of all. The military chapters of *Mo-tzu* follow the
accepted practice in the case of serious crimes of executing the offender's
whole family. The Later Mohists were aware of a moral problem here, to
judge by one of the ethical propositions:

Expounding the Canons 6. "Being concerned for them equally, one chooses one man among them for execution."
The mutilated comment contains the fragment:
"If equally beneficial to the world, there is nothing to choose between them. If a death and a life are equally beneficial, there is nothing to choose between them."

The third discipline: the sciences (knowledge of objects)

The scientific *Canons* consist of a series of geometrical definitions and a series of propositions on optics, mechanics, and economics. The two on economics defend the fixing of prices by supply and demand.[20]

We have already noticed the greatest achievement of the geometrical section, the chain of definitions establishing the circle as 'known beforehand'. We have also had occasion to quote a couple of passages which incidentally reveal in the Mohist something like the Greek reverence for geometry as the model of exact knowledge, "If square it will not rotate" (presumably the wheel) as example of knowledge by explanation, and "The circle is nowhere rectilinear" as example of explanation preceding assent.[21] There is no evidence however that the Mohists formulated geometrical proofs, the absence of which is one of the crucial gaps in Chinese as compared with Greek thought. Thus the *Chou pi*, the earliest geometrical text (dating in its present form from early Han), recognises that the sides of a right-angled triangle are in the proportions 3, 4, and 5; and a diagram belonging to or perhaps added to the commentary of Chao Chün-ch'ing (c. A.D. 200) lays out four right-angled triangles against a grid of squares, enabling us after counting and calculating to *see* that the squares of the sides will be equal to 9, 16, and 25 of them.* As a visual demonstration it is elegant and economical, but it is not the verbalised proof which in the West served as model for demonstration in physics.

The basic concepts of Mohist geometry are not line and point but the measurement and its starting-point (*tuan* 端).

A61 *(Canon)* "The 'starting-point' is the dimensionless unit which precedes all others."
To treat all points as starting-points would avoid Hui Shih's paradox

* The diagram is reproduced in Needham v. 3/22 Fig. 50 (cf. also 95f).

"The dimensionless cannot be accumulated, yet its girth is one thousand miles" (assuming this to mean that the sum of points remains a point, yet any quantity is the sum of its smallest parts, which are points). Plato, as reported by Aristotle,[22] made a similar move in substituting *archē grammēs* (beginning of line) for *stigma* (point). The Mohist seems to make it also with the moment, treating it as the commencement of a period.

> A44 *(Canon)* "To 'commence' is to come plumb with the time.
>
> *(Explanation)* There is a time of movement which has duration and another which is durationless. The commencement is plumb with the durationless."

Turning now to the physical sciences, the Mohist's thinking is strictly causal, not the Yin-Yang system-building which broke into the philosophical schools from the world of diviners, astronomers, physicians, and musicians late in the 3rd century B.C. In China, as in Europe up to the Scientific Revolution in the 17th century, the choice was almost exclusively between proto-scientific cosmos-building by classification as similar or different, allowing inference for the similarities, and the piecemeal causal explanations indispensable to technology, which give much more useful results but do not add up to a cosmology. The Later Mohist enterprise, like those led by Archimedes in Greece and by Grosseteste in 13th-century Europe, is one of those brief episodes which look in retrospect like breakaways from correlative system-building in the direction of what we now recognise as true science. We may see the school as driven to causal explanation, on the one hand by a logical rigour distrustful of the looseness of correlative thinking, on the other by a habit of piecemeal causal explanation instilled in them by their background in the crafts and their work as military engineers.

Causes are referred to as *ku* 故 'reasons'. The *ku* (cognate with *ku* 古 'ancient times') is in the first place what is at the origin of something; the word can also be used of a thing in its original state or of the fact behind a statement.† It is the very first term to be defined; we fill gaps conjecturally in the mutilated *Explanation*.

> A1 *(Canon)* "The 'reason' for something is what it must get before it will come about.
>
> *(Explanation) Minor reason:* having this, it will not necessarily be so: lacking this, necessarily it will not be so. It is the unit <*?which precedes all others?*>. (Like having a starting-point.)

† Cf. p. 124f above, and the translation of *ku* as 'fact' in *Names and Objects* 10, quoted p. 154 above.

> *Major reason:* having this, it will necessarily <*be so*>: lacking <*this, necessarily it will not*> be so. (Like the appearing bringing about the seeing)."

The minor reason is the necessary condition, the major the necessary and sufficient condition. Causation is referred to by the verb *shih* 使 , used primarily of employing a person. The Mohist is careful to distinguish its senses in the series of *Canons* on ambiguous terms.

> A77 *(Canon)* "*Shih.* To tell, a reason.
>
>> *(Explanation)* To give orders is to 'tell': the thing does not necessarily come about. Dampness is a 'reason': it necessarily depends on what is done coming about."

Dampness is one of the causes of illness, which is the Mohist's stock example of a phenomenon with multiple causes.[23] One can command without being obeyed, but cannot cause without the effect coming about. Although the sciences, like argumentation, are concerned with necessary connexions, the multiplicity of causes allows the possibility of doubt, from which only the argumentation of the fourth discipline is exempt. Among the four sources of doubt the one corresponding to the sciences is the coinciding, with the example again taken from illness.

> B10 *(Canon)* "The unknowability of whether a fighter's collapse is because of the wine he drank or the midday sun—the 'coinciding'."

The Later Mohist corpus never mentions such current proto-scientific concepts as Yin and Yang or the symbols and numbers of the *Yi*. It does once mention, but to reject it, the theory that the Five Processes conquer each other in a regular cycle (fire, metal, wood, soil, water, fire).[24]

> B43 *(Canon)* "The Five Processes have no regular conquests. Explained by: being the appropriate.
>
>> *(Explanation)* That the fire melts the metal is because there is a lot of fire, that the metal uses up the charcoal is because there is a lot of metal."

We have seen that the Mohist distinguishes three types of connexion, the exact, the appropriate, and the necessary.[25] By classing Five-Process theory under the appropriate the Mohist is perhaps allowing it a place in disciplines such as medicine confused by multiplicity of causation, but he is denying it the necessity of the sciences in which he is interested. He selects his examples exclusively from optics and mechanics, disciplines which have no place among the traditional proto-sciences, but which allow the strictly causal explanations which alone satisfy him. One notices throughout the scientific *Explanations* the constant recurrence of the word

pi 'necessarily'. He is not, as may be claimed of Archimedes, in sight of post-Galilean science (he does not mathematise his results), but he does in practice confine himself rigorously to solutions which are geometrically visualised and experimentally testable. We take as example a *Canon* on the inversion of the shadow in a concave mirror.

B23 *(Canon)* "When the mirror is concave the shadow is at one time smaller and inverted, at another time larger and upright. Explained by: outside or inside the centre.

(Explanation) Inside the centre. If the man looking at himself is near the centre, everything mirrored is larger and the shadow too is larger; if he is far from the centre, everything mirrored is smaller and the shadow too is smaller: and it is necessarily upright. This is because the light opens out from the centre, skirts the upright object and prolongs its rectilinear course.

Outside the centre. If the man looking at himself is near the centre, everything mirrored is larger and the shadow too is larger; if he is far from the centre everything mirrored is smaller and the shadow too is smaller; but it is necessarily inverted. This is because the light converges <*at the centre*> and prolongs its rectilinear course."

The 'centre' is the centre of curvature, which the Mohist does not distinguish from the focal point. The 'inside' is the mirror side, the 'outside' the observer's. The observer is moving the mirror towards and away from him. When he is between centre and mirror the image is upright, when he is outside the centre the image is inverted; in either case it is larger the nearer he is to the centre. The explanation of the phenomena is that the light travels rectilinearly, and converges on and diverges from the centre of curvature. This explains the inversion (cf. B19 "The legs cover the light from below, and therefore form a shadow above; the head covers the light from above, and therefore forms a shadow below.") and also, by the widening of the angle, the enlargement. He is conceiving a geometrical figure not visible to the eye (cf. B19 "the criss-cross has a starting-point from which it is prolonged with the shadow"). But he takes the commonsense view that the light converges *before* reaching the mirror; it would require a much more advanced optics to recognise that, in spite of the fact that we see the inverted image on the mirror surface, the light converges only after being reflected back.

The principle of the lever appears in the *Explanation* of a lost *Canon*, but without Archimedes' mathematics.

B25b. "The side of it on which you lay the weight will necessarily

> decline, because the two sides are equal in weight and leverage. If you level them up, the tip will be longer than the butt; and when you lay equal weights on both sides the tip will necessarily fall, because the tip has gained in leverage."

The noun *ch'üan* 權 here translated 'leverage' is the word for the counterpoise on the steelyard and for its positional advantage, also commonly used for the leverage exerted by political or social position. (As a verb we have already met it in the sense of 'weigh'.)[26] The Mohist explanations operate with such concepts usable *ad hoc,* and take only the first steps towards unifying them. The principle that all weight tends down vertically is brought in to explain why a weight heavy enough to lift a wheeled ladder can be stopped by a fragile support:

> B27. "Whenever a weight is not suspended from above or checked from below or forced from the side it descends vertically; slanting is because something interferes with it. That the weight which makes the ladder glide fails to descend is because it hangs vertically. That in the present case if you erect a foot-rule on flat ground the weight fails to descend is because it has no inclination to the side."

The Mohist mechanics has terms for several kinds of pull or support. But in discussing the 'supporting from below' which holds up a wall the Mohist notices that it is the same as the 'checking from below' which stops a descending weight.

> B29. "Let a square stone be one foot from the ground, put stones underneath it, hang a thread above it, allow the thread to reach just as far as the square stone. That the square stone does not fall is because it is 'supported from below'. Attach the thread, get rid of the stones; that it does not fall is because it is suspended from above. The thread snapping is because of the pull of the square stone. Without any alteration but the substitution of a name, it is a case of 'checking from below'."

Outside the Mohist corpus, there is another early document which completely breaks with the methods of Chinese proto-science. This is a series of notes preserved at the end of the astronomical chapter of *Huai-nan-tzu* (c. 140 B.C.), which explains how to estimate the true directions of the cardinal points and the dimensions of the universe by measuring the sun's shadow as cast by a vertical post, the gnomon.* The results are so out of accord with the three known schools of ancient Chinese astronomy that

* This document is fully translated and analysed by Cullen *op. cit.*

it has sometimes been taken as a relic of an unknown school, and it is tempting to speculate that it is of Mohist origin. But the great interest of the document is that its calculations start from a measurement introduced as hypothetical by the counterfactual *chia-shih* 假 使 'falsely supposing'. Instead of elaborating a system of numerological symmetries, the author describes the observations and calculations which would in theory reveal the dimensions of the universe, and his reasoning is not invalidated in principle by his wrong factual assumptions (that the earth is flat, that the sun is attached to the sky).

"If you wish to know the measurements of width and length to east, west, north, and south, set up four gnomons to make a right-angled figure one *li* square (ABCD). Ten or more days before the spring or autumn equinox, aligning along the gnomons on the north side of the square (AB), watch the sun from its first emergence to full sunrise, and wait until it coincides with them (ABS). When it does coincide, they (AB) are in line with the sun. On each occasion, aligning along the gnomons on the south side (DC) watch it and take the measurement inward from the gnomon ahead (CX) as divisor. <. . . . ?> Divide by it the length between the standing gnomons [i.e., divide 1 *li* by CX] in order to know the measurements to east and west from here.

"Supposing that you observe the sun rise one inch inwards from the gnomon ahead (CX), that is to get one *li* to an inch. One *li* amounts to 18,000 inches, so from here eastwards you get 18,000 *li*. Observing the sun just as it sets, if it is half an inch inwards from the gnomon ahead, you get one *li* to half an inch. Dividing the number of inches amounting to one *li* by half an inch you get 36,000 *li*. By the division you have the measurement in *li* from here westwards. Adding them you have the measurement in *li* eastwards and westwards, which is the extreme diameter."[27]

The measurements of one inch and of half an inch are thus

hypothetical (and of course impossible in practice at such a distance), and so is the estimate of 18,000 + 36,000 = 54,000 *li* for the diameter of the universe. The document ends with a proposal for calculating the height of the sky by the same method which Eratosthenes (276–196 B.C.) in Greece used to measure the Earth.

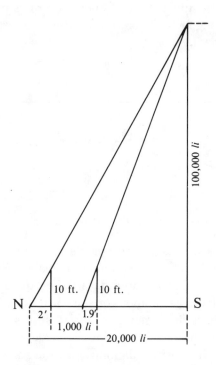

"If you wish to know the height of the sky, plant gnomons 10 feet high 1,000 *li* apart due north and south. Measure their shadows on the same day. If that of the north gnomon is 2 feet and the south gnomon 1.9, it follows that every 1,000 *li* further south the shadow shortens by 0.1 and 20,000 *li* south there is no shadow, which is being directly under the sun.

"At the position where you have a height of 10 feet to a shadow of 2 feet, the height is 5 times the distance southwards; so if you take the number of *li* from here to the position under the sun and multiply by 5, making 100,000 *li*, you have the height of the sky. Supposing a place where shadow and gnomon are equal, height and distance will be equal."

The fourth discipline: argumentation (knowledge of names)

The fourth discipline is the only one without a counterpart among the four sources of doubt, presumably because its necessity is not obscured by the possibility of coinciding conditions. ("The 'necessary' admit and do not doubt").[28] We do not know the names of the rest of the Mohist disciplines, although one may speculate that, for example, the first would be *lun* 論, the ordinary word for the ordered discourse which sorts things out into their grades or categories. But it seems clear that in the *Canons* (although not in *Names and Objects*)† the fourth is *pien*, the arguing out of alternatives to decide which is 'this', the right one, and which 'not this', the wrong one. It is defined in terms of a word probably to be identified with *fan* 仮 'converse', a Mohist coinage which we have met already.[29] This is used, for example, of the coin as price of the grain having as converse the grain being the price of the coin.[30] Assuming this identification, the Mohist thinks in terms, not of 'is *x*' and 'is not *x*' as contradictories, but of naming something '*x*' having as converse naming everything else 'non-*x*'.

> A73 *(Canon)* "'Converse' is if inadmissible then on both sides inadmissible.
> *(Explanation)* The oxen, and non-oxen separated off, will in all cases make two sides.* If without what one judges by, they are not."
>
> A74 *(Canon)*. "'Argumentation' is disputing over the converse. To win in argumentation is to fit the fact.
> *(Explanation)*. "One calling it 'ox' and the other 'non-ox' is disputing over the converse. In this they do not both fit the fact, and if they do not both fit necessarily one of them does not fit (Not like fitting 'dog')."

This definition implies what we would call the principle of the excluded middle. Once a name is adopted, whatever the object to which you apply it, it necessarily either fits it or not. The test would be whether it fits the standard for the name; the definition of 'standard' whch we quoted elsewhere[31] comes from the same sequence on argumentation. To Chuang-tzu's claim that there is no victory in argument[32] the Mohist

† Argumentation as described in *Names and Objects* 6 covers all the disciplines.

* The translation in G *ut sup.* 318 is here revised in the light of the grammatical study of *fan* 凢 in Harbsmeier *Aspects* 153–165.

replies that in argumentation in its strict sense it is necessary that one and only one of the two claims fits the fact. It is "not like fitting 'dog'", when the question is whether the object is a whelp or a dog.

> B35 *(Canon)* "To call argumentation 'without winner' necessarily does not fit the fact. Explained by: argumentation.
>
> *(Explanation)* It is called either the same thing or different things. If the same thing one calling it 'whelp' and the other 'dog', or if different things one calling it 'ox' and the other 'horse', and neither fitting the fact, is failure to engage in argumentation. In 'argumentation', one calls it this, the other not this, and the one who fits the fact wins."

For the Mohist, to say that there is no victor in argumentation is to apply the complex name 'without winner' to the objects which are instances of argumentation. Consequently, he sees all issues as of 'this/not this' on the analogy of 'ox/non-ox'. As for the logical relations between names, he speaks of them as 'following from each other' or 'excluding each other', or says that 'one cannot be dismissed without the other',[33] but shows no interest in logical forms. Although well aware of the difficulties of relating names to objects in the art of discourse, he seems to see the lucid and self-evident relations between names as raising no theoretical problems. Chinese civilization never abstracted the forms in which we observe it reasoning in practice, as in this curiously familiar-sounding syllogism of Wang Ch'ung (A.D. 27–c. 100):

"Man is a thing; though honoured as king or noble, by nature he is no different from other things. No thing does not die, how can man be immortal?"[34]

It may be noticed that in the *Canon* defending argumentation the Mohist does not say that Chuang-tzu's claim is false but that it "does not fit-the-fact (*tang* 當)." *Tang* 'be plumb with' is his usual term for the name 'fitting' the object or in general for words 'fitting the fact'. Its correspondance with our own word 'truth' is however limited to the connecting of names with objects; a name in combination with other names is judged 'admissible' (*k'o* 可), like "A white horse is not a horse" at the start of Kung-sun Lung's dialogue. For anyone bored with the ambiguities and complications of Truth it is refreshing to be introduced to this alternative terminology, in which one can, so to speak, pronounce '2 and 2 make 4' to be valid and 'Paris is in France' to be a fact without ever having to bother about truth. Of other terms related to our Truth, being 'this' or 'so' is affirmed not of words but of things, and *hsin* 信 'trustworthy' of the relation of words not to the things but the speaker's thought:

Names and Objects 13. "A thing in some cases is this and it is so, in others is this but it is not so. . . . "

A14 *(Canon)* " 'Trustworthiness' is the saying agreeing with the idea."

Besides the interlocking definitions, the occasional examples of fully developed demonstrations in the fourth discipline confirm that the Later Mohist has that combination of the sense of rigorous proof with indifference to logical forms which characterised Western science between the decline of scholasticism and the 19th-century revival of logic. The following examples resolve the problems of whether the doctrine of 'concern for everyone' is reconcilable with the possibility that the cosmos is infinite and inhabited by an infinite number'of men, and whether it is reconcilable with ignorance of the number of men.

B73 *(Canon)* "Their being limitless is not incompatible with it being for every one of them. Explained by: whether it is filled or not.

(Explanation) (Objection) The south if limited is exhaustible, if limitless is inexhaustible. If whether it is limited or limitless is not yet knowable, then whether it is exhaustible or not, whether men fill it or not, and whether men are exhaustible or not, are likewise not yet knowable, and it is inconsistent to treat it as necessary that concern for men may exhaust them.

(Refutation) If men do not fill the limitless, men are limited, and there is no difficulty about exhausting the limited. If they do fill the limitless, the limitless has been exhausted, and there is no difficulty about exhausting the limitless."

B74 *(Canon)* "Without knowing their number one knows that it is for all of them. Explained by: the questioner.

(Explanation) If they ar two, we do know their number. In 'How do we know that concern for the people extends to both of them?', some of the people are left out of the question. If his question is about all men, concern is for all whom he asks about."

In both *Canons* the logical issues involved in the defence of concern for everyone are detached and formulated without reference either to men or to concern. In the *Explanations* most of the key words have already been defined in the senses understood, 'limit', 'fill', 'exhaust', 'know', 'necessary',[35] not to mention the lost definitions of the words in *chien ai* 'concern for everyone'. In the first *Explanation* the objector sees clearly that his argument cannot establish more than that since the number of men may be infinite the possibility of universal concern "cannot be treated as necessary". But this is enough to require an answer, since it is the dearest conviction of the Later Mohists that their moral concepts *are* logically

necessary. The objector no doubt knows the now-lost arguments for both sides of Hui Shih's "The south has no limit yet does have a limit", but sees that for purposes of his argument it is sufficient to affirm that "whether it is limited or limitless is not yet knowable" (not knowable *a priori*, the opposite of 'known beforehand').[36] The Mohist in his turn narrows his answer to the crucial point that "there is no difficulty about exhausting the limitless", which he proves very neatly in two sentences.*

3. FROM YANGISM TO CHUANG-TZU'S TAOISM: RECONCILIATION WITH HEAVEN BY RETURN TO SPONTANEITY

The name 'Taoism'

Chuang-tzu is traditionally classed as the second great Taoist, after Lao-tzu, the supposed contemporary of Confucius. However, the book *Lao-tzu* is unattested until about 250 B.C., much later than the King Hui of Liang (370–319 B.C.) who had Chung-tzu's friend Hui Shih as minister. Moreover the two books differ considerably in thought, and it was some time before they came to be classed together. *Chuang-tzu* is the one ancient collection of writings of and for outsiders who preferred private life to office, while *Lao-tzu*, although attractive to the same readership, presents itself as another guide to the art of rulership. The two names were not at first associated; Hsün-tzu mentions them separately in different lists of philosophers,[1] and the classification of five schools in the 'Below in the Empire' chapter of *Chuang-tzu* puts them apart in fourth and fifth places. The Taoist school, like all the others except the Confucian and Mohist, is a retrospective creation, and the most confusing of them all.

The mystical statecraft of *Lao-tzu* quickly attracted the attention of the Legalists and already influenced Han Fei (died 233 B.C.).[2] Of the varieties of *Lao-tzu*-centred syncretism competing for acceptance at court from the rise of Han in 206 B.C. the most influential at first was called 'Huang-Lao' after Lao-tzu and the Yellow Emperor (Huang-ti). Little was known of it until the discovery in an early Han tomb at Ma-wang-tui of a manuscript of *Lao-tzu* with attached documents connected with the Yellow Emperor. With this new evidence we can recognise the doctrine as a fusion of Legalism with the teaching of *Lao-tzu*, the latter still not associated with Chuang-tzu. Since the Yellow Emperor was the legendary inventor of the

* For other demonstrations from the fourth discipline, see pp. 84f, 140f above, pp. 183–86 below.

state and of war (denounced as such in certain chapters of *Chuang-tzu*),[3] he was presumably chosen to give ancient authority to the Legalist strand.

With the classification of the Six Schools by the court historiographer Ssu-ma T'an (died 110 B.C.) we arrive at last at the Taoist School, the *Tao-chia* 'School of the Way'. The historiographer, who prefers it to the other schools, evidently understands by it the *Lao-tzu*-centred syncretism of his own time. As a court official he is classifying schools by their respective advantages and disadvantages as guides to statecraft, and he would not be counting Chuang-tzu among the thinkers who really matter. However, with the full apportioning of philosophers among a finite number of schools there would be no room for Chuang-tzu except in the Taoist, and this is where he appears in the bibliographical chapter of the *Han History*. The *fang shih* 方士 'men of secret arts' who, using the Yin-Yang cosmology, were promising Emperors the secret of immortality, would be classed by Ssu-ma T'an not as Taoist but as 'School of Yin and Yang.' It seems however that Huang-Lao was already absorbing Yin-Yang, and that the appeals to the Yellow Emperor and Lao-tzu throughout the later literature of alchemy, medicine, and magic go back to this period, when these names carried special authority at court. That the tendencies gathering around *Lao-tzu* were coming to centre on the elixir of life implies that Chuang-tzu was still seen as marginal, reconciliation with death being at the very heart of his philosophy. It is from about A.D. 200, with the breakdown of the Han and a new period of political disunion and disillusion, that the School of the Way ceases to be judged primarily by its relevance to government, and Chuang-tzu comes into his own. From this time *Chuang-tzu* with the commentary of Kuo Hsiang (died c. A.D. 312) stands in the classical literature beside *Lao-tzu* with the commentary of Wang Pi (A.D. 226–249) as one of the classics of philosophical Taoism.

In the sub-culture despised by the literati, the fusion of Huang-Lao and Yin-Yang mingling with folk belief generated the popular religion called *Tao-chiao* 'Doctrine of the Way', the foundation of which by Chang Tao-ling is traditionally dated to A.D. 142. Here we do find a persisting organisation, not indeed a philosophical school, but a church of which the sects to the present day trace their ancestry to Chang Tao-ling. Michel Strickmann has proposed to clear away confusions by confining the label 'Taoist' to this religion, which was long dismissed by scholars as a degenerate descendant of the noble philosophy of Lao-tzu and Chuang-tzu, but is nowadays studied on its own terms as the indigenous religion of China over nearly two millenia.[4]

Beyond the generalisation that since the victory about 100 B.C. of Confucianism, which is public, respectable, conventional and practical,

that other side of Chinese culture which is private, disreputable, magical, spontaneous, poetic, has tended to cohere around the name of Lao-tzu, it would be pointless to look for features common to everything called Taoism. However, Strickmann himself acknowledges that we cannot quite dispense with the term 'philosophical Taoism' for the thought of *Lao-tzu* and *Chuang-tzu* (and also, one may add, of later writings primarily inspired by them, such as *Lieh-tzu*, forged in the name of a pre-Han sage about A.D. 300). In spite of the differences between anti-political *Chuang-tzu* and political *Lao-tzu*, their retrospective classification under the School of the Way is by no means groundless. They do share one basic insight, that while other things move spontaneously on the course proper to them, man has separated himself from the Way by reflecting, posing alternatives, and formulating principles of action. This has generally impressed Westerners as the most remarkable, the most distinctively Chinese, of the exportable thoughts of ancient China. One might try coining a new name for it, perhaps inclusive of Ch'an or Zen, its continuation in Chinese Buddhism, but the name under which it has long passed among us is Taoism. It does not follow however that we have to look for any direct link between Chuang-tzu and the author of *Lao-tzu*. Philosophical Taoism as a retrospective classification is like, for example, the 20th-century coinage 'Existentialism'; to think of Lao-tzu as founder and Chuang-tzu as his heir (or the reverse) is as though, having chosen Kierkegaard and Nietzsche as the first Existentialists, one were to assume that Nietzsche was Kierkegaard's disciple. In any case a historian of Chinese thought must retain the same liberty to reshuffle names as when we push Kierkegaard temporarily into the background and shift Nietzsche and Heidegger to the ancestral line of hermeneutics, perspectivism, and deconstruction.

The book 'Chuang-tzu'

As a full-length book for the individual who wants to live his own life free of the burdens of office *Chuang-tzu* is unique in pre-Han literature. It does contain passages on the art of government, but these are in the manner of early Han syncretism, and probably come from the compilers in the 2nd century B.C. The book is in effect an anthology of writings with philosophies justifying withdrawal to private life, passing under the name of their greatest representative, and including a batch of chapters which are not Taoist at all but Yangist. Without going deeply into its textual problems,* we may distinguish five main elements.

* I shall be assuming the conclusions of my textual study of *Chuang-tzu* in *Studies* 283–321.

(1) Writings of Chuang-tzu (c. 320 B.C.)

(2) Writings classable only as 'School of Chuang-tzu'.

(3) The essays of a writer we here label the 'Primitivist', datable with unusual precision to the period of civil war between the fall of Ch'in and victory of Han, between 209 and 202 B.C.

(4) The Yangist chapters, from in or near the same period.

(5) The final Syncretist stratum, 2nd century. B.C.

The collection as it has come down to us, in an abridgement by the commentator Kuo Hsiang (died c. A.D. 312), is organised in three parts:

(1) The 'Inner Chapters' (chs. 1–7), collections of sayings, dialogues, verses, stories, brief essays, each grouped around a topic summed up in the chapter title. All bear the individual stamp of a thinker and writer of genius, commonly recognised as Chuang-tzu himself. It is likely that he left nothing but disordered jottings, which have been grouped in chapters by later editors.

(2) The 'Outer Chapters' (chs. 8–22), entitled arbitrarily by words taken from the first sentence. These start with the Primitivist essays, which end in the middle of chapter 11; the rest are 'School of Chuang-tzu' with Syncretist interludes.†

(3) The 'Mixed Chapters' (chs. 23–33), entitled like the 'Outer' from the opening words, except for the block of Yangist chapters (chs. 28–31), which have titles summing up the content. The book ends with the Syncretist 'Below in the Empire' (ch. 33), the earliest history of the schools. The remaining chapters (chs. 23–27, 32) are ragbags of odds and ends, many so badly fragmented as to suggest the assembling of broken or misplaced items from the scrolls of bamboo strips on which Chinese books were written before the discovery of paper. A good deal of *Chuang-tzu* is unintelligible in the present state of scholarship, and in these chapters much is likely to remain so. But they include considerable patches which look like authentic jottings of Chuang-tzu himself, judged too fragmented for inclusion in the 'Inner Chapters'.**

Chuang-tzu has had several English translators (including Giles, Legge, Burton Watson, and for four-fifths of the book, myself), and with the further progress of scholarship will deserve more. A disadvantage is that most translators have treated this extraordinary medley as what we

† I identify as Primitivist *Cz* chs. 8–11/28, 12/95–102 and probably 14/60–74 (translated together *Cz* tr. G 200–217); as Syncretist chs. 11/66–12/18, 13/1–45, 60–64, 14/1–5, and ch. 15, as well as ch. 33 in the 'Mixed Chapters' (translated together, *Cz* tr. G 259–285).

** Passages likely to be by Chuang-tzu include *Cz* 23/42–44, 52–67, 72–74; 24/38–48, 61–65, 88–98, 101–111; 25/15–20, 33–38, 51–59; 26/31–33; 27/1–21 (translated together, *Cz* tr. G 100–111).

nowadays understand by a *book*, divided into chapters to be paragraphed as continuous prose and reproduced complete whether or not consecutive or even intelligible, smoothing the breaks, reducing the verse to prose. This works only for integral chapters such as the Primitivist essays; elsewhere it can give the dangerously misleading impression that a thinker in brief intense bursts, like Nietzsche or the Blake of *Marriage of Heaven and Hell*, is an amiably rambling old wiseacre continually forgetting what he is talking about.

Stories about Chuang-tzu

Ssu-ma Ch'ien records of Chuang Chou (Chuang-tzu) that he lived in the reigns of Kings Hui of Liang or Wei (370–319 B.C.) and Hsüan of Ch'i (319–301 B.C.), came from the district of Meng in the present province of Honan, and held a minor post there at Ch'i-yüan ('Lacquer Garden') which he abandoned for private life.[5] The account finishes with a story of him refusing to be made Prime Minister by King Wei of Ch'u (339–329 B.C.). *Chuang-tzu* has other such tales, not to be taken seriously as history, but giving vivid glimpses of how hermits revenged themselves in imagination against the worldly.

"Chuang-tzu was fishing in P'u river. The King of Ch'u sent two grandees to approach him with the message:

'I have a gift to tie you, my whole state.'

Chuang-tzu, intent on the fishing-rod, did not turn his head.

'I hear that in Ch'u there is a sacred tortoise', he said, 'which has been dead for three thousand years. His Majesty keeps it wrapped up in a box at the top of the hall in the shrine of his ancestors. Would this tortoise rather be dead, to be honoured as preserved bones? Or would it rather be alive and dragging its tail in the mud?'

'It would rather be alive and dragging its tail in the mud.'

'Away with you! I'll drag my tail in the mud.'" (Cz 17/81–84, tr. G 122)

Other stories have him weaving sandals for a living in a back street, or being seen by a king in a patched gown and shoes tied up with string, and answering the condescension of successful men of the world with repartee which might well be treasured for a future occasion by hermits in the same straits.[6] The tales are not, however, like those of Lao-tzu in the same book, exemplary stories about the archetypal Taoist sage; they suggest rather the anecdotes which gather round a person of striking personality, Oscar Wilde, Einstein, Winston Churchill. We have already quoted a couple about Chuang-tzu and his friend Hui Shih.[7] Here is another, which

suggests that however much he mocks Hui Shih's logic it was in their clash of minds that his own anti-rationalist position defined itself.

"Chuang-tzu, among the mourners in a funeral procession, was passing by the grave of Hui Shih. He turned round and said to his attendants

'There was a man of Ying who, when he got a smear of plaster no thicker than a fly's wing on the tip of his nose, would make Carpenter Shih slice it off. Carpenter Shih would raise the wind whirling his hatchet, wait for the moment, and slice it; every speck of the plaster would be gone without hurt to the nose, while the man of Ying stood there perfectly composed.

'Lord Yüan of Sung heard about it, summoned Carpenter Shih and said "Let me see you do it." "As for my side of the act", said Carpenter Shih, "I did use to be able to slice it. However, my partner has been dead for a long time."

'Since the Master died, I have had no one to use as a partner, no one with whom to talk about things.' " (Cz 24/48–51, tr. G 124)

Besides the mockery of logic there is much else to connect the person in the stories with the voice we hear in the 'Inner Chapters', the humour, poetry and fascination with birds, animals, and trees, and such themes as the value of uselessness, violation of the funeral rites which for Chinese are the most sacred of all, and above all the lyrical, ecstatic acceptance of death—extravagances and irreverences almost absent even in the 'Outer' and 'Mixed' chapters of the same book.

"When Chuang-tzu's wife died, Hui Shih came to condole. As for Chuang-tzu, he was squatting with his knees out, drumming on a pot and singing.

'When you have lived with someone', said Hui Shih, 'and brought up children, and grown old together, to refuse to bewail her death would be bad enough, but to drum on a pot and sing—could there be anything more shameful?'

'Not so. When she first died, do you suppose I was able not to feel the loss? I peered back into her beginnings; there was a time before there was a life. Not only was there no life, there was a time before there was a shape. Not only was there no shape, there was a time before there was the *ch'i*. Mingled together in the amorphous something altered, and there was the *ch'i*; by alteration in the *ch'i* there was the shape, by alteration of the shape there was the life. Now once more altered she has gone over to death. This is to be companion with spring and autumn, summer and winter, in the procession of the four seasons. When someone was about to lie down and

sleep in the greatest of mansions, I with my sobbing knew no better than to bewail her. The thought came to me that I was being uncomprehending towards destiny, so I stopped.'" (Cz 18/15–19, tr. G 123f).

We cannot expect to learn from such anecdotes what we most want to know about the life of a thinker, the course of his development. There is however one story which differs from the rest in showing Chuang-tzu in doubt and changing his mind. He is poaching in the game reserve at Tiao-ling; he is taking aim at a huge magpie which does not see him because it is intent on a mantis which itself has eyes only for a cicada resting in the shade.

"'Hmm!' said Chuang-tzu uneasily. 'It is inherent in things that they are ties to each other, that one kind calls up another.'" (Cz 20/61–68, tr. G 118)

He throws down his crossbow and as he runs away notices that he in his turn has been seen by the gamekeeper. Afterwards he is troubled for three days. This episode, which is full of Yangist-sounding phrases ("ties to each other," "forgetting his genuineness," "preserving the body"), may be read as his awakening from the Yangist illusion that one can win security by avoiding ties with other things, his first step to reconciliation with the dissolution of personal identity in universal process.

The assault on reason

Like all great anti-rationalists, Chuang-tzu has his reasons for not listening to reason. He develops them in pieces mostly assembled in the second of the 'Inner Chapters', 'The Sorting Which Evens Things Out', a scattered series of notes which conveys more than anything else in ancient Chinese the sensation of a man thinking aloud. We see from it how Chuang-tzu learned from, in course of defying, his rationalistic mentor Hui Shih. The ten theses of Hui Shih may be read as paradoxes showing that all division leads to contradiction and therefore everything is one, a conclusion intended to justify the Mohist doctrine of 'concern for everyone'. But if this is his intention he has come dangerously near to discrediting his own tool, analytic thinking. He wishes to discredit only spatio-temporal distinctions, but it will take only one more step to observe that to analyse *is* to make distinctions, and dismiss reason for the immediate experience of an undifferentiated world, transforming 'All are one' from a moral to a mystical affirmation.

In the terminology of argumentation, as we have met it in the *Canons*, a thing or state of affairs either 'is-this' (*shih*), for example a horse, or 'is-not'

(fei), and it is either 'so' (jan) or not so that one rides the horse. These demonstratives call attention, as English 'true' does not, to the point that the relation affirmed is between objects and man-made names open to change and to disagreement. As near demonstratives they also suggest that we approve or reject in terms of nearness to or distance from ourselves. That names have a merely conventional relation to objects was being taken for granted by Hsün-tzu in the next century, and what was to become its stock illustration, a joke about a merchant who tries to buy undressed jade (p'u in Cheng dialect) and is offered rat-meat (p'u in Chou dialect), turns up soon afterwards.* But in Chuang-tzu one enjoys the shock of the discovery when it was still new, the apparent overthrow of all received ideas when it is first seen that in principle anything might be called anything.

"Said Chuang-tzu

'If archers who hit what they haven't fixed ahead as the target were to be called good archers, everyone in the world would be as great an archer as Yi—admissible?'

'Admissible,' said Hui Shih.

'If the world has no common "this" for "It's this", and each of us takes as this what is this for him, everyone in the world is as great a sage as Yao—admissible?'

'Admissible.'

'Then of the four doctrines of the Confucians and Mohists, Yang and Ping,** which with your own, sir, make five, which is really *this*?' " (Cz 24/38–41, tr. G 101)

The term 'fix ahead' (ch'i 期) was commonly used of agreeing in advance on a name in argumentation.† But it was undeniable, for example, that the first two schools mentioned differ radically on the definition of the moral term on which their conflicts centre, yi 'the right'. Confucians understood it as conduct fitting to one's position in family and state, Mohists redefined it from their utilitarian standpoint as the beneficial.[8] Nor could they simply adjust to each other's viewpoints as they might when buying jade and being offered rat-meat. Each in judging

* Cf. G. *Studies* 338 n32. The story of the misunderstanding of *p'u* is first attested in *Shih-tzu* B, 7B and *Chan-kuo-ts'e* (Ch'in 3) 1/44, tr. Crump, 113.

** Ping has not been firmly identified.

† This use of *ch'i* appears seven times in Hsün-tzu's 'Correction of Names'. Cf. also Cz 17/22, 24, 22/44, 25/67 and LSCC (ch. 18/5) Hsü 18/16A. It is not in the Later Mohist terminology.

by his 'this' or 'not this' assumes an absolute viewpoint which is 'here' for everyone. But is there even real disagreement between debaters who are only using 'this' in relation to distance from themselves? This suggestion astounds Hui Shih:

"Just now those Confucians and Mohists, Yang and Ping, are challenging me in argumentation. We formulate sentences to refute each other, shout to browbeat each other. Are you seriously suggesting that they have never denied my position?".

Chuang-tzu replies with what seem to be examples of quarrels caused by misunderstandings over words, but with the loss of the stories to which he alludes we lose track of him at this point.[9] In one of his many aspects he is himself a true sophist, fascinated by the subversion of received opinions and intoxicated by the plunge which imperils rationality in the course of discovering its possibilities. He is also, even in the flow of reason itself, a poet who changes course as new insights explode, elliptical even when most logical. One of his persisting thoughts is that in accepting what fits in with one's ideas as 'this' and rejecting what does not, analytic thinking lights up only a lesser whole around the thinker and casts the rest into darkness. (Chinese shares our familiar visual metaphor, using *ming* 明 'bright', written with a graph combining sun and moon, for clarity of understanding as well as of eyesight or of a mirror.).

"Saying is not blowing breath, saying says something; the only trouble is that what it says is never fixed. Do we really say something? Or have we never said anything? If we think it different from the twitter of fledgelings, is there a proof for argumentation? Or isn't there any proof? By what is the Way obscured, that there should be a genuine or a false? By what is saying obscured, that sometimes 'It's this', sometimes 'It's not'? Wherever we walk how can the Way be absent? Wherever saying is present how can it be inadmissible?

"The Way is obscured by formation of the lesser, saying is obscured by its foliage and flowers. Consequently we have the 'It's this, it's not' of Confucians and Mohists, by which what for one is this for the other is not, what for one is not for the other is. If you wish to affirm what they deny and deny what they affirm, the best means is illumination." (Cz 2/23–27, tr. G 52)

Chuang-tzu, for whom all things are in flux, defying our efforts to fix them by naming, finds a universal significance in Hui Shih's paradox "Simultaneously with being at noon the sun declines, simultaneously with being alive a thing dies"; in change, contradictories are admissible in

the same moment. He thinks too that we do regularly what for the Mohists was a special case, naming the whole by the part one chooses to 'go by' (*yin* 因 , which in its nominal usage we translate 'criterion').[10]

"No thing is not that, no thing is not this. If you make yourself 'that' they do not appear, if you know of yourself you know of them. Hence it is said:

'That comes out from this, this likewise goes by that', the opinion that that and this are born simultaneously. However, 'Simultaneously with being alive one dies', and simultaneously with dying one is alive. The admissible is simultaneously inadmissible, the inadmissible is simultaneously admissible. What going by something is this going by something is not, what going by something is not going by something is this. This is why the sage does not take this course, but opens them up to the light of Heaven; his too is the 'This' according to what one goes by'." (Cz 2/27–29, tr. G 52)

"This too is that, that too is this. There they say 'It's this, it's not' from one point of view, here we say 'It's this, it's not' from another point of view. Are there really this and that? Or really no this and that? Where neither this nor that finds its opposite is called the axis of the Way. When once the axis is found at the centre of the circle there is no limit to responding with either, on the one hand no limit to what is this, on the other no limit to what is not. Therefore I say 'The best means is illumination'." (Cz 2/29–31, tr. G 53)

Not only does it depend on viewpoint which of alternatives you pick as 'this', it is a matter of convenience where you draw the line and whether you draw it at all. Why then go to the trouble of arguing with Kung-sun Lung over the problems of the white horse and of pointing out from the whole?* From the ultimate viewpoint, where dividing has not yet begun, the cosmos is the horse and there are no divisions of it to be horses.

"Rather than use the pointed-out to show that 'to point out is not to point it out', use what is *not* the pointed-out. Rather than use the horse to

* There is a chronological difficulty about taking Chuang-tzu to be directly criticising Kung-sun Lung, who was a client of the Lord of P'ing-yüan (died 251 B.C.). The sophisms may be older than Kung-sun Lung, who in any case on our interpretation is not defending but refuting the thesis that 'to point out is not to point it out' (cf. pp. 90–94 above). The difficulty is not insuperable if Chuang-tzu was old enough and Kung-sun Lung young enough. However, Kung-sun Lung is never mentioned in the book except in the historical 'Below in the Empire' chapter and in an 'Outer Chapter' story of the sophist overwhelmed when he "hears the words of Chuang-tzu" (Cz 17/65–81 tr. G 154–156)—but not necessarily from Chuang-tzu's own mouth.

show that 'a horse is not a horse' use what is *not* a horse. Heaven and earth are the single pointed-out, the myriad things are a single horse." (Cz 2/31–33, tr. G 54)

"The knowledge of the men of old had arrived at something—at what had it arrived? There were some who thought there had not yet begun to be things—the utmost, the exhaustive, there is no more to add. The next thought there were things but there had not yet begun to be borders. The next thought there were borders to them but there had not yet begun to be 'It's this, it's not'. The lighting up of this and not this is the reason why the Way becomes deficient." (Cz 2/40–42 tr. G 54)

Chuang-tzu shares that common and elusive feeling that the whole is more than the sum of its parts, that analysis always leaves something out, that neither side of a dichotomy is wholly true.

"To 'divide', then, is to have something undivided; to 'argue out alternatives' is to have something which is neither alternative. 'What?', you ask. The sage keeps it in his breast, common men argue it out to show it to each other. Hence I say, to 'argue out alternatives' is to have something you fail to see." (Cz 2/57f, tr. G 57)

In Chuang-tzu's flashes of elliptical argument he once tries to pin down what it is that the dichotomies leave out. The art of argumentation, as defined in the *Canons*,[11] assumes that if you add non-oxen to oxen there is nothing left over.

"Now suppose that I speak of something, and do not know whether it is of a kind with *this* or not of a kind. If those of a kind and those not of a kind are treated as of a kind with each other, there will no longer be any difference from *that*." (Cz 2/47f, tr. G 55).

But before the beginning of things there were neither oxen nor non-oxen. Can we, by a further negation and addition, incorporate this remainder into the totality?

"However, let's try to say it. There is 'beginning', there is 'not yet having begun the having a beginning'."

But in saying this retrospectively we speak as though things were somehow present before they began, and a further negation in the same form leads only to an infinite regress:

"—There is 'there not yet having begun to be that "not yet having begun the having a beginning"'."

It is also common to oxen and non-oxen that they are 'something' in contrast with 'nothing' (the Chinese words are the nominalised existential verbs *yu* 有 there is' and *wu* 無 'there is not'). As empty space nothingness is a measurable part of cosmos; can we arrive at the totality by adding Nothing to Something? Chuang-tzu, as do Taoists in general when they

do not simply equate the Way with Nothing, thinks of Something and Nothing as dividing out of a whole which is neither one nor the other ("Who knows that Something and Nothing, death and life, have a single ancestor? He shall be my friend.")[12] So the result is the same infinite regress:

"There is 'something', there is 'nothing'.

—There is 'there not yet having begun to be nothing'.

—There is 'there not yet having begun to be that "there not yet having begun to be nothing" '."

In any case there was a contradiction at the start, in saying 'There is nothing' (*yu wu* 'There is what there is not').

"All of a sudden *there is* nothing, and we do not yet know of something and nothing really which there is and which there is not. Now for my part I have already referred to something, but do not yet know whether my reference really referred to something or really did not refer to anything."

If all division leads to contradiction must there not be at least one admissible statement, that everything is one? That had been Hui Shih's last thesis. Chuang-tzu, in a characteristic move, first restates it in the most rhapsodic of his styles, then refutes it like Plato discussing the One and its name in *The Sophist*.

"Nothing in the world is bigger than the tip of an autumn hair, and Mount T'ai is small; no one outlives the cut-off in childhood, and P'eng-tsu died young; heaven and earth were born together with me, and the myriad things and I are one.

—Now that we are one, can I still say something? Already having called us one, did I succeed in not saying something? One and the saying make two, two and one make three. Proceeding from here even an expert calculator cannot get to the end of it, much less a plain man. Therefore if we take the step from nothing to something we arrive at three, and how much worse if we take the step from something to something! Take no step at all, and the ' "This" according to what you go by' comes to an end." (Cz 2/51–55 tr. G 56)

Chuang-tzu never does say that everything is one, always puts the thought subjectively, as the sage treating as one.*

In one dialogue a sage is pressed to acknowledge that there must be something that he knows:

" 'Would you know something of which things agreed "It's this"?'

* Cf. Cz 1/32, 2/35–37, 5/7f, 12 tr. G 46, 53, 77 An 'Outer Chapter' story has the Yellow Emperor stating flatly that "the myriad things are the One" (Cz 22/12, tr. G 160). But the point of this story is that the Yellow Emperor is himself aware of being remote from the Way because he puts it into words.

'How would I know it?'

'Do you know what you do not know?'

'How would I know it?'

'Then does no thing know anything?'

'How would I know it? However, let me try to say it—"How do I know that what I call knowing is not ignorance? How do I know that what I call ignorance is not knowing?"'" (Cz 2/64–67, tr. G 58)

The point of the first answer is presumably that what from no viewpoint is 'that' could not be judged 'this'. But does one not at least know what it is one does not know? Another contradiction, or so Chuang-tzu thinks, like Meno in Plato's dialogue. Then doesn't one know that no thing knows anything? A third contradiction. The only consistent formulation is by the question casting doubt.

Chuang-tzu attacks our faith in knowledge from other directions. Why do we trust the heart, the organ of thought, and allow it to take charge of the body? Isn't it merely one of many organs each with its own function within an order which comes from outside us, that Way to be walked which it vainly tries to fix in rules of conduct?

" 'Without 'that' there is no 'I', without 'I' no choice between alternatives.'

"This is somewhere near it, but we do not know in whose service they are being employed. It is as though there were something genuinely in charge, and the only trouble is that we cannot find a sign of it. That it can be walked is true enough, but we do not see its shape; it has identity (ch'ing) but no shape. Of the hundred joints, nine orifices, six viscera all present and complete, which should I recognise as more kin to me than another? Are you people pleased with them all? Rather, you have a favourite organ among them. On your assumption, does it have the rest of them as its vassals and concubines? Are its vassals and concubines inadequate to order each other? Isn't it rather that they take turns as each other's lord and vassals? Or rather than that, they have a genuine lord present in them. If we seek without success to grasp its identity, that never either adds to or detracts from its genuineness." (Cz 2/14–18 tr. G 51)

There is another reason why that question 'How do I know that what I call knowing is not ignorance?' is unanswerable, which Chuang-tzu introduces twice in almost the same words:

"Said Chuang-tzu to Hui Shih

'Confucius by the age of sixty had sixty times changed his mind; whenever he began by judging "It's this" he ended by judging "It's not".

We do not yet know of anything we now affirm that we shall not deny it 59 times over.'" (Cz 27/10f cf. 25/51–54 tr. G 102)

The Later Mohist defence of reason

We found it convenient to discuss the Later Mohists before Chuang-tzu, to provide an advance picture of the kind of disputation which he assails. But some at least of the *Canons* are later than Chuang-tzu, and several propositions of the fourth discipline defend argumentation against criticisms to be found in his writings. They do not name him, but the *Canons* always do discuss theses impersonally and on their merits, without naming their advocates. We have then a continuing controversy over the place of reason, in which Chuang-tzu answers Hui Shih and is in turn answered by the Mohists. For anyone who wants to estimate how near Greek and Chinese philosophy came to each other, and how and why they diverged, this debate is of central importance. Of the three parties, we cannot do justice to Hui Shih, whose writings are lost; but for the Mohists we have fully developed demonstrations in their own words.

We have already quoted the *Canon*[13] which explains that in strict argumentation there is by definition (by the *Mohist* definition, Chuang-tzu would say!) necessarily a winner. The target was perhaps this passage on winning in disputation.

"You and I having been made to argue over alternatives, if it is you not I that wins, is it really in your case that 'it's this', in mine that 'it's not'? Or if it is I not you that wins, in my case that 'it's this', in yours that 'it's not'? Is one of them *this* and the other not? Or are both *this* or both not? If you and I are unable to know it of each other, other people will surely be in the dark because of us. Whom shall I call in to decide it? If I get someone of your party or of mine to decide it, being already of your party or of mine how can he decide it? If he's of a party different from or the same as both of us, being already of a different or the same how can he decide it? So you and I and he are all unable to know it of each other, and shall we find someone else to depend on?" (Cz 2/84–90, tr. G 60)

The Mohist as we saw answers that strict argumentation is confined to issues of the type 'ox and non-ox', in which one alternative necessarily fits the object and the other not. As for the relativity of the demonstratives used in judgments, the Mohist finds it irrelevant as long as the difference between the alternatives is maintained.

B68 *(Canon)* "You cannot treat here as there without reversing here

and there. Explained by: their difference.

(Explanation) In correct use of names, it is admissible to reverse here and there. As long as treatment as there stays there and as here here, to treat here as there is inadmissible; but it is admissible if there is to be treated as here. If you treat here as there on condition that there and here stay there and here, there will likewise be treated as here."

The point that what matters is the difference is made also in connexion with arbitrary renaming. The Mohists do not deny that naming is conventional (an issue not discussed in the corpus), but hold emphatically that it is bound by the differences between objects. The example is extending the name 'crane' to something which, judging by other instances of this stock illustration, would be the dog.[14] The extension does not make dogs into cranes, because you cannot conversely include cranes among 'dogs' without depriving both creatures of names specific to them. This would make it impossible to 'proceed'* from what is so of a dog or crane to other creatures of the same kind.

B72 *(Canon)* "That it is specifically what I call it is inadmissible unless that is its name. Explained by: the converse.

(Explanation) To call this 'crane' is admissible, but still it is not the crane itself. To call that and this both 'this' is inadmissible; the sayer would never have anything which is specifically what it is called. If that goes on being specifically what it is called, what I call it will not 'proceed'; if that is not specifically what it is called, what it is called will not 'proceed'."

Chuang-tzu once recommends us to leave all distinctions behind and experience everything as both this and so in a gigantic 'Yes!' to the universe:

"Treat even the not this as this, the not so as so. If this and so are really this and so, there is no difference for argumentation from not this and not so." (Cz 2/9 cf, G 60).

There is no clear line between Chuang-tzu as sophist and as poet finding words to abolish the distance between self and other, and we shall not attempt to analyse this utterance. The Mohist implies that it was supported by some argument dependent on the fallacy that, unlike a name, the demonstrative 'this' as it flits from one thing to the next does not stay in any over a period of time.

B82 *(Canon)* "You cannot treat as this without treating only this as

* For 'proceeding' (*hsing* 行), cf. p. 149 above.

this. Explained by: not all-inclusive.

(Explanation) (Argument) Of the ones not this, this one is about to be treated as this. 'This' as of now in staying in this does not stay in this, therefore 'this' does not stay.

(Refutation) If 'this' does not stay, it does treat something as this but does not stay in it. 'This' as of now in not staying in this does stay in this. Therefore you cannot show that 'this' does not stay without showing that it does."

We mentioned that Chuang-tzu like Meno assumes that you cannot know what you do not know.[15] The Mohist sees the flaw in this ambiguous formulation; you can know the name without knowing the object.

B48 *(Canon)* "One does know what one does not know. Explained by: choosing by means of the names.

(Explanation) If you mix together what he does and what he does not know and ask about them, he is obliged to say 'This I know, this I do not know'. To be able both to choose the one and exclude the other is to know them both."

The most interesting of the Mohist answers to Chuang-tzu are two arguments cognate with Aristotle's refutations of 'All propositions are true' and 'All propositions are false'.[16] They are adapted to positions which could be credited to Chuang-tzu and so are not symmetrical. The first may be taken as answer to "The admissible is simultaneously inadmissible," the latter as another answer to "Treat even the not this as this."

B71 *(Canon)* "To deem all saying inconsistent with itself is inconsistent with itself. Explained by: what he says himself.

(Explanation) To be inconsistent with itself is to be inadmissible. If what this man says is admissible, there is saying to be judged admissible, and so not inconsistent with itself. If what this man says is not admissible, to suppose that it fits the fact is necessarily ill-considered."

B79 *(Canon)* "To reject denial is inconsistent with itself. Explained by: not rejecting it.

(Explanation) If he does not reject his own denial, he does not reject denial. Whether the rejection is to be rejected or not, it is not rejecting denial."

In the first of the pair one again notices that the Mohist does not combine admissibility (logical) and fitting (factual) under a single concept of truth.[17] The inconsistent (*pei* 誖, generally the inconsistent with itself) is one variety of the inadmissible, and what is inadmissible necessarily

does not fit the fact. The Taoist teaching that learning is useless (of *Lao-tzu* however rather than *Chuang-tzu*) is easily disposed of as another example of the self-falsifying.

> B77 *(Canon)* "That it is useful to learn: explained by the denial.
> *(Explanation)* He supposes that he does not know that it is useless to learn, and therefore informs him. This is causing him to know that it is useless to learn, which is teaching. If he supposes that it is useless to learn, in teaching he is inconsistent with himself."

Throughout one sees the Mohist trying to extract from Chuang-tzu's many-sided language propositions he can put in a refutable form. To the extent that he succeeds, his answers are just to Chuang-tzu. But whether one is satisfied or repelled by this attempt to pin down Chuang-tzu's insights might serve anyone as test of how rationalistic or anti-rationalistic his ultimate sympathies are.

Spontaneity

Chuang-tzu's scepticism is not in itself a novelty for the Western reader, far from it; what is perhaps strange to him, in Chuang-tzu as in Nietzsche, is that there is no vertigo in the doubt, which pervades the most rhapsodic passages of a philosophical poet who seems always after the episode of the giant magpie to gaze on life and death with unwavering assurance. But there is anguish in ethical scepticism only if one feels bound to choose without having grounds to choose. For Chuang-tzu, to pose alternatives and ask 'Which is beneficial, which harmful?' and 'Which is right, which wrong?', and try to formulate the Way as a set of rules for ordering Empire, family and individual, is the fundamental error in life. People who really know what they are doing, such as cooks, carpenters, swimmers, boatmen, cicada-catchers, do not go in much for analysing, posing alternatives and reasoning from first principles, they no longer even bear in mind any rules they were taught as apprentices; they attend to the total situation and respond, trusting to a knack which they cannot explain in words, the hand moving of itself as the eye gazes with unflagging concentration. The many 'School of Chuang-tzu' stories about craftsmen (only that of Cook Ting[18] is from the chapters ascribable to the master himself) are especially illuminating to the Westerner grappling to understand Taoism. We learn from them that the Taoist art of living is a supremely intelligent responsiveness which would be undermined by analysing and choosing, and that grasping the Way is an unverbalisable 'knowing how' rather than 'knowing that'. The sage adapts to the course

of things instead of trying to impose his will upon it, like the swimmer who stays afloat under a huge waterfall:

"I enter with the inflow and emerge with the outflow, follow the Way of the water and do not impose my selfishness on it. That is how I stay afloat in it." (Cz 19/52f tr. G 136).

He concentrates attention and lets the act happen of itself, like the hunchback catching cicadas on a sticky rod:

" 'I settle my body like a rooted treetrunk, I hold my arm like the branch of a withered tree; out of all the vastness of heaven and earth, the multitude of the myriad things, it is only of the wings of a cicada that I am aware. I don't let my gaze wander or waver, I would not take all the myriad things in exchange for the wings of a cicada. How could I help but succeed?'

"Confucius turned and said to his disciples:
 'Intent sustained undivided
 Will verge on the daimonic'.
Wouldn't it be that venerable hunchback it is about?' " (Cz 19/19–21 tr. G 138)

Sagehood can no more be put into words than the knack of the carpenter.

"Duke Huan was reading a book at the top of the hall, wheelwright Pien was chipping a wheel at the bottom of the hall. He put aside his mallet and chisel and went up to ask Duke Huan

'May I ask what words my lord is reading?'
'The words of a sage.'
'Is the sage alive?'
'He's dead.'
'In that case what my lord is reading is the dregs of the men of old, isn't it?'

'What business is it of a wheelwright to criticise what I read? If you can explain yourself, well and good; if not, you die.'

'Speaking for myself, I see it in terms of my own work. If I chip at a wheel too slowly, the chisel slides and does not grip; if too fast, it jams and catches in the wood. Not too slow, not too fast; I feel it in the hand and respond from the heart, the mouth cannot put it into words, there is a knack in it somewhere which I cannot convey to my son and which my son cannot learn from me. This is how through my seventy years I have grown old chipping at wheels. The men of old and their untransmittable message are dead. Then what my lord is reading is the dregs of the men of old, isn't it?' " (Cz 13/68–75, tr. G 139f)

In responding with the immediacy of echo to sound or shadow to shape the sage hits in any particular situation on that single course which is uniquely appropriate yet fits no rules. This course, which meanders shifting direction with varying conditions like water finding its own channel, is the *Tao*, 'Way', in the sense specific to Taoism; and all things unerringly follow where it tends except that inveterate analyser and wordmonger, Man, who misses it by sticking rigidly to the verbally formulated codes laid down in books as the Way of the Sage or the Way of the Former Kings. As for the *te*, 'Potency', paired with *Tao* ever since Confucius, it is the spontaneous aptitude, the inherent capacity of a thing to perform its specific functions successfully. Like the Way, it belongs to man no more nor less than to other things; we read in one 'Outer Chapter' story that the training of a fighting cock ends when its *te* is complete.[19] Even in man, since there is no mind/body dichotomy in ancient China, it includes not only the full potentialities of the sage but such physical powers as eyesight and hearing, and Chuang-tzu sees it as a difficulty requiring explanation that the man of highest Potency does not necessarily grow up strong and beautiful.*

The Way is already an object of inner experience in the 'Inward Training', where with the stilling of the passions the daimon enters and the *ch'i* spontaneously streams on the morally right course. What is new in Chuang-tzu is that he sees man as coinciding with the Way by ceasing to draw distinctions. To be on the unformulable path is to merge into the unnameable whole, so that what we are trying to pin down by the name 'Way' is revealed as nothing less than the universe flowing from its ultimate source (not just the course of its flow, which would be to draw a distinction).

"As for the Way, it has identity, you can put your trust in it, but it does nothing, has no shape. It can be handed down but not taken as one's own, can be grasped but not seen. Itself the trunk, itself the root, since before there was a heaven and an earth inherently from of old it is what it was. It hallows ghosts and hallows God,† engenders heaven, engenders earth; it is farther than the utmost pole but is not reckoned high, it is under the six-way-oriented but is not reckoned deep, it was born before heaven and earth but is not reckoned long-lasting, it is elder to the most ancient but is not reckoned old " (Cz 6/29–31 tr. G 86).

* Cf. the story of Uglyface T'o, Cz 5/31–49 tr. G 79–81

†*Shen Ti* 神帝 'hallows God', literally 'daimonises Ti', the high god of the Shang, still used in the Chou as an alternative to Heaven when wishing to personify.

The stories about craftsmen help us to find our bearings when Chuang-tzu is at his most mystical. One has the impression that for him, and for Taoists in general, illumination is not an all-or-nothing *satori*, and that there are only differences of degree between Cook Ting's perfect grace in carving an ox and the ecstasy of Tzu-ch'i of Nan-kuo:

"Tzu-ch'i of Nan-kuo reclined elbow on armrest, looked up at the sky and exhaled, in a trance as though he had lost the counterpart of himself. Yen-ch'eng Tzu-yu stood in waiting before him.

'What is this?', he said. 'Can the frame really be made to be like withered wood, the heart like dead ashes? The reclining man here now is not the reclining man of yesterday.'

'You do well to ask that, Tzu-yu! This time I had lost my own self, did you know it? '" (Cz 2/1–3, tr. G 48)

One sees also from the craftsman stories that Taoist spontaneity is not 'thoughtless' in the sense of 'heedless', on the contrary it demands intense concentration on the situation. Nor is it implied that every relevant facet is perceived immediately in a moment of insight; when Cook Ting carving an ox arrives at an especially intricate knot of bone and muscle he pauses, contemplates until everything is clear to him, then slices through with a single deft stroke. Although Chuang-tzu rejects *pien* 'argumentation', disputation over posed alternatives, he always uses in a favourable sense *lun* 論 'sorting, grading', the coherent thought and discourse which arranges things in their proper relations. We have mentioned a possibility that this is what the Later Mohists would have called their first discipline, with *pien* as their fourth.[20] In common usage *lun* tended to imply grading in terms of relative value, but Chuang-tzu's kind is, to quote the title attached to his second chapter, 'The sorting which evens things out'.** It would cover all common-sense thinking about objective facts in order to arrive at a coherent picture of the conditions before responding. What Chuang-tzu does forbid is thinking about what I or others ought to do about the situation, instead of simply answering with the spontaneous act or spontaneous approval or disapproval. The sage, we are told, 'assesses' actions but does not argue over them, 'sorts' physical events but does not assess them, and as for what is outside the cosmos—presumably that remainder left over from the total of oxen and non-oxen—he 'locates' it but does not include it in the sorting.

"The Way has never had borders, saying has never had norms. It is by

** The title *Ch'i wu lun* 齊物論 may however also be understood (on a different syntactic analysis) as 'The Discourse on Evening Things Out'.

a 'This' which deems that a boundary is marked. Let me say something about the marking of boundaries. You can locate as there and enclose by a line, sort out and assess, divide up and argue over alternatives, compete over and fight over; these I call our Eight Potencies. What is outside the cosmos the sage locates as there but does not sort out. What is within the cosmos the sage sorts out and does not assess. The records of the former kings in the successive reigns in the Annals the sage assesses, but does not argue over." (Cz 2/55–57 tr. G 57).

Here the term '"This" which deems' (*wei shih* 為是) is a technical coinage of Chuang-tzu's contrasting with his '"This" according to what you go by' (*yin shih* 因是).†† It is all right to make fluid distinctions varying with circumstances, it is when we make rigid distinctions misleading us into judging that something is permanently what it is temporarily convenient to name it that thinking goes wrong.

The phrase commonly translated 'spontaneous' is *tzu jan* 自然 'so of itself'; the sage "constantly goes by the spontaneous and does not add anything to the process of life", and "in the spontaneity of according with things has no room for selfishness".[21] But a phrase more characteristic of *Chuang-tzu* may seem to contrast with it, *pu te yi* 不得已, that than which one 'cannot do otherwise', the 'inevitable'. The sage "treating all abodes as one finds his lodgings in the inevitable", and "by trusting to the inevitable nurtures the centre of him."[22] Unlike Mohists and Yangists seeking grounds for right choice Chuang-tzu's ideal is to have no choice at all, because reflecting the situation with perfect clarity you can respond only in one way. If 'spontaneous' suggests freedom and 'inevitable' compulsion, that is only another of the dichotomies we should be leaving behind. The inevitability would be that of the artist's casually drawn line, or of the single possible word which a poet finds or fails to find. The centrality of the concept of the inevitable is demonstrated by its place in the most surprising of the examples of accommodation to the rationalism of sophists and Mohists which turn up in various corners of *Chuang-tzu*. A 'School of Chuang-tzu' passage actually sketches a chain of definitions of all major Taoist concepts, imitating the *a priori* ethical system of the Later Mohists; it borrows one Mohist definition and echoes the *Explanation* of another.[23] The Mohists established the benevolent and the right as what the sage desires 'beforehand' by interlocking definitions built up from the undefined 'desire'. The Taoist however wants to show that the Way is, not

†† The distinction between *yin shih* and *wei shih* was proposed in G 'Chuang-tzu's Essay', 143f and slightly modified in G *Cz Textual Notes* 6f.

that which the sage desires, but the course on which he inevitably finds himself in his illuminated state.

"The 'Way' is Potency's laying out, 'life' is Potency's lighting up, one's 'nature' is the resources for life. The motions from one's nature are called 'doing', doing becoming contrived is called 'erring'.

" 'Knowing' is the contact, 'knowledge' is the representation; what knowing does not know is as though peered at.[24]

"It is what sets moving on the course that is inevitable which is called 'Potency', it is motion all being from oneself which is called 'order'. The names are opposed but the objects all take their direction from each other." (Cz 23/70–72, tr. G 190)

The definitions show up the contrast between the two fundamentals of Chinese moral philosophy, the spontaneous or inevitable reaction wise or unwise, and the knowledge of the object by which one evaluates it as wise or unwise. The chain of definitions (inevitable and ordered, Potency, Way and Life, nature) belongs to the former, the definitions of knowing and knowledge stand outside.

The illumination of spontaneity

The analogy of the craftsman to the Taoist sage has the limitation that the sage, instead of putting his unthinking dexterity in the service of ends, is spontaneous from the very centre of his being. In terms of the traditional Chinese dichotomy, of man who thinks and chooses and Heaven which does all that is independent of man's will, his motions derive not from himself as man but from Heaven working through him. Shall we say then that in discarding all traditional imperatives Chuang-tzu has substituted a new one of his own, 'Be spontaneous'? That has long been a common interpretation of Taoism. But with spontaneity the question always arises of which kind is being recommended. Western romanticism extols intensity of spontaneous emotion however much it distorts reality by subjectivity, Taoism the spontaneous incipience of the act when reflecting the situation objectively. The craftsman stories are again instructive in exemplifying the sort of spontaneity into which emotion can enter only as disturbance, obscuring the situation as it is *objectively*—that is, once more following the craftsman analogy, as one must see it to respond successfully. Chuang-tzu inherits what we claim as a presupposition of his tradition since Confucius, that action starts from spontaneity and is guided by wisdom, but instead of laying down rules by which the wise man adjusts spontaneous inclination to measure, he

reduces wisdom itself to its essence, the dispassionate mirroring of things as they are. The metaphor of the mirror can be traced through early and late strata of *Chuang-tzu*.

"The utmost man uses the heart like a mirror; he does not escort things as they go or welcome them as they come, he responds and does not store." (Cz 7/32f tr. G 98)

The sage does not use the heart to plan ahead, only to reflect the perfect image of the situation before he responds. Like a mirror, it reflects only the present, does not 'store' the past experience which traps in obsolete attitudes; the sage perceives and responds to every situation as new. The metaphor is at its fullest development in late strata in *Chuang-tzu*.

"Within yourself, no fixed positions:
Things as they take shape disclose themselves.
Moving, be like water,
Still, be like a mirror,
Respond like an echo." (Cz 33/56f, tr. G 281)

The first couplet relates the sage's perfect flexibility to the objectivity of his vision; the external situation as it takes shape presents itself from moment to moment as it objectively is. He is as fluid as water which is unimpeded because in moving it adapts to the contours of the ground, his response is as immediate as the echo to the sound.

"When the sage is still, it is not that he is still because he says 'It is good to be still'; he is still because none among the myriad things is sufficient to disturb his heart. If water is still, its clarity lights up the hairs of beard and eyebrows, its evenness is plumb with the carpenter's level; the greatest of craftsmen take their standard from it. If mere water clarifies when it is still, how much more the stillness of the quintessential-and-daimonic, the heart of the sage! It is the reflector of heaven and earth, the mirror of the myriad things.

"Emptiness and stillness, calm and indifference, quiescence, Doing Nothing, are the even level of heaven and earth, the utmost reach the Way and Potency; therefore emperor, king or sage finds rest in them. At rest he empties, emptying is filled, and what fills him sorts itself out. Emptying he is still, in stillness he is moved, and when he moves he succeeds." (Cz 13/2–6, tr. G 259).

The essential point here is that the sage's heart is not subject to the agitations which obscure the common man's clarity of vision, to which Chuang-tzu himself is represented as confessing after seeing the giant magpie: "I have been looking at reflections in muddy water, have gone astray from the clear pool."[25] Even in the 'sorting' *(lun)* which is the kind of

thinking permitted to Taoists, the sage is not exerting the heart; he keeps the heart empty and lets the external scene fill it, sort itself out in its own objective relations, and then 'move' him. His heart has the 'evenness', the neutrality to all human goals, of the universe itself. Having achieved this mirror-like lucidity he no longer has to evaluate, even to judge that 'It is good to be still'; it is enough that he does *not* value anything in the universe above his own clarity of vision ("None among the myriad things is sufficient to disturb his heart"). His response in unclouded illumination of his situation is perfectly apt to the goal to which at that moment he spontaneously tends; "when he moves he succeeds." His Potency, aptitude, knack, is at its height, his act coincides exactly with the Way.

Looking back, we find two stages in Chuang-tzu's thought:

(1) All principles for grounding rules of conduct are themselves groundless.

(2) At the rock bottom of scepticism there remain spontaneity and a single imperative to guide it, 'Mirror things as they are', which by the logic of our quasi-syllogism[26] permits only the reaction when most aware.

A Westerner following this line of thought might expect spontaneity guided only by awareness to be egoistic, unless human nature is morally good. But in ancient China no one except Mencius and his followers supposes that human nature is good, and no one, even a Yangist, conceives an absolute egoism as distinct from a relative selfishness. The general assumption—an explicable and defensible one[27]—seems to be that awareness of other people guides spontaneity from selfishness towards responsiveness from other viewpoints. Confucius learns to "follow what the heart desires without transgressing rule" by the practice of *shu* 'likening-to-oneself'. Chuang-tzu is interested not in man's nature but in his Potency, to be developed until the impulses aroused when mirroring perfectly prevail over the passions which cloud the mirror ("Wherever desires and cravings are deep, the impulse which is from Heaven is shallow").[28] The 'Inner Chapters' never use the word *hsing* 'nature'; the 'Outer Chapters' do, but say that "by the training of our nature we recover Potency".[29] The Taoist sage is unselfish, neither by acting out his nature nor by obeying moral principle, but by seeing through all dichotomies including self and other. ("The utmost man has no self").[30] It appears from one obscure sentence that in ceasing to choose and simply 'being about to' the sage thinks of other people as 'I'. To explain the mystery of a man who has become famous as a mourner without feeling sorrow, Chuang-tzu says

"When another man wails he wails too; it is simply that all the way up

from that which they depend on to be-about-to-be, he is with him in recognising him as 'I'. How would I know what it is I call recognising as 'I'?" (Cz 6/80, tr. G 91)

Whatever is to be made of this, there is no doubt that the sage ruler mirroring the world is conceived as responding on behalf of all without thinking of himself as concerned for other people.

"The benefits of his bounty extend to a myriad ages, but it is not deemed concern for man" (Cz 6/11, tr. G 91).

Or, according to a later writer in the book, the sage is concerned for mankind but does not know it until others tell him, as a beautiful woman knows that she is beautiful only after seeing herself in a mirror.[31]

Waking and dream

Throughout this book we have contrasted Chuang-tzu's position with the rationalism of sophists and Later Mohists not as 'irrationalist' but as 'anti-rationalist', assuming a distinction developed at length elsewhere.[32] The anti-rationalist plays down or denies the place of reason in becoming aware of objective reality, the irrationalist treats reality itself as rejectable for, or as malleable to, imagination. There can be no doubt on which side of the line Chuang-tzu falls. He accepts without question that we have to take the world as it is, denies only that analytic reason can show us how it is. What the thinker posing alternatives is trying vainly to pin down in words is objectively there: the wood which the wheelwright is chiselling, the famine or rebellion which confronts the ruler; in the stillness of the sage's heart it shows up as plain and undistorted as a face in calm water. Whether or not what he sees is a dream—the question raised in the famous tale of Chuang-tzu dreaming he is a butterfly[33]—he has to accept it as given. He may name and classify things as he pleases, as horse or non-horse, dream or waking, but if he *sees* things as he pleases, lets the passions blur the mirror of perception, his spontaneous move will no longer accord with the Way. You cannot on Chuang-tzu's position treat truth as one value among others to be weighed against the rest, and ask Nietzsche's truly irrationalist question: "Granted we want truth, *why not rather* untruth? And uncertainty? Even ignorance?".[34]

Even in *Chuang-tzu* the thought that life might be a dream seems peculiar to Chuang-tzu himself; it is among those which disappear after the 'Inner Chapters'. It was not to take root in China until after the Buddhists re-introduced it from India. A Westerner easily misconceives it in terms of his own reality/appearance dichotomy. Since words for the

existing and the real apply in Chinese primarily to concrete things,[35] to doubt their reality does not even for Chuang-tzu imply something more real behind them disguised by the veil of appearance. The centre of interest for Chuang-tzu is that waking or dreaming we cannot know the answer to the question 'Am I dreaming or awake?'. This unknowability is the perfect illustration of his point that the posing of alternatives does not give us knowledge. We must unmake even the fundamental distinctions, 'something/nothing', 'waking/dream', if we are to return to the Way.

"We dream of banqueting and at dawn wail and weep, dream of wailing and weeping and at dawn go out to hunt. While we dream we do not know we are dreaming, and in the middle of a dream interpret a dream within it; not until we wake do we know that we were dreaming. Only after the ultimate awakening shall we know that this is the ultimate dream. Yet fools think they are awake, so confident that they know what they are, princes, herdsmen, incorrigible! You and Confucius are both dreams, and I who call you a dream am also a dream." (Cz 2/81–83, tr. G 59f)

Here Chuang-tzu follows out the implications of one alternative, but in his other references the point is in the undecidibility of the issue.

"He does not know whether he is Chou who dreams he is a butterfly or a butterfly who dreams he is Chou." (Cz 2/95f, tr. G 61)

"You dream that you are a bird and fly away into the sky, dream that you are a fish and plunge into the deep. There's no knowing whether the man who speaks now is the waker or the dreamer." (Cz 6/81, tr. G 91)

Heaven and man

The most obstinate of the dichotomies which Chuang-tzu strives to throw off is that of Heaven and man. In following through one alternative, he can declare that the sage "has the shape of a man, is without what is essentially man", that he lives wholly possessed by Heaven. Hui Shih enters and raises the obvious objection.

" 'Can a man really be without the essential (ch'ing) to man?'

'He can.'

'If a man is without the essential to man, how can we call him a man?'

'The Way gives him the features, Heaven gives him the shape, how can we refuse to call him a man?'

'But since we do call him a man, how can he be without the essential to man?'

'Judging "It's this, it's not" is what I mean by the essential to man. What I mean by being without the essential is that the man does not

inwardly wound his person by likes and dislikes, that he constantly goes by the spontaneous and does not add anything to the process of life.' " (Cz 5/55–58, tr. G 82)

Am I then on the Way only when as a man I dissolve and let Heaven act through me? Here we find a recurrent tension in Chuang-tzu's thought. He does not expect to live in a permanent ecstasy moving like a sleep-walker guided by Heaven; he recognises that one must be sometimes "of Heaven's party" and sometimes "of man's party", and declares that "someone in whom neither Heaven nor man is victor over the other, this is what is meant by the Genuine Man."[36] The clearest statement of a compromise, sketched and immediately dismissed as inadequate (one of Chuang-tzu's characteristic moves) is at the head of the chapter 'The teacher who is ultimate ancestor'.

"To know what is Heaven's doing and what is man's is the utmost in knowledge. Whoever knows what Heaven does lives the life generated by Heaven. Whoever knows what man does uses what his wits know about to nurture what they do not know about. To last out the years assigned you by Heaven and not be cut off in mid course, this is perfection of knowledge." (Cz 6/1f, tr. G 84)

When ceasing to analyse, simply attending and responding, our behaviour belongs with the birth, growth, decay and death of the body among the spontaneous processes generated by Heaven. We are then doing, without knowing how we do it, what Heaven destines for us. Paradoxically, to enact the destined is, since we are always tempted to think out a better way, "the most difficult thing of all".[37] However, although my body matures and decays as Heaven decrees independently of my will, as a thinking man I have to assist the process by feeding my body and taking care of my health. Similarly I nurture a spontaneous skill by the thought and effort of apprenticeship, and sagehood by Chuang-tzu's own philosophising.

But in formulating the distinction Chuang-tzu has at once to remind himself that it is an artificial division made only while reasoning as a man, obscuring a fundamental continuity. He returns to the questions he had raised about the arbitrariness of naming.

"However, there's a difficulty. Knowing depends on something which it fits (tang); the trouble is that what it depends on is never fixed. How do I know that the doer I call 'Heaven' is not the man? How do I know the doer I call the 'man' is not Heaven?"

The dichotomy is seen to break down in the unknowability of whether the agent of my own actions is myself or Heaven acting through me, like

that of waking and dream in the unknowability of whether I am not now dreaming. One 'School of Chuang-tzu' dialogue does take the line that the agent is always Heaven.

" 'What do you mean by "Man is one with Heaven?" '

'What is of man is of Heaven, and what is of Heaven is of Heaven too. That man is unable to possess what is Heaven's is his nature.' " (Cz 20/60f, tr. G 168).

Following another line, if everything human were eliminated what would be left for Heaven except the animal?

"To be skilled in what is Heaven's and deft in what is man's, only the perfect man is capable of that. Only the animal is able to be animal, only the animal is able to be Heaven's. The perfect man hates Heaven, hates what is from Heaven in man, and above all the question 'Is it in me from Heaven or from man?' " (Cz 23/73f, tr. G 106).

There cannot for Chuang-tzu be any ultimate discontinuity between the spontaneous and the thinking person. At the centre of himself the sage is spontaneous, belongs wholly to Heaven, does not yet make any distinction between benefit and harm, self and other, even Heaven and man ("For the sage there has never yet begun to be Heaven, never yet begun to be man").[38] At the periphery he is a thinking man, finding means to the goals towards which Heaven moves him, and collecting the information towards which he is moved to respond. On this periphery he does make distinctions, although only as provisional and relative (the ' "this" according to what he goes by', not the ' "this" which deems'), and deliberately pursues what he likes and avoids what he dislikes. We have here the exact opposite of the Western rationalist's conception of himself as reasoning Ego objectivising his own spontaneous tendencies, aptitudes, and strengths as means in the service of his ends.

"The Genuine Men of old let what is Heaven's await what comes, did not let man intrude on Heaven. . . . Hence they were one both with what they liked and what they disliked, were one both when they were one and when they were not. When one they were of Heaven's party, when not one of man's party. Someone in whom neither Heaven nor man is victor over the other, this is what is meant by the Genuine Man." (Cz 6/19f; cf. 24/97f tr. G 85).

That the sage's spontaneity is at the centre of him, not the periphery, may be illustrated from a dialogue put into the mouths of Confucius and his favourite disciple Yen Hui. Like the 'Inward Training' and Mencius, Chuang-tzu conceives training for the Way as the refining of the energising fluids, the *ch'i,* by controlled posture and breathing ("The

breathing of the Genuine Man is from down in his heels, the breathing of plain men is from their throats").[39] The effect is to refine and rarify the *ch'i* to perfect tenuousness, so that it circulates freely through the relatively dense and inert which it activates. When preparing to act, you 'fast the heart', empty it of the thought normally accepted as its function as an organ, and wait for the now perfectly attenuated fluid to respond and move in one direction or the other.

"Unify your attention. Rather than listen with the ear, listen with the heart. Rather than listen with the heart, listen with the *ch'i*. Listening stops at the ear, the heart at what tallies with it. As for the *ch'i*, it is the tenuous and passive towards other things. Only the Way accumulates the tenuous. The attenuating is the fasting of the heart." (Cz 4/26–28, tr. G 68)

In renouncing control of the *ch'i* selfhood dissolves; yet paradoxically in ceasing to distinguish myself from what all the time has been acting through me, I become for the first time the true agent of my actions. It is by grasping this point that Hui convinces Confucius that he understands:

"When Hui has never yet succeeded in being the agent, a deed derives from Hui. When he does succeed in becoming its agent, there has never begun to be a Hui."

There is a possibility of misunderstanding here which the analogy of sage to craftsman may again help us to avoid. To dissolve man in Heaven, suspend divisions, treat everything as one, may sound like self-immersion in a universal blur. But if the craftsman masters his skill only after passing the apprentice stage of posing alternatives and following verbal instructions it is because he is now making finer discriminations than he can put in words. Behind the arguing out of alternatives the primary sense of *pien* is discrimination,[40] and "the greatest *pien* is unspoken."[41] The oneness of the Taoist vision seems to be of a kind with the 'Unity within Variety' of Western aesthetics.

To think in terms of Unity within Variety helps to resolve the apparent contradiction that the process by which the sage ceases to differentiate himself is regularly described not as a blending with things but as a detachment from them. Other people become entangled in circumstance, sink under the burden of their possessions, but the sage, to quote a slogan from the 'Outer Chapters', 'treats things as things and is not turned into a thing by things'.[42] He withdraws inwards towards a viewpoint from which even his own body is perceived as external. One adept is described as externalising first the world, then the things which support life, finally life itself.[43] Others are said to "treat their own flesh-and-bone as external to

them", to "travel on the inside of the flesh-and-bone".[44] The withdrawal is not an exploration of inward experience; on the contrary, Chuang-tzu's attitude to the world is uncompromisingly extroverted. The sage as he steps back into himself is still looking outward; he "uses the eye to look at the eye", he "has ears and eyes as images he perceives", he takes his stand at "the ultimate eye."[45] There being no mind/body dichotomy in ancient China, he is not of course looking out on matter from a realm of pure spirit. In detaching himself from the many he is returning to the 'root' or 'trunk' or 'seed' from which they grow, into the 'ancestor' from which they descend, the 'gate' out of which they emerge, the 'axis' round which they revolve. It is at the common point from which they all start that they are found to merge together and with oneself in a single whole, just as— although Chuang-tzu does not himself make this application of his 'root' metaphor—different branches turn out when traced back to be one and the same tree.

Language

The denial that the Way is communicable in words is a familiar paradox of Taoism. The first line of *Lao-tzu*, "The Way that can be told is not the constant Way", inevitably tempts humorists, Chinese or Western, to ask why the author went on to write the book.* The irony is especially acute in the case of Chuang-tzu, a master of sophisticated argument, aphorism, anecdote, lyrical prose and gnomic verse who professes a boundless scepticism about the possibility of ever saying anything.

On closer inspection the joke loses most of its point. Taoists are trying to convey a knack, an aptitude, a way of living, and when the carpenter tells Duke Huan that he cannot put into words how much pressure to exert in chiselling wood we both understand and agree. With philosophers who profess to know unformulable truths, an ineffable reality, no doubt we have the right to become impatient, but Taoists are not thinking of the Way as ultimate Truth or Reality. They merely have the good sense to remind us of the limitations of the language which they use to guide us towards that altered perspective on the world and that knack of living. To point the direction they use stories, verses, maxims, any verbal means which come to hand. Far from having no need for words they require all available

* Cf. *The Philosophers*, a satirical verse by Po Chü-yi (A.D. 772–846) translated by Waley, *Chinese Poems*, 173.

resources of literary art, which is why all the classics of philosophical Taoism (*Lao-tzu*, *Chuang-tzu* and, from a later time, *Lieh-tzu*) have won important places in the literary history of China.

We have quoted enough verbatim from Chuang-tzu to exhibit how he poses alternatives only to undermine them, by showing the contradictories to require each other or the issue to be undecidable, or by pushing the commonly rejected side, or both sides together, and how his language as it leaves both behind turns into poetry. We have also met enough of his double questions to see that when he doubts the difference between human speech and birdsong,[46] his "Is there a proof for argumentation? Or isn't there any proof?" will not be an idle inquiry; there will be a logical point behind it which we might risk putting in our own terms as 'How can I prove that language is meaningful without using it on the assumption that it is?' (Like his Mohist critics he has an eye for the traps of self-reference.) It is characteristic of Chuang-tzu both to talk to us on the assumption that his words mean something and to play with the opposite thought that the voices of competing thinkers are like the wind through hollows of different shapes or an organ-player blowing through tubes of varying lengths, making clashing noises to be reconciled only by the return to silence.[47]

If Chuang-tzu looks 'modern' in his sense of the complexities and inadequacies of language, he certainly does not share our temptation to slide towards linguistic solipsism. His epistemology is that of ancient China generally, naive realism. He has a perfect confidence that not only things but our ideas (*yi* 意) of them—which in the first place would be their images—would still be there if we could get rid of the nuisance of having to talk about them.

"The bait is the means to get the fish where you want it, catch the fish and you forget the bait. The snare is the means to get the rabbit where you want it, catch the rabbit and you forget the snare. Words are the means to get the idea where you want it, catch on to the idea and you forget about the words. Where shall I find a man who forgets about words, and have a word with him?" (*Cz* 26/48f, tr. G 190).

A 'Mixed Chapter' section closely related to 'The sorting which evens things out' classifies three modes of discourse of varying effectiveness available to those no longer victim to the illusion of logical demonstration.

"Saying from a lodging-place works nine times out of ten, weighted saying works seven times out of ten. Spillover saying is new every day, smooth it out on the whetstone of Heaven." (*Cz* 27/1, tr. G 106).

Explanations follow:

(1) 'Saying from a lodging-place':—"You borrow a standpoint outside to sort the matter out". This is traditionally taken as the expression of ideas through imaginary conversations, a universally accepted convention. However, in Chuang-tzu's terminology to 'lodge' (*yü* 寓) is to assume the temporary standpoints from which the sage judges with the '"This" according to what he goes by', in contrast with the fixed positions from which the unenlightened apply 'the "This" which deems'. Chuang-tzu seems to be referring to persuasion by *argumentum ad hominem*, the only kind of victory in debate which would have any point for him. You temporarily lodge at the other man's standpoint, because the meanings he gives to words are for him the only meanings, and he will not debate on any other basis.[48]

(2) 'Weighted saying':—"It is what you say on your own authority." This has to be backed by depth of experience, not merely the respect due to old age ("A man without the Way of Man is to be called an obsolete man"). The aphorism would be the most concentrated example.

(3) 'Spillover saying':—"Use it to go by and let the stream find its own channels, this is the way to last out your years." This is the most important, and is given more space than the other two together. It is traditionally, and this time convincingly, assumed to take its name from a kind of vessel designed to tip and right itself when filled too near the brim. It is the speech proper to the intelligent spontaneity of Taoist behaviour in general, a fluid language which keeps its equilibrium through changing meanings and viewpoints. Words are inherently out of joint with things, and when they seem to be saying least may be saying most.

"If you refrain from saying, everything is even; the even is uneven with saying, saying is uneven with the even. Hence the dictum 'In saying say nothing'. If in saying you say nothing, all your life you say without ever saying, all your life you refuse to say without ever failing to say. What from somewhere is admissible from somewhere else is not, what from somewhere is so from somewhere else is not" (Cz 27/5–7, tr. G 107).

For Chuang-tzu words do order themselves in discourse, not according to any rules of argumentation, but by that unanalysable knack which he discerns at the back of all successful behaviour, and which he sees as the sign that Heaven is working through us. We might illustrate 'spillover saying' by the way he handles the word 'know.' The Later Mohists are careful to define 'wits' and 'know', and to distinguish knowing how to act from knowing names, objects and how to connect them.[49] Chuang-tzu on the contrary delights in the balancing act of dancing from one usage to another in the course of a single sentence.

"The myriad things have somewhere from which they grow but no one sees the root, somewhere from which they come forth but no one sees the gate. Men all honour what wit knows, but none knows how to know by depending on what his wits do not know; may that not be called the supreme uncertainty?" (Cz 25/52f, tr. G 102).

Reconciliation with death

However far Chuang-tzu departs from the Yangism from which we suspect that he started, he never doubts that it is by trusting to the Way that you "protect the body, keep life intact, nourish your parents, last out your years."[50] This however is only a minor advantage of a Way which reconciles with the possibility of bodily mutilation and the certainty of death.

Suffering does not preoccupy Chuang-tzu, or any other pre-Buddhist thinker in China. Like the rest he is neither optimist nor pessimist, and takes it for granted that sorrow and joy alternate like night and day, death and life. The disaster ranked second only to death is deformity or mutilation of the body; thus Confucians recognised it as a duty to return one's body to the ancestors intact as when one received it from them. How to reconcile oneself to disaster to the body is therefore a crux for Chuang-tzu. The 'Inner Chapters' show a remarkable interest, not shared by later Taoists even in *Chuang-tzu* itself, in cripples, freaks, mutilated criminals, who are able to accept and remain inwardly unaltered by their condition. The criminal with a chopped foot carries about with him the visible proof of his crime and betrayal of his ancestors, but Chuang-tzu admires one who "looks at things only for that in which they are one, does not see what they have lost; he regards losing his own foot as he would throwing off mud."[51]

The liberation from selfhood is seen above all as a triumph over death. Chuang-tzu's position is not that personal consciousness will survive death, rather that in grasping the Way one's viewpoint shifts from 'I shall no longer exist' to something like 'In losing selfhood I shall remain what at bottom I have always been, identical with all the endlessly transforming phenomena of the universe.' Nothing in his unusual sensibility is more striking than the lyrical, ecstatic tone in which he writes of death. This does not reflect a disgust with life, nor is it a matter of treating death as a beautiful abstraction. In 'The Teacher Who Is the Ultimate Ancestor', in which most of Chuang-tzu's writings on this theme are collected, a dying man drags himself to a well to look at his disfigured body and wonder

what 'the Maker of Things' is turning it into; a sage lolls carelessly against the doorpost talking to his dying friend after shooing away his weeping family; others appal a disciple of Confucius by playing the zither and doing odd jobs beside the corpse. Chuang-tzu himself in various stories goes to sleep pillowed on a skull, is found thumping a pot (the most vulgar kind of music-making) on the death of his wife, and on his deathbed laughs at his disciples for preferring to have him decently buried and eaten by the worms than left in the open to be eaten by the birds. Although Chuang-tzu generally discusses the Way in impersonal terms (not that personal/impersonal would apply to it any more than other dichotomies), on the theme of death he tends to personify, representing the sage as in his lifetime 'fellow man with the Maker of Things', who will in due course transform him into something else. The concept of a Maker of Things (*tsao wu che* 造物者), which reappears in later literature only as a poetic conceit borrowed from Chuang-tzu, is remarkable since the myriad things were universally conceived as not created but generated by Heaven or by heaven and earth. Even in *Chuang-tzu* it seems peculiar to Chuang-tzu himself. The same is true of the physical confrontation with death, and mockery of the rites of mourning, for Chinese the most sacred of all. This is quite without the morbidity of the stress on corruptibility in the late-Mediaeval art of Europe, which reminds of the horrors of mortality for the good of our souls. It seems rather that for Chuang-tzu the ultimate test is to be able to look directly at the facts of one's own physical decomposition *without* horror, to accept one's dissolution as part of the universal process of transformation.

"Soon Master Lai fell ill, and lay panting on the verge of death. His wife and children stood in a circle bewailing him. Master Li went to ask after him.

'Shoo! Out of the way!' he said, 'Don't startle him while he transforms.'

He lolled against Lai's door and talked with him.

'Wonderful, the process which fashions and transforms us! What is it going to turn you into, in what direction will it use you to go? Will it make you into a rat's liver? Or a fly's leg?'

'A child that has father and mother, go east or west, north or south, has only their commands to obey; and for man the Yin and Yang are more than father and mother. Something other than me approaches, I die; and if I were to refuse to listen it would be defiance on my part, how can I blame him? That hugest of clumps of soil loaded me with a body, had me toiling through a life, eased me with old age, rests me with death; therefore that I

found it good to live is the very reason why I find it good to die. If today a master swordsmith were smelting metal, and the metal should jump up and say "I insist on being made into an Excalibur," the swordsmith would surely think it metal with a curse on it. If now having once happened on the shape of a man, I were to say "I'll be a man, nothing but a man", he that fashions and transforms us would surely think me a baleful sort of man. Now if once and for all I think of heaven and earth as a vast foundry, and the fashioner and transformer as the master smith, wherever I am going why should I object? I'll fall into a sound sleep and wake up fresh.' " (Cz 6/53–60, tr. G 88f)

A 'School of Chuang-tzu' development: the 'Great Man' metaphysic

A generalisation about Chinese philosophy to which there are few exceptions before the arrival of Buddhism from India is that it shows no impulse to metaphysical system-building. Metaphysical issues arise, of course, one of which, the split between Heaven and man, we take to be central to its development. But in struggling with problems raised by the traditional cosmos such thinkers as Mencius and Chuang-tzu show little tendency to stand back and make an organised whole of their revised world-picture. Ancient Chinese thinking at its most logical, as in Kung-sun Lung and the Later Mohists, concentrates on specific problems. There may be a metaphysic behind Hui Shih's ten theses—we shall return to this point[52]—but in the absence of his explanations there is little to go on. The early Mohists organise their teaching in ten doctrines defended in ten organised essays, but are no nearer than anyone else to organising a cosmic scheme. There is no doubt a sense in which everyone from Confucius downwards has an implicit metaphysic in which Heaven and man, Way and Potency, have their places and functions, but if we wish to clarify it we have to correlate a lot of piecemeal evidence and work out the scheme for ourselves.

Of the three major responses to the 4th-century metaphysical crisis, the most rationalistic, Later Mohism, is positively anti-metaphysical.[53] The Mohists turned their backs on the whole question of the relation between Heaven and man, and sought for ethics purely logical foundations. It is in the other two, among followers of Mencius and Chuang-tzu, that we find the few exceptions to our generalisaton. We have seen that the 'Doctrine of the Mean' does go some way towards systematising Mencius' conception of man's place in the universe.[54] On the Taoist side one full-

blown metaphysician, the 'Great Man' writer, makes a very good job of tidying up Chuang-tzu.

A divergence within the school of Chuang-tzu, in the 3rd and perhaps down into the 2nd century B.C., is between the rationalising tendencies centred on the 'Autumn Floods' chapter and the derationalising centred on 'Knowledge Roams North'. In the latter to speak articulately about the Way is enough to show one's ignorance of it; the proof of insight is that you refuse to speak, or try but forget what you meant to say, or fall into a trance while being told, or see in a flash stimulated by some aphorism which on reflection is seen to be meaningless, or burst into improvising song, or are moved by music without understanding what it is doing to you.[55] In one of the stories Confucius propounds something very like the *kōans* ('What is the sound of one hand clapping?') with which Zen Buddhists set out to smash the frame of conceptual thinking a thousand years later.

" 'There is no past and no present, no beginning and no end, before you have children and grandchildren you do have children and grandchildren—admissible?'

"Jan Ch'iu failed to reply.

'Enough, that you failed to answer. . . . ' " (Cz 22/73f, tr. G 164)

At the opposite extreme are two lengthy philosophical dialogues, closely related to each other, the 'Autumn Floods' (at the head of the chapter of that name) and the 'Know-little' dialogue at the end of the 'Tse-yang' chapter. These, together with the 'Snail' dialogue (also in 'Tse-yang'), and some fragments which may come from the broken end of the 'Autumn Floods' dialogue, expound a coherent metaphysic centred on the concepts of the Great Man (*ta jen* 大人) and his 'great scope' (*ta fang* 大方). These terms must have been the slogans of a particular school; one exchange mentions a 'School of the Great Scope', another puts the Great Man above the sage.* The only other example of either slogan in *Chuang-tzu* is where at first sight one would least expect it, in 'Knowledge Roams North'. Here personified Knowledge in his foolishness requests and receives from the Yellow Emperor a verbal exposition of the Way, in which he is told that "the myriad things are the One"; it is mentioned that only the Great Man easily returns to the root of things.[56] But the Yellow

*Cz 17/5, 25/31, tr. G 145, 154. The three dialogues about the Great Man and his Great Scope are the 'Autumn Floods' (Cz 17/1–53), the 'Snail' (Cz 25/20–33) and the 'Know-little' (Cz 25/59–82). Three scattered fragments on the integrity, the teaching, and the conduct of the Great Man (Cz 24/70–73, 11/63–66, and the misplaced 17/24–28) may be from the fragmented conclusion of the 'Autumn Floods'. Cf. tr. G 144–157 and *Textual notes* 37–41.

Emperor then repudiates his own account by adding that he and Knowledge are both far from the Way precisely because they *know*. Even here, then, 'Great Man' serves as the sign of an intellectualised Taoism. In the Great Man dialogues on the contrary the value of knowledge is unquestioned and the speaker called 'Know-little' rightly wants to know more.

Not only does the Great Man have a comprehensive view of the cosmos, the capacity to see himself in proportion within it is precisely what distinguishes him as a Great Man. The 'Autumn Floods' tells how the god of the Yellow River, riding the current in autumn to the river mouth, sees with amazement the vastness of the ocean and seeks instruction from the sea-god Jo, who confesses that "within the compass of heaven and earth I am no more than a pebble or a bush on a great mountain." The river-god asks

"In that case, would it be admissible for me to judge heaven and earth great and the tip of a hair small?" (Cz 17/14f, tr. G 145)

The sea-god answers that, beyond and within, the greater and smaller continue indefinitely. The river-god now asks whether there are an infinitely great and infinitely small, in words which rephrase Hui Shih's first thesis ("The ultimately great has nothing outside it. . . . The ultimately small has nothing inside it.")

" 'Debaters of the age all say that the most quintessential has no shape at all, the greatest cannot be encompassed. Is this trustworthy fact?' "

The reply is that there is a difference in kind between finite and infinite, and that the distinction between small and great, quintessential and massive, belongs only to the former.

" 'When the great is seen from the viewpoint of the minute, some is out of sight; when the minute is seen from the viewpoint of the great, it is invisible. The quintessential is the small as it ceases to be discernible, the outlying is the great receding out of sight, therefore their differentiation is for convenience; it is a matter of the situation from which one is seeing. The quintessential and the massive we specify in things which do have shape. What has no shape at all, number cannot divide; what cannot be encompassed, number cannot exhaust. Those which can be sorted in words are the more massive among things, those which can be conveyed through ideas are the more quintessential among things. As for what words cannot sort or ideas convey, we do not specify anything in it as quintessential or massive."

The river-god is now worried as to where in this infinity one is to find a

viewpoint from which to establish norms for right and wrong, and is told that there is none.

" 'Whether beyond or within the realm of things, to what viewpoint must one attain if one is to find norms for noble and base, small and great?'

'If we examine them in relation to the Way, things are neither noble nor base; if in relation to other things, they see themselves as noble and others as base; if in relation to custom, the nobility and baseness do not depend on themselves.

'Examining them in terms of degree, if going by a standpoint from which it is great you see it as great, not one of the myriad things is not great; if going by a standpoint from which you see it as small, not one of the myriad things is not small. When you know that heaven and earth amount to a grain of rice, that the tip of a hair amounts to a hill or a mountain, the quantities of degree will be perceived.

'Examining them in terms of achievements, if going by a standpoint from which it has them you see it as having, not one of the myriad things does not have them; if going by a standpoint from which it lacks them you see it as lacking, not one of the myriad things does not lack them. When you know that east and west are opposites yet cannot do without each other, portions in achievement will be settled.

'Examining them in terms of inclinations, if going by a standpoint from which it is right you see it as right, not one of the myriad things is not right; if going by a standpoint from which it is wrong you see it as wrong, not one of the myriad things is not wrong. When you know that sage Yao and tyrant Chieh each thought himself right and the other wrong, the commitments behind the inclinations will be perceived.' "

Good and bad depend not on fixed standards but on particular circumstances. The sea-god illustrates the point from what for ancient Chinese is the obvious example of the self-evidently good or bad, the gain or loss of a throne.

" 'In former times, Shun took the throne yielded by Yao and became Emperor, Chih took the throne yielded by K'uai and was ruined. T'ang and Wu fought for a throne and reigned, Po-kung fought for a throne and perished. Judging by these cases, the propriety of contending or deferring, the conduct of a Yao or a Chieh, will be noble at one time and base at another, and is not to be taken as a constant. . . . If then we say 'Why not take the right as our authority and do without the wrong, take the ordered as our authority and do away with the unruly?', this is failing to understand the pattern of heaven and earth, and the myriad things as they

essentially are. It is as though you were to take heaven as your authority and do without earth, take the Yin as your authority and do without the Yang; that it is impracticable is plain enough'."

In the river-god's questions a note hardly heard elsewhere in the literature becomes increasingly distinct, the terror of man's insignificance in infinite space turning to the vertigo of moral nihilism. With an infinity of viewpoints and no fixed standards, whence the confidence of Chuang-tzu and his school in the unique act inevitable in its particular conditions?

" 'If that is so, what shall I do and what shall I not do? On what final consideration am I to refuse or accept, prefer or discard?'

'If we examine them in terms of the Way,
　　What shall we think noble, what shall we think base?
　　This is called drifting back to the source.
　　Don't fix a sphere for your intent,
　　Or you'll be too lame to walk the Way.
　　What shall we belittle, what shall we make much of?
　　This is called letting their turns come round.
　　Don't walk always on one course.
　　You'll be at odds and evens with the Way. . . ."

The sea-god continues in rhymed verse over 28 lines, then returns to prose:

" 'This is how to tell the range of the grand summing-up and to sort out the patterns of the myriad things. A thing's life is like a stampede, a gallop, at every prompting it alters, there is never a time when it does not shift. What shall we do? What shall we not do? It is inherent in everything that it will transform of itself.' "

Here then rational discourse ends, there only remains submergence in universal process and poetry to point the direction which spontaneity will take if you see all things in proportion. But the river-god, one is glad to see, refuses to be fobbed off with poetry and insists on pushing his question farther. If it is simply a matter of spontaneous transformation what is there to value in the Way? The sea-god's answer, almost disappointingly moderate and sensible, is that it is good to possess the Way precisely because you react seeing all things in proportion.*

" 'But in that case what is there to value in the Way?'

'Whoever knows the Way is sure of penetrating the patterns, whoever

* Another fragment (Cz 22/16–21) likely to be from the 'Autumn Floods' is introduced as the beginning of the answer in tr. G 148f. I regret that by an oversight this transposition was not noted except in the conversion table on p. 38.

penetrates the patterns is sure to be clear-headed in weighing things, whoever is clear-headed in weighing things will not use other things to his own harm. The man of utmost Potency

Fire cannot burn,

Water cannot drown,

Heat and cold cannot harm,

Beasts and birds cannot rend,

which is not to say that he ignores them; it means that since he is perspicacious about safety and danger, secure in fortune and misfortune, careful in approaching and shunning, none of them is able to harm him. As the saying goes, "Heaven is within, man is without," and Potency goes on residing in what is from Heaven.' "

So here we are again at that rock-bottom assumption that the good is the spontaneous reaction—from Heaven, from one's Potency—which is in fullest awareness of how things are patterned. If we assume that Taoist weighing of things (unlike Mohist and Yangist, which introduce standards) is solely an objective estimation of greater and lesser effects on each other and on oneself, the sea-god's answer is logical in terms of our quasi-syllogism.[57]

When Chuang-tzu tried to differentiate the whole from the sum of its parts he did not in any writings which survive use an argument which one might have expected from a friend of Hui Shih, that infinity is more than the sum of finite quantities. But this is fundamental to the thinking of the Great Man writer, exhibited especially in the questions of Know-little to the Grand Impartial Reconciler. This dialogue shares with Kung-sun Lung and the Later Mohists both terminology (t'i/chien 'part/whole', chih 'point out')[58] and stock examples (horse, dog).

"Now the fact that when you point out from each other the hundred parts of the horse you do not find the horse, yet there the horse is tethered in front of you, is because you stand the hundred parts on another level to call them 'horse'. " (Cz 25/6f, tr. G 151)

Know-little asks about naming the totality of things; the Grand Impartial Reconciler answers by taking as illustration the word 'myriad', in Chinese as in English primarily the number 10,000 but used for an indefinitely large number.

" 'If so, is it adequate to call that the "Way"?'

'No. Suppose you were counting off the number of things you would not stop at one myriad, yet we specify them as "the myriad things", for we use a high number as a label for what we are counting towards. Similarly, heaven and earth are the greatest of shapes, and Yin and Yang the greatest

of *ch'i*, and 'Way' covers both of them impartially. If we are going by the greatness of them to label what we continue towards, that is admissible, but once we do have it, can we treat it as comparable with anything else? Then if we use it in chopping to bits and arguing over alternatives, and treat it as analogous with dog or horse, it will be much less adequate than they are.' "

Horse and dog are both members of the menagerie of animal examples common to sophists and Mohists, but it is interesting that in extant materials we find them together only in the *Explanation* of the *Canon* defending argumentation against Chuang-tzu.[59] This suggests that we have here a further stage in the continuing debate on reason we have traced from Hui Shih and Chuang-tzu through the Later Mohists. Responding perhaps to the Mohist criticisms, the Great Man writer acknowledges the validity of *pien* within the scope of the finite, but reserves the infinite for the Way. He proceeds to contrast the two realms. The finite are the things "of which name and object can be recorded, of which even the most quintessential and least discernible can be noted," which "words exhaust and knowledge attains." But "the man who perceives the Way does not pursue them to where they vanish or explore the source from which they arise. This is the point where discussion stops."

The difference in kind is reaffirmed when Know-little inquires about two rival views of the universal process ascribed to philosophers no longer known to us, "Chi Chen's that nothing does it, and Chieh-tzu's that something causes it." The reply is that the question can be raised only inside the realm of the finite, and that the Way being infinite is neither something nor nothing. As in the 'Autumn Floods', there is a reference to Hui Shih's first thesis.

" 'If you chop up into divisions, the ultimately quintessential is ungradable, the ultimately great cannot be encompassed. With "Something causes it" and "Nothing does it" we never escape from the realm of things, yet persist in supposing that we have passed beyond it.

A "something which causes" is an object,

A "nothing which does" is a void.

There *is* a name, there *is* an object

—Then it occupies a place with other things.

There is *no* name, there is *no* object

—Then it occupies the void between things.' "

" 'The Way cannot be treated as something, or as nothing either. "Way" as a name is what we borrow to walk it. "Something causes it" and

"Nothing does it" are at single corners of the realm of things; what have they to do with the Great Scope?'."

One is struck by the close connexions of these dialogues with the Sophists, in particular with Hui Shih. Although the Great Man did not necessarily write all episodes in the 'Autumn Floods' chapter, it may be significant that in two of them Chuang-tzu scores off Hui Shih and in another off Kung-sun Lung.[60] Moreover in the 'Snail' dialogue, where a Great Man introduces a king to the comprehensive vision by a story of wars with thousands of victims between microscopic states on the two horns of a snail, he has been introduced to the king by none other than Hui Shih. One is tempted to speculate that Hui Shih himself drew out the relativistic implications of his theses in a metaphysic of which this is the Taoist version. Perhaps the title of 'China's first metaphysician' should be added to the varied honours we have accorded Hui Shih.[61] But as always there is the difficulty that Hui Shih has left us no writings at all.

HEAVEN AND MAN GO THEIR OWN WAYS

We have seen that of the three main responses to the metaphysical crisis only the Mencian doctrine of the goodness of human nature successfully re-unites Heaven and man. But even within Confucianism this solution never became an orthodoxy until the Neo-Confucians of the Sung dynasty (A.D. 960–1279). During the 3rd century B.C. we find a broad consensus that process outside man's control takes a course independent of his morality. Heaven, although never entirely detached from human analogies, is increasingly seen as merely the superior member of the pair heaven and earth. Man is coming to think of himself, not so much as under Heaven as between heaven and earth, even—a thought we have met already in the 'Doctrine of the Mean' and will meet again in Hsün-tzu—as the indispensable third completing a cosmic triad.

Lao-tzu, like *Chuang-tzu*, invites man to abandon his fixed principles and put himself in accord with the universal Way as the trend of his own spontaneity. On the other hand the Confucian Hsün-tzu sees Heaven as generating man with anarchic desires which he has to learn to control, and putting resources at man's disposal without caring how he uses or misuses them. The Legalist Han Fei also sees natural desires as anarchic, but as manipulable for the common good by a system of rewards and punishments which will function as automatically as the beam and counterpoise of the balance. With Hsün-tzu and Han Fei the modern Westerner finds himself in a climate of thought which is wholly familiar. They have the sense of the real as objective and value-free, confronting man as there whether he likes it or not, and—here they differ from the Taoists—to be manipulated for his own independent ends. It is that splitting off of man from the cosmos in which he formerly belonged, to which we of the West have for some centuries been painfully adjusting ourselves. Traditional China however never did get used to it. By the end of the century the philosophers are borrowing from the previously ignored proto-sciences a style of correlative system-building which promises to reintegrate human morality in the universal order.

There are no clear breaks between the periods into which we have chosen to divide Chinese intellectual history, and both the *Canons* and the Great Man metaphysic very probably belong to the 3rd century B.C.

However, in the texts here chosen to typify the period, the debate over *pien* 'argumentation' which we have traced from Hui Shih to the Great Man philosopher seems already to be past. We find neither the autonomous realm of reason emerging in the *Canons* nor the poetic discourse in open revolt against reason which erupts in Chuang-tzu. On the one hand Hsün-tzu and Han Fei write the coherently argued essays pioneered by the early Mohists, with much greater sophistication and attention to definitions; on the other, *Lao-tzu* presents itself as a full-scale philosophical poem, a genre (perhaps originating in shamanistic hymns) of which we have so far encountered only the 'Inward Training'. But there is no sense of collision between logic and poetry, such as appears in Chuang-tzu and the Later Mohists. The two are accepted as alternative modes of philosophical discourse, roughly corresponding to the realms of means and ends, although the purpose of some of the rhymed verse is no doubt merely mnemonic. A passage already quoted from the 'Autumn Floods'[1] implies that you talk about the finite in prose and the infinite in verse. Hsün-tzu not only has his collected poems inside his works, he bursts into rhymed verse at places in philosophical essays such as the 'Discourse on Heaven'. Han Fei, ruthlessly prosaic in developing his theory of statecraft, has two chapters of comments on the poem *Lao-tzu* and writes a couple more in the same style himself.[2] Confucius, Mo-tzu, and Mencius, not to speak of Kung-sun Lung and the Later Mohists, had hardly used verse except in illustrative quotations.

Another feature of the 3rd century B.C. is a common recognition that times have changed: appeal to the sage kings has become little more than a convention. It is not that everyone would say with Wu-ma-tzu talking to Mo-tzu or the carpenter to Duke Huan that the men of old are now nothing but rotten bones.[3] That is the Taoist and Legalist view, but there is another, that one must seek the principles which remain constant through changing times and unaffected by the unreliable evidence about the past. This is the position of the Later Mohists[4] and of Hsün-tzu. We illustrate it here from the chapter 'Scrutinising the Present' in the *Lü Spring and Autumn*. It starts with the historical difficulties ("The standards of the ancient kings are documents passed down through former generations; people have added to them, people have abridged them. . . . Many of the ancient namings are unintelligible in the speech of today."), and continues:

"The standards of the former kings all answered some need of the time. The time doesn't come down to us with the standard; and even if the standard does come down to now, it can't be taken as standard. Dismiss, then, the formulated standards of the former kings, and take as standard the reasons why they made standards. What were those reasons? They

were men, and myself likewise am a man. Therefore if I scrutinise myself I may know other men, if I scrutinise the present I may know the past. It is simply that past and present are one, others and myself the same."[5]

Instead of following the standards or laws (fa) which the sage kings are dubiously recorded to have promulgated, you infer from the needs of men in the present what the sages would have ordained for the present.

"There was a man of Ch'u fording the Yangtse whose sword fell from the boat into the water. At once he cut a notch in the boat and announced 'This is where my sword fell from'. The boat stopped, and from where he had made the notch they went into the water to seek it. The boat had travelled on but the sword had not; wasn't he deluded to seek the sword like that? Governing one's state with the old standards is just the same. The time has shifted but the standard has not; how can you expect to govern with these?"

As an illustration of the completed split between Heaven and man we may take this dialogue from a minor syncretistic text probably mainly of the late 3rd century B.C., Ho-kuan-tzu.

"P'ang-tzu asked Ho-kuan-tzu
'In the Way of the Sage what is to be put first?'
'Put man first.'
'In the Way of Man what is to be put first?'
'Put arms first.'
'Why put man first instead of Heaven?'
'Heaven is too lofty to be easily known, its blessings cannot be pleaded for nor its disasters escaped; to imitate Heaven would be cruelty. Earth is broad and big, deep and thick, it benefits much but awes little; to imitate Earth would be abasement. The seasons call up and cast down and take each other's places without uniformity; to imitate the seasons would be inconsistency. These three cannot institute reforms or implant customs, therefore the sage does not imitate them."[6]

(By arms, it later turns out, Ho-kuan-tzu means 'ceremony, the right, loyalty and trustworthiness').

1. LAO-TZU'S TAOISM: THE ART OF RULING BY SPONTANEITY

Old Tan and the book Lao-tzu

In ancient China, if you wished to pass your work under a name more likely to attract attention than your own, the obvious choice was a great

statesman of past centuries or a legendary sage emperor. There is however a subtler trick, very suitable to esoteric wisdom. It is the multiple twist of hiding your pseudonymous work openly under a pseudonym presumed to conceal the identity of someone who while remaining humbly in the shadows taught some famous man the secret of his success. Thus a book which lifts, in a properly opaque style, a corner of the arts of the greatest diplomats of legend, Su Ch'in (died 321 B.C.) and Chang Yi (died 310 B.C.), is ascribed to someone known only as a recluse under whom they both studied and only under the name 'Master of the Valley of Ghosts' (*Kuei-ku-tzu*).* Another mysterious collection carries the title 'Master with the Pheasant Cap' (*Ho-kuan-tzu*), pseudonym of another recluse supposed to have taught P'ang Hsüan, the Chao general who defeated Yen in 242 B.C. Neither of these books succeeded in attracting much attention, or indeed left external evidence of its existence in the classical period, although both are likely to be from the 3rd or 2nd centuries B.C.† The great success in this line is the *Tao te ching* 'Classic of the Way and of Potency', which won a fascinated audience from its appearance about 250 B.C. under the name of the 'Old Master' (*Lao-tzu*), understood to be that Old Tan (Lao Tan) of whom only one story is told in pre-Han sources, that he was visited for instruction by none other than Confucius himself.

Apart from the Later Mohists, who with the impersonality of their school effaced themselves in the work, we know something about the lives and personalities of most of the major Chinese thinkers, however thick the overlay of legend. The author of *Lao-tzu* is the great exception. However, his pseudonymity itself is informative in its own way. To write under the name of the Yellow Emperor suggests nothing about you, not even megalomania. But one may suspect some measure of self-dramatisation in pretending to be the *éminence grise* behind some famous diplomat, general or teacher. The enigmatic styles of these books, *Lao-tzu*, *Kuei-ku-tzu*, *Ho-kuan-tzu*, tempt one to imagine a disregarded unsuccessful man, withdrawn and timid, fantasising as a secret power in history who disdained public notice. The author of *Lao-tzu*, one seems to divine, has learned in perpetual fear that habit of evasive speech so fruitful to the discovery of twisted paths to truth through falsehood, which another breed of poet

* This does not apply to the last of the three parts of *Kuei-ku-tzu*, which is commonly acknowledged to be later. For the date of *Ho-kuan-tzu*, cf. p. 296n below.

† In 1973 two silk manuscripts of *Lao-tzu* were discovered in a Han tomb at Ma-wang-tui, one (with four Huang-Lao documents added) datable by taboo characters as from the reign of Hui Ti (194–188 B.C.), the other earlier than 195 B.C. D. C. Lau (*Lz* tr. Lau *Classics*) provides both text and translation of both standard and Ma-wang-tui versions.

learns through versifying flatteries of great men. If it pleases one to indulge this fancy, one may see him as the perfect instance of the neglected genius who by the writing of the book makes the fantasy come true.

The story of Confucius consulting Old Tan is common to Confucian, Taoist and eclectic sources. For Confucians it has the authority of the *Classics* themselves, being found in the 'Questions of Tseng-tzu' in the *Record of Ceremony*, with Old Tan as simply a teacher of rites whom Confucius consults about funerals. The very earliest reference to the meeting is a casual mention as common knowledge in the *Chuang-tzu* 'Inner Chapters'.[1] The 'Outer Chapters' have a whole cycle of dialogues in which Confucius humbly accepts from Old Tan instruction in Taoism, of Chuang-tzu's kind however rather than the book *Lao-tzu*'s. The one point in common between Confucian and Taoist versions is that even in the former Old Tan as teacher addresses Confucius by his personal name Ch'iu. Why would Confucians borrow this detail from the Taoists, who exploit it to humble Confucius? A possible answer is that it is the Taoists who are the borrowers, and that Old Tan as Taoist originated as one of the various figures surrounding Confucius whom Chuang-tzu likes to use as spokesmen of his own thoughts. His unique advantage, that even Confucians acknowledge that he condescended to their own founder, would explain his rapidly growing importance in Taoist legend. A Confucian origin is also suggested by the odd fact that even the 'Outer Chapters' represent him as a keeper of archives of Chou,[2] a dry-as-dust occupation surely more suitable to a Confucian than to a Taoist hero. Why too would Taoists fail so long to provide Old Tan with a surname unless they were borrowing him from elsewhere? His traditional surname and personal name (Li Erh) are not attested before Ssu-ma Ch'ien's biography.**

However all this may be, the most famous and frequently translated of Chinese books had been written and circulated in Lao-tzu's name by about 250 B.C. Both Hsün-tzu and the *Lü Spring and Autumn* mention him in lists of philosophers and credit him with the policy of winning by yielding which distinguishes *Lao-tzu* from *Chuang-tzu*.[3] Since the 'Inner Chapters' show no clear evidence†† of acquaintance with *Lao-tzu* the book is

** The argument that Old Tan was borrowed by Taoists from a Confucian story is developed at length in G *Studies* 111–124.

†† As Robert Henricks has pointed out to me, there is a tantalising resemblance between a phrase in a discourse of Old Tan in *Cz* 7/15 and another found no less than four times in *Lao-tzu* (*Lz* 2, 10, 51 and 77); both share the words *pu/fu shih* 不 / 弗 恃 'does not depend on it'. But although suggestive, this is far from being clear evidence of influence by *Lao-tzu* in the 'Inner Chapters'.

conveniently treated after Chuang-tzu, although there is no positive proof
that it is later.

Chinese literature is often said to have no long poems, but this
judgment depends on conventions of classification. *Lao-tzu* is not classed
as a *shih* 詩 , for which 'poem' is the standard English equivalent, but for a
Westerner it is without doubt a long philosophical poem or poem cycle,
much of it rhymed. Its traditional division into two parts is at least as old as
the two manuscripts of the 2nd century B.C. discovered at Ma-wang-tui,*
which give them the titles 'The Potency' (#38–81) and 'The Way' (#1–37)
and reverse the order. The 81 stanzas (9 times 9) of the standard text
however were probably divided by later editors for convenience of
reading; the manuscripts mark only a few such divisions.†

This poet is not, like Lucretius or Dante, the versifier of a philosophy
borrowed from elsewhere. His interweaving of metaphors, water, valley,
root, gate, mother, with Way itself as only another of them, is not the
illustration of abstract thoughts, it is the thinking itself. *Lao-tzu* is the
masterpiece of a kind of intelligence at the opposite pole from the logical.
It concentrates instead of explicating, starkly juxtaposes instead of filling
in gaps; a 'therefore' or 'this is why', almost arbitrarily placed, is no more
than a signal that there is action at a distance between the aphorisms
however disconnected. At the root of the thinking, pervading this book of
evasions and retreats disguised by a pseudonym, is one dominant
emotion, fear. In *Lao-tzu* we are breathing an air very different from the
perfect fearlessness of Chuang-tzu ("The test that one holds fast to the
Beginning is the fact of not being afraid").†††[4] The pressing concern is
with how the small state and the small man survive in a world of
murderously competing powers. It is in searching for a pattern in things
which opens a prospect of eluding danger that the author finds his own
approach to the two great concepts for which each school has its own
interpretation, the Way the sage walks and the Potency in him which
empowers him to walk it. Like Chuang-tzu he holds that we discover the
Way by abandoning the prescribed courses of conduct which Confucians
and others try to formulate in words, unlearning the rigid divisions fixed
by names, and training the spontaneous harmonising of the *ch'i* which

* Cf. Lau's account (*ut sup.* 155–184) of the Ma-wang-tui text, which is richer in grammatical particles
than the standard text, and has solved various old problems arising from grammatical ambiguities.

† Cf. Henricks 'On the Chapter Divisions'.

††† The sense of fear at the back of *Lao-tzu* is noticed by Lau, who is reminded of Hobbes's remark that
his mother gave birth to twins, himself and fear (*Lz* tr. Lau *Chinese Classics*, xxvi).

sets us on the course of heaven, earth and the myriad things which are 'so of themselves'. This position sets both thinkers the problem of finding a language adequate to deal with a fluid whole with which we lose touch in dividing ourselves from it by the distinguishing, naming, and immobilisation of parts. To cope with it Chuang-tzu moves freely between many styles, *Lao-tzu* perfects just one.

The Way

The style is perfectly illustrated by the famous opening stanza dismissing all possibility of formulating the Way as a set of verbal instructions. In the first couplet we adapt English 'way' to Chinese *tao*, which has the same double use, nominal ('way') and verbal ('tell as the way') as the *ming* 'name' of the next couplet. (In translating *Lao-tzu* one cannot disturb the symmetrical placing of contrasting words without obscuring the movement of the thought).

> "The Way that can be 'Way'-ed
> Is not the constant Way.
> The name that can be named
> Is not the constant name.
> What has no name is the beginning of heaven and earth,
> What has a name is the mother of the myriad things.
> Therefore by constantly having no desire observe the sublimest in it,
> By constantly having desire observe where it tends.
> The two have the same source but different names:
> Call it the same, the 'Dark'.
> The darkest of the dark
> Is the gate of the sublime in everything.**

It might seem that *Lao-tzu* had only to tell us straightforwardly that the Way is inexpressible in words, is the source of all things, and is discovered in ridding oneself of desire. That however is not quite what it wants to say. The trouble with words is not that they do not fit at all but that they always fit imperfectly; they can help us towards the Way, but only if each formulation in its inadequacy is balanced by the opposite which diverges

** The text of the newly discovered Ma-wang-tui manuscripts by its additional particles forbids the alternative punctuation by which lines 5 to 8 may be read as about Nothing and Something ("'Nothing' names the beginning of heaven and earth "). In line 8 it establishes *chiao* 徼 as a verb, which I take to be the one sometimes translated 'seek' but meaning rather 'take the direction (not necessarily intentionally) in which something is going to happen'. Cf. Lau *ut sup.* 169f.

in the other direction. "Correct saying is as though wrong way round".[5] Can there be a name for that from which naming divides things out? It was a point which had been debated by the sophists (if we have rightly interpreted Kung-sun Lung's 'Pointings and Things'), and Chuang-tzu and his school refused to call the whole the 'Way' or the 'One'. The approach of *Lao-tzu* is to lay out couplets which, juxtaposed as parallel, imply both that there is and that there is not a constant Way with a constant name, and then try out the two alternatives in turn. Call the Way nameless, and it is put back to the time before there were things distinguished by names; name it, and it becomes itself a thing out of which all others have grown. The text proceeds to its first 'Therefore', marking as usual not an inference but the collision of abruptly juxtaposed statements which forces us to seek connexions where least expected. How does the Way being with or without a name connect with the sage being with or without desires? An answer is that dividing out and naming both are guided by and guide desire and dislike. There is a paradox in desire as in naming; to return to the undivided Way you have to cease desiring one thing more than another; yet Taoism loses all point unless when distinctions cease you do find yourself drawn in the direction which is the Way. Chuang-tzu had distinguished shallow cravings from the deeper impulse which is from Heaven.[6] *Lao-tzu*'s method is simply to smash the dichotomy of desire and desirelessness by contradictory commands both constantly to be without desire and constantly to desire. Arriving at the last pair of couplets, what are "the two"? "Named/nameless", or "desire/ desirelessness", or "the sublimest in it/where it tends"? Any or all, but the dichotomy on which the whole stanza focuses is "named/nameless". Having tried out both sides of the dichotomy the text now throws it aside; to name as 'nameless' is itself to divide named and nameless in what is ultimately the same. "*Call* them the same, the 'Dark'", use a new name to propel you towards the darkness beyond naming, and momentarily discard the name 'Way' itself for the 'gate' out of which things come in the mystery of the commencement of distinctions.

We offer this analysis with the same kind of reservations as one would for any other poem. The aphorisms of *Lao-tzu* hit the reader as successive blows from opposite sides which seem somehow to be driving the mind in one direction, leaving it to him to choose whether he needs more prosaic words to explain to himself where he is going. The text itself never departs from that language in which the sayer can himself say "The knower does not say, the sayer does not know".[7] On the one hand we have to cut up, name, set the limits within which each person "knows where to stop" (but

remembering that "the greatest cutting-up does not sever");[8] on the other we have to recognise what seems the diminishing remainder still to be divided as the inexhaustible block out of which they are cut, the 'Unhewn' (*p'u* 樸). From this point of view the Way as the still-undivided stuff is the nameless. Or again, to change the metaphor, it is like the apparently negligible depression of the ground which is setting the direction of the river towards the sea.

> "The Way is constantly nameless.
> Though the Unhewn is small
> No one in the world is able to make it his vassal.
> If lords and kings are able to hold it fast
> The myriad things will pay homage of themselves.
> Heaven and earth will join to send down the sweet dew,
> The people with no one commanding them of themselves will even out.
> 　　Only when it is cut up are there names.
> When also there are names
> No matter who will know where to stop.
> By knowing where to stop one can escape danger.

One may compare the position of the Way in the world to the relation of a small valley to the river and the sea."[9] (#32)

From another point of view, it is convenient to think of the Way as itself a thing which has a name.

> "As for the thing the Way is
> It is vague and dim.
> Dim! Vague!
> Within it is a model.
> Vague! Dim!
> Within it is a thing. . . .
> From the present to the past
> Its name does not depart" (#21)

You can get nearer and nearer to discerning it first as an image or model (*hsiang* 象), then as taking shape as a thing, yet it is itself the indefinite out of which the thing defines itself. The thing at all times has its name, not however as continuing to have it from past to present, but from the viewpoint of the namer looking back into the past.

Lao-tzu frequently calls the undivided the One, although generally in relation to the man or thing which "embraces the One" or "grasps the One". As a name however the One is no more adequate than any other. As soon as you try to conceive the Way you conceive the One, but as soon as

you conceive the One you conceive the many. Unlike Chuang-tzu, *Lao-tzu* does not raise this as a logical point. Using the language in which the Way is itself a thing with a name and "mother of the myriad things", it converts a logical into a generative sequence.

"The Way generates the One, the One two, the two three, the three the myriad things." (#42)

In seeking the One behind the many, as also in seeking the constant behind the changing, *Lao-tzu* is using concepts which seem fully identifiable with our own. There is however an important difference from the Western tradition, that no Chinese thinker conceives the One and the constant as Being or Reality behind the veil of appearance. This is inherent in the Classical Chinese language, in which the existential verbs *yu* 有 'there is' and *wu* 無 'there is not' (nominalisable as 'what there is, something' and 'what there is not, nothing') are used only of concrete things, as are *shíh* 實 'real' and *hsü* 虛 'unreal' (primarily 'solid, full' and 'tenuous, empty'; the word we have translated 'objects' in contrast with *ming* 名 'names' is nominalised *shíh* 'solids'). The further one moves from treating the Way as a thing with a name like an ox or a horse, the less unsuitable it becomes to identify it with Nothing, although it precedes the division of Something and Nothing. We may note also that Chinese, like most languages outside the Indo-European family, does not share one of the philosophically most important and questionable features of this family, that the existential verb 'to be' is used also for the copulative relation, so that for Western philosophy a thing has a being which embraces both its existence and its essence, what it is *per se*.* For *Lao-tzu* as much as for the Later Mohists you know not the essence of a thing but what name fits it; hence the enormous importance of naming and re-naming throughout the poem.

From this point of view we may understand why, in spite of full recognition of its inadequacy, the preferred Chinese name for the undivided should be the Way. If we ourselves would prefer to think of it as absolute Reality that is because our philosophy in general has been a search for being, reality, truth, while for the Chinese the question was always 'Where is the Way?' Chinese thinkers want to know how to live, how to organise community and, at the very end of the pre-Han period, how to relate community to cosmos. As for what is real, what exists, visible to the eye, audible to the ear, solid to the touch, what questions

* For the problem of the relation between the Indo-European verb 'to be' and Western ontology cf. G *Studies* 322–359 and pp. 406–13 below.

does it raise? From the Western viewpoint, pre-Buddhist Chinese philosophy is epistemologically naive. For the Chinese however the purpose of seeking the one behind the many is to find, not something more real than what appears to the senses, but a constant Way behind the changing and conflicting ways of life and government claimed by competing schools as the Way of the sage kings. What matters about the dissolution of boundaries when the fixity of naming loses its hold on us is that, in no longer splitting off deciding self from spontaneously changing other, we find ourselves moving on the same course as heaven and earth through their natural cycles. If naming this course 'Way' merely distinguishes one aspect of the undivided, so does every other name for it; and if we may equally well call it the Unhewn, the block out of which things are cut, or their mother or their root, the valley which is the lowest and emptiest in them or the gate through which they come, by all means let us use the other metaphors as correctives. But what matters for the conduct of life is the direction in which it sets one moving.

Reversal

The most characteristic gesture of *Lao-tzu* to overturn accepted descriptions is the reversal of priorities in chains of oppositions.

A	B
Something	Nothing
Doing something	Doing nothing
Knowledge	Ignorance
Male	Female
Full	Empty
Above	Below
Before	Behind
Moving	Still
Big	Small
Strong	Weak
Hard	Soft
Straight	Bent

In instructing the weak in the strategy of survival, *Lao-tzu* regularly advises him to *prefer* B to A, passive to active—in the terminology soon to become standard (but used only once in this text),[10] Yin to Yang. This inversion is hardly found in *Chuang-tzu* but astonished and impressed readers of *Lao-tzu* from the beginning. In contrasting different philosophies Hsün-tzu says: "Lao-tzu had some insight into drawing in, none into stretching out"[11] (Another of his lists has "Chuang-tzu saw no farther

than Heaven and did not know man").[12] A list of doctrines in the *Lü Spring and Autumn* has "Old Tan valued weakness (= yielding)".[13] For the modern reader too the most distinctive impression made by this philosophical poem is likely to be of a pattern running through everything which is the reverse of the one with which he is familiar. It exposes a cycle by which whatever becomes strong, hard, above, before, and something, has been and in due course will revert to being weak, soft, below, behind and nothing. The passive member is the foundation on which the active rises ("Therefore the noble has the mean as trunk, the high has the low as base", "The heavy is root of the light, the still is lord of the restless").[14] It is the passive which is vital, fluid, fecund ("When alive man is soft and weak, when dead he is hard and strong"; "In the world's intercourse the female constantly by stillness conquers the male. It is because she is still that it is proper for her to be below.").[15] In action the passivity of the sage is female; in contemplation the suspension of the thinking by which the heart controls the breath and other energising fluids of the *ch'i*, allowing them to harmonise by themselves and set the direction of spontaneous motion, is rather a return from adulthood to the state of the newborn babe. (As in *Chuang-tzu* the training of the *ch'i* may be presumed to be a breathing exercise).

> "In concentrating the *ch'i* to utmost softness,
> Are you able to be a babe?
> When the gates of Heaven open and shut,
> Are you able to play the female?" (#10)

> "Who contains abundance of Potency
> may be compared to a baby.
> Poisonous insects will not bite it,
> Savage beasts will not pounce on it,
> Birds of prey will not snatch it.
> Its bones are weak and muscles soft but its grip is firm.
> Not yet knowing the union of male and female its penis rises
> —the utmost in vitality.
> To day's end howling it does not get hoarse
> —the utmost in harmonising.
> Knowing how to harmonise is to be 'constant'.
> Knowing how to be constant is 'illumination'.
> The added on to living is the 'baleful'.
> The heart imposing service on the *ch'i* is 'forcing'.
> A thing which as soon as grown ages
> Call 'off the Way'.
> What is off the Way has too early an end." (#55)

The virtues of different passive combinations are explored through interrelated metaphors among which, for example, the valley (empty, below) suggests the generative in the female (who is soft, weak, below) and connects as channel with water, which as likewise soft, weak and below has advantages of its own:

"The highest good is like water. Water is good at benefiting the myriad things but does not compete, it settles in the place which the multitude dislikes and so is near to the Way." (#8)

"Nothing in the world is softer and weaker than water, but as assailer of the hard and strong nothing can conquer it, because there is nothing with which to replace it. That the weak conquers the strong and the soft the hard everyone in the world knows yet no one is able to act on." (#78)

Precisely because it is soft, water moves more freely than stone, and *above* it; and in finding its way through the smallest crack it is surpassed only by Nothing, which does not need even a crack to fill the place vacated by Something.

"The softest in the world gallops over the hardest in the world, Nothing finds a way in where there is no crack. This is how I know that Doing Nothing has advantages. To the teaching which is unspoken, the advantages of Doing Nothing, the world seldom attains." (#43)

The most startling of the reversals is the elevation of Nothing above Something.

"Thirty spokes share one hub; just where it is nothing is the usefulness of the cart. You knead clay to make a vessel; just where it is nothing is the usefulness of the vessel. You bore doors and windows to make a room; just where it is nothing is the usefulness of the room. Therefore it is where they are something that we find them beneficial, it is where they are nothing that we find them useful." (#11)

The spontaneous course of things, which we defy in struggling to be powerful and superior, is from up to down, from strong to weak, and then upwards again after renewal by this return to the source.

> "Returning is the motion of the Way,
> Weakness is the usefulness of the Way.
> The myriad things of the world are born from something,
> And something is born from nothing." (#40)

> "Refine to the emptiest,
> Hold fast to the stillest.
> As the myriad things arise side by side,
> By that I watch them revert.
> Of all things in their teeming growth

> Each by reversion goes home to its root.
> Going home to the root is 'stilling',
> Call it 'reversion to the destined'.
> Reversion to the destined is the 'constant',
> Knowing how to be constant is 'illumination'." (#16)

Reversion is to the source of all fecundity, the dark, the valley and the female, the gate and root of all things.

> "The daimon of the valley never dies.
> Call it the 'dark female'.
> The gate of the dark female
> Call the 'root of heaven and earth'.
> Elusive, as though present.
> However much you use, it will not wear out." (#6)

'Way' is no more than one of the names one tries out for what, when treating it as a nameable thing, one conceives as the mother of the myriad things which is also the root to which they revert.

> "There is a thing formed in confusion,
> Born before heaven and earth.
> Silent! Void!
> It stands alone without changing,
> Travels round without tiring.
> It may be deemed the mother of the world.
> I do not know its name, style it 'Way',
> Force a name on it, 'Great'.
> Great is 'gone on and on',
> Gone on and on is 'far',
> Far is 'returned'." (#25)

An alternative to saying that the name 'Way' is inadequate is to accept it but proceed to identify something still further back, the first of what if continued would be an infinite series. The same stanza ends by picking the 'so of itself' (*tzu jan* 自然), pure spontaneity.

"For standard man has earth, earth has Heaven, Heaven has the Way, the Way has the so of itself."

The poet conceives his own language as adequate to the extent that in its constant passage from one re-naming to the next it goes on springing, like the action which is "Doing Nothing", from this ultimate ancestor.

"My speech is very easy to understand, very easy to practice, but no one in the world is able to understand and practice it. Speech has an ancestor, doing has a lord. (#70)

The reversals in *Lao-tzu* have a modern parallel in Jacques Derrida's project of deconstructing the chains of oppositions underlying the logocentric tradition of the West. The parallel is indeed so striking that there is danger of missing the differences. In contrasting A with B the West tends to see them as conflicting, China as complementary, a difference which forces itself on attention in the Yin-Yang classifications.[16] Derrida explains the Western aspiration to abolish B in favour of A by a logocentric, ultimately phonocentric orientation which starts its chains of oppositions from the pair 'signified/signifier'. In silent speech, with vocal articulation suspended for apparently wordless thought, the signifier seems dissolved in the full presence of the signified. That when written the signifier does not as in speech blow away in the wind leaving only its meaning behind has been treated as irrelevant, since writing appears external to language, a mere representation of speech. Starting from the abolition of the signifier from thought and of writing from language, the West has aspired throughout a wide range of oppositions (reality/appearance, nature/culture, life/death, good/evil. . . .) to dissolve B in the pure being, the full presence of A. One of Derrida's methods of deconstructing the oppositions is to reverse them, for example elevating writing above speech—writing is not a representation of speech, speech is writing which lasts only long enough to be read by the ear; language is not living speech in contrast with dead marks on paper, it is what has meaning even if speaker or writer is dead. The affinity of *Lao-tzu* and Derrida is that both use reversal to deconstruct chains in which A is traditionally preferred to B, and in breaking down the dichotomy offer us a glimpse of another line which runs athwart it—for *Lao-tzu* the Way, for Derrida the Trace. Both use a language which already escapes the opposition 'logic/poetry', a language in which contradictory statements do not cancel out, because if made in the appropriate sequence or combination they set you in the true direction.

The Chinese tradition however is not logocentric in Derrida's sense, centred on living speech and the full presence of the signified. Reversals in *Lao-tzu* are merely of relative superiority, they are not experiments in abolishing A in revenge against the traditional effort to abolish B. The Chinese opposition *ming/shih* 'name/object' is very unlike the Saussurian 'signifier/signified' which Derrida takes to be implicit in Western thought from the beginning. A name is used to 'point out' *(chih)* an object, and if appropriate to it 'fits' *(tang)*.* Nominalised *chih* is sometimes conveniently

* For *chih* and *tang* cf. p. 91, 168 above.

translated by 'meaning'.† But Classical Chinese nominalises the verb by syntactic position alone, without the morphological changes such as number termination which in Indo-European languages encourage hypostatisation by assimilation to nouns. There is consequently no tendency (as I at one time supposed myself)[17] for the *chih* of names to turn, like 'meanings' or the 'signified', into third entities on the same level as the objects and the sounds of the names. In the hypostatising terminology of Saussurian linguistics signifier and signified are two entities combined in the sign, specifically compared to the two sides of a sheet of paper;[18] signifying has somehow disappeared, and for Derrida the object too has dissolved into the signified ("There is nothing outside the text").[19] For a Chinese thinker on the other hand there would be nothing, except the present or absent oxen to which his use of 'ox' points, which could be credited with existence or reality in detachment from the phonic exterior of the sign. A further consideration, that the Chinese would in any case be saved from phonocentrism by the habit of recognising words as written rather than as spoken, may be significant in the long run but seems less relevant to the classical age. Most teaching and debate was oral, doctrine was what someone 'said' and 'I have heard ', and the issue of names and objects was always discussed in terms of the spoken, not the written. A great difference from Derrida is that *Lao-tzu* does not of course share the background of his very Western conclusion that philosophy losing hope of discovering reality as the full presence of A has to be satisfied with the *trace* of it, which on inspection turns out to be only the trace of a trace of a Perhaps *Lao-tzu*'s Way is how the Trace will look to us when we are no longer haunted by the ghost of that transcendent Reality the death of which Derrida proclaims.

For *Lao-tzu* as for Derrida reversal is *not* a switch from preferring A to preferring B, aiming to become weak, soft, below instead of strong, hard, and above. Since all human effort is against a downward pull towards B, that direction is a first approximation to the Way of spontaneous process, to be adjusted next to the upward impulse after renewal from the fecund bottom of B. The reversal smashes the dichotomy of A and B; in preferring

† In G *Logic*, 457–468, my first attempt to translate 'Pointings and Things' on my whole/part interpretation, I did translate *chih* by 'meaning'. The translation starts: "When no thing is not the meaning the meaning is not the meaning. When there is no meaning one thing rather than another within the world, no one can call a thing *not* his meaning " (cf. p. 92 above: "When no thing is not the pointed-out, to point out is not to point it out. Without pointing out of things from world, there is nothing by which to call things *not* the pointed-out."

to be submissive the sage does not cease to be oriented towards strength, for he recognises that surviving by yielding to a rising power is the road to victory over it when its climax is past. Thus since everything which goes up will come down, you may help to strengthen an enemy in order to hasten the moment of his decline.

"If you wish to shrink it,
Be sure to stretch it.
If you wish to weaken it,
Be sure to strengthen it.
If you wish it cast aside,
Be sure to raise it up.
If you wish to take from it,
Be sure to give to it.
This call the 'subtlest illumination'.
The soft and weak conquers the hard and strong." (#36)

At the earliest stage of a rising force you can still stop it, afterwards it is too late.

"When stable it is easily upheld,
When not yet portending it is easily planned for.
When brittle it is easily broken,
When flimsy it is easily dispersed.
Do to it before it is something,
Order it before it is disordered.
A tree the span of both arms round is born from the tip of a hair,
A terrace nine storeys high rises from a pile of earth,
A journey of a thousand miles starts from under the foot." (#64)

Again, it is by refraining from rising too high that one escapes the fall.

"Rather than hold it steady to fill it to the brim
Better stop pouring.
What you hammer to a fine point
You cannot keep sharp for long.
When gold and jewels fill the hall
No one can protect it.
To be haughty when rich and noble
Brings disaster on oneself.
That one's task fulfilled one's person withdraws is the Way of Heaven."
(#9)

The image of the vessel which tips over when filled to the brim is that of Chuang-tzu's 'spillover saying'.[20] The difference in application is signifi-cant; Chuang-tzu lets it tip over in the faith that it will right itself, *Lao-tzu* takes no risks.

If it is by yielding that the weak becomes stronger, might one say that the sage is simply using submission as a means to conquer, so that at bottom he still draws the dichotomy and prefers A to B? No, for that would imply analysis and calculation of means to end. The sage, perfectly illuminated about his situation, gravitates towards his survival with the spontaneity of natural process; he simply settles in a direction towards both the preceding submission and later conquest.

"Heaven persists, earth endures. The reason why heaven and earth are able to persist and endure is that they do not generate themselves, that is why they are able to be persistently generated. Therefore the sage

Puts his own person behind yet his person is ahead,

Puts his own person outside yet his person survives.

Is it not because he is without selfishness that he is able to be successfully selfish?" (#7).

The 'therefore' once again forces us to peer after apparently invisible connexions. Heaven and earth last for ever because, unlike man, they do not try to prolong their existence; if man follows their example by not caring about his existence, treating his own person as he does the things outside him, he finds himself on the course most favourable to his own survival. But is there not a rather obvious flaw in the analogy, that if heaven and earth will last as long as there is anything, it is because by definition they are everything? But then again—it is to such immediate clashes with common sense that these aphorisms owe so much of their pregnancy—if the sage in his perfect unselfishness is no longer distinguishing himself from heaven and earth is he not in some sense participating in their immortality, as he is for Chuang-tzu?

The effect of the reversal might also be described, not as the choice of B instead of A, but as a balancing of A and B. Human codes of conduct prefer A, Heaven's Way is to equalise A and B.

"The Way of Heaven, is it not like stretching a bow?

The high it presses down,

The low it lifts up.

Excess it reduces,

Deficiency it augments.

The Way of Heaven reduces the excessive and augments the deficient. Man's way is otherwise. It reduces the insufficient to make presents to the excessive. Who is able, being in excess, to have wherewith to take and present to Heaven?.* Is it only one who possesses Heaven?" (#77)

Here the split between Heaven and Man is fully in the open. At first sight one might take *Lao-tzu* to say that man is unjust but Heaven just. But the point is rather that man always strives to enlarge A at the expense of B, fighting the natural course of things which reverts to B and so balances A and B. The sage has learned to accord with a Way independent of the will of man, by making presents to Heaven out of his own excess. Elsewhere we are told that the natural course of things is un-*jen*, cruel, ruthless, treating everything which rises and passes away as like the straw dogs honoured before being used for sacrifice and afterwards thrown away and trampled.

> "Heaven and earth are ruthless,
> They treat the myriad things as straw dogs.
> The sage is ruthless
> He treats the people as straw dogs.
> Between heaven and earth is it not as with a bellows?
> Emptied it does not collapse,
> Moving it emits more and more.
> Too many words soon run out.
> Better hold fast to what is within. (#5)

We do find one passage which in affirming seems also to deny the amorality of Heaven.

> "To the Way of Heaven none is more kin than another,
> It is constantly on the side of the good man." (#79)

But good/bad do not belong to the chains of oppositions which *Lao-tzu* deconstructs; without any qualification it is better to follow the Way than not. The good man is the one who by adapting himself to the Way has learned both to survive and (a theme however of Chuang-tzu rather than *Lao-tzu*) reconcile himself to misfortune and death; it is because alone among men he is on the side of the Way that the Way works in his favour.

* Reading 天 for 天下 with Ma-wang-tui text.

Doing nothing

The paradox that the way to attain a goal is to cease to aim at it deliberately is most explicit in the constant appeals to 'do nothing' *(wu wei)*. This term, which goes back to Confucius,[21] is often translated by such innocuous phrases as 'non-action' to avoid giving the impression that Taoists recommend idleness, but it seems better to keep the paradoxical force of the Chinese expression. *Wei* is ordinary human action, deliberated for a purpose, in contrast with the spontaneous processes of nature which are 'so of themselves'. Man takes pride in distinguishing himself from nature by his purposive action; *Lao-tzu* by a classic reversal describes the behaviour of the sage as Doing Nothing.*

> "The Way constantly does nothing yet there is nothing it does not do.
> If lords and kings are able to hold fast to it
> The myriad things of themselves will be transformed." (#37)

There are other contexts however in which it will be described not as 'doing nothing' but as 'doing but ':

> "To generate but without taking possession,
> To do but without presuming on it,
> To lead but without managing,
> This call the 'Dark Potency'." (#10 = #51)

The essential thing is not to interfere when things are already running well by themselves.

> "The more taboos in the world
> The poorer the people:
> The more the sharp tools among the people
> The stupider the state.
> The more men's arts and skills,
> The more oddities arise:
> The more laws and edicts are proclaimed
> The more thieves and bandits there will be.

* Some commentators and translators seek other meanings than 'do' for *wei* when *Lao-tzu* uses the word approvingly (*Lz* 2, 10, 51, 81), to reconcile the usage with the doctrine of 'doing nothing'. (cf. Lau, who translates 'benefit'). But to call the sage's behaviour at one moment 'doing nothing' and at another 'doing but ' seems to me a characteristic Taoist reminder that no word you use will ever fit perfectly.

Hence the sage says
> 'If I do nothing, of themselves the people are transformed.
> If I love stillness, of themselves the people are correct.
> If I meddle in nothing, of themselves the people are rich.
> If I desire nothing, of themselves the people are unhewn.'" (#57)

This is not quite a faith that all things will go right if left alone; Taoists do not share the Mencian position on the purely Confucian issue of the goodness of human nature. The assumption as in Chuang-tzu[22] is that spontaneity comes out right to the extent that people are aware of their circumstances and of each other. Consultation of our quasi-syllogism[23] will confirm that its imperative could be applied in opposite ways— become a sage aware of all possible factors, or simplify your situation to bring it within the limits of your knowledge. The second is the one inevitably preferred for the people by this instinctively cautious thinker who, as Hsün-tzu said, understands only how to draw in, not to stretch out. The passage just quoted itself illustrates a suspicion of the spread of new skills, and a passage we have connected with the Shen-nung ideal[24] has the people of Utopia living in sight of each other's villages without ever wanting to leave their own. The people are best ordered when interfered with least, but only if there are no thoughts in their hearts of a better life elsewhere, no advertisements between the television pro- grammes to tempt them with the promise of 'goods difficult to obtain'.

"Not elevating worth will stop the people competing, not valuing goods difficult to obtain will stop them becoming robbers, not displaying the desirable will stop their hearts being disorderly. This is why the sage's ordering
> Empties their hearts,
> Fills their bellies:
> Weakens their intents,
> Strengthens their bones,
> And constantly ensures that the people know nothing and desire nothing.

Ensure that the knowing never dare to do. If you do the doing of nothing everything will be in order." (#3)

The ideal state in which everything runs itself requires the placing of the ignorant masses in the simple circumstances in which they will react and interact in sufficient awareness, with all complexities left to the enlightened heart of the sage. Then he has nothing to do but maintain the concord by minimal interference to maximum effect, discerning the

incipient danger before it develops and "doing to it before it is something."[25]

The mystical and the practical

It is by now time to ask a question which some may think would have been better answered at the beginning: what is the book *about*? Mystical philosophy? Derridan deconstructionism? The art of government? Even the art of war, as was widely held in China at the time of the Cultural Revolution? Or the little man's strategy of survival, which Brecht read into the book? Certainly the audience to which *Lao-tzu* (unlike *Chuang-tzu*) is directly addressed is the ruler of a state—a small state, one might guess, which has to bend with the wind to survive among stronger states. Its strategy of retreating before a rising power until it overstretches itself and passes the point of decline has very practical applications in government, military strategy and wrestling—Japanese *Judō* ('the Way of Weakness') is named straight from the terminology of *Lao-tzu*. But what of the vision of oneness it shares with Chuang-tzu? Can it really be advising rulers that to govern their states requires nothing less than the ultimate mystical illumination?

The question 'What is it about?' is however not necessarily any more relevant to *Lao-tzu* than to other poetry. That it is hard to pin down the theme of a poem we take as a sign of richness: *Lao-tzu* as philosophical poem has a structure which helps to illuminate patterns running through many branches of life, but as a text standing by itself has as much to do with one as with another. When for example Frank Lloyd Wright drew from "Just where it is nothing is the usefulness of the room" the lesson that in architecture the spaces matter as much as the masonry[26] it would be hardly to the point to accuse him of misreading; the metaphor is apt just because the pattern it exposes shows up especially clearly in the construction of a house. *Lao-tzu* is a rare case of a poem which for readers in tune with it seems to work even through the feeblest translations, and no one who has glimpsed a coherence in its imagery has altogether failed to understand it. ("My speech is very easy to understand, very easy to practice ").

Nor need it surprise us that the pattern should run through the strategies of performers as unlike as the mystic, the ruler and the wrestler. The Western classification of certain experiences long absent from or marginal to our tradition as 'mystical' is closely connected with our un-Chinese habit of puzzling about ultimate reality. We still tend to evaluate the mystical by whether or not we think it provides an additional and superior access to reality independent of sense perception and reason,

and treat as incidental any improvements in mental and physical health said to result from the practice of meditation. 'Mystical' can be a misleading word when applied to experience conceptualised in terms not of reality but of the Way. The Taoist relaxes the body, calms the mind, loosens the grip of categories made habitual by naming, frees the current of thought for more fluid differentiations and assimilations, and instead of pondering choices lets his problems solve themselves as inclination spontaneously finds its own direction, which is the Way. He does not have to make decisions based on standards of good and bad because, granted only that enlightenment is better than ignorance, it is self-evident that among spontaneous inclinations the one prevailing in greatest clarity of mind, other things being equal, will be the best, the one in accord with the Way. Self-cultivation of this kind has been rooting itself in the West also over the last century or so, and has made increasingly familiar a stretch of previously neglected experience which has both a deep and a shallow end. At the deep end the theoretical limit would be the step from the fluidity to the disappearance of distinctions, in the absolute illumination which may still deserve to be called 'mystical'. At the shallow end, the self-cultivation may serve as a means to relaxation, poise, loosening of habit, creativity, quickening of responsiveness, for the Chinese wrestler or Californian businessman using meditative techniques to enhance his efficiency. The author of *Lao-tzu* certainly sounds familiar with the deep end, but the book has had many readers who, far from sharing the Taoist renunciation of fixed goals, sought in it only a mental discipline in the service of their ends. Even the Confucian appraisal of the philosophical schools in the bibliographical chapter of the Han History recommends as the strength of the Taoists that they teach, as "the lore of the ruler facing south", how to "hold fast to oneself by clarity and emptiness". A training of the mind in clarity and 'emptiness' (flexibility, openness) is recognised as an aid to the application of Confucian virtues in government, misused however by Taoists who wish to "discard both the benevolent and the right, and say 'By trusting solely to clarity and emptiness one can rule'."[27]

2. HSÜN-TZU'S CONFUCIANISM: MORALITY AS MAN'S INVENTION TO CONTROL HIS NATURE

Recognition that spontaneous process takes a course independent of man's morality had become so much the dominant trend in the 3rd century B.C. that it is shared by the greatest Confucian of the time, Hsün Ch'ing (Hsün-tzu). Not that it dominated Confucianism even at this

period, for the school had split into competing sects, and the eight listed by his own one-time disciple the Legalist Han Fei[1] include both the sect of Mencius and that of Tzu-ssu from which it had branched. Hsün-tzu himself denounces the 'worthless Ju' or 'vulgar Ju' of other sects as vigorously as the rival schools. He is familiar with a wide range of the latter, including two thinkers later to be classed as Legalist, Shen Tao and Shen Pu-hai. Although a fierce defender of Confucian orthodoxy, his attitude to them is already that of the *Chuang-tzu* 'Below in the Empire' chapter and of the Han bibliography, criticising not as wholly wrong but as one-sided, lacking the comprehensive vision attained only by Confucius and an otherwise unknown Tzu-kūng,* the founder presumably of his own sect.

"Mo-tzu seeing no farther than utility did not understand culture, Sung Hsing seeing no farther than desire did not understand fulfilment, Shen Tao seeing no farther than law did not appreciate personal worth, Shen Pu-hai seeing no farther than the power-base did not appreciate wisdom, Hui Shih seeing no farther than wordings was ignorant of objects, Chuang-tzu seeing no farther than what is Heaven's was ignorant of what is man's." (*Hs* 21/21f, tr. W 125)

This kind of pointed summing-up is characteristic of Hsün-tzu; the names which recur are Mo-tzu, Sung Hsing, Hui Shih and Shen Tao. The longest list is in the chapter 'Against the Twelve Masters', which actually includes the Confucians Tzu-ssu and Mencius among the twelve, and for good measure concludes with a denunciation of the 'worthless Ju' of the sects of Tzu-chang, Tzu-hsia and Tzu-yu, all of them first-generation disciples of Confucius. One has the impression that Hsün-tzu is one of those whose thought thrives on controversy and who, without ever acknowledging it, are continually learning from those they criticise. That his conception of the Correction of Names is completely refurbished from the sophists or the Later Mohists is plain enough, and he uses without hesitation such Mohist terms as 'elevation of worth and employment of ability', 'concern for everyone' and 'thrift in utilisation'. Elevation of worth is indeed one of his firmest principles; unlike Mencius, he has come fully to terms with the new bureaucratised states in which promotion from below is no longer merely an exception to the hereditary principle admitted in cases of extraordinary merit.

"Even the sons and grandsons of kings, dukes, and high officers, if they are incapable of adhering to the ceremonial and the right, reduce to

* The disciple Tzu-kung of the *Analects* has a different name which happens to be similarly romanised.

commoners. Even the sons and grandsons of commoners, if they accumulate culture and learning, correct their personal conduct and are capable of adhering to the ceremonial and the right, promote to chief minister or high officer" (Hs 9/2f, tr. W 33)

Sung Hsing's doctrine that the desires of man's ch'ing, the essential to being human, are few in number, would be the starting-point of his own thinking about the reconciliation and satisfaction of desires in organised society. Although he insists that society is held together primarily by custom, ceremony, he fully recognises the importance of law and punishment, the preoccupations of Shen Tao, and seems at times on the verge of the Legalism to which his disciples Li Ssu and Han Fei were soon converted. That throughout the classical period rationality is the fruit of controversy is a generalisation of which there is no clearer instance than Hsün-tzu. He uses more than one mode of discourse, including verse, but no other pre-Han thinker has organised the full range of his basic ideas in such coherently reasoned essays.

Ssu-ma Ch'ien gives a brief sketch of Hsün-tzu's life immediately after dealing with the thinkers whom King Hsüan of Ch'i attracted to his Chi-hsia Academy.[2] After the death of the last of them, in the time of King Hsiang (283–265 B.C.), Hsün-tzu from Chao was the most eminent of the teachers in Ch'i, and three times performed the wine sacrifice as head of the Academy. It would be here that he sharpened his case for Confucianism by debate with the spokesmen of rival schools. However, somebody slandered him, and in 255 B.C.,[3] having moved to Ch'u, he was appointed magistrate in Lan-ling in the south of the Shan-tung peninsula by the chief minister, the Lord of Ch'un-shen. After the murder of the Lord of Ch'un-shen in 238 B.C. he was dismissed. "Hsün-tzu detested the policies of a corrupt age, with misruling princes of doomed states coming one after another, who instead of pursuing the Great Way busied themselves with shamans and trusted in omens, while vulgar scholars and petty minds like Chuang-tzu frivolously threw custom into confusion",[4] so he settled down in Lan-ling to edit his works.

Hsün-tzu seems to have lived to a great age, and there is conflicting evidence about his life before and after this period.[5] But we learn from his own book that he visited Ch'in, and was impressed by the growing power of that state on the north-west borders of Chinese civilizaton, which by policies so very far from Confucianism was soon to conquer the rest. We read of him praising to the Marquis of Ying (chief minister there from 266 to 255 B.C.) the simple manners and obedient spirit of its people, the honesty of officials and efficiency of government, but he complains that

there are scarcely any Ju to teach the true principles of kingship.[6] He has an audience with King Chao (306–251 B.C.) of Ch'in in which he tries to answer the King's blunt "The Ju are no use in running a state".[7] In another dialogue he tries to dissuade one Li Ssu, who says: "Ch'in has been victorious for four generations, its arms prevail everywhere within the four seas, it overawes the lords of the states. It does it not by the benevolent and the right, but simply by following expediency."[8] This Li Ssu was later by Legalist policies to become chief minister of the First Emperor. According to Ssu-ma Ch'ien he studied with Han Fei under Hsün-tzu, but left him to seek employment in Ch'in in 247 B.C.[9] It may be mentioned that King Chao, within a few years of the audience, broke the back of Hsün-tzu's native state of Chao on the terrible battlefield of Ch'ang-p'ing in 260 B.C. He executed on the battlefield the entire surrendered army of Chao, amounting if we can trust Ssu-ma Ch'ien's figures to more than 400,000.* Hsün-tzu is defending Confucian moralism at a time when very bleak winds are blowing.

Heaven

For Hsün-tzu as for others the world outside man consists of Heaven and Earth, with Heaven as the dominant partner, directing all which is outside man's control. A modern reader may wonder to find so little even in the major philosophers to show that this power is distinguished from the sky itself. This I think is because, even for philosophers, Heaven *is* the sky. In the absence of any spirit/matter dichotomy, there are only degrees of substantiality; man's thoughts and feelings are less solid than his body, but only as the sky is more tenuous than the earth below it. The *ch'i*, the energetic fluid, which inside man is the breath and other vitalising forces of the body, is also outside him as air; and once a cosmogony develops, in *Huai-nan-tzu* (c. 140 B.C.), with the myriad things solidifying out of and dissolving into *ch'i*, it is inevitable that Heaven is seen as the finer which rises to the top and Earth as the denser which sinks to the bottom.[10] The highest controlling power, the purest intelligence, whether in the cosmos or in man himself, is conceivable only as the ultimately rarified which moves freely everywhere and has not yet begun to immobilise itself by assuming shape; and how would that differ in kind from the air above us? The Heaven of the philosophers approaches the impersonality of the Way

* That the figure, like many of ancient battle losses, is impossibly high, is argued convincingly by Bodde (Twitchett and Fairbank 99f).

that things follow and the patterns *(li)* which are specific to them, but there is never in the classical period a full identification with them; the Way indeed is increasingly described as the 'Way *of* Heaven' or 'of Heaven and Earth'. However much the concept was depersonalised, there was no paradigm shift freeing thought from the underlying analogy of Heaven with a human ruler.

Like Confucius, Hsün-tzu has a man-centred view which does not quite fit our categories of 'humanist' and 'rationalist'. Heaven and Earth follow a Way independent of man's will, leaving resources at his disposal without advising how to use them. It is for man to find the Way proper to himself, by which he co-operates in society to utilise these resources for his own benefit. If this looks like a 'scientific' approach to nature— especially when he is speaking of the universe as patternless until patterned by man—there is also in Hsün-tzu a certain residual awe of the sacred in nature which discourages curiosity or interference except for practical ends. His hostility to attempts to discover or influence Heaven's will by divination or prayer is because he sees them as violations of Heaven's secrets as well as shirkings of man's responsibility to look after his own affairs.

His 'Discourse on Heaven' is in the first place an answer to all who expect Heaven to tell us what to do, in particular those who through divination and the increasingly influential Yin-Yang cosmology seek guidance from auspicious or baleful omens.

"Heaven has a constant course, neither maintained for sage Yao nor abandoned for tyrant Chieh. If you respond to it by order it is auspicious, if you respond to it by disorder it is baleful." (*Hs* 17/1, tr. W 79)

On the one hand, "if you make the basic [agriculture] strong and utilisation thrifty, Heaven cannot make you poor", and "flood and drought cannot reduce you to famine"; on the other "if the basis is neglected and utilisation wasteful, Heaven cannot make you rich", and "there will be famine before flood and drought arrive". Similarly with "adequate diet and timely exercise" you will be healthy however hot or cold the weather, and if "you cultivate the Way with singleness of purpose" you will be lucky whatever the malign influences.

"If we enjoy the same seasons as orderly ages but differ from orderly ages in suffering disasters, it is inadmissible to blame Heaven, it is because of the Way that we follow."

For Hsün-tzu, as for the Mencian author of the 'Doctrine of the Mean', it is man's greatness that he completes a triad with heaven and earth.

"What comes about without being done, is got without being sought,

these we say are in Heaven's charge. On such as these a man however profound does not exert his forethought, however great does not exert his capability, however shrewd does not exert his perspicacity; this we call refraining from competing over what is in Heaven's charge. Heaven has its seasons, earth its resources, man his order; this we call his capability to align himself as the third. It is a delusion to neglect the means by which he aligns as the third and go begging from the other two."

Hsün-tzu's strongest statement of man's active participation is in verse:

> "Instead of magnifying Heaven and contemplating it,
> Why not domesticate and curb it?
> Instead of being subservient to Heaven and singing its praises,
> Why not curb its decree and put it to use?
> Instead of looking out for the seasons and awaiting their bounty,
> Why not respond to them and make them serve you?
> Instead of being passive towards things and overwhelmed by their
> multitude,
> Why not unleash capabilities and transform them?
> Instead of contemplating things in their independence,
> Why not make them a pattern from which none escapes?
> Instead of depending on the means by which things come to birth,
> Why not be owner of the means by which things come to completion?
>> Therefore if you put aside what is man's to contemplate what is
>> Heaven's, you let the essential in the myriad things escape you." (*Hs*
>> 17/44–46, tr. W 86)

Unusual phenomena have none of the significance omen-seekers find in them.

"When a meteor falls or wood sings, everyone in the state is frightened and asks 'Why?'. No point in asking why. These are alterations between Heaven and Earth and transformations of Yin and Yang which are rare events: to wonder at them is admissible, but it is wrong to be awed by them. Eclipses of sun and moon, unseasonable wind and rain, the occasional sight of a strange star, have been happening in every generation. If the ruler is enlightened and administration regular, even if they all occur in the same reign there is no harm in them; if the ruler is benighted and administration irregular, even if not one of them occurs it will do him no good."

There is no objection to such practices as divination as accepted

rituals, but they have nothing to do with telling the future. It is the understanding or misunderstanding of their social function which is auspicious or baleful.

"We pray for rain and it rains, why? No point in asking, it is the same as if it rains when we did not pray. Rescuing the sun or moon from an eclipse, praying in time of drought, deciding a great matter only after divining with tortoise-shell or yarrow sticks, are not because one expects to get what one asks, but to impose culture on what we do. Hence the gentleman thinks of them as cultured but the Hundred Clans think of them as daimonic. To think of them as cultured is auspicious, as daimonic is baleful."

As for what is truly 'daimonic', powerful, and intelligent in a way higher than and alien to the human, for which the Chinese word is *shen*, it is a mystery which we should not follow the diviners in trying to approach. In this respect one might say that Hsün-tzu is positively anti-scientific, that he discourages the curiosity about the reasons for events of diviners, physicians, and other proto-scientists only just beginning to force themselves on the notice of the philosophical schools.

"The constellations revolve in sequence, sun and moon take turns to shine, the four seasons in succession guide, the Yin and Yang universally transform, wind and rain reach everywhere, of the myriad things each gets the harmonies by which it is born, the nourishment by which it is completed. That of which, without seeing the work, we see the results, we call the 'daimonic': that which, though all know it is the means to their completion, none knows in its absence of shape, we call 'Heaven'. Only the sage may be deemed to refrain from seeking to know Heaven." (*Hs* 17/8–10, W 80).

The sense of a mystery at the heart of things is seldom altogether missing in early Chinese thinkers, except in the Legalists and perhaps the Mohists (whose explicit theism is curiously empty of a sense of the numinous). The definitive statement of it in the Confucian Classics is in the 'Great Appendix' of the *Yi*: "It is the unfathomable in the Yin and Yang which is called the 'daimonic'."[11] For Hsün-tzu legitimate curiosity is limited to the human and to the directly useful to man, and when speaking of excess knowledge he can sound like a Taoist.

"Therefore the greatest dexterity is in what he refuses to do, the greatest wisdom in what he refuses to think about. His attention to Heaven stops at the visible models [sun, moon, stars] by which to fix dates ahead; his attention to earth, at the visibly appropriate to increase of

growth; his attention to the four seasons, at the visible phases usable for work; his attention to Yin and Yang, at the visible harmonies by which to put in order." (*Hs* 17/16–18, tr. W 81f).

According to the 'Discourse on Heaven', Heaven has generated man as an organism analogous to a community. The heart is 'the ruler from Heaven', the senses are 'the officials from Heaven', and all other things 'the nourishment from Heaven'. As counterpart presumably of the people below, "liking and disliking, being pleased with or angry with, sadness and joy" are 'the *ch'ing* from Heaven', using that word *ch'ing* which for Sung Hsing, Mencius, Chuang-tzu and the Later Mohists meant whatever in X is essential to being named 'X'. Hsün-tzu is the first to use it rather of the authentic in man which is disguised by ritual and morality, therefore his passions. When all these components are functioning properly man has fully at his disposal everything else in the universe: "Heaven and earth are reduced to officials and the myriad things to servants."[12] This account of man's place in the cosmos is unusual in Hsün-tzu's writings in making no reference to the conflicts between the passions. We are told only that man should "nourish the authentic (*ch'ing*) from Heaven in him", not "go contrary to the authentic from Heaven in him." It is possible that the essay is early, and that during Hsün-tzu's long life in increasingly desperate times his view of human nature darkened; his more usual emphasis is on the anarchy of the passions, which are to be satisfied certainly, but are satisfiable only after we have learned by an arduous moral training to reduce them to order.

In the verse quoted above we let pass without comment the couplet:

"Instead of contemplating things in their independence,

Why not make them a pattern from which none escapes?"

Pattern (*li* 理) is the arrangement of father and son, ruler and subject, within the grand scheme of things, in the places which are fitting (*yí*) and with the duties which fit them as the Right (*yi*). According to the view being newly elaborated by Tsou Yen and the cosmologists, this is the pattern of the whole cosmos, with Heaven and Earth corresponding to superior and inferior among men. Hsün-tzu is remarkable in holding that this order is *not* the Way of Heaven, which is merely the regularity of the cycles of the seasons and the heavenly bodies; it arises from man as the third, patterning things from his own point of view. To quote a passage to which we shall later supply the context, the myriad things are "without fittingness (*yí*) except in having uses for man."[13]

"The Way is not the Way of Heaven, nor the Way of Earth, it is what

man uses to make his way, what the gentleman adopts as the Way." (*Hs* 8/24, tr. Dubs 96)

"Therefore Heaven and Earth generate the gentleman, and the gentleman patterns Heaven and Earth. The gentleman is the third aligned with Heaven and Earth, the totaliser of the myriad things, the father and mother of the people. Without the gentleman, Heaven and Earth would be unpatterned, the ceremonial and the right unorganised, there would be no ruler and teacher above, no father and son below; it is this that is called utmost disorder. Ruler and minister, father and son, elder brother and younger, husband and wife, one beginning or ending as another ends or begins, share the same pattern with Heaven and Earth, the same duration with a myriad ages; it is this that is called the most fundamental." (*Hs* 9/65–67, tr. W 44f)

Is Hsün-tzu saying that man imposes his own meaning on an otherwise meaningless universe? He is very near to this modern idea. But although "without the gentleman Heaven and Earth are unpatterned", human institutions "share the same pattern with Heaven and Earth". We shall later be examining the systems of correspondences by which cosmology was being elaborated.[14] We may understand Hsün-tzu as meaning, not that man personifies Heaven and Earth after the analogy of ruler and minister, father and son, but rather that the ratio 'Heaven : Earth :: ruler : minister' is as valid as 'ruler : minister :: father : son', but of course requires man to complete it. Elsewhere Hsün-tzu not only explains how ceremonies and musical performances are adjusted to the cosmic regularities, but once in a poetic passage treats ceremony as the source of order in the universe.

> "By this Heaven and Earth join.
> By this sun and moon shine,
> By this the four seasons proceed,
> By this the stars take their courses,
> By this Yangtse and Yellow River flow,
> By this the myriad things flourish,
> By this love and hate are apt,
> By this favour and anger are just." (*Hs* 19/26f, tr. W 94)

But a little further on from this passage in the 'Discourse on Ceremony' he writes in prose:

"When Heaven and Earth join, the myriad things are generated; when Yin and Yang meet, alterations and transformations arise; when nature

and artifice join, the world is brought to order. Heaven is capable of generating things but not of making distinctions between them, Earth of sustaining man but not of bringing him to order; the myriad things within Space, and all who belong among living men, await the sage to allot them their portions." (*Hs* 19/77–79, tr. W 103)

Human nature

Hsün-tzu's attack on the Mencian theory of human nature illustrates the progress of argumentation in the Confucian school. Mencius' case has to be re-assembled from scattered dialogues and discourses; Hsün-tzu develops his in a consecutive essay, 'Our Nature Is Bad', with Mencius as the named target, and a terminology clarified here and elsewhere in the book by scrupulous definitions. The main definitions stand appropriately at the head of another essay, 'Correction of Names'. They fall into seven pairs, three of them defining the same word in different senses. He may well have marked them as different words by radicals eliminated by later graphic standardisation, since for one pair a graphic differentiation is made just once in the text as we have it (*chih* 'know' distinguished from *chih* 'wits' by addition of the 'sun' radical as in the *Canons*, where it is also partially eliminated by graphic standardisation).[15] In any case translation forces us to shift between verbal, adjectival and nominal forms of the English word.

Besides distinguishing the wits from knowing like the Later Mohists, he makes a corresponding distinction for *neng* 能 'capable, able'.

"The means in man by which he knows is called the 'wits': the meeting of the wits with something is called 'knowing'.

The means in man by which he is capable is called 'capability'; the meeting of capability with something is called 'being capable of'." (*Hs* 22/5f, tr. W 140)

Previously *hsing* 'nature' had been used without distinguishing man's nature from his spontaneous processes; Hsün-tzu draws a distinction strictly parallel with the preceding, and extends it to the opposite of nature, *wei* 偽 'artifice' (*wei* 為 'do' written with the 'man' radical, so 'man-made').

"The means by which something generated is so is called its 'nature'; its nature harmonising what is generated, the quintessential as it meets something being aroused and responding spontaneously without working for it, is called 'the natural'." (*Hs* 22/2f, tr. W 139)

"Capability being acted on by the thinking of the heart is called

'artifice'; the matured only after accumulation of thinking about it and habituation of capability to it is called 'the artificial'." (*Hs* 22/4 tr. W 139f).

The pair 'arousal' (*kan* 感) and 'response' (*ying* 應), oddly similar to modern 'stimulation' and 'response' if we extract the latter from their neurological background, were becoming current in this period for describing the spontaneous reactions which precede thought; we find them also in the 'Outer Chapters' of *Chuang-tzu* and the appendices of the *Yi*. Here the initial reactions are ascribed to the quintessences (*ching*), which we first encountered in the 'Inward Training';[16] as the purest of the *ch'i* they would be the fluids from which spontaneous motions start.

Artifice, as culture, morality, ceremony, disguises the *ch'ing* of man, what he is in himself. By this period however, in discussions of ritual in the *Record of Ceremony* and *Han Fei-tzu* as well as in *Hsün-tzu*, one notices that *ch'ing* is shifting in usage when applied to man.* Rather than the essential to being named 'man', what distinguishes him from other creatures, it is now the genuine and unassumed which underlies and threatens to break through the civilized exterior, therefore primarily the passions. In later Chinese *ch'ing* comes to mean the passions; in *Hsün-tzu* this is the reference of the word but it may be doubted whether it is yet the sense. For this text a convenient equivalent is 'the authentic'. According to Hsün-tzu's 'Discourse on Ceremony',

"The cultured and patterned, and the authentic and useful, becoming each other's exterior and interior, and mixing as they proceed together, is the midstream of ceremony." (*Hs* 19/38f, tr. W 96)

'Correction of Names' defines the authentic in contrast with thinking.

"The liking or dislike, pleasure in or anger against, sadness or joy which are from our nature are called the 'authentic' in us. The authentic in us being such, the heart making choices on behalf of it is called 'thinking'." (*Hs* 22/3f, tr. W 139)

Later in the same essay, again using 'response' in implicit contrast with 'arousal', Hsün-tzu writes:

"Our nature is the tendency which is from Heaven, the authentic in us is the stuff of our nature, desire is the response of the authentic in us." (*Hs* 22/63, tr. W 151)

'Our Nature Is Bad' starts off on a fine note of challenge. "Man's nature is bad, the good in him is artifice. Now man's nature from birth has the love of profit in it; he follows this, therefore jostling and grabbing spring up and forbearance and deference are missing from him. From birth he has

* For the changing sense of *ch'ing*, cf. G *Studies* 64f.

jealousy and hatred in him: he follows these, therefore injury and violence spring up and loyalty and trustworthiness are missing from him. From birth he has the desires of ear and eye and the love of women and song in him; he follows these, therefore excess and disorder spring up and the ceremonial and the right, culture and pattern are missing from him. Consequently, if you indulge man's nature, if you follow the authentic in man, you inevitably start off in jostling and grabbing, take the course of violation of allotments and disordering of pattern, and become settled in crime. Hence there must be transformation by teachers and standards, the Way of the ceremonial and the right, before you can start off in forbearance and deference, take the course of the cultured and patterned, and become settled in the ordered." (*Hs* 23/1–4, tr. W 157)

Man's nature has to be forced straight like crooked wood, sharpened like blunt metal—very un-Mencian similes which the Legalists also use for reshaping man by harsh law.

"Hence crooked wood inevitably requires steaming and bending with the arrow-straightener to straighten it, blunt metal inevitably requires the whetstone to sharpen it; and granted that man's nature is bad, it inevitably requires teachers and standards to correct it, the ceremonial and the right to order it."

If we look at Hsün-tzu's very careful definitions, it is clear that his argument starts from a conception of human nature quite different from Mencius', and for a Western reader much easier to grasp. Mencius thinks in terms of a natural tendency to goodness as to long life, actualised only if nourished by educaton as the healthy body is nourished by food. For Hsün-tzu on the other hand whatever has been affected by education is by definition *not* man's nature, which consists of the inclinations born as his energies first respond to external stimulation, before the beginnings of thought. Hsün-tzu's case against Mencius, although lucid and coherent, is consequently always a little off target.

"Mencius says: 'The nature of men who learn is good'. I say that this is not so, it is failure to know man's nature, failure to discern the distinction between nature and artifice. In everyone nature is the tendency which is from Heaven; it cannot be learned, cannot be worked for. The ceremonial and the right were generated by the sages; they are what man becomes capable of by learning, accomplishes by working for them. That in man which cannot be learned or worked for is called his nature, that in man which he may become capable of by learning, may accomplish by working for it, is called artifice."

Hsün-tzu represents Mencius as holding that man becomes wicked by

losing his nature, and answers that in that case what should be as natural to us as sight to the eye and hearing to the ear must be lost to us from birth. However, if human nature is wholly immoral, there is a profound question for Hsün-tzu to answer.

"A questioner says: 'If man's nature is bad, from what were ceremony and right born?'."

Hsün-tzu answers that they were invented by the sages as pots and tools were invented by the artifice of potters and craftsmen.

"The sage by accumulation of thought, by habituation to the artificial, generated the ceremonial and the right, and initiated standards and measures. Consequently, the ceremonial and the right, standards and measures, were born from the sage's artifice, were not originally born from man's nature."

The proposal that the sages simply invented morality, as something useful to man like pots and tools, is perhaps less remarkable in China than in a culture such as our own which has inherited its morality from a revealed religion. It seems to have been generally assumed that rules of conduct (as distinct from the disinterested concern for others which lies behind them) have their origin in the wisdom of the sages. Confucius himself said that "man is able to enlarge the Way, it is not that the Way is able to enlarge man",[17] and the Mohist 'Conforming Upwards' treats a universal morality as, if not an invention, at any rate a unification of the moralities of conflicting individuals and families by the sage rulers of antiquity.[18] However, no one had yet questioned that in discovering his wisest course man also discovers what Heaven has decreed for him. Taoists who recognise that Heaven and the Way diverge from man's moral rules take the side of Heaven against them. Hsün-tzu's claim has no full parallel except in Legalism, which recognises no morality but the law laid down by the ruler.

It might be asked how man comes to invent and let himself be bound by a morality unless it has a basis in his nature.

"A questioner says: 'The ceremonial and the right, the accumulated and the artificial, are from man's nature, and that is why the sage is able to generate them'. I answer that this is not so. The potter by kneading clay generates a pot; is then the clay of the pot from the nature of the potter? A carpenter by carving wood generates a tool; is then the wood of the tool from the nature of the carpenter?"

The point of the comparison is that useful institutions may be as independent of human nature as useful tools, and that without going outside his nature man may desire social order as useful to him in the same

way as tools. At this point we may pause to consider whether Hsün-tzu has reached the limits of traditional Chinese moral philosophising based on the spontaneous preferences of the wisest. Should the logic of his position force him to postulate a transcendent Right independent of inclination? Elsewhere he says that men have both 'desire for profit' and 'love of the right', and that neither is abolished except in the extremes of good or bad government.[19] Does then the love of right also belong to human nature? Here we have to remind ourselves that the badness of human nature is not being conceived as egoism. That absolute egoism which in the West haunts moral philosophy as solipsism haunts epistemology appears to be a blank in the philosophical consciousness of China, whether for sociological or for philosophical reasons—for philosophical, I have argued elsewhere.[20] For Hsün-tzu human nature is bad in that desires are anarchic, in conflict both within and between individuals. But since disordered desires frustrate one another, the intelligent man as he learns will spontaneously come to desire the order which will make it possible to satisfy them. Love of the right is not then incompatible with the badness of man's nature, on the contrary may be claimed to confirm it.

"All man's desire to become good is because his nature is bad. The meagre wishes to be ample, the ugly to be beautiful, the constricted to have scope, the poor to be rich, the lowly to be noble; what you lack within you have to seek outside. Hence being rich you do not wish for wealth, being noble you do not wish for position; for what you do have within, you surely will not go outside."

Hsün-tzu's doctrine has important differences from the Western idea of Original Sin, of which one is too easily reminded when for example his slogan is translated 'Man's nature is *evil*'. He does not of course have the Christian conception of a corrupted nature in permanent rebellion, successfully kept under only with the help of divine grace. He holds that the gentleman can by unremitting accumulation of stern thought and effort bring his conflicting desires to orderliness, and so "transform his nature"; the metaphor of the arrow-straightener implies that human nature has to be bent by force, but can be bent permanently straight. It is interesting that Hsün-tzu constantly speaks of morality as being 'born' from or 'generated' by the sage's artifice, using the same verb *sheng* from which *hsing* 'nature' itself derives; even when introducing pots and tools as the analogy he speaks of the craftsman as 'generating' them from clay and wood. The sage transforms human nature by re-directing the generative process, so that in the end like Confucius he can follow his

heart's desire without transgressing rule. According to the chapter 'Grand Summary',

"Shun said: 'I am the one who sets in order by following desire'. Therefore the generating of ceremony is for the sake of those from the worthier down to ordinary people, not for the perfected sage. However, it is also the means of perfecting himself as a sage; unless he learned he would not have been perfected." (*Hs* 27/11f)

Hsün-tzu holds that with sufficient thought and effort it is possible for the man-in-the-street to equal the sage Yü; on this point he fully agrees with Mencius.[21]

"In general the reason why Yü became Yü was that he practiced the benevolent and the right, the standard and the correct. It follows that all these have a pattern to them by which it is possible to know and become capable of them. However, any man in the street has the stuff in him by which it is possible to know them, and the resources by which it is possible to become capable of them. Consequently, that it is possible for him to become a Yü is plain." (*Hs* 23/60–63, tr. W 166).

The evidence that anyone can become a sage is that he does have the understanding of ordinary moral obligations which by a process of accumulation may become sagehood.

"It is possible for any man-in-the-street, at home to know what is right between father and son, abroad to know what is correct between ruler and subject. Consequently it is plain that the stuff by which it is possible to know and the resources by which it is possible to become capable, are present in the man-in-the-street."

Morality has the pattern *(li)* by which it is knowable by thought; man has, presumably in his nature, the equipment by which, although his desires run the other way, it is possible for him to know it. Here Hsün-tzu draws a distinction between the possibility and the capability. 'Capability' *(neng)* is a term we have met in his series of contrastive definitions.[22] The word used to pronounce something physically possible is *k'o* 'admissible' (morally or logically) with which we are already familiar in argumentation; an affirmation pronounced *k'o* is valid, an action or process merely possible.

"It will be said: 'If sagehood is achievable by accumulation, why is it not however accumulable by everyone?' I answer that it is possible for us, but not possible that we be made to. Hence it is possible for the vulgar man to become a gentleman, but he refuses, and for the gentleman to become a vulgar man but he refuses. For one of them to become the other is always

possible, however they do not, because although it is possible for us it is not possible that we be made to. Therefore it may be agreed that it is possible for the man-in-the-street to become a Yü, but it is not necessarily so that he is capable of it; but even if he is not, that is not incompatible with it being possible for him to become a Yü. It is possible for the feet to walk everywhere in the world, but there has never been anyone capable of it; it has always been possible for craftsmen, farmers and merchants to do each other's jobs, but they have never been capable of doing them."

We develop the capability of doing some things at the cost of others equally possible to us. Sagehood is possible for all, and a few do become capable of it, but most of us lose the opportunity by developing capabilities in other directions.

We noticed that Hsün-tzu criticises the doctrine of natural goodness from a definition of human nature which is not that of Mencius, so that his objections although lucidly argued are not quite to the point. It is indeed far from easy to locate any issue of fact on which they disagree. Both recognise the need of learning, the moral acceptability of all fully reconcilable desires, the function of the heart as arbiter between them, and the possibility of anyone becoming a sage; and if one of them prefers to see education as nourishing a spontaneous tendency to good, the other as disciplining a spontaneous tendency to disorder, on what tests would one decide between them?* As is arguably the case with Western disagreements over human nature, the issue seems to come down to different proportions of trust or distrust in human spontaneity, with practical consequences for education. It is worthy of remark that pre-Han thinkers scarcely ever say 'Man's nature is good/bad/neither/a mixture of both/good in some and bad in others' except in controversy or in formulae summing up doctrines. Mencius never says it is good except in debate with Kao-tzu and in answer to a disciple asking why he disagrees with the three current doctrines; and elsewhere in the book we find only one narrative statement that in conversation with a crown prince he "preached that our nature is good".[23] The 'Admonitions' in *Kuan-tzu* which seem to reflect Kao-tzu's position on human nature never says there is neither good nor bad in it; it is Kao-tzu in debate with Mencius, and the disciple who asks about the three doctrines, who formulate his thesis in these terms. The other documents which take the Mencian position, the 'Doctrine of the Mean' and the appendices of the *Yi*, never positively say that human nature is

* Cf. Lau 'Theories of Human Nature'.

good. Hsün-tzu never says it is bad except in the chapter 'Our Nature Is Bad' which is a direct answer to Mencius.

It is not in question that Mencius and Hsün-tzu have complex and distinctive theories of man arising from opposite attitudes of trust or distrust in spontaneity. However, since they use their respective slogans only as convenient labels and pivots of debate, one may suspect that they had some inkling that the formulae unduly simplify what they have to say. In the case of Hsün-tzu there is good reason to doubt whether the label he pinned on himself to distinguish himself from Mencius gives an adequate idea of his position. According to Hsün-tzu, Heaven and earth are morally neutral, and the spontaneous course of things goes neither for nor against man; the conflicting desires with which Heaven has endowed us, like the cycles of the seasons and resources of earth, are simply neutral facts with which we have to deal. Man's nature, like his environment, has to be reduced to order if he is to satisfy his desires; but there can be no culture without something to cultivate, and aside from 'Our Nature Is Bad' Hsün-tzu's tendency is to think of nature and culture as each making its contribution to the good life.

"Our nature is the basic and original, the raw material; artifice is culturing and patterning, developing to the full. Without nature there would be nothing on which to impose artifice, without artifice nature is incapable of beautifying itself. Only after nature and artifice join is there achievement of the fame of perfect sagehood and success in unifying the world. Therefore it is said: 'When Heaven and earth join, the myriad things are generated; when Yin and Yang meet, the alterations and transformations arise; when nature and artifice join, the world is in order." (*Hs* 19/76–78, tr. W 102f)

The heart

We have seen that his doctrine of human nature by no means requires Hsün-tzu to abandon what we have identified as an assumption common to all the schools, that the good is what the wisest spontaneously desire. The desires in their natural state are bad only in the sense of being anarchic, and to seek to conquer them requires only enough intelligence to see that to reconcile and order them is a condition of satisfying them. He is in fact optimistic about man's prospect of satisfying the most varied desires if he organises his resources rightly; this is one of the sides to him which looks 'scientific', although like all Chinese thinkers of the classical

age he assumes the technology of his time without any Baconian anticipations of progress. He dismisses both Sung Hsing's proposal to reduce desires and the strand in the paradoxical thought of *Lao-tzu* which recommends desirelessness.

"Whoever speaks of order as depending on the abolition of desire is one so helpless to guide desires that he finds it troublesome to have them at all. Whoever speaks of order as depending on reduction of desires is one so helpless to regulate desires that he finds it troublesome to have so many. Those with desires and those without are different in kind, the living and the dead, not the ordered and the disordered. Those with many desires and those with few are different in kind, in the number of those essential to them [few for animals, many for man], not in order and disorder." (*Hs* 22/55–57, tr. W 150).

What matters is to use the heart, the organ of thought, to judge whether or not action to satisfy a desire is admissible (*k'o*), whether it fits the pattern of affairs as physically possible or morally allowable.

"Therefore when performance stops short of desire, it is because the heart checks it; but if the heart's judgment as admissible coincides with pattern, however many the desires what harm is it to order? When performance goes beyond desire, it is because the heart makes it do so; but if the heart's judgment as admissible misses pattern, however few the desires what can save us from disorder? Therefore order and disorder depend on what the heart judges admissible, not on what the authentic in us desires." (*Hs* 22/60–62, tr. W 151)

Like Yangists and Mohists Hsün-tzu discusses choice in terms of weighing desires, with the same metaphor of the scales.

"The sage knows the ill effects of the heart's training, sees the calamities from obstructed vision, and therefore whatever he desires or dislikes, whether at start or end, far or near, ample or trivial, past or present, with the myriad things each one spread out before him he coincides with the scales as they settle. For this reason things in their multitude however diverse cannot shut each other off from his view and disorder his gradings. What am I calling the 'scales'? I mean the Way." (*Hs* 21/28–30, tr. W 126f).

Hsün-tzu is of course very different from Chuang-tzu in insisting that to follow the Way one must employ the heart to think and to control the body. He shares with Chuang-tzu, however, a good deal of the psychological terminology of the time, although with considerable differences in the usage: 'emptiness', 'stillness', the 'daimonic and clear-seeing' (*shen ming*).

"The heart is the ruler of the body and master of the daimonic-and-

clear-seeing. It issues commands and has nothing from which it receives them. It forbids itself to or makes itself do, takes from or to itself, makes itself go or stop. Hence the mouth can be forced to be silent or to speak, and the body to bend or stretch, but the heart cannot be forced to change an idea. What it approves it accepts, what it rejects it refuses." (*Hs* 21/44–46, tr. W 129).

"How does man know the Way? By the heart. How does the heart know? By being empty, unified, and still. The heart never ceases to store, yet something in it is to be called empty; to be multiple, yet something in it is to be called unified; to move, yet something in it is to be called still. From birth man has knowledge, and in knowledge there is memory; 'memory' is storing, yet something in it is to be called empty—not letting the already-stored interfere with the about-to-be-received is called being empty. From birth the heart has knowledge, and in knowledge there is difference; of the 'different' it knows each at the same time, and if it knows each at the same time is multiple, yet something in it is to be called unified—not letting one of them interfere with another is called being unified. The heart when sleeping dreams, when idling takes its own course, when employed makes plans, so never ceases to move, yet something in it is to be called still—not letting dream and play disorder knowledge is called being still." (*Hs* 21/34–39, tr. W 127f).

According to Chuang-tzu "the utmost man uses the heart like a mirror, he does not escort things as they go or welcome them as they come, he responds and does not store."[24] He responds to everything as new, refuses to let an accumulation of memories tie him in obsolete habits. For Hsün-tzu on the contrary knowledge depends on storing memories; but the heart of the sage does at bottom remain empty in always remaining open to new impressions. Chuang-tzu recommends seeing everything as one, while Hsün-tzu holds that knowledge depends on differentiation but that the heart must nonetheless remain basically one to unify its knowledge however diverse, not accepting one item at the cost of another. Finally, beneath all its motions is a stillness, not of Taoist contemplation but of unchanging knowledge, unaffected by the transitory play of thought and imagination. But although Hsün-tzu trusts to the heart's judgments while Chuang-tzu does not, the underlying psychological picture is the same. For both, man starts by responding in the light of his developing understanding to the things which stimulate him, and is on the Way when his understanding attains the perfection of the 'daimonic and clear-seeing'. Each uses for his own purposes the simile of the perfect reflection in a mirror or in clear water.

"Hence man's heart may be compared to a pan of water. If you lay it level and do not disturb it, the muddy settles below and the transparent above, so that it is adequate to see whiskers and eyebrows and discern the pattern of them. But if a faint breeze passes over, and the muddy is stirred up below and the transparent blurred above, you cannot perceive even the general outline correctly. It is the same with the heart. Therefore we guide it by pattern, nurture it by clarifying, and if no thing upsets it, it is adequate to fix the right alternative and the wrong and decide the doubtful and confusable. But if the smallest thing tugs at it, then the correct is distorted outside and the heart upset within, so that it is inadequate to decide between the broadest patterns." (Hs 21/55–58, tr. W 131f)

Hsün-tzu gives a string of examples of judgment distorted by fear of the dark, drunkenness, seeing double when you press an eyeball, big things looking small in the distance. Characteristically he uses them to combat superstition.

"Whenever someone sees a ghost, you can be sure he identified it at a time of panic in bewildering circumstances. These are the times when people think that there is what there isn't and there isn't what there is." (Hs 21/76f, tr. W 134f).

One has the impression that although for Hsün-tzu thinking is inferring from the regularities of 'patterns' (li) he conceives it primarily as correlation rather than analysis. The correlative system-building with the Yin and Yang and the Five Processes, soon to come into fashion, is as foreign to him as to all thinkers down to Han Fei; but for him, as for all but Sophists and Later Mohists, intelligence is what Anglo-Saxons call 'common sense', the sort which values a synthesising grasp of how things hang together above analysis, and which prefers not to push analysis farther than is needed to resolve issues arising in controversy. Throughout our quotations it may be noticed that even by the standards of pre-Han writing his style is highly parallelistic. There is nothing artificial about his parallels, but they testify that for him too the process of thought is a continuing play of comparison and contrast, which analysis serves to keep on course by defining key terms and making such fine discriminations as between social and moral disgrace[25] or between possibility and capability.[26] He has no sympathy for analyses pushed beyond the limits of usefulness, by Hui Shih or by another Sophist whose book Teng Hsi-tzu is now lost.

"That mountains and abysses are level, and Heaven and earth side by side, that Ch'in in the far west and Ch'i in the far east overlap, that

[mountains?] enter into ears and come out of mouths,* that a hook has whiskers and an egg has hair, these are arguments difficult to sustain but Hui Shih and Teng Hsi were capable of it. However, the gentleman does not value them, because they have nothing to do with the ceremonial and the right." (*Hs* 3/2–4).

Ceremony and music

The conflict over human nature gives Mencius and Hsün-tzu different attitudes to what had been the two main preoccupations of Confucius, ceremony and the *jen* which was in process of defining itself as benevolence. Mencius puts more stress on the benevolence which flows spontaneously from the goodness of man's nature. Hsün-tzu on the other hand sees ceremony as the alternative to punishment in imposing order on man's anarchic desires. As for *yi*, 'the right, morality', its importance remains constant, although less obtrusive than the other two. For Hsün-tzu *yi* (not, as for the West, reason) is the defining characteristic of the human; he says so explicitly in laying out a chain of being from the mineral through the vegetable and animal to man.

"Water and fire have *ch'i* but not life, plants and trees have life but not knowledge, birds and animals have knowledge but not morality; man has *ch'i*, life, knowledge and morality as well, and so of all that is in the world he is the most noble. He lacks the force of the ox, does not run as fast as the horse, yet ox and horse are his to use, why? Because men are capable of association and they are not. How are men capable of association? By apportioning. How are they capable of making association effective? By morality. Consequently, apportioning according to morality they harmonise, harmonising they unite, united they have more forces, with more forces they are stronger, being stronger they conquer other things, and so can live secure in their homes. Hence that they synchronise with the four seasons, and share out the myriad things, to the benefit of everyone in the world, has no other reason than that they achieved it by morality in apportioning." (*Hs* 9/69–73, tr. W 45f)

The allotment of 'portions' *(fen)* we have already met as a Later Mohist concept.[27] Without the morality *(yi)* which supports it, there is nothing in the universal scheme of things which makes one thing more 'fitting' *(yi)*

* Cf. *Cz* 33/75, tr. G 284, where one of the paradoxes of the Sophists is 'Mountains come out of mouths' (you can think of them as not rising from earth but descending from holes in the sky?).

than another except in relation to the anarchic desires of men; there are only the number of things and the nature of man, which prefers the more in number to the less.

"The myriad things in the same Space being different units, without fittingness except in having uses for man, is their number: that grades of men dwelling side by side seek the same by different Ways, desire the same but differ in knowledge, is our nature. In that all judge something or other admissible, the wise and the foolish are the same; but in the judgments being different, wise and foolish diverge. If those similar in status but different in knowledge behave selfishly without suffering for it, and indulge desire without restriction, the people's hearts will rebel and become intractable. In such circumstances the wise will not succeed in ordering, in which case achievement and reputation will not take form, in which case the multitude will have no settled stations, in which case there will be no institution of ruler and subject. Without ruler to curb subject or superior to curb inferior, the whole world will indulge desire to the injury of life. Desiring or disliking the same things, there will be too few things to satisfy desires, and since they are too few there will inevitably be competition." (*Hs* 10/1–5, tr. Dubs 151)

Hsün-tzu, like Mencius criticising Hsü Hsing,[28] now appeals to the division of labour.

"Hence the products of all the hundred crafts are the means of support for any one man, but capabilities are not capable of every craft nor men of every office. If we dwell apart without mutual dependence we are poor, if we associate without apportioning we compete. Poverty is a misfortune and competition a disaster. The best way to ward off misfortune and disaster is to make men associate by clarifying portions." (*Hs* 10/5–7, tr. Dubs 152)

Like Confucius Hsün-tzu looks back to the institutions of early Chou, which rival schools were now disparaging on the still more venerable authority of Shen-nung, the Yellow Emperor and others coming to be classified among the Five Emperors placed before the Three Dynasties. Hsün-tzu however was not a native of Lu, where the Chou tradition was claimed to be still alive. Nor is his special concern with the more recent of the sage rulers (the 'later kings', as he calls them) inspired, as in Confucius, by a faith in the superiority of Chou to its predecessors. His position is that the principles of ideal government are the same at all times, but there are no adequate records of it before the Chou. "Irresponsible people say: 'Past and present are essentially different, and the Ways by

which they are ordered or disordered are different."[29] The foolish multitude is misled by this claim, but they "can be deceived about something in front of their eyes, not to speak of the tradition of a thousand generations". Why is not the sage deceived? Because he can think out the ideal form of government by himself. This thinking begins with what Confucius called *shu* 'likening to oneself', although Hsün-tzu does not use the word in the present context. You discover how relations between people should be ordered by measuring them by analogy to yourself.

"Why is the sage not deceived? The sage is one who measures by himself. Hence he measures man by man, authentic by authentic, kind by kind; he measures achievement by explanation and observes everything by the Way. Past and present are one; if kinds are not violated, however long it continues the pattern is the same." (*Hs* 5/35f, tr. Dubs 74)

Although Hsün-tzu is fond of illustrating points from the *Songs*, his appeal is regularly to argument rather than to the authority even of early Chou. He objects to the 'vulgar Ju' not only that "they do not know how to take their standard from the later kings" but that they "do not know how to give the topmost place to the ceremonial and the right and diminishing importance to the *Songs* and *Documents*"[30] and that they "do nothing but study odds and ends and follow the *Songs* and *Documents*".[31]

The 'Discourse on Ceremony' starts by declaring that the whole purpose of enlightened conventions is to enable the desires of all to be satisfied according to their places in the social hierarchy.

"From what does ceremony originate? Man from birth has desires, and what desiring he fails to get it is beyond his capabilities not to seek; and if he seeks it without measuring of degrees and marking out of portions, it is beyond his capabilities not to compete. With competition there is disorder and with disorder poverty. The former kings hated the disorder, and therefore instituted the ceremonial and the right to allot portions, in order to nurture man's desires and provide what he seeks, and ensure that the desires are never in excess of the things and the things never inadequate to the desires, the two developing in support of each other. It is from this that ceremony originates." (*Hs* 19/1–3 tr. W 88)

This is the crux of his disagreement with the Mohists, from whom he has without acknowledgement learned so much. The Mohists, who think in terms of perpetual shortage and not of the apportioning by ceremony which restrains desires and increases production, fail with both the things and the desires, which are mutually dependent.

"Hence if man unifies them through the ceremonial and the right, he

wins on both sides; if he unifies them through the authentic and the natural, he loses on both sides. Hence the Ju are the ones who will enable man to win on both sides, the Mohists the ones who will cause him to lose on both sides; this is where the Ju and the Mohists diverge." (*Hs* 19/21f, tr. W 91)

In perfection of ceremony natural desires and dislikes are cultured without loss of authenticity. But such perfection is rare, and authenticity may even have to be recovered by return to the oneness before portions are allocated.

"Therefore at its most complete, the authentic and the cultured are both at their fullest; at the next, the authentic and the cultured prevail in turn; at the least, one reverts to the authentic and so returns to universal oneness." (*Hs* 19/26, tr. W 94).

Ceremony, which in the widest sense is the totality of social convention, centres on control of the passions when they are most dangerous, at the extremes of joy and grief.

"Ceremony is that which trims the long and augments the short, reduces the excessive and increases the inadequate, universalises the acculturing of concern and respect, and enhances the beauty of practicing the right. Hence though embellishment and austerity, singing and wailing, cheerfulness and mournfulness are opposites, ceremony uses each of them, evokes them when timely and guides them in turn. Hence embellishment, singing and cheerfulness are the means to maintain oneself in tranquility in presence of the auspicious, while austerity, wailing and mournfulness are the means to maintain oneself when disquieted in the presence of the baleful. Therefore its institutions do not exaggerate the embellished to become pretty and charming, or the austere to emaciation and self-neglect, singing and cheerfulness to indulgence and license or wailing and mournfulness to depression and injury to life— such is the midstream of ceremony." (*Hs* 19/63–67, tr. W 100f)

Like all Confucians Hsün-tzu gives first place to the funeral ceremonies and ancestral sacrifices which are the ultimate expressions of filial piety. He explains in detail why the authentic emotion of grief has to be guided by a process of mourning lasting three years, a period which to everyone but Confucians seems unnecessarily long. When Confucius speaks of sacrificing to spirits "as though they were present"[32] we are left to speculate whether he thinks of them as surviving or not. Hsün-tzu however leaves no room for doubt; the ancestors are dead and gone, the whole purpose of the rite is to guide the grief and reverence of the

descendants. On the debated question of whether or not the dead 'have knowledge', whether they are conscious, he takes it for granted that they are not.

"To neglect when dead someone you cared for when alive is to respect him while he has knowledge and be rude to him when hasn't." (Hs 19/44, tr. W 97)

"I say then sacrifice is memory and imagination, contemplation and yearning at their most authentic, the utmost in loyalty and trustworthiness, love and respect, the perfection of ceremonial formality and cultured demeanour. If it were not for the sages no one would be capable of understanding it. The sage understands it clearly, knights and gentlemen practice it steadily, officials have it as a responsibility, the Hundred Clans incorporate it into custom. Among gentlemen it is deemed Way of Man; among the Hundred Clans, it is deemed the service of ghosts." (Hs 19/117–122, tr. W 109f).

Although Hsün-tzu puts the main stress on the ordering and refining of the passions, he does see ceremony as rooting man not only in family and state but in cosmos. The split from Heaven does not mean for him man's isolation in an alien universe.

"Ceremony has three roots. Heaven and earth are the root of generation, the ancestors are the root of one's kind, ruler and teacher are the root of order. Without Heaven and earth, from what would one be generated? Without ancestors, from what would one descend? Without ruler and teacher, by what would one be ordered? If just one of the three were missing there would be no fixity for man. Therefore by ceremony one serves heaven above and earth below, honours ancestors and exalts ruler and teacher; these are the three roots of ceremony." (Hs 19/13–15, tr. W 91).

It would seem that it is primarily by the sacrifices by Emperor to Heaven and by lords of fiefs to the gods of earth (to which Hsün-tzu proceeds in his next sentences) that man as the third joins his Way to theirs to put himself inside the universal pattern.

The affinity of ceremony and music had been recognised by the Ju since Confucius himself, but Hsün-tzu's 'Discourse on Music' is the first document which theorises about it. The Mohists ignored ceremony and specifically condemned music; this is the issue which shows up most clearly the difference between the two great moralistic schools, the Confucians who see morality as inseparable from a tradition of conventional behaviour, the Mohists who detach it as a set of abstract principles. We have noticed[33] that yüeh 'music' (inclusive of dance) is written with the

same graph as *lo* 'joy', and in spite of a very early phonetic differentiation was originally the same word, comparable with English 'entertainment' or 'amusement'. The 'Discourse on Music' begins:

"Music is joy (= entertainment is an entertaining), what the authentic in man inevitably refuses to do without. Therefore, man being incapable of dispensing with joy, when he enjoys he inevitably breaks out in sound, expresses in movement and pause; and in the Way of Man, the modifications which are the crafting of one's nature are nowhere else but in the sounds, and the movement and pause. Hence man being incapable of doing without joy, and when he enjoys of doing without expression, if in expression he is unguided he is incapable of avoiding disorder. The former kings hated the disorder, so instituted the songs of the Ya and Sung to guide it, to ensure that their sounds were enjoyable but not licentious, their words eloquent but not florid, that their variations, complexities, richness of texture and tempo should be adequate to stir man's heart to good, and that vicious *ch'i* have nowhere through which to come in touch with it. This is the secret of the music established by the former kings, why does Mo-tzu condemn it?" (*Hs* 20/1–5, tr. W 112)

Music, then, like ceremony, acts directly on man's tastes, it can modify his natural inclinations for the better. Sounds and movements act on the vitalising fluids, the *ch'i*, by 'arousal' and 'response'.

"Whenever depraved sounds arouse man, discordant *ch'i* responds to it, and in modelling itself disorder is generated; when correct sounds arouse man, accordant *ch'i* responds to it, and as it takes form order is generated." (*Hs* 20/26–28, tr. W 116)

Hsün-tzu inherits from Confucius a conviction of the profound effects of music for better or for worse, as the music of the former kings or as "the lascivious songs of Cheng and Wei." The Greeks had the same conception of the moral power of music, which came to seem strange to the West with the prevalence of a purely aesthetic conception, for which there are only differences of taste, whether on a scale of good and bad, or to be dismissed with a *de gustibus non disputandum*. Jazz and rock, flamboyantly subversive not only of esthetic but of all conventional values, have reawakened us to the power of music to modify the whole attitude to life of those who fully respond to it. For Hsün-tzu the music and its dance can like ceremony show man his place in the pattern of Heaven and earth.

"The gentleman uses the bells and drums to guide intent, the zithers to delight the heart. He dances with shield and battleaxe, adorns with feathers and yaktails, accompanies with stone chimes and flutes. So the

clear and bright in it <melody?> has Heaven for model, the broad and vast <the ground beat?> has earth as model, and the looking up and down and circling round has its likeness to the four seasons." (*Hs* 20/28f, tr. W 116)

Ceremony and music are alike in setting the community on the Way by improving effects which start from the clarifying of the senses concentrated on sounds and sights and from the harmonising of the bodily forces.

"Hence with the performing of music intent clarifies, with training in ceremony conduct matures. Ear and eye hear and see more clearly, the blood and *ch'i* are harmonious and calm. They shift manners and replace customs, until the whole world is at peace, and the honourable and good delight in each other." (*Hs* 28/29f, tr. W 116f).

Ceremony and music differ in that music inspires a sense of unity, ceremony of harmonious but graded functions, with different forms for superior and inferior.

"Hence when the music is in the temple of the royal ancestors, and ruler and subject, superior and inferior, listen to it together, all of them harmonise in reverence; when it is in the household, and father and son, and elder and younger brother, listen to it together, all harmonise in kinship; when it is in the neighbourhood, and elder and younger listen to it together, all harmonise in obedience." (*Hs* 20/5f, tr. W 113).

"Moreover 'music' is the unalterable in harmonising, 'ceremony' is the irreplaceable in patterning. Music joins the similar, ceremony separates the different. The centralising by ceremony and music threads together men's hearts." (*Hs* 20/33f, tr. W 117).

Theory of naming

Hsün-tzu's practice of working out in essay form all of what he sees as his main ideas makes his 'Correction of Names' the fullest and most easily intelligible of pre-Han writings on the relation between names and objects. It has close connexions with the *Canons*, and may be seen as largely a digest of Later Mohist disputation for Confucian use. It starts by laying down standards for the correct use of names, as established by the 'later kings' whom he recognises as better documented than the earlier.

"As for the names established by the later kings, for names of punishments follow the Shang dynasty, for names of titles the Chou, for cultural names the ceremonies, for the miscellaneous names applied to the

myriad things follow what has been fixed ahead everywhere as the established custom of the Chinese peoples. As for districts in remote regions with different customs, let them go by these and accept them as current." (*Hs* 22/1f, tr. W 139)

Next come 14 definitions of miscellaneous names, half of which we have utilised already; they have the same place in the essay as the 75 definitions which introduce the *Canons*. Using a comparison between naming and measuring found also in the *Canons* ("A name by what you are clear about corrects what you do not know Like measuring an unknown length by a foot rule."[34] Hsün-tzu declares that to use names differently from established usage is like falsifying tallies and measures.

"Hence hair-splitting wordings and invention of names on your own authority, to disorder correct names and put people in doubt and confusion, multiplying argument and litigation between persons, are to be pronounced the worst of subversions, to be condemned like the crime of falsifying tallies and measures."

With the breakdown of Chou, names are now in confusion. "If a true king should arise, he will certainly follow some of the old names and invent some new names. Consequently it is indispensable to scrutinise the purpose of having names, and the evidence for assimilating and differentiating, and the pivotal requirements for instituting names."

The rest of the essay scrutinises the 'purpose', 'evidence' and 'pivotal requirements' in turn, then classifies under them three kinds of fallacy resulting from different ways of manipulating names and objects. Two points which we have treated as implicit throughout Chinese philosophy show up especially clearly. One is the assumption that naming starts from dividing and classifying as similar or different, which Hansen connects with the affinity of Chinese nouns to the mass rather than the count nouns of Indo-European languages.[35] The other is an absence of the fact/value distinction. Since we are already spontaneously reacting to things before dividing them up, a clarifying of the similarities and contrasts between the sage's reactions to them is assumed to be inseparable from his act of naming.

A comparison with the *Canons* shows that the purpose, evidence and pivotal requirements of naming correspond to the three Later Mohist branches of knowledge which concern names and objects, and that they are treated in the same sequence as in the *Canons*. The essay has one more section, on the weighing of benefit and harm; it seems irrelevant to the rest until one sees that it corresponds with the one remaining Mohist discipline, knowing how to act.

	Fallacies	Mohist Disciplines
The purpose of having names	Disordering names by confusion in operating with names	Knowing how to connect names with objects (discourse)
The evidence for assimilating and differentiating	Disordering names by confusion in operating with objects	Knowing objects (the sciences)
The pivotal requirements for instituting names	Disordering objects by confusion in operating with names	Knowing names (argumentation)

(1) The purpose of having names

Hsün-tzu like the Later Mohists thinks of objects as concrete bits of stuff; the function of names is to 'point them out' from each other, by assimilating them to and differentiating them from other objects. The verb *chih* 'point out' is the one nominalised by Kung-sun Lung in his 'Pointings and Things'.

"When with differences in expression and divergence in thought we communicate with each other, and different things are obscurely confounded in name or as objects, the noble and the base will not be clarified, the same and the different will not be distinguished; in such cases intent will inevitably be hampered by failure to communicate, and action will inevitably suffer from frustration and obstruction. Therefore the wise made for them apportionments and distinctions and instituted names to point out objects, in the first place in order to clarify noble and base, secondly to distinguish same and different. When noble and base are clarified, and same and different distinguished, intent is not hampered by failure to communicate and action does not suffer from frustration and obstruction. This is the purpose of having names."

The purpose of names, then, is to show up clearly the similar and the different, particularly in grades of value ('noble and base'). Even if there are no errors of fact or logic, which belong to the next two categories, there may be the mistake of naming inconsistently. The Later Mohist art of consistent description is the one we label 'discourse', which appears in its final form in the fragmentary essay *Names and Objects*. That this is what Hsün-tzu is talking about here becomes clear when he proceeds to list the corresponding fallacies. According to *Names and Objects* one has to distinguish types of sentence and decide before describing something which type is applicable (which alternative 'proceeds' from a sentence to others of the same type). Thus one may be tempted to say 'Killing robbers

is killing people', assimilating to 'Riding white horses is riding horses'; but on closer inspection it turns out that 'Killing robbers is *not* killing people' ('killing people' being understood as murder), parallel with 'Loving her younger brother is not loving a handsome man'. Hsün-tzu uses the same example, but takes the common-sense view that the alternative which 'proceeds' *is* the one parallel with 'Riding white horses is riding horses'.

"'To be insulted is not disgraceful', 'The sage has no concern for himself', 'Killing robbers is not killing people', these are cases of disordering *names* by confusion in operating with *names*. If you test them by the purpose of having names, and observe which alternative proceeds, you will be able to exclude them from consideration."

The second of the fallacies is unknown, but 'To be insulted is not disgraceful' is the thesis of Sung Hsing which Hsün-tzu criticised elsewhere on the grounds that it confuses moral with social disgrace.[36]

(2) The evidence for assimilating and differentiating

"On what evidence then does one assimilate and differentiate? On the evidence of the senses. For whatever is the same in kind and the same in essentials *(ch'ing)*, the representation of a thing by the senses is the same; therefore having compared them we find them similar and mistakable for each other and treat them as interchangeable; this is why we agree to fix them ahead by using a conventional name for them generally. Shape, parts, colour, and pattern are differentiated by the eye; the distinct sounds of voice or instrument, clear or thick, soft or loud, by the ear; the distinct tastes, sweet, bitter, salty, mild, acrid, sour, by the mouth; the distinct smells of savoury or putrid food, fragrant or rotting herbs, of pig, dog, horse, and ox, by the nose; pains and itches, cold and hot, smooth and rough, light and heavy, by the parts of the body; explanations and reasons, pleasure in and anger against, sadness and joy, love, hate and desire, by the heart. The heart has the knowledge which specifies what they are. With the knowledge which specifies, it is possible on the evidence of the ear to know sounds, on the evidence of the eye to know shapes. However for the knowledge which specifies to be possible necessarily requires the senses to coincide with them in their kinds. If with the five senses in touch with them you do not know, or with the heart specifying them you cannot explain why, no one will fail to say that you do not know. This is the evidence for assimilating and differentiating."

This corresponds to the Mohist knowledge of objects, and as in the

Canons it is recognised that knowledge is not attained through the five senses alone.[37] Again Hsün-tzu lists three fallacies belonging to the category, errors due to defying the evidence of the senses.

" 'Mountains and abysses are level', 'The essential desires are few', 'Fine meats do not make tastier, nor the music of the great bell more joyful', these are cases of disordering *names* by confusion in operating with *objects.* If you test them by the evidence for assimilating and differentiating and observe which accords, you will be able to exclude them from consideration."

Hsün-tzu elsewhere objects to Sung Hsing's 'The essential desires are few' that it is a matter of simple fact that the senses arouse a multitude of desires.[38] The third thesis is unattested, but his answer to the thesis of Hui Shih which he quotes here and elsewhere as 'Mountains and abysses are level'[39] would no doubt be that however subtle the argument anyone can see that mountains are higher.

(3) The pivotal requirements for instituting names

Having explained how the senses and the heart assimilate and differentiate objects, Hsün-tzu continues with the naming of the similar by the same name. This is essentially the Later Mohist position (in Western terms, Nominalism not Realism), but he has more to say about the overlapping and varying generality of names, and of their origin in convention.

"Only then do we proceed to name them, if they are similar similarly, if different differently. If a single name is enough to communicate, make it single; if not, combine. If the single is nowhere in conflict with the combined, it is the more general; but general though it is, there is no harm in it. Knowing that different objects have different names, and therefore causing every different object to have a different name, so that they cannot be disordered, would be no better than causing all different objects to have the same name. Hence although the myriad things are so numerous there are times when we wish to refer to them overall, so call them 'things'. 'Thing' is the name of broadest generality; in pushing generalisation further, beyond the general is the more general, and only at the point where there is nothing more general do we stop. There are times when we wish to refer to some rather than others, so call them 'birds' or 'animals'. 'Bird' and 'animal' are the names of broadest distinction; in pushing distinction further, there is distinction within distinction, and only at the point where there is no further distinction do we stop.

"Names have no inherent appropriateness, we name by convention; when the convention is fixed and the custom established, we call them appropriate, and what differs from the convention we call inappropriate. No object belongs inherently to a name, we name by convention, and when the convention is fixed and the custom established, we call it the object's name. Names do have inherent goodness; when straightforward, easy and not inconsistent, we call them good names."

That as in the Later Mohist dialectic 'objects' (*shíh* 實) are concrete and particular, in contrast with 'things' (*wu* 物), used generally, is especially clear in the next paragraph.

"There are things with the same characteristics but different in place, and things with different characteristics but the same in place; they are to be distinguished. Those deemed different in place though the same in characteristics, though joinable are to be called two objects. Those deemed different in that the characteristics have altered without division of the object are called transformed; what has transformation without division is called one object. This is how in affairs we test objects and fix number. These are the pivotal requirements for instituting names."

This third category corresponds to the Mohist knowing of names, which is the sphere of logical inference. Two of the three fallacies in this class are unattested elsewhere and doubtfully intelligible; but it is plain that this is the one category in which fallacies are to be refuted logically.

" 'You introduce yourself by what is not your name (?)', 'The pillar has the ox (?)', 'A horse is not a horse', these are cases of disordering *objects* by confusion in operating with *names*. If you test them by the convention for the name, and use the accepted to refute the rejected, you will be able to exclude them from consideration."

'A horse is not a horse' is evidently Kung-sun Lung's 'A white horse is not a horse'. Hsün-tzu no doubt agrees with K'ung Ch'uan[40] that the objection to this sophism is simply that 'horse' is more general than 'white horse'. It would be a perfect instance of his observation under this category that a single name ('horse') is more general than a combination including it ('white horse') but if they are fully compatible may be applied to the same object. It may be noticed that this thesis is seen as factually wrong ('disordering *objects*') but 'Killing robbers is not killing people' merely as confused description ('disordering *names*'). This difference in classification makes sense since the latter thesis, even for the Mohists who defended it, did not alter the fact that 'Robbers are people'.

The parallelism of the three categories would have led us to expect the test here to be by the 'pivotal requirements for instituting names'. Instead

it is by a sub-class of that, the 'convention for the name', from which one infers by "using the accepted to refute the rejected." The Mohist inference through chains of definitions would fit well into this description. Hsün-tzu like the Later Mohists has no deductive forms like the syllogism, but does mark off deductive inference as a separate type of thinking.

Under the enlightened rulers of the past there was no need for explanation or argumentation because the gentleman was in power and could enforce correct policies by punishment. Unhappily this is no longer the case.

"Now the sage kings are gone, the world is disordered, wicked doctrines arise, and the gentleman has no power with which to oversee them or punishments with which to forbid them, so argues out alternatives and explains. Only when the object is not communicated does one name, only when naming fails to communicate does one fix ahead, only when fixing ahead fails to communicate does one explain, only when explanation fails to communicate does one argue over alternatives."

The term *ch'i* 期 'fix ahead' (used primarily of fixing a date') appears widely in the literature of disputation,[41] apparently of concurring beforehand on the use of a name in debate, presumably by an agreed definition. As for the sentence, Hsün-tzu has little to say about it, and it remains unclear whether he sees it as more than a string of names.

"Objects being communicated when the names are heard is the use of names. Enchaining to make a text is the linking of names. When uses and links are both grasped one is said to know the name. A 'name' is the means to fix ahead the enchained objects. A 'sentence' is a combination of the names of different objects in order to sort out a single idea."

3. LEGALISM: AN AMORAL SCIENCE OF STATECRAFT

During the 3rd century B.C., as the intensifying struggle between the states approached its final crisis, rulers were hardly pretending any longer to listen to the moralising of Confucians and Mohists, they preferred more practical teachers of statecraft. Except for the books of Han Fei (died 233 B.C.), the greatest of them, and of a predecessor the Chi-hsia academician Shen Tao (fl. 310 B.C.) of whom only fragments survive, the writings on statecraft carry the names of famous ministers in certain of the states: *Kuan-tzu* (Kuan Chung, chief minister in Ch'i, died 645 B.C.), the lost *Li-tzu* (Li K'uei, chief minister of Marquis Wen [424–387 B.C.] of Wei), *Shang-*

tzu (Lord Shang, chief minister of Ch'in, died 338 B.C.), and the book of Shen Pu-hai (chief minister in Hán, died 337 B.C.), another of which only fragments survive. Of these the two which we possess complete are much later than their supposed authors. *Kuan-tzu* is a miscellany of writings from the 4th, 3rd, and 2nd centuries B.C.; the chapters of *Shang-tzu* datable by historical references come from about 240 B.C. Presumably it was the convention for a state to ascribe its tradition of political thought to one of its chief ministers.

In the early Han when Ssu-ma T'an classified the philosophers under his Six Schools he grouped the teachers of realistic statecraft under a 'School of Law' *(Fa chia)*, for which the current English abbreviation is 'Legalists'. All these books have come to be known as Legalist, even the very heterogeneous *Kuan-tzu*, classed as Taoist in the Han bibliography. Law is not however the central concept of all of them. Han Fei sees Lord Shang's thought as centred on law but Shen Pu-hai's on 'methods' (*shu* 術), techniques for controlling administrators, a distinction born out by *Shang-tzu* and the remains of Shen Pu-hai; he himself declares law and method both indispensable.[1] Elsewhere he mentions Shen Tao as giving central importance to the power-base (*shih* 勢);[2] some take this as evidence of a third tendency preferring the power-base to law.[3] However, law is prominent in the Shen Tao fragments, and Hsün-tzu (who seems not to know *Shang-tzu*), associates law primarily with Shen Tao[4] and names Shen Pu-hai as doctrinaire of the power-base.[5] No doubt the relative importance of law, method, and power-base for the different thinkers was a matter of emphasis. But they do have common ground in the conviction that good government depends, not as Confucians and Mohists supposed on the moral worth of persons, but on the functioning of sound institutions. Only *Kuan-tzu* gives both morality and law places in the organisation of the state, in proportions not very different from the Confucian Hsün-tzu's.

The great synthesiser of Legalism is Han Fei, and the simplest approach to his rather shadowy predecessors is through the issues on which he argues for or against them. According to Ssu-ma Ch'ien's biography, Han Fei belonged to the ruling family in the state of Hán, and studied under Hsün-tzu with Li Ssu, who was later to be chief minister in Ch'in. Unlike the teachers of other schools, who (with the remarkable exception of Hui Shih) seldom got within sight of high office, Han Fei did in the last year of his life find access to the scene of real politics. He had failed to win employment in Hán, but his writings attracted the attention

of the King of Ch'in who was to become First Emperor. In 234 B.C. he was sent as Hán envoy to Ch'in, where he was at once slandered by his old fellow-student the minister Li Ssu. He was imprisoned and accepted the proffered option of suicide in 233 B.C. He was nonetheless the most immediately relevant to his times of all Chinese thinkers, the theoretician of the policies by which the First Emperor and Li Ssu united China and laid the foundations of the bureaucratised empire which replaced Chou feudalism. His personal fate, like that of Lord Shang (ripped to pieces by chariots in 338 B.C.) and Li Ssu (cut in two at the waist in 208 B.C.) helps one to appreciate why Yangists and Taoists recommended the relative security of private life. The lengthy book *Han Fei tzu* raises the usual textual problems about how much was actually written by Han Fei, but most of it is homogeneous in thought and unlikely to be much later than his time.

How old is the Legalist tradition? As in intellectual history generally, in China or elsewhere, chronological sequences are to a great extent imposed by ourselves for convenience. Legalism comes into the open towards the end of the classical period, but something like it must have long existed as an arcanum of government. Ever since centralisation and bureaucratisation began, statesmen would have been thinking more in the style of Han Fei than of Confucius. However there is more in Legalism than a cynicism which, with the intensification of struggle, drops its last disguises. These are political philosophers, the first in China to start not from how society ought to be but how it is. Han Fei has often been compared with Machiavelli, but as Schwartz observes Machiavelli taught an art rather than a science of politics while the Legalists "seem closer in spirit to certain 19th- and 20th-century social-scientific 'model builders' ".[6] Since we are accustomed to think of the social sciences as late and perhaps questionable attempts to extend to human behaviour approaches first developed in astronomy and physics this may seem a surprising claim; how would thinkers 'proto-scientific' elsewhere become 'scientific' in politics? But it is perhaps not so remarkable in a supremely man-centred and politically oriented culture, inclined to causal thinking only when it promises immediately useful results. To quote Schwartz again, "we may find in China more anticipations of contemporary Western social sciences than of the natural sciences",[7] and in spite of Max Weber's claim that Chinese bureaucracy remained patrimonial, "however rudimentary its details, Shen Pu-hai's 'model' of bureaucratic organisation is much closer to Weber's modern ideal-type than to any notion of patrimonial bureaucracy," much closer than anything in Greco-Roman thought.[8]

Adapting to change

The *Book of the Lord Shang* or *Shang-tzu* opens with a debate in the presence of Duke Hsiao of Ch'in (361–338 B.C.) to "consider the changes in the affairs of the age, inquire into the basis for correcting standards, seek the Way to employ the people." This dialogue, a highly literary fiction in a stilted parallelistic style in which Kung-sun Yang (Lord Shang) persuades the Duke to change with the times, is the classic statement of the Legalist attitude to antiquity. The Duke, supported by his grandees Kan Lung and Tu Chih, is afraid that the world will criticise him if he alters the *li* 'ceremonies, conventions' and *fa* 'standards, laws' handed down from the past. These are words of which we generally translate *li* in Confucian contexts by 'ceremony' and *fa* in Legalist by 'law'. We are here however at a stage in terminological change where we shall have to take liberties, as when we used 'nobility' for *jen* at the transitional stage represented by Confucius. For Legalists the *li* have no significance except as the customs current at the time (Shen Tao says explicitly "For the *li* follow custom"[9]), and in this dialogue we translate it 'convention'. As for *fa*, it is the old word for a model or standard for imitation, now assuming a specialised sense as the standards enforced by punishments, so laws. In this dialogue we continue to translate it 'standard'.

Lord Shang enters the debate in answer to the conservatism of Kan Lung.

" 'You are saying what vulgar opinion says. Ordinary people stay content with the familiar, scholars remain immersed in the second-hand. These are both the sort one uses to fill offices and uphold the standard [= law], not the sort one consults when going outside the standard. The Three Dynasties reigned by dissimilar conventions [= ceremonies], the Five Overlords lorded by dissimilar standards. Hence the wise invent the standards by which the foolish are curbed, the worthy reform the conventions by which the inadequate are constrained. It is pointless to speak of affairs with men constrained by convention, or to discuss the altered with men curbed by the standard. Have no more doubts, my lord.'

" 'I have heard', said Tu Chih, 'that unless benefit is hundredfold one does not alter a standard, unless results are tenfold one does not replace a tool. I have heard that if you take antiquity as standard there will be no mistake, if you conform to convention there will be no deviation. My lord, think about that.'

"Kung-sun Yang (Lord Shang) said: 'Former generations did not share the same doctrines; which antiquity shall we take as standard? The Emperors and Kings did not repeat each other; to which convention shall

we conform? Fu-hsi and Shen-nung taught and did not punish; the Yellow Emperor, Yao and Shun punished but spared the families of the condemned. Coming down to Kings Wen and Wu, each established standards fitted to the times, instituted conventions as affairs prompted them. Since conventions and standards were fixed according to the times, restrictions and commands were appropriate to the circumstances, and armaments and equipment each convenient for its purpose. I say then that there is more than one Way to bring order to one's generation, and to do what is best for the state one does not have to take antiquity as standard. T'ang and Wu rose to kingship without following antiquity, Yin and Hsia fell to ruin without change of conventions. Consequently, rejection of antiquity is not necessarily to be condemned, and conformity to convention does not deserve to be made much of. Have no more doubts, my lord.' " (*Shang-tzu* [ch. 1] Kao 16f, tr. D 170–73)

The denial that ancient authority is necessarily relevant to changing times is by this period common to Legalists, Taoists, Later Mohists, syncretists, to everyone except Confucians; on the other hand it does not stop even Legalists from occasionally falling into the convention of ascribing their own doctrines to the former kings. But *Shang-tzu* and *Han Fei tzu* are unique in seeking a root historical cause of changing conditions, which they find in population growth. The Mohists, and Hsün-tzu also, had assumed that the benevolent and the right prevail only under sagely government and that nothing preceded the origin of the state except a primaeval war of all against all. *Shang-tzu* instead presents a scheme of three historical periods; men are united at first by blood ties ('sticking to kin'), then by moral persuasion ('elevating worth'), finally by government ('honouring rank'), the first two breaking down when increase of population leads to competition.

"When Heaven and earth were established mankind was born. At this time people knew their mothers but did not know their fathers. Their Way was to stick to kin and be selfish in their concerns. Sticking to kin they diverged, being selfish in their concerns they were insecure. The population multiplied, and since their aims led to divergence and instability the people fell into disorder.

"At this time people aimed to conquer and settled issues by force. Aiming to conquer led to contention, settling issues by force to accusation. With nothing to judge the correctness of accusations, no one could live out his life. Therefore men of worth established the unprejudiced and correct, instituted the unselfish, and the people delighted in benevolence. At this time, sticking to kin was abandoned for elevating worth.

"The benevolent always take concern for others as their aim, but the worthy make it their Way to excel each other. The people multiplied, with nothing to control them; and when making it their Way to excel each other had been going on for a long time they again fell into disorder. Therefore the sages who came next originated divisions between lands, between properties, and between man and woman. Portions being fixed were unenforceable without controls, so they established prohibitions. The prohibitions being established were unenforceable with no one in charge of them, so they established officials. The officials being installed were insufficient with no one to unify them, so they established a ruler. When they established a ruler, elevating worth was abandoned for honouring rank.

"In the remotest ages, then, they stuck to kin and were selfish in their concerns; in the middle ages they elevated worth and delighted in benevolence; in recent ages they have honoured rank and dignified officials." (*Shang-tzu* [ch. 7] Kao 73f, tr. D 225f)

Since Han Fei and Li Ssu studied under Hsün-tzu it is often assumed that Legalism inherits Hsün-tzu's doctrine of the badness of human nature.[10] Certainly it sees the people of the age as ruthlessly selfish and responsive only to the hope of reward and fear of punishment. However, the goodness or badness of human nature is a purely Confucian issue. The Legalists think of human behaviour not in genetic but in sociological terms. The 'Extravagance' chapter of *Kuan-tzu*, acknowledging that punishment was unnecessary with the more abundant resources of ancient times, says explicitly: "It is not a matter of man's nature, but of poverty."* Indeed the Legalists freely acknowledge, which no Confucian does, that an underpopulated society can be held together by moral ties without any government at all. We have noticed elsewhere that *Shang-tzu* accepts the historicity of the Golden Age of Shen-nung (presumably in its "middle ages"), an acceptance perhaps encouraged by experience of the homogeneity of small tribal populations on the edges of the great states.[11] It sees the change from voluntary co-operation in the small community to subjection by force in the great state neither as degeneration (as do Taoists and the Yangist author of 'Robber Chih'), nor as progress, simply as adaptation to changing conditions. Han Fei has a similar view of history, with the growth of population seen in Malthusian fashion as a geometrical progression.

* *Kz* (ch. 35) 2/45. The second 'Ruler and Minister' chapter (ch. 31) also recognises a period before the origin of the state when order was ensured by the moral guidance of worthy men (*Kz* 2/31 tr. RG 412)

"In ancient times the men did not plough, because the fruit of herbs and trees was sufficient for food; the women did not weave, because the skins of animals were sufficient for clothes. Provision was adequate without the effort of work, there was a small population with excess of resources; consequently people did not compete. This is why the people were orderly of their own accord without the bestowing of rich rewards or infliction of heavy punishments. Nowadays it is not exceptional for a man to have five children, the children in their turn have five children, and before the grandfather dies he has 25 grandchildren. This is why there is a numerous population with sparse resources, work is laborious and provision scanty; therefore people compete, and even by doubling rewards and multiplying punishments there is no escape from disorder. . . . It follows that the generosity with resources in ancient times was not benevolence, it was because resources were ample; the competition and robbery of today is not dishonesty, it is because resources are sparse." (HF [ch. 49] Ch'en 1040f, tr. Liao 2/276f)

Han Fei objects to ancient authority, not only that times change, but that historical evidence is uncertain. The eight Confucian and three Mohist sects all give different versions of the teaching of the Three Dynasties they profess to follow.

"It being some seven hundred years since the foundation of Chou, some two thousand years since the foundation of Hsia, they are unable to fix which is the genuine Confucianism or Mohism; if now you wish to inquire into the Way of Yao and Shun three thousand years ago, may I suggest that one can hardly be certain of it? To be certain of it without evidence is foolishness, to appeal to it though unable to be certain of it is fraud." (HF [ch. 50] Ch'en 1080, tr. Liao 2/299)

Standards and laws

The term *fa* 法 'standard' first attracted our attention in the *Canons*, where the instance is using the idea of a circle, another circle or the compasses as the standard for identifying a circle.[12] Outside logical contexts the *fa* is more usually a standard or exemplar to be imitated in action, but still characteristically illustrated from geometrical instruments. Thus Mencius tells us that the craftsman's clear eye and skill of hand and the ruler's benevolent heart will not achieve effective results without the aid of standards, the carpenter's compasses and L-square, the benevolent government of the sage kings to be taken as models. "Hence it is said, 'Goodness alone is insufficient for governing, standards alone

cannot work of themselves'."[13] The comprehensiveness of the term may be illustrated by the essay 'Seven Standards' in *Kuan-tzu*, which is of great interest as presenting what amounts to a total categorisation of the knowledge required by the ruler. It uses *fa* generally of all seven but also specifically of No. 3 (we introduce the numbers for convenience).

"[1.] What are rooted in the *ch'i* of Heaven and earth, in the harmonising of cold and hot, the natures of water and soil, the life of man, birds, animals, plants and trees, which though things are so many belong equally to all of them and never alter, are called 'principles (*tse* 則)'.

[2.] Exemplar, name, the timely, the resembling, the kind, the comparable, the characteristics, are called 'models (*hsiang* 象)'.

[3.] Foot and inch, the carpenter's ink and line, compasses and L-square, the scales, the volume measures and the grain leveler, are called 'standards *(fa)*'.

[4.] Imbuing, rearing, wearing away, prolonging, taming, habituating, are called 'transformings'.

[5.] Giving to or taking from, endangering or securing, benefiting or harming, making difficult or easy, opening or closing, killing or giving life, are called 'incentives and deterrents'.

[6.] Being genuine and sincere, being generous and bountiful, measuring and likening-to-oneself *(shu)*, are called 'the methods of the heart'.

[7.] Consistencies, weights, sizes, densities, distances, quantities, are called 'statistics'." (*Kz* ch. 6, 1/22f, tr. RG 128f)

Of these items No. 1 has attracted attention for its bearing on the question of whether the concept of laws of nature appears in Chinese thought.[14] *Tse*, like other words for norm, rule or principle, tends to be used without any 'is/ought' distinction between those which physical phenomena do follow and those which man should follow. Here it does seem that with the establishing of the split between Heaven and man, *tse* is being reserved for the sphere of the former.

There is certainly a recognition at this period that physical principles are independent of moral; and in that it is the former which are 'decreed' *(ming)* by Heaven, there is even something in common with the metaphorical structure of our 'laws of nature' conceived after the analogy of laws ordained by a divine ruler. In the 'Seven Standards' *tse* are constants in the objective conditions with which man has to deal.

"If without being clear about the principles you wish to position exemplars and demarcate controls, it will be like estimating east and west from a rotating potter's wheel, or wishing to hold the tip steady while you are shaking the rod."

The models *(hsiang)* of No. 2 correspond roughly with the standards of the *Canons,* by comparison with which one decides what the object is. But they are seen purely from the viewpoint of the administrator, who if ignorant of people's qualities will fit them into the wrong jobs.

"If without being clear about the models you wish to sort out talents and become aware of how to employ them, it will be like cutting off the long to make it short, or adding to the short to make it long."

No. 3, the standards in the narrowest sense, include compasses and L-square; they are the instruments and measures specifically designed for exact comparison by which to fix universally accepted figures or measurements. The unification of weights and measures throughout the Empire was soon to be a prominent item in the Ch'in unification of *fa.* Nos. 4 through 6 are methods taken as standard, for transforming or reforming the people, correcting by reward and punishment, and training the ruler. The last ('methods of the heart') is one of the elements in the *Kuan-tzu* statecraft which is foreign to classic Legalism, and we shall not be meeting it again. Finally, No. 7 are the statistics already proving indispensable with the increasing complexity of states. The state bureaucracies were coming to see things as manageable to the extent that they were countable and measurable.

The essential novelty of the Legalist position is in its repudiation of an assumption expressed almost in the same words by Mencius and by Hsün-tzu,[15] that "*Fa* alone cannot work by itself". If standards are fully formulated they can work automatically; the ruler has simply to compare a man's act with the wording of the standard, and respond with the reward or punishment laid down for it, without being swayed either by benevolent or by selfish considerations. With the characteristic Chinese tendency to think in pairs, reward and punishment are seen as parallel, although it is the standards enforced by punishment (what for us is penal law) which get fully codified. The scope of *fa* thus contracts towards what in Western terms is law; but even among those classed as Legalists it can include, for example, methods of regulating the bureaucracy.

"The ruler must have clear standards and correct exemplars, as though letting the scales hang to weigh light and heavy, as the means to unify the team of ministers." (*Shen Pu-hai* 3)

The old metaphors of compass and L-square assume enormous significance in Legalism, and above all the metaphor of the scales; they illustrate the mechanical precision and objectivity of the law.

"The scales are the means of finding the number for a weight. That in spite of everything people do not try to influence them is not because at heart they don't want profit; the counterpoise is unable for their sakes to

increase or decrease its number, the beam is unable for their sakes to estimate as lighter or heavier. Men don't try to influence the scales because they know it would be useless. So when there is a clear-sighted ruler on the throne officials have no opportunity to bend the law, magistrates have no opportunity to practice partiality. The people know it would be useless to try to influence the magistrates, so bribes are not passed to the magistrates; the scales stand level and correct waiting for the load, so traitors and tricksters have no opportunity to get decisions partial to themselves." (*Kz* [ch. 67] 3/55)

The conception of the standard enforced by punishment as the basis of political order must have been developing gradually among practical statesmen from the first appearance of public codes of punishment in the 6th century B.C. It can be seen from the accounts in the *Tso Commentary* that the publication of codes was a decisive step in the bureaucratisation of the states, highly controversial, and widely felt to violate the old person-to-person relations of feudalism. In 536 B.C. Tzu-ch'an, chief minister of Cheng, inscribed a code of punishments on metal. A critic, Shu Hsiang, objected that the former kings maintained order by instilling the benevolent and the right, choosing wise and loyal officials and severely punishing crimes, but without publicly formulated laws, which can only lead to litigation.

"If the people know about the statutes, they will not be in awe of their superiors, they will all have contentious hearts, testing by what is written down, taking any opportunity to win their own way; it will be impossible to deal with them."[16]

In 513 B.C. the ruler of Chin "levied from the state of Chin one *ku* of iron, in order to smelt a punishment tripod and make public the code of punishments written by Fan Hsüan-tzu" (this by the way is the earliest reference to iron in Chinese literature). The *Tso Commentary* records the horror of Confucius himself that matters which should be settled in private by the noble class according to their family traditions are now to be judged by impersonal laws exposed to the sight of all.[17]

The accusation that law undermines the differences between noble and mean has a very definite meaning when it comes to Legalism; against the general practice in China both before and since, the Legalists treated all below the ruler as equal before the law. Soon after the fall of the Ch'in dynasty one of the Confucian Chia Yi's main objections to the tyranny of its Legalist policies was that the people lose respect for their betters unless gentlemen are permitted suicide instead of execution, and are exempt from bonds, beating, and mutilation.[18] Lord Shang as chief minister of

Ch'in is said to have refused in principle to spare even the Crown Prince, and to have solved the problem of how to deny him exemption without actually punishing him by punishing his tutor instead. The book ascribed to him affirms this undeviating rule in the essay 'Rewards and Punishments'.

"What I mean by 'unifying punishment' is that for punishment there are no differences of rank. From ministers and generals down to officers and commoners any who disobeys the royal command, defies the state prohibitions, disrupts controls from above, is condemned to death without reprieve. One does not reduce the punishment for the sake of credit for deeds before his lapse, nor leave the law unapplied for the sake of good conduct before he erred. Loyal ministers and filial sons are judged without fail according to the extent of their error." (*Shang-tzu* [ch. 17] Kao 130, tr. D 278f)

"Law does not flatter the noble, the carpenter's line does not bend with the crooked. What law imposes the wise are unable to refuse, the brave do not dare to contest. Punishment of error does not avoid the great ministers, reward for good does not overlook commoners." (*HF* [ch. 6] Ch'en 88, tr. W 28)

Han Fei argues from many directions that harsh law is more effective than benevolence or honesty in benefiting the people. Few people, even the paragons Tseng and Shih, can be trusted to remain honest when they can get away with it:

"If you lay out cheap goods in a dark corner, even Tseng and Shih would be under suspicion; if you hang up a hundred in gold in the marketplace, even the greatest thief would not take it. The difference is in whether it will be known; therefore when a clear-sighted ruler governs a state he has many to police it, comes down heavily on crime, and ensures that people are forbidden by law rather than restrained by honesty." (*HF* [ch. 46] Ch'en 950, tr. Liao 2/241)

People's concern for each other, on which Confucians and Mohists depend, is a weak motive even at its most intense as family love.

"The mother's love for the son is twice the father's, but the father's orders to the son are ten times more effective than the mother's. The magistrate has no love for the people at all, but his orders to the people are a myriad times more effective than their fathers'." (*HF* [ch. 46] Ch'en 950, tr. Liao 2/241)

Policies motivated by benevolence do good only on the short run.

"Now of families making a livelihood, if here they are callous about each other's hunger and cold, and force each other to work hard, the

family which even if they happen on the troubles of military occupation or the hardships of famine will have warm clothes and fine food is sure to be this one; if there they clothe and feed each other out of pity and let each other idle out of kindness, the family which in the famine of a bad year marries off the wife and sells the children into slavery is sure to be that one. Therefore the Way proper to the law is to be harsh at first but beneficial in the long run; the Way proper to benevolence is to be indulgent in the short run but afterwards run out of resources. The sage weighs light against heavy and extracts the most beneficial, so he employs the callousness of the law and rejects the pity of the benevolent man." (*HF* [ch. 46] Ch'en 950, tr. Liao 2/242)

The debate over power, morality and law

The Legalist orders the state not by moral appeals but by fitting the 'Two Handles', reward and punishment, to the likes and dislikes which belong to man's *ch'ing*, what he essentially is. A Legalist digest called the 'Eight Canons' puts it succinctly at the start.

"In ordering the Empire one must always take as basis what is essential in man. What is essential in man is to have likes and dislikes, which is why reward and punishment are effective. Once they are effective, prohibitions and commands can be established and the Way of Order is complete. The ruler grasps the Handles and occupies the power-base, and so his orders are carried out and his prohibitions deter. The Handles are the controls for killing and giving life; the power-base is the requisite for conquering the multitude." (*HF* [ch. 48] Ch'en 996, tr. Liao 2/258)

The image of water tending downwards, which Mencius used of man's natural proneness to good[19] is put to characteristically Legalist effect in *Shang-tzu*:

"The people are to benefit as water is to going downwards; they will take one direction as easily as another. What, simply to get benefit from it, the people will do depends on what the ruler will be giving them." (*Shang-tzu* [ch. 23] Kao 171, tr. D 316)

One chapter in *Han Fei tzu*, 'Objections to the Primacy of the Power-base', presents a three-sided discussion of the relation between power, morality and law. It starts with a quotation from Shen Tao on the ineffectiveness of moral influence which is not backed by a 'power-base' (*shih* 勢, a situation of strength, or on occasion weakness, in relation to circumstances, for example strategic position on the battlefield). Shen Tao

is then criticised at length by a moralist, apparently a Confucian of the school of Hsün-tzu. Since Han Fei studied under Hsün-tzu, who frequently mentions Shen Tao among rival thinkers (although not on the issue of power), one may guess that Han Fei is here making his reckoning with his old master's defence of morality in politics. The essay concludes with Han Fei's case, that what is missing in Shen Tao's doctrine of power is not morality but law.

"Shen Tao says: 'If the flying dragon rides the clouds and the soaring serpent floats in the mist, yet when cloud or mist dissolves they might as well be earthworms or ants, it is because they have lost what they were riding. When men of worth are crushed by the unworthy, it is because their pull is light and position lowly; when the unworthy are reduced to submitting to them, it is because their pull is heavy and position high. Yao as a commoner couldn't rule three men, yet Chieh as Emperor could ruin the world; by this I know the dependability of power and position, the unenviability of worthiness and wisdom. That an arrow flies high from a weak crossbow is because it is driven up by the wind; that the orders of the personally unworthy are executed is because they have the multitude to help them. When Yao was teaching among menials the people would not listen; when the time came that he reigned over the world from the south-facing throne his orders were executed, his prohibitions deterred. Judging by this, worthiness and wisdom are not enough to win submission from the multitude, while power and position are all you need to crush the worthy." (*HF* [ch. 40] Ch'en 886, tr. Liao 2/199)

The Confucian answers that although the dragon depends on support by the cloud, the fact that he can ride it while the earthworm cannot is because of the superior qualities of the dragon. Similarly it is because Yao is morally superior to Chieh that when in power he brings order to the state while Chieh disorders it. The power-base is like the horses and chariot which the great Wang Liang can drive a thousand miles in a day, but which a slave cannot handle without making himself a laughing-stock. The great problem is that power in the wrong hands is positively dangerous, but the virtuous who can use it rightly are the minority. It is here that this speaker most reminds us of Hsün-tzu, for he assumes that human nature is bad.

"It is not that there is any ability in the power-base itself to get itself invariably employed by the worthy rather than the unworthy. The world is ordered when it is the worthy who are employing it, disordered when it is the unworthy. It belongs to man's essential nature that the worthy are fewer than the unworthy, and the benefits of authority and power being

available to unworthy men who disorder the age, it follows that those who use the power-base to disorder rather than order the world are the majority. The power-base is what facilitates and benefits the orderly and the disorderly alike. . . . Supposing that Chieh and Chòu had been commoners, before they had taken the first step they would have been executed with all their kin. The power-base is the nurturer of the tigerish and wolfish heart and the accomplisher of tyrannical deeds. This is the world's greatest misfortune."

Here we have what Han Fei might well see as a fatal admission by his master Hsün-tzu; if government depends on the moral worth of rulers, to admit that there will be few good rulers condemns the world to almost uninterrupted misgovernment. Han Fei now replies to both positions, which he sums up as "judging the power-base all that is needed to put offices in order" and "order necessarily depending on men of worth." His answer is that what matters is whether the power-base itself is fully ordered; if it is, it will continue to impose orderly government throughout the Empire irrespective of the moral worth of the ruler. Both Shen Tao and the Confucian have been using shih 'power-base' in its common sense of a natural position of advantage in relation to others; but the strength of a throne depends on institutions made by man.

"The power-base is something with a single name but innumerable variations. If it necessarily derived from the spontaneous there would be no point in talking about the power-base. When I speak of the power-base it is of something instituted by man. Now it is not that I deny what he says about there being order when Yao and Shun, and disorder when Chieh and Chòu, got the power-base; the point is that it was not something that a single man could institute. That when a Yao or Shun is born and on the throne even ten Chiehs and Chòus could not disrupt order is because the power-base would be ordered; and conversely if the throne were Chieh's or Chòu's."

For Han Fei then political order depends not on power as such, and not on moral worth at all, but on the power-base itself being ordered, by which he means that it has settled and clearly defined laws rigorously enforced. He continues with a story which is the source of the later cliché mao-tun 矛 盾 'spear and shield', which in due course became the standard word for 'contradiction'.

"A man selling spears and shields was praising his shields as so hard that nothing could penetrate them. Immediately afterwards he said in praise of his spears 'My spears are so sharp they will penetrate anything'. When someone answered 'What if I penetrate your shield with your

spear?' he was at a loss to answer. If you deem them as 'impenetrable shield' and a 'spear which penetrates anything', the two names cannot both be made to stand. That the Way of the Worthy may not be forbidden, yet it is the Way of Power to forbid anything, is a 'spear and shield' explanation. That worth and the power-base have no room for each other is plain enough."

Here the folksy little story lifts the argument to an unexpected level of abstraction. Han Fei is saying that to conceive the state power as a 'spear which penetrates anything', entitled to forbid anything, is incompatible with treating morality as an 'impenetrable shield', which no power is entitled to forbid. To conceive Yao and Shun as combining power with morality amounts to arming them with both the shield and the spear. The issue is of course one which in other forms arises in Western political philosophy, at its simplest in any clash between the authority of law and of a moral code by which one judges a law unjust.

Han Fei now takes up the Confucian's admission that good government which depends on good men, a permanent minority, will be the exception rather than the rule, and shows that Legalism escapes this dilemma.

"Moreover if a Yao or Shun, a Chieh or Chòu, appears once in a thousand generations, this is being born shoulder to shoulder and treading on each other's heels, yet generations which were orderly continued in between. My concern when I speak of the power-base is with the rulers in between. Those in between do not reach as high as Yao and Shun or sink as low as Chieh and Chòu. When by embracing the law they occupy the power-base there is order, when by rejecting the law they lose the power-base there is disorder. If now one abandons the power-base and rejects law expecting order only when a Yao or Shun arrives there will be one generation of order for a thousand of disorder; if one embraces law and occupies the power-base expecting disorder only when a Chieh or Chòu arrives, there will be one generation of disorder for a thousand of order."

Han Fei concludes the chapter by taking up the Confucian's example of charioteering. There is an art of driving which the average man can master; the Confucian has used his illustration as though the only choice were between the genius of great drivers like Wang Liang and the clumsiness of the man who has never learned to drive.

In the Legalist conception of the law there is a shift from the man-to-man relations of feudalism, in which the *fa* as standards are the examples of actions and persons to be imitated, to the impersonal relations of

bureaucracy, in which the standards have become laws backed by reward and punishment. There is a similar shift in the concept of power. In Legalism we do not hear much about the *te* 'potency', the power in a man which inspires awe in his presence. Power is seen in terms of occupying the key position in impersonally functioning institutions.

Control of the bureaucracy

A further issue dividing the thinkers who came to be classed as Legalists is the relative importance of the laws advocated by Lord Shang and the 'methods' (*shu*) of bureaucratic control evolved by Shen Pu-hai. Han Fei examining this issue finds both indispensable for good government.

"Now Shen Pu-hai speaks of method but Lord Shang deals in laws. Method is bestowing office suiting assignments to qualifications, making responsible for the object as laid down by the name, holding fast to the Handles which deal death or life, and testing the abilities of all the ministers. These are in the hands of the ruler. Law is having the statutes publicly available in the government offices, punishments which the people know for certain will be applied, rewards given consistently for punctiliousness in the law, and punishments imposed consistently on violators of the decrees. These are what the subjects take as their exemplars. Without method for the ruler there are abuses up above, without law for the subject there is disorder down below. Neither is dispensable, both are tools for emperor or king." (*HF* [ch. 43] Ch'en 906, tr. Liao 2/212)

According to Han Fei, Shen Pu-hai failed to win hegemony for Hán because he neglected to unify the laws, leaving the old statutes of Chin (of which Hán was a succession state) to stand side by side with the new ones of Hán itself. Lord Shang on the other hand failed to win hegemony for Ch'in because of lack of method in controlling ministers. The effect of Ch'in conquests had been to strengthen not the ruler but his ministers, who were enfiefed in the new lands. (When Ch'in imposed Legalist policies on the united Empire it did in fact abandon the policy of enfiefment.)

Elsewhere Han Fei distinguishes between law as public and method as private, the arcanum of the ruler ("Therefore it is best that law be manifest, but method one does not wish to be seen").[20] It is possible that the distinction between the two terms sharpened with the need to contrast

the doctrines of Lord Shang and Shen Pu-hai; the fragments of the latter, admittedly sparse, do not use *shu* 'method' but include it within *fa* 'standard'.

"Marquis Chao of Hán said to Shen Pu-hai 'Standards and degrees are not at all easy to apply.'

'By standards', said Shen Pu-hai, 'one bestows rewards for visible results, and assigns offices as qualified by ability. Now my lord institutes standards and degrees yet listens to the pleas of courtiers, that is why they are hard to apply." (*HF* [ch. 32] Ch'en 662, tr. Liao 2/58 *Shen Pu-hai* 23) The story continues with Shen Pu-hai later himself pleading for office for a cousin, and apologizing when the Marquis points out the contradiction.

Shen Pu-hai's doctrine that office should depend on ability, not favour, descends from the Mohist principle of 'elevating worth and employing ability'. The novelties credited to Shen Pu-hai are the doctrines summarised by Han Fei as "making responsible for the object as laid down by the name" and "testing the abilities of all the ministers". The testing of abilities was to become a permanent concern of government in China, leading to the development from the Han onwards of the civil service examinations. Since Europe adopted civil-service examinations only after becoming familiar with the Chinese institutions idealised by 18th-century *philosophes*, one may agree with Creel[21] in seeing Shen Pu-hai as the ancestor of a now-worldwide institution crucial to bureaucratic organisation. As for the comparison of name and object, the checking of an administrator's acts against verbal formulations (the title of his office, the general law or particular command he should obey, any proposal of his own he is pledged to fulfil), it is essential to the Legalist enterprise of reducing all government to the automatic application of objective and exact criteria. In its full development in *Han Fei tzu* it contrasts sharply with the Confucian 'Correction of Names'. Although a Legalist system certainly assumes an accepted usage for fitting names to objects, titles to offices, Han Fei is generally concerned not with naming correctly but with 'aligning' (*ts'an* 參) and 'matching' (*wu* 伍) the 'shape' (*hsing* 形) of a man's performance against its 'name', the verbal formulation of his own proposal or the ruler's command. *Hsing ming* (形名) 'shape and name' is from Han Fei onward the technical name for checking against names in contrast with correcting them; Creel has proposed as English equivalent 'title and performance'.

The term *cheng ming* 'correction of names', not used by Han Fei, is however prominent in *Kuan-tzu* and in the Shen Pu-hai fragments. Creel,

who regards the *cheng ming* reference in the *Analects* as a late interpolation, has suggested that the Confucians took the concept from Shen Pu-hai.* In historical terms however it seems preferable to suppose that Shen Pu-hai took over a Confucian concept belonging to a traditional world where everything has its correct name, and shifted its relevance to the checking of the deed against the name; by Han Fei's time Legalism has shed its old-fashioned associations and adopted the new term 'shapes and names'. An example of the transition is the last of the 'Nine Maxims' in *Kuan-tzu*, a book which keeps traditional morality side by side with law.

"*Scrutinising names*. Scrutinise the object according to the name, fix the name depending on the object. Name and object give birth to each other, and reversing become each other's *ch'ing* (the essential without which the object will not fit the name). If name and object fit there is order, if not, disorder.

"The name is born from the object, the object from the potency, the potency from the patterning, the patterning from knowing, the knowing from the fitting." (*Kz* [ch. 55] 3/14 f)[22]

Here the name is clearly not the words of a minister's proposal but rather his title; being a real minister (or king, or father, or son) implies fulfilling the duties which belong to the name. Name and object interact; you must have the *ch'ing* of a minister to be named one, but then the name itself turns round to reveal a *ch'ing* which you must actualise if you are to live up to the name. When name and object everywhere coincide there is perfect order in which everyone fulfils his duties. The potency *(te)* specific to developing into a true minister or ruler itself develops in coming to see one's place in the pattern of things. This derives from knowing, and knowing from one's names fitting the objects. Development thus describes a full circle from fitting names to objects to becoming oneself adequate to one's name within the social system to which one belongs. It may be noticed that the circle is complete only if, once again, development is seen as prompted by additions to knowledge but in itself spontaneous.

This doctrine of names seems indistinguishable from the Confucian. We may contrast Han Fei's accounts of the technique of 'shape and name'. He insists on a perfect matching of deeds and words, even when a deviation would be beneficial on the short run.

"If the lord of men wishes to suppress treason, he is thorough in joining shape with name. Shape and name are the words and the task.

* Creel, *Shen* 116, cf. p. 24n above. Han Fei, without using the formula *cheng ming*, does once say "If names are correct things are fixed" (*HF* [ch 8] Ch'en 121, tr. W 36)

When someone serving as minister puts a proposal in words, the ruler entrusts him with the task in accordance with his words, and solely according to the task makes him responsible for the result. If the result fits the task, the task with the words, he is rewarded; if not, he is punished. Hence when ministers whose words are bigger than the results are punished, the punishment is not for the small results but for the results not fitting the name. Ministers whose results are bigger than their words are likewise punished, not because one is displeased with the big result, but because one judges the harm in failure to fit the name more important than a big result.

"Formerly Marquis Chao of Hán fell asleep drunk. The cap-bearer saw that his lord would be cold and spread a coat over him. When he woke he was pleased and asked the courtiers 'Who put the coat over me?'. 'The cap-bearer', they said. The Marquis consequently judged guilty both the coat-bearer and the cap-bearer, the former for not doing his job, the latter for exceeding his job. It wasn't that he didn't mind being cold, but he deemed usurpation of office much more harmful than cold." (*HF* [ch. 7] tr. W 31f)

Legalism and Lao-tzu

In *Shang-tzu* and in most of *Han Fei tzu* there is no attempt to relate the political philosophy to a general world-picture. But in parts of *Han Fei tzu* there is a sustained effort to find a metaphysical context for Legalism in the thought of *Lao-tzu*. Two chapters, 'Interpreting Lao-tzu' (ch. 20) and 'Illustrating Lao-tzu' (ch. 21) consist of notes on the book, lucid and sensible in Han Fei's usual manner, although with little to mark them as Legalist; they are an early demonstration that one does not have to be a mystic to be excited by what one extracts from or reads into that astonishing text. There are also chapters, 'The Way of the Ruler' (ch. 5) and 'The Grand Total' (ch. 8) which develop a *Lao-tzu*-Legalist fusion, largely in rhymed verse like *Lao-tzu* itself. That this strand in the thought is nearly confined to a few isolated chapters suggests, even on the debatable assumption that Han Fei is the author, that it is a not wholly assimilated element. We shall keep to the convention of using Han Fei's name; in any case the synthesis cannot be significantly later than his time, since it dominates the documents, some of them in the name of the Yellow Emperor, attached to one of the Ma-wang-tui manuscripts of *Lao-tzu*. The *Lao-tzu*-Legalist synthesis seems in fact to be the Huang-Lao ('doctrine of the Yellow Emperor and Lao-tzu') widely current at the beginning of the Han. Ssu-ma Ch'ien describes Shen Tao, Shen Pu-hai and Han Fei as all

studying Huang-Lao,[23] which suggests that most Legalist writing available to him showed the influence of *Lao-tzu* which in retrospect would mark it as Huang-Lao.

'Interpreting Lao-tzu' is remarkable for an examination of the relation between the Way and the 'patterns' (*li* 理) of things and affairs, understood like the 'principles' *(tse)* of the 'Seven Standards' in *Kuan-tzu*[24] as objective regularities in nature which man utilises or else ignores at his own cost. We have already met the term *li* (not to be confused with *li* 禮 'ceremony', although perhaps related to it phonetically and semantically), in Hsün-tzu and the Great Man philosopher;[25] in the Neo-Confucianism of Chu Hsi (A.D. 1130–1200) it was to become the central metaphysical concept, in terms of which Heaven, the Way, the Decree, and Nature were all re-defined. Han Fei is the first to give an extended account of it.

"All things which have shape are easily sliced out, easily hacked out. How shall we show this? If they have shape they have length or shortness, so largeness or smallness, so squareness or roundness, so hardness or softness, so lightness or heaviness, so whiteness or blackness. It is being long or short and square or round and hard or soft and light or heavy and white or black which is called 'pattern'. The pattern being fixed the thing is easily hacked out." (*HF* [ch. 20] Ch'en 377, tr. Liao 1/200)

This is a striking example of the Chinese tendency, which Hansen explains by the grammatical resemblance of the nouns to Indo-European mass rather than count nouns, to treat things as divisions of the universe rather than the universe as the aggregate of things.[26] Distinctions are seen in binary terms, as in the first place between pairs of opposites (with even figure and colour reduced to square/round and white/black); having drawn them, and recognised some recurring or persisting pattern (for example, large, round, hard, heavy, and white) we detach a stone from other things as we cut out a piece of cloth or chop off a piece of meat. Things are not conceived as isolated each with its own essential and accidental properties; on the contrary, distinguishing characteristics are seen as mostly relative (of the six selected in this passage, all but figure and colour).

"The Way is that through which the myriad things are so, that in which the myriad patterns run together. A pattern is the texture of a thing as a whole, the Way is the means by which the myriad things become wholes. Hence it is said, 'The Way is what patterns them'. Things having patterns cannot encroach on each other; consequently, the patterning of them is the cutting up of things. Each of the myriad things has a different

pattern, and with each having its own pattern there is no more of the Way. It runs together the patterns of the myriad things, therefore it necessarily transforms, and therefore has no constant commitment to one or another. This is why the *ch'i* of living and dying are received from it, why the myriad intelligences draw from it, why the myriad affairs rise and decline by it." (*HF* [ch. 20] Ch'en 377, tr. Liao 1/191f)

By relating the universal Way to the local patterns of things Han Fei is able to give a rational account of the opening sentence of *Lao-tzu* "The Way that can be 'Way'-ed [formulated in words as the Way] is not the constant Way." Since the Way includes all the contrasting courses which things follow, the way which a thing may be described as following can only be one of the localised regularities.

"All patterns are apportionings of square or round, short or long, dense or loose, hard or soft. Hence it is only after a pattern is fixed that one can get to 'Way' it. In the fixed patterns, then, there are surviving or perishing, birth or dying, flourishing or decaying; and the things which now survive and now perish, which die as suddenly as they are born, which first flourish and afterwards decay, may not be called 'constant'. Only that which was born with the dividing of heaven and earth and until their dissolution will not die or decay may be called constant." (*HF* [ch. 20] Ch'en 369, tr. Liao 1/194f)

Han Fei reminds us frequently throughout the essay that the purpose of grasping the patterns (of death and life, rise and decline) is strictly practical.

"If thinking is thorough you grasp the patterns in affairs. . . . If you grasp the patterns in affairs you are certain to achieve results." (*HF* [ch. 20] Ch'en 341, tr. Liao 1/176)

The term *li* has sometimes (by myself among others) been translated 'principle'. This might suggest that the thinking here is primarily deductive and inductive. But it is rather a matter of correlating affairs through which the same pattern is seen to run:

"Therefore observing it in terms of pattern, if employing a great multitude you keep changing things around you achieve few results, if storing a great vessel you keep shifting it somewhere else it will be badly damaged, if in boiling a small fish you keep on meddling with it you rob it of freshness, if in ordering a great state you keep altering the laws the people will suffer from it. This is why a ruler who has the Way values stillness and does not keep on altering laws." (*HF* [ch. 20] Ch'en 355, tr. Liao 1/185)

The Way itself, since it embraces all opposites, is neutral to man's

prospects, and whether one succeeds or fails depends entirely on how one uses its patterns.

"The Way may be compared to water; if a drowning man swallows too much he dies, if a thirsty man swallows just enough he lives. Or it may be compared to a sword or halberd; if a fool uses it to wreak revenge misfortune is born, if the sage uses it to punish crime good fortune results. So

> You get it to die by,
> You get it to live by.
> You get it to perish by,
> You get it to succeed by." (*HF* [ch. 20] Ch'en 366, tr. Liao 1/193)

The poetic chapters 'Way of the Ruler' and 'The Grand Total' use a superficially paradoxical language like *Lao-tzu* but without its ambiguities; such terms as 'the Way', 'empty', 'still', 'Doing Nothing', 'so of itself', become a code with a precise meaning within the Legalist scheme.

> "The Way is the beginning of the myriad things,
> The skein of the right alternatives and the wrong.
> Hence the clear-sighted ruler holds fast to the beginning
> To know the source of the myriad things.
> He orders the threads in the skein
> To know the origins of good and ill.
> Therefore he waits in stillness and emptiness,
> Lets the names of themselves command,
> Lets the tasks of themselves be fixed.
> Being empty he knows the facts about the object,
> Being still he becomes corrector of the moving.
> The one who has the words, of himself makes the name;
> The one who has the task, of himself makes the shape.
> Shape and name align as the same.
> Then the ruler has no task to do, refers it to the facts."
> (*HF* [ch. 5] Ch'en 67, tr. W 16)

The ruler, empty of thoughts, desires, partialities of his own, concerned with nothing in the situation but the 'facts' (*ch'ing* how they are in themselves irrespective of naming), selects his ministers by objectively comparing their abilities with the demands of the offices. Inactive, doing nothing, he awaits their proposals, compares the project with the results, and rewards or punishes. His own knowledge, ability, moral worth, warrior spirit, such as they may be, are wholly irrelevant; he simply performs his function in the impersonal mechanism of state.

"Hence having knowledge he does not use it to think,
He makes the myriad things know their positions.
Having worth he does not use it to act,
He observes what it is that ministers and subjects act on.
Having courage he does not use it to rage,
He draws out all the warlike in his ministers.
Hence by doing without knowledge he possesses clear-
 sightedness
By doing without worthiness he gets results,
By doing without courage he achieves strength.
The teamed ministers stick to their duties,
The hundred officials have their own constants.
On the basis of ability he employs them,
This is what one calls 'reinforcing the constant' "
 (*HF* [ch. 5] Ch'en 67, tr. W 17)

It is as though Han Fei and the author of *Lao-tzu* lived in parallel universes. In *Lao-tzu* you adapt to the uncontrollable order in the play of natural forces on all sides, which is that of the Way which cares nothing for man. Han Fei on the other hand holds that you can understand and master the natural forces to create an automatic social order parallel with that of Heaven and earth, into which the natural inclinations of man can be forced by the Two Handles of reward and punishment. He is indeed one of the minds in which ancient China comes nearest to the modern West. Hsün-tzu too saw the order of Heaven and earth as no more than regularities which man can utilise; but Han Fei is without even Hsün-tzu's residual need for a cosmos in which man finds a place by patterning it himself through ceremony. A metaphor which shows up sharply his difference from Lao-tzu is that of the tally, the wood or bamboo broken in two pieces kept by debtor and creditor, the debt being proved by fitting one half to the other. Like the scales, compasses and L-square it is one of the instruments for precise unimpugnable decisions so prominent in Legalist metaphor. Taking once again the case of the minister committing himself to a proposal:

"The words once accepted, he grasps his tally; the task having progressed, he holds fast to his own half. Where the halves of the tally join is where reward and punishment are born." (*HF* [ch. 5] Ch'en 68, tr. W 19)

It is assumed that obligations remain frozen however circumstances change, the point which the unfortunate cap-bearer of the Marquis of Hán failed to appreciate. He would have been luckier with the author of *Lao-tzu*, for whom nothing ever remains the same.

"This is why when the sage holds the left half of the tally he does not hold the other man to his responsibility."[27]

The Legalist concept of *fa* shares several features with that of law in the West; it is precisely formulated, detached from all personal considerations, public, and invariable until publicly replaced. The ruler is himself bound by it in imposing punishments, although he is above it in not being himself subject to its punishments. The great difference from Western law is that it is designed not as a protection to the citizen (even if it may protect him as a side effect), but as an instrument for effective control from above. The business of the Legalist state, at its full development by Han Fei, is primarily war, and secondarily agriculture, the feeding of the people as fodder for war. The system is the most authoritarian ever conceived in China, nothing less than totalitarian, and it centres all power on the ruler alone. The maintenance of that power is one of Han Fei's principal concerns.

"One who knows that the interests of ruler and minister are different will reign, one who thinks they are the same will be dispossessed." (*HF* [ch. 48] Ch'en 1005, tr. Liao 2/261)

His detailed analyses of how rulers fail to deal with this perennial problem amounts, as Hsiao says,[28] to "a prophecy outlining all the failures of government that were to be committed by all the muddle-headed rulers of the two thousand-year imperial era."

The question may be raised whether Legalism is concerned with the public good at all, or solely with the good of the ruler. All other Chinese philosophies conceive orderly government as to the good of everyone, if only to the degree proper to his station. But is Legalism anything more than a programme for unlimited power, to be put at the disposal of the one man at the top, in the hope of winning some of his rewards for oneself? In the case of *Shang-tzu*, it seems indeed to be nothing more. In spite of occasional remarks about the people being too stupid to see that the harsh laws are to their own benefit in the long run, the author is unique for his brutal cynicism and relish in the exercise of force. He is especially contemptuous of the morality which, at least in its Confucian form, requires you to put family before state.

"If you employ the good the people will prefer their own kin, if you employ the scoundrels the people will prefer the system. To club together and keep your mouth shut is to be good, to be alienated from and spy on each other is to be a scoundrel. If you glorify the good, errors will be hidden; if you put scoundrels in charge crime will be punished Hence

I say that if you use good men to rule you can be sure of disorder and utmost loss of territory, if you use scoundrels to rule you can be sure of order and utmost strength." (*Shang-tzu* [ch. 5] Kao 53, tr. D 207)

"If in war you perform what the enemy would not venture to perform, you will be strong; if in enterprises you undertake what the enemy would be ashamed to do, you have the advantage." (*Shang-tzu* [ch. 20] Kao 157, tr. D 305)

"How does one know that a people has been made usable? If the people see war as a hungry wolf sees meat, the people have been made usable. Generally war is something the people hate; one able to make the people delight in war will reign." (*Shang-tzu* [ch. 18] Kao 138, tr. D 286)

There is not much pretence that there can be a harmony of interests between people and state.

"In government if you introduce the policies people hate the people are weakened; if policies they enjoy, they are strengthened. The people being weak the state is strong, the people being strong the state is weak." (*Shang-tzu* [ch. 20] Kao 160, tr. D 307)

This is not however the tone of the great Han Fei, whose cold and lucid mind simply accepts without fuss the harsh conditions of life as he sees it. He regards the people as disorderly, lazy, and too ignorant of their own interests to see that they benefit by the harsh punishment of crime, but there is no reason to doubt that he wants the order which is to be bought at so great a price for the sake of all.

"When the sage brings order to the people, he measures by the most basic; he does not indulge their desires, he simply looks ahead for what will benefit the people. Therefore when he imposes punishments on them, it is not out of hatred of the people, it is basic to his concern for them." (*HF* [ch. 54] Ch'en 1134, tr. Liao 2/326).

There is in any case something equivocal in the place of the ruler in Han Fei's scheme. The ruler himself is reduced to one component in the machinery of state; the ministers have all the ideas and do all the work, the ruler simply checks shape against name and rewards or punishes accordingly. He has no functions which could not be performed by an elementary computer; indeed, a government could hardly attain the required elimination of the human factor without replacing the ruler by a computer. Since at time of writing we are still in the habit of thinking of ourselves as governed by human beings rather than by machines, might one even say that in Han Fei's system it is ministers who do the ruling? Does the system make full sense unless seen from the viewpoint of the

bureaucrat rather than the man at the top? One would not expect a king, however dazzled by the Taoist-sounding rhetoric, altogether to welcome being the umpire who never plays in the game, preserving his perfect neutrality by 'doing nothing', remaining 'still' and 'empty' of all inclinations which could bias him or knowledge which could intrude into the comparison of the project with the result. Indeed he could hardly be reduced to this state unless overawed by the specialist knowledge which the bureaucrat wields and encourages him not to burden himself with. The bureaucrat on the other hand has realised his vision of perfect order, in which his own promotion or demotion is secure from arbitrary or prejudiced decisions from above. The aim of confining the Emperor to the acceptance of advice, visible in a moralistic guise in the Confucian bureaucracy of later centuries, may already be suspected in Legalism.

Much as one may be repelled by the amorality of the Legalists, it can be refreshing to turn to them after reading too much of the ineffective moralising of Confucians and Mohists. The Legalists stand alone in appreciating that the realisation of beneficial policies depends on institutions rather than good intentions. In the clashes between Legalism and Confucianism one sees only too clearly that the Confucian conception of moral obligation as radiating outward in diminishing degrees from the family would in practice justify the collective selfishness of the most powerful families. The initial resistance to the publication of law codes, as hindering the noble from deciding cases as they think best, was soon abandoned. But we have seen from the example of Chia Yi[29] that the Confucian revulsion against inhumane punishments was in the first place against inflicting on the upper class the punishments proper to the lower. As for the Confucian preference for imposing order by moral influence, and training in ceremony rather than by punishment, only the leisured class would have time to master the rituals codified in the *Record of Ceremony*, where we read that "Ceremony does not reach down to the commoners, nor punishment up to the grandee" (the intervening knightly class would be subject to both).[30]

4. TWO POLITICAL HERESIES

1. Criticism of hereditary monarchy

The Mohist principle of 'elevation of worth' reflected the growing practice throughout the new bureaucratising states, and by the 3rd

century B.C. was taken for granted even by Confucians. No school, however, extended it to the throne itself. Since for all except Legalists good government depends on the wisdom of the ruler, or at any rate of his advisers, and it was accepted that with misgovernment dynasties lose the right to rule, one might expect that some would have the dangerous thought of eliminating this exception, at least from the ideal government of the ancient sage kings. The thoughts which cannot safely be put in writing (such as atheism in Europe before the 18th century) present a special problem in the history of thought; such evidence as we find is likely to be the tip of the iceberg. But it is surprising how often one does find this thought breaking surface in literature between the 4th and 2nd centuries B.C.

Two classes of exception to hereditary rulership were commonly accepted: the Shang and Chou dynasties had overthrown their predecessors by force, and at the beginning of history there had been a stage before hereditary succession began, when Yao passed the throne to Shun and Shun to Yü, founder of the first dynasty, the Hsia. For Confucians these irregularities were justified by the villainy of the dispossessed Emperors and by the sagehood of Shun and Yü, for the Legalist Han Fei they were simple usurpations.[1] But there is a significant difference between the two kinds of exception. The overthrow of the Shang by the Chou was a historical fact which no one could afford to ignore. The predynastic abdications on the other hand were legend accepted on the evidence of documents forged in an archaising style which were circulating widely by the 4th century B.C. The 'Statutes of Yao', which got into the *Documents* in the five Confucian Classics, tells how after a reign of 70 years Yao abdicated to Shun, and a fragment in the same archaising style in the suspect last chapter of the *Analects* has Shun passing the throne to Yü as well as Yao to Shun.[2] Outside these sources *Mo-tzu* (where the 'Compromising' and 'Reactionary' series quote heavily from these suspect documents) uses the enthronement of Shun, represented as a ploughman, potter, and fisherman, as one of its examples of 'Elevation of Worth'.[3] Mencius quotes the 'Statutes of Yao' on the succession of Shun, although he refuses to believe that Yao actually abdicated before his death.[4] The predynastic legend seriously embarrassed Mencius, who favoured the hereditary principle even for offices,[5] and there seems no point in it unless someone was using the safe and effective method of forgery to publicise his conviction that rulers should pass the throne to the best man, and before they are themselves senile. Whether the Mohists privately ex-

tended the 'elevation of worth' to the ideal ruler we cannot know, but that there were many people who did is plain from the evidence of Mencius himself:

"Wan Chang inquired: 'People have a saying, "By the time of Yü the Potency had decayed, he passed the throne not to the worthiest but to his own son." ' Do you agree?"[6]

Mencius does not agree, and answers at some length. For him, the test of whether a ruler has the mandate of Heaven is support by the people, and he interprets the story in these terms. Yao, Shun and Yü all chose the worthiest and recommended him to Heaven as successor; after they died the recommended man waited to see whether the people preferred him to the son. Yü recommended his minister Yi, but this time the people went over to the son Ch'i. Why this choice committed them to the son for ever after is not explained by Mencius; he is doing his best to explain the whole story away.

There are several stories of kings of this period professing to follow Yao and Shun by offering their thrones to a better man. King Hui of Liang (370–319 B.C.), whom Mencius visited, is later reported to have offered his throne to Hui Shih.[7] One episode, in which a king did give up his throne, is certainly historical, the abdication of Tzu-k'uai of Yen to Tzu-chih, about 316 B.C.* Mencius was questioned about it in Ch'i, which was preparing to use it as an excuse to attack Yen; he saw the abdication as a dangerous breach of the hereditary principle justifying attack, although only, as he later explained, by a ruler authorised by Heaven.[8] Such abdications, whether real or pretended, historical or fictitious, would have no meaning unless it was widely believed that the true sage does pass the throne not to his son but to the best man. As late as 78 B.C. a Confucian, Sui Hung, after observing omens pointing to the coming of a new dynasty, got himself executed by sending up a memorial inviting the Han Emperor to follow Yao's example by abdicating to the worthiest commoner.[9]

The 'Admonitions', the chapter in *Kuan-tzu* which shares the ideas which Mencius ascribes to Kao-tzu,[10] states flatly that the sage ruler follows the example of Yao who passed the throne to Shun after reigning seventy years.

"He is benevolent, so refuses to use the Empire to his own profit; he does the right, so refuses to use the Empire to make a name for himself. He

* *HF* (ch. 35) Ch'en 774–76, tr. Liao 2/128–131, quotes three varying accounts of the event, in each of which Tzu-k'uai is tricked into thinking he can win the reputation of Yao without losing control of the state.

is benevolent, so does not keep the throne from generation to generation;†
he does the right, so after seventy years gives up the government."[11]

What of Hsün-tzu, who is as insistent as a Mohist or Legalist on
appointment by fitness for the job at every level below the throne? The
main body of his book discusses the Yao and Shun stories only in
connexion with their supposed abdications during their lifetimes, which
he considers incompatible with sagehood and the dignity of the throne.[12]
This however leaves open the question of hereditary succession. Among
the poems written at the end of his life, in which one suspects that private
thoughts may be coming to the surface, in the chapter called by its verse
form *Ch'eng hsiang* (very late, since it mentions the death of his patron the
Lord of Ch'un-shen in 238 B.C.), there is one which traces the history of
Imperial abdications. It uses several found elsewhere only in Yangist and
Taoist legend. There they testify to the sage's indifference to the throne as
a worldly possession, but for Hsün-tzu to his respect for the principle of
elevation of worth. The history starts with Yao and Shun ("Yao and Shun
elevating worth resigned their own thrones"; "Shun resigned to the
worthiest and became a commoner"), ignores Yü's foundation of the Hsia
dynasty and proceeds from the minister Hsieh to his descendant T'ang
who founded the Shang, ending with his attempted abdications first to
Pien Sui and then to Wu Kuang. There are by the way so many proper
names that for once the reader of a Chinese poem in translation may catch
a glimpse of the rhymes.

> "Hsieh the dark king
> Begat Chao-ming
> Who was lord at Ti-shih
> And shifted to Shang.
> After fourteen generations
> There was T'ien-yi
> Who was Ch'eng T'ang.
> T'ien-yi T'ang
> Appraised and raised up the best man,
> Himself resigned to Pien Sui
> And raised up Wu Kuang."[13]

A text which explicity ascribes the misgovernment of the present to

† The clause is more usually understood as "so does not usurp a throne" (cf. RG 379), which weakens
the point of mentioning Yao's abdication after reigning 70 years. I take *tai* 代 as the T'ang substitute for
the tabooed *shih* 世 , with Chang P'ei-lun (Kuo, Wen and Hsü 432).

the shift to hereditary succession is the book of the 'Master of the Pheasant Cap' (*Ho-kuan-tzu*), which we mentioned with *Lao-tzu*[14] among the mysterious works disguised under the names of otherwise unknown teachers of famous men. A couple of chapters avoid the taboo on the personal name of the First Emperor (221–210 B.C.), and the rest cannot be far from the same period.** It assumes that its view of succession is general among those who prefer morality to self-interest.

"Yao passed on the Empire to Shun; consequently, lovers of the right judge Yao wise, lovers of profit judge him foolish. T'ang and Wu [the founders of the Shang and Chou] banished or murdered their predecessors to profit their own sons; lovers of the right judge them to be without the Way, lovers of profit judge that they acted worthily. In those dynasties they did not pass on to the worthiest, that is why there was a banished lord; their lords loved faction and flattery, that is why there was a murdered ruler. Wherever banishment and murder have been inflicted there will be a ruined state. I have never seen any who enjoyed the throne in comfort and occupied it in security."[15]

Elsewhere the book describes the ideal government of the primordial Nine August Ones (*Chiu huang* 九皇).

"The supremely worthy became Emperor, the next in worth became his chancellors, the lofty became lords of fiefs. That they reigned changing surnames instead of becoming ruler by ancestral lineage was because they wished to share the security of the good which is in unity Coming down to the times of ancestral lineages, those who though themselves unworthy sit facing south and call themselves by the royal 'We' and still escape final ruin are the ones who are able to receive instruction from knights who have the Way."[16]

That writers were cautious in questioning hereditary succession is confirmed by the story of Po-ch'eng Tzu-kao, said to have received a fief from Yao which he kept under Shun but resigned on the accession of Yü to plough the fields with his own hands. In the more familiar accounts[17] his objection to Yü is that he relies on rewards and punishments. These seem

** *Cheng* 正 is avoided for its Ch'in substitute *tuan* 端 in ch. 1, 2. *Ho-kuan-tzu*, formerly dismissed as a late forgery, has attracted new attention because of parallels with the recently discovered Ma-wang-tui Yellow-Emperor manuscripts from the beginning of Han (Wu Kuang 151–165). The administrative system of ch. 9 uses the titles current in the pre-Han state of Ch'u; the argument at the beginning of ch. 8 that harsh punishments disturb the conquest cycle of the Five Processes looks like a criticism of Ch'in (which claimed to rule by the ascendancy of Water, p. 371 below). The language is pre-Han or early Han; thus the negative *fu* 弗 is used over sixty times with verbs without object or with object *chih* 之 .

however to be expurgated versions of an account preserved only in a Former Han miscellany.[18] There he explains to Yü:

"Formerly, when Yao ruled the Empire, he passed the whole Empire to another man, which is the utmost in desirelessness; he gave his throne to the one he chose as worthiest, which is the utmost in impartiality. He displayed to the Empire conduct of the utmost desirelessness and utmost impartiality, therefore the people were induced without reward and awed without punishment. It was still so under Shun. Now you punish and reward yet the people desire and are much inclined to partiality. This is because what you are meditating is a partiality [to pass the throne to your son] and the people know it. The springing up of greed and contention will start from now; from now the Potency will decline, from now punishments by mutilation will multiply."

Here the selfishness which causes the disorder of later times results from the Emperor's selfish intention to keep the throne for his own family. We find the same idea, with precisely the same vocabulary (*t'an cheng* 貪爭 'greed and contention', *chih kung* 至公 'utmost impartiality', *ssu* 私 'partiality', *yü* 欲 'desire'), showing itself guardedly here and there in the *Lü Spring and Autumn*. In one of its stories King Hui of Liang hypocritically offers his throne to his minister the sophist Hui Shih:

"In ancient times the possessor of a state was always the worthiest man. Now I am really not your equal, I wish you to allow me to pass the state to you. . . . If I pass it to the worthiest, the spirit of *greed and contention* will cease."[19]

The chapter 'Being Rid of *Partiality*' has the following as its first illustration:

"Yao had ten sons, but instead of giving the throne to his son he transmitted it to Shun. Shun had nine sons, but instead of giving the throne to his son he transmitted it to Yü. It was the *utmost impartiality*."[20]

In the chapter 'Way of the Circle' the ruler (like Heaven, which is round) circles freely around all affairs of state while his ministers (like Earth, which is square) stand square each with his own fixed functions. However worthy the ruler he requires ministers to fill the complementary role.

"Yao and Shun were worthy rulers who both took the worthiest for successor instead of giving the throne to their own descendants; but even they in establishing officials were sure to make them stand square. The rulers of the present all desire not to lose the throne for future generations, and give it to their own descendants, but in establishing officials are unable to make them stand square, because they throw them into disorder

by *desire which is partial.* Why is that? Their desires reach far ahead but all they know is the near."[21]

Remarkably, the dangerous thought which Mencius refused to read into the 'Statutes of Yao' appears ascribed to Confucius himself in another work which found its way into the Five Classics, the 'Revolutions of Ceremony' in the *Record of Ceremony.* This Former Han document contains the only early Confucian Utopia, and was later to become very important for K'ang Yu-wei (1858–1927) and other reformers looking for evidence of democratic thought in their own tradition. It distinguishes two ages, those of the Greater Community (*Ta t'ung* 大同) and of the Lesser Prosperity (*Hsiao k'ang* 小康). The latter is the time of the Three Dynasties and begins with Yü, so the former is the predynastic period. The body of the document explains the supreme importance of ceremony throughout the Lesser Prosperity and its changes through successive dynasties. What makes the 'Revolutions of Ceremony' unique in early Confucian literature is its claim that in the preceding Golden Age there was universal harmony without ceremony, formulated Right *(yi)* or preference for one's own family. Although there is no direct reference to a ruler it can hardly be doubted that even for so unusual a Confucian this would be the age of Yao and Shun, as assumed by the commentator Cheng Hsüan (A.D. 127–200).

"When the Great Way prevailed there was impartiality throughout the world. They chose the worthy and capable, studied to be trustworthy and cultivated harmony (Cheng Hsüan: "They abdicated the throne to a sage, did not keep it for the family"). Therefore they did not treat only their own parents as parents, their own sons as sons. They enabled the old to live out their term, the ablebodied to have employment, the young to be reared; they pitied the widow, orphan, childless and sick, and provided nurture for all. Men had their portions, women had their home. They hated wealth going to waste, but not necessarily to hoard it for themselves; they hated effort not being exerted, but not necessarily for the sake of themselves. Therefore, plots having no outlet did not start up, and theft and banditry did not arise, so outer doors were left unshut. It is this one calls the Greater Community.

"Now, the Great Way being already obscured, the world is identified with one's family (Cheng Hsüan: "They transmit the throne to the son."). Each treats only his own parents as parents, only his own son as son. Wealth and effort are for the sake of oneself, it is hereditary succession which great men recognise as ceremonially required. It is by walls and moats that we secure ourselves, by ceremony and the right that we are regulated, in order to keep ruler and subject correct, father and son

sincere, elder and younger brother in harmony, husband and wife in accord, and in order to institute restrictions and measures, to lay out fields and villages, to give preference to courage and knowledge; we treat achievements as our own. So as a result of this plots spring up, because of this war arises. Yü, T'ang, Wen, Wu, King Ch'eng and the Duke of Chou were the most eminent during this time. There is not one of these six gentlemen who was not assiduous in ceremony, in order to manifest the right and verify the trustworthy, in order to call attention to the erring and give a shaping to benevolence and a training to deference, and show the people existing norms. Wherever there is failure to follow this, those in power are expelled, and the multitude recognises them as evildoers. It is this one calls the Lesser Prosperity."[22]

2. The question of Chinese anarchism

One of the constant assumptions of early Chinese political thought is that government is by its nature authoritarian, and that the only alternative to absolutism is the reduction or abolition of government. Theoretically, the alternative is an ideal set in antiquity; in more practical terms, it is a minimalisation of interference from above in the affairs of individual, family, clan, and village conducting their own affairs in accordance with custom rather than externally imposed law. Only in two of the schools, the Mohists and the Legalists, does everyone seem wholly satisfied with the new centralised state. The other school which recognises the duty to take office, the Confucian, continues to hanker after Chou feudalism even as it learns to adapt to changing circumstances. Thinkers who retreat into private life (the Shen-nung idealists, the Yangist author of 'Robber Chih', the Taoists) all have visions of a world in which there are no public careers to flee from. To put it in Western terms, one is tempted to say that the anti-authoritarian in China is the anti-political, inclining not to democracy but to anarchism. Western anarchists have claimed Lao-tzu as one of themselves ever since his book became known in the West in the 19th century; more recently it has been suggested that even Confucius might be seen as an anarchist.[23]

No one conceives any limits to power except moral limits—Legalists, not even those. It is assumed (again excepting the Legalists) that good government depends on the moral goodness of those who govern. The ideals of Mohists, just as much as Legalists, are nothing less than totalitarian; how could a wise and good ruler do his best for his people unless he appoints and controls right down to village level, ensures the

moral reform of local custom, sees danger in all signs of people 'allying with each other below' (*hsia pi* 下 比)? It may seem surprising that in a tradition centred on the art of government, with a rich variety of political philosophies, no one as much as glimpses the possibility of democratic institutions. But we need go no farther for an answer than Max Weber's generalisation that the Asian world is one of huge states and tiny villages, in which cities are primarily administrative and military centres where, however much trade flourishes, the main road to wealth is through office, so that the self-governing institutions of the Mediterranean trading cities could never develop.[24] Although some of the smaller Chinese states have perhaps something of the look of Greek city states early in their evolution,[25] the great states of the classical age are already on the scale of European nations; and even in Europe the possibility of extending democracy from the city to the nation-state is no older than the 18th century. On the other hand we have the question of how far government, as distinct from the power to chop off heads, extends in Oriental despotism. How far is the bureaucracy which imposes law controlling rather than being controlled by families and clans managing their own affairs by their own customs? To what extent does it truly govern (as distinct from tax and conscript for war or labour on public works) outside the walls of the cities? A striking dictum of Weber's is that in Imperial China "a 'city' was the seat of the mandarin and was not self-governing; a 'village' was a self-governing settlement without a mandarin."[26] The considerable Chinese talent for self-government has up to our own times been exercised through kinship organisations, village communities or trade corporations well adapted, not to replace, but to evade or corrupt power at the centre. From this standpoint the ideal of self-government in Chinese political philosophy seems predestined to take a direction which in our terms would be anarchistic rather than democratic.

There is some danger of overlooking the elements both of reality in the Taoist rural Utopias and of fantasy in the absolutist programmes of Mohists and Legalists. In the writings of the two latter we catch only occasional glimpses of centralised power running up against its limits. (Might one see *Lao-tzu*, on one of its multiple readings each as legitimate as another, as reflecting a deeper understanding of how little despotic command can actually do against the uncontrollable forces of society?). The Mohist 'Conforming Upwards' bravely projects appointment by centralised authority right down to village level, but the version which makes most concessions to practical difficulties (the one we call 'Reactionary') replaces 'village heads' by 'lords of families'.[27] Judging by later

Chinese experience one would suppose that to appoint a village head would be merely to confirm him officially in authority. We read a great deal in *Kuan-tzu* about the reforming of custom, but one essay in this miscellany ('Correcting the Age')[28] speaks instead of the sage ruler as simply following custom as it changes with the times. Among those remarkable social scientists the Legalists there is one who seems to have a uniquely objective and comprehensive view of society as a whole, with bureaucracy and law as no more than the frame within which the people govern themselves by custom. This is Shen Tao, whom we have already met as a theoretician of centralised power.[29] Hsün-tzu pairs him with a certain T'ien P'ien in his 'Against the Twelve Philosophers', and briefly summarises their doctrine:

"Elevating standards (= laws) yet without standards, decrying study and fond of innovation, in dealings above approving obedience to those above, in dealings below approving accord with custom. . . . "[30]

The fragments of his book, although mostly about law and the power-base, have one with a similar reference to custom.

"For convention (= ceremony) follow the custom, in administration follow those above, on a mission follow your lord."[31]

The full significance of this emerges in the passage which, in the T'ang anthologist's selection from his book which is our main source for him,* stands at the head of his first essay.

"Heaven which has the light does not care about man being in the dark, earth which has the resources does not care about man being poor, the sage who has the Potency does not care about man being unstable.

"Though Heaven does not care about man being in the dark, since by opening doors and windows man is sure of winning himself light there is no more for Heaven to do.

"Though earth does not care about man being poor, since by chopping down the trees and cutting away the grass man is sure of winning himself wealth there is no more for earth to do.

"Though the sage does not care about man being unstable, since the people by taking those above as their water-level and allying with each other below are sure of winning themselves stability there is no more for the sage to do."[32]

Government, then, is not the source of order; it simply establishes the condition for the people to order themselves by co-operation. For Shen Tao as a Legalist, this condition would be law deterring by punishment actions

* *Ch'ün shu chih yao* ch. 37. Cf. the textual study by Thompson, *Shen Tzu*.

disruptive of harmony. The use of the term *hsia pi* 'allying with each other below' is especially remarkable; Confucians, Mohists and Legalists alike use it pejoratively, of factionalism below, which threatens the ruler's authority.

The Confucians cannot be counted with the Mohists and Legalists among those dedicated to the authoritarian state. However much they may insist, as in the 'Great Learning',[33] that it is through the example of piety to the father that one learns loyalty to the ruler, the Confucians remain committed to the family rather than the state, and to ceremony rather than law. They were becoming reconciled to the centralised state and were soon to dominate it, but their family-centred moralism conflicted with that ideal of a true Weber-style bureaucracy briefly triumphant under the Ch'in, and ruined its prospects for the rest of Imperial history. The solidarity with one's own family which according to the 'Great Learning' serves to nourish solidarity with state and Empire also very much outweighs it, so that Confucians may see as not merely excusable but obligatory what for Legalists (and for us) is nepotism, corruption, the aggrandisement of one's own family at the expense of the weaker. Confucius himself had conceived the ideal of a society in which all relations between persons function not by force but by ceremony, so that punishments will lapse. It is possible to think of this as one of the varieties of Chinese 'anarchism', with some stretching of the word; one would have to conceive a hierarchical anarchism, in which the ceremonial acts which are perfectly voluntary for all participants include the issuing and obeying of a properly ritualised command of ruler to minister.

The name more usually associated with a Chinese anarchism is Lao-tzu, whose book assumes and indeed addresses itself to the ruler, but advises him to 'do nothing', leave things spontaneously to order themselves.† To what extent does *tzu-jan* 'being so of itself', which we translate 'spontaneity', overlap Western ideas of liberty? (We are I hope past that naive stage when one asks of another culture 'Do they have a word for liberty?'). We have suggested that for Chinese moral philosophising the good is what the wisest spontaneously prefer. For Confucians as for Taoists social order is the harmonising of men's spontaneous inclinations, most commodiously as they develop and are awakened from other viewpoints through the closest personal relations, those of kinship; a sense that they are thwarted by too-consistently defined principles is near

† The question of Chinese anarchism is discussed from different angles by Frederick Bender, Roger T. Ames, David L. Hall, and John P. Clark in JCP 10/1 (March '83).

the root of that revulsion against Mohist 'concern for everyone', Kung-sun Lung's logic, Han Fei's law, which turned China decisively against rationalism so soon after discovering its prospects. For Confucians however the attitudes of authority and deference emerge as spontaneously as any other, the patriarchal family itself being a supremely authoritarian institution. (Mencius offers as examples of "what men are capable of without learning" and "know without thinking" not only that "everyone in infancy knows how to love his parents" but that "when he grows he knows how to respect his elder brother").[34] Moreover it is by a hard training in the conventions that a Confucian learns what only after becoming wise he will spontaneously prefer. It is here that Confucians and Taoists (and their respective counterparts in the West) start off on divergent paths. For Taoists it is by unlearning the conventions and ambitions which society tries to convince you that you share that you discover your true spontaneous tendency. The ideal Taoist society, then, is a community which encourages the spontaneous trend of inclination instead of distorting it by conceptualising it for you as 'knowledge', one in which the sage nourishes you with his Potency instead of forcing you for your own good.

In earlier chapters we have traced the development from the Utopia of Shen-nung through *Lao-tzu* to the Primitivist and Yangist chapters of *Chuang-tzu*.[35] Discussing *Lao-tzu* on 'Doing Nothing' we noticed that its version of the ideal society requires on the one hand a very simple mode of life, on the other a sage who keeps the masses ignorant of the multiple objects of desire which complicate civilization. We noticed also[36] that this is in keeping with a tradition of moral philosophy which starts from the value, not of spontaneity as such, but of spontaneity in sufficient awareness, and so must recommend either expanding awareness or contracting experience within the limits of awareness. As a basis for a political ideal this is very different from the faith in the absolute value of individual liberty which underlies Western anarchism. To risk an oxymoron as outrageous as 'hierarchic anarchism', this amounts to a paternalistic anarchism. *Lao-tzu* is unusual in presenting it as an art of government from the viewpoint of the ruler, but the assumption is the same in versions seen from the subject's viewpoint, already visible in the Shen-nung ideal, with the ruler as teacher of agriculture to a simple-hearted people who do not hanker after 'goods difficult to obtain', and developed in detail in the Primitivist essays.

It will perhaps be objected that no kind of an anarchist regime can have an Emperor, not to mention Shen-nung's thousands of fiefs. On

closer inspection however one sees that since the sage exerts no force and maintains the equilibrium of the order by the influence of his wisdom alone it is of no importance what title he carries or whether he carries one at all. Whether there is a named Emperor, unnamed sages or a universal innocence in the childhood of man is an unimportant variable in otherwise very similar accounts of the Golden Age. According to *Huai-nan-tzu* (c. 140 B.C.) decline began with the very first Emperor at the beginning of verbal knowledge; in the preceding perfection the nameless sages "exhaled and inhaled the *ch'i* of Yin and Yang, and everything living reverently looked up to their Potency and harmoniously accorded with it."[37] Chuang-tzu has a story implying that the perfect order under Yao issued not from himself but from his subject Hsü Yu, who, when Yao offered him the throne, refused it on the grounds that it does not matter in the least who is on the throne.[38] In a *Chuang-tzu* 'Outer Chapters' story there is a ruler but the people treat him as though he were a natural object under which they shelter. Here one may notice that the 'elevation of worth and employment of ability' is seen negatively as a temptation to all to use knowledge to compete for power.

"In an age of utmost Potency, they do not elevate worth or employ ability. The one above is like the treetop, the people are like wild deer. They are upright but do not know how to think of it as the right, are concerned for each other but do not know how to think of it as benevolence, are honest but do not know how to think of it as loyalty, fit the fact but do not know how to think of it as trustworthiness. They make each other move as the insects stir in spring, they do not think of it as a gift from above. Therefore their steps leave no footprints, their deeds leave no records behind them."[39]

In *Lao-tzu* the people know that a ruler exists but think of everything as done by themselves.

> "The very highest, those underneath know to exist.
> The next, they are fond of and praise.
> The next, they are in awe of.
> The next, they slight.
> Only if he is not trustworthy enough is there distrust.
> Meticulous, his care for words!
> When his task is accomplished and work complete the Hundred Clans all say
> 'It was so with us of ourselves.' "[40]

'Mending Nature', one of the 'Outer Chapters', does assume a universal balance of awareness and spontaneity without sages. This is

appropriate because Utopia is placed not at an indefinite period in the past but at the absolute origin; it is then inevitable that the unconscious equilibrium without sages to sustain it is sooner or later lost, without raising any problem of a Fall (rather as in modern theories of a perfect balance of man and his environment in the time of hunters and food-gatherers, upset by the discovery of agriculture). Morality is conceived to spring directly from man's nature, but only as long as he preserves a perfect combination of knowing with calm.

"The men of old who cultivated the Way used calm to nurture knowing. They knew how to live but did not use knowing to *do*; one may say that they used knowing to nurture calm. When knowing and calm nurture each other, harmony and pattern issue from our nature. Potency is the harmony, the Way is the pattern. Potency harmonising everything is benevolence, the Way patterning everything is the right. . . .

"The men of old lived in the midst of the merged and featureless, and found tranquility and mildness with those of their own time. At this era the Yin and Yang were harmonious and peaceful, gods and ghosts did no harm, the four seasons were perfectly proportioned, the myriad creatures were unharmed, all that lived escaped untimely death. Even if men did have knowledge, they had nothing to use it on. It is this that is called being in utmost oneness. At this era things were *done* by nobody, and were constantly so of themselves.

"A time came when Potency declined, to the point when Sui-jen and Fu-hsi took charge of the world. In consequence there was compliance but not oneness. Potency declined a stage further, to the point when Shen-nung and the Yellow Emperor took charge of the world. In consequence there was stability but not compliance. . . ."[41]

Since the rise of rulers, the sage has had no choice but to withdraw from the world.

"If he is lucky in his times and there is full scope for him in the world, he returns to the oneness and leaves no trace behind. If he is unlucky in his times and there is no scope for him in the world, he deepens his roots, secures the ultimate in him and waits. This is the Way to save your life."[42]

Ho-kuan-tzu also has a primitive Utopia without lord and vassal.

"When Potency was at its culmination there were no paths over the mountains, no bridges over the marshes, no coming and going, no communication by boat or carriage. Why? The people were like children. Those who had cleverness did not use it to deceive and enslave each other, those who had strength did not use it to make each other vassal and lord. That is why you could peep down into a crow's or magpie's nest, and from a herd of deer tie whichever you pleased on a lead."[43]

The Chuang-tzu 'Primitivist'

The great document of Taoist anarchism, if we are to allow the name to this generally paternalistic doctrine, is a block of four essays in *Chuang-tzu* which we call 'Primitivist' (chs. 8–11, excluding the pieces which follow the essay in the last chapter). These are the chapters which, except for the 'Inner Chapters' by Chuang-tzu himself, stand out from the rest of the book as most idiosyncratic in style and thought.* It so happens that they can be dated with unusual precision, placing them in a historical setting which helps us to relate the Utopian myth to real demands to contract the scope of government. The Primitivist wrote after the destruction of the state of Ch'i in 221 B.C. which completed the Ch'in reunification,† and the time of disunion in which he writes can only be the brief interregnum of 209–202 B.C. between the fall of the Ch'in dynasty and the final victory of the Han. The philosophers, silenced under the uniquely repressive regime of Ch'in, are already re-emerging to compete for influence. The Primitivist's great fear is that the Legalist tyranny of Ch'in has gone only to be replaced by the moralistic tyranny of Confucians or Mohists.

"In the present age the condemned to death lie back to back, the shackled in cangues and stocks are elbow to elbow, there is always a mutilated man somewhere in sight, yet it is just now that the Confucians and Mohists start putting on airs and come flipping back their sleeves among the fettered and manacled." (Cz 11/25f, tr. G 213)

Morality, says the Primitivist, is useless in ordering society, because it serves whoever wins power. Its rules are like the boxes and bolts with which we try to secure possessions against thieves; a strong enough thief carries off the whole box and only worries that the bolts will not hold. It is the same with the state; witness Ch'i which was so perfectly run.

"However in one morning T'ien Ch'eng killed the lord of Ch'i and stole his state. Nor was it only the state he stole; he stole it complete with all its wise and sagely laws. So T'ien Ch'eng has gone on having the reputation of a thief and bandit, yet the man himself lived as secure as Yao or Shun; small states did not dare to condemn, great states did not dare to punish, and for twelve generations his house possessed the state of Ch'i. Then isn't it on the contrary that he stole the state of Ch'i complete with all

* For the distinctiveness of the Primitivist's style, cf. G *Studies* 301–03. In addition to Cz 8–11/28 the fragment 12/95-102 is identifiable as Primitivist; it is likely to belong at 8/26, where I have placed it in my translation (Cz tr. G 202).

† The "twelve generations" of the house of T'ien mentioned in the passage quoted below on this page ended with the destruction of the state. Cf. G *Studies* 305.

its wise and sagely laws and used them to keep safe his robbing, thieving self?" (Cz 10/6–8, tr. G 207)

In any case morality is necessary for the organisation of crime.

"So when one of Robber Chih's band asked him 'Do robbers too have the Way?', Chih answered

"'Where can you go unless you have the Way? A shrewd guess at where the things are hidden in the house is the sage's intuitiveness. Being first man in is courage. Being last man out is righteousness. Knowing whether or not you can bring it off is wisdom. Giving everyone fair shares is benevolence. Without the five at his disposal, no one in the world could ever make a great robber.'

"Judging by this, without the Way of the Sage the good man would not stand, without the Way of the Sage Robber Chih would not walk. If the good men in the world are fewer than the bad, the sages have benefited the world less than they have harmed it. With the birth of the sages the great robbers arise. Smash the sages, turn the thieves and bandits loose, and for the first time the world will be in order." (Cz 10/10–15, tr. G 207f)

Morality only puts you in the service of the robber.

"The man who steals a buckle is put to death, the man who steals a state becomes a prince, and at the gates of a prince you'll see the benevolent and the righteous. Then isn't this stealing the benevolence and righteousness, the sagehood and wisdom?" (Cz 10/19f, tr. G 208)

Man is by nature like the horse when he runs wild, not as the great trainer Po Lo taught us to singe, shave, clip, and brand him, tie him with martingale and crupper and cramp him in stables. The error is in supposing that you keep man in order as Po Lo trains a horse, a potter moulds clay, or a carpenter trims wood to fit compasses and L-square.

"In my opinion being good at governing the world is not like this. The people have a nature which is constant:

By their weaving clothed, by their ploughing fed—
This call 'sharing the Potency'.
In oneness and without faction—
The name for it is 'Heaven-loosed'. . . .

In the age when Potency was at its utmost, men lived in sameness with the birds and animals, side by side as fellow clansmen with the myriad creatures; how would they know the gentleman from the small man?

In sameness, knowing nothing!
Not parted from their Potency.
In sameness, desiring nothing!—
This call the 'simple and unhewn'.

In the simple and unhewn the nature of the people is found.

"Then came the sages, trudging along after Benevolence, straining on tiptoe after Right, and for the first time the world was in doubt. . . ." (Cz 9/6–11, tr. G 204f)

To impose order by force only results in disorder; "ultimate Potency ceases to be shared, and our nature and destiny are frayed and smudged."[44] So there has been disorder ever since the Yellow Emperor "used Benevolence and Right to meddle with the hearts of men,"[45] ending that line of Emperors down to Shen-nung of whom the Primitivist's favourite is the otherwise almost unknown Ho-hsü.[46]

"As for horses, when they live out on the plains they eat the grass and drink the water, when pleased they cross necks and stroke each other, when angry swing round and kick at each other. That is as far as a horse's knowledge goes. If you put yokes on their necks and hold them level with a crossbar, the horses will know how to smash the crossbar, wriggle out of the yokes, butt the carriage hood, spit out the bit and gnaw through the reins. So if even a horse's wits can do all the mischief of the robber, it's the fault of Po Lo.

"In the time of the House of Ho-hsü, the people when at home were unaware of what they were doing, when travelling did not know where they were going, basked in the sun chewing a morsel or strolled drumming on their bellies. This was as far as the capabilities of the people went. Then came the sages, bowing and crouching to Ceremony and Music, groping in the air for Benevolence and Right, in order to soothe the hearts of the world, and for the first time the people were on tiptoes in their eagerness for knowledge. Their competition became centred on profit, it could not have been otherwise. This too is the error of the sages." (Cz 9/14–19, tr. G 205f)

The Primitivist's furious attacks on sagehood, wisdom and knowledge may seem to make him an exception to our generalisation that even Taoists value not the spontaneous as such, but the reaction with a clear vision of the object. But as with Taoists generally the attack is on kinds of knowledge conceived as interfering with awareness. The Primitivist identifies man's Potency with the powers of the senses and heart in their primitive purity, when the eye is not dazzled by "greens and yellows and multicoloured vestments", the ear by "instruments of bronze and stone and silken strings and bamboo", the heart by Yangist and Mohist argumentation about "the hard and white, the same and the different".[47] The consequences of civilization have been that man's nature is stimulated by luxury and sophistication to grow ambitions and desires as an excess like the superfluous flesh of webbed toes, and his Potency is diverted into

offshoots like a sixth finger on the hand. Once they are grown he cannot bear to sacrifice them; "even someone with webbed toes will weep when they are ripped apart, even someone with a sixth finger will scream when it is bitten off."[48] Those thinkers of the rival schools who are coming out of their hiding under the Ch'in, newly aroused by worldly ambitions, are making themselves the slaves, inwardly of the temptations of eye and ear, outwardly of duties and conventions.

"If the Yangists and Mohists are just now starting to put on airs and think they are getting somewhere, it is not what I would call getting somewhere. If the man who gets somewhere is caught where he can't get out, is that what you think is getting somewhere? Then the pigeons and doves in a cage must be supposed to have got somewhere too. And to have ambitions and avoidances, sounds and sights, blocking up the inside of you, and leather cap or snipe-feather hat, memorandum tablet in belt and trailing sash, constricting the outside of you, to be inwardly squeezed inside the bars of your pen, outwardly lashed by coil on coil of rope, and complacently in the middle of the ropes suppose that you have got somewhere, amounts to claiming that the condemned man with his chained arms and manacled fingers, or a tiger or a leopard in its cage, has got somewhere too." (Cz 12/98–102 tr. G 202)

The problem is to restore man to the true course which is the Way, so that he grows again in the right direction, which is different for different people.

"The man on that absolutely true course does not lose the essentials of our nature and destiny. So his joins are not webbings, his forkings are not offshoots; the long in him does not constitute a surplus, the short in him does not constitute an insufficiency. Just so, though the duck's legs are short, if you added more on he would worry; though the crane's legs are long, if you lopped some off he would pine. Then what by nature is long is not to be lopped off, what by nature is short is not to be added to; there is nothing to get rid of or to worry over. May I suggest that Benevolence and Right do not belong to the essentials of man? Why is it that those benevolent people worry so much?" (Cz 8/8–10, tr. G 200f)

The moral and the immoral spring equally from the loss of this path.

"Po Yi died for reputation at the foot of Mount Shou-yang, Robber Chih for profit at the top of East Ridge. What the two men died for was not the same, but in damaging life and injuring nature there was nothing to choose between them. Why must it be Po Yi's alternative we judge right and Robber Chih's we judge wrong? . . .

"To see something, but not with your own eyes, to gain something,

but not by your own grasp, this is gaining what is gain for other people, not gaining by your own grasp what is gain for yourself; it is being suited by what suits other people, not suiting yourself by what is suitable to yourself. Those suited by what suits other people, not suiting themselves with what is suitable to themselves, even Robber Chih on the one hand and Po Yi on the other, are the same in being vitiated by excess and aberration. I remain humble before the Way and the Potency, and that is why I would not venture either to act on the elevated tenets of Benevolence and Right or to perform the debased deeds of excess and aberration." (Cz 8/23–33, tr. G 202, 203)

What then should one do if reluctantly driven to accept the throne of the Empire?

"Therefore if the gentleman is left with no choice but to preside over the world, his best policy is Doing Nothing. Only by Doing Nothing will he find security in the essentials of his nature and destiny." (Cz 11/13f, tr. G 212)

There is however a positive side to this Doing Nothing: to remove people from the artificial stimulations which make them grow in the wrong direction. It is here that we discover the positive function of those ancient Emperors down to Shen-nung, and the single paternalist element in the Primitivist's otherwise flawless anarchism.

"I have heard of keeping the world in place and within bounds, I haven't heard of *ordering* the world. 'Keeping it in place' is out of fear that everyone may indulge man's nature to excess: 'keeping it within bounds' is out of fear that everyone may displace man's Potency. If everyone refused to indulge his nature to excess and displace his Potency, would there be any such thing as ordering the world?" (Cz 11/1f, tr. G 211)

The ancient Emperors, it may be presumed, had no task but to keep the people ignorant of the arts and luxuries which were eventually to corrupt them, so that they still "found their own food sweet enough, their own dress beautiful enough, were happy in their customs, content in their abode", without even bothering to visit the next village.* By the time of the Ch'in collapse a restoration of primitive simplicity would hardly be offered as practical politics. But it would be a time when this kind of Utopia with a social analysis behind it would be more than a nostalgic dream. The Primitivist's lively polemic might well be a force for personal liberation and the minimalisation of the scope of government, reminding rulers that suppression leads to revolt, encouraging knights to flee office

* Cz 10/31f tr. G 209, a close parallel of Lz 80, quoted p. 68f above.

for the simpler life of the countryside, discouraging officials trying to reform peasants "happy in their customs", impressing everyone with the dangers of meddling and advantages of leaving things alone.

One may notice that in the classical period even the most Utopian thinkers find it difficult to imagine a society without any ruler or sages at all; the only exceptions we have noticed are in 'Mending Nature' and *Ho-kuan-tzu*. The concept of pure community explicitly described as without ruler and subject belongs rather to the revival of philosophical Taoism in the 3rd century A.D.[49]

THE REUNIFICATION OF THE EMPIRE AND

OF HEAVEN AND MAN

The unique creative impetus in the small states of the Axial Period flagged in Greece and India with the coming of the Macedonian and Mauryan empires. In Isreal it survived conquest by Babylon, but in a small people stimulated by the threat of absorption to hold on to its identity; and in Iran the single figure of Zarathustra preceded the foundation of the Achaemenid empire. China too confirms that the principle 'Small is beautiful' holds for the political units in which the thought of the Old World cultures took its lasting shape. The three hundred years of radiant originality and variety end with the unification by the Ch'in in 221 B.C., followed after brief disruption by the more stable unification under the Han (206 B.C.–A.D. 220). The tendency is now towards syncretism, the formation of an Imperial administrative apparatus and ideology out of the usable elements in the pre-Han schools, with Confucianism at the forefront from about 100 B.C. The one significant novelty is the introduction of correlative cosmos-building, formerly the province of astronomers, diviners, musicmasters, physicians, and other technicians outside the philosophical schools. It is through a cosmology rooted in the Yin and Yang and the Five Processes, which by correlating moral with physical categories incorporates human morality into the cosmic order, that the threatening gulf between Heaven and man was closed in China before man had time to rethink himself as a solitary exception in a morally neutral universe. The one older attempt to close it, the Mencian doctrine of the goodness of human nature, for a long time to come tempted without fully convincing China. For 1,500 years, even in times of philosophical stagnation, thinkers continued to debate whether human nature is good, bad, neutral, mixed, or good in some and bad in others. It seems always to have been suspected that the Mencian would be a deeper solution than the cosmological, if only one could get round the evidence of common experience that human nature is *not* good. During the Sung dynasty (A.D. 960–1279) the Neo-Confucian movement, which in spite of its fascination with the *Yi* treated correlative system-building as marginal, again sought a true philosophical explanation of the

relation between Heaven and man. Ch'eng Yi (1033–1107) achieved a great paradigm-shift, by which *li* 'pattern', which has only a modest place in pre-Han thought, as in the 'Great Man' writer and in Han Fei's 'Interpretation of *Lao-tzu*', moved to the centre, and 'Heaven', 'the Way', 'nature' and 'destiny' were redefined in terms of it. With the dualist metaphysic of Chu Hsi (1130–1200), in which *li* patterns the *ch'i*, which already by the end of the classical period had become the universal fluid out of which all things condense and into which they dissolve, there was at last a context in which the Mencian doctrine of human nature could win acceptance as Confucian orthodoxy.*

We cannot leave the limits of this book to search the live currents in later Chinese thinking; we must finish by watching older streams running together into a stable synthesis, as China achieves that equilibrium by which it has outlasted all other empires, and turns its back on just those tendencies which opened prospects in *our* direction, the logical demon-strations of Sophists and Later Mohists, the neutralisation of nature by Hsün-tzu and Han Fei. Not that this final stage is of merely historical interest. The ascendancy of Yin-Yang, the Five Processes and the *Yi* no doubt reflects an intellectual deterioration; but it touches on important issues, the relation between correlative and analytic thinking and of proto-science and modern science.

The search for a unified world-view to back a politically unified world is common to East and West at the end of the Axial Period. It is symptomatic of the Chinese drive to stability and integration that it found its solution almost immediately, while the West's was delayed and only partial. The Macedonian and Roman empires opened the way for proselytising world religions, of which Christianity prevailed in the Roman Empire only at the very end of its unity, although Christian Byzantium and the Holy Roman Empire remained as foci for an ideal world unity. Chinese unification likewise opened the way to proselytising religions, Indian Buddhism and the native 'Teaching of the Way' (religious Taoism). But the conversions of any number of Chinese Constantines never led to the lasting establishment of a new state religion. The problem had been solved at the start by the rapid adoption of the cosmology of the court astronomers and diviners, whom rulers must always have taken more seriously than the philosophers to whom they granted an occasional audience. The cosmology may be classed as 'proto-science', with the negative implication that it lacks the strict testability of modern science,

* For the Neo-Confucian solution as a paradigm shift cf. G *Studies* 412–435.

but also the positive implication that it is science in contrast with religion, that it relates observable phenomena to each other rather than to transcendent beings. Such a system may include gods, but in correlating them with colours, sounds, numbers, it reduces them to the same level and denies them transcendence.† China with its man-centred perspective preferred proto-science for the organising of its world-view, while the West made a delayed choice of religion and confined proto-science to the explanation of natural phenomena. The Chinese choice is of an integrated solution of the problems both of placing oneself in the world and of manipulating it for one's purposes; the Western reserves the former for religion and leaves room for the latter to be solved in its own way, an advantage perhaps for the ultimate emergence of modern science.

1. THE COSMOLOGISTS
Proto-science and modern science

The nature of Chinese science has raised problems for Westerners ever since they began to suspect that such basic inventions as the compass and gunpowder, paper and printing, had reached them from the Far East. It has been our habit to think of science and technology as from the first intimately connected, and gradually progressing side by side as causal thinking comes to prevail over the correlative thinking of primitive magic and Mediaeval proto-science. Our bias inclines us therefore, either to think of China as on the verge of modern science but somehow (for reasons which it would be of great interest to discover) failing to reach it, or else to be suspicious of claims to Chinese priorities in technology. The great work of Joseph Needham has brought this issue to a head. Granted that many of his findings remain controversial, there can no longer be any doubt about the immense fertility of China in practical inventiveness; it may be an error of perspective even to see it as declining in recent centuries, since the unprecedented acceleration of technological progress in the West has made all other cultures seem stagnant by comparison. On the other hand it has become clear that traditional China was never in sight of an alternative to the correlative system-building which distinguishes Mediaeval from post-Galilean science. Occasional episodes in which

† Cf. Lévi-Strauss's analysis of the systems of totemism (metaphorical in orientation) and of sacrifice (metonymic) as "on different levels from the epistemological point of view in that the latter "makes a non-existent term, divinity, intervene" (Lévi-Strauss 294–302).

causal thinking replaces correlative, notably the Later Mohist, pass as quickly as similar episodes in the pre-modern West, the scientific mini-revolution of Grosseteste and Roger Bacon, and the still more 'modern' Archimedean science in Greece.

This seems paradoxical only if we cling to certain increasingly discredited assumptions about the relations between science, causal thinking, and concern for the useful. There has been a persisting assumption that even if the Chinese did make great inventions they failed to exploit them, leaving them to be picked up by foreigners who could appreciate their utility. Examples are the old legends that the Chinese having invented gunpowder and the compass used them only for firecrackers and geomancy, and that the use of the compass in navigation attested in Canton about A.D. 1100 was by Arab traders. It is by now recognised that the supposed reference to the Arabs depends on a simple mistranslation,[1] and that during the same period the Chinese were using gunpowder for the ancestors of a variety of weapons the benefits of which we enjoy today. Inventions of their own which the Chinese neglected seem generally to be ones not obviously useful—equal temperament in music, the Sung algebra, movable type (less convenient than block printing for a script with thousands of characters). It is in any case hard to judge objectively whether the failure of a discovery to catch on in another civilization has any significance; I am always more surprised that you fail at once to appreciate my idea than that I took so long to appreciate yours. We do not, for example, see a problem in what might well be taken as one of the most remarkable examples in history of cultural resistance to a foreign idea, the reluctance of the West to assimilate the place-value numeral systems long current from China to the Middle East and even in Central America. Not to mention that the Greeks failed to exploit the Babylonian system except in the astronomy which they borrowed from Babylon, the 'Arabic' numerals which came from India (ultimately, it appears, from China)[2] took almost the whole of the Middle Ages to conquer Europe. The Syrian bishop Sebokht in A.D. 662 already pointed out the Indian numerals as a proof that the Greeks did not know everything.[3] One might have thought that this basic prerequisite of the Scientific Revolution would also have had overwhelming practical advantages. Yet a thousand years later John Aubrey (1625–1697), who fully appreciated the newly discovered inverse square law of gravitation, could still report:

"All old accounts are in numeral letters. Even to my remembrance, when I was a youth, gentleman's bailiffs in the country used no other, e.g.,

i, ii, iii, iiii, v, vi, vii, viii, ix, x, xi, etc; and to this day in the accounts of the Exchequer."[4]

It must be taken for granted that in China concern for the practically useful stimulated causal thinking in technology as strongly as in the West, and contributed as much or more to material wellbeing until it was outstripped in the last few centuries. But to suppose that this would be bringing China nearer to modern science assumes an obsolete conception of science as developing by continuous progress in rationality. We now think in terms rather of a Scientific Revolution about A.D. 1600, the 'discovery of how to discover', the quite sudden integration of the idea of explaining all natural phenomena by mathematised laws of nature testable by controlled experiment. The breakthrough was made by Galileo; even his contemporary Kepler, whose three planetary laws are the first modern laws of nature, still belongs to the old regime of correlative system-building. The Scientific Revolution appears as a unique and complex event, depending on a variety of social and other conditions including a confluence of discoveries (Greek, Indian, Chinese, Arabic, scarcely ever Roman) centred on the combining of Indian numerals and algebra with Greek logic and geometry. Since this crucial combination, for primarily geographical reasons, came about among the Arabs, afterwards passing to Latin Christendom, it becomes pointless to ask why the Scientific Revolution did not happen in some other part of the world. The whole question of why the Chinese never arrived at modern science seems to me a pseudo-problem.* One generally asks why an event did happen, not why the same complex set of conditions did not come together at some other time and place. Thus the formation of an empire, covering a fifth of mankind and still, after several thousand years, surviving even the extreme pressures of the 20th century, is an event which like the Scientific Revolution has happened only once in history. We may ask what unique conjunction of factors has stabilised China, we do not ask 'Why have not Egypt and Babylon lasted to the present day?'.

Both in China and in Europe up to the Renaissance there is an incongruity to the modern eye between the flourishing of causal thinking in technology and its failure to dislodge correlative thinking from cosmology. Success in invention depends on a habit of thinking causally, while on the other hand the technology proper to correlative schematising is magic; one has only to look at any proto-science, Western or Eastern, to

* Cf. my 'China, Europe and the Origins of Modern Science' in Nakayama and Sivin 45–70, criticised in Qian 92–94 and passim.

see that if one can predict at all by such correlations one can predict the death of kings and whether the lonely girl will meet a dark handsome man next week. But there seems to be very little connexion between the extent to which a civilization uses causal thinking in practice and in the theory of its sciences. Mankind has always had technology other than magic, and must always have depended on discoveries that when you do x the consequence is generally y. It is a familiar observation that even pre-literate cultures do not resort to magic within fields, such as the crafts, which they understand causally. Both in China and in the ancient and Mediaeval West one meets a great deal of causal explanation and scepticism towards the excesses of correlative system-building. But piecemeal causal explanations do not add up to a cosmos, or even to a single organised science. Until the Scientific Revolution, the choice was between a correlative cosmos and no cosmos at all.

Until the West grasped the complicated idea of formulating mathe-matised laws of nature and testing them by controlled experiment, its own temporary swings in favour of causal explanation never broke the hold of correlative system-building. In the 15th and 16th centuries indeed the swing had been in the opposite direction. The Renaissance, tiring of Aristotelian common sense, revived Pythagorean numerology, and by revelling in its fantasies opened the way to the mathematisation of laws of nature. Inspired by Hermes Trismegistus and the Kabbalah, it conceived the prospect of conquering nature through magic before possessing the scientific means to realise it. (Prospero and Faustus are almost realistic pictures of the pioneers on the course which has led us to atom-splitting and space travel.) On the very threshold of modern science Kepler was trying to fit his planetary laws into the symmetries of a cosmos in which sun, stars, and planets correlate with the persons of the Trinity. Even after Galileo correlative schematising remained indispensable in any field not yet conquered by the new physics. Newton himself could without incongruity busy himself with alchemy and with correlating historical events with the predictions of the Apocalypse. In biology, brought very late within the scope of modern science, German *Naturphilosophie* main-tained the tradition of proto-scientific cosmos-building right into the 19th century; thus Lorenz Oken (1779–1851) could still fit the Black, White, Mongol and Amerindian races to the Four Elements, earth, fire, air and water.

It seems from John B. Henderson's recent *Development and Decline of Chinese Cosmology* that it was a positive disadvantage to Chinese science that it did eventually see through the artificialities of its own Yin-Yang theorising. Throughout most of Chinese history sceptics merely became

more cautious in theorising themselves in the same style. From the 17th century, however, thinkers such as Wang Fu-chih (1619–1692) do attack the basis of the traditional proto-sciences. The coincidence in time with the Scientific Revolution is remarkable; but although Western mathematics and astronomy introduced by the Jesuits certainly contributed to the growing scepticism, the main impetus seems to have come from the progress of indigenous studies such as observational astronomy, geography, and historical and textual criticism. The effect was a suspicion of all systems extended to Western science itself, a contentment with piecemeal explanations, acceptance that nature is inherently untidy and that it is useless to demand the complete resolution of anomalies. The suspicion that anomaly is inherent in nature, which could have debilitated modern science at the start, not quite escaped even by Galileo,[5] came to dominate Chinese science. One might draw the lesson that it was to the advantage of Western science that it did not see through the inadequacies of proto-science too early, before there was something not less but more systematic to put in its place.

We may note also that in both China and the West the persistence of correlative schematising in the sciences has nothing to do with the level of sophistication of thought in other fields. In the West the logic accepted as complete until the 19th century goes back to Aristotle, yet correlative thinking in the sciences prevailed right up to 1600. If we ask why Western thought was for two thousand years 'primitive' in one field and 'modern' in the other, there is an obvious answer; the solution of logical problems requires no resources outside one's own head, of scientific a vast quantity of discrete information which, until some alternative approach is found, can be organised and utilised only by classifying as similar or different and inferring from similarities. As for China, throughout the classical period correlative schematising belongs only to professions such as diviners and physicians; the philosophers from Confucius to Han Fei do not engage in it at all. Granted that analytic thinking develops less among Chinese than among Greek philosophers, we find different levels of thinking in philosophy and proto-science very much as in the West.

Correlative thinking and correlative cosmos-building

The Chinese cosmology which assumed its lasting shape by the beginning of the Han is a vast system starting from chains of pairs correlated with the Yin and Yang, branching out into fours and fives (Four Seasons, Four Directions, Five Colours, Five Sounds, Five Tastes, Five

Smells) correlated with the Five Processes, and down through successive divisions correlated with the Eight Trigrams and Sixty-four Hexagrams of the *Yi*. This scheme, in which to explain and infer is to locate within the pattern, provides the organising concepts of proto-sciences such as astronomy, medicine, music, divination and, in later centuries, alchemy and geomancy. The system-building of China, to which Marcel Granet's *La pensée chinoise* (1934) remains unsurpassed as an introduction, is not wholly strange to a Westerner who remembers the Four Elements, Four Humours and Pythagorean numerology in the past of his own tradition, but during the last few centuries this style of thinking has become so remote from most of us that access is now difficult except for people temperamentally in sympathy with the one Western study in which it still flourishes, occultism. It is not just that the explanations of Chinese as of Western Mediaeval and Renaissance proto-science may impress us as obscure or fallacious like the arguments of the philosophers; the trouble is that for post-Galilean science they are not explanations at all.

However, the strangeness to us of Yin-Yang thinking, unlike that of *Lao-tzu* or 'A white horse is not a horse', has little to do with being Chinese. What Granet saw as the difference between Chinese and Western thought may nowadays be seen as a transcultural difference between proto-science and modern science. Correlative cosmos-building is most conveniently approached as merely an exotic example of the correlative thinking used by everyone, which underlies the operations of language itself. To analyse it we shall borrow from structural linguistics the approach and terminology of Roman Jakobson.*

We start from the truism that thinking is conducted in sentences composed of words drawn from the vocabulary of one's language, and that the words are already grouping in the 'language' (Saussure's *langue*) before entering the sentences of 'speech' (Saussure's *parole*). In speaking we on the one hand select words from pairs or larger sets ('paradigms'), on the other combine them in phrases and sentences ('syntagms').

	A	B	Paradigm
1.	He	They	
2.	posted	collected	
3.	a	the	
4.	letter.	mail.	

Syntagm

* Jakobson, in particular pp. 239–259, 'Two Aspects of Language'.

Verbal thinking draws on a stock of paradigms already grouping syntagmatically in chains of oppositions which at their simplest are binary. This time we number only for convenience without implying succession or completeness.

	A	B	Paradigm
1.	Day	Night	
2.	Light	Darkness	
3.	Knowledge	Ignorance	
4.	Good	Evil	

Syntagm

The proof of such a chain in the background of thinking in English is that before the formation of sentences the words already combine syntagmatically in vocabulary or cliché: 'daylight', 'the light of knowledge', 'the darkness of ignorance/of evil'.

The paradigmatic relation is of similarity/contrast:

A1 : B1 :: A2 : B2 (Day *compares* with night as light with darkness).

The syntagmatic relation is of contiguity/remoteness:

A1 : A2 :: B1 : B2 (Day *connects* with light as night with darkness).

When relations tend to similarity rather than contrast, or to contiguity rather than remoteness, one of a pair may substitute for another, by the figures of speech called 'metaphor' and 'metonymy':

	A	B	A	B
1.	King	Lion	King	Chairman
2.	Men	Beasts	Throne	Chair

King compares with lion as men with beasts, so by metaphor the lion is king of the beasts and the king a lion among men. King connects with throne as chairman with chair, so by metonymy the monarchy is the throne and the chairmanship is the chair.

Before thinking in sentences we already 'think' in the broad sense that we pattern experience in chains of oppositions and expect the filling of gaps in the pattern. When the pattern is familiar this is no more than the recurrence of habitual expectation, when a new pattern takes shape it is sudden insight, whether as the everyday intuitions of common sense or the illuminations of the visionary and the fantast. The expectations spring from and are initially confirmed by experience. We do regularly encounter light by day and darkness by night, the night does bring ignorance of surroundings and dangers and evils. Since the distinguishing of oppositions is guided by desire and aversion, which enchain the pairs with good and evil, someone thinking correlatively is satisfied not only of what to

expect but of what to approve and disapprove; values appear self-evident and he needs analytic thinking only in the service of what immediately presents itself as good. However, the connexions between light and knowledge, darkness and evil, are vaguer and less regular than between day and light, not to mention that there are times when one even encounters darkness by day. One is then forced to analyse the syntagmatic relations critically and seek the precise, invariable and so causal connexion. A tension grows between the pressure of fact and the need for the security of remaining inside a fully comprehensible world. Causal relations begin to interlock, opening the prospect of another cosmos, that of modern science, in which prediction is more accurate than ever before but there is nothing to tell us what to approve or disapprove. Our position however is that there never was a serious prospect that piecemeal causal explanation would interrelate in a completed order until the 'discovery of how to discover' about 1600; previously, in the West as in China, the choice was between the cosmos of correlative system-building and no cosmos at all.

The prevalence of correlative cosmology before Galileo ceases to surprise when we recognize that even in its most luxuriant elaborations it is the refining of a cosmos in which the thinker *already* finds himself before analysis begins; the correlation of concepts precedes their analysis. I have only to discern, for example, that the sun and the King are alike in being 'above' in power and glory, in the proportional opposition 'sun : world :: king : men', to find myself already in a cosmos where both have intelligible places, so that I can infer from their similarity both what to expect and how to respond; I must bow down in awe to the King as to the sun, grateful for his beneficence and reconciled to the incomprehensible caprices of unchallengable power. Causal thinking on the other hand merely breaks things up, until the discovery of mathematised laws of nature re-unifies them in another kind of cosmos. One might put it this way: while explaining analytically, attention is diverted from the correlating of concepts in the background; but as long as analysis has nothing to put in front, correlative thinking is necessarily in the foreground.

How does correlative relate to analytic thinking? The common-sense thinking of daily life may be conceived as a stream of correlation redirected by analysis whenever we have occasion to doubt a comparison or connexion. Much of the most accessible Chinese philosophising (Hsün-tzu, Han Fei) is of this sort, with the correlations made more visible than in English by the parallelism of phrases and sentences. We do get pure analytic thinking in the Sophists and Later Mohists; it is what they

understand by *pien* 'argumentation'. But it is notable that even the Later Mohists offer no forms for argumentation which we would recognise as belonging to logic; the discipline which they do recognise as requiring formal procedures is the one we have called the 'art of discourse', and in *Names and Objects* the procedures are for criticising the parallelism of correlated sentences. From another direction we have *Lao-tzu* resorting to a poetic language to undermine conventional oppositions, in a manner which we have compared with Derridan deconstruction. The Chinese assumption seems to be that you can criticise correlations but you cannot dispense with them.

The Western tradition on the other hand has long persisted in trying to detach the analytic completely from its background in the correlative, dismissing the latter as the loose argument from analogy which we need in practical life but exclude from strict logic. It is only in the last half-century, with Ryle's exposure of the category mistake, Kuhn's proposal that all science assumes paradigms subverted not by demonstration but by correlative switches, Derrida's uncovering of chains of oppositions at the back of logocentric thought, that the West seems finally to be losing faith in its two-thousand-year-old enterprise. Wittgenstein showed that the similarities which we try to pin down by naming are 'family resemblances' by which A may be like B and B like C without A being like C, so that the hope of drawing an absolute distinction between literal and metaphorical meanings and fixing the former in a system of mutually definable terms seems baseless outside logic and mathematics. We find correlations of the building-blocks of thought, of the same kind as in the most exotic cosmologies, in the operation of language itself, which may be claimed as the one activity to which correlative thinking is *perfectly* adequate. The learner becoming familiar with the oppositions 'cat/cats', 'shoe/shoes', 'stone/stones' immediately fills the gap in 'house/_____' with 'houses'; and if he slips into the error 'goose/gooses' and is corrected, he automatically correlates 'goose/geese' with 'foot/feet', 'tooth/teeth'. In learning to speak grammatically it is analytic thinking which is inadequate, useful as it is as a preliminary tool; it is when one is no longer deliberately applying a memorised rule distinguishing singular from plural that a foreign language is beginning to be mastered. The same correlative process is required for the understanding of utterances whether in one's own language or another, the completion of an analysis into intertranslatable units being an unattainable ideal. Certainly no serious reader of Chinese philosophy can forget that his capacity to clarify in English never catches up with his understanding of the original, and

that in analysing he always has to uncover the metaphorical roots not only of the Chinese terms but of the English which he uses to explain them.*

One of the first to appreciate that the analysis of concepts does not detach them from presupposed correlations was Ryle, the argument of whose *Concept of Mind* may be converted into the correlative ratios we have been using. Ryle sets out to discredit the dichotomy of a body which is extended in space and a mind which is not. He observes that our habit of treating the mind as different in kind from, yet interacting with, the body which is a machine, implies crediting it with a similarity, that its activities like the body's have causes and effects. The mind as 'ghost in the machine' has to be conceived as 'a spectral machine'. This has led to well-known difficulties; how can willing, which is non-spatial, cause the limbs to move in space, or the mind's perception of a colour be the effect of a process in the optic nerve? Ryle sees the problem as arising from an improper correlation at the back of thought: 'Mind : head, hands, feet :: ruler : subjects' (the 'para-political myth'), which the advent of mechanistic science turned into 'Mind : head, hands, feet :: governor engine : other engines' (the 'para-mechanical myth'). He invites us instead to try out new correlations, 'Mind : head, hands, feet :: University : colleges, libraries, playing fields', or 'Mind : head, hands, feet :: British constitution : Parliament, judiciary, Church of England'. On this approach, analytic thinking can never escape the correlations deposited by habit or initiated by new insights; in criticising one it has to surrender to another. When we do become aware of alternatives, however, we can choose between them by judging whether arguments proceeding from one or other lead into or avoid logical difficulties.

We seem to be moving nearer to the classical Chinese philosophers in taking correlation as prior to analysis (not of course nearer to the Yin-Yang proto-scientists). It is curious to notice that when exposing, like a Later Mohist, overlooked distinctions between formally similar statements, Ryle falls into just the sort of parallelism we find in *Names and Objects*. Thus in pointing out the difference between tasks (aiming, treating, scanning) and achievements (hitting, curing, seeing), overlooked when we assume them to be "co-ordinate species of activity or process", he writes:

"This is why we can significantly say that someone has aimed in vain or successfully, but not that he has hit the target in vain or successfully;

* Cf. G *Reason and Spontaneity* 57–60 and ch. 1.5 *passim*. This gives a fuller account of the dependence of analytic on what I there call 'analogical' thinking, a cruder version of the correlative thinking which I am now treating in Jakobsonian terms.

that he has treated his patient assiduously or unassiduously, but not that he has cured him assiduously or unassiduously; that he scanned the hedgerow slowly or rapidly, systematically or haphazardly, but not that he saw the nest slowly or rapidly, systematically or haphazardly."[1]

Cosmology before the Han

Cosmological speculation, which is at the beginning of Greek philosophy, entered the main current of Chinese thought only at the very end of the classical period.* Down to about 250 B.C. it belongs to a world right outside the philosophical schools, that of the court historiographers, astronomers, diviners, physicians, and musicmasters, and our information about it comes primarily from historical sources, notably the 4th-century *Tso Commentary*. Thus in 541 B.C. the physician Ho, diagnosing the Marquis of Chin's illness as the effect of sexual excess and incurable, is represented as sketching for him the fundamentals of the proto-science of medicine.

"Heaven has the Six *Ch'i*, which descending generate the Five Tastes, issue as the Five Colours, are evidenced by the Five Sounds, and in excess generate the Six Diseases. The Six *Ch'i* are shade (*yin* 陰) and sunshine (*yang* 陽), wind and rain, dark and light. They divide to make the Four Seasons, in sequence make the Five Rhythms, and in excess bring about calamity. From shade in excess cold diseases, from sunshine hot; from wind in excess diseases of the extremities, from rain of the stomach; from dark in excess delusions, from light diseases of the heart. Woman being a thing of the sunshine but of the dark time, in excess she generates the diseases of inward heat and delusion-inducing poisons."[1]

The *ch'i* are the energetic fluids in the atmosphere and inside the body, where they are primarily the breath. The words *yin* and *yang* here still have their pre-philosophical senses, shade and sunshine (used especially of the north or shady and south or sunny sides of a mountain), and are two of the six atmospheric influences. They are the sources of cold and heat rather than, as later, of dark and light, which are separately classed among the six. Besides the Six *Ch'i* belonging to Heaven the *Tso Commentary* has a set of Five *Hsing* 行 ('goings') which belong to Earth, not yet as later classed as *ch'i*. These are associated, and later identified, with wood, fire, soil, metal, and water. The term was until recently commonly translated 'Five Elements', although they are certainly not conceived as components of

* The detailed evidence for the claims in this chapter (as of much else in Part 4/1) is in G *Yin-Yang*.

things; 'Five Phases' is the equivalent increasingly preferred.[2] However, right down to the syncretistic *Huai-nan-tzu* (c. 140 B.C.), the Five *Hsing* appear to be, not the materials, nor phases in cycles, but processes such as fire rising and burning, water wetting and sinking. Wood, fire, soil, metal and water were called the Five Materials (*ts'ai* 材) or, with the addition of grain, the Six Stores (*fu* 府), and were simply the basic resources for human livelihood.[3] I therefore prefer the equivalent 'Five Processes' at least for the pre-Han period. The earliest reference is in the 'Great Plan' (*Hung fan*) in the *Documents,* not, as it claims, a work of early Chou but unlikely to be later than 400 B.C. This lists in nine enumerated sets the essentials for government, starting with the five natural processes most useful to man and continuing with the five kinds of conduct required of him.

"1. The five processes. 1, water : 2, fire : 3, wood : 4, metal : 5, soil. Water : wetting, sinking. Fire : flaming, rising. Wood : bending, straight. Metal : yielding to moulding. In soil one plants and harvests

"2. The five things to do. 1, demeanour : 2, speech : 3, looking : 4, listening : 5, thinking. Demeanour : respectful. Speech : accordant. Looking : seeing clearly. Listening : hearing clearly. Thinking : under-standing"[4]

It is not surprising that after 100 B.C. the first series was understood as listing water, fire and the rest of them as themselves the Five *Hsing,* in spite of the fact that the ordinary meaning of *hsing* is 'going'. But in both series the concept is split into two components. In the second the thing to do is not the demeanour, nor the respect, but assuming a respectful de-meanour; similarly the process is not water, nor wetting and sinking in general, but water wetting and sinking. The *hsing* would seem to be the processes specific to each material, of which the workman takes advan-tage when he waters ground, sets alight from below, carpenters following the grain, casts metal, plants grain.

It was noticed from an early period that the processes conquer each other in a regular cycle, water quenching fire, fire melting metal, metal cutting wood, wood digging soil, and coming round again with soil damming water; some at least of these conquests were in use by the diviners of the *Tso* narrative. The conquests are always ascribed to the Five Processes (not the Five Materials or Six Stores), and there is some evidence that the term itself was established with the discovery of the cycle. Although it is uncertain how far one can rely on the discourses ascribed to historical persons in the *Tso Commentary,* it is noticeable that both the conquest cycle and the term Five *Hsing* appear quite suddenly during the

last half-century of the record, starting from 517 B.C. and mostly in answers between 513 and 484 B.C. by the Historiographer Mo of Chin to the noble Chao Chien-tzu of the same state, while the terms Five Materials and Six Stores are last attested in 531 B.C.

Asked in 486 B.C.whether Chao can successfully attack Sung, Mo replies:

"Ying (the Chao surname) is a water name, Tzu (the Sung surname) is a water position. Name and position match, it is not to be attacked. Yen-ti ('Flaming Emperor') was director of fire, the Chiang clan are his descendants; water conquers fire, it is admissible to attack the Chiang."[5]

All the pre-Ch'in schools are indifferent if not hostile to the cosmology of the proto-sciences, generally ignoring even the *Yi*, the early Chou manual of divination regularly consulted by statesmen in the *Tso Commentary* and later included in the Confucian Classics. Confucius himself set the example: "The Master did not speak of wonders, feats of strength, disturbances, the daimonic."[6] In the standard text of the *Analects* he once praises the *Yi*, but the reading is in doubt.*[7] Otherwise the first Confucian to mention the *Yi* is Hsün-tzu, who cites it but does not name it among the Classics.[8] He also mentions Mencius as teaching the Five *Hsing*, but this is now known, from a Confucian document attached to a Ma-wang-tui manuscript of *Lao-tzu*, to refer not to the Five Processes but to five kinds of moral conduct.[9] Not only the Mohist *Canons* but the military classic *Sun-tzu* declare flatly that "the Five Processes have no regular conquests".[10]

With the apparent exception of Hui Shih, of whose views we know nothing, the only philosophers who discuss scientific questions are the Later Mohists. But the *Canons* do not appeal to Yin and Yang, Five Processes or the hexagrams; they confine themselves to strictly causal explanations in optics and mechanics. Moreover, as we have seen, the practice has a principle behind it: conjunctions of events may be 'necessary' or merely 'appropriate', conjunction with a cause is necessary but the conquest of metal by fire in the cycle of the Five Processes is merely appropriate, the outcome depending on the quantities of fuel and metal.[11] Here we have what is perhaps the most striking Chinese parallel to those pre-modern Western swings towards causal explanation which do not lead to the 'discovery of how to discover'. The Mohist approximation to what we would nowadays approve as true scientific method is of course quite exceptional, resulting from an interest in logical clarification and also

* *An* 7/17 The alternative reading is preferred for example by Lau, *Analects* p. 88.

in crafts such as military engineering which was almost limited to the Mohist school; but in philosophical literature before about 250 B.C. it is the only kind of science that we find.

One may however suspect one early influence from the proto-sciences; Yangists 'nurturing life' to last out its full term would be likely to borrow concepts from medicine. The first evidence of this is from Chuang-tzu, who in the 'Inner Chapters' speaks of the sage "charioteering the changes of the Six *Ch'i'*, presumably still including sunshine and shade among them, also of the 'inward heat' of a man making himself ill by worry as "a *yin-yang* affliction", quite in the manner of physician Ho. [12] The point at which Yin and Yang detached themselves from the Six *Ch'i* is not easily determined. In later parts of *Chuang-tzu*, which may be of the late 3rd or even 2nd century B.C., Yin and Yang have definitely emerged as the two primal *ch'i*:

"Therefore heaven and earth are the greatest of shapes, Yin and Yang are the greatest of *ch'i*." [13]

A consequence of this development is that all things can now be conceived as condensing out of and dissolving into a universal *ch'i* which as Yang is pure and so free moving and active, and as Yin is impure and so inert and passive.

"Man's life is the assembling of *ch'i*. The assembling is deemed birth, the disperal is deemed death. . . . Running through the whole world there is nothing but the one *ch'i*." [14]

The general indifference of the schools to cosmology ends, from motives which seem to have been essentially political, with the growing influence on rulers of Tsou Yen (c. 250 B.C.) and his theories about Yin-Yang and the Five Processes. Although Ssu-ma T'an's retrospective classification of the philosophers under the 'Six Schools' includes a 'school of Yin and Yang', Tsou Yen belongs to the world not of philosophers but of the court diviners and physicians of the *Tso Commentary*, except that he is a newcomer winning the ear of princes by the promise of esoteric knowledge; his followers in the states of Ch'i and Yen in the far North East are the first to be remembered as *fang shih* 方 士 'men of secret arts'. Like the cosmology documented in the *Tso Commentary*, Tsou Yen's is known to us almost exclusively from a historical source, the *Historical Records* of Ssu-ma Ch'ien, for whom he is important for the influence of his ideas on the First Emperor. The historian himself contrasts the honours accorded Tsou Yen by rulers with their indifference to such better men as Confucius and Mencius. As for the philosophers, they do not even execrate or deride him as they do the 'egoist' Yang Chu or the sophist Kung-sun Lung, they

simply ignore him, even in the numerous lists of leaders of the various schools in *Hsün-tzu*, the *Chuang-tzu* 'Below in the Empire' chapter, the *Lü Spring and Autumn*, *Shih-tzu* and *Huai-nan-tzu*. Even after the triumph of cosmology during the Han they hardly mention Tsou Yen himself except to deride as fantasy some geographical speculations recorded by Ssu-ma Ch'ien; his voluminous works seem to have been unread and were soon lost.*

Tsou Yen won public attention by the arresting thought that the rise and fall of dynasties is governed by the conquest order of the Five Potencies *(te)*, the virtues or powers of the Five Processes by which water conquers fire and so on through the cycle. The Chou reigned by the potency of fire which will be conquered by water; its successor will be recognised by its adoption of the colour, number, season and so forth which correlates with water in a system of correspondances apparently already current in court ritual. This scheme first enters the surviving literature in the *Lü Spring and Autumn*. Although like other philosophical texts this never mentions Tsou Yen by name, it gives a full account of the dynastic cycle starting with the Yellow Emperor, as well as laying out the full system of correlations in its calendrical chapters.

"Whenever emperor or king is about to arise, Heaven is sure to display a good omen beforehand to the people below. In the time of the Yellow Emperor, Heaven displayed beforehand big earthworms and big ants [creatures of the soil]. The Yellow Emperor said 'The *ch'i* of soil has conquered.' Because the *ch'i* of soil had conquered, as his colour he honoured yellow, for his affairs took soil as norm [that is, he chose the correlates of soil]."[15]

The account continues through the dynasties as each *ch'i* is conquered by the next.

A	B	C	D	E
Yellow Emperor	Hsia	Shang	Chou	(Coming dynasty)
Soil	Wood	Metal	Fire	Water
Yellow	Green	White	Red	Black

The First Emperor put the system into practice by proclaiming that the Ch'in reigned by the potency of water, and adopting in ritual the colour black and the rest of the correlates. It is to the political appeal of the system that we may ascribe the universal reclassification of the Five Processes as *ch'i* and as the prime correlates of sets of four and five, as the Yin and Yang *ch'i* are the prime correlates for pairs. Some older schemes of ritual

* Cf. G *Yin-Yang* 11–15. For Ssü-ma Ch'ien's account of Tsou Yen, cf. *Shih chi* (ch. 74) 2344f, tr. Yang 71f.

correspondances survive in the *Kuan-tzu* miscellany, but in these the Five Processes are absent or secondary and are clearly distinguished from a corresponding series of *ch'i* recognisably descended from the Six *Ch'i* of the older cosmology.[16] A further consequence of making the Five Processes prime correlates is that the order in which they are fitted to the four seasons establishes a cycle in which they generate each other, independent of the conquest cycle.

B	D	A	C	E
Spring	Summer	――	Autumn	Winter
Wood	Fire	Soil	Metal	Water

With the reunification of the Empire acceptance of the new cosmology became indispensable to success at court, where 'men of secret arts' from the North East, claiming the authority of Tsou Yen, won the favour of the First Emperor and of the Han Emperor Wu (140–87 B.C.) by promising the elixir of life. The suppression of the Classics under the Ch'in drew the attention of the Confucians to the *Yi*, an ancient Chou work tolerated by the Ch'in as a book on that indispensable science, divination; from at latest very early in the Han they were including it among the Classics and expanding it with appendices ascribed to Confucius himself. The appendices introduce into the Classics Yin-Yang dualism but not the Five Processes. From this time an orthodoxy rooted in the Classics could no longer ignore cosmology.

Pairs: Yin and Yang

Whichever position one takes on the disputed issue of whether all thinking is ultimately binary, there can be no doubt of the centrality of binary oppositions in Chinese culture. Everywhere from the pairs and the sets of four, five or more in cosmology to the parallelism of prose and the tone patterns of regulated verse we find groups which, even when the number is odd, divide neatly into pairs with one left over. The traditional cosmology as it settles into its lasting shape after 250 B.C. is ordered by lining up all binary oppositions along a single chain, with one member Yin and the other Yang. The *Ch'eng*, one of the additional documents on Ma-wang-tui manuscript B of *Lao-tzu*, not much later than 250 B.C., provides the earliest comprehensive list of which we know.

"Whenever sorting out be sure to use the Yin and Yang to make plain the overall scheme. Heaven is Yang, Earth is Yin. . . . "[1]

The list continues in parallel phrases on the same model, 'X is Yang, Y is Yin'.

A	Yang	B	Yin	Paradigm
1. Heaven		Earth		
2. Spring		Autumn		
3. Summer		Winter		
4. Day		Night		
5. Big states		Small states		
6. Important states		Unimportant states		
7. Action		Inaction		
8. Stretching		Contracting		
9. Ruler		Minister		
10. Above		Below		
11. Man		Woman		
12. Father		Child		
13. Elder brother		Younger brother		
14. Older		Younger		
15. Noble		Base		
16. Getting on in the world		Being stuck where one is		
17. Taking a wife, begetting a child		Mourning		
18. Controlling others		Being controlled by others		
19. Guest		Host		
20. Soldiers		Labourers		
21. Speech		Silence		
22. Giving		Receiving		

Syntagm

Throughout the chain A is superior to B but the two are mutually dependent; it does not, like the illustrative series starting 'Day/night' with which our argument began,[2] lead to 'Good/evil'. As has long been recognised, China tends to treat opposites as complementary, the West as conflicting. It is the explicitness of the Yin-Yang system which shows up this difference, the first between the conceptual schemes* to attract attention. That Western thought not only has a chain of oppositions at the back of it but has a preconception about their relation to be exposed and challenged has been appreciated only since Derrida. Now that the links are becoming visible one begins to see an affinity even between Western attitudes as far apart as the Christian faith in the immortality of the soul and the scientist's (before quantum mechanics) in universal causation;

* By a 'conceptual scheme' I intend a system of names correlated prior to analysis, as explained on pp. 319–25 above. This is not the same as Quine's idea of the conceptual scheme as composed of sentences assumed to be true, criticised in Donald Davidson's 'On the Very Idea of a Conceptual Scheme'.

given the pairs 'Life/death' and 'Necessity/chance', the West strives to abolish B and preserve only A. David Hall and Roger Ames in *Thinking Through Confucius* suggest that the whole reductionist enterprise in Western philosophy may be seen as the conquest of B by a transcendent A, (for example the dissolution of things into component atoms which can themselves exist without composing things), and that comparison with the Chinese treatment of polarities can help us to see it in perspective and criticise it.

Let us now take the plunge into the most developed cosmogony in early Chinese literature, at the beginning of the astronomical chapter of the syncretistic *Huai-nan-tzu*. In translating we italicise all sentences with a 'Therefore. . . . '.

"When Heaven and Earth were not yet shaped, it was amorphous, vague, a blank, a blur; *call it therefore 'the Primal Beginning'*. The Way began in the tenuous and transparent, the tenuous and transparent generated Space and Time, Space and Time generated the *ch'i*. There was a shoreline in the *ch'i*; the clear and soaring dissipated to become Heaven, the heavy and muddy congealed to become Earth. The concentration of the clear and subtle is easy, the concretion of the heavy and muddy is difficult; *therefore Heaven was completed first and Earth afterwards*.

"The superimposed quintessences of Heaven and Earth became the Yang and Yin, the concentrating quintessences of Yin and Yang became the Four Seasons, the scattering quintessences of the Four Seasons became the myriad creatures. The hot *ch'i* of the accumulating Yang generated fire, the quintessence of the *ch'i* of fire became the sun; the cold *ch'i* of the accumulating Yin became water, the quintessence of the *ch'i* of water became the moon; the overflow of the quintessences of sun and moon became the stars. Heaven received the sun, moon and stars, Earth received the showers of water and the dust and dirt."

After a mythological interlude to explain corresponding asymmetries of Heaven and Earth, the account continues:

"The Way of Heaven is to be round, the way of Earth is to be square. It is primary to the square to be dim, primary to the round to shine. To shine is to expel *ch'i*, *for which reason fire and sun cast the image outside*. To be dim is to hold *ch'i* in, *for which reason water and moon draw the image inside*. What expels *ch'i* does *to*, what holds *ch'i* in is transformed *by*. *Therefore the Yang does to, the Yin is transformed by*.

"Of the *ch'i* inclining to Heaven, the raging became wind; of the combining *ch'i* of Heaven and Earth, the harmonious became rain. When Yin and Yang clashed, being roused they became thunder, crossing paths

they became lightning, confusing they became mist. When the Yang *ch'i* prevailed, it scattered to become rain and dew; when the Yin *ch'i* prevailed, it congealed to become frost and snow.

"The furred and feathered are the kinds which fly and run, and *therefore belong to the Yang*; the shelled and scaly are the kinds which hibernate and hide, and *therefore belong to the Yin*. The sun is ruler of the Yang, and *for this reason in spring and summer the herd animals shed hair, and at the solstice the deer shed their horns*; the moon is ancestor of the Yin, *which is why when the moon wanes the brains of fishes diminish, and when the moon dies the swollen oyster shrinks.*

"Fire goes up and trails, water goes down and flows; *therefore the birds flying up go high, the fish when stirred go down*. Things which are of a kind stir each other, what is at the root and what are at the tips respond to each other. *Therefore when the Yang burner* [concave mirror] *sees the sun it ignites and makes fire, when the square 'chu'* [an object laid out at night to catch the dew] *sees the moon it moistens and makes water.*"

Further examples follow, but these will be enough. The cosmos is seen as evolving by division along a chain of binary oppositions. The Tao as 'Way', course, path, introduces the first opposition, between the amorphous as spatially extended and as temporally enduring, so that it becomes the mobile *ch'i* 'air, breath'. The *ch'i*, which we experience as the influences in the atmosphere and in the body which brighten or darken, activate or clog, divides into 'clear/muddy' (*ch'ing* 清/*cho* 濁, both written with the 'water' radical and used primarily of water). With the rising of the clear and sinking of the muddy they become Heaven and Earth. From this point onwards we notice the clauses falling into parallel pairs. *Huai-nan-tzu* orders its cosmos by taking crucial binary oppositions, as they are drawn in Chinese culture, and arranging them in the sequence which shapes the simplest and most comprehensive pattern.

CH'I

	A	B	Paradigm
1.	Clear and subtle	Heavy and muddy	
2.	Heaven	Earth	
3.	Yang	Yin	
4.	Hot	Cold	
5.	Fire	Water	
6.	Sun	Moon	
7.	Round	Square	
8.	Shines	Is dim	
9.	Expels	Holds in	

10. Does to	Is transformed by
11. Scatters	Congeals
12. Rain or dew	Frost or snow
13. The furred or feathered	The shelled or scaly
14. Flies or runs	Hibernates or hides
15. Rises	Sinks

Syntagm

Throughout the table A and B contrast as parallel structures, with the connexions varying from one position to the next but corresponding at each.

Positions 1,2 The clear *becomes* Heaven, the muddy becomes Earth.

3,5 The Yang *generates* fire, the Yin generates water.

5,15 Fire rises, water sinks: 'fire/water' and 'rise/sink' share the connexion of agent and action.

The cosmologist is in effect trying to lay out the whole system of paradigmatic and syntagmatic relations which, we suggested,[4] analytic thinking never ceases to assume but leaves implicit, and which prove vulnerable on examination when presuppositions are questioned. One interest of such system-building is that it is the only kind of thinking which makes this try at bringing everything submerged to the surface. The result is a largely coherent but of course very simplified scheme. The cosmologist is now equipped to explain, not by isolated analogies, but by contrasts and connexions throughout the whole scheme; if fire contrasts with water in that one goes up and one goes down, and birds contrast with fish as fire with water, then birds like fire will go up and fish like water will go down. Yang and Yin are introduced as the quintessences, the purest *ch'i*, of Heaven and Earth, but it is not that he is applying a theory about them; for purposes of explanation and inference, Yang and Yin function like our 'A' and 'B', they mark the series within which something connects and the opposite series with a member of which it contrasts.*

In exploring proto-scientific thinking it has been usual to start from what we find peculiar in pre-modern views of nature; here we follow the example of Lévi-Strauss (although not the detail of his methods) in starting from the opposite direction, from structures common to pre-modern and modern thinking. To infer correlatively from how concepts interconnect is (except when equating them by such a word as 'become') to

* The analysis of the *Huai-nan-tzu* cosmology which follows was first attempted in G *Yin-Yang* 33–40, where there are confusions which I hope now to have cleared up.

think of them as interacting; the ancient Chinese think of the cosmos as like an organism, but this is consequence not cause of thinking correlatively. In the large area of ordinary life which is too complex and transient to be unravelled by analysis, so that we have to trust to spontaneous expectations springing from the immediate perception of pattern, we likewise see ourselves as involved in a multiplicity of interacting factors. There are differences of course between common-sense thinking and correlative system-building, but the inferiority of the latter derives from the poverty of information at its disposal. In the fluid patterning of shifting experience the thinker is on the near side of his analytically ordered information; on the far side is the immense realm which, before the time of Galileo, could be reduced to order only by the same kind of patterning. Out there however correlative thinking loses the assurance and suppleness with which we exercise it in practical life. On the near side, it is disciplined to an art by the recurrent defeat of expectations in urgent situations; on the far side, obstacles to the flight of fancy are weaker and fewer. On the near side, subtle discriminations can draw a constantly veering line between the similar and the contrasting, the contiguous and the remote, unhampered by verbal formulation; on the far side the rigidity of schemes is equalled by license in applying them. On the near there is too much information to be confined by any system, on the far too little to correct any system.

The effect of imposing a scheme of Yin-Yang type is to sharpen contrasts and blur connexions. The scheme can work only if two complementary conditions hold.

(1) A1 connects with A2 as B3 with B2, and so for any corresponding elements. Thus at Positions 4, 5, water connects with cold as fire with hot. This forces the connexion between fire and hot to transfer to water and cold (a metaphoric shift); water is conceived, for modern science wrongly, as inherently cold as fire is inherently hot.

(2) A1 contrasts with B1 as A2 with B2, and so for any corresponding elements. Thus at Positions 5, 13, 15 birds contrast with fish as fire with water. This forces the connexions of fire with rising and water with sinking to transfer to birds and fish (a metonymic shift); the result is what is for us a false explanation of why startled birds fly up and startled fish plunge deep.

Once imprisoned in formulae correlative thinking loses its capacity for fine discriminations. There is indeed a rough similarity between the contrasts between A and B all down the table, enough to give a meaning to 'Yang' and 'Yin', commonly described as the active and passive or the

positive and negative principles (cf. "Therefore the Yang does *to*, the Yin is transformed *by*"); but all in all the similarity is a Wittgensteinian 'family resemblance', by which 1 can be like 2 and 2 like 3 without 1 being like 3. What the system does retain of the correlative thinking of practical life is just what post-Galilean science strives to escape, the incompleteness of explanations which assume interrelations with all parts of an indefinitely limited structure. Should one ask why, if square connects with moon as round with sun (Positions 6, 7) the moon is not square, one would be expected to look higher up the chain and take into account that moon like sun connects with Heaven, which is round. Every explanation therefore is modifiable from elsewhere in an indefinitely extendable pattern, permitting a license which the cosmologist tries to restrict by his principle that the higher in the chain is 'ruler' or 'ancestor' of the lower.

Among the sentences introduced by 'Therefore' italicised in the translation we shall ignore the cosmologist's reason at the start for speaking of the 'Primal Beginning', as well as a genuinely causal explanation (Heaven took shape before Earth because the heavy takes longer to come together than the rarified) and an unimpeachable deduction (the Yang *ch'i* shines, 'to shine is to expel *ch'i*, 'what expels does *to*', and 'therefore the Yang does *to*'). Each correlative explanation presents what is seen as the crucial among the innumerable factors bearing on the case, very much as we pick out the crucial factor in offering a causal explanation. We shall supply from the total scheme what we take to be the other most relevant factors. It may be noticed that the conclusion is always a contrastive pair which is added to the chain of oppositions. The scheme explains only contrasting connexions (whether of becoming, generating, concave mirror interacting with sun and fire), by the similarity to the contrasts between other connexions.

Question 1. Why do fire and sun radiate their glow and cast shadows outside, moon and water contain their glow and draw shadows within?

Answer: Because to shine is to expel *ch'i*, to be dim is to hold *ch'i* in.

Assumptions: Holding in contrasts with expelling as being dim with shining (and hibernating or hiding with flying or running, congealing with scattering), so holding in connects with dimness as expelling with shining (the metaphoric shift).

Question 2. Why are animals and birds Yang, invertebrates and fish Yin?

Answer: Because the former run or fly, the latter hibernate or hide.

Assumptions: Running or flying contrasts with hibernating or hiding

as shining with being dim, expelling with holding in, rising with sinking; being furred or feathered contrasts with being shelled or scaly as scattering with congealing, hot with cold. All are contrasts of A with B, so of Yang with Yin.

Question 3. Why do animals throw off hair and horns as the sun advances in the early year and the fish and oysters shrink as the moon wanes in the late month?

Answer: Because the sun is ruler of Yang things and the moon is ancestor of Yin things.

Assumptions: Animals (Yang), sun, heat, expelling and scattering interconnect as do fish (Yin), moon, cold, holding in and congealing. Animals contrast with fish as sun with moon, so when animals meet the advancing sun they get hot, expel, and scatter like the sun, whereas when fish meet the waning moon they get cold, hold in and congeal like the moon (the metonymic shift). All this is too obvious for the cosmologist to lay out explicitly; he asks only why sun and moon act on the things with which they connect, rather than being acted on by them. The answer is that they are in ruling or ancestral positions higher up in the chain.

Question 4. Why when disturbed do birds fly up but fish dive down?

Answer: Because fire goes up and water goes down.

Assumptions: Birds differ from fish as fire from water. Fire and water differ in respectively rising and sinking, so birds and fish differ likewise (the metonymic shift).

Question 5. Why does the Yang mirror draw fire from the sun and the square *chu* draw dew from the moon?

Answer: Because "things of a kind stir each other, the root and the tips respond to each other".

Assumptions: This example contrasts strikingly with the purely causal explanation of the inversion of the shadow in the concave mirror in the Mohist *Canons*.[5] The cosmologist seeking to explain why the sun reflected in a concave mirror ignites tinder looks for a structurally parallel phenomenon, and thinks that he has found it in the square *chu* (of which there is little information, but said also to be a mirror) which accumulates dew when laid out at night. The Yang mirror is Yang not only in name but in being round; the *chu* is Yin because square. Once their relation is seen, it becomes too obvious to deserve explicit mention that there are contrasting interconnections between sun, concave mirror and fire and between moon, square *chu* and water. The cosmologist remarks only that each interaction being of members of the same column is because "things of a

kind stir each other", and that the sun and moon acting on rather than reacting to other things is because, by their positions higher or lower in the evolutionary branching, the former are 'root' and the latter 'tip'.

We noticed one causal explanation, that Heaven took form before Earth because the clear and subtle coalesce more easily than the heavy and muddy. Should we expect correlative explanation to have lost its persuasiveness once explanations of this sort were appreciated? That would be to look at the problem from the wrong angle. Modern science is dissatisfied with causal explanations until they can be subsumed under systematised laws of nature, and in approaching the purity of physics tends to dispense with them; similarly proto-science is dissatisfied with them unless they can be fitted to a correlative scheme, and dispenses with them as the scheme approaches perfection. To explain a particular conjunction as an instance of a general recurrence after all only shifts the question one stage back, to why the events recur. The point may be illustrated by an account of the conquest cycle in the 'Five Processes' chapter of the *White Tiger Discussions (Po hu t'ung)*, based on a conference on the interpretation of the Classics at the White Tiger Hall in A.D. 79. The conquest cycle of the Five Processes, to which we shall return,[6] is independent of correlations. Consequently the discussants, although noted for the extravagance of their speculative cosmology, had to be content with mere causal explanations of why water extinguishes fire, fire melts metal, metal cuts wood, wood digs soil and soil dams water.

"As to why the Five Processes obstruct each other, by the nature of Heaven and Earth much conquers little, therefore water conquers fire; quintessential conquers firm, therefore fire conquers metal; hard conquers soft, therefore metal conquers wood; compact conquers loose, therefore wood conquers soil; solid conquers tenuous, therefore soil conquers water."[7]

These are seen as genuine explanations, not because they are causal but because they too correlate in a scheme, which is why the unconvincing "Much conquers little" is needed to fit the first of them to the rest.

Throughout the *Huai-nan-tzu* arguments it is never *said* that anything is similar to or different from anything else. To shift 'similarity/contrast' from the paradigmatic to the syntagmatic dimension and say 'X is like/ unlike Y', as Chinese thinkers do often enough outside cosmology, is to move away from correlative towards analytic thinking.

A practice common to Chinese and Western proto-science is correlation between the universe as macrocosm and man as microcosm. We shall take examples from Kepler's *Epitome of Copernican Astronomy* (which, in

spite of his three planetary laws, belongs not to modern but to Mediaeval science) and from chs. 3 and 7 of *Huai-nan-tzu*.[8] For the ancient Chinese, Heaven with its revolving luminaries is round like the head, Earth spreading in the four directions is rectangular like the feet; similarly for Kepler the curved represents God and the rectilinear His creatures, and since the most perfect rectilinear figures are the five regular solids, the distances between the planets correspond to their proportions, starting with the cube, tetrahedron and dodecahedron, since (it is as though Kepler were waiting to be analysed by a structuralist), "in these figures there appears the first of the metaphysical oppositions, that between the same and the other or the different".[9] He correlates world with soul, *Huai-nan-tzu*, world with body.

Kepler		Huai-nan-tzu	
A	B	A	B
Perfections	Faculties	1. Heaven	Head
of world	of soul	2. Earth	Feet
1. Light	Sentient	3. Four seasons	Four limbs
2. Heat	Vital	4. Twelve months	Twelve joints
3. Movement	Animal	5. Sun and moon	Ears and eyes
4. Harmony	Rational	6. Wind and rain	Blood and bodily *ch'i*

In the proportional oppositions of *Huai-nan-tzu*, Heaven connects with Earth as head with feet (former above latter); the four seasons connect with the twelve months as the four limbs with their twelve joints (latter within former). On the paradigmatic dimension (similarity/contrast), the relation is here of similarity; Heaven compares with head as Earth with feet, allowing the possibility of using one as metaphor for the other. Kepler in fact shifts metaphorically from B to A, writing: "The adornment of the world consists in light; its life and growth in heat; and, so to speak, its action in movement; and its contemplation—wherein Aristotle places blessedness—in harmonies."[10] He also, at a point where his correlations approach *Huai-nan-tzu*'s Position 5, says the sun "is as if the eye of the world".[11]

Still avoiding the disputed issue of whether all thinking is at bottom binary, one may notice that the binary tends to leave out the maker of the opposition. 'Left/right', 'above/below', 'before/after' (not however 'I/you', 'here/there', 'now/then') imply a spatial or temporal centre from which the opposition is drawn, inviting the expansion of the pair to a triad. Thus in China the pair Heaven above and Earth below grows towards the end of the classical period to the triad Heaven, Earth and man. Kepler too has a taste for triads, with ourselves living on the third member (the planets,

among which Earth is itself a third, being located between the correlates of the primary and secondary regular solids). The symmetry of the following table provides one of the proofs by which the heliocentric theory won acceptance at the beginning of modern science.[12]

	A	B	Between/within
(God)	Father	Son	Holy Spirit
(Sphere)	Centre	Surface	Intermediate space
(Universe)	Sun	Stars	Planets

Fours and fives: the Five Processes

Turning now to larger paradigmatic sets, they tend to lack the apparent inevitability of binary oppositions. This inevitability is of course culture-bound, but even a Westerner with some experience of Chinese thought can generally guess which of a pair is Yin and which Yang; he is seldom so lucky correlating the Five Processes with the Five Colours or the Five Tastes. In China too, the Five Processes were never as deeply rooted in the tradition as the Yin and Yang. Larger sets are also harder to fit to the facts and to develop consistently. They function like the Western correlation of races with the colours white, yellow, red, brown and black, likewise branching from a pair, 'light/dark', which, if correspondences are not critically analysed, tends to correlate with 'good/evil'. Here naming is by contrast within the scheme rather than by adequacy to the object; the Mongol is to the eye often whiter than the Caucasian, American Indians are red because the brown people live in Asia and Polynesia. We classify peoples, indeed see them, as they are conventionally coloured; and schemes in other cultures similarly develop through contrast and resist conflicting observation. Lévi-Strauss has called attention to the elaborate correlative schemes of pre-literate cultures and to their resemblance to those of "the naturalists and hermetics of antiquity and of the Middle Ages, Galen, Pliny, Hermes Trismegistus, Albertus Magnus",[1] for example this one from the Hopis:[2]

	A	B	C	D	E	F
(Directions)	NW	SW	SE	NE	Zenith	Nadir
(Colours)	Yellow	Blue-green	Red	White	Black	Multicolored
(Animals)	Puma	Bear	Wild cat	Wolf	Vulture	Snake
(Birds)	Oriole	Bluebird	Parakeet	Magpie	Swallow	Warbler

The earliest schemes documented in China are in various calendars regulating the ruler's conduct throughout the year. The standard one is in

the *Lü Spring and Autumn*, from which it passed into the Confucian tradition as the 'Monthly Orders' in the *Record of Ceremony*, Chapter 6. While pairs correlate with Yin and Yang, sets of four or five correlate with what this text, like Tsou Yen,[3] calls 'potencies' (*te*), those of wood, fire, soil, metal and water, implicitly distinguishing their distinctive processes from the virtue or power by which each proceeds. We shall however follow later convention in speaking only of the Five Processes themselves. We have seen that Tsou Yen explained the rise and fall of dynasties by the conquest cycle already employed by the diviners of the *Tso Commentary*:[4]

> Soil (which dams water)
> Wood (which digs soil)
> Metal (which cuts wood)
> Fire (which melts metal)
> Water (which extinguishes fire).

The full correlation of the Five Processes with other fours and fives is not attested before the *Lü Spring and Autumn*; the *Kuan-tzu* miscellany has probably older calendrical schemes in which the Five Processes are missing, or attached in a subsidiary position, or fitted to five divisions of the year without correlations.* Their correspondences with the Four Seasons required a different sequence, which came to be interpreted as the order in which the Five Processes generate each other:

> Wood (which catches fire)
> Fire (which reduces to ash)
> Soil (in which metals form)
> Metal (which liquifies when melted)
> Water (which nourishes wood)

We first consider the structural relations of the more easily analysable of the *Lü Spring and Autumn* series (tastes and smells, for example, are too indefinite and affected by subjective influences for us to see clearly how the Five Tastes and Five Smells fit the structural relations).

Five Processes	A Wood	B Fire	Between Soil	C Metal	D Water
Numbers	8	7	5	9	6
Four Seasons	Spring	Summer	—	Autumn	Winter
Four Directions	East	South	(Centre)	West	North
Five Colours	Blue-green	Red	Yellow	White	Black
Five Creatures	Scaly	Feathered	Naked	Furred	Shelled
Five Notes	*Chüeh*	*Chih*	*Kung*	*Shang*	*Yü*

* *Kz* chs. 8, 9, 40, 41, 85. For the evidence for their relatively early date, cf. G *Yin-Yang* 84–89.

The numbers follow the enumeration of the Five Processes in the 'Great Plan' of the *Documents*,[5] continued into a second cycle to place 5 between 1–4 and 6–9.

Water	Fire	Wood	Metal	Soil
1	2	3	4	5
6	7	8	9	

The reason for the choice of higher numbers was no doubt practical; the coming Emperor who would reign by the potency of water would hardly be content, for example, to ride a chariot drawn by only one horse. But why does the enumeration in the *Documents* agree neither with the conquest nor with the generation cycles of the Five Processes? One might answer that it is older than either cycle, and perhaps merely an arbitrary order in enumeration. But then why would the later choice of numbers follow this order rather than either of the cycles which have a theoretical significance? One may suspect that it is the correlation of the numbers with the Four Directions which is most ancient, older than the Five Processes:

South 2

East 3 Centre 5 West 4

North 1
(We follow Chinese practice in putting North below South.)

The positions would be counted from the throne in the North from which the ruler faces South.

The central position in this diagram, corresponding to the 'Between' column of the table, represents the one left over from binary division, and in most cases is recognisable as the position from which the oppositions are drawn—the soil in which the other materials are grounded, the number 5 midway between 1 and 9, the centre from which one sees in the four directions, the creature without scales, feathers, fur or shell who is man, and the note *Kung* fundamental to the pentatonic scale. There is none for the Four Seasons because the only temporal centre corresponding to

'We' and 'Here' is 'Now'. The *Lü Spring and Autumn* shirks this difficulty by simply appending the correlations for the non-existent middle season at the end of the 6th month, the last of summer. The calendar in *Huai-nan-tzu*, Chapter 5, adopts the desperate solution of detaching the 6th month from summer as a separate season.

In inferring from sets of four or five it is not that one is applying a theory about the Five Processes, any more than one applies a theory about Yin and Yang to the binary oppositions. Inferences are from correspondences of series, which the introduction of the Five Processes into pre-existing schemes served to identify like the letters at the top of our columns. The basic correlation, fully rooted in observation and no doubt older than the Five Processes, is of the Four Seasons with the Four Directions. Within both there is a proportional opposition:

	A	**C**	**Paradigm**	**A**	**C**
1.	Spring	Autumn		East	West
	B	D		B	D
2.	Summer	Winter		South	North
Syntagm					

(Spring *compares* with autumn as summer with winter, spring *connects* with summer as autumn with winter, and similarly with the Four Directions).

The two sets correlate because in both of them A/C and B/D are observably the opposite positions of the sun in its recurring cycles, its temporal positions through the year and its spatial through the day:

<div align="center">

B
South
Summer

</div>

A East	Centre	West C
Spring		Autumn

<div align="center">

North
Winter
D

</div>

Thinking which starts from this correlation will already be predis-
posed to what may seem one of the oddest of ancient Chinese assump-
tions, that Heaven (Yang, so in motion) is round like the head, and Earth
(Yin, so at rest) is square or rectangular like the feet, following a chain
which we might simplify as follows:

A	B
1. Heaven	Earth
2. Motion round cardinal points	Rest at cardinal points
3. Round	Square

The fitting of the Five Processes to the pre-existing scheme seems at
first sight quite arbitrary, but once it is recognised that they have to fall into
two pairs and a remainder may be seen to be bound by the structural
relations. The numbers ascribed to them firmly identify the pairs:

1/2	3/4	5
6/7	8/9	
Water/fire	Wood/metal	Soil

Even without the numbers 'water/fire' is a solidly established pair
throughout the early literature; we have already noticed it in the *Huai-nan-
tzu* cosmogony,[6] which ignored the other three, and it is the only pair
shared by the Five Processes and the symbols of the Eight Trigrams in the
Yi. Soil is plainly destined for the isolated central position : wood grows in
it, fire rises from it, metal is buried in it, water sinks into it. The remaining
pair would therefore have to be 'wood/metal'. We saw in discussing the
Huai-nan-tzu cosmogony that as the opposite of fire it is the virtue of water
to withdraw into the dark and the cold, so that the fitting of 'fire/water' to
'summer/winter' would seem inevitable. One can imagine that at this
point the further observation that 'wood/metal' do contrast as 'spring/
autumn' (branches and leaves grow in spring and turn brittle, rigid,
metalic in autumn), and then that the whole sequence is interpretable as
the order in which the Five Processes generate each other throughout the
year,[7] would impress with a strong conviction of having perceived a true
structural relationship.

The fitting of the Five Colours lacks this inevitability. None of them
stands out as qualified for the central position, and the one established
opposition ('white/black') was not, as one might think theoretically
conceivable, accepted as corresponding to 'summer/winter'. An old
calendrical scheme in *Kuan-tzu* chapter 85, which links only the Four
Seasons with directions and colours, fits 'green/white' to 'spring/autumn'

(the contrast of vivid and paling leaves) and 'yellow/black' to 'summer/ winter' (the contrast of sunshine and darkness). With the introduction of the Five Processes into the scheme the second pair is changed to 'red/ black', and yellow, as the colour of soil, is reserved for the middle position.

Although the tight scheme of the Seasons, Directions and Processes loosens in extending to the colours and beyond, it interrelates remarkably with another sequence wholly independent of it, the conquest cycle of the Five Processes. Among Chinese proto-scientific concepts the conquest cycle stands out as independent of all correlations, and probably derives directly from observation of the basic resources at the workman's disposal. Struggling with water, fire, metal, wood or soil, there is little room for disagreement as to which of the others is most required to dam, quench, melt, cut or dig the resisting material. Granted that fire as well as metal can conquer wood, one burns wood to get rid of it or to warm oneself, it is metal which is used to shape it to one's will. In noticing that there is a single and *different* answer in each case (at any rate before metal superseded wooden spade and plough), and that the conquests connect in an unbroken cycle, one would seem to have discovered in the courses of action specific to the basic materials a regularity on Earth comparable to the cycles observed in Heaven ("Heaven has the Three *Ch'en* 辰 [sun, moon, stars], Earth has the Five Processes").[8] Why is it then, ancient cosmologist and modern structuralist are alike compelled to ask, that when the two independent sequences are compared, it turns out that in the one required to correlate with the seasons and directions each Process is generating the immediate predecessor of the Process which it conquers?

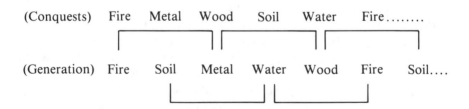

To answer that the fitting of the Processes to seasons and directions must have been guided by this symmetry would be to overlook the structural constraints which allowed no other option except to fit 'fire/ water' implausibly to 'spring/autumn' and 'wood/metal' to 'summer/ winter'. One can only suppose that the symmetry is an effect, accidentally surviving the interposition of soil, of pairs of oppositions having to adjoin in the conquest cycle (since conquest implies opposition) but stand on

facing sides of the square in the pattern correlating with seasons and directions. The Chinese cosmologists themselves have a much neater explanation. Like scientists subsuming under a wider law of nature, they discover a larger structure which accounts for both sequences. *Huai-nan-tzu* chapter 4 postulates that each of the Five itself passes through five stages of rise and decline:[9]

Birth	Wood	Fire	Soil	Metal	Water
Prime	Water	/Wood	Fire	Soil	Metal
Ageing	Metal	Water	/Wood	Fire	Soil
Immobilisation	Soil	Metal	Water	/Wood	Fire
Death	Fire	Soil	Metal	Water	/Wood

So at its prime each generates the one which is born and conquers the one which dies.

One's first impression that the correlations of Chinese proto-science are inherently loose and arbitrary requires some qualification. It has a structure which loosens as it expands, but with interrelations tight enough to impress a modern analyst as requiring explanation in his own terms, genetic explanation; he may see the system as growing and integrating under the influence of chance factors rather as an organism develops by incorporating chance mutations. (The looseness with which it has to be applied in accounting for phenomena is another matter). It is not that the conquest cycle as a series of relations is too vague for us to acknowledge it as significant—water does quench fire, which does melt metal—but that for us any cycle of physical relations between things selected and associated solely for their utility to man can only be accidental. From a modern viewpoint Chinese proto-science can be discovering significant connexions between phenomena only when there are indeed parallel causal relations between things contrasted as Yin or Yang, or there are causal relations with the seasons or the directions, the two strong correlates of the Five Processes. Where the system takes leave altogether of what nowadays we would recognise as fact, its fruitful possibilities will presumably be limited to the mathematical relations of numerology. Here we may consider a problem raised by the numbers in the correlations.[10] The Five Processes and their numbers correlate, as we have seen,* with the four cardinal points arranged as in a mandala around a centre.

* Cf. p. 342 above. For the importance of variations on this mandala-like figure throughout Chinese culture, cf. Major, 'Five Phases'.

2,7
Fire

3,8 Wood Soil 5 Metal 4,9

Water
1,6

This, with some further elaborations, is the diagram which from the Sung dynasty (A.D. 960–1279) was identified as the 'River chart' (*Ho t'u* 河 圖) mentioned in the 'Great Appendix' of the *Yi*.[11] Reading from Soil at the centre through Metal and proceeding clockwise this gives the generation cycle (Soil, Metal, Water, Wood, Fire, Soil). Reversing Fire and Metal and reading through Wood one would have the conquest cycle (Soil, Wood, Metal, Fire, Water, Soil).

4,9
Metal

3,8 Wood Soil 5 Fire 2,7

Water
1,6

Suppose now we fill the intermediate positions with the Yin or even numbers, placed behind the Yang or odd. This forms the diagram recognised since the Sung as the 'Lo document' (*Lo shu* 洛書) of the 'Great Appendix'.

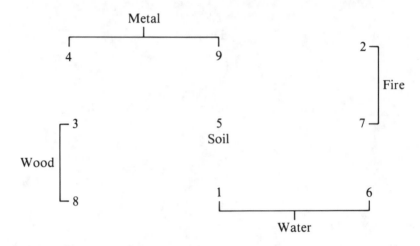

Why has this procedure resulted in a magic square, with the numbers adding up to 15 in every direction? Is it possible that the magic square was first discovered by this very operation? It is documented in China from the 1st century A.D.,[12] earlier than in any other civilization,[13] and became a speciality of Chinese mathematics, which by the 13th century had developed magic squares to the order of 10. An alternative solution which has been proposed† is that the numbers of the Five Processes were themselves derived from a magic square interpreted as a symbol of the conquest cycle. If so, the order of enumeration in the 'Great Plan' derives not from the position of the throne but from the magic square, which must be some 500 years earlier than its first documentation.[14] It may seem that the first proposal assumes a nearly incredible mathematical coincidence which the second eliminates. But this impression fades on closer examination. The Five Processes are a set of five each allotted a number and the number plus five. When the mandala-like grouping round a centre is extended from the cardinal to the intermediate points we have a five surrounded by pairs of numbers separated by five, which is already approaching the magic square. A numerologist at work on it will be trying out every option looking for some fascinating symmetry. All six ways of arranging the even numbers at the corners will make a diagram readable either clockwise or anti-clockwise as representing the conquest, the generation or the 'Great Plan' order. The one which makes the magic square happens to lead to the conquest order, but would have been equally impressive if it had led to one of the others. The agreement with

† Major now prefers this alternative solution, 'Five Phases' 163 n17

the conquest cycle is therefore irrelevant; what matters is that the prospect of the magic square was latent from the start in the allotment of numbers to a group of five correlated with centre and cardinal points. Whether or not the discovery was made in this way—it is not a question to which one would expect a definitive answer—this well illustrates the possibility of speculation about the Five Processes leading to an important discovery. To the numerologist himself of course the agreement with the conquest order would seem highly relevant. One can imagine the joy and wonder of discovering that in the *observed* order in which the basic materials of Earth conquer each other (for anyone can see that fire melts metal, metal cuts wood, and so on round the cycle) each one at every stage is united to all the rest by changing numbers which always add up to the same. Better still, the outer four derive from Soil at the centre through the two of Yin and Yang; the numbers on either side of five always add up to twice five. The discovery of the Inverse Square Law of gravitation itself would hardly have made a stronger impression of seeing right through to the mathematical secret of the cosmos.

Another line of thought springing from the contemplation of this mandala fitted to the cardinal points is traced by Needham in v. 4/1 of *Science and Civilization in China.* The importance of placing oneself in relation to the cosmic influences inspired an exploration of the South-pointing property of the lodestone and then of magnetised iron, and its use in geomancy and, from about A.D. 1100, in navigation. The principle of needle and dial, so fecund for technology, seems to have been the discovery of Chinese diviners and geomancers, whose compass has the needle pointing to the Five Processes and the Eight Trigrams of the *Yi* as well as to the cardinal points. The invention and development of the compass, however, in having to survive the practical testing of effects, brings us down to the realm of causal thinking, irrelevant to proto-scientific cosmology. Causal thinking would have to be the main factor in the extraordinary fertility of invention in China. We have insisted throughout that the organising of proto-sciences by correlation within a society's patterning of concepts has nothing to do with the extent to which the concepts are being used for causal explanation and practical invention, and that the only technology proper to correlative cosmos-building itself is magic, as in Renaissance Europe, where Kepler earned his living as a court astrologer and Giordano Bruno, the great defender of the Copernican hypothesis, was primarily a master of the hermetic and cabbalistic arts.[15] Magical thinking follows directly from correlative by confusion of the metaphoric and metonymic with the literal, so that one sticks pins in the

wax image (Frazer's 'homoeopathic' magic) or practises on a strand of hair or a glove (his 'contagious' magic) as though they were the enemy himself. Frazer, as Jakobson noticed, distinguished the two kinds of magic by the same terms 'similarity' and 'contiguity' by which he himself distinguishes paradigm and syntagm.*

We have so far been treating pre-Galilean cosmologies with some condescension as mere proto-science, the superseded predecessors of Newtonian physics. But a cosmos of the old kind has also an advantage to which post-Galilean science makes no claim; those who live in it know not only what is but what should be. In correlating one is not yet detached from the spontaneous comparing and connecting which precedes analysis, in which expecting the same as before one is already responding in favour of it or against; in anticipating what will happen one knows how to act. The objectivised world of modern science dissolves this primitive synthesis of fact and value, and in facilitating successful prediction leaves us to find our values elsewhere. Many are unhappy to be thus exiled from the sources of value; Westerners today who toss coins to read the hexagrams seem actually to feel more at home in the traditional cosmos of China. There man still stands at the centre of things in interaction with the rest, and has only to contrast A with B to respond to them immediately as superior and inferior, better and worse.

Seen from this direction as a scheme relating man to community and cosmos, a correlative world-view discloses a much more favourable aspect. The primary social institution, language, is the one with which it fully shares its structure and for which correlative thinking is perfectly adequate; although one may have to analyse paradigms and syntagms in order to learn a language, one can speak it only when correlating them without analysis. Institutions in general require that for most of the time we adjust to pattern automatically, analysing only when faced with an occasion for choice. Politics, sociology, and psychology have never attained that purity of analytic thinking which, on the analogy of physics, should be required by their claim to be 'sciences'. Apart from all theories, much of ordinary practical life belongs irrevocably to correlative thinking. So does thinking in the arts; and any correlative cosmology is poetically stimulating to those in sympathy with it, a treasury of metaphor and metonym. The thinking which relates 'white/black' to 'West/North', 'autumn/winter' or 'metal/water' no longer looks silly when it relates them

* Frazer 12. "Homoeopathic magic is founded on the association of ideas by similarity: contagious magic is founded on the association of ideas by contiguity." Cf. Jakobson v. 2/258

to 'weddings/funerals', nor is one embarrassed that the Chinese choose white for funerals and the West black. Even the scientific pretensions look better from the social perspective. They provide a solution to the universal problem of how to act in insufficient knowledge. When information is inadequate, it is better to decide by a diviner's prediction than not to decide at all, not to mention that a suitably opaque prognostication may stimulate rather than exempt from thought and decision.

In tabulating correlations of fives we did not explain their function in the source used, the calendrical chapters of the *Lü Spring and Autumn*.

We repeat the major correlations.

	A	B	Between	C	D
(Five Processes)	Wood	Fire	Soil	Metal	Water
(Four Seasons)	Spring	Summer	—	Autumn	Winter
(Four Directions)	East	South	(Centre)	West	North
(Five colours)	Blue-green	Red	Yellow	White	Black

Throughout the year the Yang *ch'i* waxes at the expense of the Yin up to the solstice in the fifth month (the mid-summer month) and then wanes in favour of the Yin up to the solstice in the 11th month (the mid-winter month). With each season the Grand Historiographer announces which of the potencies of the Five Processes is now in ascendancy, robes are changed to the appropriate colour, and the ruler occupies the appropriate quarter of the palace, from East to South to West to North, moving from month to month through the three rooms of a quarter. Thus at the beginning of the year, when "the East wind melts the ice and the hibernating insects stir," the Historiographer reports "Such-and-such a day is the start of spring; the fullness of potency is in Wood." The ruler, wearing blue-green, then leads out his nobles to welcome spring in the East suburb, rewards civil officials, issues orders to be merciful and bountiful to the people, pushes the plough three times to encourage farming, and commands the superintendant of agriculture to take up residence in the East suburb. Correspondingly, when "the chill winds come, the white dew falls and the cold cicada chirps" the Historiographer reports "Such-and-such a day is the start of autumn; the fullness of potency is in Metal." The ruler wearing white leads out the nobles to welcome autumn in the West suburb, rewards this time his military officials, and issues orders to learn the laws, repair the prisons and punish crime. Each month of the calendar ends with a warning against neglect of the prescribed ritual and practical measures.

"If in the first spring month you enact the orders for summer, wind and rain will be untimely, grass and trees will wither early, the state will suffer alarms. If you enact the orders for autumn, the people will suffer plagues, whirlwinds and rainstorms will come frequently, brambles and weeds will spring up densely. If you enact the orders for winter, there will be damage from floods and disaster from snow and frost, and the first sowing will not take root."[16]

With the conduct of the ruler through the four seasons we may compare the regime throughout the year recommended as healthy in chapter 2 of the medical classic *Inner Classic of the Yellow Emperor (Huang-ti nei-ching),* uncertainly dated but not far from the same period. While the ruler imitates Heaven by being generous in spring and stern in autumn, the healthy man helps the *ch'i* of the body (the vital forces nourished by the *ch'i* which are influences in the atmosphere) to revive in the kindness of spring and survive the severity of autumn. Both accounts conclude each sequence by recording the consequences of behaviour inappropriate to the season. In both, correlation with the seasons presents the problem of having to omit the middle member of the five, which in the case of the Five Viscera of the medical classic is the spleen.

	A	B	C	D
(Four Seasons)	Spring	Summer	Autumn	Winter
	Coming to life	Growing up	Gathering in	Storing away
(Five Viscera)	Liver	Heart	Lungs	Kidneys

The second position transfers metonymically from the crops to the *ch'i* of the body.

"The three months of spring one calls 'the issuing and laying out'.
Together Heaven and Earth give life,
The myriad creatures thereby blossom.
Sleep at night and rise early,
Stroll at ease around the yard,
Loose the hair, relax the body,
Allow intent to come to life.
Let it live, don't kill it:
Give to it, don't steal from it:
Reward it, don't punish it.

"This is the response to the *ch'i* of spring, the way to nourish the coming to life. If you go against it you harm the liver and in summer will suffer from chills; there will be too little provision for the growing up.

"The three months of summer one calls 'the thriving and fulfilment'.
The *ch'i* of Heaven and Earth mingle,
The myriad creatures flower and ripen.
Sleep at night and rise early,
Don't be too greedy for the sunshine,
Don't let intent get out of hand,
Let flowering fulfil its growth,
Allow the *ch'i* to seep out from you,
As though the not-to-be-wasted were outside.

"This is the response to the *ch'i* of summer, the way to nourish the growing up. If you go against it you harm the heart and in autumn will suffer from fevers; there will be too little provision for the gathering in.

"The three months of autumn one calls 'the contained and calm'.
The *ch'i* of Heaven is then gusty
The *ch'i* of Earth is then bright.
Sleep early, rise early,
Be up with the cock.
Keep intents firm and stable,
To ease the penalties of autumn.
Gather in the harvest of daimonic *ch'i*,
Keep the *ch'i* of autumn calm.
Don't let intent stray outside,
Keep the *ch'i* in the lungs clear.

"This is the response to the *ch'i* of autumn, the way to nourish the gathering in. If you go against it you harm the lungs and in winter will suffer from diarrhoea; there will be too little provision for the storing away.

"The three months of winter one calls 'the shutting up and storing away'.
Water freezes, ground cracks,
Don't put strain on the Yang.
Sleep early, rise late,
Be sure to wait for the sunshine.
Keep an intent as though lurking, hiding,
As though it were a private thought,
As though you had succeeded already.
Avoid the cold, stay near the warm,
Don't allow the seeping through the skin
Which lets the *ch'i* be quickly stolen away.

"This is the response to the *ch'i* of winter, the way to nourish the storing away. If you go against it you harm the kidneys and in spring will suffer from impotence; there will be too little provision for the giving of life."[17]

Western medicine for some two thousand years used the same sort of correlations to explain the seasonal variations of diseases, as already in the Hippocratic *Nature of Man* (c. 400 B.C.).[18]

	A	B	C	D
(Four seasons)	Spring	Summer	Autumn	Winter
	Hot-and-wet	Hot-and-dry	Cold-and-dry	Cold-and-wet
(Four Humours)	Blood	Yellow bile	Black bile	Phlegm

This system relates to the Four Elements as the Chinese to the Five Processes, with 'fire/water' correlating with 'summer/winter' in both:

A	B	C	D
Air	Fire	Earth	Water

Both the royal calendars and the medical regime place us in a world which is not, like that of Newtonian science, bound by invariable law. The interactions of things are seen as either orderly or chaotic; they are orderly to the extent that in the symmetries of space and cycles of time the harmonious are together and the conflicting apart. The correlation of Four Directions with Four Seasons establishes the framework of an order in which the contrasting (paradigmatic A, B) are distributed in spatial and temporal positions which do not conflict, while the connected (syntagmatic 1, 2) stand together harmoniously in the same positions. This cosmology differs also from modern science in that man's action belongs within the total interaction, supporting or disturbing the order. That it is inside the interaction is especially plain in the medical account, where the *ch'i* of the body is responding through the seasons to the *ch'i* of the atmosphere; even the 'intent' *(chih)*, a word we met first in the sayings of Confucius,[19] the nearest in Classical Chinese to our 'will', is far from being a Kantian will detached from spontaneous inclination, it is impulse roused by spring and stabilised by autumn. In the sense that a regular recurrence exciting an impulse to corresponding movement is called a 'rhythm', the cycle of the seasons is not merely a recurrence usable for prediction but a rhythm with which man like other creatures stays in step. When the ruler issues largesse in spring and punishes in autumn, it is not at all that he observes nature objectively and infers how to act from a set of

artificial analogies and a logically unjustified jump from 'is' to 'ought'; he is spontaneously moved to generosity by the kindly breath of spring and to just wrath by the breath of autumn which kills the leaves when their time has come. To interfere with the natural rhythm which inclines him to benignity in spring and severity in autumn would damage his own capacity to reconcile the conflicting demands of the Benevolent and the Right. Nor is there anything artificial in his wearing green in spring and white in autumn; they are the colours which by Chinese custom will put him in the mood to respond fully to the seasons, as in Western culture the spirit in which you participate in a wedding or funeral is assisted by the bride wearing white and the mourner black.

In this cosmos it is hard to recognise the line we are accustomed to draw between fact, which belongs to science, and value which is outside it. Let us ask once again, for the last time, our recurrent question as to whether the line is genuinely absent or merely obscured. Suppose we try to draw it, taking as example the proportional opposition 'spring : bounty :: autumn : punishment'.

Paradigm Spring compares with autumn as bounty with punishment.
Syntagm Spring connects with bounty as autumn with punishment.
How *does* Heaven act in the two seasons?
Heaven generates life in spring and kills it off in autumn.
How *ought* the ruler to act?
The ruler ought to be bountiful in spring and punish in autumn.
How *ought* one to take care of one's health?
One ought to indulge the body in spring and restrain it in autumn.

The question is whether there is here a hiatus between 'does' and 'ought to do'. That word 'ought', which has no equivalent in the Chinese texts (although they do use the negative imperative), seems not quite apt; the texts tell us not what man ought to do but what he is stimulated to do when the cosmic interactions are orderly. Shall we look for the 'ought' further back, in an obligation to take the measures which maintain rather than disturb the order? But in the medical example one is not taking the measures good for one's health because one judges order better than disorder; they are the measures one is moved to take when one understands how the seasons act on the body. Similarly the actions prescribed for the ruler are the ones to which he is spontaneously moved, within the interactions of Heaven and Earth, *if* he understands how things compare and connect. Man is in spontaneous interaction with things, but responds differently according to the degree of his understanding of their similarities and contrasts, connexion or isolation. The 'ought' then finally

detaches itself as an imperative to know how things compare and connect, in particular whether in connecting they support or conflict with each other, which is to know their patterns (*li*) and the Way which unites them all; to know what to do is to know what one would be moved to do in the sage's full knowledge of how things are related in fact. Once again then value separates from fact only as the value of wisdom itself.

A Kuan-tzu cosmology based on water

The *Wu hsing*, which we translate 'Five Processes', were until recently generally known in English as the Five Elements. They differ however from the Four Elements of Greek and Mediaeval philosophy (fire, water, earth, air, which share three of the five) in not being conceived as the constituents of things; they are related to the myriad things not by composition but by generation. Not that the resemblance is altogether fortuitous. The Greek difficulty about reconciling Being with change tended to convert into unchanging elements variously combined what at first were, as in China, the sources or stages of generative process. The Four Elements as presented by Empedocles (c. 450 B.C.) were called the 'Four Roots' (*rizōmata*). Among them air had been chosen by Anaximenes (c. 550 B.C.) as the original stuff which by condensation becomes in turn fire, wind, cloud, water, earth, stone, an exceptionally close parallel with the condensing *ch'i* of China. Thales (c. 600 B.C.), remembered as the earliest of Greek philosophers, was credited in retrospect with treating water as the primary stuff, although we cannot be sure that he claimed more than that things in some way originated in water.[1] Thales too has a Chinese parallel, the author of the 'Water and Earth' chapter of *Kuan-tzu*. Like the *Kuan-tzu* calendar chapters, this conflicts in some respects with the cosmology which crystalised about 250 B.C., and is likely to be earlier. It mentions neither Yin and Yang nor the Five Processes, and has unorthodox correlations of the Five Tastes with the Five Viscera.

"Earth is the original source of the myriad things, the root of all that lives, that from which beautiful and ugly, worthy and unworthy, foolish and eminent are born. Water is the blood and *ch'i* of Earth, like that which courses through the muscles and veins. Hence it is said 'In water the stuff of everything is complete".[2]

The stuff (*ts'ai*) of a thing is the material in it on which its functions depend (for example, the stuff a man is made of, his talents). The proof that all *ts'ai* are latent in water is the presence in it of the moral virtues,

from which we select humility, an example we have met already in *Lao-tzu*.[3]

"While all men aim for the heights, itself alone aiming downwards is humility."

But it is not only the moral which emerges from water.

"The water-level is ancestor of the Five Measures,* the pallid is the substance of the Five Colours, the insipid is the mean between the Five Tastes."

Water is present everywhere, metal becomes it in melting (it will be remembered[4] that in the generation cycle too, Metal generates Water), and the growth of living things depends on the quantity of water imbuing them.

"This is why there is nothing it does not fill, nowhere it does not reside. It gathers in Heaven and in Earth, and is stored within the myriad things; it is engendered from metal and stone, and gathers in all that lives; hence it is said, 'Water is daimonic'. When it gathers in herbs and trees, the root gets its measure from it, the flowers their number from it, the fruit their dimensions from it. When birds and animals get it, bodies are plump, fur or plumage thrives, articulation of members is clearly manifest; that the myriad things all fulfil the prospects of their germination and attain the norm for them is because there is the proper measure of water within."

Water is described as 'gathering in', as 'generating' or as 'becoming' all the various kinds of thing. Man himself grows from a mingling of fluids.

"Mankind is water. When the quintessential *ch'i* of man and woman combine, the water flowing takes shape."

In the third month of gestation the Five Tastes begin (sour, salt, acrid, bitter, sweet), presumably from the insipidity characteristic of water; these generate the Five Viscera (spleen, lungs, kidneys, liver, heart), which then generate the rest of the body. By the fifth month eyes, ears and other sense organs have opened, so that by the time of birth in the tenth month we can see, hear and think, all because water "congealed and inert, became man".

Among other beings, the tortoise and the dragon owe their daimonic powers to being born from water. The author now transfers to water the claim he originally made for Earth.

* The Five Measures are likely to be the five enumerated in *Kz* (ch. 78) 3/87, the counterpoise and beam of the steelyard, compasses and L-square, and the water-level. As the odd one left over from the rest the water-level would be in the basic position, like Soil in the Five Processes.

"I say then, what is water? It is the original source of the myriad things, the ancestral home of all that lives, that from which beautiful and ugly, worthy and unworthy, foolish and eminent are engendered. How do we know that this is so?"

He answers by arguing that the temperamental differences between the peoples of the seven major states result from differences in the local waters, and draws the practical conclusion that the sage ruler morally transforms his people by ensuring that the water throughout the state is the same and is pure.

The interest of this essay is in seeing Chinese thought on one of its by-paths coming to what in the West is the first recorded philosophical idea, but discarding it to continue on its own course.

The *Yi*

During the Shang dynasty one divined by the cracks formed by burning holes in bones or tortoise shells; the prognostications written on them provide the bulk of the earliest Chinese inscriptions. During the early Chou this method of divination was partially replaced by a system employing 64 hexagrams, figures composed of 6 broken or unbroken lines. The hexagrams may be seen as combinations of 3-line figures, the 'Eight Trigrams', a possibility which follows from the fact that 64 is the total of choices of alternatives for six lines. All are built up from the bottom, each successive line selected by a procedure for arbitrarily distributing and then counting off yarrow sticks. The hexagrams, together with written auspices for the lines and for the figures as wholes, compose the oldest layer of the book called the *Chou Yi* ('*Yi* of Chou'), called also since its recognition as a classic the *Yi ching* ('*Yi* classic').* It is a manual of

* The two major English translations of the *Yi* are by James Legge (first published as *Yi King* in the *Sacred Books of the East*, 1882) and by Caryl F. Baynes from the German version of Richard Wilhelm (first published as *I Ging: das Buch der Wandlungen*, Jena 1924). Legge was a great 19th-century sinologist trying to be fair to a book altogether foreign to him; Wilhelm on the other hand, although his version is much freer, had a profound sympathy for the *Yi*, and attracted attention to it outside scholarly circles by introducing it to the analytic psychologist Jung. I therefore give references for translated passages to the Wilhelm-Baynes version; but my translations (which are more literal, and benefit from the advances in Classical Chinese grammatical studies over the last half century) are sometimes so different that readers hunting up the context may have trouble finding them on the page.

The principal appendix to the *Yi* is the *Hsi tz'u chuan* ('Commentary on the Attached Verbalisations') or *Ta chuan* ('Great Commentary'). I follow Legge in calling it the 'Great Appendix'; Wilhelm-Baynes has it as the 'Great Treatise'.

divination without philosophical relevance, and although the *Tso Commentary* records statesmen as consulting it as far back as 674 B.C., there is no certain reference to it by a philosopher before Hsün-tzu, who still does not include it among the Classics.[1] The Ch'in 'Burning of the Books' spared writings on divination including the *Yi*; its availability, and the temptation for persecuted people to trust in omens, would explain the growing interest of Confucians in the one relic of Chou culture which they had neglected. Most or all of the appendices called the 'Ten Wings', which relate the diagrams to cosmology, later to be ascribed to Confucius himself, may be dated within a few decades on either side of 200 B.C.†

The meaning of *Yi* as the name of a system of divination is obscure, like much else in the terminology of the ancient manual. The graph (易) represents two words originally distinct in pronunciation,[2] *yi* 'easy' and *yi* 'substitute, exchange' (X replacing or changing places with Y), which with *hua* 化 'transform' (X changing into Y) and *pien* 變 'alter' (X changing but remaining X), is one of the three major Chinese words translatable by 'change'. Once the replacements of lines or diagrams were conceived in philosophical terms as corresponding to such cosmic changes as sun alternating with moon the title was identified as *Yi* 'substitutions, exchanges', and it is therefore commonly translated 'Book of Changes' (or with less justification, 'Book of Change'). But Fung Yu-lan, the great 20th-century historian of Chinese philosophy, lent his authority to the theory that the name *Yi* was originally understood as 'easy'.[3] That the *Yi* was intended as 'Divination Made Easy' may seem odd to the modern reader struggling with one of the most difficult of Chinese texts, but in comparison with the reading of oracles in the cracks of bones and shells the Chou system with automatic procedures for selecting from written auspices may well have appealed as a rationalisation, a simplification. The issue would not be material if by the time of the Appendices, when the *Yi* became philosophically significant, it was already understood as 'the Changes'. But in fact the predominant use of the graph in the Appendices is for *yi* 'easy'. They do once say, referring to the 'hard' (unbroken) and 'soft' (broken) lines taking each other's places in the diagrams, that "the hard and soft substitute [*yi*] for each other", also that "the hard and soft pushing each other aside generate the alterations and transformations", and that "sun and moon push each other aside and light is generated from them. . . . Cold and hot push each other aside and the year is completed by them."[4] But although the *Yi* is not only the substitutions of the diagrams

† For the distinguishing and dating of successive layers of the *Yi* text, cf. Shchutskii 129–195. For the dating of the appendices, cf. Fung v. 1, 381f, Peterson 71–77.

but the pattern of universal process which they symbolise, there is no clear example of *yi* used for the cosmic changes themselves, which are called alterations and transformations. We read that "Heaven and Earth have established positions and the *Yi* proceeds between them," but also, of the diagrams Ch'ien (Heaven) and K'un (Earth), "Ch'ien and K'un have a completed arrangement and the *Yi* goes on *standing* between them".[5] Since it is not clear that *Yi* yet means 'Changes' even for the writers of the Appendices, I leave it untranslated.

The evolution of binary oppositions (with the possibility of the 'Between' supervening at any stage) has a numerical structure, which for Chinese cosmology is the structure of the cosmos itself. Among the classical thinkers, whose cosmos is no more than Heaven and Earth proceeding along the Way through the Four Seasons, the author of *Lao-tzu* has a glimpse of it:

"The Way generates the One, the One generates the two, the two generate the three, the three generate the myriad things."[6]

The 'Great Music' chapter of the *Lü Spring and Autumn* has a fuller account:

"The source from which music comes is far back. It is born from measure, rooted in the Supreme One. The Supreme One emits the Two Exemplars, the Two Exemplars emit the Yin and Yang, the Yin and Yang alter and transform. . . . The Four Seasons arise in turn, now hot now cold, now short now long, now soft now hard. At the source from which the myriad things issue they are set going by the Supreme One, are transformed by the Yin and Yang."[7]

It is in the ancient diagrams of the *Yi* that cosmologists discovered the perfect symbolism for the numerical structure of the evolving cosmos. When the broken and unbroken lines are identified with Yin and Yang, the building upwards of the hexagrams line by line with two choices for each line corresponds to the successive stages in the generation of things.

"Therefore in the *Yi* there is the Supreme Pole, which generates the Two Exemplars. The Two Exemplars generate the Four Models, the Four Models generate the Eight Trigrams, the Eight Trigrams fix the auspicious and the baleful." (Great Appendix A,11, tr. WB 318 f)

The two alternatives at the first step are the 'exemplars' of all pairs (Heaven and Earth, Yin and Yang. . . .), the four at the next step are the 'models' of all fours (Four Seasons, Four Directions. . . .), the eight at the third step are the trigrams, and so on up to the 64 hexagrams. The trigrams have a wide range of symbolism expounded in the appendix 'Exposition of the Trigrams', but represent primarily the four pairs Heaven/Earth,

mountain/marsh, water/fire, thunder/wind. This symbolism, attested in the 4th century B.C. in the *Tso Commentary* as already current among diviners,[8] is independent of the system of the Five Processes, nowhere mentioned in the *Yi*.

Eight Trigrams

K'un	Ken	K'an	Sun	Chen	Li	Tui	Ch'ien
Earth	Mountains	Water	Wind or wood	Thunder	Fire	Marshes	Heaven

Four Models

Two Exemplars

↑

Supreme Pole (unsymbolised)

Continuing to build upwards stage by stage one arrives at the 64 hexagrams, not however in the order of their arrangement in the book, but in the 'Ahead of Heaven' order, first attested in the numerology of Shao Yung (A.D. 1011–1077). For a modern reader, the perfection of the diagrams as symbols of binary unfolding is confirmed by the fact that if he substitutes the figures 0 and 1 for the broken and unbroken lines he can at each level read off the binary numerals counting from 0.

Two Exemplars: 0,1

Four Models: 00, 01, 10, 11 (Decimal numerals 0 to 3)

Eight Trigrams: 000, 001, 010, 011, 100, 101, 110, 111 (Decimal numerals 0 to 7)

The completed hexagrams in the 'Ahead of Heaven' sequence then read as the binary numerals from 0 to 63. This correspondence has attracted the attention of Westerners ever since Leibniz, who noticed it almost immediately after he had established the foundations of binary arithmetic.[9] Not that the Chinese had discovered binary arithmetic, for the number ascribed to the unbroken or Yang line is 1 and to the broken or Yin line is 2. They supposed themselves to have discovered the structure of the cosmos (which indeed was its significance for Leibniz), and had indeed

discovered the structure of binary thinking as it organises a cosmos, the pattern in the unfolding of "the first of the metaphysical oppositions, that between the same and the other", which for Kepler too was still not the start but the end of cosmology.[10] From another point of view, this system unfolding from an origin unsymbolisable within the system, laying down both how things develop and how one is to respond to them as auspicious or baleful, is the perfect formulation of what Chinese thought understands by the Way.

An implication of the system is that any concrete phenomenon or situation will, when analysed into 6 stages, share the structure of one of the 64 hexagrams, and of the various images correlated with the hexagram and its parts. These structures and the images which exhibit them are called *hsiang* 象 , here translated 'models'. *Hsiang*, primarily 'elephant, ivory', may have assumed this meaning through carved ivories, but there is a different explanation in Han Fei's 'Interpretation of *Lao-zu*' which is illuminating even if grounded in a misunderstanding.

"Men seldom see a live elephant, but finding the skeleton of a dead elephant they rely on their picturing of it to imagine it alive. Therefore everything people use to get the idea of or imagine is called a *hsiang*."[11]

This suggests that the *hsiang* is like a skeleton to be fleshed out, a structure rather than a delineated image. According to the Appendices the diagrams were invented in order to display these structures.

"In ancient times when Fu-hsi reigned over the world, looking up he observed the models in Heaven, looking down he observed the standards on Earth. He observed the markings on birds and animals, and how things fit together on Earth, and took comparisons near at hand in himself and far away in other things. Then he invented the Eight Trigrams, in order to fathom the potency of the daimonic and clear-seeing, in order to arrange the essentials of the myriad things according to their kinds." ('Great Appendix' B 2, tr. WB 328f)

"Therefore, as for the models, the sage has the means to see the occulted in the world, and finds analogues for it in his representations. He models on the fitting together of things; this is why they are called 'models'." ('Great Appendix' A 12, tr. WB 324)

The models correlate with Ch'ien and Heaven; fully shaped things (which as means at man's disposal are called 'instruments') correlate with K'un and Earth.

"In Heaven they become complete as models, on Earth they become complete as shapes." ('Great Appendix' A 1, tr. WB 280)

"Repeated generation is what is called the *Yi*, the completion of

models is what is called Ch'ien, the imitation of standards is what is called K'un." (*ut sup.* A 5, tr. WB 299f)

"Visible it is called the model, shaped it is called the instrument." (*ut sup.* A 10, tr. WB 318)

The *hsiang* 'model' is the only ancient Chinese concept which reminds one of the ideas and universals of our own Platonist tradition, but is in several respects profoundly different. Ancient Chinese theories of naming (in the *Canons* and Hsün-tzu), being 'nominalist' in that particulars are assumed to be named by similarity to one of them taken as standard, have no place for universals. The sophism "The L-square is not square, the compasses cannot make circles"[12] suggests recognition that any drawn geometrical figure is imperfect, but there is no suggestion in the literature that perfect squares and circles are to be found somewhere outside the material world. Things of the same kind seem to be conceived in the Appendices not as reproducing one model but as resembling many; models have the multivalence of poetic images. Moreover, although less substantial than fully shaped things, they are not essentially different. The models which Fu-hsi saw in Heaven are none other than the heavenly bodies, things which existing in the rarified regions above have not assumed definite outlines, and which as omens serve as models for human action.

"Of the suspended models which are manifest and bright none is greater than the sun and moon. . . . Heaven suspends models to show the auspicious and the baleful." ('Great Appendix' A 11, tr. WB 319f)

The Way itself is only relatively insubstantial; material things with their different uses for man are the Way above assuming shape below.

"Ch'ien and K'un have a completed arrangement and the *Yi* goes on standing between them. If Ch'ien and K'un broken down, there would be no means of seeing the *Yi*; if the *Yi* were invisible, Ch'ien and K'un might be on the verge of ceasing. Therefore what is above the taking of shape is called the Way, what is below the taking of shape is called the instruments." ('Great Appendix' A 12, tr. WB 322f).

This passage was to become a crux in the controversy between dualists and monists in the Neo-Confucianism of the Sung and later.[13] But for a reading of the Appendices in their context in the classical age a dualist interpretation must be rejected as anachronistic.

The awakening of interest in the ancient diagrams of the diviners opened a new approach to the problem of communication. The Later Mohists and Hsün-tzu had trusted verbal language and theorised about the fitting of names to objects; Chuang-tzu and the *Lao-tzu* author on the

other hand had exposed the limitations of language. In the *Yi*, Confucians discovered a new set of symbols conceived as iconic, diagrams structurally related to phenomena both directly and through the models. It was now possible for them to agree with Taoists about the inadequacy of words without losing faith that everything is symbolisable. The solution is put in the mouth of Confucius himself:

"The Master said: 'Writing does not exhaust the said, saying does not exhaust the idea.' Then would it be that the ideas of the sages are unseeable? The Master said: 'The sages established models to exhaust the ideas, provided diagrams to exhaust genuine and false, attached verbalisations to them to exhaust what they had to say.'" ('Great Appendix' A 12 tr. WB 322).

The *Yi* also satisfied the Confucian need for a cosmology which would close the gap between Heaven and Man by rooting morality in the cosmic order. Once the unbroken (Ch'ien) and broken (K'un) lines are identified as Yang and Yin, the first two hexagrams (☰☰, ☷☷), doublings of the trigrams Ch'ien and K'un and called by the same names, come to represent all Yang-Yin pairs (Heaven/Earth, high/low, moving/still, hard/soft, sun/moon, hot/cold, male/female), throughout which the superiority of A over B is seen as self-evident.

"Heaven being august and Earth lowly, Ch'ien and K'un are fixed. Lowly and high being set forth, noble and base are in position. Moving and still having constancy, hard and soft are decided. . . . Sun and moon proceed in cycles, cold and hot alternate. The Way of Ch'ien completes the male, the Way of K'un completes the female. Ch'ien is in charge of the first beginnings, K'un originates the completed thing." ('Great Appendix' A 1, tr. WB 280, 284f).

The cosmology is seen as confirming an essentially Mencian view of human nature.

"Yin and Yang in alternation is what is called the Way. The successor to it is the good, the completer of it is one's nature. The benevolent seeing it call it 'benevolence', the wise seeing it call it 'wisdom', the people employ it daily without knowing it." ('Great Appendix A 4, tr. WB 297f)

Good and bad are assumed to originate with the polarities; the Way itself seems never to be described as good by the classical philosophers. As an example of Yin and Yang alternating we may take Hexagram No. 37, Chia-jen, 'the household' (☲☴, equivalent to ABABAA). The two most important lines of a hexagram are the central ones of the two component trigrams, Nos. 2 and 5 counting upwards, the most important of all being No. 5, since it is in the upper or outer trigram. We see that a Yin or broken

line, which in the household corresponds to woman, rightly occupies No. 2 in the lower or inner trigram, while a Yang or unbroken line, so male, has its proper place at No. 5.

"In Chia-jen woman has her correct position inside the house, man his correct position outside the house. Man and woman being correct is the supremely fitting between Heaven and Earth. Chia-jen has stern rulers in it, namely father and mother. Father acting as father, son as son, elder brother as elder brother, younger brother as younger brother, husband as husband and wife as wife, the Way of the family is correct. Correct the family and the whole world is settled." (Hexagram No 37, T'uan appendix tr. WB 570).

The system of the *Yi* develops correlative thinking in two directions. On the one hand it relates all pairs, fours and larger sets to abstract symbols interrelated with mathematical rigour; on the other, the different patterns which can be read into the 64 arrangements of six lines, all with their own levels of symbolism, open up unlimited possibilities of correlation, with no rules to judge between them. There is none of the rigidity of the Five Processes system, which may for example impose the Five Colours on a parallel series with little regard for the colours as they appear to the eye. From the viewpoint of modern scientific explanation and prediction one must class it as not 'proto-science' but 'pseudo-science'*; whether there is another viewpoint from which it is not regress but progress is a question we leave open for the moment. In the first place the appendix 'Exposition of the Trigrams' presents a variety of correlations from which we select four series.

A	B	C	D	E	F	G	H
==	==	==	==	==	==	==	==
Chen	*Sun*	*Li*	*K'un*	*Tui*	*Ch'ien*	*K'an*	*Ken*
1. Thunder	Wind or wood	Fire	Earth	Marshes	Heaven	Water	Mountains
2. E	SE	S	SW	W	NW	N	NE
3. Moving	Entering	Attaching	Docil-ity	Enjoy-ing	Viril-ity	Sinking	Stopping
4. Eldest son	Eldest daughter	Middle daughter	Mother	Youngest daughter	Father	Middle son	Youngest son

* Cf. Needham v. 2, 304–345, which treats the development of the *Yi* system as a disaster in the history of Chinese science.

The first two series share one correlation with the Five Processes system, 'Fire/Water' with 'South/North'. The third series is of activities corresponding to the first, with 'Heaven/Earth' as male and female correlating with 'Virile/Docile'. The fourth, entirely independent except for 'Father/Mother', relates the trigrams to the family, crucial both to Confucian morality and to the general conception in the Appendices of cosmic process as a cycle of generation by male Heaven and female Earth. In this case the correlations are completely bound by the family relations. The unbroken and broken lines must correlate with male and female, the trigrams uniform throughout with father and mother, the sequence upwards with the sequence of birth. Since it is the rule that whether the whole trigram is Yin or Yang is fixed by the single line contrasting with the other two, everything else follows.

We have seen that Heaven and Earth correlate with Ch'ien and K'un, whether as trigrams or as hexagrams, taking all other Yin-Yang pairs with them. But the three lines of any trigram also correlate with Heaven, Earth and Man; the pairs then have to be distributed between the lines.

"Formerly when the sages invented the *Yi*, the purpose was to accord with the patterns of our nature and destiny. Hence they set up the Way of Heaven as 'Yin and Yang', the Way of Earth as 'soft and hard', the way of Man as 'the benevolent and the right'. Having put the three constituents side by side they doubled them, so the *Yi* completes a hexagram in six strokes". ('Exposition of the Trigrams' 2, tr. WB 264)

Again, numbers are assigned to Heaven and Earth on the principle that in each pair "Ch'ien is in charge of the first beginnings, K'un originates the completed thing".[14]

"Heaven, 1: Earth, 2. Heaven, 3: Earth, 4. Heaven, 5: Earth, 6. Heaven, 7: Earth, 8. Heaven, 9: Earth, 10." ('Great Appendix' 10 tr. WB 308).

This implies an ideal sequence of lines alternating all the way up the hexagram. This sequence provides one principle for explaining why the ancient text pronounces a step auspicious or baleful; a line should be unbroken at Nos. 3 or 5 from the bottom, broken at Nos. 2 and 4. It happens however that the apparently perfect Hexagram No. 63 ☵☲ Chi-chi ('Already crossed over') has as its original prognostication "Beginning auspicious, end disorderly." But it is in the nature of the system that anything can be made to fit. There is the further principle that to end on the broken line which completes the pair offers no further prospect of advance. In Chi-chi "the hard and the soft are correct and the positions fit", but "when it stops at the end it is disorderly, because its Way is

exhausted." Each hexagram is incomplete in that it corresponds to only one segment detached from the process.

The ideal sequence implies that the central lines of the trigrams, Nos. 2 and 5, respond to each other as opposites. But this further principle is applied to explain an auspicious prognostication even when No. 2 is unbroken and No. 5 broken.

Hexagram No. 7 ☲☵ Shih ('Army')

"The hard is at the centre (No. 2) and is responded to (at No. 5)" ('T'uan appendix', tr. WB 421).

Hexagram No. 32 ☳☴ Heng ('Constant')

"That regret disappears is because it is able to endure at the centre." ('Model appendix' on line 2, tr. WB 548).

What would be the point of this unrestricted correlation, of which we have given only a few illustrations? We may note in the first place that, unlike the system of the Five Processes as it applies for example to royal calendars, the *Yi* is primarily an art of decision-making in particular situations, by the interpretation of vague and enigmatic instructions as to how circumstances will develop and how to deal with them. It does share with the royal calendars the underlying assumption that man interacts with the events ordained by Heaven and discovers in understanding them how to respond to them.

"The great man joins his potency with Heaven and Earth, joins his clarity with the sun and moon, joins his sequences with the Four Seasons, joins what is auspicious or baleful for him with the ghosts and gods. When he acts ahead of Heaven, Heaven does not go counter to him; when he follows after Heaven, he is blessed with opportunities from Heaven. If Heaven itself does not go counter to him how much less man, how much less the ghosts and gods!" ('Words on the Text' appendix, on Hexagram No. 1, tr. WB 382f)

The theory of the Five Processes, however, although it too bred techniques of divination,† applies primarily to general and recurring situations such as the changing of ritual with phases of the year, while the *Yi* is a guide to unique conjunctions of circumstance. The difference may not appear significant at first sight, since inference from correlations is the same in both systems. For pure correlative thinking which ignores causality and can accept that water, winter and black share the same pattern as fire, summer and red, it is equally easy to accept that the

† Cf. the system of fate-calculation described by Ho Peng Yoke, 27–32

diviner's placing of 6 lines by shuffling yarrow sticks may share the pattern of the 6 stages of the situation he is divining; and in a culture where, whatever the reservations of such thinkers as Mo-tzu, Hsün-tzu and Han Fei,* most people accepted that the success of divination is confirmed by common experience, the correlation would seem unquestionable. Contemporary Western users of the Yi tend to follow Jung in defending Chinese divination by appeal to an a-causal principle of 'synchronicity', which "takes the coincidence of events in space and time as meaning something more than mere chance, namely a peculiar interdependence of objective events among themselves as well as with the subjective (psychic) states of the observer or observers."[15] I would suggest however that it is on the contrary by dismissing synchronicity and accepting the fall of yarrow sticks as mere chance that one comes to understand the function of free correlation in the Yi. An openness to chance influences loosing thought from preconceptions is indispensable to creative thinking. In responding to new and complex situations it is a practical necessity to shake up habitual schemes and wake to new correlations of similarities and connexions. The correlations of the Five Processes scheme can be rigid because they are designed to establish the conduct appropriate to stable and recurring situations, such as the ruler wearing green in spring and white in autumn. The Yi on the other hand is designed for responding to unique and complex situations in which correlative thinking must be fluid.

In favour of this explanation is the remarkable interest in inventions displayed by the 'Great Appendix'.

"There are four points on which the Yi has the way of the Sages: who uses it to speak esteems its verbalisations, who uses it to move esteems its alterations, who uses it to design instruments esteems its models, who uses it to divine esteems its auspices." ('Great Appendix' A 9, tr. WB 314)

It is at first sight surprising that invention should be put beside

* References to divination by the pre-Ch'in thinkers generally combine scepticism with acceptance of its place in ritual. In one of the exemplary stories about Mo-tzu he is warned by a diviner not to travel North because his colour is black and "Today God is killing the black dragon in the North"; he ignores the warning, fails to get through, but tells the diviner that the white failed too and that to listen to such advice would bring all travel to a stop (Mo 47/48–53, tr. Mei 228f). The military chapters however include divination in the rite for preparing against enemy attack (Mo ch. 68). Hsün-tzu classes divination with praying for rain, as a ritual which puts a civilized polish on behaviour but has nothing to do with the outcome of events (cited p. 240f above). Han Fei derides rulers who decide by divination when to go to war, citing several examples of rulers defeated in spite of favourable auspices (HF ch. 19, Ch'en 307, tr. Liao 1/156ff).

divination as one of the purposes of the *Yi*. But the same appendix describes at length the development of civilization by the successive discoveries of the sages. The inventions which followed Fu-hsi's construction of the trigrams, of nets for hunting and fishing by Fu-hsi himself, of the plough and of markets by Shen-nung, of boats, domestication of ox and horse, mortar and pestle, bow and arrow, houses, coffins, writing, are all ascribed to insight into similarities and connexions inspired by contemplation of some trigram, for example:

"They hollowed out wood to make boats, shaved wood to make oars. The advantage of boat and oars was to cross to the inaccessible and deliver over distances to the advantage of the whole world. Evidently they took it from Huan (☴☵)." ('Great Appendix' B 2, tr. WB 332)

The suggestion is that the idea of a boat first came to someone pondering the hexagram composed of the trigram for wood (☴) on top of the trigram for water (☵), with its attached auspice "Advantageous for crossing a great river." Has this something to do with why the Chinese, without moving in the direction of modern science, have proved themselves so good at basic inventions? Plainly the *Yi* is relevant, not to scientific explanation, but to the unexpected insight into a similarity or connexion which sparks off discovery, in the sciences as elsewhere. The 64 hexagrams, instead of organising a cosmological scheme, lay out every possible way in which wood, water or any other correlates of the trigrams can be put above or below and outside or inside each other, which are likewise every possible sequence for 6 steps correlatable with Yin and Yang. The precision, rigour and completeness of the scheme, qualities shared with modern mathematised science but quite different in purpose, serve on the one hand to clarify binary thinking, on the other to rid binary thinking of every preconception as to how concepts are related.

The same explanation will apply to the use of the *Yi* in divination. There is no reason to doubt that divination systems do help many people to reach appropriate decisions in situations with too many unknown factors, and that the *Yi* is among the more successful of them. Unless we are to follow Jung in postulating an a-causal principle of synchronicity, we must suppose that the *Yi* serves to break down preconceptions by forcing the diviner to correlate his situation with a chance sequence of six prognostications. If their meaning were unambiguous, the overwhelming probability would be that the prognostications would be either obviously inapplicable or grossly misleading. Since on the contrary the hexagrams open up an indefinite range of patterns for correlation, in the calm of withdrawal into sacred space and time, the effect is to free the mind to take account of all information whether or not it conflicts with preconceptions,

awaken it to unnoticed similarities and connexions, and guide it to a settled decision adequate to the complexity of factors. This is conceived not as discursive thinking but as a synthesising act in which the diviner sees into and responds to everything at once, with a lucidity mysterious to himself. The *Yi* is not a book which pretends to offer clear predictions but hides away in tantalising obscurities; it assumes in the diviner that kind of intelligence we have discussed in connexion with Chuang-tzu, opening out and responding to stimulation in perfect tranquility, lucidity and flexibility.[16]

"The *Yi* thinks of nothing, does nothing: in tranquility, unmoving, it fathoms what is at the back of everything in the world. What else but that which in all the world is most daimonic would be able to share in this?" ('Great Appendix' A 9, tr. WB 315)

This comes close to personifying the *Yi*; one consults the yarrow sticks as though seeking advice from a daimonic presence. But the state of mind would be that of the diviner himself, who "thinking of nothing and doing nothing" seems more a Taoist than a Confucian. It was in *Lao-tzu* that we first noticed an attempt, comparable although from a different direction, to undermine established chains of oppositions. Perhaps it is significant that in spite of the success of the Five Processes cosmology, no work expounding it ever won the authority of the *Yi*, which entered the Classics, or of *Lao-tzu*, the most influential of unorthodox writings. It is as though Chinese civilization has been careful to preserve a certain latitude in the organisation of its cosmos, in order that throughout its long history originality and creativity should never die out.

2. SYNCRETISM AND THE VICTORY OF CONFUCIANISM

The age of the Warring States ended quite abruptly in 221 B.C., the final struggle of the seven remaining states ending in a few years with the victory of Ch'in. It was a unique situation; even the legendary Five Emperors before the Hsia, as his advisers told the King of Ch'in, had been suzereigns of feudal lords whom they were helpless to control; now "within the four seas everywhere there are commanderies and counties, decrees issue from a single centre, something there has never been since the remotest past, which the Five Emperors never attained." In response to their proposals for a new Imperial title he announced "I shall be First

Emperor (Shih-huang-ti), later reigns shall be counted from me, Second, Third, to the 10,000th, the transmission will never end."[1]

Instead of declaring like the Chou that Heaven had called him to overthrow his unrighteous predecessors, the First Emperor ascribed his victory to the natural course of history according to Tsou Yen's application of the conquest cycle of the Five Potencies, by which Water prevails over the Fire which sustained Chou. Since Water correlates with winter, black, and the number 6, he shifted the New Year to the first of the tenth month, and ordered black robes and banners, and six horses for his chariot. The cosmic cycle justified not only his own power but the black and wintery policies of Legalism already imposed in Ch'in under Duke Hsiao (361–338 B.C.) by the reforms of Lord Shang. "Only a resolute harshness, deciding all things by law, incising and deleting without benevolence, generosity, mildness or righteousness, fits in with the numbers of the Five Potencies."*

In the same year 221 B.C. the question came up of whether he should follow the Chou example by enfiefing his sons in the conquered states. Instead he followed the advice of his Legalist minister Li Ssu, to reward not with lands but with stipends out of the taxes, and divided the whole Empire into 36 commanderies. In 213 B.C. the proposal to enfief his sons and younger brothers on the Chou model was revived by the academician Ch'un-yü Yüeh, who observed that "I have never heard of anyone who was able to last long without taking antiquity as his model in affairs." This time Li Ssu recommended, not merely rejection, but the suppression of all the schools.

"When the lords of the states of other times were in conflict, they were generous in patronising wandering scholars. Now the Empire is settled, decrees have one source, on the one hand the family heads of the people work hard at farming and the crafts, on the other the knights become practiced in the decrees and statutes. If scholars today take their examples not from the present but from the past and condemn our times, it will delude the masses. When people hear that a decree has come down, everyone will criticise it in terms of his own learning, when at home will privately disagree, when abroad will criticise it in the streets."

The First Emperor on his recommendation then ordered the historiographers to burn all past records except those of the state of Ch'in. He

* *Shih chi* (ch. 6) 237f, tr. Chavannes, v. 2, 128–30. The historicity of the First Emperor's commitment to the conquest cycle and the ascendancy of Water, which has been questioned, is defended by Bodde in Twitchett and Fairbank, v. 1, 96f.

forbade private ownership of "the *Songs, Documents,* and sayings of the Hundred Schools" (still allowed however to the officially recognised academicians, who even at this critical period seem to have included Confucians), and of all other books except "writings on medicine, divination, and planting and sowing." He ordered execution of the whole family of anyone who "appealed to the past to condemn the present."†

Among other measures which were to be the basis of the persisting although frequently interrupted unity of China was the unification of the script, that unique instrument of assimilation unaffected by temporal and spatial differentiation in the spoken language; previously writing had been diversifying in different states. But one unprecedented historical event, universal administrative unification, was soon followed by another which exposed its fragility, the first Empire-wide popular rebellion. The building of the Great Wall and other grand designs of the First Emperor overstretched the power of which he had forgotten the limits. In 209 B.C., almost immediately after his death, rebellion broke out under the peasant Ch'en Sheng, to end in 202 B.C. with the victory of Liu Pang (himself a commoner of obscure origin who began his career as a petty local official) and the foundation of the Han. The Han at first tried to combine the Ch'in administrative system with a restoration of the fiefs inside the command-eries, but after a succession of rebellions the fiefs were effectively eliminated under the Emperor Wu (141–87 B.C.). The Prince of Huai-nan (executed after rebellion in 122 B.C.) was the last of the territorial lords inviting philosophers to his court in the manner of the rulers of the pre-Ch'in states. From now on, it was no longer a matter of travelling from state to state offering a new theory of government, which might give the advantage to a ruler over his rivals. Competition was now for the ear of a single ruler, and adapted to the lowest common denominator of rulers, with the aim of distracting them from the realities of political power by frightening them with omens or promising them the elixir of life.

Chinese society was now settling into that equilibrium which in spite of all changes it was never quite to lose, and its philosophies into that synthesis which in the *Introduction* we proposed half seriously to formulate as "the Chinese secret of social immortality":

† *Shih chi* (ch. 6) 254f, tr. Chavannes, v. 2, 169–74. Our information about the First Emperor comes from the Han dynasty which replaced the Ch'in, and from the historian Ssu-ma Ch'ien who like any literatus would be prejudiced against the burner of the books. Bodde accepts his account of the burning but dismisses as legend his story of the execution of 460 scholars in 212 B.C. (Twitchett and Fairbank, v. 1, 69–72, 95f.)

(From Confucianism). An ethic rooted, below the level of conscious reflection, in the most fundamental social bonds, kinship and custom, which models the community on the family, relates ruler/subject to father/son and past/present to ancestor/descendant.

(From Legalism). A rational statecraft with the techniques to organise an empire of unprecedented size and partially homogenise custom throughout it.

(From Yin-Yang). A proto-science which models the cosmos on the community.

(From Taoism, reinforced from the Later Han by Buddhism). Personal philosophies relating individual directly to cosmos, allowing room within the social order for the unassimilable which might disrupt the community.

(From Mo-tzu through the argumentation of the competing schools). A rationality confined to the useful, which leaves fundamental questions outside its range.

The relative submergence and public repudiation of Legalism under the Han was not the result simply of the universal revulsion against the brutality of Ch'in policies and its exclusive reliance on force, a revulsion symbolised by the Han abolition of punishment by mutilation. An amoral statecraft which breaks explicitly with all traditional models can work effectively only as the arcanum of government. The First Emperor himself required a public morality, and Confucian academicians to draft his proclamations. He required also the proto-science of Tsou Yen, both for a theory of history to justify his rule, and to flatter his personal hope of physical immortality—for he was a pioneer also as the earliest ruler known to have embarked on the persistent Chinese quest for the elixir of life. The first abortive experiment in the kind of syncretism which was to develop during the Han had been made in Ch'in itself early in his own reign. It is the system of the *Lü Spring and Autumn (Lü-shih ch'un-ch'iu)*, a philosophical encyclopedia compiled about 240 B.C. by the clients of Lü Pu-wei, chief minister of Ch'in under his predecessor King Chuang-hsiang (249–247 B.C.) and still in office for a few years after his own accession as a child in 246 B.C. Lü Pu-wei, who had been a rich merchant, is a remarkable example of the promotion from low status which had become common by the 3rd century B.C. He fell from favour when the king came of age, and committed suicide in exile in 235 B.C. His book, the humane doctrines of which are quite unlike those the King of Ch'in was soon to adopt, sets the lines of all later syncretism by detaching the indispensable elements of Legalist statecraft from the Legalist theory of the state, and combining them with Confucian and to a lesser extent

Mohist moralism, all inside the frame of Yin-Yang cosmology. Unlike later syncretisms it is not much influenced by *Lao-tzu*; its organising doctrine, as Hsiao has pointed out,[2] is not Taoist but Yangist, that the throne is no more than a means to the protection and fulfilment of personal life for both ruler and subject.

Confucianism was becoming the overtly dominant element in the synthesis from about 100 B.C., but its victory was gradual. The Han Emperors were not finally persuaded to derive their authority like the Chou from the mandate of Heaven, and to sacrifice to Heaven rather than such gods as T'ai-yi ('Supreme One'), until near the end of the last century B.C.[*] In the 2nd century B.C. the movement most influential in court had been Huang-Lao, the 'doctrine of the Yellow Emperor and Lao-tzu'. Little was known about it until the discovery in 1973 in a Former Han tomb at Ma-wang-tui of two silk manuscripts of *Lao-tzu*, one of which has four appended documents of which one is in the form of dialogues between the Yellow Emperor and his ministers. These combine *Lao-tzu* with Legalism; they identify the principle of rewarding and punishing according to the law and checking 'name' against 'shape' (title against performance) with the Way itself, and the ruler's abstention from intervening in the impersonal mechanism of the state with the sage's 'Doing Nothing', a move already made in a couple of chapters of *Han Fei tzu* which may or may not be by Han Fei himself.[†] Other ingredients are Yin-Yang dualism, without systematic correlations or the Five Processes, and a little of the moral terminology of Confucianism (benevolence, the right, the gentleman). By being circulated under the name of the Yellow Emperor, this toned-down Legalism is given the ancient authority to which classic Legalism did not deign to pretend. Since the Yellow Emperor was the founder of the state and of war, who ended the Golden Age of Shen-nung when there were as yet no laws or punishments, his name would serve also to repudiate the Shen-nung Utopianism which had flourished briefly during the civil wars following the collapse of Ch'in authoritarianism.[3]

But *Lao-tzu*, for all its ambiguities, cannot be convincingly exploited in the interests of Legalism. In *Huai-nan-tzu*, compiled by the clients of the Prince of Huai-nan about 140 B.C., and in the probably contemporary passages and chapters which are the latest stratum in *Chuang-tzu*, we find a much more comprehensive synthesis in which punishment and reward

[*] For the revival of the concept of the mandate of Heaven under the Han, cf. Michael Loewe, in Twitchett and Fairbank v. 1, 733–37. For the Han Imperial cults, cf. Loewe *ut sup.* 661–68.

[†] *HF* chs. 5, 8. Cf. p. 285–89 above. For preliminary investigations of the newly discovered Yellow Emperor texts cf. the articles by Jan Yün-hua.

are detached from the mechanical model of Legalism and subordinated to the spontaneity of the Way as expounded not only in *Lao-tzu* but in *Chuang-tzu*. The *Chuang-tzu* chapter 'Way of Heaven' identifies nine stages in learning how to govern, the understanding of

1. Heaven
2. The Way and the Potency
3. Benevolence and right
4. Portions and responsibilities
5. Shape and name (the comparison of title with performance)
6. Grounds for appointment
7. Inquiry and inspection
8. Approving and condemning
9. Reward and punishment.

Only the first two directly concern the ruler, who moves as spontaneously as Heaven, prompted according to the Way by the Potency in himself, simply responding to events as they are mirrored in the clarity of his heart, the Taoist sage as conceived by Chuang-tzu himself. In that his motions have the spontaneity of natural events he "does nothing"; his ministers on the other hand have fixed jobs to do, the understanding of which starts from the third stage, the learning of the Confucian virtues of benevolence and right. The remaining stages belong to the technique of administration in which the Legalists have specialised. The writer insists that 'shape and name', and reward and punishment, which Legalists take as the basis of government, belong only to its periphery.

"When the men of old expounded the comprehensive Way, at the fifth of the stages 'shape and name' deserved a mention, by the ninth it was time to speak of reward and punishment. To be in too much of a hurry to expound 'shape and name' is to be ignorant of the root of them, to be in too much of a hurry to expound reward and punishment is to be ignorant of their origin. The men whose words turn the Way upside down, whose explanations take the direction counter to it, it is for others to govern, how would they be able to govern others? To be in too much of a hurry to expound 'shape and name' and reward and punishment, this is to have the tools for knowing how to govern, it is not the way of knowing how to govern. Such men are employable by the Empire but inadequate to be employers of the Empire; it is these which are called the specialists, each with his own little corner. The detail of ceremony and law, numbers and measures, 'shape and name', did exist among the men of old, but as means for those below to serve those above, not for those above to care for those below."[4]

Another syncretistic chapter in the latest stratum of *Chuang-tzu*,

'Below in the Empire', sets out to place all the thinkers earlier than Chuang-tzu in its new scheme. For us these thinkers are the most creative in Chinese history, but the ideologist of a united Empire has a very different viewpoint. He assumes that the ancient sage Emperors, who knew all that there is to know, possessed a unified system of lore rooted in the Way mankind shares with Heaven and Earth, and ramifying out into the detail of rites, morals and administration. In the present decadence some of this lore survives where it belongs within the official hierarchy, as administrative techniques preserved by the historiographers or as the teaching of *Ju* expert in the Classics, but the rest has been fragmented and scattered over the Hundred Schools of the philosophers 'Below in the Empire'. Each has 'the tradition of a formula' (*fang shu* 方 術), which is only one facet of the comprehensive 'tradition of the Way' (*tao shu* 道 術). The chapter examines what is to be accepted or discarded in the teaching of philosophers presumed earlier than Chuang-tzu whom it groups in five sets:

1. Mo-tzu and his disciple Ch'in Ku-li
2. Sung Hsing and Yin Wen
3. P'eng Meng, T'ien P'ien and Shen Tao
4. Kuan-yin and Lao-tzu
5. Chuang-tzu

Of the writings of these thinkers we now possess only *Mo-tzu, Lao-tzu, Chuang-tzu* and a few fragments. Having finished with the five, the chapter concludes by discussing the one school which is entirely worthless, Hui Shih and the Sophists. These did not even have the 'tradition of a formula'; Hui Shih "had many formulae" and boasted "I depend on no tradition." This passage deriding Hui Shih *because* he was an original thinker remains our main source for the little we know about his thought. Features of the classification deserving of notice are that the Confucians are treated as officially recognised teachers of the Classics, not among the schools "Below in the Empire", and that Lao-tzu and Chuang-tzu are not yet associated under a Taoist school. The syncretist has an especial animus against the third group which is at first sight surprising, since his description of them as "evening out the myriad things" and rejecting self, knowledge, and judgment between alternatives would seem to apply as well to Lao-tzu and Chuang-tzu, whom with reservations he approves. We know however from the surviving fragments of Shen Tao that he was among the founders of the Legalist theory of the state, which the Huang-Lao school was confusing with the teaching of *Lao-tzu*. The Way of Legalism has the impersonality of the true Way, its

neutrality to self and to moral principle, but it is a mechanically functioning system into which people have to be forced by, as the syncretist says, "rounding off the corners." He derides it as a Way not for the living but for the dead, and pronounces: "that which they called the Way was not the Way, and even in the right things they did they did not escape from being wrong."[5]

A firm classification of the pre-Han schools begins with Ssu-ma T'an (died 110 B.C.), Grand Historiographer and father of Ssu-ma Ch'ien. He recognises six schools:

1. Yin-Yang
2. *Ju* (Confucian)
3. Mohist
4. School of Law (Legalist)
5. School of Names (Sophists and specialists in 'shape and name')
6. School of the Way, first introduced as 'School of the Way and Potency' (Taoist).

Here Tsou Yen's Yin-Yang school and the Confucians are for the first time included among the philosophical schools, and the Sophists win a recognised place in the School of Names, although as contributors to the administrative task of comparing 'shape and name'. Ssu-ma T'an does not name the thinkers, but Lord Shang, Shen Pu-hai, and Shen Tao would come under the School of Law, and Lao-tzu, Chuang-tzu and Huang-Lao under the School of the Way. The 'men of secret arts' from the North East who promised the elixir of life to the First Emperor and to the Emperor Wu of Han would come under the Yin-Yang school; they had claimed the authority of Tsou Yen under the Ch'in and there is no evidence that they yet passed as Taoists under the Former Han. However, the name of Tsou Yen was already losing credit under the Han, and like later alchemists they probably preferred to cite Lao-tzu and the Yellow Emperor, as the sages who inspired most awe during the ascendancy of Huang-Lao. In any case, Yin-Yang thinking was by now pervading all schools.

For Ssu-ma T'an the comprehensive vision is that of Taoism, which transcends the one-sidedness of the other five schools.

"I have examined the Yin-Yang lore; it is too detailed and multiplies superstitious taboos, it keeps people restrained by excessive fears; but its phasing of the overall harmonies with the four seasons is not to be neglected.

"The *Ju* are learned but short on the essentials, strenuous but to little effect, which is why their practices cannot be observed in full; but there is no substitute for their grading of ceremonial between ruler and minister,

father and son, and of distinctions between husband and wife, elder and younger.

"The Mohists take frugality to an unacceptable extreme, which is why their practices cannot be followed generally; but their strengthening of the basic and thrift in utilising is not to be abandoned.

"The School of Law is harsh and merciless; but their rectification of the spheres of ruler and subject, superior and inferior, cannot be improved on.

"The School of Names makes people glib and prone to lose sight of the genuine; but it is indispensable to scrutinise their correcting of names and objects.

"The School of the Way makes intelligence quintessential and dai- monic, concentrated and unified, every prompting in accord with the formless, in tranquility bringing the myriad things to sufficiency. As for the lore which is theirs, it is grounded in the overall harmonies of the Yin- Yang school, selects the best from the *Ju* and Mohists, picks out the essentials of the Schools of Names and Law. It shifts with the times and changes in response to other things; in establishing as custom and applying in practice there is nothing to which it is inappropriate; its point is condensed but easy to hold on to, the effort is little but to much effect."[6]

Ssu-ma T'an is the first to give the name of *Tao* or Way to one philosophical tendency, and it is plainly the *Lao-tzu*-centred syncretism of the 2nd century B.C. 'School of the Way' seems indeed to be an abbreviation of 'School of the Way and Potency', the term he uses in first introducing it. It no doubt had a powerful appeal to Emperors, as leaving them exempt from the moral rules applied to their subjects. For that very reason however it would finally be no more satisfactory as a public ideology than naked Legalism. Under the Emperor Wu (140–87 B.C.) Confucianism began to prevail, led by scholars such as Tung Chung-shu (c. 179–c. 104 B.C.) who learned from the Yin-Yang cosmologists the art of interpreting natural events as omens, and used them to make the Emperor worry about losing the favour of Heaven by failing to govern by Confucian standards of morality. The Confucians, like the 'Below in the Empire' syncretist and Ssu-ma T'an, treat their rivals not as wholly wrong but as one-sided, an attitude which would have been inconceivable to Mencius but is already assumed by Hsün-tzu.[7] Since the 3rd century B.C. there had been a general shift from 'You are wrong, I'm right' to 'You have a narrow view, I have a wide view'. We may see this as one more example of the Chinese tendency to rank A above B rather than eliminate B; as the tendency to compromise rather than conflict it is another factor in the persisting stability of China.

All that interests us now is the manner in which the intellectual currents of the pre-Han period are coming to find their places in an enduring synthesis. The process is completed in the bibliographical chapter of the *Han History* by Pan Ku (A.D. 32–92), itself based on the now lost *Seven Summaries* of the Imperial librarian Liu Hsin (died A.D. 23).[8] The writers who for us are the philosophers of ancient China are classified as the *Tzu* 子 , those who have the word *tzu* (primarily 'son') added to their surnames as the mark of a teacher, as in 'Chuang-tzu', 'Hsün-tzu'. They represent the second of six classes of literature.

1. The Six Classics (*Yi, Documents, Songs, Ceremony, Annals,* and the already lost *Music*), preserving that unsurpassable culture which lasted until the early Chou, also their attendant literature including the *Analects* of Confucius.

2. The *Tzu*, now grouped in nine schools (a tenth, the school of 'Small Talk', of popular wisdom picked up in the street, is pronounced occasionally instructive but unworthy to be ranked with the rest). These divergent schools arose when "the Way of the King faded and the lords of the states ruled by force." Each has its own strengths and weaknesses, so that "although they have blind spots and shortcomings, their crucial tendencies being combined they are after all the branchings and outcomes of the Six Classics."

3. Poetry.

4. The art of war.

5. *Shu shu* 數術 (literally 'number lore'), computational sciences such as astronomy, the calendar, Five-Process theory, divination.

6. *Fang chi* 方技 (literally 'prescriptive techniques'), life-giving sciences such as medicine, sexology, and the art of the elixir.

The nine schools of the *Tzu* are headed by the school of the *Ju*, which "in the Way is loftiest of all", and has no weaknesses except in its degenerate representatives. Nevertheless, there are gaps in its knowledge which can be filled from the other schools.

1. The *Ju*. The books include *Mencius* and *Hsün-tzu*, but not the *Analects* which already appeared in the literature of the Classics. The *Ju* "take pleasure in the elegance of the Six Classics, lodge their thoughts within the bounds of Benevolence and Right, pass on the tradition of Yao and Shun, and have Kings Wen and Wu as their authorities and Confucius as founder."

2. The Taoists. The books include *Lao-tzu* and *Chuang-tzu*, but also *Kuan-tzu, Ho-kuan-tzu* and the 'Four classics of the Yellow Emperor', which may well be the four Huang-Lao documents found at Ma-wang-tui. But

works on the Five Processes and the arts of longevity, which might later be classed as Taoist, are excluded from the *Tzu* and placed under the computational or life-giving sciences. Strengths of the Taoists: they "know how to grasp the crucial and cling to the basic, maintain oneself by clarity and emptiness, uphold oneself by humility and yielding: this is the lore of the ruler who faces South." Weaknesses: some "wish to be rid of ceremony and learning, to discard both Benevolence and Right, and say 'By trusting solely to clarity and emptiness one may rule'." Here the Taoist training of the mind to perfect clarity and emptiness (in Western terms, rather to flexibility and openness) is recognised as an aspect of the art of government which Confucians neglect; but it is denied that this exempts the ruler from Confucian morality.

3. Yin-Yang. The books, which include the voluminous writings of Tsou Yen, are now all lost. Strengths: they "reverently accord with august Heaven, calculate the motions of sun, moon and stars, reverently inform the people about the seasons." Weaknesses: some "are drawn into superstitious prohibitions, degenerate into fortune-tellers, neglect human affairs and leave things to the ghosts and gods." The lost books presumably provided the theoretical background for the more practical works classified under the sciences.

4. The Legalists. The writers include Lord Shang, Shen Pu-hai, Shen Tao and Han Fei. Strengths: "they make reward dependable and punishment inescapable, as a support to control by ceremony." Here we have the Confucian assumption that society is held together primarily by ceremony, only secondarily by law. Weaknesses: some "dispense with reform by teaching, reject Benevolence and concern for others, wish to perfect government by trusting solely to punishment and law, to the extent of inflicting corporal punishment even on closest kin, atrophying mercy and demeaning generosity."

5. School of Names. The writers include Kung-sun Lung, Hui Shih, and also Sung Hsing's associate Yin Wen. All the books are now lost, apart from the three surviving pieces by Kung-sun Lung. Strengths: the correcting of names required by Confucius. Weakness: hair-splitting.

6. Mohists. Of the books none now survive but *Mo-tzu* itself. Strengths: "valuing frugality," "concern for everyone," "elevation of worth," "assisting the ghosts" (by ancestral sacrifices), "rejection of Destiny," "conforming upwards" (by "regarding the Empire from the viewpoint of a filial son"). Here approval is extended to five out of the ten Mohist doctrines. Weaknesses: some "having seen the benefits of frugality, for the sake of it reject ceremony; and they extend the idea of

concern for everyone to the point of ignoring the distinction between kin and stranger."

7. Verticalists and Horizontalists (advocates of a 'vertical' alliance against Ch'in in the West or a 'horizontal' alliance against Ch'u in the South). The books are now all lost. The bibliographer judges the diplomatic practices recommended both in practical and in moral terms. Strength: the diplomats "weigh up the affair before deciding what is suitable, attending to their orders rather than to how they are phrased." Weakness: in some cases "the ruler becomes deceitful and no longer keeps his word."

8. Syncretists. Of the largely syncretistic literature of the Ch'in and early Han the bibliographer includes only works such as the *Lü Spring and Autumn* and *Huai-nan-tzu* which he cannot fit elsewhere into his scheme. Strengths: "they combine *Ju* and Mohist, join School of Names with Legalist, know that these belong within the articulation of the state, perceive that everything in royal government is interconnected." Weakness: some "are muddled and do not focus their thought anywhere."

9. Farmers' School. The books, all now lost, are manuals of farming, mostly of the Han, but starting from the Utopian *Shen-nung.* The bibliographer classes *Shen-nung* with the rest purely for its technical information. That he includes agriculture under the *Tzu* rather than the sciences shows (as does his inclusion of Verticalists and Horizontalists) that for him the teaching of the *Tzu* is not limited to what we would call philosophy; it embraces all knowledge required for the organisation of state and society. Strengths: they "sow the hundred grains, and encourage agriculture and sericulture, to provide a sufficiency of food and clothing." Weaknesses: some "see no point in serving a sage king, wish to make the ruler plough side by side with the subject, overthrow the grading of superior and inferior."

Although Confucianism was in due course to detach itself from direct engagement with Yin-Yang cosmology, in the Former Han it was grateful that the terrifying gap between Heaven and man acknowledged by Hsün-tzu had at last been closed, by the Five Process correlations rooting the Five Constants (benevolence, right, ceremony, wisdom, trustworthiness) in the order of a moralised Heaven and Earth. It is likely that these correlations go back to Tsou Yen himself, since Ssu-ma Ch'ien says of his system "If you get its essential drift, it always terminates in benevolence and right, thrift and frugality, and the dealings between ruler and subject, superior and inferior, and the Six Kin."[9] About 205 B.C. the *Chuang-tzu* Primitivist derides correlations of the moral norms with the Five Viscera,

protesting that this attempt to root Confucian morality in man's nature makes benevolence and right like webbed toes or a sixth finger, function-less flesh which it is painful to tear off.[10] In the 1st century A.D. the full context of these correlations appears in the *White Tiger Discussions*.

	A	B	Between	C	D
(Five Processes)	Wood	Fire	Soil	Metal	Water
(Four Seasons)	Spring	Summer	—	Autumn	Winter
(Four Directions	East	South	(Centre)	West	North
(Five Colours)	Green	Red	Yellow	White	Black
(Five Viscera)	Liver	Heart	Spleen	Lungs	Kidneys
(Five Norms)	Benevolence	Ceremony	Trustworthiness	Right	Wisdom

As examples of the explanations of the correlations we take the contrastive pair 'benevolence/right', the life-giving kindness and stern justice which we found corresponding to spring and autumn in the calendrical scheme of the *Lü Spring and Autumn*. The two seasons are unmentioned but implicit in the parallel sequences of sentences.

"Of the Five Viscera, liver is benevolent and lungs righteous, heart ceremonial and kidneys wise, spleen is trustworthy. Why is the liver benevolent? The liver is the quintessence of wood. The benevolent love to give life. The East is Yang, the myriad things are first coming to life. Therefore the liver resembles wood, is green in colour and has branches and leaves

"Why are the lungs righteous? The lungs are the quintessence of metal. The righteous judge crime. The West too is metal, is the killing off of the myriad things. Therefore the lungs resemble metal and are white in colour."[11]

We take leave of ancient Chinese thought at a suitably low point in its debasement, when the excesses of correlative system-building have temporarily penetrated to the heart of philosophy, and ignore the great sceptic Wang Ch'ung (A.D. 27–c. 100) whose time we have already reached, and all the revivals and innovations of the next 2,000 years. In the same sense in which we can say that the directions of Western thought were set in the Axial Period by Greek philosophy and Hebrew religion, the main lines of Chinese thought are already laid down.

APPENDIX 1

A CLASSIFICATION OF CHINESE MORAL PHILOSOPHIES IN TERMS OF THE QUASI-SYLLOGISM

Chinese ethical thinking starts from the spontaneity of inclination and the value of wisdom. We have suggested[1] that it follows an implicit logical form approximating to the syllogism, applicable directly to concrete situations.

In awareness from all viewpoints, spatial, temporal and personal, of everything relevant to the issue, I find myself moved towards X; overlooking something relevant I find myself moved towards Y.

In which direction shall I let myself be moved?

Be aware of everything relevant to the issue.

Therefore let yourself be moved towards X.

Like the standard syllogism, a form into which Chinese thinking sometimes falls in practice,[2] this quasi-syllogism is never identified in Chinese proto-logic. Let us start by clarifying our presentation of it in Western terms. It implies that 'awareness' (which we define as the capacity to take into account in choices) varies in degree, is welcomed or resisted as one is pulled in one direction or another, and in turn acts on inclination. Assuming the value of wisdom, reactions in awareness will be better than reactions in ignorance. Inclination in increasing or diminishing awareness shifts 'spontaneously', in the sense that its swings are not chosen but caused by the changes in awareness. Factors are 'relevant' to the extent that they do act causally on inclination; the flavours of dishes, which spontaneously arouse desire or aversion, are relevant to choosing between them, the size of the dining room is not. A commitment that one is now sufficiently aware of *everything* relevant (without which there could be no confident choice) raises only the same difficulties as commitment to 'All men are mortal' and is to be dealt with in the same way, for example by appeal to Popper's criterion of sustained failure to refute.

It is assumed, most explicitly in the Confucian concept of *shu* 'likening to oneself', that to the extent that you see from another person's viewpoint you are also moved from it, just as from another spatial or temporal viewpoint of one's own. I have elsewhere defended this unfamiliar assumption.[3] Here I wish only to try out the proposal that the underlying logic of the quasi-syllogism, valid or invalid, establishes the problematic of Chinese philosophy in the classical age.

Translating into these terms, the ideal sage will for all Chinese schools be the man perfectly aware from all viewpoints, with the spontaneous desire and the ability to benefit all by orderly government. We may see the various schools as offering a full range of answers to questions raised by the quasi-syllogism.

(1) What is wisdom?

(1/1) Knowing how to correlate. We have suggested that ancient China did not share the Western assumption that analytic thinking can wholly escape dependence on correlative. The sage, however much or little he may analyse, in the first place distinguishes, classifies, and fixes by naming; he reacts similarly to the similar, connectedly to the connected, and in distinguishing two sides spontaneously prefers one to the other. Cosmos and community divide into superior A and inferior B, Heaven/ Earth, ruler/subject, father/son. What each in his position in cosmos and community would spontaneously incline to do in perfect awareness thus follows for Confucius immediately from correctness in naming,[4] that is, from naming which correctly assimilates, contrasts, and connects. Until you have yourself achieved this awareness you have to control spontaneity and obey the instructions of those who know better, but afterwards like Confucius you can "follow the heart's desire without transgressing rule."[5]

(1/2) Knowing how to analyse. Attention shifts from correlation to analysis to the extent that controversy forces the schools into *pien* 'argumentation'. Later Mohism goes so far as to build its ethic by analysis of moral concepts, to prove them to be "what the sage desires or dislikes beforehand on behalf of men"; even here the assumption is that the good is what the wisest spontaneously prefer.[6] Attention shifts to analysis also in schools concerned with questions of means, the Legalists and to some extent the Mohists. There is a tendency to lose sight of the desires which means are designed to serve, even among the Mohists, who reject music as useless without denying that it is enjoyable for itself.[7] Legalism verges on a pure system of means, with the ruler himself reduced either to a means or to an arbitrary will outside the system. This explains why Legalism could find a philosophical basis only by identifying the ruler

with the Taoist sage, whose illumination confirms the value of the inclinations served by the state apparatus.

(1/3) Illumination, the mirroring of the particular situation without forcing it into classifications by naming (Taoism). Knowledge itself tends to be identified with distinguishing and naming, and rejected as inadequate to the complexity of the moment. For Taoists, as much as for Confucians, the untrained have to control their spontaneity; but you surrender to pure spontaneity once you have unlearned the distinctions which channel inclination into habitual desires and dislikes.

(2) What is the spontaneous in man?

(2/1) For most schools, the opposites 'desire/dislike' or (as in the 'Doctrine of the Mean'), 'being pleased with/being angry with', 'joy/ sorrow', from which all action starts. These reactions are described from the 3rd century B.C. in the terminology of *kan* 'arousal' (by external things) and *ying* 'response', curiously similar to the stimulation and response of Western behaviourism.

(2/2) Action itself when it is *wu wei* 'doing nothing' (Taoism). Desire and dislike spring from distinguishing and classifying; the behaviour of the sage who has unlearned distinctions springs directly from impulsion which is neither desire nor dislike. Chuang-tzu sometimes calls it 'impulse' or 'impulse from Heaven' (*t'ien chi* 天機). Taoism does not however, as Buddhism was later to do, wholly refrain from calling it 'desire'. All names being inadequate, this name too may be used and undermined by paradox, as in the first stanza of *Lao-tzu*, which requires us to be "constantly without desire" yet "constantly have desire".

(3) How does one settle on the Way, which is the course preferred in fullest awareness?

(3/1) Let inclination settle in one direction after contemplating the situation, without posing alternatives. This is the position not only of Taoists, who reject considered choice, but of Confucius, who seems not yet to have conceived it.[8]

(3/2) Pose alternatives and wait for inclination to settle on one of them. With considered choice we meet such metaphors as weighing and the crossroads (Mohists, Yangists, Mencius, Hsün-tzu, Legalists).

(4) How do spontaneous desire and dislike become unselfish?

(4/1) One is spontaneously unselfish to the extent that one perceives the other man's likeness to oneself (Confucian *shu*), or unlearns the whole distinction between self and other (Hui Shih, Taoism), and so is moved from other viewpoints as well as from one's own. In terms of the quasi-syllogism, to let oneself be moved unselfishly would be a causally

necessary condition of obeying 'Be aware from all viewpoints', so that its value would follow from the quasi-syllogism alone, without any need to claim that man is unselfish by nature irrespective of awareness.

(4/2) Human nature is good (Mencius). One grows into spontaneous unselfishness by nourishing inclination on its natural line of development, but sinks into selfishness if the growth is thwarted or starved. This doctrine, although not needed to justify moral behaviour, is important to Mencius because it reunites Heaven and man, assures us that in behaving morally we are not cutting ourselves off from the cosmic order.

(4/3) Human nature is bad (Hsün-tzu). The individual's natural desires conflict with each other and with other men's, but spontaneous unselfishness follows extension of awareness to other viewpoints as in 4/1. Recognising that conflicting desires frustrate one another, one spontaneously desires to reconcile them; the sage successfully trains them to harmonise with one another, and with other men's.

(5) How is the sage moved to act from other viewpoints?

(5/1) He is moved equally on behalf of all (Mohism).

(5/2) He prefers kin to strangers (Confucianism).

(5/3) He prefers self to others (Yangism). The preference is a matter of degree; the pure egoism of acting solely on behalf of self seems not to be represented in the tradition.[9]

(5/4) He responds fluidly without distinctions and classifications, and so without constant preferences (Taoism).

(6) How does the sage bring the ignorant into harmony with the wise?

(6/1) He educates the educable by the refining of custom through ceremony (Confucianism), or by teaching them to distinguish the socially beneficial from the harmful (Mohism), or by training them to unlearn distinctions (Taoism).

(6/2) He simplifies life to a degree manageable even in relative ignorance. By reducing the range of desirable things one can have small communities of voluntarily co-operating villagers (Shen-nung, *Lao-tzu*, the *Chuang-tzu* Primitivist).

(6/3) He constricts and steers desires and dislikes by reward and punishment, and so enforces obedience to the sage ruler (Legalism).

(7) What is the relation between Heaven and man, between the Way of spontaneous process within and outside man and the Way of human morality?

(7/1) They harmonise within a universal Way. For Yin-Yang thinking, this is shown by correlating the five moral norms of man with the Five Processes of cosmology.

(7/2) They are one in the spontaneity of human nature, which is good (Mencius).

(7/3) Human nature is bad; train natural inclination to goodness by following the Way proper to man, not the Way of Heaven (Hsün-tzu).

(7/4) Man departs from Heaven by channelling his spontaneity through self-made divisions and classifications; unlearn them and return to the course which is from Heaven (Taoism).

No thinker in this tradition objectivises the spontaneous in man, as morally neutral inclination to be utilised or checked in the service of ends chosen independently, by deducing from rational principles or by an Existentialist leap in the dark. To do so would lead to a quite different problematic, that of post-Kantian philosophy in the West. Is it a limitation of Chinese thought that it overlooked the approach which seems natural to ourselves? It may be more profitable to ask the questions from the opposite direction. How did I as a Westerner get trapped into pretending that I can fully objectivise the spontaneous in myself, shrink myself to a point of rational Ego pursuing ends independent of my spontaneous goals, observing unmoved even my own emotions? What have I gained from following a line of thought which first detached supposedly rational ends from the goals of inclination, then failed to discover any rational grounds for them? I may indeed choose duty against present inclination, but am I not even then choosing the course which I spontaneously prefer in the perhaps rare moments when I can bring myself to see clearly from other people's viewpoints?

Appendix 2

The Relation of Chinese Thought to the Chinese Language

Chinese thought before the introduction of Buddhism from India is the unique instance of a philosophical tradition which, as far as our information goes, is wholly independent of traditions developed in Indo-European languages (Arabic philosophy descends from Greek, Tibetan from Indian). It therefore provides the ideal test case for Whorf's hypothesis that the thought of a culture is guided and constrained by the structure of its language.

Classical Chinese is a language of mainly monosyllabic words, each syllable with its own written character, organised by word-order and the placing and functions of grammatical particles. The script is not, as used to be supposed, ideographic; different monosyllabic words, however near they approach synonymity, are written with different graphs, and particles like other words have their own graphs. The combination of graphic wealth with phonetic poverty has the result that the etymology of a word and its relation to similarly sounding monosyllables is displayed in the structure of the graph rather than of the vocable. The graph serves also to identify the same word throughout different Chinese dialects (which by the test of mutual intelligibility are in many cases distinct languages) and throughout the whole history of the script. The intelligibility of Classical Chinese however pronounced has been one of the great unifying and stabilising factors in Chinese civilization.

The script evolved in form until standardised with the unification of the Empire, and new graphs continued to be devised for words newly coined or arising from the colloquial. The language written in it has suffered two major revolutions. Texts older than the *Analects* are in varying degrees 'pre-classical'; true Classical, first documented in the writing down of Confucian and Mohist oral teaching, perhaps originated

in the attempt to get nearer to the spoken language already diverging from the literary, and its earlier texts show marked dialect differences among themselves. The spoken language in due course diverged again from the literary; 'modern' Chinese was already being written under the T'ang (A.D. 618–907) and Sung (A.D. 960–1279), with the recorded sayings of teachers, Ch'an and Neo-Confucian, again standing out as especially colloquial. Neighbouring cultures have been able to treat the graphs as ideograms, assign them readings in their own languages, and in the case of the Japanese *Kambun* system, add special signs by which a Chinese text may be read in the different word order and with the word terminations and particles of the Japanese language, which is structurally as different from Chinese as either is from English.

The monosyllabic words in their modern pronunciation have a very high proportion of homophones; even in this book the reader may notice how many words are romanised as *shih* or *chih* and distinguished only by the graphs. In archaic Chinese there were many more phonetic distinctions, but one may still wonder with Rosemont,[1] whether it was possible to speak it intelligibly unless there was already considerably more of the modern compounding of monosyllables into bisyllabic words than we find in the texts. One is also struck by the bareness of Classical compared with Modern Chinese, which has words regularly distinguishing definite and indefinite, and singular, a few, and more in number, distinctions close to those of English. One learns with increasing experience that the bareness of the written language involves little loss of information, but one may again wonder whether the same would be the case in living speech. The philosophers teach orally, always say 'I have heard ' not 'I have read ', theorise about names in terms of sound, not graphs, but when they write would not necessarily include every spoken word. However, such abbreviation would not affect the syntax. Classical Chinese is not like headline or telegram English in which you can drop the main verb.

The philosophising of most cultures has been in Indo-European or Semitic languages with inflections which call attention to word classes and sentence structure. Their absence in Chinese, with its sequences of uniform and unchanging monosyllables, rendered the Chinese to a considerable extent blind to the structure of their own language. Linguistic scholarship concentrated on lexicography; grammatical consciousness, even in late Imperial China, was nearly limited to commentators' observations when for example a noun is being used in a verbal sentence position ("A dead word [*ssu tzu* 死字] is being used as a live word [*huo tzu*

活字]"), or to collecting particles (*hsü tzu* 虛字 'empty words') and defining them in terms of each other. We have noticed how even among the Later Mohists the distinction between a sentence and a string of names was noticed only at the very end of the movement, in *Names and Objects*.[2] Even with the resources of Western linguistics it is proving very difficult to analyse Classical Chinese syntax. It was widely assumed up to the middle of the present century that Classical Chinese has no parts of speech and no grammar apart from a word order rather like that of English (subject-verb-object, adjective before noun, but also adverb before verb, to put it naively in English terms), so you simply look up the characters and guess, the guesses improving with increasing experience. Although there has been much progress since, no adequate textbook of Classical Chinese is yet available, and much of the information is still scattered over learned journals or belongs to the unwritten lore of different centres of learning.

That the sequences of punctuated phrases in Classical texts constitute genuine sentences has long been plain to readers of Japanese *Kambun*, the apparatus of which makes it immediately obvious that a sequence is either a verbal sentence with a main verb (with the words translatable by adjectives counting as verbs) or else a nominal sentence with a complement followed in Japanese by the verb *nari*, the copulative 'is'. Yet the assumption that you can identify anything as the main verb or supply one of your own as 'understood' has been extraordinarily persistent among sinologists who do not read Japanese; it has a lot to do with the curiously unfocussed look of the English in so many translations from Chinese. Translators were even failing to notice that a possessive subject marks as not a sentence but a nominalised clause until well into the present century.[3] The conviction that Chinese has no parts of speech is still not extinct. But it is by now coming to be recognised, not only that nominal sentence positions such as subject and object are distinguishable from verbal (most particles being classifiable as pre-verbal, pre-nominal, inter-verbal and so forth), but that lexicographically words can be classed as nouns and verbs by their behaviour in these positions. Admittedly Chinese words have a syntactic mobility which at first sight seems unrestricted. But although such verbs as *chiao* 敎 'teach' and *ch'iang* 強 'strong' move freely between verbal positions ('teaches', 'is-strong') and nominal ('teaching', 'strength'), their behaviour differs from that of the nouns *shih* 師 'teacher' and *li* 力 'strength', which cannot stand in verbal positions (one finds only *yu li* 有力 'has strength') or else do so with restricted distribution and a causative function (*shih* 'treats as

teacher'). Recently Cikoski and Harbsmeier have taken the first steps towards classifying ergative and neutral verbs, count, generic and mass nouns.* It is characteristic of the still-backward state of the art that until Cikoski's work on verbs, first published in 1978, nobody knew how to tell whether an objectless transitive verb is active or passive except by guessing from context. Sinology still depends heavily on the kind of linguistic skill which picks up a language without bothering much about grammatical analysis. This approach can be successful with many kinds of text, including the pre-Han 'philosophers' at their simpler—but not when they are really doing what a Western philosopher might guardedly acknowledge to be relevant to his profession. Imagine an exposition of *Cogito ergo sum* by someone who thinks it a matter of context whether the verbs are 1st- or 3rd-person and is not sure whether it is a sentence or not. The understanding of the Mohist *Canons*, for example, depends so much on grammatical issues that when translating them in *Later Mohist Logic, Ethics and Science* I was forced to devote more than 50 pages of the introduction to the grammar. To approach Chinese philosophy trusting to the dictionaries and one's instinct for the language is to fail to take it altogether seriously, and the practice has been a perpetual drag on progress in discovering how much or little that we call philosophising is actually there.

Under these circumstances it is perhaps inevitable that in the no-man's-land on the common borders of linguistics, philosophy, and sinology, among those from whom one looks for stimulating new approaches (Rosemont, Hansen, Hall), most generalisations about the Chinese language start from totally obsolete assumptions. During the 1960s and 1970s, in the controversy over Chomsky's postulation of linguistic universals, there were people offering Classical Chinese as a counter-example ("Apart from context, it was argued, grammatical relations could not be expressed in Chinese"), or denying its relevance on the grounds that it is not a natural language.[4] As recently as 1974 Henry Rosemont was arguing that Classical Chinese is an artificial language, on the basis of observations which must seem extraordinary to anyone who has worked on its grammar, that "it may be seriously questioned whether the written language has a syntax at all," "apart from context, no Chinese character has a grammatical function," "order is not fixed in the classical

* Cikoski's 'Essays' 8/128–143, and the earlier and fuller account of the verb in his unpublished thesis 'Word-classes' 54–71. For Harbsmeier, cf. p. 402 below.

language," "virtually every passage is ambiguous," "syntactically correct but semantically anomalous passages like the famous 'colorless green ideas sleep furiously' cannot be communicated in classical Chinese."† The very recent book of Hall and Ames, which I have so far been mentioning with nothing but praise, throws off the most amazing generalisations:

"Classical Chinese is not, as are most Western languages, grounded in the propositional utterance. The dominance of the noun function precludes limiting meaningful statements to those possessing the sentential, subject-predicate form. The tendency of classical Chinese philosophers to be concerned with the ordering of names is a consequence of the dominance of the noun function. The striking claim that classical Chinese doesn't depend upon sentences and propositions for the expression of semantic content entails the consequence that all Chinese words are names, and that compound terms, phrases and sentences are strings of names. This consequence, in turn, requires that one appreciate the lack of interest on the part of the early Chinese in questions of 'truth' and 'falsity'. Words, as names, may be judged appropriate or inappropriate; only propositions may, in the true sense, be true or false."[5]

No grammatical evidence is offered for these claims; indeed we are explicitly told that "the claims we wish to make about classical Chinese are themselves consequences of the broader cultural contrasts for which we have repeatedly argued throughout this work."[6] These broader cultural contrasts are in themselves very interesting, and in so far as Hall and Ames are relating them to the discourse of Confucius rather than to the language as such they are fully relevant, but what have they to do with such essentially grammatical issues? To speak of Chinese sentences as

† Rosemont, 'Abstractions' 80, 82 n15, 83. There is little point in trying to translate a nonsensical English sentence into a dead language with a largely unexplored grammar, but I cannot imagine any version of Chomsky's famous sentence which would be syntactically ambiguous. Taking *lü yi* 綠 意 for 'green ideas', *wu se* 無 色 ('have-not colour') could not be subordinated to it without the particle *chih* 之 . Since *chih* is the particle of subordination inside a nominal combination, this would establish *wu se chih lü yi* ('green ideas which have no colour') as a noun phrase. However one deals with 'sleep furiously' the phrase will occupy the main verbal position, *nu* 怒 ('be-furious') and *wo* 臥 (the usual pre-Han word for 'sleep') are verbs, and the two could hardly be juxtaposed without an inter-verbal particle such as *erh* 而 . *Wu se chih lü yi nu erh wo* ('Green ideas which have no colour sleep raging') would be an odd-looking sentence, and could no doubt be improved on, but there is no obscurity in its syntax. That few Chinese could be induced to play this game (any more than English speakers who are not highly conscious of grammar) goes without saying.

'strings of names' is to revert to the grammatical knowledge of the ancient Chinese themselves (and not quite catching up with *Names and Objects*).** Grammatically the noun, far from being dominant in function, seems to be less so in Classical Chinese than in Indo-European languages. Indo-European adjectives, in languages which inflect them, are declined like nouns, even in English require when predicated the copula like nouns, and indeed in one terminology are grouped with substantives as nouns; the corresponding words in Chinese share the pre-verbal particles and take the main verbal position without the final particle *yeh* 也 which generally concludes a nominal sentence. Indo-European adjectives and verbs cannot stand in syntactically nominal positions except in nominalised forms which easily assimilate to concrete nouns to breed hypostatised entities; the corresponding Chinese words stand unaltered in nominal positions. Moreover, the Indo-European sentence is noun-centred in that the main verb has to be predicated of a noun, its subject, from which it takes person and number; in the Classical Chinese verbal sentence the subject is an optional element and the minimal form is the verb by itself. One might also ask why, even if they insist on discussing the issue in such general terms, Hall and Ames do not draw the opposite conclusion, that the verb is dominant, from their attractive thesis that Chinese thinking assumes a 'process' rather than a 'substance' ontology. Hansen, from whom they take the idea of the dominance of the noun, treats it as inseparable from a substance ontology.[7]

Hall and Ames seem in the quoted passage to imply that a Chinese sequence cannot be a sentence or a propositional utterance expressing a truth unless it has subject-predicate form. On this Aristotelian principle one would have to agree that no truths were ever spoken in China, for even a verbal sentence with a subject is not conveniently analysed in subject-predicate form. But surely for modern logic propositions require this form only when quantified. 'It is raining' is just as much true or false as 'All men are mortal', although it has no logical subject, only the dummy 'it' supplied in English to establish the person and number of the verb. Ridding oneself of the subject-predicate presupposition may itself be claimed as one advantage of an education in Chinese which Hall and Ames seem to have missed. Take the sentence with which in a *Chuang-tzu* story Lieh-tzu reports to his teacher after being sent to catch a man who is running away:

Yi mieh yi 已 滅 矣 "(He) has vanished"[8]

** Hansen, 'Truth' 517, has an appendix rejecting my claim that *Names and Objects* discovers the sentence, but without criticising or even mentioning my case for it (summarised pp. 153–55 above).

(Ergative verb *mieh* 'is-extinguished' preceded by the pre-verbal particle *yi* 'already' reinforced by the perfective final particle *yi* limited to verbal sentences).

It would be artificial to insist that *mieh* is predicated of an implicit subject; the agent is understood only in the same sense as is the time and place of the event. This is none the less a sentence with a main verb; and what it says is true or false, to be accepted if the man has indeed disappeared but not if he is still present.

With this example we touch on a crucial issue, in what sense the ancient Chinese display what Hall and Ames describe as a "lack of interest . . . in questions of 'truth' and 'falsity'." It is a commonplace, repeated more than once in the present book, that Chinese philosophising centres on the Way rather than on Truth. But we must insist in the first place that this difference from our own tradition has nothing to do with everyday questions of fact. Neither Western nor Chinese philosophy is concerned primarily with factual issues; to the extent that they are, as in Mohist argument for the existence of spirits, there is no significant difference from ourselves. If your wife announces 'Dinner is on the table', or the corresponding words in any language, you are disappointed if the dinner turns out to be still in the oven; a language without sentences in which it is impossible to affirm a fact would lack the communicative function without which it could not serve as a language. However much or little the words used to assent (Chinese *jan* 然 'so', *yu* 有 'there is', *hsin* 信 'trustworthy' and so forth) resemble or differ from English 'true', one assents if and only if dinner *is* on the table. Hansen has argued that even in the Mohist discussion of spirits the question is not whether it is true that they exist but whether it is socially appropriate in distinguishing the existing from the non-existent to put the spirits on one side or the other.[9] But the issue being purely factual (whether spirits exist, are conscious, appear before men's eyes, reward the good and punish the wicked) with the second of the three Mohist tests being a direct appeal to reports of seeing and hearing spirits, what would this difference amount to? Hansen objects that the other two Mohist tests, the authority of sages and the social consequences, are not for you and me relevant to truth, so truth is not what the Mohist is after. But even in the modern West only the logically sophisticated fully succeed in detaching questions of truth from appeals to authority and to social benefit. We noticed that the three Mohist tests are very like those assumed in popular discussions of the existence of God.[10] Moreover if the existence of spirits raised for Chinese only the question whether it is socially appropriate to affirm it, how was it ever possible to doubt it, since no one denied the social duty of sacrificing to spirits? Mohists reproach Confu-

cians for both requiring sacrifice to the spirits and denying their existence.[11] The common formula posing alternatives, 'If the dead have knowledge If the dead lack knowledge ', which appears in several of our quotations,[12] implies that even outside philosophical circles the question was widely regarded as open, however socially appropriate it might be to behave as though the dead are conscious. Indeed Westerners have often been surprised by the Chinese capacity to combine scepticism with orthodox practice; the attitude of the philosophers to divination provides other examples.[13]

But does the Chinese confirming that, as his wife said, his dinner is on the table, necessarily have the *concept* of Truth? Let us say that to have the concept implies having a word the meanings of which have the same range of family resemblances as 'true'. We use the word 'true' in the first place of such matters as whether the money, as you told me, is already in the bank. Outside such factual issues, on which we confront the Chinese and everyone else as inhabitants of the same world, we speak of the logical truth of tautologies, of the truth to life or nature of a fictitious narrative, of metaphysical truths, of the moral truths in the Sermon on the Mount, extending the word along chains of similarities linking to the factual. Finally 'true' comes to be not much more than the word by which we assent to any kind of utterance to which we attach a certain importance. Such words as *jan, yu* and *hsin* would not be expected to, and do not, have the same metaphorical spread as 'true'. Even if one of them did approximate to it we should have to dismiss the correspondence as an amusing coincidence. To say that Chinese philosophers display a "lack of interest in questions of truth and falsity" amounts then to saying that like Western they are not primarily concerned with the factual, but unlike Western they do not use a word which assimilates other questions to the factual. That they would have no concept of Truth is to be taken for granted, but is trivial. The game of demonstrating that some important concept of ours ('morality', 'ethics', 'rights', 'philosophy', 'civilization', 'science', 'art', what you will) is missing in Chinese thought, although still popular, is quite pointless, since it can be played with any philosophical term one chooses, and not only with philosophical; in that *yang* 羊 embraces the goat ('mountain *yang*') as well as the sheep, the Chinese have no concept of sheep. One explores Chinese philosophy by comparing and contrasting Western and Chinese concepts. Even when one fails to notice distinctions they may be expected to emerge if one finds it profitable to push analysis farther.

Hall and Ames discuss also, together with the supposed paucity of

entification in Chinese which we shall consider shortly, a new proposal originally offered for modern Chinese by Alfred Bloom.

"Another important characteristic of classical Chinese for our present concerns is the relative unimportance of the sorts of locutions termed 'counterfactuals'. Thus statements such as 'had it not been the case that . . . so-and-so would have occurred' are not efficaciously present in Chinese philosophy.

"The relative absence of both a language of entification and of condition-contrary-to-fact expressions suggests that the classical Chinese would have found scientific and ethical reflections and deliberations unappealing. Both abstract nouns and conditionals are foundations of the sort of theoretical thinking which permits one's thoughts and attitudes to be detached from the manner in which one actively presents himself to the world. Theoretical thinking presupposes that one can be objective and dispassionate in the consideration of the differential consequences of alternative possibilities. The 'either-or' sensibility underlies the dominant modes of ethical and scientific thinking."[14]

As a general reflection this is not without interest. One conclusion drawn is that "whereas Confucius presents a 'way without [ethical] crossroads', his reason for doing so is embedded in the character of the language he employs." That his apparent aversion to posing alternatives connects with his presumed disinclination to use counterfactuals is not implausible, although one cannot resist noting that Confucius never sounds more himself than when saying "If Kuan knew ceremony who doesn't know ceremony?", or on another occasion in a friendlier spirit of the same man, "If there had been no Kuan Chung we should be wearing our hair unbound and robes folded to the left".[15] The trouble is that the unimportance of counterfactuals is presented as general throughout "classical Chinese philosophy" and "characteristic of Classical Chinese", that is, of the language itself. As admitted in a footnote, Bloom's case, based in any case on modern Chinese, has already been damagingly criticised.* Classical Chinese has, among other 'if' words with different

* Hall and Ames 364 n29. Cf. the review articles on Bloom by Wu Kuang-ming *op. cit.* and Fang Wan-chuan *op. cit.* It is characteristic of the dangerous failure of communication between philosophical and grammatical specialists in Chinese studies that Hall and Ames do not mention the section entitled 'Counterfactual *shih* 使' in Harbsmeier, *Aspects* 272–287, which attacks in detail the same questions about the Chinese which they raise only in the most general terms: "Could they unambiguously articulate a counterfactual proposition? What sorts of counterfactual arguments did they use? And what did they use them for?" (Harbsmeier *ut sup.* 272f).

and still imperfectly analysed functions, a very common counterfactual *shih* 使 'supposing that', often reinforced by *chia* 假 'falsely, pretending', with a whole family of alternative phrases, not to mention the rather rare negative *wei* 微 'if there were not', and the phrases of the type *chin yu jen yü tz'u* 今有人於此 'Now here we have a man who ' which regularly introduce imaginary examples. Hall and Ames therefore insist only on "the infrequent resort to such locutions in Chinese philosophical argument".[16] But philosophical *argument* starts only after Confucius and teems with these locutions. We have seen that the argument of the type 'If I gave you a cap in exchange for cutting off your head ' is an established convention of Yangist, Mohist, and Mencian disputation,[17] that an essay of Kung-sun Lung ends with a whole string of counterfactuals,[18] that there is even an instance of hypothetical measurements of the universe starting off from a number introduced counterfactually.[19] The "way without a crossroads" ended with Confucius; "ethical deliberation" and the image of the crossroads itself appeared with the first rival schools. The 'either-or' sensibility awakens with Mo-tzu, *pien* 'argumentation' being essentially arguing out which of two alternatives is X and which is not. It may be admitted that when philosophical argument dies down China does show that aversion from the 'either-or' sensibility implied by Hall and Ames's general thesis (that China demands not the transcendence of A but its superiority to and interdependence with B). The final tendency of the schools was towards syncretism; philosophers settle for 'I see the whole thing, you are one-sided' rather than 'I am right, you are wrong'.[20] But to say that "the deemphasis upon scientific and ethical reasoning of the sort most closely associated with Western philosophy is intrinsically related to the relative absence of counterfactuals in the classical Chinese philosophy"[21] surely lacks all explanatory value. Given the richness of counterfactual resources in the language itself, their presumed unimportance in philosophical discourse would in any case have to be the effect rather than the cause of any "deemphasis upon scientific and ethical reasoning."

In linking entification with counterfactuals, Hall and Ames, again following Bloom, renew the traditional claim that the absence in Chinese of morphological means of distinguishing the noun 'goodness' from the adjective 'good' or, as an example of a technical coinage, 'analyticity' from 'analytic', hinders the formation of abstract concepts. This does seem to me to be still an interesting and highly debatable question; but why is the claim always thrown off as a generalisation without offering anything concrete for debate? As with such words as 'evil' which lack such

conveniences in English, in Chinese one identifies the word as nominal only by putting it in a syntactically nominal position.[26] However, in English this does not interfere with talking in abstract terms about the 'problem of evil', 'nature of evil', 'conflict between good and evil'. To get the full hypostatising, not to say personifying effect, one perhaps needs a capital letter, 'Evil', but is that a logical as distinct from a poetic or religious advantage? Let us take the word *hsiao* 'filial piety'. In a verbal sentence this will generally be in a verbal position, where we may represent it by 'is-filial'. We shall italicise our equivalents for Chinese particles, such as *tse* '(if) . . . then' and give them their English sentence-positions:

An. 2/20	*Hsiao*	*tz'u*	*tse*	*chung*
	孝	慈	則	忠
If	is-filial	is-compassionate	*then*	is-loyal

("If you are filial and compassionate you will be loyal")

In a nominal sentence (in which we represent the final particle *yeh* by '*is*'), *hsiao* becomes 'being-filial', as in the Later Mohist definition.

Canon A 13	*Hsiao*	—	*li*	*ch'in*	*yeh*
	孝		利	親	也
	Being-filial	*is*	benefiting	parent	

("Filial piety is benefiting parents").

In nominal sentences then Chinese syntax does not hinder treating *hsiao* as a concept, although it does interfere with thinking of filial piety as somehow different from children being filial, for example as the Platonic form of their behaviour. Here Chinese syntax shows the side of it which has a pleasing resemblance to symbolic logic, in which you move the symbols around without having to manipulate parts of speech. But what of verbal sentences where *hsiao* stands in a nominal position? There, when lacking a possessive subject (X *chih* 之 *hsiao* 'X's being filial'), it will generally turn into 'the filial', the person who is filial, no longer the concept. The issue then reduces itself to whether it would be a restriction to the handling of abstract concepts not to be able to use them freely with verbs. In verbal sentences *hsiao* is used rarely of the concept except as object of a limited range of verbs, for example

An. 2/7	Tzu-yu	wen	hsiao
	子游	問	孝
	Tzu-yu	ask-about	being-filial

("Tzu-yu asked about filial piety").

Sometimes a word in changing position changes sense and becomes recognised as a new word, distinguished by phonetic and/or graphic differentiation. Thus in nominal positions the verbs *sheng* 生 'be born, live' and *ch'eng* 成 'become whole' diverge into *hsing* 性 'nature' and *ch'eng* 誠 'integrity', while themselves remaining 'life' and 'becoming whole' in a nominal position.[23] Of these *hsing* is classifiable lexicographically as a noun, in that it cannot be freely used in a verbal position. Later graphic standardisation perhaps eliminated many cases of concept-formation which failed to take root, like the Later-Mohist trifurcation of *chih* 知 'know' into 'wit/wot/wise'.[24] The new word if a noun becomes assimilable to concrete nouns, opening the prospect of hypostatisation. This however happens only with a change of sense. It cannot happen, for example, in the many cases where Chinese nominalises pairs of opposites, saying *ta hsiao* 大 小 'being big or small' and *ch'ang tuan* 長短 'being long or short' where we would say 'size' and 'length', or *yu wu* 有無 'there being or not being', *jan pu jan* 然不然 'being so or not so', *shih fei* 是非 'being or not being this', in the sort of contexts where we would be talking about being or truth. In an Indo-European language on the other hand, nominalised forms being obligatory in nominal positions, the prospect opens for all verbs and adjectives with or without change of sense. Thus having fixed the concept of being true by the noun 'truth' we have the opportunity for unlimited variations, 'truth will prevail', 'unveil the naked truth', 'flies in the face of truth'. But are these metaphorical luxuries a logical advantage? We have touched briefly on the question whether 'meaning' and the 'signified' have not involved Western thought in excesses of hypostatisation avoided by Chinese with its verb *chih* 指 'point out'.[25] Although the question is a complicated one which I leave open, it may be suggested that Western philosophers who are behaving themselves do not take advantage of the liberty to use these nominal formations except with a limited range of verbs which cluster round the copulative 'is'. To take at random the first four sections of Quine's paper 'Two Dogmas of Empiricism',[26] which are on 'analyticity', he never uses this word as subject of a verb, and otherwise

only with such verbs as 'is', 'explain', 'assume', 'presuppose', 'derive', 'define', 'clarify', 'equate with', 'take as', 'recognise'.

Here there does seem to be something different about thinking in Chinese, especially interesting in that it may be seen either as the limitation of having to think concretely or as the virtue of avoiding hypostatisation. I think also that the thesis of Chad Hansen that Chinese nouns resemble the mass rather than the count nouns of Indo-European languages has been a genuine forward step in the understanding of Chinese thought, although I no longer as formerly find it persuasive. This treatment of nouns is most plausible for languages which regularly supplement numerals with sortals, including modern but not Classical Chinese. In modern Chinese one counts much as one counts cattle in English: *yi ko jen* 一個人 'one head of man' (one man), *yi chung jen* 一種人 'one breed of man' (one kind of man), both formally indistinguishable from *yi pei shui* 一杯水 'one cup of water'. One might say that the sortals assimilate count to mass nouns, while our own number terminations do the reverse. It is not immediately obvious that this observation is relevant to Classical Chinese, which has neither the grammatical number of Indo-European count nouns nor the regular sortals of modern Chinese. However, the postulate that Classical nouns do approximate to mass rather than count nouns inspired Hansen to an insight from which we have profited in the present book, that the tendency of Chinese thought is to divide down rather than to add up, to think in terms of whole/part rather than class/member.

"The mind is not regarded as an internal picturing mechanism which represents the individual objects in the world, but as a faculty that discriminates the boundaries of the substances or stuffs referred to by names. This 'cutting up things' view contrasts strongly with the traditional Platonic philosophical picture of objects which are understood as individuals or particulars which instantiate or 'have' properties (universals)".[27]

Hall and Ames, replacing Hansen's 'substance' by a 'process' ontology, prefer to speak of 'field/focus' rather than 'whole/part'. But they adopt enthusiastically his claim that Classical Chinese does not have count nouns and draw the most radical conclusions, that in the absence of classes of particulars to be picked out by index words language will be non-referential, "no ontological referencing serves to discipline the act of naming," "there is no object language in the strict sense," "names 'reference' functions or roles which are themselves other names," "there

can be neither connotative nor denotative definition in the strict sense."[28] One is left wondering how it would be possible to write a historical narrative in Chinese, and how a filial Confucian identifies his own father. All this is supposed to follow from the absence of count nouns. But can we simply take the mass-noun hypothesis for granted, without the criteria on which the claim might be made of modern Chinese? (Not that any such consequences would follow for modern Chinese!) Christoph Harbsmeier has pointed out to me in correspondence that if we look for such grammatical tests it turns out that they differentiate types of noun in Classical Chinese. He suggests a three-fold classification:*

(1) Mass nouns, with numeral and sortal as in modern Chinese (*yi pei shui* 'one cup of water').

(2) Count nouns with preceding numeral (*erh ma* 二 馬 'two horses'), or with numeral and sortal after the noun (*ma erh p'i* 'horse, two head'). Counting being of individuals can be in only one way.

(3) Generic nouns, also with preceding numeral, but counting kinds; these being variously divisible are also variously countable. Thus although *ma* 'horse' is a count noun, *shou* 'animal' and *ch'u* 'domestic animal' are generic (*pai shou* 百 獸 'the hundred kinds of animal', *liu ch'u* 六 畜 'the six kinds of domestic animal').

This classification, although not necessarily the final one which Harbsmeier will commit himself to publishing, is already enough to show that the mass-noun hypothesis is no longer tenable, at least in its original form. It is characteristic of the slow progress of Chinese grammar that it has taken the stimulus of Hansen's proposal to awaken us to these distinctions. But one may notice that the insight of Hansen which seemed especially valuable survives the upheaval. Most philosophical terms which allow counting at all, such as *Tao* 'Way', *li* 'pattern', *ch'i* 'air, breath', *wu* 'thing', would seem by this classification to be generic nouns. Thus Chinese thinkers refer indifferently to 'the one *ch'i'* (*yi ch'i*), to Yin and Yang as 'the two *ch'i'* (*erh ch'i*), to sunshine, shade, wind, rain, light and dark as 'the six *ch'i'* (*liu ch'i*). It remains acceptable that Western philosophising in languages with number termination starts from the adding up of particulars, leading at two of its limits to the reduction of cosmos and community to aggregates of atoms and of individual persons, while the Chinese operating with generic nouns think in terms of variously divisible Way, pattern, *ch'i*, and kind of thing.

* 'The mass-noun hypothesis', to appear in Rosemont, *Chinese Texts*.

An old thought about the Chinese language is that the absence of tense and number terminations would hinder logic. Like other such thoughts (no sentences, words all like nouns), it springs from the Westerner's reactions when first confronted with columns of supposed ideograms and wondering how they can represent a language at all. How well does this first impression stand up to further experience? As far as the utility of the distinctions is concerned, one soon learns that, for example, the occasional placing of a temporal particle is quite enough to clarify the time relations between events; one does not have to be reminded by the tense of the verb in every narrative sentence of the *Decline and Fall of the Roman Empire* that the events occurred in the past. Nor is it especially useful to know whether there is one of a thing or between two and infinity; even in English we do not say 'Men went out of the room' but 'Two men ', 'Some men '. Waley explained several of the Chinese sophisms as resulting from confusion between singular and plural or past and present, also between identity and class membership.[29] Although none of his proposals is any longer tenable[30]—indeed, they are no longer credible as the sort of mistake a Chinese thinker would make—Waley deserves credit for descending from the plane of high abstraction on which these issues are generally discussed to come to grips with particular cases.

However, although the distinctions made by Indo-European terminations are not of much use in themselves (gender in languages which mark it is frankly irrational, the English tense system is largely detached from time relations), it remains hard to shake off one's general impression that the necessity in every sentence of imposing the distinctions and keeping to them consistently would be a stimulus to logical thinking. In Indo-European languages learning to speak and write grammatically is to some extent a logical exercise, an education in the ancient languages more highly inflected than one's own has traditionally been defended as a training of the mind, and the history of logic has been tied up with the history of grammar. The point is *not* that our languages are inherently more logical than Chinese. Classical Chinese, with its unchanging words organised by syntax alone, has a beautifully logical structure, warped by idiom of course, but perhaps nearer to symbolic logic than any other language. But logic as a discipline will develop only with consciousness of thinking illogically. Is it perhaps that Indo-European languages, which force thought into a straitjacket, imposing a subject, number, tense even when logically there should be none (in English we talk by such implicit rules-of-thumb as 'When in doubt put "It" for subject and use the present tense'), by their very irrationalities remind us of what rationality is? In

Classical Chinese on the other hand nothing compels the thinker to raise logical questions; unconscious of his own grammar, free to be vague or to clarify with further particles as occasion arises, he seems to look out on the world through language as a perfectly transparent medium. How logically the Chinese think must therefore always be ascribed to extra-linguistic causes—above all, as the present book illustrates throughout, the extent of controversy between rival schools. The language itself tightens with the need for clear thinking, as was the case with English when it replaced Latin as the medium for an Englishman's serious thoughts. The most striking illustration is the Mohist *Canons,* which consistently use only one particle for one function, and the same word in the same sense in syntactically regular sentences which sometimes defy current idiom— plainly the result of a deliberate decision, like the cleaning up of English in the 17th century by the Royal Society.[31]

Following this line of thought, one would expect that a training in Classical Chinese style would be an education primarily in sensitivity to similarities and differences, and so in correlative rather than analytic thinking. The parallelism so noticeable in Chinese style is not mere decoration but an indispensable aid to syntax. Given a language in which sentences are structured by word-order, and not only can verbs stand in nominal positions but nouns have causative and putative uses in which they stand in verbal positions, a sentence or clause of any length will be structurally ambiguous unless clarified either by particles or by parallelism with another similar in structure. Hsün-tzu and Han Fei, for example, exploit the resources of both syntax and parallelism to build long and complex sentences. On the other hand a poet or a Yin-Yang thinker, being primarily interested in correlation, tends to dispense with particles and rely on parallelism alone. The choice between these alternatives with the rise or the waning of intellectual controversy returns in later periods. Thus Han Yü (A.D. 768–824), the initiator of the Confucian revival which took the offensive against Buddhism and Taoism and led to the Neo-Confucianism of the Sung, was also the rebel against the 'Parallel Prose' dominant for some centuries and founder of the 'Ancient Prose' movement which took its stylistic models from such early Confucians as Mencius.

As an example of parallelism removing the need for particles we may take the main clauses of two parallel sentences in *Huai-nan-tzu.*[32]

"The clear being luminous, in the water in a cup you see the pupil of the eye. The muddy being dark, in the water of the River you do not see Mount T'ai."

The syntax of the main clauses is established by word order alone;

dependent words (which we bracket) precede what they depend on, the subjectless verb precedes the object, and there is an exposed element in front.

Exposed	Verb	Object
杯水	見	眸子
(Pei) shui	chien	mou-tzu
河水	不見	太山
(He) shui	(pu) chien	T'ai-shan
(Cup) water	see	pupil-of-eye
(River) water	(not) see	Mount T'ai

("In the water in a cup you see the pupil of the eye. . . . In the water of the River you do not see Mount T'ai.")

How does the exposed element relate to verb and object? Solely by the proportional oppositions between the two clauses, which we may analyse in the same terminology we used in coming to grips with Yin-Yang thinking;[33] the vertical relations are paradigmatic, the horizontal syntagmatic.

(1) *Paradigmatic*. The water in a cup *compares* with the water of the River as the pupil with Mount T'ai (as minute by contrast).

(2) *Syntagmatic*. The water in a cup *connects* with seeing the pupil as the water of the River with seeing Mount T'ai (as contiguous with the seen, what one sees it in).

The first proportional opposition functions alike in English and in Chinese; it would be pointless to expand the translation to say explicitly " . . . you see even something as small as a pupil . . . you do not see even something as big as Mount T'ai." A sentence in English as in Chinese floats on a sea of unformulated similarities and contrasts; one correlates first and analyses afterwards. In the second case however the difference between the priorities for the two languages emerges, with English making the nature of the contiguity explicit by the preposition 'in' ("*In* the water in a cup "). Differently organised Chinese sentences unsupported by parallelism would likewise have to clarify the contiguity by the prenominal particle *yü* 於 translatable in such contexts by 'in'.

In this section I have been doing my best to discredit the persisting

habit of generalising about Classical Chinese from antiquated assumptions and without reference to its grammar. The book of Hall and Ames, in many respects admirable, which opens up possibilities of interaction with contemporary philosophy which I heartily welcome, has unfortunately presented itself as the main target, providing both the most recent and the most extreme example. Back in 1959, following Waley's precedent in examining particular cases, I published a paper on the implications for comparative philosophy of the differences between Indo-European 'to be' and corresponding words and constructions in Chinese. At that time I was naive enough to expect that with the appearance of one grammatically grounded study speculation without reference to the facts of the language would be recognised as obsolete. Clearly the hope was premature. But a claim that, for example, there are no sentences in English, offered without even an alternative account of the grammatical differences between the so-called 'sentence' and the nominalised clause, would be meaningless; why is the claim supposed to be meaningful if the language is Chinese? I conclude by summarising for the general reader three detailed studies, to which specialists are referred for the full development of the arguments.*

Being

The dependence of Western ontology on the pecularities of the Indo-European verb 'to be' is evident to anyone who observes from the vantage point of languages outside the Indo-European family. It is unusual for a language to use its existential verb also as copula, and far from universal to use the copula not only with nouns ('Socrates is a man') but with adjectives ('Socrates is mortal'). In other language families the existential verb tends to overlap our 'have' rather than copulative 'be'; for the latter, there may be another verb, or there may be the nominal sentence with simple juxtaposition ('X Y') or with pronoun resuming the subject ('X, this Y') or with a particle (Classical Chinese 'X Y yeh'). As for the adjective, it needs no copula in languages which like Chinese class it not with the noun but with the verb. Our 'be' may be seen as no more than an existential verb adapted as a stop-gap word to satisfy a rule (not universal

* 'Being in Philosophy and Linguistics' (on Greek, Arabic and Latin), ' "Being" in Western Philosophy Compared with *shih/fei* and *yu/wu* in Chinese Philosophy' (rewritten for non-sinologists as ' "Being" in Classical Chinese'). 'Relating categories to question forms in pre-Han Chinese thought' (G *Studies* 360–411). For 'Being' in Greek and Arabic cf. the specialist studies of Kahn and of Shehadi.

even among Indo-European languages) that the sentence requires a main verb.

The existential/copulative distinction is reflected in the ontological contrast between existence and essence. Historically, this pair of concepts emerged first in Arabic philosophy, during the stage when the Western tradition was passing from one Indo-European language (Greek) to another (Mediaeval Latin) through the medium of Semitic languages, Syriac, Arabic, and Hebrew. Greek philosophers, with the notable exception of Aristotle, confused the existential verb with the copula. Greek *ousia*, a noun derived from *einai* 'be', is still substance (what there is) as well as essence (what it is in itself); even Aristotle, although translators resort to 'essence' and 'existence' to clarify him in English, formulates the distinction not by technical terms but by cumbersome phrasings with *einai* ("whether or not it simply is, not whether it is white or not", or "the *ousia* being not this or that but simply, or not simply but in itself or accidentally").[34] The Arabs, philosophising in a Semitic language which deals with the existential and the copulative by different words and constructions, had to develop a new terminology centred on *wujūd* 'existence' and *māhiyyah* 'quiddity'. Simply by the medium of otherwise very literal translations into Arabic, Aristotle was transformed into a thinker who speaks sometimes of existence, sometimes of quiddity, never about being; and a new ontology emerged in which existence does not belong to the quiddity of anything except the single necessary existent, God, who according to Ibn Sīnā (Avicenna, 980–1037) creates by adding existence to the quiddities of things. Latin translators from Arabic coined *quidditas* for *māhiyyah* but also reserved for it *essentia* (a derivative of *esse* 'be' originally coined as a general equivalent of Greek *ousia*), while using *esse* itself for *wujūd*; the difference was further clarified as the verb *existere* emerged to distinguish the latter. Consequently, for the Scholastics the essence and existence imported from the Arabs became incorporated into the Being inherited from the Greeks, even in the Latin translations of the Arabic philosophers themselves.

A verb 'be' combining the two functions is unstable even in Indo-European languages. In Greek, *einai* is primarily existential, and the nominal sentence without copula is common; in modern languages on the other hand English 'be' and French *être* are copulae, superseded for existence by 'there is' and *il y a*. A philosopher may archaise English to say 'I think, therefore I am', but even a philosopher's English cannot stretch 'be' to cover all uses of *einai* and *esse*. One cannot, for example, replace

'There is no life on Mars' or 'Life does not exist on Mars' by 'Life is not on Mars', where the 'is' would be understood as the copula. Being has vanished altogether in symbolic logic, which has distinct signs for the existential quantifier and for several copulae (for identity, class membership, class inclusion). The abstract noun 'being' remains of course as freely manipulable in philosophical discourse as any other noun; but one may well ask in what sense Western thinkers, however confidently they may talk of Being, may still be said to retain a concept which no longer has a place in either their natural or their artificial languages.

Chinese concepts comparable with Being

As with the concept of Truth, we refuse to play the pointless game of seeking and failing to find the concept of Being in Chinese thought; instead we look for the relevant concepts with which to compare it. Chinese philosophical discourse has three relevant verbs or pairs of verbs which can stand freely in nominal positions.

(1) *Jan* 然 'is-so', with an opposite usable in some contexts, *fou* 否 'is-not-so'. Nominalised *jan* ('being-so') covers only verbal concepts; but since these cover everything we express adjectivally, Chinese *pai* 白 'is-white' is something 'so' of a horse, while for us 'white' is something the horse *is*.

(2) *Shih* 是 'is-this', opposite *fei* 非 'is-not'. *Shih* unverbalised is a resumptive pronoun 'this' (the aforesaid, the one in question). This pair apply in the first place to nominal sentences, which have the final particle *yeh* without a copulative verb, but are negated by the copulative verb *fei* 'is-not' with or without *yeh*. (We continue to italicise and displace the English equivalents of particles.)

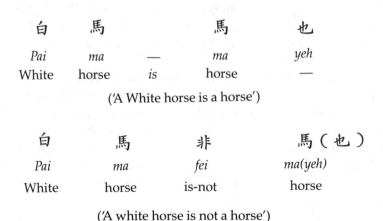

白	馬		馬	也
Pai	*ma*	—	*ma*	*yeh*
White	horse	is	horse	—

('A White horse is a horse')

白	馬	非	馬（也）
Pai	*ma*	*fei*	*ma(yeh)*
White	horse	is-not	horse

('A white horse is not a horse')

In the corresponding uses *shih* is the unverbalised pronoun.

X	—	shih	yeh
X	is	this	—
X	fei		yeh
X	is-not		—

There is however a complication which explains why all *pien* 'argumentation' is conceived as debate over alternatives judged by verbalised *shih* and *fei*. Both *yeh* and *fei* may also be attached to whole sentences (with *fei* immediately preceding the verb), turning them into judgments between alternatives without nominalising them. Thus a king asked by Mencius why, when moved to pity by an ox about to be sacrificed, he had substituted a sheep equally deserving of pity, says in his reply:

Me 1A/7

我	非	愛	其	財	而	易	之	以	羊	也。
— Wo	fei	ai	ch'i	ts'ai	erh	yi	chih	yi	yang	yeh
Is-not I	—	grudg-ing its	expense	—	exchange it		for	sheep	—	

("It isn't that I exchanged it for a sheep because I grudged the expense of it")

Mencius explaining his inconsistency to him says:

見	牛	未	見	羊	也。
— Chien	niu	wei	chien	yang	yeh
Is see	ox	not-yet	see	sheep	—

("It's that you had seen the ox but hadn't seen the sheep.")

Argumentation, as debate between alternatives, has as its paradigm the issue whether something is X, for example an ox or a horse, but because of this usage can embrace within its compass all *jan* issues as well. Describing something as white is saying what is 'so' (*jan*) of it, but debating whether it is or is not the case that it is white comes within the scope of whether or not it 'is-this' or 'is-not' (verbalised *shih/fei*). In the absence of an affirmative copulative verb there is no *being* an ox, any more

than there is *being* white, and so no essence intervening between name and object; the term closest to Aristotelian essence, *ch'ing* 情, covers everything in the ox without which the name 'ox' would not fit it, not everything without which it would not *be* an ox. One begins to understand why in Chinese philosophy argumentation is conceived solely in terms of whether the name fits the object.

The nominal sentence does not admit temporal particles; it reflects the atemporal relations expressed in English by the nomic present and on occasion by other tenses, as in 'Augustus *was* the greatest Roman Emperor' (Has he ceased to be the greatest? Did he become the greatest before the last of them died?). In English we have to choose a tense for the verb whether time is relevant or not. The Classical Chinese word used with temporal particles is a copulative verb *wei* 為 'constitute, become' (transitively, 'do, make'). Since *wei* is usable also with the equivalents of our adjectives, Chinese translators from Western languages sometimes, as we shall see shortly, find it a convenient word for dealing with our copula. But we shall not discuss *wei* further because it is rarely nominalised. We do find it nominalised, and so generating a philosophical concept, in the *Canons*.[35] But outside this text on one of the outer limits of the tradition, attention turns to *wei* as a concept only in the sense of 'do, make', as in *wu wei* 無為 'doing nothing'.

The specialised copula of identity *chi* 即, common in philosophy from about the 3rd century A.D. ('X *chi* Y', 'X is Y and Y is X'), is not attested in the classical period.

(3) *Yu* 有 'have, there is', opposite *wu* 無 'have not, there is not'. When used impersonally these are the normal existential verbs; they are the words which when nominalised many translators represent by 'Being' and 'Non-being'. The syntax is clearest if we translate the verb *yu* by 'have'.

'White Horse' E/7

馬	固	有	色		使	馬	無	色	
Ma	*ku*	*yu*	*se*	*Shih*	*ma*	*wu*	*se*
Horse	certainly	have	colour	Supposing	horse	not-have	colour

("Certainly horses have colour Supposing horses did not have colour ")

Mo 31/6

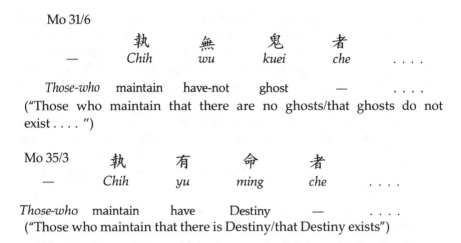

	執	無	鬼	者	
—	*Chih*	*wu*	*kuei*	*che*

Those-who maintain have-not ghost —
("Those who maintain that there are no ghosts/that ghosts do not exist ")

Mo 35/3

	執	有	命	者	
—	*Chih*	*yu*	*ming*	*che*

Those-who maintain have Destiny —
("Those who maintain that there is Destiny/that Destiny exists")

An important difference from existential 'be' and from 'exist' itself is that while 'ghosts' is the subject of the verb in English, *kuei* is the object of the verb in Chinese. The existence of a thing is affirmed by saying that the cosmos has it as itself it has shape, colour, sound. Since in verbal sentences the nominalisation of a verb generally shifts the reference from action to agent, nominalised *yu* 'having' and *wu* 'not-having' become 'that which has (shape, colour and other characteristics)' and 'that which does not have', which however logically implies also being had by the cosmos or not being had; the most convenient English equivalents are 'something' and 'nothing'. One may see *yu* as illustrating the Chinese tendency to divide down from a wider whole, 'is' and 'exists' our own tendency to start from the thing itself.

To have and be had is to have characteristics distinguishing from other things. Not to have or be had is to be without distinguishing properties, which for Taoists is the potentiality of becoming anything; in *Lao-tzu*, as we have seen,[36] Nothing is not the absence but, so to speak, the positive counterpart of Something. Consequently, while the West on its Platonist side denies true being to the concrete and reserves it for a higher realm of ideas, the Chinese tradition on its Taoist side reserves *yu* for the concrete, the limited and imperfect, and pronounces the Way to be either Nothing or prior to the distinction between Something and Nothing. Kuo Hsiang (died c. A.D. 312), commenting on Chuang-tzu's idea of a 'maker of things', offers a kind of reversed Ontological Argument which assumes that *yu* implies imperfection.

"I should like to ask whether the maker of things is something *(yu)* or nothing *(wu)*. If he is nothing, how is he able to make things? If he is something, he is unequal to making things in their multitudinous shapes. Therefore it is quite pointless to discuss the making of things with someone until he understands that the multitudinous shapes become things of themselves."[37]

Serious metaphysical argument over *yu/wu* is outside our period; it begins with Wang Pi (A.D. 226–249), who identified the Way with Nothing, and others of his period such as P'ei Wei (267–300), who in answer to Taoist mystification about Nothing and Doing Nothing objected that Nothing is merely the absence of Something.

It may be noticed that in the functions here discussed Classical Chinese syntax is close to symbolic logic: it has an existential quantifier *(yu)* which forbids mistaking existence for a predicate and is distinct from the copulae (which come to include a special copula for identity), and it has no copula linking subject to predicative adjective and no common symbol for them all.

Modern translation of Western ontology into Chinese

A Western confusion between existence and essence is inevitably exposed by the frustrated effort to translate it into Chinese. Thus when Plato argues that since what *is* double X is half Y, and the large and heavy in comparison with X is small and light compared with Y, "one can't think of them either as *being* or as not being, or as both or neither",[38] there is no step in the argument from questioning essence to questioning existence; the distinction is not yet seen, as it is later by Aristotle and of course by the Arabs. Such a fallacy cannot be reproduced in Chinese. In Wu Hsien-shu's translation of the quoted sentence the questioning of existence has to be tacked on as a further doubt somehow suggested by doubt as to what the thing is and what is so of it.

"It is truly no easy matter to know whether they are this *(shih)* or it is not so *(fou)*, whether there are *(yu)* these things or there are not *(wu)*."[39]

We saw that Kuo Hsiang operating with *yu* produces a reversal of Anselm's Ontological Argument for the existence of God. Can the Ontological Argument itself be reproduced in Chinese? Yes, but only by substituting for *yu* a new word which has the syntax of English 'exist'. This modern coinage is *ts'un-tsai*, a compound of *ts'un* 存 'persist' and *tsai*

在 'is-in, is-present', and takes as subject what would be the object of *yu*:

Yu	X
There-is	X
X	*ts'un-tsai*
X	exists.

By a modern convention one forms by the addition of *hsing* 性 'nature' the abstract noun *ts'un-tsai-hsing* 'existence', allowing it to be included among a thing's 'qualities' (*hsing-chih*, compounded of *hsing* 'nature' and *chih* 質 'stuff'). One can thus introduce into Chinese thought the error of treating existence as a predicate, which it took the West 2,000 years to expose. One sees that philosophical translation from another language, which seems to enrich terminology, can involve a deterioration of syntax. I translate the following account of the Ontological Argument, successful on its own terms, from a modern text-book.[40]

"God is the highest existent (*ts'un-tsai*). To suppose that there is an existent higher than God is inconceivable to the human mind; therefore, among everything that exists, only God is (*wei*) perfect. Whatever is called absolutely perfect must have no deficiency among the qualities (*hsing-chih*) which comprise it. Therefore God must include existence (*ts'un-tsai-hsing*). If God did not have (*wu*) existence, he could not be called perfect."

Since the coinage of *ts'un-tsai* admits the original fallacy into Chinese thought, one might suppose that it would also allow translation of Kant's refutation. Kant however moves freely between the existential *sein* 'be' and *sein* as copula with the adjective, for which there is nothing available in Chinese except *wei*. I extract the following from Norman Kemp Smith's English translation from the German, supplying the Chinese equivalents from Lan Kung-wu's translation from his English.

"*Being* (*ts'un-tsai*) is obviously not a real predicate; that is, it is not a concept of something which could be added to the concept of a thing. It is merely the positing of a thing, or of certain determinations, as existing (*ts'un-tsai*) in themselves. Logically, it is merely the copula of a judgment. The proposition 'God is (*wei*) omnipotent' contains two concepts, each of which has its object—God and omnipotence. The small word 'is' (*wei*) adds no new predicate, but only serves to posit the predicate *in its relation* to the subject. If, now, we take the subject (God) with all its predicates (among which is omnipotence) and say 'God is (*tsai*)' or 'There is (*yu*) a God' (note by Lan Kung-wu: "The three words *wei*, *tsai* and *yu* above are

Sein in German and *Being* in English"), we attach no new predicate to the concept of God, but only posit the subject in itself with all its predicates, and indeed posit it as being an *object* that stands in relation to my concept."[41]

One sees that fully successful Chinese translation would require, not merely the coinage of the predicable *ts'un-tsai* for 'exist', but its extension to cover the copulative use of 'be'. It would be a word with no function in the language except in the translation of Western philosophical arguments.

Does this line of inquiry threaten us with the sort of linguistic relativism for which the existence of God might be both demonstrable in Latin and refutable in Chinese? This would be so only if it were impossible for us to discover distinctions between things and between the functions of words which are not already made explicitly by grammar or vocabulary. Having the same word *yü* 玉 'jade' for both jadeite and nephrite does not abolish the differences between them; using the same word 'is' with a variety of functions did not prevent the West from learning to distinguish these functions. One is hindered but not finally trapped by the initial choices among similarities and differences behind the formation of one's language; the similarities and differences are there to be analysed in one's own or any other language. Nor is the extreme sort of linguistic relativism implied by the untranslatability of certain fallacious arguments into Chinese, which suggests on the contrary that the logical invalidity is independent of particular language structures. Whenever a logical distinction is marked in Language A but not in Language B, one must expect confusions of thought in B which can be analysed but not reproduced in A. It is not that the distinction is relative to the language, real for A but not for B. On the contrary, thinkers in B can learn the distinction from A (as Latin scholasticism learned the existential/copulative distinction from the Arabs), or discover it out of the resources of B itself (as Aristotle had already done).

Categories and question forms

That people of another culture are somehow thinking in different categories is a familiar idea, almost a commonplace, but one very difficult to pin down as a topic for fruitful discussion. The most promising approach would seem to be to identify the question forms in the language which are answered by grammatically distinct sentence units. It has long been noticed, and demonstrated in detail by Benveniste,[42] that Aristotle's

categories do largely coincide with Greek grammatical forms, not all of them shared by modern languages.

The first six Aristotelian categories are linked to questions:

Category	Question	Examples in 'Categories'
1. Substance	'What is it?' (*ti esti*)	Nouns
2. Quantity	'How much?' (*posos*, Latin *quantus*)	Adjectives incorporating numerals.
3. Quality	'Of what sort?' (*poios*, Latin *qualis*)	Adjectives
4. Relation	'With reference to what?' (*pros ti*)	Nouns in genitive case
5. Place	'Where?' (*pou*)	Nouns in dative case with prepositions
6. Time	'When?' (*pote*)	Temporal adverbs

Aristotle names these categories after the interrogative words or phrases (not excluding substance in the *Topics*, although the *Categories* calls it *ousia*). Of the technical terms later current, 'quantity' and 'quality' descend from *quantus, qualis*.

Since the verb lacks a corresponding interrogative word, and such questions as 'What does it do?' (answerable only by active verbs) separate out the voices, the verbal categories adjust to the three Greek voices and to the perfect (variously classed by Greek grammarians with the middle voice or as a tense).

Category	Examples
7. Posture	Middle voice
8. State	Perfect
9. Action	Active voice
10. Passion	Passive voice

Since modern languages lack equivalents to the Greek middle and perfect, the two corresponding categories have lost their significance for us.

No Chinese thinker classifies categories. But in Chinese too we can find correspondences between interrogative words or phrases, the sentence units, and vernacular categorial words of the type of our own 'thing', 'characteristics', 'action'. I employed these correspondences to pose as a Chinese Aristotle in the paper 'Relating Categories to Question Forms in Pre-Han Chinese Thought', published in my *Studies in Chinese Philosophy*. It is an enterprise which, like the inquiry into Being, wakes suspicions of wishing to plunge us all into a chaos of linguistic relativism. Jean-Paul Reding has objected that on the one hand Aristotle can recognise, for example, logical relations which are not marked by the

Greek genitive case, and on the other that the proto-logic of the Later Mohists implies that they draw the same categorial distinctions as ourselves.*

> B6 *(Canon)* "Different kinds are not comparable. Explained by: measuring.
> *(Explanation)* Which is longer, a piece of wood or a night? Which is there more of, knowledge or grain? Which is to be valued most, aristocratic rank, one's parents, proper conduct, a price? Which is higher, a deer or a crane? "

This passage, by the mere fact that it can be translated fairly literally into English, does confirm that logical distinctions are not simply imposed by the structure of one's language. That was not however what I wished to claim. Each language, by its choice of the same or contrasting words or constructions, makes its own assimilations and differentiations, but starting from similarities and differences which were discernible before being marked by them, and which are discernible also by speakers of languages which assimilate and differentiate otherwise; we can acknowledge this point without going further into the problem of extra-linguistic 'natural kinds'.[43] Differences between categorial systems need not prevent thinkers in any language co-ordinating and where relevant criticising them, by analysing the similarities and differences from which they start. One may take this position even without the faith, which I do not share, in the full intertranslatability of languages. By co-ordination I understand in the first place the correlation which precedes analysis, on which the understanding of one's own or another's language finally depends, and which analysis and translation criticise and clarify but can never wholly replace.[44]

Categories and the nominal sentence

The nominal sentence is analysable into subject and complement; there is no objection (as with the verbal sentence) to conceiving the remainder as predicated of the subject. However, for Aristotle the corresponding Greek sentence with copulative verb is not merely like other sentences, it is the characteristic type of sentence. We may anticipate

* Reding, 'Categories', criticises in detail Benveniste, myself, and also the observations on categories in Gernet 238–247.

that categorisation comparable with his will appear in Classical Chinese only in the verbal sentence.

Aristotle starts by establishing the category of substance by the question 'What is it?'. In Classical Chinese the question is asked with the interrogative pronoun *ho* 何 'what?': *ho yeh* 'What is it?'. However, this question is seldom or never asked of a particular in pre-Han literature. One asks of the object (*shih* 實) 'What tree is this?', 'What bird is this?', 'What man is this?',[45] and answers with the kind (*lei* 類), comparable with Aristotle's species rather than essence. Once again we find the Chinese dividing down towards the particular rather than starting from it. When *ho yeh* is used it is generally in requesting an enumeration of the kinds, as in a Mohist account of the three tests of argument, here called the Three Standards:

Mo 36/3

Subject		Post-nominal particle		Complement	
三	法	者		何	也
(San)	*fa*	*che*	—	*ho*	*yeh.* . . .
(Three)	standard	—	*is*	what?	—

Subject		Complement					
此		言	之	三	法	也	
Tz'u	—	*((yen*	*chih))*	*(san)*	*fa*	*yeh.*	
This	*is*	*((saying*	*'s))*	*(three)*	standard	—	

("What are the Three Standards? These are the three standards for saying.")

A definition is requested by *ho wei* 謂 X 'What is meant by "X"?', more literally 'What does one call "X"?'. It is asked of the *ming* 名 'name' and answered with the *ch'ing* 情 'essentials' (the word which, with the reservation that it is independent of Being, is comparable with Aristotelian essence).

Me 7B/25 "What is meant by the 'good'? It is the desirable that is meant by the 'good' "

There are nominal but not real definitions; again one is reminded that Chinese philosophy is concerned not with essences but with the fitting of names to objects.

Categories and the verbal sentence

Classical Chinese word order is determined by a fixed order of sentence units with rules for inversion and exposure; and by a rule that units dependent on sentence units precede them. (We mark the dependent by bracketing). Ignoring particle positions, we may for present purposes identify the sentence units and major dependents of the verbal sentence as follows.

1. Temporaliser (dependent on Units 2,3)
2. Subject (dependent on Unit 3)
3. Verb phrase
 3a. Verb
 3b. Object
 3c. Directive
 3d. Measurer

For simplicity of exposition we take examples from simple sentences with few or no particles. The minimal sentence is Unit 3a alone.

(1) *Temporaliser.* Question asked of Units 2,3 : *ho shih* 何時 (pre-verbal) 'What time?', answered with the *shih* 'time' (moment or period).

(2) *Subject.* Question asked of Unit 3: *shu* 孰 (pre-verbal) 'which?' answered with the *wu* 物 'thing'. This unit is not a subject of which the verb phrase is predicated but a dispensable unit dependent on the verb phrase; one might prefer to call it the 'agent', if it were acceptable to include the states which Indo-European languages call by adjectives among the 'actions'. *Shu* with *huo* 或 'some', *mo* 莫 'none' and *ko* 各 'each' constitutes a set of grammatically similar words, all pre-verbal.

Me 1A/6		*Verbs*		*Object*	
孰	能	與	之		
(Shu)	*neng*	*yü*	*chih*	
(Which)	is-able-to	give-to	him	

Subject			Verb	

天下	莫	不	與	也
T'ien-hsia	*((mo))*	*(pu)*	*yü*	*yeh.*
world	((none))	(not)	give-to	—

It's that

(Of the Empire: "Who is able to give it to him? No one in the world will not give it to him.")

It seems remarkable that one asks for the subject with *shu* 'which?', reserving *ho* 'what?' for the object. It is further confirmation that Chinese thinking proceeds not from the thing referred to but from a whole or aggregate from which one divides it. What consequences might we expect to follow from approaching things with the question 'Which?'. Aristotle starts with the isolated thing, asks 'What is it?', proceeds to describe it in isolation, and even when he comes to the category of action, with cutting and burning as his examples, excludes from consideration the cut and burned. He allows intrusion on this isolation only for the category of relation, with the examples 'half', 'double', 'bigger'. 'Which?' on the other hand is a dichotomising question, starting from two or more things. 'Which is white?' picks out the white from others which are not white; the opposite being negative, we remain ignorant of their colour. But the opposite may be positive: 'Which moves?' picks out from the still, 'Which is big?' from the small. The philosopher constructing a cosmos will be equally interested in both sides, will ask 'Which is big, which small?' and answer 'X is big, Y small'.

	Verb		Verb

孰	大	孰	小
(Shu)	*ta*	*(shu)*	*hsiao*
(Which?)	is-big	(which?)	is-small

Subject	Verb	Subject	Verb
X	*ta*	Y	*hsiao*
X	is-big	Y	is-small

By this approach, typical full statement is not as for Aristotle a simple

sentence ('X is bigger than Y') but a pair of co-ordinate clauses, in which nothing is required to distinguish 'big/small' as relative from 'moves/still' as not. A cosmology which starts from the question 'Which?' might be expected then to build on parallel clauses with paired subjects and verbs. This is indeed what we find in China, with Yin and Yang as the unifying principles running down each side of the dichotomy.

Although *shu* 'which?' may be asked of persons, there is also a pronoun *shui* 誰 'who?' (= which person) usable in any nominal position, distinguishing 'man' (*jen* 人) from all other 'things' (*wu*).

(3) *Verb phrase.* Question asked of Unit 2 : *ho jo* 何若 (or synonyms) 'What is it like?', answered when the request is for the description of a thing by its *chuang* 狀 'appearance, characteristics' (replaced in Later Mohist terminology by *mao* 兒). More generally, the verb phrase tells us that something is 'so' (*jan* 然), whereas the complement of a nominal sentence tells us that something is 'this' (*shih* 是); these are the 'this' and 'so' so often contrasted by Chuang-tzu and the Later Mohists.

Shuo-yüan 11/4A

		Subject	Verb phrase	
彈	之	狀	何若
(Tan	*chih)*	*chuang*	*ho-jo*	
(Tan	*'s)*	characteristic	is-like-what?	

Subject	Verb	Object	Inter- verbal particle			Verb	Object		
彈	之	狀	如	弓	而	以	竹	為	弦
(Tan	*chih)*	*chuang*	*ju*	*kung*	*erh*	*(yi*	*chu)*	*wei*	*hsien*
(Tan's)	characteristic	is-like	bow	but	(by-means-of	bamboo)	make	string	

("What are the characteristics of a *tan* like? The characteristics of a *tan* are like a bow's, but with a string made of bamboo").

Chuang approximates to Aristotle's category of quality, but the word is not a count noun; what for us are qualities belong to the *chuang* of the thing. Nor does it have the philosophical importance of quality in our own tradition; Chinese attention is centred on things and on actions, and one has the impression that the verbs translatable by our adjectives do not stand out from the rest. Western thought on the contrary regularly

converts dispositions to action into qualities by manufacturing adjectives, saying 'Lions are carnivorous' for 'Lions eat meat', and 'Man is rational' for 'Man can reason'.

The practice of asking of something, not what it is, but what is meant by its name and what it is like, may be seen as guiding all ancient Chinese thinking towards the nominalism explicit in the Later Mohists and Hsün-tzu.

Shui 'who?' distinguishes the human realm for Unit 2; for Unit 3 it is distinguished by *ho wei* 何為 'what does he do?' (asked of Unit 2) and by *jo chih ho* 若之何 'what's to be done about it?' (asked of Unit 3b), the answer in both cases being the *shih* 事 'action'. These questions carve out the realm of man from the realm of Heaven, what is done from what is merely so; it is against this background that Taoists invite us to 'do nothing' (*wu wei* 無為) and return to the spontaneous, the *tzu-jan* 自然 'so of itself'.

(3a.) *Verb.* Questions as in Unit 3.

(3b). *Object.* Question asked of Unit 3a: *ho* 'what?' (pre-verbal), as in combinations we have met already:

> *Ho jo* 'what? is-like' (What is it like?)
>
> *Ho wei* 'what? do' (What does he do?)

Since the same thing may be referred to by the subjects and objects of different sentences, the object does not introduce a new category. It does however introduce the active/passive distinction, as well as a difference of reference in ergative verbs (type of English 'move, stop, end, break'). Ergative verbs often correspond in English and in Chinese; the change of reference from the activating process to the activated is exposed by questions with *ho* 'what?' and *shu* 'which?'. We take as example *tung* 動 'move'.

X *tung* Y	*Shu tung* Y	X *ho tung*
X moves Y	Which moves Y?	What does X move?
Y *tung*	*Shu tung*	—
Y moves	Which moves?	—

With neutral verbs (type of English 'kill, know, see, beat') the reference is unaltered by the dropping of the object. We take as example another case where English and Chinese agree, *sha* 殺 'kill'

> X *sha* Y
>
> X kills Y
>
> X *sha*
>
> X kills

In Indo-European languages active and passive voice are distinguished by the morphology of the verb; the ergative verb on the other hand, distinguished only by syntax, has only recently become a preoccupation of grammarians.* In Classical Chinese there are passive constructions but no scope for rendering all active verbs passive; ergative verbs on the other hand are so prominent that, until Cikoski noticed the ergative/neutral distinction, it was commonly assumed that all verbs can behave like *tung* 'move'. Thus verbs translatable by our adjectives are ergative, although with some limitations on their transitive uses.

> Y *pai*
> Y is-white
> X *pai* Y
> X 'whites' Y (makes or deems Y white)

Aristotle is guided by grammatical voice to the categories of action and passion. In Chinese philosophy the great categorial distinction among processes is between *kan* 感 'arousal' and *ying* 應 'response', the activating and activated processes distinguished by the syntax of the ergative verb.

(3c) *Directive.* The directive unit following intransitive verb or transitive verb and object is introduced by the pre-nominal particle *yü* 於, 'taking-direction-from', translatable according to the direction implicit in the verb by 'from, to, in, than, by'.

ch'u 出 ('come-out') *yü* X	come out from X
ju 入 ('go-in')	go into X
li 立 ('stand')	stand in X
ta 大 ('be-big')	be bigger than X
shang 傷 ('suffer-wound')	be wounded by X

Questions asked of Units 3a or 3b: *wu-hu* 惡乎, or *an* 安 or, *yen* 焉 (pre-verbal), 'whence, whither, where?'.

Cz 14/45 (of the Way)

Units			Exclamatory final				
2	3a	3b	particle	2	3a	3b	3c
子	惡乎	求	之 哉	吾	求	之	於 度 數
Tzu	(wu-hu)	ch'iu	chih tsai	Wo	ch'iu	chih	yü tu shu
You	(where?)	seek	it !	I	seek	it	in measure number

* For a general account of the ergative verb, cf. Lyons 351f.

You (where?) seek it! I seek it in measure number ("'Where do you seek it?' 'I seek it in measures and numbers'")

One might take the category as Aristotle's relation, with place losing its categorial status and reduced to one relation. But Aristotle's first six categories are immobilised by detachment from any verb except 'is'; he asks the 'where *(pou)*' of 'Where is it?', not the 'whence *(pothen)?*' and 'whither *(poi)?*' which require other verbs. The Chinese preoccupation on the other hand is with the direction of process away from or towards persons and things, with position as only the absence of direction away from. The directive category should then be none other than that central Chinese concept *tao* 道 'way', with *so* 所 'place' as a stopping point of process.

For a Westerner there seems to be a striking asymmetry of time and place in Classical Chinese. Instead of our paired 'When?' and 'Where?' we find *ho shih* 'what time?', surprisingly rare and answered by an initial unit dependent on the rest of the sentence, and the very common *wu-hu* and its synonyms with a range much wider than 'where?' and answered by a unit inside the verb-phrase which is the sentence core.

Cz 18/33

1		2	3a			3c
昔者	海	鳥	止	於	魯	郊
Hsi-che	(hai)	niao	chih	yü	(Lu)	chiao
Formerly	(sea)	bird	stop	in	(Lu)	outskirt

("Formerly a seabird stopped in the outskirts of Lu")

It is as though the direction or position were inherent in the action, but the time is something external with which the action coincides. It may be noticed that Whorf's examination of Hopi, the model for subsequent attempts to relate the thought of a people to its language, also found a dissociation of time and place; and that the rather Bergsonian look of the world-view he ascribed to the Hopis reminds us that our tendency to assimilate time to space has been criticised inside our own tradition. But we shall see under Unit 3d that the parallelism of spatial and temporal measurements, from which the assimilation starts, is the same for the Chinese as for ourselves.

A difference of some importance is that while the West tends to put

the moral under the category of quality, Chinese philosophy deals with it through directive concepts. The virtues seem never to be included in a person's *chuang* 'characteristics', the nearest equivalent of our 'quality'; they belong to his *tao* 'way', the way he behaves and more intimately to his *te* 'potency'. Mencius contrasts the two major virtues, Benevolence and Right, in terms of position and path:

Me 7A/33

	2		3a	Subject			Complement	
居	惡乎		在	仁			是	也
Chü	*(wu-hu)*		*tsai.*	*Jen*	—		*shih*	*yeh*
Dwelling	(where?)		is-in.	Benevolence	*is*		this.	—
路	惡乎		在	義			是	也
Lu	*(wu-hu)*		*tsai.*	*Yi*	—		*shih*	*yeh*
Path	(where?)		is-in.	Right	*is*		this.	—

Dependent clause

3a	3b	3a	3b
居	仁	由	義
Chü	*jen*	*yü*	*yi*

Dwelling-in benevolence setting-course-by right,

Main clause				2	3	*Perfective particle*
大	人	之		事	備	矣
(((*ta*)	*jen*	*chih*))		*shih*	*pei*	*yi.*
(((great)	man	's))		action	is-completed	—

("Where is the abode? Benevolence is that. Where is the path? Right is that. Abiding in benevolence and setting one's course by right, the work of the great man is completed.")

Even good is conceived not as a quality but as a way of behaving. There is a formulaic introductory phrase which we shall not attempt to analyse:

X 之 為 人 ／ 物 ／ 道
X *chih* *wei* *jen/ wu/ tao*
X 's constituting man/ thing/ way
('As for the man/thing/way X is ')

'As for the man X is ' introduces an account of his personal character.
We find the formula with 'way' in an account of goodness by Hsün-tzu:

Hs 3/30

			Post-nominal particle		

善	之	為	道	者	
Shan	*chih*	*wei*	*tao*	*che,*	
Good	's	constituting	way	—,	
—	*Pre-verbal particle*	3	*Inter-verbal particle*	*Pre-verbal particle*	3

不	誠	則	不	獨	
—	*(pu)*	*ch'eng*	*tse*	*(pu)*	*tu,*
if	(not)	is-integral	then	(not)	stand-alone,



—	不	誠	則	不	獨
if	(pu)	ch'eng	tse	(pu)	tu,
	(not)	is-integral	then	(not)	stand-alone,

—	不	獨	則	不	形
if	*(pu)*	*tu*	*tse*	*(pu)*	*hsing,*
	(not)	stand-alone	then	(not)	take-shape,

—	不	形	則
if	*(pu)*	*hsing*	*tse*
	(not)	take-shape	then

Pre-verbal particle	3a		3c

雖	作	於	心
(sui)	*tso*	*yü*	*hsin*
(even-if)	arise	in	heart,

見	於	色
hsien	*yü*	*se,*
appear	in	expression,

出	於	言		
ch'u	*yü*	*yen*		
issue	from	speech,		
—	2	*Pre-verbal particles*	3a	*Final particle*

	民	猶若未	從	也
—	*min*	*(yu-jo wei)*	*ts'ung*	*yeh.*
it's-that	people	(still not-yet)	follow.	—

("As for the way Good is, without integrity you will not stand alone, if you do not stand alone it will not take shape, and if it does not take shape, even if it arises in the heart, shows in the expression, and issues in speech, the people still will not follow you.")

This passage, it may be noticed, is a good test case for a question we left open,[46] whether the absence of terminations to mark abstract nouns interferes with forming an abstract concept of, for example, the good. The virtues specific to an individual would belong primarily to his *te* 'potency', but this too is a directive concept paired with *tao* 'way' from Confucius onwards. Combinations in which directive interrogatives such as *wu-hu* constantly recur are with *chih* 知 'know' ('Whence do you know . . . ?'), *neng* 能 'be able' ('Whence are you able . . . ?), *te* 得 'get to, succeed' ('Whence do you get to ?). Their effect is to turn attention to the source of one's capacities from which action on the Way starts, one's *te* 'potency', a word phonetically and semantically related to *te* 'get'.

It is also through the directive unit that the Chinese tradition seeks the constant (*ch'ang* 常) behind the changing. The West tends to seek it through the subject, as eternal substance with being both as existence and as being what is predicated of it; but for China there is nothing unchanging except the paths which things follow. Confucians think of the Way as formulable, in particular as the ways laid down for behaviour, known from the Han onwards as the Five Constants, benevolence, the

right, ceremony, wisdom and trustworthiness. They can ask of the Way 'What is it?' *(ho yeh)*, but as we saw[47] this question asks only for an itemisation of components:

Hs 16/41 "What is the 'Way'? I say: ceremony, deference, loyalty, trustworthiness, are that."

For Taoists on the contrary only the transient is formulable in words: "The Way that can be 'Way-ed' is not the constant Way". One can ask only to be guided to where it is.

Cz 22/44 " 'Where *(wu-hu)* is it, that which is called the Way?' Chuang-tzu said 'There is nowhere it is not' "

(3d) *Measurer.* Question asked of Units 3abc: *chi-ho* 幾何 'how much?', answered with the *shu* 數 'number'. This approximates to the Aristotelian category of quantity. Although there is asymmetry of time and place there is symmetry of temporal and spatial measurements, both relegated to this final unit in the sentence.

Me 3A/4

		2	3a	3b				3d
子	之	兄	弟	事	之	數	十	年
(Tzu	*chih)*	*hsiung*	*ti*	*shih*	*chih*	*(((shu)*	*shih))*	*nien*
(You	's)	elder brother	younger brother	serve	him	several	ten	year

("You and your brother served him for several tens of years.")

Me 1A/5

	3a	3b		3c				3d
西	喪	地	於	秦	七	百		里
(Hsi)	*sang*	*ti*	*yü*	*Ch'in*	*(((ch'i*	*pai))*		*li*
(West)	lose	land	to	Ch'in	(((seven)	hundred))		li

("In the West we lost 700 *li* of land to Ch'in.")

Consequently the asymmetry of time and place does not prevent Chinese thought from pairing measured time and measured space. We noticed the parallel definitions of space and duration in the *Canons*.[48] Outside this text the pair are usually called *yü* 宇 and *chou* 宙 . Although conveniently translated 'Space' and 'Time' it is not clear that these are fully

abstracted as in the *Canons*; they seem rather to be the 'cosmos-as-it-extends' and the 'cosmos-as-it-endures'. A standard definition appears in *Huai-nan-tzu* and elsewhere:

HN ch. 23 (Liu 11/13B) "What goes back into the past and comes down to the present is called Time, the four directions and above and below are called Space."

<p style="text-align:center">*　　　*　　　*</p>

The great interest in exploring alien conceptual schemes is in glimpsing how one's own looks from outside, in perceiving for example that the Being of Western ontology is culture-bound, not a universally valid concept which by a lucky coincidence our own language family (Greek and Latin at least) happens to express perfectly, whereas Arabic and Chinese obscure it. However, the rooting of schemes in the structures of language families is an enterprise hindered by more than one obstacle. One of them, the fear that Whorfianism plunges us into a chaos of linguistic relativism, may not be insuperable; I myself do not think it does,* and in any case there are plenty of acute minds ready to welcome chaos. Another obstacle is practical. We professional sinologists are at best amateur philosophers; professional philosophers are hard-worked people with enough to do without undertaking the mastery of remote languages, and consequently reluctant to recognise that any linguistic barriers to their thinking will be more clearly visible from outside than from within.

* My position on this crucial issue is developed in 'Conceptual schemes and linguistic relativism in relation to Chinese', *Synthesis philosophica* (Zagreb, Yugoslavia), forthcoming 1989, and *Epistemological Questions on Classical Chinese Philosophy*, ed. by H. Lenk, Honolulu: University of Hawaii Press, forthcoming 1990.

NOTES

(See "Bibliography" at end of book for details of publications.)

Introduction (pages 1–8)

[1] Jaspers, *Origin*.

[2] Schwartz 63

[3] Needham v. 5/2, 35

[4] Cf. G 'China, Europe' 48f

I. THE BREAKDOWN OF THE WORLD ORDER DECREED BY HEAVEN

1. A Conservative Reaction: Confucius (pages 9–33)

[1] *Tso*, Hsiang 29, Chao 2, tr. L 549f, 583

[2] Schwartz 324

[3] *An* 4/11, 13/3

[4] *An* 11/17, 13/9

[5] *Shuo yüan* (ch. 18) 18/14B. Also *Chia Yü* (ch. 2), 2/10B, tr. Kramers 238

[6] *HF* (ch. 23) Ch'en 469, tr. Liao 1/253

[7] *Chan kuo ts'e* (Ch'in 2) 1/34f, tr. Crump 111f

[8] Cf. p. 48 below.

[9] Cf. p. 47 below.

[10] *An* 2/4

[11] *Shih-tzu* A, 9B

[12] *Hs* 30/14–16

[13] *Tao shu* ('Lore of the Way') *Chia Yi hsin shu* B, 32A

[14] *An* 7/34

[15] Fingarette, *Confucius* vii

[16] Fingarette 13

[17] Fingarette 16

[18] Cf. pp. 121–23 below.

[19] Fingarette 43

[20] Fingarette 55

[21] Creel, 'Fingarette'. Schwartz 75–85

[22] Cf. p. 22 above.

[23] Fingarette, 'Rosemont' 512

[24] Fingarette 18

[25] Schwartz 79

[26] Cf. p. 59 below.

[27] *An* 14 36

[28] Fingarette 22

[29] G *Reason and Spontaneity* 4–7

[30] G *ut sup.* 14–29

[31] Hall and Ames 13

[32] Cf. p. 330f below.

[33] Cf. p. 18 above.

[34] Cf. p. 377 below.

[35] *An* 6/13

[36] *Cz* 33/8f tr. G 275

[37] Cf. p. 10 above.

[38] *Mo* 39/35-54 tr. W 130–34

[39] *Shih chi* (ch. 28) 1366f, tr. Chavannes, v.3, 430
(ch. 121) 3116f

[40] Ibid., (ch. 6) 242, tr. Chavannes, v.2, 140

[41] Ibid., (ch. 6) 255, tr. Chavannes, v.2, 171f

2.　A Radical Reaction: Mo-tzu (pages 33–53)

[1] *Mo* 47/8, tr. Mei 223

[2] *Mo* 50, tr. Mei 257–59

[3] Cf. *Mo-tzu* ed. Sun, 468

[4] Cf. G. *Logic* 8

[5] *Tso* Chao 22, tr. L 693

[6] *Tso* Ai 17, tr. L 850

[7] Schwartz, 151

[8] *Mo* 8, tr. W 18–22. *Hs* 9, tr. W 33–55

[9] *Mo* 46/15–18, 49/81–84, tr. Mei 214, 254

[10] *Mo* 49/61–64, tr. Mei 251

[11] G　*Divisions in Early Mohism*

[12] *Mo* 8/1, 18/1, 35/1.

[13] Cf. Confucius, as cited p. 28f above.

[14] Cf. p. 30 above.

[15] *Mo* 39/13, tr. W 127

[16] Cf. p. 260 below.

[17] *Mo* 32/6, tr. W 110f

[18] Harbsmeier, *Syntax* 50–55, 67f, 85. G in Munro *Individualism* 82 n 27.

[19] *LSCC* (ch. 1/5) Hsü 1/20A

[20] *Me* 2A/6

[21] *Shu ching* (ch. 29) 'Proclamation of K'ang' 9, tr. Karlgren 40.

[22] *Me* 3A/5

[23] *Mo* 18/10, tr. Mei 102

[24] *LSCC* (ch. 19/3) Hsü 19/11B

[25] Cf. p. 62 below.

[26] Cf. p. 38 above.

[27] *Cz* 33/29–31, tr. G. 277. HF (ch. 50), Ch'en 1080, tr. Liao 2/298

[28] Cf. G. *Divisions* 1–17

[29] G. *ut sup.* 18–20

[30] *Mo* 28/21–23, tr. Mei 153

[31] *Mo* 10/20, tr. Mei 49

[32] *Mo* 9/13,31; 12/40, 37/43, tr. W 24, 27; Mei 64, 199

[33] Cf. Hawkes, *Songs of the South.*

3.　Retreat to Private Life: The Yangists (pages 53–64)

[1] *Cz* 15/1–5 tr. G. 264f

[2] *Shuo yüan* (ch. 7) 7/17B

[3] LSCC (ch. 17/7) Hsü 17/30AB

[4] HN (ch. 13) Liu 13/10B

[5] Cf. Fung *History* 134

[6] Cf. Fung *ut sup.* 137–140

[7] *Cz* 8/6f, tr. G. 200.

[8] *Cz* 29/7, 8, 18, 33

[9] *An* 17/2. Cf. p. 18 above.

[10] G. *Studies* 9

[11] LSCC (ch. 1/2) Hsü 1/6B–7A, 8A, 8B

[12] *Cz* 31/32–39, tr G. 251f

[13] LSCC (ch. 21/4) Hsü 21/8B-9A. *Cz* 28/9–15, tr. G. 225

[14] LSCC (ch. 2/2), Hsü 2/4B-5A. *Cz* 28/3–5, tr. G. 224

[15] *Lz* 13

[16] Cf. p. 40f above.

[17] *Cz* 29/56–76, tr. G. 239–241

[18] LSCC (ch. 21/4) Hsü 21/8A

[19] Cf. p. 27 above.

[20] Cf. p. 27 above.

[21] *Hs* 11/86

[22] LSCC (ch. 2/2) Hsü 2/6A

[23] *Cz* 29/89–92, tr. G. 242f

[24] G. *Studies* 272, 279

[25] *Lieh-tzŭ* 7/4B–5A, tr. G 148f

[26] *Mo* 46/24f, tr. Mei 215

[27] Cf. p. 185f below.

[28] *Mo* 47/1–3, tr. Mei 222

[29] Cf. p. 45f above.

[30] LSCC (ch. 21/4) Hsü 21/9B–10A. *Cz* 28/18–23, tr. G 226

[31] LSCC (ch. 2/2) Hsü 2/7AB

[32] *Cz* 29/48–53, tr. G 238f

4. Idealisation of the Small Community: The Utopia of Shen-nung (pages 64–74)

[1] G *Studies* 310f

[2] *Cz* 29/44f, tr. G 238

[3] Cf. pp. 292–99 below.

[4] *Mo* 49/40–54, tr. Mei 248–250

[5] *Me* 3B/10

[6] LSCC (ch. 6/1) Hsü 6/3A. *Li chi* (ch. 6) SPTK 5/13A

[7] *Kz* (ch. 35) 2/61

[8] *Han shu* (ch. 30) 1743

[9] *Shih-tzu* B, 10B

[10] HN (ch. 19) Liu 19/16B

[11] HN (ch. 13) Liu 13/6B, 7A

[12] *Shih chi* (ch. 61), 2123, tr. W 13

[13] LSCC (ch. 17/6) Hsü 17/25B

[14] *Cz* 10/30f, tr. G 209

[15] *Lz* 80

[16] HN (ch. 9) Liu 9/2A

[17] *Liu t'ao* ap. *Ch'ün-shu chih-yao* 31/19A

[18] Francesca Bray, Needham v. 6/2, 416f

[19] *Kz* (ch. 78) 3/91

[20] *Me* 3A/4

[21] *Shih chi* (ch. 6) 255, tr. Chavannes v.2, 173

[22] *Han shu* (ch. 30) 1743 n1

[23] *Shang-tzu* (ch. 18) Kao 136, tr. D 284

[24] Cf. G *Studies* 76 n27

[25] Han Fei cf. p. 272f below.

[26] *Shih chi* (ch. 5) 192, tr. Chavannes, v.2, 41

[27] *Cz* 11/19 cf. 14/16–73, tr. G 212, 215

[28] *Cz* 10/30f, tr. G 209

[29] *Cz* 29/27–32, tr. G 237

[30] *Yü-tzŭ* A, 6B. *Yü-tzŭ* ap. *T'ai-p'ing yü-lan* 79/2B

5. The Sharpening of Rational Debate: The Sophists (pages 75–95)

[1] For *pien* cf. p. 36 above.

[2] Cf. p. 160f below.

[3] LSCC (ch. 18/1) Hsü 18/3B

[4] *Cz* 24/48–51, tr. G 124

[5] LSCC (ch. 18/5) Hsü 18/18B–19A

[6] *Cz* 17/84–87, tr. G 123

[7] *Cz* 33/81–83, tr. G 285

[8] Cf. pp. 161f below.

[9] *Cz* 33/69–74, tr. G 283f

[10] G *Studies* 271

[11] *Cz* 17/87–91, tr. G 123

[12] *Canons* A 31, 78; B 70.

[13] *Shuo-yüan* (ch. 11) 11/4AB. Cf. G *Logic* 444f.

[14] G *Studies* 126–166

[15] G *Studies* 169–177

[16] Fung, *History* v. 1, 203–205

[17] Cf. pp. 140f, 265f below.

[18] Chmielewski Part 1 (1962), criticised G. *Studies* 181–184.

[19] Hansen, *Language* 140–172. For objections to the mass-noun hypothesis, cf. p. 401f below.

[20] Cf. p. 145 below.

[21] G *Logic* 457–468

[22] *Ut sup.* 171f

[23] HN (ch. 11) Liu 11/18B, commentary.

[24] *Cz* 2/32, tr. G 53

[25] *Hs* 22/14, tr. W 142 (cf. p. 263 below). *Cz* 22/47, tr. G 53.

[26] *Canons* B 38, 73, 82

[27] *Cz* 2/33, tr. G 53

[28] *Cz* 33/76, tr. G 284

6. The Discovery of Subjectivity: Sung Hsing (pages 95–105)

[1] *Hs* 6/4–6, tr. Dubs 78

[2] *Me* 6B/4

[3] *Cz* 33/34–41, tr G 278f

[4] *Cz* 1/18, tr. G 44

[5] LSCC (ch. 16/8) Hsü 16/29A–30A

[6] *Hs* 18/104–107, tr. Dubs 207–209

[7] *Hs* 18/93–97, tr. Dubs 206f

[8] LSCC (ch. 13/3) Hsü 13/11AB

[9] LSCC *ut sup.* 12AB

[10] LSCC (ch. 16/7) Hsü 16/27B

[11] Cf. pp. 406–8 below.

[12] LSCC (ch. 2/3) Hsü 2/8AB

[13] *Hs* 18/114–118, tr. Dubs 209–211

[14] Cf. Rickett, RG 15.

[15] *Kuo yü* (ch. 18) 559

[16] Cf. p. 126f below.

II. FROM SOCIAL TO METAPHYSICAL CRISIS: HEAVEN PARTS FROM MAN

[1] *Cz* 17/51f, tr. G 149

[2] 'Doctrine of the Mean' tr. Chan 98

[3] LSCC (ch. 1/2) Hsü 1/6AB

[4] G *Logic* 245. *Mo* 44/9f, 11f

[5] Cf. pp. 144–46 below.

[6] *Cz* 20/61–68, tr G 118. Cf. p. 176 below.

[7] *Me* 7A/4. Cf. p. 127 below.

[8] Cf. p. 29 above.

[9] 'Lore of the Way' *(Tao shu), Chia Yi hsin shu* B, 30A–34A

[10] Cf. p. 11 above.

[11] HF (ch. 20) Ch'en 329, 330, tr. Liao 1/171

[12] *Cz* 23/70–72, tr. G 190. Cf. p. 190f below.

1. From Confucius to Mencius: Morality Grounded in Man's Nature as Generated by Heaven (pages 111–137)

[1] *Shih chi* (ch. 74) 2343, tr. Yang 70

[2] Cf. Lau, *Mencius* 205–213

[3] *Me* 6B/6

[4] Cf. Eno 169

[5] Cf. pp. 100, 103 above.

[6] *Me* 1A/3,7

[7] *Me* 1B/5, 7. 3A/3

[8] Cf. p. 114 above.

[9] Cf. pp. 47, 52 above.

[10] Cf. p. 31f above.

[11] *Lun heng* (ch. 13) Liu 62, tr. Forke, v.1, 384

[12] *Me* 2A/2

[13] Cf. p. 56 above.

[14] Cf. p. 244f below.

[15] Cf. p. 325 below.

[16] *Kuan-tzu* (ch. 26) 2/15f, tr. RG, 379

[17] Waley, *Three Ways* 194

[18] Reprinted Lau, *Mencius* 235–263

[19] Cf. pp. 86–90 above.

[20] Waley *ut sup.* 205

[21] Cf. p. 129 below.

[22] *Me* 6A/8

[23] Cf. p. 56f above.

[24] *Me* 6A/7

[25] *Me* 7B/25

[26] *Me* 6A/8

[27] *Me* 6A/6

[28] Cf. p. 98f above.

[29] Cf. p. 126 above.

[30] *Me* 6A/8

[31] Cf. Fung, *History* v.1, 125 n1 and Waley as cited p. 123f above.

[32] Cf. p. 62 above.

[33] *An* 6/29

[34] *Shih chi* (ch. 47) 1946, tr. Chavannes v. 5, 431

[35] Cf. p. 245 below.

[36] *Me* 7A/2

2. From Mo-tzu to Later Mohism: Morality Re-grounded in Rational Utility (pages 137–170)

[1] G *ut sup.* 235f

[2] Cf. pp. 141, 167 below.

[3] Cf. p. 140 above.

[4] Cf. p. 139 above.

[5] For *chien-pai* cf. p. 84 above.

[6] Cf. G *ut sup.* 188f, 223f

[7] Cf. pp. 83, 93 above.

[8] Cf. p. 58f above.

[9] G *ut sup.* 52

[10] Cf. p. 29 above.

[11] *Me* 7B/25

[12] Cf. p. 140 above.

[13] Cf. pp. 322–25 below.

[14] *Canon* B41

[15] Cf. p. 145 above.

[16] Cf. p. 58 above.

[17] Cf. p. 61 above.

[18] Cf. p. 42 above.

[19] *Canon* A8, cf. p. 146 above.

[20] *Canons* B30, 31

[21] *Canons* A80, 98, quoted pp. 138, 149 above.

[22] Aristotle, *Metaphysics* I, 9/25

[23] G *ut sup.* 226

[24] Cf. p. 341 below.

[25] *Canon* A83, cf. p. 143 above.

[26] Cf. p. 157 above.

[27] *HN* (ch. 3) Liu 3/32A–33B

[28] *Canons* A83, cf. p. 143 above.

[29] Cf. p. 143 above, and G *ut sup.* 184–186

[30] *Canon* B30

[31] *Canon* A70, quoted p. 148 above.

[32] Cf. p. 183 below.

[33] *Canons* A93. B3, 4, 7

[34] *Lun heng* (ch. 24), Liu 147, tr. Forke, v. 1, 335f

[35] *Canons* A5, 42, 43, 51, 65

[36] Cf. p. 157 above.

3. From Yangism to Chuang-tzu's Taoism: Reconciliation with Heaven by Return to Spontaneity (pages 170–211)

[1] *Hs* 17/51, 21/22, tr. W 87, 125.

[2] Cf. pp. 285-89 below.

[3] Cf. p. 73f above.

[4] Strickmann, 164–168

[5] *Shih chi* (ch. 63) 2143f

[6] *Cz* 20/45–50, 32/22–26, 42–46 tr. G 119f

[7] Cf. pp. 77, 80 above.

[8] *Canon* A8, cf. p. 146 above.

[9] *Cz* 34/45–48, tr. G 101f

[10] Cf. p. 148f above.

[11] Cf. p. 167 above. *Canon* A74.

[12] *Cz* 23/60f, tr. G 104

[13] Cf. p. 168 above. *Canon* B35

[14] G *Logic* 219f

[15] Cf. p. 182 above.

[16] Aristotle, *Metaphysics* 1063b/30–35.

[17] Cf. p. 168 above.

[18] *Cz* 3/2–12, tr. G 63f

[19] *Cz* 19/46–49, tr. G 135f

[20] Cf. p. 167 above.

[21] *Cz* 5/58, 7/11, tr. G 82, 95

[22] *Cz* 4/30, 53 tr. G 69, 71

[23] *Canon* A4, 5

[24] Cf. *Canon* A4, 5

[25] *Cz* 20/66, tr. G 118

[26] Cf. p. 29 above.

[27] Cf. G *Reason and Spontaneity* 14–29

[28] *Cz* 6/7 tr. G 84

[29] *Cz* 12/39 tr. G 156

[30] *Cz* 1/21f tr. G 45

[31] *Cz* 25/12f, tr. G 141

[32] G *Reason and Spontaneity* Part 3

[33] *Cz* 2/94–96 tr. G 61

[34] Nietzsche, *Beyond Good and Evil*, tr. R. J. Hollingdale, London 1973, #1

[35] Cf. p. 222 below.

[36] *Cz* 6/20 tr. G 85

[37] *Cz* 4/53 tr. G 71

[38] *Cz* 25/17 tr. G 111

[39] *Cz* 6/6f tr. G 84

[40] Cf. p. 36 above.

[41] *Cz* 2/59, tr. G 57

[42] *Cz* 11/62, 20/7, 22/75, tr. G 121, 162, 164, 185

[43] *Cz* 6/39f, tr. 87

[44] *Cz* 5/23, 6/66, tr. 78, 89

[45] *Cz* 5/12, 24/96, 106f tr. G 62, 77, 85

[46] Cited p. 178 above.

[47] *Cz* 2/1–9, tr. G 48f.

[48] Cf. G *Cz* 106f

[49] Cf. pp. 138, 140 above.

[50] *Cz* 3/2 tr. G 62

[51] *Cz* 5/8 tr. G 77

[52] Cf. p. 211 below.

[53] Cf. G *Logic* 59f

[54] Cf. p. 136f above.

[55] *Cz* ch. 22 *passim*, 14/13–30; 20/50–61, tr. G 159–168

[56] *Cz* 22/10, tr. G 160.

[57] Cf. p. 29 above.

[58] Cf. pp. 90–94, 145 above.

[59] *Canon* B35 cf. p. 168 above.

[60] *Cz* 17/65–81, 84–91 tr. G 122f, 154–156

[61] Cf. p. 76f above.

III. Heaven and Man Go Their Own Ways

[1] Cf. p. 208 above.

[2] Cf. pp. 285-89 below.

[3] Cf. p. 61 and p. 187 above.

[4] Cf. pp. 141–43 above.

[5] LSCC ch. 15/8

[6] *Ho-kuan-tzu* (ch. 7) 33

1. Lao-tzu's Taoism: The Art of Ruling by Spontaneity (pages 215–235)

[1] *Cz* 5/29 tr. G 79

[2] *Cz* 13/46 tr. G 128

[3] *Hs* 17/51 tr. W 87, LSCC (ch. 17/7) Hsü 17/30A

[4] *Cz* 5/11 tr. G 77

[5] *Lz* 78

[6] *Cz* 6/7 tr. G 84

[7] *Lz* 56

[8] *Lz* 28

[9] Following Ma-wang-tui reading of 𠂢 for 川 .

[10] *Lz* 42

[11] *Hs* 17/51 tr. W 87

[12] *Hs* 21/22 tr. W 125

[13] LSCC (ch. 17/7) Hsü 17/30A

[14] *Lz* 26, 39

[15] *Lz* 61, 76

[16] Cf. p. 331 below.

[17] G. 'Meanings and Things'

[18] Saussure 113

[19] Derrida 158

[20] *Cz* 27/1 tr. G 106. Cf. p. 201 above.

[21] *An* 15/5 Cf. p. 14 above.

[22] Cf. pp. 191–94 above.

[23] Cf. p. 29 above.

[24] *Lz* 80 cf. p. 68f above.

[25] *Lz* 64

[26] Cf. Frank Lloyd Wright 300

[27] *Han shu* (ch. 30) 1732

2. Hsün-tzu's Confucianism: Morality as Man's Invention to Control His Nature (pages 235–267)

[1] *HF* (ch. 50) Ch'en 1080, tr. Liao 2/298

[2] *Shih chi* (ch. 74) 2348, tr. Yang 74

[3] *Shih chi* (ch. 78) 2395

[4] *Shih chi* (ch. 74) 2348, tr. Yang 74

[5] Cf. Knoblock, 'Chronology'

[6] *Hs* 16/61

[7] *Hs* 8/10, tr. Dubs 93

[8] *Hs* 15/72, tr. W 70

[9] *Shih chi* (ch. 87) 2539

[10] HN (ch. 3) Liu 3/1A, cf. p. 32 below.

[11] *Yi*, 'Great Appendix' A 5/9, tr. WB 301

[12] *Hs* 17/15, tr. W 81

[13] *Hs* 10/1, tr. Dubs 151, quoted p. 256 below.

[14] Cf. pp. 330–56 below.

[15] Cf. p. 139 above.

[16] Cf. p. 101 above.

17 *An* 15/29. Cf. p. 18 above.

18 Cf. p. 45f above.

19 *Hs* 27/65–67

20 Cf. G *Reason and Spontaneity* 14–29

21 *Me* 6B/2

22 Cf. p. 244 above.

23 *Me* 3A/1, 6A/2, 6

24 *Cz* 7/32f, tr. G 98. Cf. p. 192 above.

25 Cf. p. 97 above.

26 Cf. p. 249 above.

27 Cf. p. 158 above.

28 Cf. p. 70f above.

29 *Hs* 5/34, tr. Dubs 73

30 *Hs* 8/92 cf. 95, tr. Dubs 110

31 *Hs* 1/36, tr. W 21

32 *An* 3/12 cf. p. 16 above.

33 Cf. p. 41 above.

34 *Canon* B 70, cf. p. 141 above.

35 Hansen, *Language* cf. p. 401f below.

36 *Hs* 18/93–114, tr. Dubs 206–09. Cf. p. 97 above.

37 *Canon* B 46. Cf. p. 140 above.

38 *Hs* 18/114–18, tr. Dubs 209f

39 *Hs* 3/2 quoted p. 254 above.

40 Cf. p. 83f above.

41 For *ch'i* 'fix ahead', cf. p. 177 above.

3. Legalism: An Amoral Science of Statecraft (pages 267–292)

1 *HF* (ch. 43) Ch'en 906, tr. Liao 2/212

2 *HF* (ch. 40) Ch'en 886, tr. Liao 2/199

3 Cf. Fung, *History* v. 1, 318

4 *Hs* 6/6, 21/21 tr. Dubs 79, W 125

5 *Hs* 21/22 tr. W 125

6 Schwartz, *World of Thought* 348

7 Schwartz, *World of Thought* 333

8 Schwartz, *World of Thought* 336

9 Shen Tao 74

10 Cf. Fung, *History* v. 1, 327–330

11 Cf. p. 73 above.

12 *Canon* A 70. Cf. p. 148 above.

13 *Me* 4A/1

14 Needham v. 2, 518–584. Rickett, RG 126.
Bodde, *Essays* 299–315

15 *Me* 4A/1, *Hs* 12/2

16 *Tso* Chao 6

17 *Tso* Chao 29

18 *Chia Yi hsin shu*, 'Grades' (*Chieh-chi*)

19 *Me* 6A/2. Cf. p. 121 above.

20 *HF* (ch. 38) Ch'en 868, tr. Liao 2/188

21 Creel, *Shen* 4f

22 *Kz* ch. 55 also appears in *Kuei-ku-tzu*, as ch. 12.

23 *Shih chi* (ch. 63) 2146, (ch. 74) 2347.

24 Cf. p. 274 above.

25 Cf. pp. 207–9, 239–61 above.

26 Cf. p. 401f below.

27 *Lz* 79

28 Hsiao p. 418

29 Cf. p. 276 above.

30 *Li chi* (ch. 1) SPPY 1/16A

4. Two Political Heresies (pages 292–311)

1 Cf. Allan 136–139

2 *Shu ching* chs. 1, 2. *An* 20/1

3 *Mo* 8/21, 9/47, 10/22 tr. W 21, 29, Mei 50

4 *Me* 5A/4

5 Cf. p. 115 above.

6 *Me* 5A/6

7 Cf. p. 297 below.

8 *Me* 2B/8

9 *Han shu* (ch. 75), 3153f

10 Cf. p. 118 above.

11 *Kz* (ch. 26) 2/16, tr. RG 379. The passage overlaps with the one quoted p. 119 above.

12 *Hs* (ch. 18) 18/53–72

13 *Hs* (ch. 25) 25/18–27

14 Cf. p. 216 above.

15 *Ho-kuan-tzu* (ch. 13) 91f

16 *Ho-kuan-tzu* (ch. 11) 79, 81

17 *Cz* 12/33–37 tr. G 174f. LSCC (ch. 20/2) Hsü 20/5AB

18 *Hsin hsü* (ch. 7) SPTK 7/1AB

19 LSCC (ch. 18/6) Hsü 18/19B–20B

20 LSCC (ch. 1/5) Hsü 1/18B–19A

21 LSCC (ch. 3/5) Hsü 3/19A

22 *Li chi* (ch. 9) SPPY 7/1A–2A

23 Rosemont, review of Fingarette, 474

24 Weber 3–20

25 Cf. Rubin 'Tzu-ch'an', G *Logic* 8–10

26 Weber 91

27 *Mo* 13/22–27 Cf. p. 52 above.

28 *Kz* ch. 47

29 Cf. p. 278 above.

30 *Hs* 6/6–8

31 Shen Tao 74

32 Shen Tao 1

33 Cf. p. 132 above.

34 *Me* 7A/15

35 Cf. pp. 64–74 above.

36 Cf. p. 233 above.

37 *HN* (ch. 2) Liu 2/13B

38 *Cz* 1/22–26 tr. G 45

39 *Cz* 12/80–83 tr. G 174

40 *Lz* 17

41 *Cz* 16/1–8 tr. G 171

42 *Cz* 16/14f tr. G 172

43 *Ho-kuan-tzu* (ch. 13) 90f

44 *Cz* 11/23 tr. G 213

45 *Cz* 11/19 tr. G 212

46 *Cz* 10/30f tr. G 209

47 *Cz* 8/4–7 tr. G 200

48 *Cz* 8/10f tr. G 201

49 Cf. Balacz 242–46, Hsiao 619–630, G. *Lieh-tzu* 10f.

IV. THE REUNIFICATION OF THE EMPIRE AND OF HEAVEN AND MAN

1. The Cosmologists

Proto-science and Modern Science (pages 315–319)

1 Needham v. 4/1, 279

2 Needham v. 3, 15

3 Needham v. 1, 219

4 Aubrey 36

5 Henderson 254

Correlative Thinking and Correlative Cosmos-building (pages 319–325)

1 Ryle 149, 151

Cosmology Before the Han (pages 325–330)

[1] *Tso.* Chao 1, tr. L 580f

[2] Cf. Major, *Note*

[3] G. *Yin-Yang* 74–79

[4] *Shu ching* tr. Karlgren 30

[5] *Tso* Ai 9, tr, L 819

[6] *An* 7/21

[7] *An* 7/17

[8] Cf. *Hs.* 1/29f, tr. W 19f, which ignores the *Yi.*

[9] Cf. G *Yin-Yang* 76

[10] *Canon* B 43 *Sun-tzu* 6/33B

[11] Cf. p. 77 above.

[12] *Cz* 1/21, 4/36, 38 tr. G 44, 70

[13] *Cz* 25/67 tr. G 151

[14] *Cz* 22/11 tr. G 160

[15] LSCC (ch. 13/2) Hsü 13/7A

[16] *Kz* chs. 8,9, 40, 41, 85. Cf. G *Yin-Yang* 84–87

Pairs: Yin and Yang (pages 330–340)

[1] *Ching fa* 94f

[2] Cf. p. 321 above.

[3] *HN* (ch. 3) Liu 3/1A–2B. Emendations follow Liu's notes.

[4] Cf. p. 323–25 above.

[5] *Canon* B 23. Cf. p. 000 above.

[6] Cf. p. 341 below.

[7] *Po hu t'ung* 3/14B, tr. Tjan v. 2, 438

[8] *HN* (chs. 3, 7) Liu 3/30A, 7/2A, 3A

[9] Kepler 864

[10] Kepler 854

[11] Kepler 855

[12] Kepler 853

Fours and Fives: The Five Processes (pages 340–356)

[1] Lévi-Strauss 57

[2] Lévi-Strauss 64

[3] Cf. p. 329 above.

[4] Cf. p. 325f above.

[5] Cf. p. 326 above.

[6] Cf. p. 333 above.

[7] Cf. p. 341 above.

[8] *Tso* Duke Chao, 32, tr. L 741

[9] *HN* (ch. 4) Liu 4/11A

[10] Cf. Major, 'Five Phases' 146–150

[11] For the 'River Chart' and 'Lo Document', cf. Needham v. 3/56–58

[12] Needham v. 3/58

[13] Needham v. 3/61

[14] For the 'Great Plan' cf. p. 326 above.

[15] Cf. Yates, *Bruno*

[16] LSCC (ch. 1/1) Hsü 1/5B

[17] *Huang-ti nei-ching* (ch. 2) 1/11A–13A

[18] *Nature of Man* vii (Hippocrates v. 4)

[19] Cf. p. 27 above.

A Kuan-tzu Cosmology Based on Water (pages 356–358)

[1] Kirk and Raven 89

[2] *Kz* (ch. 39) 2/74

[3] Cf. p. 225 above.

[4] Cf. p. 341 above.

The *Yi* (pages 358–370)

1 Cf. p. 327 above.

2 Karlgren, *Grammata* No. 850a

3 Fung v. 1, 380

4 'Great Appendix' B7, A2, B3 tr. WB 348, 288, 338

5 'Great Appendix' A5, 12 tr. WB 303, 322

6 *Lz* 42

7 LSCC (ch. 5/2) Hsü 5/4B–5A

8 *Tso*, Chuang 22, Chao 5 and 32

9 Needham v. 2, 340–345. Rosemont and Cook 158–165

10 Cf. p. 339 above.

11 *HF* (ch. 20) Ch'en 368, tr. Liao 1/193f

12 Cf. p. 81 above.

13 Cf. Fung v. 2, 509–512, 534–544, 588–591, 642f, 652–654.

14 'Great Appendix' A 1, cited p. 364 above.

15 Jung's foreword to Wilhelm-Baynes, xxiv.

16 Cf. pp. 191–93 above.

2. Syncretism and the Victory of Confucianism (pages 370–382)

1 *Shih chi* (ch. 6) 236, tr. Chavannes, v. 2, 127

2 Hsiao 556–70

3 Cf. p. 73f above.

4 *Cz* 13/37–41, tr. G 262

5 *Cz* 33/41–54, tr. G 279f

6 *Shih chi* (ch. 130) 3289

7 Cf. p. 236 above.

8 *Han shu* ch. 30

9 *Shih chi* (ch. 74) 2344, tr. Yang 72

10 *Cz* 8/1–8, tr. G 200

11 *Po-hu-t'ung* 8/2A, tr. Tjan v. 2, 567.

Appendix 1 (pages 383–387)

1 Cf. p. 29 above.

2 Cf. p. 168 above.

3 G *Reason and Spontaneity* ch. 1.2

4 Cf. p. 322f above.

5 *An* 2/4, cf. p. 28 above.

6 Cf. p. 146 above.

7 Cf. p. 41 above.

8 Cf. p. 27f above.

9 Cf. pp. 59–63 above.

Appendix 2 (pages 389–428)

1 Rosemont, 'Linguistic Innateness' 73f

2 Cf. p. 153f above.

3 Mullie 181f, 309f

4 Rosemont 'Linguistic Innateness' 135f, 146 n19.

5 Hall and Ames 298f

6 Hall and Ames 261

7 Hall and Ames 261–263

8 *Cz* 7/28

9 Hansen, 'Truth'. 511–514

10 Cf. p. 37 above.

11 Cf. p. 48 above.

12 Cf. pp. 16, 38 above.

[13] Cf. pp. 240f, 368n above.

[14] Hall and Ames 264f

[15] *An* 3/22, 14/17

[16] Hall and Ames 364 n29

[17] Cf. pp. 59–63, 131, 157f above.

[18] Cf. p. 93f above.

[19] Cf. p. 165 above.

[20] Cf. p. 373–81 above.

[21] Hall and Ames 364 n30

[22] Cf. Hsün-tzu on the concept of good, cited pp. 424–26 below.

[23] Cf. p. 135 above.

[24] Cf. p. 139f above.

[25] Cf. p. 228 above.

[26] Quine, *Logical Point of View* 20–37

[27] Hansen, *Language* 30

[28] Hall and Ames 294, 264.

[29] *Lz* tr. Waley 63f

[30] G *Studies* 331–334

[31] G *Logic* 111–113, 161–165

[32] *HN* (ch. 16) Liu 16/2B

[33] Cf. p. 320f above.

[34] Aristotle, *Posterior Analytics* 89b 33, 90a 10.

[35] G *Logic* 118

[36] Cf. p. 225 above.

[37] Kuo Hsiang on *Cz* (ch. 2) Kuo 111.

[38] *Republic* 479, tr. Lee 242f

[39] Plato, tr. Wu Hsien-shu, A, 388f

[40] Fan Ping-ch'ing 497

[41] Kant, tr. Smith 504f, tr. Lan Kung-wu 430

[42] 'Catégories de pensée et catégories de langue', Benveniste 63–74

[43] Cf. Quine, 'Natural Kinds', *Ontological Relativity* 114–138

[44] Cf. p. 322–25 above.

[45] *Cz* 4/76, 20/62, 5/3

[46] Cf. pp. 398–401 above.

[47] Cf. p. 417 above.

[48] Cf. p. 142 above.

Romanisation Conversion Table:
Wade-Giles/Pinyin

This book employs the Wade-Giles romanization which prevails in English-language studies of Chinese thought. The *Pinyin* romanization of the People's Republic (in which, for example, Chuang-tzu becomes Zhuangzi) is now also common.

Pinyin spellings drop all apostrophes and hyphens. Otherwise they are identical to Wade-Giles, with the following exceptions:

Cha	zha		chih	zhi
chai	zhai		ch'ih	chi
chan	zhan		chin	jin
chang	zhang		ch'in	qin
chao	zhao		ching	jing
che	zhe		ch'ing	qing
chei	zhei		chiu	jiu
chen	zhen		ch'iu	qiu
cheng	zheng		chiung	jiong
chi	ji		ch'iung	qiong
ch'i	qi		cho	zhuo
chia	jia		ch'o	chuo
ch'ia	qia		chou	zhou
chiang	jiang		chu	zhu
ch'iang	qiang		chua	zhua
chiao	jiao		chuai	zhuai
ch'iao	qiao		chuan	zhuan
chieh	jie		chuang	zhuang
ch'ieh	qie		chui	zhui
chien	jian		chun	zhun
ch'ien	qian		chung	zhong

ch'ung	chong	jui	rui
chü	ju	jun	run
ch'ü	qu	jung	rong
chüan	juan		
ch'üan	quan	ka	ga
chüeh	jue	kai	gai
ch'üeh	que	kan	gan
chün	jun	kang	gang
ch'ün	qun	kao	gao
		ke, ko	ge
erh	er	kei	gei
		ken	gen
ho	he	keng	geng
hsi	xi	ko, ke	ge
hsia	xia	k'o	ke
hsiang	xiang	kou	gou
hsiao	xiao	ku	gu
hsieh	xie	kua	gua
hsien	xian	kuai	guai
hsin	xin	kuan	guan
hsing	xing	kuang	guang
hsiu	xiu	kuei	gui
hsiung	xiong	k'uei	kui
hsü	xu	kun	gun
hsüan	xuan	kung	gong
hsüeh	xue	k'ung	kong
hsün	xun	kuo	guo
i	yi	lieh	lie
		lien	lian
jan	ran	lo	luo
jang	rang	lün	lun
jao	rao	lung	long
je	re	lüan	luan
jen	ren	lüeh	lue
jeng	reng		
jih	ri	mieh	mie
jo	ruo	mien	mian
jou	rou		
ju	ru	nieh	nie
juan	ruan	nien	nian

nung	nong	tiao	diao
nü	nu	tieh	die
nüeh	nue	t'ieh	tie
		tien	dian
o	e	t'ien	tian
		ting	ding
pa	ba	tiu	diu
pai	bai	to	duo
pan	ban	t'o	tuo
pang	bang	tou	dou
pao	bao	tsa	za
pei	bei	ts'a	ca
pen	ben	tsai	zai
peng	beng	ts'ai	cai
pi	bi	tsan	zan
piao	biao	ts'an	can
pieh	bie	tsang	zang
p'ieh	pie	ts'ang	cang
pien	bian	tsao	zao
p'ien	pian	ts'ao	cao
pin	bin	tse	ze
ping	bing	ts'e	ce
po	bo	tsei	zei
pou	bou	tsen	zen
pu	bu	ts'en	cen
		tseng	zeng
shih	shi	ts'eng	ceng
so	suo	tso	zuo
ssŭ, szŭ	si	ts'o	cuo
sung	song	tsou	zou
szŭ, ssŭ	si	ts'ou	cou
		tsu	zu
ta	da	ts'u	cu
tai	dai	tsuan	zuan
tan	dan	ts'uan	cuan
tang	dang	tsui	zui
tao	dao	ts'ui	cui
te	de	tsun	zun
tei	dei	ts'un	cun
teng	deng	tsung	zong
ti	di	ts'ung	cong

tu	du		yeh	ye
tuan	duan		yen	yan
tui	dui		yu	you
tun	dun		yung	yong
tung	dong		yü	yu
t'ung	tong		yüan	yuan
tzŭ	zi		yüeh	yue
tsŭ	ci		yün	yun

ABBREVIATIONS

Texts

An	*Analects*
Cz	*Chuang-tzu*
HF	*Han Fei-tzu*
HN	*Huai-nan-tzu*
Hs	*Hsün-tzu*
Kz	*Kuan-tzu*
LSCC	*Lü-shih ch'ün-ch'iu ('Lü Spring and Autumn')*
Lz	*Lao-tzu*
Me	*Meng-tzu ('Mencius')*
Mo	*Mo-tzu*

Editions and Journals

BSOAS	*Bulletin of the School of Oriental and African Studies* (London)
BSS	*Basic Sinological Series (Kuo-hsüeh chi-pen ts'ung-shu)* 國學基本叢書
ed.	edited
HJAS	*Harvard Journal of Asiatic Studies*
HY	*Harvard-Yenching Institute Sinological Index Series*
JAOS	*Journal of the American Oriental Society*
JCP	*Journal of Chinese Philosophy*
PEW	*Philosophy East and West*
SPPY	*Ssu-pu pei-yao* 四部備要
SPTK	*Ssu-pu ts'ung-k'an* 四部叢刊
tr.	translated

Translators

D	Duyvendak
G	Graham
L	Legge
RG	*(Kuan-tzu)* Rickett, *'Guanzi'*
RK	*(Kuan-tzu)* Rickett, *'Kuan-tzu'*
W	Watson
WB	Wilhelm-Baynes

Bibliography

(This bibliography is designed primarily for the reader who wishes to investigate Chinese thought through translations and studies in Western languages.)

ALLAN, Sarah. *The Heir and the Sage: Dynastic Legend in Ancient China.* San Francisco: Chinese Materials Center, 1981.

AMES, Roger T. *The Art of Rulership.* Honolulu: University of Hawaii Press, 1983.

Analects (An) HY

Analects. Tr. by James Legge. *Classics,* vol. I. Hong Kong: University of Hong Kong Press, 1961.

Analects. Tr. by Arthur Waley. *Analects of Confucius, The.* London: Allen & Unwin, 1938.

Analects. Tr. by D. C. Lau. *Confucius: The Analects.* Harmondsworth, Middlesex: Penguin Classics, 1979.

Analects. Tr. by D. C. Lau. *Chinese Classics: Confucius, the Analects.* (Contains text & translation.) Hong Kong: Chinese University Press, 1983.

AUBREY, John. *Aubrey's Brief Lives.* Ed. by Oliver Lawson Dick. Harmondsworth, Middlesex: Penguin Books, 1972.

BALAZS, Etienne. *Chinese Civilization and Bureaucracy.* Tr. by H. M. Wright. New Haven and London: Yale University Press, 1964.

BENVENISTE, Emile. *Problèmes de linguistique générale.* Paris: Gallimard, 1966.

BERGSON, Henri. *Time and Free Will*. Tr. by F. L. Pogson. London: Allen & Unwin, 1910.

BLOOM, Alfred H. *The Linguistic Shaping of Thought: A Study in the Impact of Language and Thinking in China and the West*. Hillsdale, NJ: Lawrence Erlbaum, 1981.

BODDE, Derk. *China's First Unifier*. Leiden: E. J. Brill, 1938.

──────. *Essays on Chinese Civilization*. Princeton, NJ: Princeton University Press, 1981.

──────. "Chinese Categorical thinking," *JAOS* 59 (1939) 200–219.

Chan kuo ts'e 戰國策 BSS

Chan kuo ts'e Tr. J. L. Crump, Jr. *Chan-Kuo Ts'e*. Oxford: The Clarendon Press, 1970.

CHAN Wing-tsit. *A Source Book in Chinese Philosophy*. Princeton, NJ: Princeton University Press, 1963.

CHANG, Leo S. "The Metamorphosis of Han Fei's Thought in the Han," in Rosemont and Schwartz (cited below), pp. 503–548.

CHAO Y. R. "Notes on Chinese Grammar and Logic," *PEW* vol. 5, no. 1 (1955), 31–41.

CHENG Chung-ying and SWAIN, Richard H. "Logic and Ontology in the Chih Wu Lun of Kung-sun Lung Tzu," *PEW* vol. 5, no. 2 (1970), 137–154.

Chia Yi hsin shu 賈宜新書 SPTK.

Chia yü 家語 SPTK.

Ching fa 經法. *Ma-wang-tui Han-mu pai-shu* 馬王堆漢墓帛書 Peking: Wen-wu Publishing Co., 1976.

CHMIELEWSKI, Janusz. "Notes on Early Chinese Logic." *Rocznik Orientalistyczny*, 1962ff.

CHOMSKY, Noam. *Aspects of the Theory of Syntax*. Cambridge, MA: MIT Press, 1965.

Chuang-tzu (Cz) 莊子 *HY*

Chuang-tzu (Cz) Ed. by Kuo Ch'ing-fan 郭慶藩. *Chuang-tzu chi-shih* 莊子集釋 Peking: Chung-hua Book Co., 1961.

Chuang-tzu (Cz). Tr. by James Legge in *Sacred Books of the East* vols. 39, 40. Oxford: Oxford University Press, 1891.

Chuang-tzu (Cz). Tr. by Herbert A. Giles, *Chuang Tzu, Mystic, Moralist and Social Reformer*. (First ed'n. 1889.) London: Allen & Unwin, 1961.

Chuang-tzu (Cz). Tr. by Burton Watson (W), *The Complete Works of Chuang Tzu*. New York: Columbia University Press, 1968.

Chuang-tzu. Tr. by A. C. Graham (G). *Chuang-tzu: The Seven Inner Chapters and Other Writings from the Book 'Chuang-tzu'*. (Four-fifths of book.) London: Allen & Unwin, 1981.

[*Chuang-tzu*]. *Chuang-tzu: Composition and Interpretation*. Ed. by Victor H. Mair. Symposium issue, *Journal of Chinese Religions* 11 (1983).

[*Chuang-tzu*]. *Experimental essays on Chuang-tzu*. Ed. by Victor H. Mair. Honolulu: University of Hawaii Press, 1983.

Ch'ün-shu chih-yao 群書治要 *SPTK*.

Chung yung ("Doctrine of the Mean"). 中庸 Tr. by James Legge in *The Chinese Classics* (cited below under 'Legge').

Chung yung ("Doctrine of the Mean"). Tr. by Chan (cited above) pp. 95–114.

CIKOSKI, John S. *Classical Chinese Word-classes*. New Haven, CT: Yale University thesis, 1970.

———. "On Standards of Analogical Reasoning in the Late Chou." *JCP* 2 (1975), 325–357.

———. "Three Essays on Classical Chinese Grammar." *Computational Analyses of Asian and African Languages* 8 (1978), 17–152, 9 (1978), 77–208.

CREEL, Herrlee G. *Confucius and the Chinese Way.* (Previous title: *Confucius, the Man and the Myth.*) New York: Harper Torchbooks, 1949.

———. *What is Taoism?* Chicago: University of Chicago Press, 1970.

———. *Shen Pu-hai.* Chicago: University of Chicago Press, 1974.

———. "Discussion of Professor Fingarette on Confucius," in Rosemont and Schwartz (cited below) pp. 407–416.

CUA, A. S. *Ethical Argumentation: A Study in Hsün Tzu's Moral Epistemology.* Honolulu: University of Hawaii Press, 1985.

CULLEN, C. "A Chinese Eratosthenes of the Flat Earth: A Study of a Fragment of Cosmology in Huai Nan-tzu." *BSOAS* vol. 39, no. 1 (1976), 106–127.

DAOR, Dan. *The Yin Wenzi and the Renaissance of Philosophy in Wei-Jin China.* University of London thesis, 1974.

DAVIDSON, Donald. "On the Very Idea of a Conceptual Scheme," in Rajchman and West (cited below) pp. 129–144.

DERRIDA, Jacques. *Of Grammatology.* Tr. by G. C. Spivak. Baltimore and London: Johns Hopkins University Press, 1976.

DUBS, H. H. *Hsuntze, the Moulder of Ancient Confucianism.* London: Arthur Probsthain, 1927.

ENO, Robert. *Masters of the Dance: The Role of T'ien in the Teachings of the Early Juist (Confucian).* Ann Arbor, MI: University of Michigan thesis, 1984.

FAN, Ping-ch'ing 樊炳清 . (ed.) *Che'hsüeh tz'u-tien* 哲學辭典 . Shanghai: Commercial Press, 1930.

FANG, Wan-chuan. "Chinese Language and Theoretical Thinking." *Journal of Oriental Studies,* vol. 22, no. 1 (1984), 25–32.

FINGARETTE, Herbert. *Confucius: The Secular as Sacred.* New York: Harper Torchbooks, 1972.

———. "Following the 'One Thread' of the Analects" in Rosemont and Schwartz (cited below), pp. 373–406.

———. "Response to Professor Rosemont," *PEW* vol. 28, no. 4 (1978), 511–514.

———. "The Problem of Self in the *Analects*." *PEW* 29 (1979) 129–140.

———. "Reply to Professor Hansen." *JCP* vol. 7, no. 3 (1980) 259–266.

———. "The Music of Humanity in the *Conversations* of Confucius," *JCP,* 10 (1983), 331–356.

FORKE, Alfred. "The Chinese Sophists," *Journal of the China Branch of the Royal Asiatic Society* 34 (1901–1902) 1–100.

———. *World Conception of the Chinese.* London: Arthur Probsthain, 1925.

———. *Geschichte der alten chinesischen Philosophie,* (First ed'n. 1927.) Hamburg: Cram, DeGruyter & Co., 1964.

FRAZER, J. G. *The Golden Bough.* (Abridged ed'n.) London: Macmillan & Co., 1941.

FUNG Yu-lan. *A Short History of Chinese Philosophy.* Tr. by Derk Bodde. New York: Macmillan & Co., 1958.

———. *The Spirit of Chinese Philosophy.* Tr. by E. R. Hughes. London: Kegan Paul, 1962.

————. *A History of Chinese Philosophy.* Tr. by Derk Bodde. Princeton, NJ: Princeton University Press, 1952, 1953.

GERNET, Jacques. *China and the Christian Impact: A Conflict of Cultures.* Tr. by Janet Lloyd. Cambridge: Cambridge University Press, 1985.

GRAHAM, A. C. (G) "Kung-sun Lung's 'Essay on meanings and things'." *Journal of Oriental Studies.* vol. 2, no. 2 (1955), 282–301.

————. (G) "The Dialogue Between Yang Ju and Chyntzyy." *BSOAS*, vol. 22, no. 2 (1959), 291–299.

————. (G) " 'Being' in Western Philosophy Compared with *Shih/Fei* and *Yu/Wu* in Chinese Philosophy" *Asia Major* n.s. 7 (1959), 79–112. (Reprinted in G's *Studies.*)

————. (G) " 'Being' in Classical Chinese," in Verhaar (cited below), vol. 1 (1967), pp. 1–39.

————. (G) "Chuang-tzu's Essay on Seeing Things as Equal," *History of Religions* 9 (1969/1970), 137–159.

————. (G) " 'Being' in Linguistics and Philosophy," in Verhaar (cited below), vol. 5 (1972), pp. 225–233.

————. (G) "China, Europe and the Origins of Modern Science" in Nakayama and Sivin (cited below) pp. 45–70.

————. (G) *Later Mohist Logic, Ethics and Science.* Hong Kong: Chinese University Press; London: School of Oriental and African Studies, 1978.

————. (G) *Chuang-tzu: Textual Notes to a Partial Translation.* London: School of Oriental and African Studies, 1982.

————. (G) "Value, Fact, and Facing Facts." *Journal of Value Inquiry* 19 (1985), 35–41.

————. (G) *Reason and Spontaneity.* London: Curzon Press, 1985.

———. (G) *Divisions in Early Mohism Reflected in the Core Chapters of Mo-tzu.* Singapore: National University of Singapore, Institute of East Asian Philosophies, 1985.

———. (G) *Studies in Chinese Philosophy and Philosophical Literature.* Singapore: National University of Singapore, Institute of East Asian Philosophies, 1986.

———. (G) *Yin-Yang and the Nature of Correlative Thinking.* Singapore: Institute of East Asian Philosophies, 1986.

———. (G) "A Neglected Pre-Han Philosophical Text: *Ho-kuan-tzu.*" Forthcoming, *BSOAS*, autumn, 1989.

GRANET, Marcel. *La pensée chinoise.* Paris: Albin Michel, 1934.

GRAZIA, Sebastian de. (ed.) *Masters of Chinese Political Thought.* New York: Viking Press, 1973.

HALL, David L., and AMES, Roger T. *Thinking Through Confucius.* New York: State University of New York Press, 1987.

Han Fei tzu (HF) 韓非子 . Ed. by Ch'en Ch'i-yu 陳奇猷 . *Han Fei tzu chi-shih* 韓非子集釋 Peking: Chung-hua Book Co., 1958.

Han Fei tzu (HF). Tr. by W. K. Liao, *Han Fei Tzu.* London: Arthur Probsthain, vol. 1, 1938; vol. 2, 1959.

Han Fei tzu (HF). Tr. by Burton Watson (W), *Han Fei tzu: Basic Writings.* (12 chs.) New York: Columbia University Press, 1964.

HANSEN, Chad. *Language and Logic in Ancient China.* Ann Arbor: University of Michigan Press, 1983.

———. "Chinese Language, Chinese Philosophy and 'Truth'." *Journal of Asian Studies* 44 (1985), 491–517.

Han shu 漢書 (Han History) Peking: Chung-hua Book Co., 1962.

HARBSMEIER, Christoph. *Wilhelm von Humboldts Brief an Abel Rémusat und die philosophische Grammatik des Altchinesischen*. Stuttgart-Bad Cannstatt: Friedrich Fromann Verlag, 1979.

———. *Aspects of Classical Chinese Syntax*. Scandinavian Institute of Asian Studies Monograph Series no. 45. London: Curzon Press, 1981.

———. "Language and Logic in Ancient China," in Needham, vol. 7, no. 1 (forthcoming).

HAWKES, David. *Ch'u-tz'u, the Songs of the South*. Oxford: The Clarendon Press, 1959.

HENDERSON, John B. *Development and Decline of Chinese Cosmology*. New York: Columbia University Press, 1984.

HENRICKS, Robert G. "Examining the Ma-wang-tui Silk Texts of the *Lao-tzu*, with Special Note of Their Differences from the Wang Pi Text', *T'oung Pao* 65 (1979), 166–199.

———. "On the chapter divisions in the *Lao-tzu*." *BSOAS* vol. 45, no. 3 (1982), 501–524.

HIPPOCRATES. *Hippocrates and the Fragments of Heracleitus*. Tr. by W. H. S. Jones and E. T. Witherington, 4 vols. London and New York: Loeb Classical Library, 1923–31.

Ho-kuan-tzu 鶡冠子 . (*Wan-yu wen-k'u* 萬易文庫).

Ho-kuan-tzu. Tr by Klaus Karl Neugebauer, *Hoh-kuan tsï. Eine Untersuchung der dialogischen Kapitel (mit Übersetzung und Annotationen)* (7 chs.). Frankfurt am Mein: Peter Lang, 1986.

Essays on Islamic Philosophy and Science. Ed. by George F. Hourani. Albany, NY: State University of New York Press, 1975.

HO Peng Yoke. *Li, qi and shu: An Introduction to "Science and Civilization in China."* Hong Kong: Hong Kong University Press, 1985.

HOURANI, George F. (ed.) *Essays on Islamic Philosophy and Science*. Albany, NY: State University of New York Press, 1975.

HSIAO Kung-chuan. *A History of Chinese Political Thought*. Tr. by F. W. Mote. Vol. 1. Princeton, NJ: Princeton University Press, 1979.

Hsin hsü 新序 *SPTK*.

HSU Cho-yun. *Ancient China in Transition*. Stanford, CA: Stanford University Press, 1965.

Hsün-tzu (Hs) Tr. by H. H. Dubs, *The works of Hsuntze*. HY London: Arthur Probsthain, 1928.

Hsün-tzu (Hs) 荀子 HY.

Hsün-tzu (Hs) Tr. by Burton Watson (W), *Hsün Tzu: Basic Writings*. (10 chs.) New York: Columbia University Press, 1963.

Hsün-tzu (Hs) Tr. by John Knoblock, *Xunzi: A Translation and Study of the Complete Works*, vol. 1 (chs. 1–6). Stanford, CA: Stanford University Press, 1988.

HU, Shih. *The Development of the Logical Method in Ancient China*. Shanghai: Commercial Press, 1922.

Huai-nan-tzu 淮南子 Ed. by Liu Wen-tien. *Huai-nan hung-lieh chi-chieh* 淮南鴻烈集釋 . Shanghai: Commercial Press, 1933.

Huang-ti nei-ching 黃帝內經 ("Inner Classic of the Yellow Emperor") *SPTK*.

JAKOBSON, Roman. *Selected Writings* vol. 2. The Hague and Paris: Mouton, 1971.

JAN Yun-hua. "Tao, Principle and Law: The Three Key Concepts in the Yellow Emperor Taoism." *JCP*, vol. 7, no. 3, (1980), 205–228.

———. 'Tao Yuan or Tao: The Origin', *JCP* vol. 7, no. 3, (1980), 195–204.

———. "The Silk Manuscripts on Taoism." *T'oung Pao* 63 (1977), 65–84.

JASPERS, Karl. *The Origin and Goal of History*. New Haven, CT: Yale University Press, 1953.

KAHN, Charles. "The Greek Verb 'to be' and the Concept of Being." *Foundations of Language* 2 (1966), 245–266.

———. "The Verb 'be' in Ancient Greek." Verhaar (cited below), vol. 6 (1973), 1–486.

KAIZUKA, Shigeki. *Confucius.* Tr. by G. Bownas. London: Allen & Unwin, 1974.

KANDEL, J. E. *Ein Beitrag zur Interpretationsgeschichte des abstrakten Denkens in China: die Lehren des Kung-sun Lung und deren Ausnahme in der Tradition.* Hochberg: privately printed, 1976.

KANT, Immanuel. *Critique of Pure Reason.* Chinese translation by Lan Kung-wu 藍公武 . K'ang-te 康德 , *Ch'un-ts'ui li-hsing p'i-p'an* 純粹理性批判 . Peking: San-Lien Book Co., 1957.

———. *Critique of Pure Reason.* Tr. by Norman Kemp Smith. London: Macmillan, 1964.

KAO, Kung-yi and OBENCHAIN, Diane B. "Kung-sun Lung's *Chih wu lun* and Semantics of Reference and Predication." *JCP* vol. 2, no. 3 (1975), 285–324.

KARLGREN, Bernhard. "Le proto-chinois langue flexionelle." *Journal asiatique* 11 (1920), 205–232.

———. *Grammata serica recensa. Bulletin of the Museum of Far-Eastern Antiquities,* vol. 29. Stockholm, 1957.

KEPLER, Johannes. *Epitome of Copernican Astronomy.* Books 4 and 5. Tr. by Charles Glenn Wallis, in *Great Books of the World* vol. 16. Chicago: University of Chicago Press, 1952.

KIRK, G. S. and RAVEN, J. E. *The Pre-Socratic Philosophers.* Cambridge: Cambridge University Press, 1960.

KNOBLOCK, John H. "The Chronology of Xunzi's Works." *Early China* 8 (1982/1983), 29–52.

KRAMERS, R. P. *K'ung Tzu Chia Yü: The School Sayings of Confucius,* Leiden, 1950.

KUAN Feng 關鋒 in *Chuang-tzu che'hsüeh t'ao-lun chi* 莊子哲學討論集. Peking: Chung-hua Book Co., 1962.

Kuan-tzu (Kz) 管子 BSS.

Kuan-tzu (Kz) Tr. by W. Allyn Rickett (RK), *Kuan-tzu.* BSS. (10 chs.) Hong Kong: Hong Kong University Press, 1965.

Kuan-tzu (Kz) Tr. by W. Allyn Rickett (RG). *Guanzi* (35 chs.) Princeton, NJ: Princeton University Press, 1985.

KUHN, Thomas S. *The Structure of Scientific Revolutions.* Chicago: University of Chicago Press, 1970.

Kung-sun Lung tzu. 公孫龍子 (Taoist Patrology ed'n.)

Kung-sun Lung tzu. Tr. by Y. P. Mei, "The *Kung-sun Lung tzu* with a Translation into English." *HJAS* 16 (1953), 404–437.

Kung-sun Lung tzu. Tr. by Kou Pao-koh, *Deux sophistes chinois: Houei Che et Kong-Souen Long,* Paris: Presses Universitaires de France, 1953.

Kung-sun Lung tzu tr. German, Kandel 61–117.

Kung-sun Lung tzu. Chs. 2–6, Tr. by Chan (cited above), pp. 235–243.

K'ung-ts'ung-tzu 孔叢子 SPTK.

KUO Mo-jo 郭沫若, WEN Yi-to 聞一多, and HSÜ Wei-yü 許維遹 *Kuan-tzu chi-chiao* 管子集校 Peking: Scientific Publishing Co., 1956.

———. 郭沫若. *Ch'ing-t'ung shih-tai* 青銅時代. Peking: Scientific Publishing Co., 1957.

Kuo yü 國語 ('Sayings of the States') Shanghai: Ku-chi Publishing Co., 1978.

Lao-tzu (Lz) 老子 . Tr. by Arthur Waley. *The Way and its Power.* London: Allen & Unwin, 1934.

Lao-tzu (Lz). Tr. by J. J. L. Duyvendak. *Tao Te Ching.* London: John Murray, 1954.

Lao-tzu (Lz). Tr. by Chan (cited above) pp. 136–176.

Lao-tzu (Lz). Tr. by D. C. Lau, *Lao Tzu, Tao te ching.* Harmondsworth, Middlesex: Penguin Classics, 1963.

Lao-tzu (Lz). Tr. by D. C. Lau, *Chinese Classics: Tao te ching.* (Text and translation of both standard and Ma-wang-tui *Lao-tzu.*) Hong Kong: Chinese University Press, 1982.

LAU D. C. "Some Logical Problems in Ancient China." *Proceedings of the Aristotelian Society* n.s. 53 (1952/1953), 189–204.

———. "Theories of Human Nature in *Mencius* and *Shyuntzyy*." *BSOAS* vol. 15, no. 3 (1953), 541–565.

———. "The Treatment of Opposites in *Lao-tzu*." *BSOAS* 21 (1958), 344–360.

———. "On Mencius' Use of the Method of Analogy in Argument." *Asia Major* n.s. 10 (1963), 173–194.

———. "Taoist Metaphysics in the *Chieh Lao* and Plato's Theory of Forms." *Wen lin* 文 林 vol. 6, (forthcoming).

LEE, Cyrus. "Mo-tzu: On Time and Space." *Chinese Culture* vol. 6, no. 1 (1964), 68–78.

LEGGE, James (L). *The Chinese Classics.* (First ed'n. Hong Kong, 1861-1873.) Hong Kong: Hong Kong University Press, 1961.

LEIBNIZ, G. W. *Discourse on the Natural Theology of the Chinese.* Tr. by Henry Rosemont Jr. and Daniel J. Cook. Honolulu: University Press of Hawaii, 1977.

LESLIE, Donald. *Argument by Contradiction in Pre-Buddhist Chinese Reasoning*. Canberra: Australian National University, 1964.

LÉVI-STRAUSS, Claude. *La pensée sauvage*. Paris: Plom, 1962.

LIANG Ch'i-ch'ao 梁啓超 . *Mo-ching chiao-shih* 墨經校釋. Shanghai: Commercial Press, 1922.

Li chi 禮記 "Record of Ceremony"). Tr. by James Legge, *The Li Ki, Sacred Books of the East*, vols. 27, 28. Oxford: Oxford University Press, 1885.

Lieh-tzu 列子 *SPTK*

Lieh-tzu. Tr. by A. C. Graham, *The Book of Lieh-tzu*. London: John Murray, 1960.

LOEWE, Michael. "Manuscripts Found Recently in China." *T'oung Pao* vol. 63, nos. 2, 3 (1977), 99–136.

Lun heng 論衡. Ed. by Liu P'an-sui 劉盼遂 . *Lun heng chi chieh* 論衡集解 . Peking: Ku-chi Publishing Co., 1957.

Lun heng. Tr. by Alfred Forke, *Lun Heng, Essays of Wang Ch'ung*. New York: Paragon Book Gallery, 1962.

Lü-shih ch'un-ch'iu (LSCC) 呂氏春秋 (Lü Spring and Autumn). Ed. by Hsü Wei-yü 許維遹 .*Lü-shih ch'un-ch'iu chi-shih* 呂氏春秋集釋 . Peking: Commercial Press, 1955.

Lü-shih ch'un-ch'iu (LSCC). Tr. by R. Wilhelm, *Frühling und Herbst des Lü Bu We*. Jena: Diederichs, 1928.

LYONS, John. *Introduction to Theoretical Linguistics*. Cambridge: Cambridge University Press, 1969.

MAJOR, John. "A Note on the Translation of two Technical Terms in Chinese Science." *Early China* 2 (1976) 1–3.

———. "The Five Phases, Magic Squares and Schematic Cosmography," in Rosemont *Explorations* (cited below) pp. 133–166.

MASPERO, Henri. *La Chine antique* (*Histoire du monde,* vol. 4) Paris: Boccard Editeurs, 1927.

—. "Notes sur la logique de Mo-tseu et de son école." *T'oung Pao* 25 (1928), 1–64.

—. "L'astronomie chinoise avant les Han." *T'oung Pao* 26 (1929), 267–356.

—. *Taoism and Chinese Religion.* Tr. by Frank A. Kierman, Jr. Amherst, MA: University of Massachusetts Press, 1981.

MEI Tsu-lin. "Subject and Predicate: A Grammatical Preliminary," *Philosophical Review* 70 (1961), 153–175.

—. "Chinese Grammar and the Linguistic Movement in Philosophy." *Review of Metaphysics* 14 (1961), 463–492.

MEI Y. P. *Mo-tse, the Neglected Rival of Confucius.* London: Arthur Probsthain, 1934.

Meng-tzu 孟子 (Mencius) *HY*

Meng-tzu (Mencius) *(Me)* Tr. by Legge (cited above), *Classics.*

Meng-tzu (Mencius) *(Me)* Tr. by D. C. Lau. *Mencius.* Harmondsworth, Middlesex: Penguin Classics, 1970.

MORITZ, R. *Hui Shi und die Entwicklung des philosophischen Denkens in alten China.* Berlin: Akademie Verlag, 1973.

Mo-tzu (Mo) 墨子 *HY*

Mo-tzu (Mo) Ed. by Sun Yi-jang 孫詒讓. *Mo-tzu chien-ku* 墨子閒詁 Peking: Chung-hua Book Co., 1954.

Mo-tzu. (Mo) Tr. by Y. P. Mei. *The Ethical and Political Works of Mo-tse.* (Chs. 1–39; 46–50.) London: Arthur Probsthain, 1929.

Mo-tzu. (Mo) Chs. 40–45 Tr. by A. C. Graham (G) in *Later Mohist Logic* (cited under 'Graham' above), pp. 243–494.

Mo-tzu. (Mo) Tr. by Burton Watson (W), *Mo Tzu: Basic Writings.* (14 chs.) New York: Columbia University Press, 1963.

Mo-tzu. (Mo) Tr. (complete) by Alfred Forke. *Me Ti des Sozialethikers und seiner Schüler philosophische Werke.* Berlin: Mitteilungen des Seminars für Orientalische Sprachen, vols. 23–25, 1922.

MULLIE, Joseph. "Le mot-particule 之 *tche*," *T'oung Pao* 36 (1942), 181–400.

MUNRO, Donald J. *The Concept of Man in Early China.* Ann Arbor, MI: University of Michigan Press, 1977.

———. (ed.), *Individualism and Holism.* Ann Arbor, MI: University of Michigan Center for Chinese Studies, 1985.

NAKAYAMA, Shigeru and SIVIN, Nathan. (eds.), *Chinese Science.* Cambridge, MA: MIT Press, 1973.

NEEDHAM, Joseph. *Science and Civilization in China.* Cambridge: Cambridge University Press, 1954ff.

———. *The Grand Titration: Science and Society in East and West.* Toronto: University of Toronto Press, 1969.

NIETZSCHE, Friedrich. *Beyond Good and Evil.* Tr. by R. J. Hollingdale. Harmondsworth, Middlesex: Penguin Classics, 1973.

NIVISON, David Sheperd. "The Dates of Western Chou," *HJAS* 43 (1983), 481–580.

———. "1040 as the Date of the Chou Conquest," *Early China* 8 (1982/1983) 76–78.

———. "Mencius and Motivation," in Rosemont and Schwartz (cited below), pp. 417–432.

PANKENIER, David W. "Astronomical Dates in Shang and Early Chou." *Early China* 7 (1981/1982), 2–37.

PARKES, Graham (ed.), *Heidegger and Asian Thought.* Honolulu: University of Hawaii Press, 1987.

PETERSON, Willard J. "Making Connections: 'Commentary on the Attached Verbalisations' of the Book of Change." *HJAS,* vol. 42, no. 1 (1982), 67–116.

PLATO. *Republic.* Chinese trans. by Wu Hsien-shu 吳獻書 . *P'o-la-t'u chih li-hsiang-kuo* 栢拉圖之 理想國 Shanghai: Commercial Press, 1920.

———. *Republic.* Tr. by H. D. P. Lee. Harmondsworth, Middlesex: Penguin, 1955.

Po hu t'ung 白虎通 *SPTK*

Po hu t'ung (White Tiger Discussions) Tr. by Tjan Tjoe Som. *Po hu t'ung.* 2 vols. Leiden: E. J. Brill, 1949, 1952.

POPPER, Karl R. *The Logic of Scientific Discovery.* London: Hutchinson, 1972.

QIAN Wen-yuan. *The Great Inertia: Scientific Stagnation in Traditional China.* London: Croom Helm, 1985.

QUINE, W. V. *Ontological Relativity and Other Essays.* New York: Columbia University Press, 1969.

———. *From a Logical Point of View.* (First ed'n. 1953.) Cambridge, MA: Harvard University Press, 1980.

RAJCHMAN, John and WEST, Cornel (eds.) *Post-analytic Philosophy.* New York: Columbia University Press, 1985.

REDING, Jean-Paul. *Les fondemonts philosophiques de la rhétorique chez les sophistes grecs et chez les sophistes chinois.* Berne: Peter Lang, 1985.

———. "Analogical Reasoning in Early Chinese Philosophy." *Asiatische Studien* 40 (1986).

———. "Greek and Chinese Categories." *PEW,* vol. 36, no. 4 (1986) 349–374.

RIEMANN, F. "Kung-Sun Lung, Designated Things and Logic." *PEW,* 30 (1980), 305–319.

ROSEMONT, Henry, Jr. "On Representing Abstractions in Archaic Chinese," *PEW,* vol. 24, no. 1 (1974).

———. Review article on Fingarette's *Confucius: The Secular as Sacred. PEW,* vol. 26, no. 4 (1976) 463–477.

———. "Reply to Professor Fingarette." *PEW,* vol. 28, no. 4 (1978) 515–519.

———. "Gathering Evidence for Linguistic Innateness," *Synthèse* 38 (1978) 127–148.

———. "State and Society in the *Hsün Tzu." Monumenta serica* 29 (1970-1971).

———. (ed.) *Explorations in Early Chinese Cosmology.* Chico, CA: *Journal of the American Academy of Religion,* Studies vol. 50, no. 2. 1984.

———. (ed.) *Chinese Texts and Philosophical Contexts.* La Salle, IL: Open Court, forthcoming 1990.

ROSEMONT, Henry Jr. and SCHWARTZ, Benjamin I. (eds.) *Studies in Classical Chinese Thought. Journal of the American Academy of Religion* Thematic Issue vol. 47, no. 3 (1979).

RUBIN, Vitaly A. "Tzu-ch'an and the City-state of Ancient China." *T'oung Pao* 52 (1965), 8–34.

———. *Individual and State in Ancient China.* New York: Columbia University Press, 1976.

———. "Wu hsing and Yin-yang." *Journal of Chinese Philosophy,* vol. 19, no. 2 (1982) 131–155.

RYLE, Gilbert. *The Concept of Mind*, London: Hutchinson's University Library, 1949.

SAUSSURE, Ferdinand de. *Course in General Linguistics*. Tr. by Wade Baskin. London: Fontana/Collins, 1974.

SCHLEICHERT, Hubert. *klassische Chinesische Philosophie*. Frankfurt am Main: Klostermann, 1980.

SCHWARTZ, Benjamin I. "On the Absence of Reductionism in Chinese Thought." *JCP*, vol. 1, no. 1 (1973), 27–43.

————. *The World of Thought in Ancient China*. Cambridge, MA: Harvard University Press, 1985.

Shang-tzu 商子(Book of Lord Shang). Ed. by Kao Heng 高亨 . *Shang-chün shu chu-yi* 商君書注譯 Peking: Chung-hua Book Company, 1974.

Shang-tzu. Tr. by J. J. L. Duyvendak (D), *Book of the Lord Shang*. London: Arthur Probsthain, 1928.

SHCHUTSKII, Iulian K. *Researches on the I Ching*. Tr. by William L. MacDonald and Tsuyoshi Hasegawa with Hellmut Wilhelm. Princeton, NJ: Princeton University Press, 1979.

SHEHADI, Fadlou. "Arabic and 'to be'." in Verhaar, vol. 4 (1969) (cited below), pp. 112–125.

————. "Arabic and the Concept of Being," in Hourani (cited above), pp. 147–157.

Shen-tzu 慎子 (Shen Tao). Tr. by Paul M. Thompson. *The Shen Tzu Fragments*. University of Washington thesis, 512–575. (Translation not included in published version, cited under Thompson, below.)

Shen-tzu 申子 (Shen Pu-hai). Fragments tr. by Creel, *Shen Pu-hai*, 344–392.

Shih chi 史記 *(Records of the Historiographer)* by Ssu-ma Ch'ien 司馬遷 Peking: Chung-hua Book Co., 1959.

Shih chi Tr. by Burton Watson (W), *Records of the Historian*. (19 chs.) New York: Columbia University Press, 1969.

Shih chi. Tr. by Yang Hsien-yi and Gladys Yang. *Selections from "Records of the Historian."* (31 chs.) Peking: Foreign Language Press, 1979.

Shih chi. Tr. by Edouard Chavannes. *Les mémoires historiques de Se-Ma Ts'ien.* Vols. 1–6. (Fullest translation. First ed'n. 1895–1905.) Paris: Ernest Leroux, 1969.

Shih ching 詩經 ("Songs") Tr. by Bernhard Karlgren. *The Book of Odes.* Stockholm: Museum of Far-Eastern Antiquities, 1950.

Shih-tzu 尸子. *SPPY.*

Shu ching 書經 ("Documents") Tr. by Bernhard Karlgren. *The Book of Documents. Bulletin of the Museum of Far-Eastern Antiquities,* vol. 22. Stockholm, 1950.

Shuo yüan 説苑 *SPTK.*

SIVIN, Nathan. *Chinese Alchemy, Preliminary Studies.* Cambridge, MA: Harvard University Press, 1968.

———. *Cosmos and Computation in Early Chinese Mathematical Astronomy.* Leiden: E. J. Brill, 1969.

———. (ed.) *Science and Technology in East Asia.* New York: Science History Publications, 1977.

SOLOMON, Bernard S. "The Assumptions of Hui Shih." *Monumenta serica* 28 (1969), 1–40.

STRICKMANN, Michel. "On the Alchemy of Ta'o Hung-ching." Welch and Seidel (cited below), pp. 123–192.

Ta hsüeh 大學 ("Great learning") Tr. by Legge (L) (cited above), *Classics.*

Ta hsüeh ("Great learning") Tr. by Chan (cited above) pp. 84–94.

T'ai-p'ing yü-lan 大平御覽. *SPTK.*

THOMPSON, Paul M. *The Shen Tzu Fragments.* Oxford: Oxford University Press, 1979.

Tso chuan 左傳 ("Tso Commentary") Tr. by Legge (L) (cited above) *The Ch'un ts'ew with the Tso chuen, Classics* vol. 5.

TU Wei-ming. *Humanity and Self-cultivation: Essays in Confucian Thought.* Berkeley, CA: Asian Humanities Press, 1979.

TWITCHETT, Denis and FAIRBANK, John K. (eds.) *The Cambridge History of China.* Vol. 1. Cambridge: Cambridge University Press, 1986.

VAN DER LOON, P. "On the Transmission of Kuan-tzu." *T'oung Pao* 41 (1952), 357–393.

VANDERMEERSCH, Léon. *La formation du légisme.* Paris: Ecole Française Extrême Orient, 1965.

VERHAAR, John W. M. (ed.) *The Verb 'be' and its Synonyms. Foundations of Language, Supplementary Series.* Dordrecht, Holland: D. Reidel, 1967ff.

VERVOORN, Aat. "The Origins of Chinese Eremitism." *Journal of the Institute of Chinese Studies of the Chinese University of Hong Kong* 15 (1984) 249–295.

WALEY, Arthur. *Three Ways of Thought in Ancient China.* London: Allen & Unwin, 1939.

————. *Chinese Poems.* London: Unwin Books, 1946.

WEBER, Max. *The Religion of China.* Tr. by Hans H. Gerth. New York: Free Press, 1968.

WELCH, Holmes and SEIDEL, Anna. (eds.) *Facets of Taoism.* New Haven and London: Yale University Press, 1979.

WHORF, B. L. *Language, Thought and Reality.* New York: John Wiley, 1956.

WILHELM, Hellmut. *Change: Eight Lectures on the I Ching.* Tr. by Carey F. Baynes. New York: Pantheon Books, 1960.

————. *Heaven, Earth and Man in the Book of Changes.* Seattle, WA: University of Washington Press, 1977.

WILHELM, Richard. *Lectures on the I Ching.* Tr. by Irene Eber. Princeton, NJ: Princeton University Press, 1979.

WITTGENSTEIN, Ludwig. *Philosophical Investigations.* Tr. by G. E. M. Anscombe. Oxford: Basil Blackwell, 1953.

WRIGHT, Frank Lloyd. *Writings and Buildings.* Ed. by Edgar Kaufmann and Ben Raeburn. Cleveland, OH: World Publishing Co., 1960.

WU Kuang 吳光. *Huang-Lao chih hsüeh t'ung-lun* 黃老之哲學通論. Hangchou: Che-chiang Peoples' Press, 1985.

WU, Kuang-ming. "Counterfactuals, Universals and Chinese Thinking." *PEW,* vol. 37, no. 1 (1987) 84–94.

YATES, Frances. *Giordano Bruno and the Hermetic Tradition.* London: Routledge & Kegan Paul, 1964.

YATES, Robin. *Towards a Reconstruction of the Tactical Chapters of Mo-tzu (chüan 14),* University of California (Berkeley) thesis, 1975.

———. "The Mohists on Warfare: Technology, Technique and Justification," in Rosemont and Schwartz (cited above), pp. 549–603.

Yi ching 易經 HY

Yi ching. I Ching, Book of Changes. Tr. by James Legge (L). Edited, with introduction and study guide by Ch'u Chai with Winberg Chai. *HY* (From 2nd ed'n. *Sacred Books of the East,* vol. 16, Oxford, 1899.) New York: Bantam Books, 1969.

Yi ching. Tr. by Richard Wilhelm, *I Ging. Das Buch der Wandlungen,* Jena: Diederichs, 1924.

Yi ching. I Ching or Book of Changes. (Richard Wilhelm translation rendered into English by Cary F. Baynes [WB], foreword by C. G. Jung. Preface to third ed'n. by Hellmut Wilhelm.) London: Routledge & Kegan Paul, 1968.

Yü-tzu 鬻子. (Taoist Patrology ed'n.)

Name Index

Subject Index

(For some items, a selection of examples of the word used in quoted passages is introduced by 'Examples:')

sition, 97

As 'situation' from which one sees, Example: 206

Shih 使 'to cause'

Distinguished by Later Mohists from *shih* in its primary sense, 'employ on a mission', 162

Chieh-tzu's 'Something causes it', 210

Outside technical contexts variously translated: 'make to', 249; 'be the agent', 198; 'make serve you', 240; 'employ', 182

Cf. as particle *shih* 'supposing that' (causing it to be that), counterfactual, 165, 397n, 398

Examples: 86, 88, 93, 280, 410

Shih 是 'this, is this' and *fei* 非 'is not'

Used to judge between right and wrong alternatives in *pien* 'argumentation' (when translated 'right' and 'wrong' not to be confused with the moral concept *yi*, the 'right' as the socially fitting), 36, 167f, 176–183

Shih 'this' and *jan* 'so', 151, 154, 168, 184

Their relation to the grammar of nominal and verbal sentences, 154, 408, 420

Cf. *Wei shih* and *yin shih*

Shih 實 'solid, full, real' and *hsü* 虛 'tenuous, empty, unreal', 222

Only the concrete is solid, real, 222

The empty or tenuous in Taoism, 192, 198, 235; in *Hsün-tzu*,

253; in *Han Fei tzu*, 288

'Full' words and 'empty' words, 391

Cf. *Ming and shih* 'name and object'

Shih-tzu 尸子 (syncretistic text, about 3rd century B.C.), 20

Shu 恕 'likening to oneself'

The correlation of self and other crucial to Chinese ethical thinking, 20, 383

Shih-tzu definition, 20

For Confucius, 20f, 30, 193, 385; Mencius, 109, 127; 'Great learning', 133f; Hsün-tzu, 20, 257; 'Seven standards', 274

Shu 術 'method' (the traditional lore of a profession or craft)

For Legalism, methods of bureaucratic organisation, 268

'Methods of heart', 274f

Cf. *Fang shu* and *Tao shu*

Similarity and difference

four types in *Canons*, 147f

eight in *Names and objects*, 153f

In Jakobsonian linguistics, 321

In correlative thinking, 338, 404

As theme of Sophists, 75, 78f; of Later Mohists, 147–155; of Hsün-tzu, 264–6

Likeness as basis of naming, 140f, 264f; of a Hui Shih definition, 81

Cf. *Analogy, Shu* 'likening to oneself'

Six Stores. *See Liu fu*

Social contract, 46

Something and nothing. *See Yu and Wu*

Songs (*Shih ching* 詩經), 9–11, 19,